Impressionism, Fashion, & Modern

he American presentations f *Impressionism, Fashion, Modernity* are anchored y generous loans from e Musée d'Orsay, Paris, uy Cogeval, President ıd Director.

Organizing Institutions

MUSÉE D'ORSAY, Paris
Guy Cogeval, President and Director, Musée d'Orsay
 and Musée de l'Orangerie
Thierry Gausseron, former Chief Finance Officer
Anne Mény-Horn, Associate Finance Officer
Olivier Simmat, Director of Patron and
 International Development
Hélène Flon, Exhibitions Director
Doris Grunchec, Exhibitions Manager
Élise Bauduin, Exhibitions Manager
Robert Carsen, Exhibition Designer and
 Artistic Director

THE METROPOLITAN MUSEUM OF ART, New York
Thomas P. Campbell, Director and Chief
 Executive Officer
Jennifer Russell, Associate Director for Exhibitions
Carrie Rebora Barratt, Associate Director for
 Collections and Administration

THE ART INSTITUTE OF CHICAGO
Douglas Druick, President and Eloise W. Martin
 Director
Dorothy Schroeder, Vice President for Exhibitions
 and Museum Administration

Impressionism, Fashion, & Modernity

Edited by Gloria Groom

With contributions by Heidi Brevik-Zender, Helen Burnham, Guy Cogeval, Justine De Young, Gloria Groom, Stéphane Guégan, Birgit Haase, Elizabeth Anne McCauley, Sylvie Patry, Aileen Ribeiro, Valerie Steele, Françoise Tétart-Vittu, Philippe Thiébaut, Gary Tinterow, and David Van Zanten

Exhibition organized by

Guy Cogeval
President and Director, Musée d'Orsay, Paris

Gloria Groom
David and Mary Winton Green Curator,
The Art Institute of Chicago

Susan Alyson Stein
Curator, The Metropolitan Museum of Art, New York

Philippe Thiébaut
Curator, Musée d'Orsay, Paris

THE ART INSTITUTE OF CHICAGO
in association with
THE METROPOLITAN MUSEUM OF ART, New York,
and MUSÉE D'ORSAY, Paris

Distributed by YALE UNIVERSITY PRESS, New Haven and London

Impressionism, Fashion, and Modernity was published in conjunction with an exhibition of the same title organized by The Art Institute of Chicago, The Metropolitan Museum of Art, New York, and the Musée d'Orsay, Paris.

EXHIBITION DATES

Musée d'Orsay, Paris
September 25, 2012–January 20, 2013

The Metropolitan Museum of Art, New York
February 26–May 27, 2013

The Art Institute of Chicago
June 26–September 22, 2013

The major funding for *Impressionism, Fashion, and Modernity* at the Art Institute of Chicago has been generously provided by Alexandra and John Nichols.

JPMorgan Chase is the Corporate Sponsor of *Impressionism, Fashion, and Modernity* at the Art Institute of Chicago.

The Auxiliary Board of the Art Institute of Chicago is the Lead Affiliate Sponsor of *Impressionism, Fashion, and Modernity*.

ART INSTITVTE CHICAGO THE AUXILIARY BOARD THE ART INSTITUTE OF CHICAGO

The exhibition catalogue has been underwritten by Laurie and James Bay and the Elizabeth F. Cheney Foundation.

Annual support for Art Institute exhibitions is provided by the Exhibitions Trust: Goldman Sachs, Kenneth and Anne Griffin, Thomas and Margot Pritzker, the Earl and Brenda Shapiro Foundation, the Trott Family Foundation, and the Woman's Board of the Art Institute of Chicago.

In New York, the exhibition is made possible in part by The Philip and Janice Levin Foundation and the Janice H. Levin Fund. Additional support is provided by the William Randolph Hearst Foundation. Educational programs are made possible by The Georges Lurcy Charitable and Educational Trust.

The exhibition in Chicago and New York is supported by an indemnity from the Federal Council on the Arts and the Humanities.

Published by
The Art Institute of Chicago
111 South Michigan Avenue
Chicago, Illinois 60603-6404
www.artic.edu

Distributed by
Yale University Press
302 Temple Street
P.O. Box 209040
New Haven, Connecticut 06520-9040
www.yalebooks.com/art

Produced by the Publications Department of the Art Institute of Chicago, Robert V. Sharp, Executive Director
Edited by Susan E. Weidemeyer and Amy R. Peltz
Production by Sarah E. Guernsey and Joseph Mohan
Photography research by Lauren Makholm
Proofreading by Christine Schwab
Index by Lori Van Deman-Iseri
Designed and typeset in Atma Serif and Syntax by Roy Brooks, Fold Four, Inc., Milwaukee, Wisconsin
Separations by Professional Graphics, Inc., Rockford, Illinois
Printing and binding by Conti Tipocolor, Florence, Italy

This book has been printed on paper certified by the Forest Stewardship Council.

The essays by Guy Cogeval and Stéphane Guégan, Philippe Thiébaut, and Françoise Tétart-Vittu were translated from the French by Jean Coyner. The essay by Sylvie Patry was translated from the French by Marie-Caroline Dihu and Gloria Groom. The essays by Birgit Haase were translated from the German by Michael Winkler.

Photography of objects in the collection of the Art Institute of Chicago was produced by the Department of Imaging, Christopher Gallagher, Director. Unless otherwise stated, photographs of all other artworks appear by permission of the private or institutional lenders or owners identified in their respective captions. Every effort has been made to identify, contact, and acknowledge copyright holders for all reproductions; additional rights holders are encouraged to contact the Publications Department of the Art Institute of Chicago. Credits for all images for which separate acknowledgment is due are provided in the Photography Credits on page 336.

Cover and Jacket Images
Front: Claude Monet, *Women in the Garden* (detail of cat. 45), 1866; oil on canvas; Musée d'Orsay, Paris.
Back: American, Day dress (cat. 36), 1862/64; white cotton piqué embroidered with black soutache; The Metropolitan Museum of Art, New York.

Details
Page 16: James Tissot, *The Marquis and Marquise de Miramon and Their Children* (cat. 1), 1865. Page 27: Édouard Manet, *Young Lady in 1866* (cat. 9), 1866. Page 32: Pierre-Auguste Renoir, *The Loge* (cat. 12), 1874. Page 45: Claude Monet, *Camille* (cat. 16), 1866. Page 52: Constantin Guys, *Reception* (cat. 18), 1847/48. Page 62: French, Summer dress worn by Madame Bartholomé in the painting *In the Conservatory* (cat. 29), 1880. Page 79: Édouard Manet, *The Parisienne* (cat. 33), c. 1875. Page 84: Claude Monet, *Bazille and Camille (Study for "Luncheon on the Grass")*(cat. 35), 1865. Page 101: Claude Monet, *Women in the Garden* (cat. 45), 1866. Page 106: Édouard Manet, *Lady with Fan* (cat. 50), 1862. Page 125: Édouard Manet, *Nana* (cat. 57), 1877. Page 134: Gustave Caillebotte, *Portrait of a Man* (cat. 72), 1880. Page 147: James Tissot, *The Circle of the Rue Royale* (cat. 73), 1868. Page 152: James Tissot, *The Shop Girl* from the series *Women of Paris* (cat. 75), 1883–85. Page 164: Mary Cassatt, *Woman with a Pearl Necklace in a Loge* (cat. 88), 1879. Page 187: Gustave Caillebotte, *Paris Street; Rainy Day* (cat. 93), 1877. Page 196: André-Adolphe-Eugène Disdéri, Untitled carte de visite (see page 302), 1859. Page 208: Edgar Degas, *Madame Jeantaud at the Mirror* (cat. 100), c. 1875. Page 219: Edgar Degas, *The Millinery Shop* (cat. 105), 1879/86. Page 232: Édouard Manet, *Woman Reading* (cat. 122), 1879/80. Page 245: Pierre-Auguste Renoir, *Madame Georges Charpentier and Her Children* (cat. 124), 1878. Page 252: American, Day dress (cat. 132), 1883/85.

First edition, second printing
Printed in Italy
Library of Congress Control Number: 2012940084
ISBN: 978-0-300-18451-8 (hardcover)
ISBN: 978-0-86559-253-7 (softcover)

Contents

The major funding for *Impressionism, Fashion, and Modernity* at the Art Institute of Chicago has been generously provided by Alexandra and John Nichols.

The exhibition catalogue has been underwritten by Laurie and James Bay and the Elizabeth F. Cheney Foundation.

The Auxiliary Board of the Art Institute of Chicago is the Lead Affiliate Sponsor of *Impressionism, Fashion, and Modernity.*

Annual support for Art Institute exhibitions is provided by the Exhibitions Trust: Goldman Sachs, Kenneth and Anne Griffin, Thomas and Margot Pritzker, the Earl and Brenda Shapiro Foundation, the Trott Family Foundation, and the Woman's Board of the Art Institute of Chicago.

JPMorgan Chase is the Corporate Sponsor of *Impressionism, Fashion, and Modernity* at the Art Institute of Chicago.

JPMorgan Chase believes that arts and culture are the lifeblood of vibrant communities. We support a range of programs and events that foster creativity, provide access to the arts to underserved audiences, promote self-expression, and celebrate diversity.

Celebrating more than a half century of collecting and philanthropic support for arts and culture, our commitment to excellence, diversity, and originality remains steadfastly at the heart of our approach. The focus has remained the same: provide visual and intellectual interest to nourish the imagination.

Impressionism, Fashion, and Modernity is the first exhibition to exclusively examine the ways in which the Impressionists used fashion to communicate the idea of the "modern." It gives visual light to the time in which the modern fashion industry began. By capturing the everyday, these celebrated artists give us a view of a world where the department store was born and fashion magazines came into being. Examining Impressionist masters like Caillebotte, Degas, Manet, Monet, Renoir, and Seurat alongside fashion portraitists like Stevens and Tissot brings new thinking to the way these great artists worked.

JPMorgan Chase is proud to be a decades-long partner of the Art Institute of Chicago, serving as the Founding Civic Sponsor of the Modern Wing and the lead corporate sponsor of this exhibition in Chicago. We share in the museum's mission to bring the very best art objects from around the world in service to the community and scholarship, and we welcome you to enjoy *Impressionism, Fashion, and Modernity*.

Art Gallery of Ontario, Toronto
The Art Institute of Chicago
Association des Amis du Petit Palais, Geneva
Chicago History Museum
The Cleveland Museum of Art
The Courtauld Gallery, London
Fine Arts Museums of San Francisco
The J. Paul Getty Museum, Los Angeles
Solomon R. Guggenheim Museum, New York
Hamburger Kunsthalle
Kent State University Museum
Kunsthalle Bremen
Los Angeles County Museum of Art
Manchester Art Gallery, Gallery of Costume
The Metropolitan Museum of Art, New York
Musée des Beaux-Arts, Rouen
Musée d'Orsay, Paris
Musée du Louvre, Paris
Musée Fabre, Montpellier
Musée Marmottan Monet, Paris
Museu de Arte de São Paulo Assis Chateaubriand
Museum Folkwang, Essen
Museum of Art, Rhode Island School of Design, Providence
Museum of Fine Arts, Boston
Museum of Fine Arts, Budapest
Museum of the City of New York
National Gallery of Art, Washington, D.C.
Nationalmuseum, Stockholm
National Portrait Gallery, London
Ordrupgaard, Copenhagen
The Henry and Rose Pearlman Foundation, New York
Petit Palais, Musée des Beaux-Arts de la Ville de Paris
Philadelphia Museum of Art
Princeton University Art Museum
The John and Mable Ringling Museum of Art, Sarasota
Staatliche Kunstsammlungen Dresden, Galerie Neue Meister
Tate
Wallraf-Richartz-Museum & Fondation Corboud, Cologne
Vera Wang
Diane B. Wilsey
And other private collectors who wish to remain anonymous

Impressionism, Fashion, and Modernity is the first exhibition to focus on the defining role of fashion in the works of the Impressionists and their contemporaries. Some eighty major figure paintings—shown in concert with period costumes, accessories, fashion plates, photographs, and popular prints—highlight the vital relationship between fashion and art during the pivotal years from the mid-1860s to the mid-1880s, the period when Paris, as the style capital of the world, provided the inspiration for modern artists.

With the rise of the department store, the advent of ready-made clothing, and the proliferation of fashion magazines, those at the forefront of the avant-garde—from artists such as Édouard Manet, Claude Monet, Berthe Morisot, and Pierre-Auguste Renoir to writers such as Charles Baudelaire, Stéphane Mallarmé, and Émile Zola—turned a fresh eye to contemporary dress, embracing fashion as the quintessential symbol of modernity. The novelty, vibrancy, and fleeting allure of the latest trends proved seductive for a generation of artists and writers who sought to give expression to the pulse of modern life in all its nuanced richness. Without rivaling the meticulous detail of fashion portraitists like Alfred Stevens and James Tissot or the graphic flair of fashion plates, the Impressionists nonetheless engaged similar strategies in the making (and marketing) of their pictures of stylish men and women who reflect the spirit of the age.

Four years ago Gloria Groom, the David and Mary Winton Green Curator at the Art Institute—encouraged by Douglas Druick, who was then the Searle Curator of Medieval to Modern European Painting and Sculpture at the Art Institute—proposed the concept for this exhibition to Gary Tinterow, then Engelhard Chairman of Nineteenth-Century, Modern, and Contemporary Art at The Metropolitan Museum of Art, and to Guy Cogeval of the Musée d'Orsay and Musée de l'Orangerie. Both were immediately enthusiastic, seeing an opportunity to present their renowned collections of Impressionist paintings alongside examples of the contemporary fashions that inspired them. From the start, the organizing team has included curators Philippe Thiébaut of the Musée d'Orsay and Susan Alyson Stein of the Metropolitan Museum. We have been extremely fortunate to have been able to rely on the expertise of the curators and staff of the Metropolitan's Costume Institute in New York and at the Palais Galliera and Musée des arts décoratifs in Paris to guide the selection and handling of costumes for this exhibition. This catalogue was likewise a collaborative effort involving the exhibition team and a host of scholars representing many fields of history—literature, architecture, photography, fashion, and art—whose thoughtful explorations of the confluences of the fashion industry and avant-garde painting in the Impressionist era have provided new lenses through which to appreciate many of the period's most iconic paintings.

No matter how cogent the curatorial vision, such an undertaking as this would not have been possible without the generosity of our lenders around the world, and to them we express our profound gratitude. Nor would a project of this scope and complexity have been possible without substantial financial support. The Art Institute of Chicago is especially indebted to Alexandra and John Nichols, who expressed immediate interest in this project and pledged major support to underwrite it, and to the generous contributions of JPMorgan Chase and the Auxiliary Board of the Art Institute of Chicago. We are also grateful to Laurie and James Bay and the Elizabeth F. Cheney Foundation, whose contributions have enabled this catalogue to be as sumptuous as it is scholarly. Thanks also to the members of the Exhibitions Trust, who provide generous annual support for exhibition programs in Chicago. We wish to acknowledge the important support provided to The Metropolitan Museum of Art by The Philip and Janice Levin Foundation and the Janice H. Levin Fund, as well as by the William Randolph Hearst Foundation. We would also like to thank The Georges Lurcy Charitable and Educational Trust for supporting the educational programming associated with the exhibition in New York. In Paris the exhibition was realized thanks to the support of LVMH/Moët Hennessy . Louis Vuitton and Christian Dior. Finally, in the United States, we are enormously indebted to the Federal Council on the Arts and the Humanities, whose indemnity has assisted substantially with insurance costs for the two American venues.

Douglas Druick
President and Eloise W. Martin Director
The Art Institute of Chicago

Thomas P. Campbell
Director and Chief Executive Officer
The Metropolitan Museum of Art

Guy Cogeval
President
Musée d'Orsay and Musée de l'Orangerie

The exhibition *Impressionism, Fashion, and Modernity*, which was launched four years ago and has managed to bring together some of the world's most recognized and iconic Impressionist paintings with contemporary costumes and a variety of contextual materials, could not have been realized without the acknowledged expertise of the collaborating institutions and their directors: James Cuno and his successor, Douglas Druick, President and Eloise W. Martin Director, The Art Institute of Chicago; Philippe de Montebello and his successor, Thomas P. Campbell, The Metropolitan Museum of Art, New York; and Guy Cogeval, President, Musée d'Orsay and Musée de l'Orangerie, Paris. Their faith in this project has been unwavering.

Equally important for developing the concept of the exhibition and catalogue were the many discussions among the members of the organizing committee: Douglas Druick, Gary Tinterow (formerly the Engelhard Chairman of Nineteenth-Century, Modern, and Contemporary Art at the Metropolitan Museum, and since February 2012, Director, Museum of Fine Arts, Houston), Curator Susan Alyson Stein of the Metropolitan Museum, and Guy Cogeval and Curator Philippe Thiébaut of the Musée d'Orsay. The multidisciplinary approach we have taken to show how the confluences of photography, literature, textile and fashion industry, fashion illustration, and the history of ready-to-wear made fashion attractive as subject and vehicle for vanguard artists and writers in the second half of the nineteenth century was the subject of a two-day brainstorming session held at the Art Institute in November 2009. We are grateful to the catalogue authors who participated: Heidi Brevik-Zender, Assistant Professor of French and Comparative Literature, University of California, Riverside; Helen Burnham, Pamela and Peter Voss Curator of Prints and Drawings, Museum of Fine Arts, Boston; Justine De Young, Preceptor, Harvard University, Cambridge, Massachusetts; Birgit Haase, Professor of Fashion History and Theory, Hamburg University of Applied Sciences; Elizabeth Anne McCauley, David Hunter McAlpin Professor of the History of Photography and Modern Art, Princeton University, Princeton, New Jersey; Aileen Ribeiro, Emeritus Professor, the Courtauld Institute of Art, London; Valerie Steele, Director and Chief Curator, the Museum at the Fashion Institute of Technology, New York; Françoise Tétart-Vittu, Art and Fashion

Historian, former Print Room Curator, Palais Galliera, Paris; Philippe Thiébaut; Gary Tinterow; and David Van Zanten, Mary Jane Crowe Professor in Art and Art History, Northwestern University, Evanston, Illinois. We owe thanks to the other participants as well, including Douglas Druick; Susan Alyson Stein and Rebecca Rabinow of the Metropolitan Museum; Gillion Carrara, Adjunct Professor and Director of the Fashion Resource Center, and Caroline Bellios, Instructor and Assistant to the Director of the Fashion Resource Center; André Dombrowski, Assistant Professor, University of Pennsylvania; Akiko Fukai, Director and Chief Curator, the Kyoto Costume Institute; Robert L. Herbert, Andrew W. Mellon Professor Emeritus of Humanities, Mount Holyoke College; Timothy Long, Curator, Chicago History Museum; Mark Krisco and Debra Mancoff, the School of the Art Institute of Chicago; and Jean Goldman, independent art historian and curator, who sponsored an elegant luncheon for the group. The catalogue evolved to include two additional authors, Stéphane Guégan, Curator, and Sylvie Patry, Chief Curator, Musée d'Orsay, whose contributions we gratefully acknowledge, as we do the descriptive captions written by Michaela Hansen and Caroline Bellios.

Although this is the first major loan exhibition to examine thoroughly the role of contemporary fashion as a catalyst for modern painters, all who have been involved are acutely aware of the debt we owe to scholars whose publications have laid the groundwork that we depended upon as we worked on our project. We recognize, in particular, Ruth E. Iskin, author of *Modern Women and Parisian Consumer Culture in Impressionist Painting* (2007); Marie Simon, author of *Fashion in Art: The Second Empire and Impressionism* (1995); and Valerie Steele, author of *Paris Fashion: A Cultural History* (1988). Other scholars whose work helped us focus our efforts include Therese Dolan, Aruna d'Souza, Dorothee Hansen, Ann Hollander, Peter B. Miller, Aileen Ribeiro, and Françoise Tétart-Vittu.

An exhibition of this scope would not have been possible without the assistance of numerous individuals who helped us to locate specific works, secure loans, identify essential research materials, and collect photographs, and who generously shared their insights and expertise. We owe special thanks to Judith Barter, Cheryl Bell, Caroline Bellios,

Joseph Berton, Helen Burnham, Kate Bussard, Yassana Croizat-Glazer, Justine De Young, Fiona Fimmel, Paul Florian, Jean Goldman, Carrie Heinonen, Ann Hoenigswald, Nancy Ireson, Nena Ivons, Michael Korey, Mark Krisco, Anne Leonard, Nancy Mowll Mathews, Patricia McGraff, Charles S. Moffett, David Nash, Janet Olson, Dimitrios Papalexis, Maria-Cristina Pirvu, Patricia Plaud-Dilhuit, Rebecca Rabinow, Dominique Rouet, William Rudolph, Barbara Scharres, Bill Scott, Isabelle Servajean, George T. M. Shackelford, Stephanie Sick, Elizabeth Siegel, Laurie Stein, Eve Straussman-Pflanzer, Ann Summer, Françoise Tétart-Vittu, Richard Thomson, Gayle Tillis, Pala Townsend, Malcolm Warner, Jennifer Thévénot White, Juliet Wilson-Bareau, Matthew Witkovsky, and Peter Zegers. We are also grateful to costume curators Joanne Dolan Ingersoll, Kate Irvin, Kevin L. Jones, Pam Parmal, and Lauren Whitley.

For this ambitious exhibition, which demanded key Impressionist paintings and costumes, we were rewarded by the interest and generosity of institutions around the world. The names of these collections are printed on a separate page, but I would like to thank the following individuals for their role in making these loans possible: Matthew Teitelbaum and Elizabeth Smith, Art Gallery of Ontario; Claude Ghez and Marjorie Klein, Association des Amis du Petit Palais, Geneva; Gary T. Johnson, Russell Lewis, Katherine Ploud, Becca Doll, and Timothy Long, Chicago History Museum; David Franklin, Griffith Mann, and William Robinson, the Cleveland Museum of Art; Deborah Swallow and the late John House, the Courtauld Gallery, London; Lynn Federle Orr and the late John Buchanan, Fine Arts Museums of San Francisco; David Bomford, Scott Schafer, and Scott Allan, the J. Paul Getty Museum, Los Angeles; Richard Armstrong and Vivien Greene, Solomon R. Guggenheim Museum, New York; Hubertus Gassner and Jenns E. Howoldt, Hamburger Kunsthalle; Jean Druesedow, Joanne Fenn, and Sara Hume, Kent State University Museum; Wulf Herzogenrath, Christoph Grunenberg, and Dorothee Hansen, Kunsthalle Bremen; Michael Govan, Clarissa Esquera, Patrice Marandel, and Sharon Takeda, Los Angeles County Museum of Art; Maria Balshaw and Miles Lambert, Manchester Art Gallery, Gallery of Costume; Sylvain Amic, Musée des Beaux-Arts, Rouen; Henri Loyrette and Sébastien Allard, Musée du Louvre, Paris; Jacques Taddei and Marianne Mathieu, Musée Marmottan Monet, Paris; João da Cruz Vicente de Azevedo, Teixeira Coelho, and Eugênia Gorini Esmeraldo, Museu de Arte de São Paulo Assis Chateaubriand; Ute Eskildsen and Mario-Andreas von Lüttichau, Museum Folkwang, Essen; John W. Smith, Ann Woolsey, and Maureen O'Brien, Museum of Art, Rhode Island School of Design, Providence; Malcolm Rogers and George T. M. Shackelford, Museum of Fine Arts, Boston; László Baán, Judit Geskó, and Melinda Erdohati, Museum of Fine Arts, Budapest; Susan Henshaw Jones, Jean-Luc Howell, and Phyllis Magidson, Museum of the City of New York; Earl A. Powell III, Franklin Kelly, Kimberly Jones, and Mary G. Morton, National Gallery of Art, Washington, D.C.; Solfrid Söderlind, Torsten Gunnarsson, Karin Sidén, and Per Hedström, Nationalmuseum, Stockholm; Sandy Nairne and Peter Funnell, National Portrait Gallery, London; Anne-Birgitte Fonsmark, Gry Hedin, and Nanna Kronberg Fredriksen, Ordrupgaard, Copenhagen; Marjorie Scheuer, the Henry and Rose Pearlman Foundation; Gilles Chazal, Isabelle Collet, and Maryline Assante, Petit Palais, Musée des Beaux-Arts de la Ville de Paris; Timothy Rub, Joseph Rishel, and Jennifer Thompson, Philadelphia Museum of Art; James Steward, Princeton University Art Museum; Steven High and John Wetenhall, the John and Mable Ringling Museum of Art, Sarasota; Hartwig Fischer, Dirk Syndram, and Heike Biedermann, Staatliche Kunstsammlungen, Dresden; Caroline Collier, Tate National; Nicholas Serota, Tate, London; Andreas Blühm and Götz Czymmek, Wallraf-Richartz-Museum, Cologne.

The generosity of our institutional lenders was matched by that of the private lenders and agents to whom we are greatly indebted: Vera Wang and Diane B. Wilsey. For those lenders who have opted to remain anonymous, we thank our colleagues who served as intermediaries: Guy-Patrice Dauberville, Bernheim-Jeune et Compagnie, Paris; Waring Hopkins, Galerie Hopkins, Paris; Stephan Wolohojian, Harvard Art Museums/Fogg Museum; David Nash, Mitchell-Innes & Nash, New York; Yasuko Yamada, Sotheby's Japan; Simon Stock, Sotheby's London; Benjamin Doller, Sotheby's New York; and Jayne Warman, New York.

In addition to Susan Alyson Stein, this project enjoyed the essential cooperation of many staff members, both past and present, from the Metropolitan Museum. Gary Tinterow, and his

assistant Nykia Omphroy, contributed enormously to shaping and overseeing the genesis of the exhibition, from fall 2009 until their departure in early 2012 for the Museum of Fine Arts, Houston. Laura Corey ably served as the project's exhibition assistant, dedicating her keen research and organizational skills to all aspects of its planning and realization. The Metropolitan Museum's Costume Institute played a vital role in ensuring the integrity of the fashion component of the American venues. We are indebted to Harold Koda for his generous support; to Andrew Bolton for the benefit of his curatorial oversight and advice throughout the organization of the project; and to Kristen Stewart and Amanda Garfinkel, respectively, for the benefit of their collections and curatorial expertise. We have also valued the assistance of Joyce Fung, Jessica Glasscock, Julie Le, Bethany Matia, Wong Ng, Glenn Peterson, and Sarah Scaturro. The installation of the Metropolitan Museum's venue recognizes the talents of exhibition designer Michael Lapthorn and graphic designer Sophia Geronimus. In addition, we gratefully acknowledge the contributions of Jennifer Russell, Director's Office; Linda Sylling, Design Department; Keith Christiansen, Rebecca Grunberger, and Patrice Mattia in the Department of European Paintings; George Goldner, Cora Michael, and Elizabeth Zanis in Drawings and Prints; Malcolm Daniel, Anna Wall, and Meredith Friedman in Photographs; Kenneth Soehner, Watson Library; Charlotte Hale, Paintings Conservation; Marjorie Shelley and Rachel Mustalish, Paper Conservation; Kathryn Galitz, Education; Julie Zeftel, Digital Media; and Meryl Cohen, Registrar's Office.

At the Musée d'Orsay, Paris, where we conducted many of our early organizational meetings under the enthusiastic guidance of Guy Cogeval, we wish to thank, in addition to Stéphane Guégan, Sylvie Patry, and Philippe Thiébaut, the other members of the team: Martine Bozon, secretary to Guy Cogeval; Hélène Flon, Exhibitions Director; Marie-Pierre Gaüzès, Head Registrar, Musée d'Orsay, Musée de l'Orangerie, and Musée Hébert; Élise Bauduin, Exhibitions Manager; Scarlett Reliquet, cultural officer in charge of classes, seminars, and lectures; Amélie Hardivillier, Head of Communications; Annie Dufour, Head of Publications; and Doris Grunchec, Exhibitions Manager.

I feel particularly rewarded by the amazing collaborations among my colleagues, each of whom has, in important ways, played a role in the birth, adolescence, and final flowering of this exhibition and catalogue. In the Department of Medieval to Modern European Painting and Sculpture, I give warmest thanks to Stephanie D'Alessandro, Gary C. and Frances Comer Curator of Modern Art; Eve Straussman-Pflanzer, Patrick G. and Shirley W. Ryan Associate Curator of European Painting and Sculpture before 1750; and Martha Wolff, Eleanor Wood Prince Curator of European Painting and Sculpture before 1750; as well as Geri Banik, Department Secretary; Robert Burnier, Departmental Specialist; Florence Cazenave, Research Assistant; Marie-Caroline Dihu, Research Assistant; Christina Giles and Stephanie Strother, Old Masters Society coordinators; Adrienne Jeske, Senior Collections Manager; Marina Kliger, Special Projects Research Associate; Jane Neet, Collection Manager and Research Assistant; Aza Quinn-Brauner, Department Technician; Jill Shaw, Research Associate; Genevieve Westerby, Digital Assets and Research Assistant; and the interns from near and far who have over the years worked on research for the exhibition and catalogue: Kat Baetjer, Elizabeth Benjamin, Sarah Fischel, Michaela Hansen, Blandine Landau, Grace Londono, Brittany Luberda, Elizabeth Oliver, Allison Perelman, Juliette Poggioli, and Austin White. I am particularly grateful to Stacy Kammert and Susanna Rudofsky, both of whom have worked tirelessly over a four-year period to see this project to its completion. Above all I thank Jennifer Paoletti, Exhibitions Manager, whose title in no way covers her total involvement in every aspect and every challenge of this project, which she has coordinated with efficiency, meticulous attention to detail, professionalism, and grace.

From its earliest inception the exhibition has enjoyed the counsel, expertise, and leadership of the Art Institute's President and Eloise W. Martin Director, Douglas Druick. I am also grateful to Dorothy Schroeder, Vice President for Exhibitions and Museum Administration; David Thurm, Chief Operating Officer; and Maria Simon, Associate General Counsel, who have all been unflappable in the face of escalating budgets and complex loan negotiations.

In the Publications Department I thank Robert V. Sharp, Executive Director, for his support from

the outset to make this a catalogue *hors pair*, and Sarah Guernsey, Director, whose skills, equanimity, and humor kept the project on a positive note. Their efforts were ably assisted by those of Joseph Mohan, Production Coordinator; Lauren L. Makholm, Photography Editor; and Bryan Miller, Manager of Financial and Technical Systems for Publications. For her diligent oversight and many valuable suggestions, I am immensely indebted to editor Susan Weidemeyer, and to her successor on this project, editor Amy R. Peltz, who so commendably took charge of the final stages of its overall completion, consolidated all of its parts, and ensured the consistency of this publication. For their elegant and sensitive translations of the French and German, we wish to acknowledge Jean Coyner and Michael Winkler. My thanks go also to Jack Perry Brown, Marie-Caroline Dihu, Jennifer Paoletti, Jill Shaw, Susan Alyson Stein, and proofreader Christine Schwab for their careful review of the catalogue manuscript; and to Lori Van Deman-Iseri for preparing the index. We are especially indebted to the catalogue's designer, Roy Brooks, for his fresh and intelligent ideas and for making beautifully simple our ambitious and complex vision; and to color specialist Pat Goley at Professional Graphics, whose dedication to the project included an essential color-correction blitz for the works coming from Paris. Finally, we are grateful for the support of our publishing partners at Yale University Press.

At the Art Institute I would like to acknowledge colleagues who contributed in innumerable and essential ways to the ideas behind and research for the catalogue and the exhibition itself. Supporting our research from the outset was Jack Perry Brown, Director of the Ryerson and Burnham Libraries, who acquired or helped us find important publications, such as the very rare volumes of the periodical *La Vie Moderne* that he arranged to have shipped to Chicago for our research and imaging. I am also grateful to the dedicated staff of the Ryerson and Burnham Libraries, especially Susan Augustine, Melanie Emerson, Nancy Ford, and Curtis Osmun. For the technical support that allowed members of the team to share all relevant information with our partners, we are grateful to Samuel Quigley, Elizabeth Neely, and Carissa Kowalski Dougherty.

For their ongoing support and generosity, thanks are extended to Suzanne Folds McCullagh, Harriet Stratis, Mark Pascale, Martha Tedeschi, Suzanne Karr-Schmidt, Emily Vokt Ziemba, Chris Conniff-O'Shea, and Kim Nichols in Prints and Drawings; Frank Zuccari, Allison Langley, and Faye Wrubel in Paintings Conservation; Sara Moy, Objects Conservation; and from the Department of Textiles, Daniel Walker, Odile Joassin, and Lauren Chang. From the registrarial team I would like to thank Patricia Loiko; her successor, Jennifer Draffen; and especially Darrell Green, Senior Registrar for Loans and Exhibitions, who so expertly coordinated the many and complex loans and attendant shipping arrangements.

For the construction of the installation at the Art Institute and the production of wall texts, labels, and the multitude of exhibition-related graphic materials, I am indebted to William Caddick, Bernice Chu, Marcus Dohner, Jeff Wonderland, and their staffs. Additional thanks go to renowned opera designer Robert Carsen, the mastermind behind the installation of the exhibition at the Musée d'Orsay who also helped with the Chicago venue's conception for the exhibition. For the educational and marketing outreach that accompanied the exhibition, I wish to thank Gordon Montgomery, Gary Stoppelman, Erin Hogan, Chai Lee, Nora Gainer, and Oksana Paluch, as well as David Stark and the staff of the Museum Education Department.

Finally, I would like to offer personal thanks to Mary Winton Green and her family for their friendship and support, and to Joseph, Alexander, and Philip Berton, who tolerated the ripple effects of this project on our home life with bemused good nature.

Gloria Groom
David and Mary Winton Green Curator
The Art Institute of Chicago

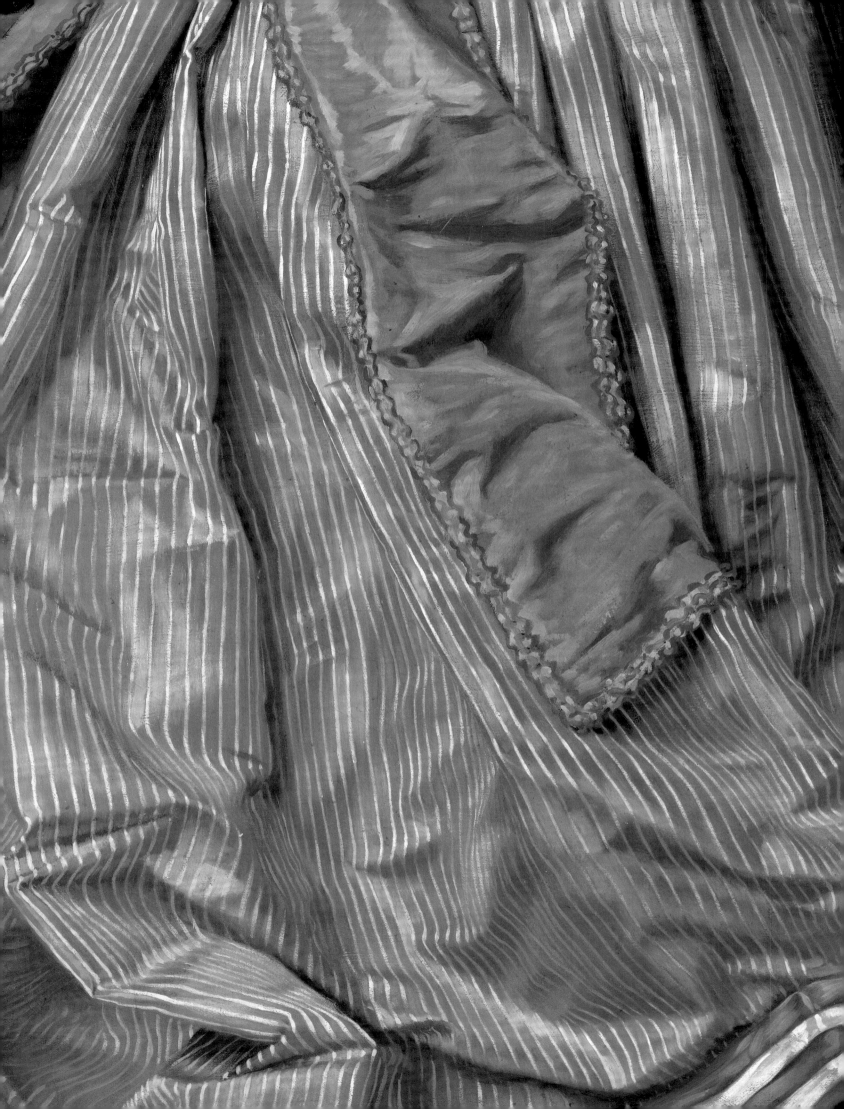

The Rise and Role of Fashion in French Nineteenth-Century Painting

Gary Tinterow

> What we need are the special characteristics
> of the modern individual—in his clothing,
> in social situations, at home, or on the street.
>
> — Edmond Duranty, *La nouvelle peinture*[1]

To show modern man and woman as they are, in the words of Edmond and Jules de Goncourt, "the reality of man and his costume transfigured by the magic of shadows and light, by the sun, a poetry of the colors which fall from the hand of the painter,"[2] was the primary program for most of the French artists involved in the *nouvelle peinture* in the 1860s and 1870s, Émile Zola's "painters who love their era with all the artist's mind and heart."[3] As Zola wrote on the occasion of the Salon of 1868, "We find ourselves faced with the only reality— despite ourselves we encourage our painters to reproduce us on their canvases, just as we are, with our costumes and customs."[4]

It is fascinating that critics as diametrically opposed as the Goncourt brothers, the courtly and

recidivist Parisian Aesthetes, and Zola, the stubborn Realist from the south, should all define the goal of modern art as a spirited but accurate rendering of the appearance of life in and around Paris, the capital of modernity. While they would never agree on which painters succeeded or failed in that task, these writers neatly confirm this commonly held ambition. That the forward-looking Zola and the backward-looking Goncourts were searching for the same thing also corroborates the extraordinarily diverse styles of painting manifest at the Paris Salons in the 1860s and 1870s. Precise recorders of costume and social mores, from Auguste Toulmouche to James Tissot (see cat. 1); grand painters in the style of the Old Masters, like Franz Xaver Winterhalter and

The Marquis and Marquise de Miramon and Their Children, 1865

Oil on canvas
177 × 217 cm (69 ¹¹⁄₁₆ × 85 ⁷⁄₁₆ in.)
Musée d'Orsay, Paris

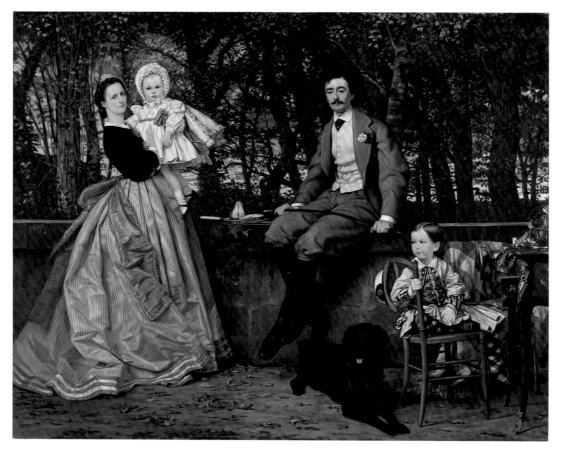

The people in Tissot's family portrait are dressed in fashionable contemporary garments and presented in a monumental scale appropriate to their wealth and aristocratic titles. The marquise's tasteful striped silk skirt with lavish bow, her lace-trimmed cuffs, and her ribbon-folded rosettes attest to her stylishness, while her role as a virtuous mother is reinforced through her baby's coordinating vivid blue sash. The young heir sits closest to his father and wears a skirted ensemble with elaborate soutache trim and youthful plaid stockings. The marquis wears country sporting attire: knee-length knickerbockers and a matching jacket. Despite the charm and naturalness of the group, the painting was criticized for its supposed use of an almost unrelieved monochromatic gray palette.

Jean-Auguste-Dominique Ingres, and boldly modern painters such as Gustave Courbet, Edgar Degas, Édouard Manet, Claude Monet, and Pierre-Auguste Renoir faced the challenge of expressing contemporary man and woman through a heightened emphasis on costume and fashion—so much so that Zola felt obliged to dismiss "banal and unintelligent fashion pictures," no doubt because they had become ubiquitous.[5]

FASHION AND HIGH ART: INGRES AND WINTERHALTER

The minute recording of the details of dress and fashion is present throughout the history of art. Costume was an essential indicator of status and function in society; hence fashion was always an important component of representational portraiture. But with the rise of genre painting in the seventeenth century, especially in the Low Countries and France, the depiction of fashion took on a life of its own, independent of the identity of the specific individuals portrayed.

In France throughout the nineteenth century, one can detect a growing insistence on fashion in formal portraiture, concomitant with the increase in the number of portraits and genre paintings exhibited at the Salons. As many social historians have noted, this paralleled the rise of middle-class consumption of artistic production as the state's purchases of paintings became less important. Léon Rosenthal called the increase of portraiture and genre scenes "one of the most striking products of middle-class patronage."[6] And needless to say, this same increasingly numerous and affluent bourgeoisie consumed fashion to a much greater degree than before; naturally, it expected to see its interests and behavior reflected in the art that it acquired. Honoré de Balzac reflected the prevailing philosophy of the great bourgeois awakening under Louis Philippe's July Monarchy (1830–48) when he wrote that "fashion is the expression of society . . . fashion is, all at once, a science, an art, a custom, a sentiment."[7]

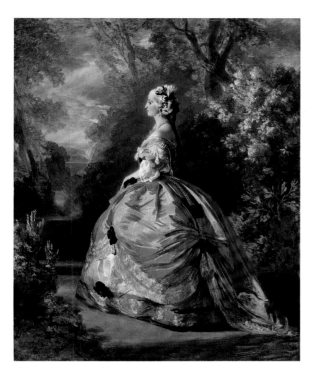

FIG. 1. FRANZ XAVER WINTERHALTER (GERMAN, 1805–1873). *Empress Eugénie*, 1854. Oil on canvas; 92.7 × 73.7 cm (36 ½ × 29 in.). The Metropolitan Museum of Art, New York, Purchase, Mr. and Mrs. Claus von Bülow Gift, 1978 (1978.403).

FIG. 2. JEAN-AUGUSTE-DOMINIQUE INGRES (FRENCH, 1780–1867). *Madame Moitessier*, 1851. Oil on canvas; 147 × 100 cm (57 ⅞ × 39 ⅜ in.). National Gallery of Art, Washington, D.C., Samuel H. Kress Collection, 1946.7.18.

Although the court of the Empress Eugénie preferred the Rubensian verve of Winterhalter, Ingres was the touchstone for portraiture during the reign of Louis Philippe, the standard against whom all were measured. By the 1860s, when the aged painter was no longer working, critics and artists alike were nearly unanimous in their belief that his portraits were his most important achievements, regardless of their esteem, or lack thereof, for his art. Upon viewing the 1867 posthumous retrospective of Ingres's career, Frédéric Bazille remarked, "Almost all of his portraits are masterpieces, but [his] other paintings are quite boring."[8] As Charles Baudelaire wrote already in 1846: "Ingres is still alone in his school. His method is the result of his nature, and however bizarre and obstinate it might be, it is sincere, which is to say involuntary. Passionate lover of antiquity and its model, respectful servant of nature, he makes portraits that rival the best Roman sculptures."[9]

A crucial component of Ingres's portraiture was his attention to costume. It is no coincidence that fashion historians consult his paintings as if they were dressmakers' patterns: each outfit is rendered so that the seams, construction, fabric, lining, and accessories are unmistakably legible—which cannot be said of the work of Winterhalter, the favored portraitist of the European nobility during the Second Empire (see fig. 1). It was not for nothing that Ingres was married to a milliner: his female portraits can be reduced to a face, a pose, and a dress. His immense trouble over the depiction of the dresses in the two portraits of Madame Moitessier (fig. 2 and 1856 version; National Gallery, London) was a legend in Paris's ateliers, as was his titanic struggle to complete pictures that were years in the making, such as the portrait of Betty de Rothschild. The Musée Ingres in Montauban is filled with dozens of studies of details of his portrait costumes, which are often more numerous than studies of faces or hands for the same picture.

Baudelaire detected a kind of mania in Ingres's approach to costume, and that seems to have informed the critic's own attitude toward fashion. As Aileen Ribeiro noted,

> While Baudelaire waxes lyrical over the fusion of woman and her clothing, he also discusses female dress as though it assumes a life of its own, almost separate from the

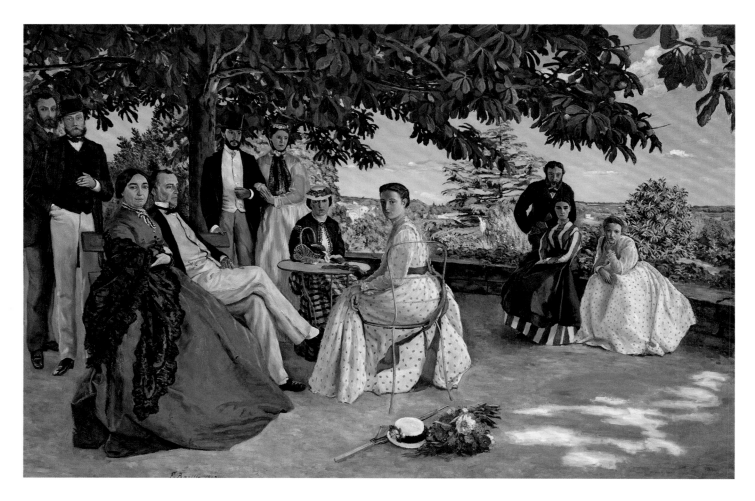

CAT. 2 Frédéric Bazille **(FRENCH, 1841–1870)**
Family Reunion, 1867

Oil on canvas
152 × 230 cm (58 7/8 × 90 9/16 in.)
Musée d'Orsay, Paris

In his review of the Salon of 1868, Émile Zola wrote
that this portrait represents each family member
with an "appropriate attitude," and suggests that,
by truthfully painting his own time, Bazille would
succeed as a modern artist. Here Bazille's mother,
seated beside her husband, wears a dignified blue
dress with a high neckline and long sleeves. It is
made slightly more formal by the black lace shawl
draped over her shoulders. In contrast, three of the
younger women are clad in playful white summer
dresses. The men, all clothed in neutral-colored
relaxed coats, are distinguished by their choice of
waistcoat color, collar style, and type of hat.

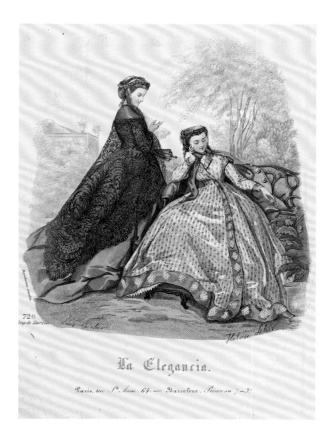

CAT. 3 Héloïse Leloir **(FRENCH, 1820–1873)**
"Two Women Outdoors," *La Elegancia*
(Barcelona), 1865/66

Lithograph with hand coloring
Sheet: 29.5 × 21.9 cm (11 5/8 × 8 5/8 in.)
The Metropolitan Museum of Art, New York

body it arrays; in this there is a definite sympathy with the way Ingres treats costume, particularly in the portraits of the 1840s and 1850s. . . . It may be that the concept of fashion as a kind of metaphysical conceit, allied to, yet divorced from the body which is its raison d'être, was linked with the new stress placed on the art of the dress designer, who emerged as an all-powerful force in the middle of the nineteenth century.[10]

THE PAINTING OF MODERN LIFE: BAUDELAIRE AND MANET

In 1878 Manet moaned that no one had ever realized the "prototype of an era . . . the woman of the Second Empire," thus indicating that he, like many of his fellow Impressionists, believed that the prototype was the proof of the painter.[11] *Music in the Tuileries Gardens* (fig. 3, p. 169) was in large part an effort to catalogue Parisian types, and the power of that precedent reverberated among like-minded painters, as seen in Degas's racetrack scenes, Monet's *Women in the Garden* (cat. 45), and Bazille's *Family Reunion* (cat. 2). Manet went on to compose many iconic images, including *Young Lady in 1866* (cat. 9), and *Mademoiselle V in the Costume of an Espada* (1862; The Metropolitan Museum of Art, New York) that were emulated by Monet, Renoir, Paul Cézanne, and Degas. But Henri Loyrette has made the important point that Manet really was comparing his work and that of his colleagues to "the earlier success of Ingres, who with *Monsieur Bertin* [1832; Musée du Louvre], among many others, had depicted 'the prototype of the bourgeoisie of 1825 to 1850.'"[12] By the end of the 1870s, when the majority of the New Painters had found a small but influential audience, Baudelaire's dictum on modern life, in which he equated the depiction of contemporary mores and costumes with modernity, was fully assimilated by the artists who admired the critic—as well as nearly every other figure painter at the Salon, excepting the Classicists, the descendants of Ingres, and the Orientalists, the descendants of Eugène Delacroix (some, such as Théodore Chassériau and Jean-Léon Gérôme, had a foot in each camp). One wonders whether what really bothered Manet was Baudelaire's failure to recognize his achievement,

rather than that of the unlikely Constantin Guys, as the true painter of modern life (see fig. 1, p. 54 and cat. 18). Perhaps Baudelaire was himself too much a child of the epoch of Louis Philippe to understand Manet's true accomplishment, and his illness in 1865 and untimely death two years later, at age forty-seven, denied him the necessary perspective.

C'EST NE PAS UN PORTRAIT, C'EST UN TABLEAU

Guided by the example of Courbet and Manet, and encouraged by the writings of critics of all stripes, the prototype of the Parisienne became in the 1860s a fashion statement; the dress, not the face, was the focus. As Ruth Iskin noted, "For the Impressionists (excluding Pissarro), the chic Parisienne replaced the earlier interest of Realist painters in rural working women. She also played a central role in the shift from academic to modern painting led by Manet and the Impressionists, replacing nude or draped mythological figures with modern Parisiennes in contemporary fashions."[13] Like Rosenthal, Iskin saw this as a result of economic and social change:

> The historical conditions for the rise of the chic Parisienne were a convergence of mass-production, consumption and the spread of a visual culture promoting consumption. The stereotype of the chic Parisienne played an important role in the shaping of femininity as integral to modernity and the nation. . . . Thus, the chic Parisienne's national role was both as a symbolic icon and as a consumer of French goods.[14]

LA TOILETTE VAUT UN TABLEAU

The icon's identity was expressed as costume, and hymns were written to dresses as, in earlier times, they had been to the figure of Liberty. In *Notes sur Paris* (Notes on Paris; 1867), Hippolyte Taine wrote,

> A perfect toilette is equal to a poem. There is a taste, a choice in the placing and the shade of each satin ribbon, in the pink silks, in the soft silvered satin, in the pale mauve, in

CAT. 4 James Tissot (FRENCH, 1836–1902)

The Two Sisters, also called *Portraits in a Park*, 1863

Oil on canvas
210 × 136 cm (82 ½ × 53 9/16 in.)
Musée d'Orsay, Paris

At the Salon of 1864 Tissot's *The Two Sisters* was seen as a direct reference to Gustave Courbet's shocking 1856–57 painting *Young Ladies on the Banks of the Seine* (cat. 34) and encountered a quite critical reception. Salon visitors mockingly called the figures in Tissot's painting "les dames vertes" (the green ladies) for the greenish tint the artist gave their diaphanous white summer dresses. Many viewers also felt a contradiction in his attempt to evoke natural light filtering through leaves on trees in what was obviously a studio painting, and they likened the artificiality of the backdrop and the sisters' studied poses and disinterested gazes to fashion illustrations.

FIG. 3. ALFRED STEVENS (BELGIAN, 1823–1906).
Autumn, c. 1876. Oil on canvas; h. 76 cm (29 ¹⁵/₁₆ in.).
Guildhall Art Gallery, London.

the tenderness of the softer colors, still more tender beneath their coverings of guipure, their puffings of tulle, and the ruches which rustle with every motion. Shoulders and cheeks wear a charming tint in this luxurious nest of blonde and lace. . . . This is the only poetry left to us, and how well they understand it [see cat. 4].[15]

But when it came to Salon painting, the conservative Taine regretted the omnipresence of costumed portraits:

> Illustrated reviews are full of them; they might almost be called fashion plates; every exaggeration of costume is therein displayed . . . the artist is heedless of the deformity of the human body. That which gives him pleasure is the fashion of the moment, the gloss of stuffs, the close fitting of a glove, the perfection of the chignon. . . . Numbers of portraits in our annual exhibitions are nothing but portraits of costumes.[16]

At the Salons, Edmond Duranty lamented the artists who

> have discovered shimmering iridescences, brilliant highlights, and scintillating contrasts. They turn out a virtuoso pageant of arpeggios, trills, chiffons, and crepons derived without benefit of observation, thought, or the desire to examine. They have dressed up, made up, and prettied up Nature, covering her with curls and frills. Like hairdressers, they have coiffed and styled her as if for an operetta. Profit and commerce play far too important a role in their work [see fig. 3].[17]

It is fascinating that Camille Corot and Degas would both construct studio paintings that were, above anything else, portraits of dresses in the strong indigo blue that became so fashionable in the early 1870s, worn by their beloved model Emma Dobigny, herself the prototype of the chic Parisienne (cats. 5, 6). For his part, Cézanne, whose early work serves as a running commentary on the obsessions of the avant-garde, made painted copies of fashion illustrations in 1871, and included figures in outlandish costumes in his scenes of social leisure, no doubt a satirical reflection on the state of the arts (cats. 25–27).

CAT. 5 Edgar Degas (FRENCH, 1834–1917)

Sulking, c. 1870

Oil on canvas
32.4 × 46.4 cm (12 ¾ × 18 ¼ in.)
The Metropolitan Museum of Art, New York

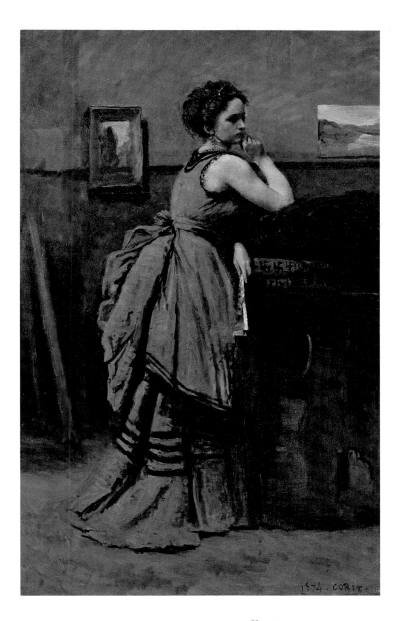

CAT. 6 Jean-Baptiste-Camille Corot
(FRENCH, 1796–1875)

Lady in Blue, 1874

Oil on canvas
80 × 50.5 cm (31 ½ × 19 ⅞ in.)
Musée du Louvre, Paris

The woman in this painting wears an extremely fashionable *tablier*, or apron-style dress, with a bustle and a trained underskirt trimmed with black velvet stripes and a deep flounce. Her ensemble is accessorized with a fan, a diadem, and earrings; she also originally wore gloves, which were painted out by Corot. The presence of these adornments would normally indicate evening dress, but the bodice of the woman's gown is too plain for evening. It is, however, also too revealing to have been worn for day, given its lack of sleeves. Whatever the exact nature of the garment, depicting such contemporary dress was a departure for Corot, whose earlier paintings showed models wearing Italianate outfits. Here the artificiality of place and pose aligns this late painting with those of younger "moderns" like Édouard Manet and Edgar Degas.

FASHION FATIGUE: HUYSMANS

It was inevitable that the tide would turn and thinking men and women would tire of the parade of ribbons and bows. Joris-Karl Huysmans reflected:

> I shall never be persuaded that a woman reading a letter in a blue dress, a lady looking at a fan in a pink dress, a girl raising her eyes to heaven to see if it is going to rain in a white dress, represent interesting aspects of modern life. . . . Ten photos in an album will give me the full quota of modernity contained in such paintings, the more so as the lady and the girl are not taken from 'real life' but are brought to the studio for a hundred sous a session, to wear the above-mentioned dresses and to represent modern life.[18]

Huysman's sentiments were but a step and a decade away from those widely held by the artists of the next generation who saw themselves as successors to the Impressionists. Vincent van Gogh, for one, sought to create a "modern portrait . . . by way of color. . . . portraits which would look like apparitions to people a century later." He further explained, "I don't try to do [depict] us by photographic resemblance but by our passionate expressions, using as a means of expression and intensification of the character our science and modern taste for color."[19] Paul Gauguin, disinterested in contemporary fashion, found in the women of Provence "with their elegant headdresses, their Grecian beauty, and their shawls with pleats like you see in the early masters, [which] remind one of the processions on Greek urns . . . one source for a beautiful modern style."[20]

Like many other artists of their generation, they left behind the streets and shop windows of Paris for new vistas, where crinolines gave way to pareos, elaborate bonnets to peasant kerchiefs, and satin slippers to wooden clogs, and the parade of ribbons and bows slowed and halted, replaced by a circling back to "the processions on Greek urns" or hieratic Egyptian friezes, a search for timeless style rather than fleeting fashion. While the pendulum would continue to swing as artists continually reestablished or rejected the role of fashion in modern art, it would never again assume the central role it occupied in French painting of the 1860s and 1870s.

Édouard Manet
Young Lady in 1866

Gary Tinterow

Édouard Manet's *Young Lady in 1866* (cat. 9) is one of the most striking examples of the artist's ability to astonish and seduce the viewer simultaneously. An over-life-size depiction of his model, Victorine Meurent, in a coy, coquettish pose that belies the knowing conceit of the picture, this is neither a genre scene nor a portrait, but rather an elaborate allegory of the five senses set in the artist's studio: "taste (the orange); sight (the man's monocle she holds); smell (the nosegay of violets, given perhaps by the owner of the monocle); touch (the smooth satin peignoir, or perhaps the objects she holds in her hands); and hearing (Victorine's ear cocked to listen to the parrot's squawk)."[1] Following on the heels of James McNeill Whistler's *Symphony in White, No. 1: The White Girl* (fig. 1); Manet's own sonata in gray, *Street Singer* (1862; Museum of Fine Arts, Boston); and Edgar Degas's *Girl in Red* (fig. 2), the artist clearly sought to garner attention with this symphony in pink, which shows a confident and alluring woman posing self-consciously and even impudently with accessories that point to a provocative but invisible male presence.

The most prominent feature of the painting is the spectacular salmon-colored peignoir or dressing gown, an article of undress that would have been worn indoors, visible only to intimates of the household. Subverting convention, Manet dressed his model in a garment featured in Rococo boudoir scenes and contemporary genre pictures of domestic interiors by artists such as Alfred Stevens and James Tissot, but painted her at a scale typical of state portraits. In Tissot's 1866 portrait of the Marquise de Miramon (cat. 7), the subject wears a chic, ruffled gown and is depicted in an equally stylish, well-appointed interior, both designed to

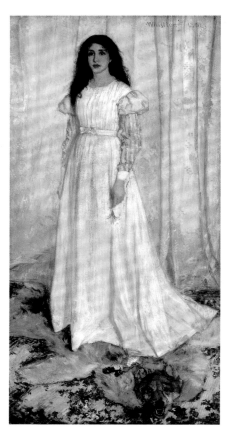

FIG. 1. JAMES MCNEILL WHISTLER (AMERICAN, 1834–1903). *Symphony in White, No. 1: The White Girl*, 1862. Oil on canvas; 213 × 107.9 cm (83 ⅞ × 42 ½ in.). National Gallery of Art, Washington, D.C., Harris Whittemore Collection, 1943.6.2.

FIG. 2. EDGAR DEGAS (FRENCH, 1834–1917). *Girl in Red*, 1866. Oil on canvas; 98.9 × 80.8 cm (38 ¹⁵⁄₁₆ × 31 ¹³⁄₁₆ in.). National Gallery of Art, Washington, D.C., Chester Dale Collection, 1963.10.17.

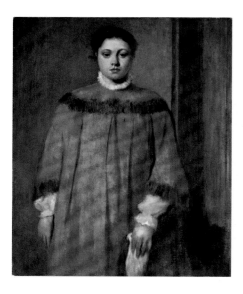

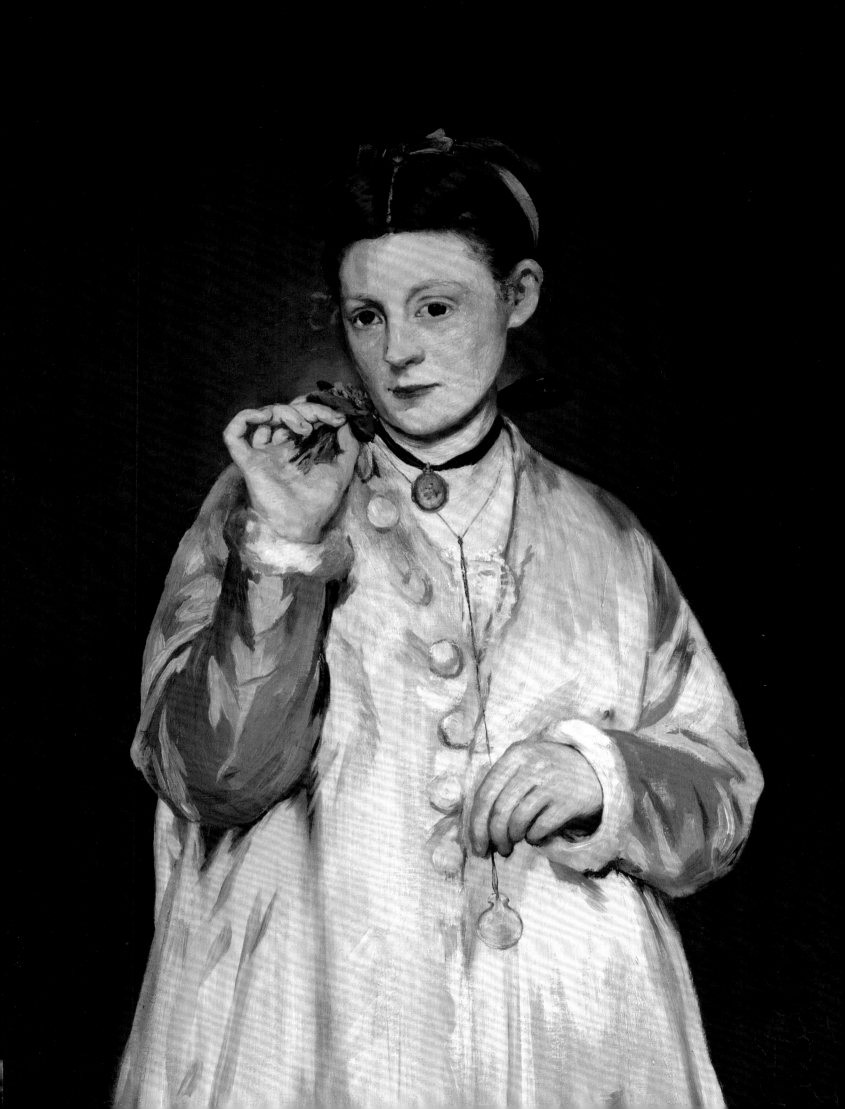

James Tissot (FRENCH, 1836–1902)
Portrait of the Marquise de Miramon, née Thérèse Feuillant, 1866

Oil on canvas
128.3 × 77.2 cm (50 9/16 × 29 15/16 in.)
The J. Paul Getty Museum, Los Angeles

CAT. 8 Sample from the Marquise de Miramon's peignoir, 1866

Silk, velvet
12.4 × 32.5 cm (4 7/8 × 12 13/16 in.)
The J. Paul Getty Museum, Los Angeles

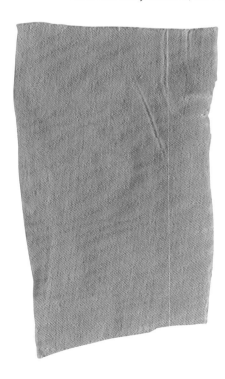

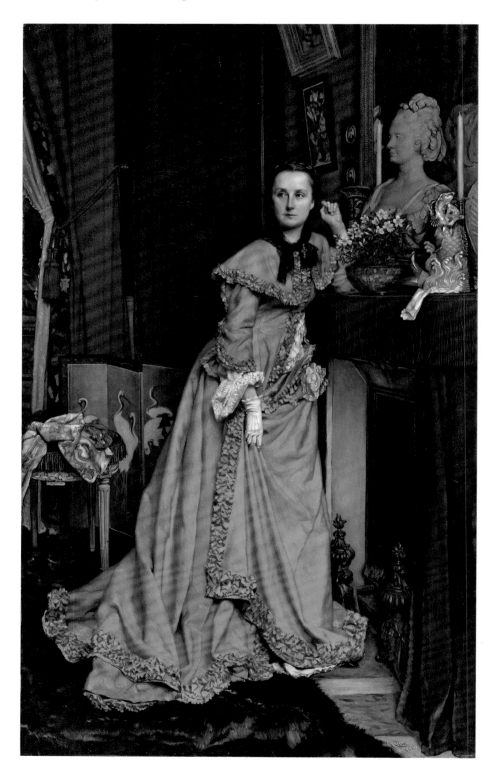

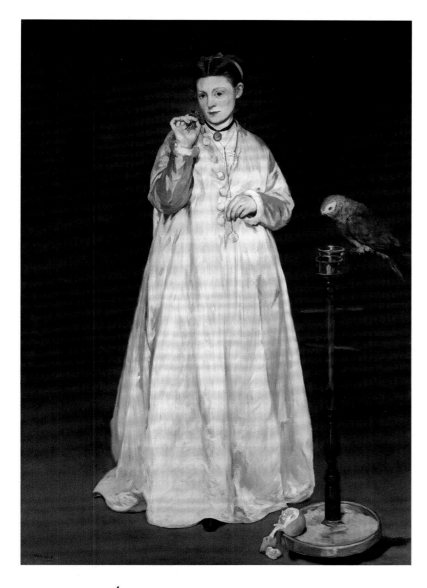

be seen. In contrast, the simple peignoir of Manet's *Young Lady in 1866* could not have been worn outdoors or for an encounter with a stranger.[2] Tellingly, Manet made no pretense of depicting a domestic environment, instead clearly representing a staged conceit in an artist's studio.

The peignoir and its color—a pale salmon produced by an aniline dye that became available for commercial textiles only after 1860—were the focus of the critical attention given to the painting when Manet showed it at his private one-man show in 1867 and again at the Salon of 1868, under the shortened title *Jeune Femme* (Young Lady). Although the unseen male presence was never articulated in published criticism, the implication of impropriety was reflected in the critics' use of adjectives such as "false" and "louche." As the critic Théophile Gautier declared, "Made of a pink that is both false and louche, the dress does not reveal the body it covers."[3]

Instead, the critics almost universally confined themselves to discussions of Manet's painting of the peignoir, comparing it to his painting of Victorine's flesh. Paul Mantz, perhaps sensing an analogy to Whistler, used the word *symphonic* to describe Manet's picture:

> The intention of Mr. Manet, was, we might assume, to engage in a symphonic dialogue, a sort of duet, between the pink dress of the young woman and the pink tones of her face. He did not succeed in that attempt because he does not know how to paint the flesh; nature does not interest him; the spectacles of life do not move him.[4]

Théophile Thoré, more approving than Mantz, found the color "delicious" and used another musical term, "harmony," to describe it: "The pale pink dress delightfully matches the background that is of a light pearl color. . . . The head, despite the fact that it is facing us and is in the same light as the pink fabric, we are not paying attention to: it is lost in the modulation of pink."[5] Émile Zola dismissed questions of the painter's ability and pointed instead to the fashionability of the costume:

I will not talk about the painting called *A Young Lady*. We know it, we saw it at the painter's personal exhibition. I would simply advise these talented men who dress up their dolls with dresses copied from fashion plates, to go see that pink dress that this young woman is wearing. We cannot distinguish the weaving of the fabric, we cannot count the holes made by the needle, but it drapes itself admirably around a living body. It is of the same family as the clothes so soft and amazingly rendered that painters have thrown on their characters' shoulders. Nowadays, painters buy from good fashion houses, just like little ladies.[6]

It is not clear, however, to what degree Manet intended to insist on the fashionability of this particular garment. It is true that the Empress Eugénie had conspicuously abandoned the crinoline in favor of a less structured but nonetheless full skirt, and Victorine's peignoir exhibits that current silhouette.[7] But if fashion had been the artist's primary statement, surely he would have chosen a more elaborate toilette that would have allowed him to exhibit his knowledge of the dernier cri. As Juliet Wilson-Bareau observed, Manet was acutely conscious of details of contemporary dress—small and large—from the beginning of his career until the very end.[8]

Contemporary French literature is filled with references to peignoirs, inevitably in the context of undressing, a recent bath, preparing for the day, rising from bed or going to bed, and, above all, availability for sex. In a scene from Honoré de Balzac's *Le père Goriot* (1835) from *La comédie humaine*, the peignoir heightens the erotic environment:

> The countess did not pay attention to the entrance of Rastignac's tilbury. He turned around abruptly and saw the countess coquettishly dressed in a peignoir made of white cashmere, with pink knots, her hair done negligently, as it is in fashion for Parisian women in the morning. She smelled nice and had probably had a bath, and her beauty, one might say relaxed, seemed more

FIG. 3. PAUL GAVARNI (FRENCH, 1804–1866).
"Lorette in Dressing Gown with a Parrot," from Étienne de Neufville, *Physiologie de la femme* (1842). Lithograph. The Getty Research Institute, Los Angeles, 1558-256.

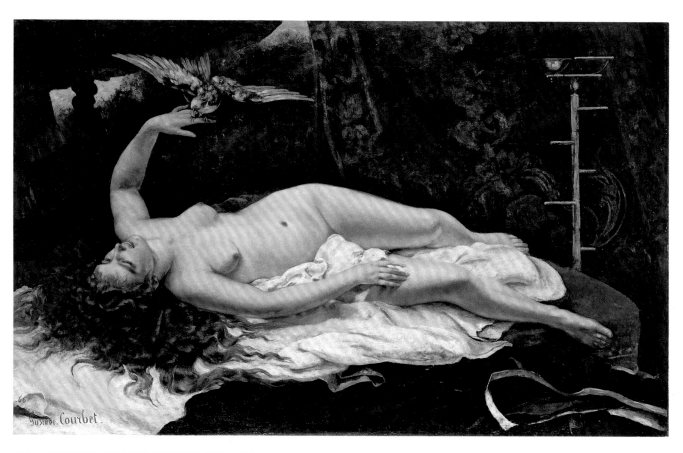

FIG. 4. GUSTAVE COURBET (FRENCH, 1819–1877).
Woman with a Parrot, 1866. Oil on canvas; 129.5 × 195.6 cm
(51 × 77 in.). The Metropolitan Museum of Art, New York,
H. O. Havemeyer Collection, bequest of Mrs. H. O. Havemeyer,
1929, 29.100.57.

voluptuous; her eyes were moist. Young people's eyes see everything: their atoms unite to the spark of a woman as a plant breathes in substances in the air that are its own; Eugene felt the freshness of that hand without needing to touch it. He could see through the cashmere, the pink tones of the décolletage, that the dressing gown, slightly opened, left naked and that he was admiring at length. The countess did not need the corset, the belt only was enhancing her supple waist, her neck was an invitation to love, her feet were beautiful in her slippers. When Maxime took that hand to kiss it, Eugene saw Maxime and the countess saw Eugene.[9]

Not unlike Manet's *Young Lady in 1866*, Paul Gavarni's illustration of a *lorette*, or kept woman, for Étienne de Neufville's *Physiologie de la femme* depicts a woman cooing to a parrot and wearing a loose peignoir (fig. 3). The identity of this woman may well be the key to understanding Manet's choice to dress his subject in a peignoir. Why else would he have included so many masculine attributes in the painting, from the raucous parrot—the infamous male presence in Courbet's scandalous *Woman with a Parrot* (fig. 4)—to the monocle?

The Social Network of Fashion

Gloria Groom

Approaching the boulevards of Paris from the Gare de Lyon,
where he had just arrived, the Italian Edmondo De Amicis
noted with wonderment the "grandeur" of the city,
"the théâtres, . . . the elegant cafés, the department stores,
the fine restaurants, and the crowd."[1]

Struck by the "immensity of Paris" compared to Turin, Milan, and Florence, De Amicis concluded, "Yesterday we were rowing on a small lake, today we are sailing on the ocean." In his eyes, Paris provided "an infinite variety of treasures, dainties, playthings, works of art, ruinous trifles and temptations of every kind."[2] Among these temptations was the Parisienne, a stylish, modern type of woman, whom Octave Mouret, the newly arrived provincial in Émile Zola's *Pot-Bouille* (Pot Luck; 1883), put at the top of his list of tourist attractions.[3]

By the 1860s and 1870s, the Parisienne, a concept conceived in the previous century, occupied the center of a cultural wheel whose radiating spokes included the fashion industry and the avant-garde. As Arsène Houssaye, editor of *L'Artiste*, noted in 1869, there were only two ways to be a Parisienne—by birth or by dress.[4] The shared and sometimes overlapping circles of the fashion industry had implications for advanced visual and literary expressions in the decades preceding and following the fall of the Second Empire, in 1870. The Impressionists joined other painters of modern urban life in exploiting fashion (and the Parisienne) as a powerful marketing strategy. Their social network—artist friends, models, patrons, and individuals within the industry—helped them to self-brand and self-fashion in response to a vibrant consumer culture that, like fashion itself, demanded innovation and visibility.

THE CIRCLE OF ALFRED STEVENS AND THE CREATION OF THE PARISIENNE

At the 1867 Exposition Universelle, the Belgian-born artist Alfred Stevens showed paintings of single females in sumptuous interiors and dress, described as "eighteen chapters from the life of *des femmes de qualité*."[5] The series constituted his definitive breakthrough into the larger art world, at the time of his most concerted association with Charles Carolus-Duran, Edgar Degas, Eva Gonzalès, Édouard Manet, Berthe Morisot, James Tissot, and Auguste Toulmouche. Modestly scaled, with Vermeer-like smooth surfaces, Stevens's compositions described the material luxury of dress and setting to define the Parisienne. Seen in various interiors, these women served as windows onto an unattainable version of reality, whose sentimental overtones could be appreciated by a burgeoning group of middle-class consumers. In the absence of fashion photography, works like *Autumn Flowers* (fig. 1), in which a carte de visite pose is combined with the domestic imagery found in fashion plates,

FIG. 1. ALFRED STEVENS (BELGIAN, 1823–1906).
Autumn Flowers, 1867. Oil on canvas;
74.5 × 55 cm (29 5/16 × 21 11/16 in.).
Musée des Beaux-Arts de Belgique, Brussels.

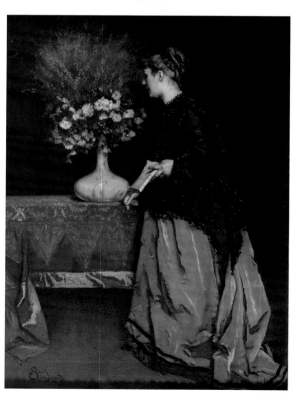

were admired by many authors and artists, including the Impressionists, who took to heart Stevens's fixation on the Parisienne as the emblem of modernity.[6]

By the 1860s, Stevens and his wife, Marie, were socially well positioned within such circles as the Thursday soirées hosted by Manet's mother, where, in addition to Édouard and his brothers, Charles Baudelaire, Degas, and Zola were regulars.[7] In turn, both Manet and Degas belonged to Marie's Wednesday group, which was attended by established artists such as Pierre Puvis de Chavannes, as well as the younger artists Carolus-Duran, Henri Fantin-Latour, Morisot, and Gonzalès, whose "conversation pieces" painted in 1865–68 showed Stevens's influence, although she was never his student.[8]

These familial salons cannot be overlooked as an important social connector to the art world, especially for female artists. Morisot's double portrait (cat. 10) of her sister, Edma, and herself wearing identical voile print dresses shows the degree to which fashion was a highly calculated affair. This painting reflects the tastes of her family home and, through the painted fan on the wall given to her by Degas, her shared interests with artist friends of her family's circle. Both Gonzalès and Morisot gained entrée to the vanguard through the circle of Manet and Stevens. Daughters of privilege, they would have had ready access to the best dressmakers and tailors, whose "originals" could be admired and talked about on the intimate stage offered at these gatherings.[9]

In several of Morisot's letters, she revealed her pique at Manet's attentiveness to Gonzalès's perfectly coiffed hair and dress, both of which featured in a portrait he painted of Eva shortly after their first meeting. Manet no doubt consulted with Eva about her wardrobe, writing to her mother three days before the scheduled Sunday sitting that he would "pick up her toilette" on Sunday morning.[10] In the painting, Eva sits at an easel with her paintbrush held out, wearing a gauzy white summer dress, so that her style is inseparable from her professional interests. Three years later, Stevens painted Eva at a piano wearing a modestly cut, high-collared white satin or taffeta peignoir with a flounced skirt (cat. 11). Although the elements (young woman playing music in a bourgeois interior) were formulaic, Eva's severe profile and the restrained palette

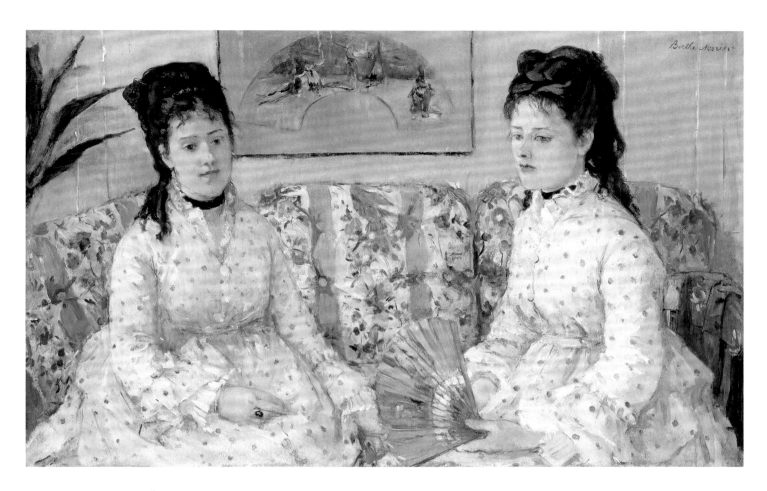

CAT. 10 Berthe Morisot (FRENCH, 1841–1895)
The Sisters, 1869

Oil on canvas
52.1 × 81.3 cm (20 ½ × 32 in.)
National Gallery of Art, Washington, D.C.

A moment of quiet reflection is captured here as two young women, the painter and her sister Edma, sit near one another wearing identical dotted and frilled dresses, black velvet collars, and cascading hair styles. It was not unusual for young sisters to dress alike, but this painting was probably made shortly after Edma married and her primary identity changed from sister to wife. The youthful matching outfits may have been Morisot's way to capture their close relationship now that society no longer viewed them as equals. The fan on the wall was painted by Degas and given as a gift to Berthe, which confirms that the setting is the Morisot home.

of gray-white walls decorated only with thin gold filet provide a realistic portrayal by an artist otherwise renowned for the fastidious delineation of expensive fashions (which he collected) and other conventional signs of material wealth. Pierre-Auguste Renoir's similarly themed composition *Woman at the Piano* (cat. 55), painted three years earlier, speaks to his different intentions. His model, Nini Lopez, wears a whipped confection of whites and blues. The glimpse of pink skin showing through the transparent sleeves and the gold glints of impasto highlights on the sconces create a tactile and evocatively sensuous surface. The model's ability to play the piano is less important than the overall impression of fashionable femininity and musicality, far removed from Stevens's representation of a woman in a particular peignoir in a recognizable interior.

For Renoir and Claude Monet, access to fashion and the fashionable world was limited by their social and economic backgrounds. Monet, by all accounts a clotheshorse consistently in debt with his preferred tailor, and Renoir, the son of a bespoke tailor and dressmaker, were equally

CAT. 11 Alfred Stevens (BELGIAN, 1823–1906)
Eva Gonzalès at the Piano, 1879

Oil on canvas
54.9 × 45.4 cm (21 ⅝ × 17 ⅞ in.)
The John and Mable Ringling Museum of Art,
Sarasota

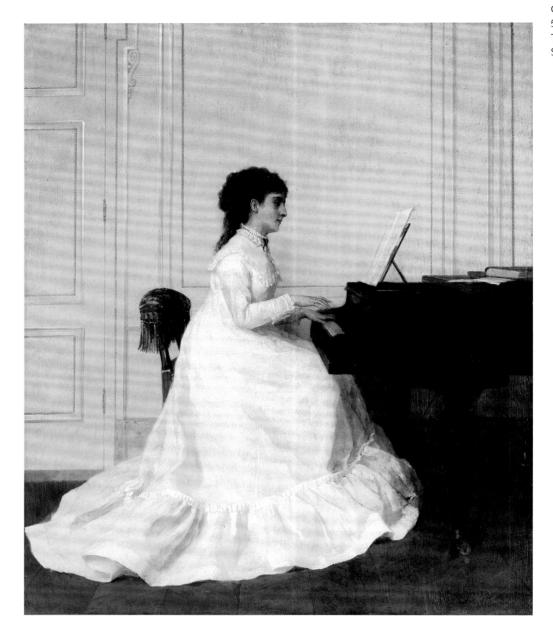

fascinated with fashion. Both, however, would have been excluded from the refined social network of the circle of Degas, Manet, and Stevens.[11] Even Monet, who in the early 1860s was temporarily under the wing of his cousin Auguste Toulmouche, a Stevens imitator and "the big man in the family," remained a stranger to his relative's milieu.[12] For most of the future Impressionists, the alternative to salon society was the Café Guerbois in the Batignolles/Clichy neighborhoods and the Nouvelle Athènes in place Pigalle.[13] Socially, Degas, Manet, and Stevens could feel at home in both of these circles.[14]

Modernism as an artistic concept in the 1860s and 1870s—a rejection of history painting to focus on modern-life subjects—was key not only to the Impressionists, but also to many of their friends and colleagues who were successful at the Salon. In his essay *La nouvelle peinture* (The New Painting; 1876), Edmond Duranty listed among modernism's adherents Stevens, whom he called the "man of modernity," and Carolus-Duran, "who set out with this movement, was a brother in art, a mate of . . . [Manet, Degas, Monet]" but preferred "to return to a firmly established approach to execution."[15] These artists represented not opposite

camps but rather two sides of modernity connected by an interest in contemporary fashion.

PRODUCER-COLLABORATORS: MODELS

Duranty's pamphlet, written at the time of the Second Impressionist Exhibition, describes the Impressionist's model as "the ideal of his heart and mind," his wife or mistress, or someone in his intimate circle with whom he had a relationship.[16] The choice of a *modèle privilégié*, as opposed to the professional or paid model of the academic tradition, resulted in a higher degree of realism and the depiction of recognizable attributes, even if the model was unknown.[17] Certainly, the tradition of using the artist's intimates as models— as in Monet's *Camille* (cat. 16)—was a long one. Convenient and self-interested, these models many times also provided inspiration through their own

FIG. 2. ALFRED STEVENS (BELGIAN, 1823–1906).
Woman in Pink, 1866. Oil on canvas; 87 × 57 cm (34 ¼ × 22 ⁷⁄₁₆ in.). Musée des Beaux-Arts de Belgique, Brussels.

personal style, rather than serving as the object of the artist's fashioning.[18] Stevens's modern-life narratives, in which professional models posed in clothes from his studio wardrobe, did not enter the Realist discourse in the same way as Monet's *Camille*. Nor did they elicit the same personal comments as a picture of Renoir's mistress, Lise, exhibited in 1868, which Zola saw as "the sister of Claude Monet's *Camille*... one of our women, or one of our mistresses rather, painted with great truthfulness and successful innovation in the modern way."[19]

Many times the artist's *modèle privilégié* had her own relationship with fashion. Camille may be wearing a rental dress (see p. 47 in this volume), but she was known to be knowledgeable about fashion.[20] Lise, listed as a dressmaker in some documents (and shown sewing in at least one painting), wears the same dress with a different sash in several paintings (see cat. 40), suggesting that it might have been of her own creation.[21] In other paintings for which she modeled between 1866 and 1872, however, the cut and simplicity of her clothing emphasize her ample figure and the earthiness that Renoir found so appealing, rather than her fashionability. The concept of the model as active participant— a creator or consumer of fashion, and an artistic decision maker rather than a mannequin—is one of the tenets of Ruth Iskin's important study on the modern woman and consumer culture.[22] As Iskin noted, dress patterns, previously the purview of tailors and professional seamstresses, were available by the 1860s in reasonably priced fashion journals accompanied by instructions. For the first time, working-class models featured in Impressionist canvases could be active contributors to painted fashion.[23]

Some professional models were also *modèles privilégiés* with special relationships to their employers. The lively Emma Dobigny was a particular favorite, refashioned on canvas to play a variety of characters by artists as diverse as Camille Corot, Degas, Jean-Jacques Henner, Puvis de Chavannes, and Tissot. The blue dress she wears in Degas's fictionalized scene *Sulking* (cat. 5) may represent a transitional garment that could be transformed into evening wear by the removal of the sleeved bodice, as shown in Corot's *Lady in Blue* (cat. 6), indicating her own tastes in fashion.[24] The same can be said of Victorine Meurent, Manet's preferred model in the

CAT. 12 Pierre–Auguste Renoir
(FRENCH, 1841–1919)
The Loge, 1874

Oil on canvas
80 × 63.5 cm (31 ½ × 25 in.)
The Courtauld Gallery, London

In *The Loge*, Renoir depicted his favorite model, Nini Lopez, in a box seat at the theater, highlighting both the theater as a site of public display and the significance of dress as a form of unspoken communication in modern life. The ostentatiously dressed Nini wears pink flowers in her hair and on her bodice, a strand of pearls, a gold bracelet, earrings, and noticeable makeup. In her gloved hands, she holds a fan and gold opera glasses. This display of wealth might have been appropriate for a married woman, but Nini's relationship with her male companion is unclear.

first half of the 1860s, who also sat for Degas and Stevens, and was herself an aspiring artist. In Manet's full-length composition *Young Lady in 1866* (cat. 9), the oddly monocled and accessorized Victorine wears a pink peignoir, which she probably did not own. Compared to Manet's woman in pink, the anonymous model admiring a Japanese bibelot next to an ebony chinoiserie cabinet in Stevens's exactly contemporary but smaller canvas *Woman in Pink* (fig. 2) is mannequin-like and devoid of expression. Whereas Stevens outfitted his model for optimal commercial appeal, Manet chose a

garment and pose that allowed Victorine to take on the persona of an ambiguous character.

As Baudelaire and later Joris–Karl Huysmans emphasized, Manet portrayed fashion not simply as an "excellent couturier," but also as someone who was intimately related to the wearer.[25] In his many portraits of Morisot painted between 1869 and 1872, her personal style was often the subject. Even before acknowledging her artistic talents, Manet was drawn to her beauty and fashion, highlighting both in the painting he showed at the 1869 Salon, *The Balcony* (cat. 76). Morisot's preference for

CAT. 13 "The Latest French Fashions,"
The Queen, The Lady's Newspaper and Court Chronicle, 1871

Lithograph
Sheet: 42.7 × 28.4 cm (16 ¹³⁄₁₆ × 11 ³⁄₁₆ in.)
The Metropolitan Museum of Art, New York

In comparison to Renoir's *The Loge* (cat. 12), this fashion
plate shows a variety of evening dresses—from similarly
striped, sleeveless gowns, to long-sleeved versions
more suitable for a demitoilette. Here, however, no males
intrude upon the simpler narrative of sumptuously
dressed women.

relatively unadorned dresses—dominated by black
and white—in an age of flouncy laces, elaborate
trim, and aniline dyes, actively played into Manet's
recognition of the inherent beauty of blacks.

Manet was able to experiment with the
superficial evidence of fashion to create new forms
and meanings for traditional art categories, but
Monet's and Renoir's approaches to fashion were
different. When they chose to announce themselves
publicly by painting their mistresses in recognizably
up-to-date dresses, their objective was more seri-
ous, since the stakes (not only for recognition but
also for monetary gain) were higher.[26] Renoir's
painting *The Loge* (cat. 12), depicting his favorite
model, Nini, began not as a representation of a lux-
uriously dressed ingénue-cum-cocotte (as she was
deemed by the critics of the First Impressionist
Exhibition, in 1874), but rather as a more straight-
forward portrait, showing Nini with her hair down,
wearing a simple black dress with white lace at the
collar and cuffs and a blue ribbon at the center of
her décolleté bodice (fig. 3). Her disheveled hair
and gypsylike earrings suggest her true identity as
the girl from Montmartre known as "gueule de raie"
or "ray-fish mouth."[27] Even at this preliminary stage,
however, Renoir suggested the balcony setting that
would become the opera box of the title. Having
selected the context, he transformed Nini from
model to upper-class patron of the Opéra by giving
her a deluxe outfit and adding the dress-coat- or
tailcoat-clad male figure behind her. Although she
is not dressed in the same mode as her companion
(she wears a demitoilette and he full evening wear),
her ensemble—a black-and-white striped satin
bodice trimmed in lace topped by an ermine man-
tle—was absolutely up-to-date (see cat. 13). It was
also clearly out of reach for both artist and model.[28]

Was Renoir already sufficiently friendly with
the Charpentiers—the well-placed editor of the
publishing firm Flammarion and his salon hostess
wife, whose family portrait the artist would paint
four years later (cat. 124)—to have borrowed one of
Marguerite's designer dresses?[29] Or does *The Loge*
simply illustrate a memory of a dress that the artist
admired and reimagined in paint?[30] Clearly playing
with fashion was not Renoir's aim; instead, he
hoped to create a convincing lifestyle for his model
and, by extension, for himself. Although critics per-
ceived Nini's makeup and disheveled hair to be evi-
dence of her status as a cocotte or kept woman

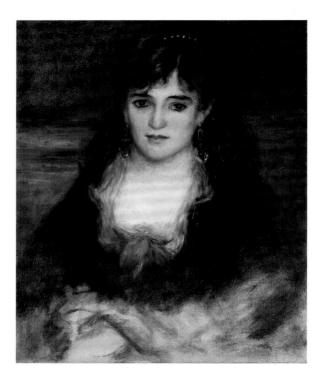

FIG. 3. PIERRE-AUGUSTE RENOIR (FRENCH, 1841–1919).
Portrait of Nini, 1874. Oil on canvas; 61 × 50 cm (24 × 19 ½ in.).
Private collection.

**FIG. 4. STUDIO OF FÉLIX NADAR (FRENCH, 1820–
1910).** *Ellen Andrée*, 1879. Gelatin-silver print on glass;
18 × 24 cm (7 ⅛ × 9 ⁷⁄₁₆ in.). Ministère de la culture,
Médiathèque de l'architecture et du patrimoine, diffusion
RMN, NA 238 0079 N.

(whose access to fashion depended on an outside benefactor), Renoir was unambiguous when he presented himself as a painter of fashion and the Parisienne. Ironically, *The Loge* was compared with Renoir's *Parisienne* (cat. 32), also exhibited in 1874, for which an unknown seventeen-year-old actress, Henriette Henriot, posed in an equally up-to-date fashion (cat. 32); Nini was seen as an older version of that cocotte.[31]

Fashion and art depended on celebrities to endorse or regenerate them, and Manet, in particular, was susceptible to the lure of these trendsetters. Having painted dramatic fashion fictions in the 1860s, followed by paintings inspired by his fashionable artist friends Gonzalès and Morisot, in the final chapter of his career, he focused on well-known actresses, demimondaines, and other women in his intellectual circle. The rich blackish-blue silk taffeta or satinlike dress worn by the actress Ellen Andrée in *The Parisienne* (cat. 33) is a *robe de promenade* (walking dress) that also alludes to the riding costume of the *amazone*. To this Manet added dramatic theatrical and historicizing touches: a gold chain necklace, white ruff around the collar, and jauntily placed and exaggerated hat. Although Manet's title signals that Ellen is the pert, small-footed, delicately featured feminine ideal exalted by Stevens, her hybrid outfit and aggressive frontal pose subvert her role as the Parisienne, which was also conveyed in contemporary publicity photographs and cartes de visite (fig. 4). The daughter of a military officer and a salesgirl in a department store, Andrée was undoubtedly well versed in fashion, and it is probable that she conspired with Manet to create this enigmatic statement.[32]

Manet had a rigorously modern understanding of dress fashion and fashionability, both as a consumer and as an admirer of others. One of his favorite fashion inspirations was Isabelle Lemonnier, the young haute-bourgeois sister-in-law of publisher and collector Georges Charpentier, with whom the artist would have a sustained relationship in the last years of his life. The subject of a series of pastels and watercolors demonstrating an almost fetishistic fascination with umbrellas, hats, and hair, Lemonnier represents yet another character in nineteenth-century French networks of art and literature, artists and consumers.

Mary Cassatt, like Morisot, was both an artist and a *modèle privilégié* (see cat. 14). As an American

CAT. 14 Mary Cassatt (AMERICAN, 1844–1926)
Portrait of the Artist, 1878

Watercolor and gouache on wove paper, laid down
to buff-colored wood-pulp paper
60 × 41.1 cm (23 ⅝ × 16 ³⁄₁₆ in.)
The Metropolitan Museum of Art, New York

in Paris, Cassatt was not only interested in fashion herself but was also responsible for having clothes made for her wealthy friends and family back home.[33] Degas followed her on trips to dressmakers and milliners, although it is not clear whether he portrayed her at any of her fittings.[34] Between 1879 and 1886, he began preparing a painting of young fashionables at the Louvre. *Portraits in a Frieze* was never realized, but a charcoal preparatory sketch of the same title shows three women—at least one of whom has been identified as Cassatt—wearing the same ultra-fashionable tailored suit that Cassatt wears in the etching Degas made of her and her sister, also at the Louvre (cats. 125, 126).

DISTRIBUTORS AND CONSUMERS: THE LITERARY VANGUARD

While *modèles privilégiés* inspired artists to set fashion at the forefront of the new visual language, authors, poets, and journalists created new forms of language for its expression. Some produced highly original, serious parodies of fashion magazines, while others established their own journals to connect art, fashion, and modernity. Stéphane Mallarmé directed eight issues of *La Dernière Mode*, which was intended "to study fashion as an art."[35] Its visual model was *La Vie Parisienne,* a racy illustrated journal whose purpose was to advise the upper middle classes about fashion and accessories, but its subtitle—*Gazette du Monde et de la Famille*—and content more closely conformed to the popular middle-class family magazine *La Mode Illustrée.*[36] Mallarmé's experimental, short-lived journal owed much to his friendship with Manet, who had fostered his appreciation and intimate knowledge of material culture and the significance of feminine fashion.[37] And it is not impossible that the poet's hyperdescriptive and mannered articles on women's dresses and accessories were a response to his friend's images of ultra-chic Parisiennes, including *Lady with Fans* (cat. 15). Painted in 1873, the year Manet and Mallarmé first met at the home of the painting's subject, Nina de Callias—the ex-wife of a journalist for *Le Figaro*, a writer in her own right, and a promiscuous salon hostess—wears an Algerian blouse, harem pants, and Asian slippers. This may well have been one of the works Mallarmé

CAT. 15 Édouard Manet
(FRENCH, 1832–1883)
Lady with Fans (Portrait of Nina de Callias), 1873

Oil on canvas
113 × 166.5 cm (44 ½ × 65 ⁹⁄₁₆ in.)
Musée d'Orsay, Paris

When this portrait was painted, Nina de Callias was no more than thirty years old but regularly presided over an important and lively Paris salon. Although the work was painted in Manet's studio, he captured the unconventional decor of Callias's townhouse: an eclectic mix of "oriental" elements and Japanese motifs typified by the Japanese robe and fans in the background. Callias also loved clothes in this style and often entertained guests in Turkish costume. Here she is depicted in sequined harem pants and an embroidered bolero, underneath which she wears a sheer Algerian blouse with a low neckline. Earrings, gold rings, wide gold bracelets, a decorative hair comb, and Asian slippers complete the ensemble. The background, clothing, and semi-recumbent pose all allude to the erotic. In fact, Callias's estranged husband forbade Manet from exhibiting the painting, and it remained in Manet's studio until the artist's death.

admired in the artist's studio.[38] In the composition, Nina lounges against a background of a Japanese screen, the same that the artist would use for his smaller portrait of Mallarmé, painted in 1876 (fig. 3, p. 59).

Among the guests at the Callias salon was Arsène Houssaye, whose home on the Champs-Elysées featured an art gallery with works by Monet and his circle.[39] A man of society and the longtime

editor of the journal *L'Artiste*, Houssaye often wrote on the social, political, and artistic scene in which fashion reigned.[40] As the foreign correspondent for a New York newspaper, he noted the fleeting quality of Parisian fashion, observing: "In antiquity and the Middle Ages, a fine dress lasted a long time. The historians tell us that gala robes reappeared on every great occasion; the dresses of great-grandmothers were proudly worn. Today our queens and courtesans

wear their gowns but once. They would think themselves dishonored if they did not change their clothes every day."[41]

Other more specialized, fashion-specific journals also emphasized the importance of art and dress. Among these were the illustrated journals *La Vie Moderne*, founded in 1879 by the Charpentiers, and *L'Art et la Mode*, founded the following year by Ernest Hoschedé, one of the Impressionists' most erratic and enthusiastic collectors.[42] Although both Charpentier and Hoschedé collected work from the artists of the Impressionist circle, their journals also promoted and marketed Carolus-Duran, Federico de Madrazo, Stevens, and other notable fashion portraitists who, like the Impressionists, were commissioned to illustrate the journals.[43] In April 1881, Manet wrote to Mallarmé letting him know about Hoschedé's new venture, for which the artist provided names of friends as potential subscribers and writers.[44] Hoschedé, whose background was in textile manufacturing and retail luxury goods, was intimately in tune with fashion, and *L'Art et la Mode* was the first publication to include a fashion photograph.[45] Charpentier went even further in his promotion of current art, holding one-man exhibitions in the offices of *La Vie Moderne*.[46] Despite the proliferation of journals advertising women's fashions, these progressive publications were owned, managed, written, and subscribed to by men, who saw fashion as intimately tied to modern life.

DISTRIBUTORS AND CONSUMERS: DEPARTMENT STORE MAGNATES

The fashion industry and the fashioning of the Parisienne intersected with strategies for manufacturing, politics, and international marketing in the late nineteenth century.[47] Department store magnates were many times serious collectors of avant-garde art. Industrialists like Hoschedé—whose shop, Hoschedé Blémont et Cie, at 35, rue Poissonière, specialized in cashmere imported from India and laces—played an important role as distributors and consumers. Jean Dollfus (from a family of Alsatian textile manufacturers) was a collector of the work of Eugène Boudin, Manet, Monet, and Alfred Sisley, and was particularly close friends with Renoir, buying the study for *The Loge*

(1874) at the Impressionist sale in March 1875.[48] The couple Ernest Cognacq and Marie-Louise Jay, who in 1872 founded La Samaritaine department stores, early on collected the work of Boudin, Degas, and Monet.[49] As Ulrich Lehmann pointed out, these giants of merchandising preached the ideal of exclusivity and originality, which they delivered on a mass-market scale, and it was this openness to novelty and speculation that led to their appreciation of the unique and absolute newness of avant-garde art.[50] They were also strategists and marketers; their stores sought to attract the same enlightened, financially enabled consumers as the neighboring galleries of Georges Petit and Paul Durand-Ruel, from which they also purchased paintings for their own private collections. Like their literary counterparts, Dollfus and the Cognacq-Jays helped establish the taste for modern lifestyles with fashions and merchandise that were mirrored in the paintings they collected. Industrialists studied the art market and developed relationships with dealers and artists. In turn they were important allies to the Impressionists.

One of the truisms understood by this merchant class was that what was à la mode one day was just as quickly démodé. This was especially true for fashion portraitists like Stevens, whose precise renderings of women in interiors were quickly outdated. In the wake of the Second Empire and the disaster of the Franco-Prussian War, Stevens's *femmes de qualité* provided a less powerful artistic message and were usurped by the other images of the Parisienne on boulevards, in public places, and with crowds, such as those popularized by Jean Béraud and, in a more limited way, the Impressionists. And although Stevens's social connections to Carolus-Duran, Degas, Manet, and Morisot continued, professionally he and his closest imitators, Gustave de Jonghe and Toulmouche, could not move beyond the vehicle of fashion and the Parisienne. For Manet and the Impressionists, in contrast, painting these subjects was a means to other ends. They were nurtured and supported by their relationships with models, writers, and distributors and collectors of fashion and art, but not defined by them. The social network of the Parisienne offered a preexisting framework of support for the Impressionists, whose new expressions of modern life reached past the metropolis, requiring the continued renewal, innovation, and change essential to the larger aspirations of their enterprise.

Claude Monet
Camille

Gloria Groom

In February 1866, having temporarily abandoned his monumental *Luncheon on the Grass* (cats. 38, 39), Claude Monet hurriedly prepared a new canvas showing his nineteen-year-old mistress, Camille Doncieux, in a green-and-black striped walking dress, small "Empire" bonnet, and fur-trimmed jacket (cat. 16). For an artist with no official academic standing at the Salon (where he refused to be listed as a student of his official teacher, Charles Gleyre), Monet's life-size *Camille* was the equivalent of a Prix de Rome, his first success in the Parisian art world and his largest finished canvas to date.[1] It was both courageous and conservative, undertaken to garner critical support as well as to placate his aunt Marie-Jeanne Lecadre, who had threatened to cut off his monthly allowance.[2]

Portraits were a mainstay of the Salon of the Second Empire and in 1866 made up approximately one in seven of the 1,998 paintings listed in its catalogue. Some were designated by full names and titles, or more commonly by the euphemistic "Monsieur X," "Madame X," or "Mademoiselle X." Just a handful of the portraits at the 1866 Salon, *Camille* among them, were titled with first names only.[3] If Monet's intention for *Camille* was to elevate his mistress to a bourgeois status more in keeping with his family's, as Mary Gedo suggested, by titling it thusly he "inadvertently or purposefully, cast aspersions on the moral and social status of his companion."[4] *Camille* was deemed familiar but not recognizable, or, as Charles Blanc perceived, not quite a portrait.[5] Devoid of anecdotal, moral, or physiognomic details, the painting was commented upon, if not admired, by almost every critic. Théophile Thoré, for example, praised the "large portrait of a standing woman seen from behind

trailing a magnificent green silk dress, as dazzling as the fabrics painted by Veronese."[6] Its subject appeared as a signifier of either the chic and elegant Parisienne or a *fille,* slang for a girl of easy virtue. A caricature of the portrait section of the 1866 Salon published in *La Vie Parisienne* (fig. 1) indicates the painting's unconventional nature: its huge scale was typically reserved for royal or distinguished personages, and it deviated from bourgeois portraiture, whose primary characteristic was flattering fidelity to physiognomic details. Set against a

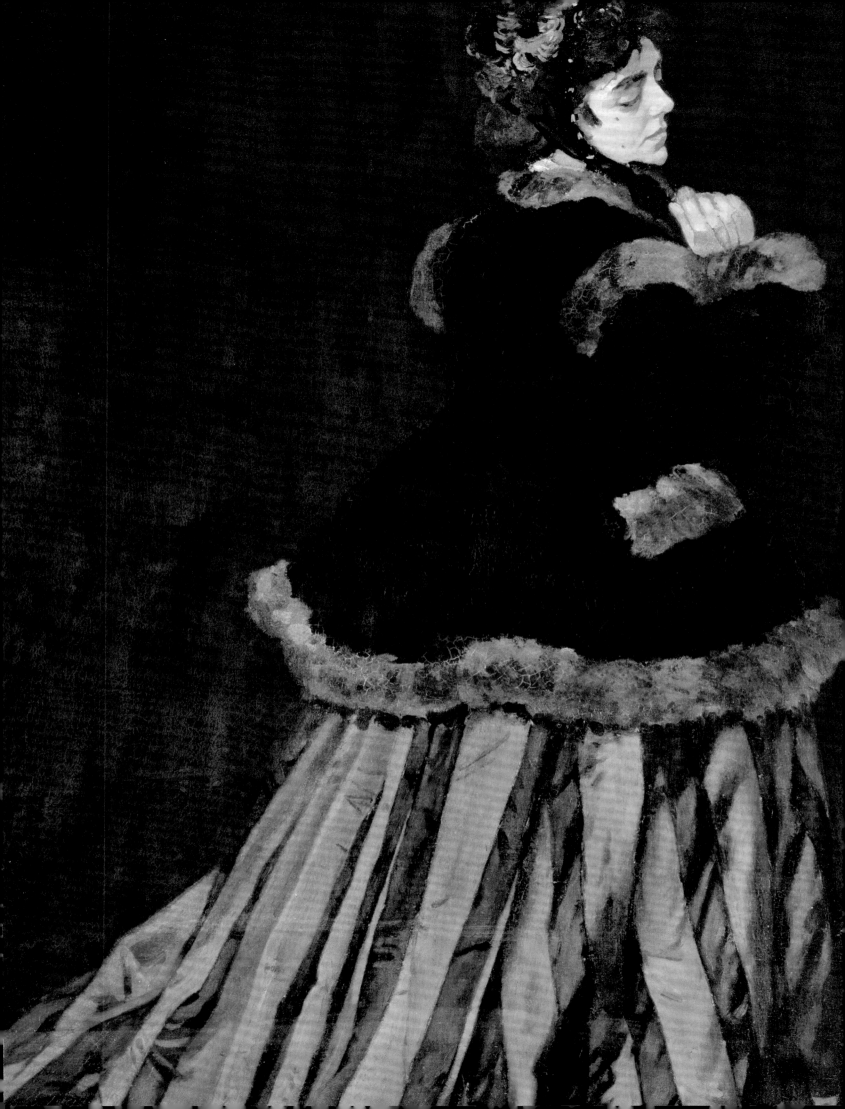

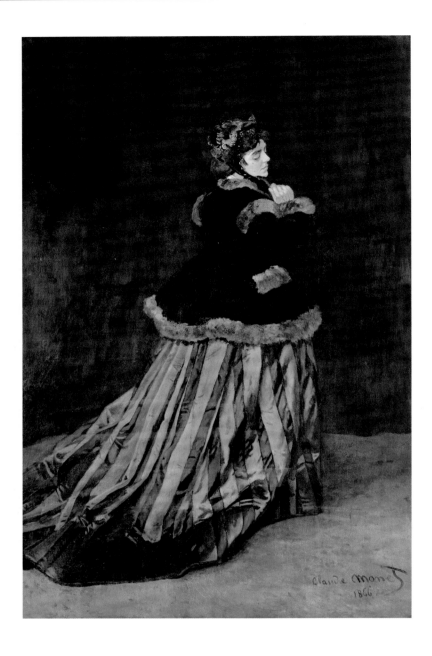

CAT. 16 Claude Monet (FRENCH, 1840–1926)
Camille, 1866

Oil on canvas
231 × 151 cm (90 ¹⁵⁄₁₆ × 59 ½ in.)
Kunsthalle Bremen

dark-red curtain in a neutral space, yet shown moving away from the viewer and dressed for the street, Monet's monumental, unclassifiable figure stood apart from the smaller portrait and genre scenes popularized by artists like James Tissot and Alfred Stevens (fig. 3, p. 23; fig. 1, p. 34).

Other contemporary caricatures (see fig. 2) targeted the mixed, confusing codes offered by Monet's portraitlike image of a nobody, her pose and setting denying the viewer the context to explain the scene. Conservation research carried out for the 2005 exhibition *Monet und Camille*, held at the Kunsthalle Bremen, revealed that in an earlier iteration Camille posed on an elaborate Oriental rug or carpet akin to that in the commissioned portrait of Madame Gaudibert that Monet painted two years later (cat. 97)—an interior that would have made Camille's identity more readily legible.[7]

Instead, the only information offered resides in her dress and its exaggerated train. For Zola it was the dress that identified the wearer: "Notice the dress, how supple it is, how solid. It trails softly, it is alive, it declares loud and clear who this woman is."[8] But who she is remained in question. In his caricature of *Camille*, Bertall's caption—"*Camille, ou Le souterrain*" (*Camille*, or the underground)— puns on the idea of the train as both a locomotive and a piece of fabric that is literally out of control, or, as Zola put it in his otherwise positive review, "plunging into the wall as if there were a hole there."[9] However much Camille's facial characteristics differed from the expectations of traditional portraiture, the dress itself was reassuringly recognizable from contemporary fashion plates (see fig. 3).[10] Two years later, when *Camille* was awarded a silver medal at the Exposition Maritime du Havre, for example, Léon Billot found the painting but a pretext for "the most splendid dress of green silk ever rendered by a paintbrush," regarding the model herself "from the provocative way in which she tramps the pavement" to be "not a society woman but a Camille."[11]

Part of the ambiguity expressed by reviewers stemmed from the way the dress seemed to relate to its wearer. The caption accompanying Félix Régamey's caricature (fig. 1) noted Camille's dragging, uncrinolined dress and thumb-sucking, insinuating perhaps her childishness, as if she is

FIG. 2. BERTALL (ALBERT D'ARNOUX, FRENCH, 1820–1882). Detail of Monet's *Camille* from "The Salon of 1866," *Le Journal Amusant*, May 12, 1866.

FIG. 3. *Petit Courrier des Dames* 86 (November 18, 1865). Staatliche Museen zu Berlin, Kunstbibliothek.

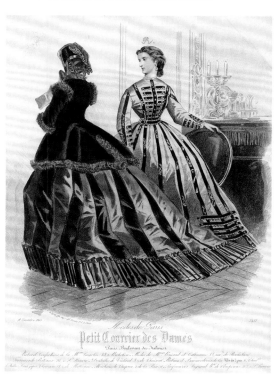

dressing up in clothes that are too big for her (fig. 1).[12] This idea of a childish woman dressing up in an overly large garment can also be seen in Bertall's caricature (fig. 2). The perceived excessiveness of her train also implies the idea of borrowed luxury; in yet another caricature, a small dog takes a ride on the dragging train (fig. 4). Despite Monet's choice of serious fashion to "dress up" his mistress, both sartorially and sociologically, the fit of the dress seems to have been unconvincing.

Recent interest in Monet's *Camille* has not fully addressed the existence and economics of the dress itself.[13] The trendy silhouette and expensive fabrics featured in Camille's silk *robe de promenade* (walking dress) and fur-trimmed *paletot* would have been outside the reach of most. Although a pattern for this outfit was available in the many fashion periodicals aimed at middle-class women, fabric and assembly would have been prohibitively expensive for the majority. Mark Roskill, who first posited the relationship of fashion plates to early Impressionist compositions, concluded that "in view of Monet's and Camille's extreme poverty at this time, . . . some, and perhaps all, of the other costumes in question were in fact rented in Paris," though he did not offer any further information on where or how such rentals might have occurred.[14]

Costume historian Birgit Haase believes that Camille owned the summer dresses featured in *Women in the Garden* (cat. 45), based on what she considers Camille's financially stable family and enthusiasm for stylish clothes (see p. 102).[15] Little in fact is known about Camille's economic situation at the time she posed for that painting. The daughter of a Lyonnais merchant, she met Monet in the summer of 1865, leaving the security of her family to follow Monet to Chailly, where she seems to have been as impoverished as he was. Unless, as Haase suggests, she owned these dresses while still with her family, it is unlikely she would have had access to the dresses featured in Monet's *Women in the Garden* or the green-and-black striped dress from February 1866.[16] Depending on the fabric, having a dress made by a professional dressmaker was expensive.[17] Although secondhand shops existed, the contemporaneity of this ensemble rules out such an origin. It is also possible—as suggested by a letter from Frédéric Bazille to his mother written in

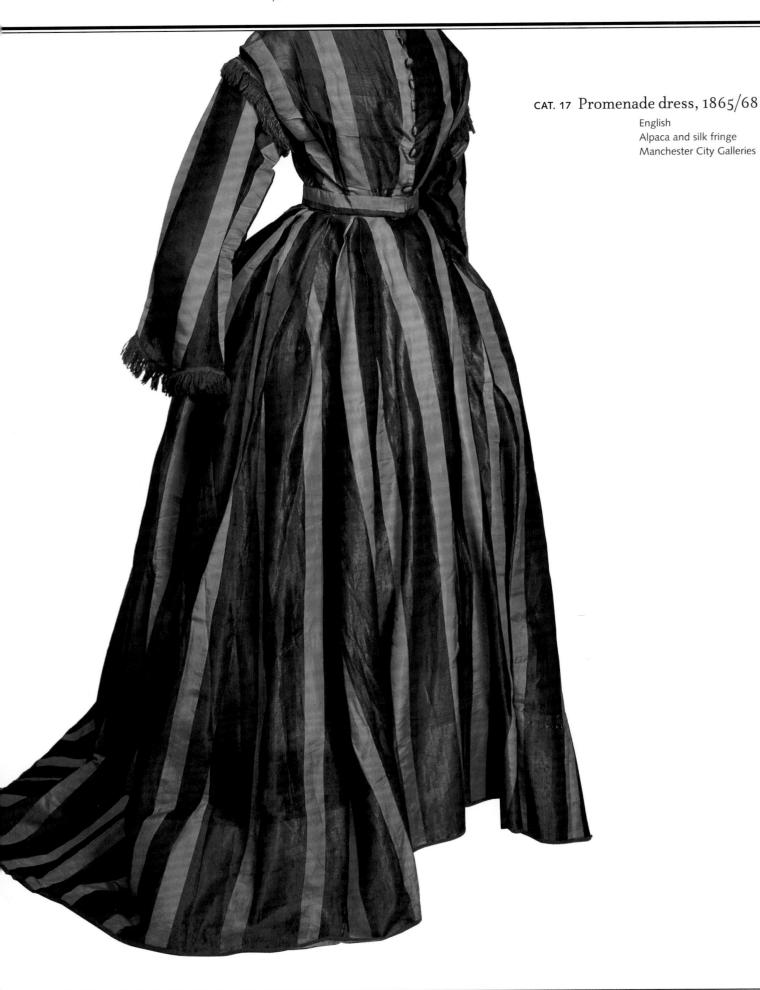

Claude Monet: *Camille*

CAT. 17 Promenade dress, 1865/68

English
Alpaca and silk fringe
Manchester City Galleries

January 1866, mentioning a green satin dress that he had rented—that Monet may have borrowed Camille's dress from his friend.[18] The other possibility is that Camille's outfit was a department store purchase—a *robe mi-confectionnée*, or almost-ready-made dress—purchased off the rack and fitted to her by the store's seamstresses. But even this would have been pricey; until later in the century, such machine-made items were just as costly as those made by couturiers.[19]

Much has been written about the impact of *grands magasins*, or department stores, on the democratization of fashion. What relationship did Zola's fictional department store, Au Bonheur des Dames, have to the Impressionists' choices of fashion? Their paintings do not allude to department stores explicitly, but the accessories, jackets, and even *robes mi-confectionnées* that they depicted were certainly available in department stores,

thanks to modern technologies that allowed the middle class access to machine-made laces, dress patterns, and standardized or even precut fabrics (see p. 64). Indeed, Monet's painted silk may have originated, despite Bazille's mention of a green satin dress, as a different fabric altogether. While we cannot know the status and price of the dress Camille wears, her stylishness is confirmed by the painting. In comparison to Monet's portrait of Madame Gaudibert, a private commission that was never exhibited publicly, *Camille* was a manifesto that aimed to impress both the academic and avant-garde artistic communities. In the former, Monet looked to *peintres-couturiers* (fashion portraitists) like Stevens, trying to replicate the sheen of Madame Gaudibert's lavish satin dress and tapestry shawl. With *Camille*, he instead chose to re-create a recognizable and fashionable ensemble not with the aims of a portraitist or photographer but as a strategy for expressing modern life.

Comparing Camille's painted gown to a similar green-and-black striped dress from the same period (cat. 17) raises more questions about the meaning of Monet's choice of garment and his adjustments to it. X-radiographs of the canvas reveal that in addition to painting over the patterned rug and toning down the floor-length drapery, the artist shortened the front hem of the dress and slimmed the silhouette by covering the dress's outlines with the background color.[20] A comparison of the Salon version to the smaller replica of the painting commissioned by the Galerie Cadart and Luquet for an American client in 1866 (fig. 5) shows how Monet reinstated the full skirt in the latter work and increased the canvas's width to accommodate it. Camille's jacket is also more fitted in the smaller version of the painting, creating a dramatic silhouette, and though equally conspicuous, the train is more articulated, naturally conforming to Camille's movements.

In the Salon version of *Camille*, Monet either diminished the effect of the wedge-shaped crinoline or Camille went without it. This would explain the noticeable drag of her train. It might also signal the artist's ability to capture the subtleties of fashion's vagaries. For although the crinoline was not abolished until 1868, already by 1865 it was losing ground, criticized for its exaggerated size and

FIG. 4. STOCK (G. GAUDET, FRENCH, ACTIVE 19TH CENTURY).
Page from *L'Épâtouflant, salon du Havre* (Victor Coupy, 1868). Bibliothèque de la ville du Havre.

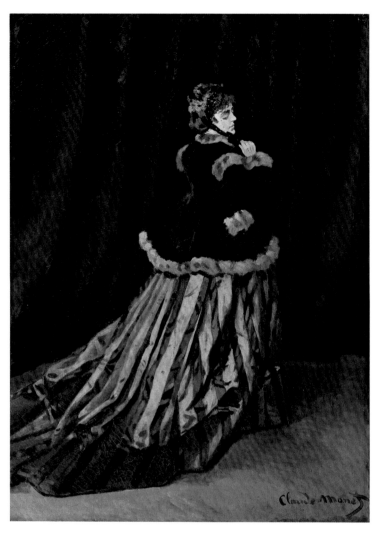

FIG. 5. CLAUDE MONET (FRENCH, 1840–1926).
Camille, the Green Dress, 1866. Oil on canvas;
81.2 × 55.2 cm (32 × 21 ¾ in.). Muzeul Naţional de
Artă al României, Bucharest, inv. 8268/302.

pavement" provide unsubtle indicators of her "loose" moral character.[22] What then was Monet's intention in removing Camille's crinoline? Was it Camille's choice to shed this cumbersome layer? Is *Camille* a prescient image, or the result of Monet reimagining the dress modeled by his mistress? In a painted study for the unrealized *Luncheon on the Grass* (cats. 38, 39), Camille is posed with a similar *profil perdu* and an equally unsupported train. It is possible that among the many items hauled from Paris to the forest of Chailly, where Monet first conceived his subject, the crinoline was less critical to the sketch, but would have featured in the final studio production. And yet the fact that volumetric, presumably crinolined dresses reappear in Monet's next composition, destined (but ultimately rejected) for the Salon of 1867, *Women in the Garden*, makes the crinoline's absence in *Camille* all the more puzzling.

Like the portrait itself, Camille's fashion statement defied easy categorization. Although wearing a recognizable fashion, she is not on display but on the go, reflecting Zola's distinction between artists who made fashion plates and artists who painted "from life" and with "all the love they [the painters] feel for their modern subjects."[23] Instead of showing off her finery, Camille leaves the interior (considered a woman's domain), physically and metaphorically abandoning the ties (or, in this case, steel-ribbed crinoline cage) that bind.

In the summer of 1867, Monet left Camille and their newborn son in Paris and returned to his family on the Normandy coast. He requested that Bazille and Zacharie Astruc send several paintings to him from Paris, especially *Camille* and his smaller replica of it. Clearly he wanted to use these two works, which represented his first noteworthy achievement in the larger Parisian art world, to advertise his talent and taste. Although nothing seems to have come of his strategy, the next summer he re-exhibited *Camille*, along with five other works, at the Exposition Maritime. Perhaps it is not surprising that the award-winning canvas was acquired shortly afterward by Arsène Houssaye, the longtime editor of *L'Artiste* and a popular commentator on feminine fashion. An excerpt from his series of books on the Parisienne, published in *L'Artiste* in August 1869, offered his very male-centric assessment of this type of woman and may well have been written with *Camille* in mind:

the extraordinary amount of fabric it required.[21] Nonetheless, popular imagery from the second half of the nineteenth century often parodied or praised the crinoline as a standard trope for the bourgeois woman. An illustration by Félicien Rops, commissioned to accompany an article by Amédée Achard for his article in *Paris-guide, par les principaux écrivains et artistes de la France* (Paris Guide, by the Major Writers and Artists of France) in 1867, shows a woman in a dress with a train but no crinoline (fig. 6). The work's title, "Parisian Type: Bal Mabile" [*sic*], alludes to a popular but slightly risqué outdoor dance hall, while her dragging dress, her sly expression, and the fact that she literally "tramps the

The Parisienne is not in fashion, she is fashion—whatever she does—whatever barbaric outfit she decides to wear, — When a provincial walks down the boulevard, one recognizes that her dress is brand new. The dress of the Parisienne could well date from that very instant, from [Charles Frederick] Worth or from any ordinary seamstress, and it will appear as if she's been wearing it for a certain time. The Provincial is dressed by the dress, the Parisienne wears the dress.

And how much this dress is hers and not another's! The dress is supple; the dress caresses her like a woman caresses a dress. If it's a long dress, then she takes on a romantic, sentimental mood, her train languishing.[24]

FIG. 6. FÉLICIEN ROPS (FRENCH, 1833–1898), engraved by M. Boetzel. "Parisian Type: Bal Mabile" [*sic*], *Paris-guide, par les principaux écrivains et artistes de la France* (1867), p. 1248.

In Houssaye's mind, Monet had successfully transformed his mistress into a Parisienne, synonymous with style, seduction, and fashionability. Despite the ambiguity of the meaning of the dress and its wearer, Camille was seen as embodying *le chic*. She was a real someone, though not quite anyone— "a girl of our times," as Zola put in it in 1868 when comparing Monet's *Camille* to Renoir's *Lise* (cat. 40). Incongruously subverting traditional codes of legibility, *Camille* was also perceived as embodying Parisian femininity and style, an export commodity.[25]

In his review of the 1879 Salon, the Symbolist poet and critic Joris-Karl Huysmans complained about artists who were more couturiers than painters, and whose elegantly clothed mannequins were but a pretext for modern life. In his view, the Impressionists trumped the more acclaimed fashion painters of the day in their understanding of modernity. For Huysmans the true artist revealed both a woman's exterior and her interior without relying on the cut and fabric of her dress. Two women wearing the "same armor" by a famous couturier would still be recognized for what they were. In the Impressionists' works, he concluded, "A tart is a tart and a society woman is a society woman."[26] One wonders how Huysmans would have judged Monet's *Camille*, neither trollop nor grande dame, whose true modernity resides in her dress— its fashion and fit—and the multiple readings of the model it provoked.

Writing Fashion from Balzac to Mallarmé

Heidi Brevik-Zender

If I were permitted to choose amidst the jumble of books
that will be published a hundred years after my death,
do you know which one I would pick? No, it is not a novel
that I would choose inside this future library, nor a history book:
which, when it offers anything of interest, is just another novel.
I would quite simply pick, my friend, a fashion magazine in order
to see how women will dress a century after my passing.
And these rags would tell me more about humanity's future than
philosophers, novelists, preachers, or scholars.

— Anatole France[1]

Anatole France's tongue-in-cheek claim that fashion magazines say more about humanity than novels suggests a separation between fashion, literature, and human experience that is easily challenged by numerous French literary works of the nineteenth century. For to read French literature produced during the period of the Impressionists is to realize that—for numerous novelists, poets, playwrights, essayists, and composers of short stories—fashion was a veritable preoccupation. In fact, the sartorial turn in literature was not restricted to the 1860s and 1870s. Rather, it spanned the entire nineteenth century, both predating Impressionism and remaining relevant after the movement faded.

Over three decades before the first Salon des Refusés, in 1863, Honoré de Balzac published his 1830 novella *La maison du chat-qui-pelote* (At the Sign of the Cat and Racket), which was set in a fabric shop, anticipating the mid-century use of fashion as a metaphor for modern urban life. Late in

FIG. 1. CONSTANTIN GUYS (FRENCH, 1802–1892).
Elegant Ladies, 1852–60. Watercolor and ink on vellum;
17.3 × 22.2 cm (6 13/16 × 8 3/4 in.). Musée Carnavalet,
Paris, M.C.D. 1280.

FASHION AND THE TRANSIENCE OF MODERNITY

If fashion emerged as a narrative motif throughout the first half of the nineteenth century, it came to fruition as a central literary theme during the Second Empire (1852–70), the period that has come to define modernity, due in part to the swift urban modernization of Paris that took place under the direction of city planner Baron Haussmann. In literature of the nineteenth century, modernity is most frequently linked to Paris, a rapidly transforming metropolis. It was in this context that writers sought the aesthetic qualities of commodity culture, negotiating the ambivalence of the industrialized city and discovering expressions of universal beauty, no matter how fleeting. As Rita Felski noted, in the literature of Paris, modernity was concerned with a "sense of dislocation and ambiguity" that was found in "the more general experience of the aestheticization of everyday life, as exemplified in the ephemeral and transitory qualities of an urban culture shaped by the imperatives of fashion, consumerism and constant innovation."[2]

Felski's description of French modernity is indebted in part to Charles Baudelaire, perhaps the most influential mid-nineteenth-century writer of fashion and the city. In 1863 the newspaper *Le Figaro* published "Le peintre de la vie moderne," an essay penned in the late 1850s that included Baudelaire's now-iconic definition of the modern: "Modernity is the transitory, the fugitive, the contingent, the half of art of which the other half is the eternal and the immutable."[3] For Baudelaire the modern urban experience was characterized by temporariness, by the ephemerality of daily life that existed in balance with the permanence of beauty and art. Fashion, he perceived, shared many features with the transience of modernity. For example, modern clothing styles, adornment, and ornamentation maintained a pattern of consistent change that mirrored the variable rhythms of life in the capital city. The writer believed that this constant movement, seen in the "undulating"[4] motion of the crowd and the seductive "gesture"[5] of a woman's dress, was best represented in the works of Constantin Guys, whose genius lay in his "swiftness of execution"[6] and uncanny ability to paint "the circumstantial"[7] by capturing modern life in fluid images of passing moments (see fig. 1 and

the century, as currents in painting evolved from the concerns of the first wave of Impressionism to the Symbolism and primitivism that would become the hallmarks of fin-de-siècle art, Stéphane Mallarmé, the father of Symbolist poetry, continued to pen fashion-inflected verse and prose. Mallarmé's late works ushered in a new era of twentieth-century modernist aesthetics that Marcel Proust, in his monumental work *À la recherche du temps perdu* (In Search of Lost Time; 1913–27), would take up, in part through his nostalgic treatment of the fashion of the previous generation.

Nineteenth-century authors wrote about myriad aspects of fashion: clothing styles and their transformations, the evolution of the ready-to-wear and haute couture markets, the commercialization and mass production of articles of clothing, and the symbolic and aesthetic qualities of garments and accessories. Indeed, fashion is interwoven throughout the very fabric of the literary works of this era, forming a complex textual discourse through which writers examined profound social and cultural changes associated with the experience of living as modern citizens. To follow fashion, chart styles, and chronicle fashion's influences was to participate in modern society. Writing about fashion was thus a form of cultural critique, but one that doubled as a self-conscious expression of modernity itself.

cat. 18). With the aid of his "eagle eye," Guys could observe almost imperceptible modifications in the cut and fit of garments:

> If a fashion or the cut of a garment had been slightly transformed, if knots or loops of ribbons had been dethroned by cockades, if *bavolets* had been enlarged and chignons had descended into waves on necks, if belts had been raised and skirts amplified, believe that, from even an enormous distance, his eagle eye had already made this all out.[8]

For Baudelaire the adjustments that Guys perceived in ribbons, bows, hat ornaments, hairstyles, and skirts corresponded to continual shifts in Parisian social and cultural conventions. His paintings of prostitutes, horse-drawn carriages, and high society faithfully rendered the "rapid movement" of modern life, which was enhanced visually by his quick brushstrokes and rough washes of color.[9] Guys's images entered into a dialogue with the writings of Baudelaire, for the latter's poetry and prose similarly depicted an ambivalent modern existence rife with fleeting encounters and isolated moments of beauty in a metropolis otherwise plagued by corruption and squalor. In his poem "À une passante," Baudelaire captured a chance encounter with a beautiful passerby amid the thunderous chaos of the "deafening" city street:

> The traffic roared around me, deafening!
> Tall, slender, in mourning—noble grief—
> a woman passed, and with a jeweled hand
> gathered up her black embroidered hem;
>
> stately yet lithe, as if a statue walked . . .
> And trembling like a fool, I drank from eyes
> as ashen as the clouds before a gale
> the grace that beckons and the joy that kills.
>
> Lightning . . . then darkness! Lovely fugitive
> Whose glance has brought me back to life!
> But where is life—not this side of eternity?
>
> Elsewhere! Too far, too late, or never at all!
> Of me you know nothing, I nothing of
> you—you
> whom I might have loved and who knew
> that too![10]

The brevity of the instant in which the "lovely fugitive" walks past characterizes the ephemerality of modern public interactions, just as the stranger's black mourning dress expresses the "noble grief" of such exquisite, yet unexplored encounters. As the woman lifts her embroidered hem with a bejeweled hand, the motion of her skirt contrasts with the eternal, statuelike quality of her leg, which is momentarily revealed by the swaying fabric. Juxtaposing the ephemeral movement of the woman's skirt with the permanence of a statue, Baudelaire used dress to illustrate his vision of modernity.

Charles Carolus-Duran's *The Lady with the Glove* (cat. 19), which depicts an elegant woman in black reminiscent of Baudelaire's passing mourner, debuted at the Salon of 1869, six years after the publication of "Le peintre de la vie moderne." Although different in approach and medium from Guys's quickly sketched watercolors, the painting can be understood as another visual example of the

CAT. 18 Constantin Guys
(FRENCH, 1802–1892)

Reception, 1847/48

Pen and brown ink with brush and watercolor, over graphite, on ivory laid paper
17.8 × 19.7 cm (7 1/16 × 7 13/16 in.)
The Art Institute of Chicago

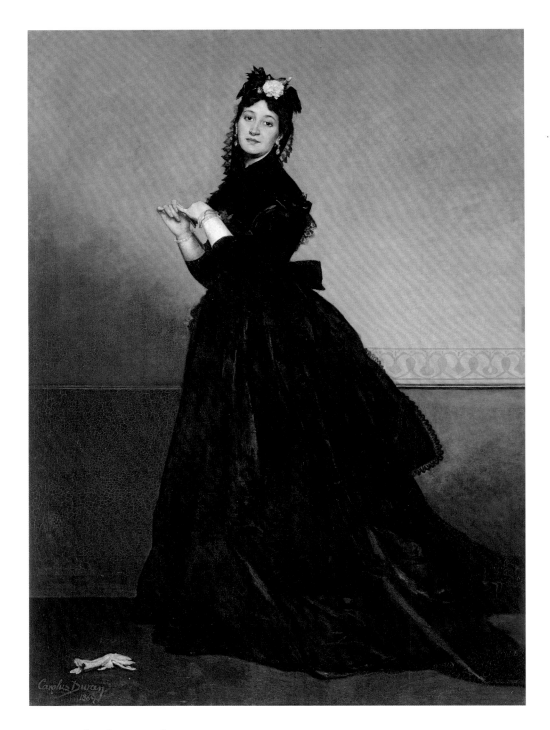

CAT. 19 Charles Carolus–Duran

(FRENCH, 1837–1917)

The Lady with the Glove, 1869

Oil on canvas
228 × 164 cm (89 ¾ × 64 ⁹⁄₁₆ in.)
Musée d'Orsay, Paris

Like a photograph, this painting documents an exact moment in time. The model, the painter's wife, is dressed not to be timeless, but of the moment, wearing a cap trimmed with flowers and lace lappets, a style that, while briefly very fashionable, would soon become démodé. Carolus-Duran's highly detailed rendering makes details of the embellishments, like the lace edging on the armhole and waist sash, and the bow at the tip of the left sleeve cap, visible against the black silk of the gown. Gloves were worn so tightly at this time that their removal would be accompanied by a graceful fluttering of the hands to regain circulation.

type of modernity that Baudelaire was instrumental in constructing in verse and prose. In his depiction of his wife, Pauline Croizette, Carolus-Duran's attention to the details of her hair accessories highlights a fleeting style. By making her fashionable adornments a focal point of his composition, the artist, like Baudelaire, emphasized the transitory nature of modernity.

Claude Monet's *Camille* (cat. 16) also exemplifies Baudelaire's definition of modernity. Both *The Lady with the Glove* and *Camille* show women lightly touching (and thus drawing attention to) an accessory—Pauline tugs at the finger of her glove, its mate lying at her feet, while Camille adjusts the ribbons of her hat—serving as a reminder that the images represent split seconds caught in time, as fleeting as yesterday's fashions. In both paintings, the sensual movement of the model's skirt, emphasized by the sinuous disorder of her hem, recalls Baudelaire's fascination with the rhythmic, hypnotic cadence of satin and silk skirts in motion.

FASHION, FEMININE ARTIFICE, AND THE CHANGING ROLES OF WOMEN

In addition to using fashion to embody the qualities of transience in modernity, nineteenth-century writers associated it with the artifice of machine-made garments, rigidly shaped underclothes, and cosmetics. Théophile Gautier, author of the 1858 work *De la mode* (On Fashion), commended the manipulations of the natural body effected by nineteenth-century dress and makeup. A woman's crinoline skirt, for example, which some artists considered "hideous, savage, abominable, contrary to art"[11] for the way in which it concealed the human form, was in fact to be valued, serving as a pedestal for the bust and head, which Gautier believed were the two most important areas to highlight on a clothed figure.[12] Rice powders, he continued, enhanced modern feminine beauty by eliminating what he described as "the ruddy-faced healthy look that is an indecency in our civilization,"[13] bringing women closer to art by replacing their natural reddish skin tones with the desirable, marblelike pallor of statuary. He also praised eye makeup for its ability to lengthen the lids, enhance the arches of the brows, and increase the brightness of the eyes, much like the finishing touches on great paintings.

Gautier's linking of his ideal woman to a statue—a static work of art—coupled with his suggestion that the flawless artifice of modern dress was desirable because it perfected the natural female body, demonstrates the ways in which fashion writing exposes important gender ideologies in the works of nineteenth-century male authors, ideologies that typically reflected their concerns over perceived threats to traditional gender hierarchies. Like Gautier, Baudelaire praised artifice in his tributes to women's garments and cosmetics, revealing an uneasy, misogynistic view of women's bodies that was typical of many male authors of his day. Baudelaire fantasized the female body as a work, not of nature, but of artistic perfection. Viewing fashion and makeup as improvements over nature that approximated the ideal in beauty and art, he wrote, "Fashion should therefore be considered as the symptom of a taste for the ideal . . . like a sublime deformation of nature, or more like a permanent and repeated attempt at the reformation of nature."[14] Evoking Gautier's admiration for powdered skin, Baudelaire also suggested that makeup on the face functioned like the maillot worn by dancers and actresses: both brought the female wearer nearer to a statue, that is, to "a divine and superior being."[15] Black kohl, which transformed the eye into a "window open to infinity,"[16] and rouge, which added to a woman's face "the mysterious passion of a priestess,"[17] were not, according to Baudelaire, attempts to imitate nature, but rather to lift the wearer above it.[18] Édouard Manet illustrated Baudelaire's admiration for dark, exotic eye makeup in his portrait of his friend Nina de Callias (cat. 15), using cosmetics to highlight her status as an eccentric salon hostess. Fashion's deliberate manipulation of the feminine figure, its celebration of artfulness in makeup and jewelry, and its self-conscious replication of skin through man-made fabrics all echoed Baudelaire's aesthetic principles, which deemed the natural woman "abominable" and turned to the artificial for what they thought of as "true" beauty.

As these texts by Gautier and Baudelaire imply, in the literature of the second half of the nineteenth century, women were inextricably linked to their clothes, their bodies canvases for and carriers of garments and accessories charged with

FIG. 2. Cover of *La Dernière Mode*, October 18, 1874.

in his 1880 novel *Nana* by forging connections between the courtesan's clothing and the gaudiness he deemed symptomatic of the period. Pierre-Louis Pierson's striking 1856/57 photograph of the Countess de Castiglione, a mistress to Napoléon III, similarly emphasizes this nexus of sartorial frivolity, feminine promiscuity, and exaggerated opulence (cat. 20).

Fashion was thus a useful vehicle through which writers could critique one of the aspects of modernity that they found particularly troubling: the way in which women were claiming agency and power. As the concept of the emancipated "New Woman" entered mainstream French vocabulary, and women became increasingly vocal about their desire to reform education laws for girls, ensure protection for women workers, and vote in national elections, many authors were critical of the changes they perceived in women's public and private roles, framing their disapproval of women's actions through discussions of their garments.[20] Zola, recognizing the rise of women as primary consumers in the modern department store, distorted them into the hysterical shoppers and kleptomaniacs of his novel *Au bonheur des dames* (The Ladies' Paradise; 1883).

polyvalent, ambivalent meanings. To write about women in late-nineteenth-century Paris—from idealized portraits of feminine innocence to dangerous prostitutes and decadent femmes fatales—often meant writing about fashion, and vice versa. Baudelaire's influence on this literary phenomenon is not to be underestimated: as early as the 1850s, he posited the close relationship between femininity and adornment by declaring that "everything that ornaments woman, everything that serves to illustrate her beauty, is a part of her."[19] The figure of the Parisienne and her outfits, whether haute couture ball gowns or subversive riding pants worn under long *amazone* skirts, became fashionable topics in artistic and literary circles as well as the mainstream press. Fashion's vocabulary and symbolic connotations were appropriated to evoke issues that were especially current. For example, the opulent garments of wealthy courtesans were effective metaphors for the wasteful decadence, corruption, and declining morality of Second Empire society. Émile Zola famously exploited these metaphorical properties

THE FASHION PRESS AND MALLARMÉ'S *LA DERNIÈRE MODE*

A number of famous literary figures of nineteenth-century Paris, though typically celebrated for their fiction and poetry, also wrote for the fashion press, sometimes before they had made names for themselves or in order to make ends meet when income was scarce. In 1830, for example, Balzac wrote his *Traité de la vie élégant* (Treatise of Elegant Living), a series of articles on fashionable living that appeared in five installments in the newspaper *La Mode*. The author Barbey d'Aurevilly, who discussed masculine style in his 1843 essay "Du Dandysme" (On Dandyism), also wrote for the popular ladies' fashion magazine *Le Moniteur de la Mode*.[21] Yet none rivaled Mallarmé, who authored an entire fashion magazine almost singlehandedly: the luxury ladies' periodical *La Dernière Mode* ran under his direction from September to December 1874. Writing as "Marguerite de Ponty" and

"Mademoiselle Satin," and giving voice to "Olympe, a negress," "Zizy, a mulatto maid from Surate," and "a Créole lady," Mallarmé wove together what has been likened to a Platonic dialogue among members of an all-female group that evoked "le high-life" and the opulent late-nineteenth-century world of Parisian haute couture.[22]

La Dernière Mode was superficially consistent with other fashion magazines of its time. Each ten-page issue included a fashion plate, a report on "la mode," a gossip column, theater reviews, travel reports, menus, and decorating advice. What distinguished the magazine from many of its rivals was its elegant presentation and luxurious appearance. It used paper of the highest quality, and the front cover was printed on a striking bluish sheet (fig. 2) that would have been easily distinguishable from the ordinary newsprint of most fashion periodicals. To prevent articles from streaming from one page to the next—a layout technique that risked causing the magazine to resemble too closely a daily newspaper—Mallarmé took care to limit columns to one or two facing pages, so that the reader could view an entire article at once without turning a page. Rather than filling all spaces with type, he incorporated large margins of white to border the periodical's illustrations and articles, like frames on works of art. This attention to paper quality and design suggests that Mallarmé wished for his creation to stand out from other magazines as an object that

connoted sumptuousness, refinement, and beauty, both visual and tactile.

Despite the fact that Mallarmé's name appeared on the title page of the gazette as a literary contributor, nowhere did the periodical explicitly state that almost every word printed in it had been written by him. Although he was not particularly attuned to the materiality of feminine styles, Mallarmé may have been tutored by Manet, whom he met in 1873 and who would paint a fashionable portrait of the writer in 1876 (fig. 3). Still the question remains, why would Mallarmé, a writer not known for having any particular interest in either the cultivation of women readers or the commercial fashion press, create a luxury illustrated periodical designed ostensibly for female readers? As several scholars have suggested, his ladies' magazine was in some ways dedicated not to women but rather to an elite class of masculine artists and writers.[23] Mallarmé's exquisite depictions of fashionable women and his use of multiple feminine pseudonyms thus served more to reinforce the cultural authority of his male readers than to question conventional gender hierarchies.

A number of scholarly studies of the periodical and its relationship to Mallarmé's other works have also convincingly shown that the domain of feminine fashion that *La Dernière Mode* presented was important to what we now understand to be his greatest poetic project: to invent a new lyrical language. In 1864 he famously described what would define his mission for the rest of his life: "To paint, not the thing, but the effect it produces."[24] For him the poet's task was to yield to the inherent capacity of words to shimmer both in isolation and in relation to one another. Words, he suggested, are like precious stones that can stand alone as beautiful, self-referential objects, but can also be placed alongside one another to activate scintillating new meanings. It was by respecting these qualities that a talented poet could produce an effect rather than a simple descriptive referent. Fabrics and ornaments of feminine fashion were adept metaphors for poetic language because the elements that comprised ladies' dress— including lace, satin, embroidered cloths, jewels, and precious metals—collectively created a beautiful "flow of impressions" that occurred in a single fleeting moment, in the manner of ideal poetry.[25]

FIG. 3. ÉDOUARD MANET (FRENCH, 1832–1883).
Stéphane Mallarmé, 1876. Oil on canvas; 27.5 × 36 cm (10 13/16 × 14 3/16 in.). Musée d'Orsay, Paris.

CAT. 20 Pierre-Louis Pierson
(FRENCH, 1822–1913)

Woman Leaning on Her Elbow, 1856/57

Albumen silver print from glass negative
11.1 × 7.6 cm (4 ⅜ × 3 in.)
The Metropolitan Museum of Art, New York

Decadent, opulent, and often risqué, photographs of Virginia Oldoini, the Countess de Castiglione and mistress of Napoléon III, were read as extravagant emblems of declining morality. The most notorious celebrity of the Second Empire, the countess indulged her exhibitionism in private as well as public and directed numerous personal photo shoots. For the sessions, which resulted in over 400 portraits, the countess wore sumptuous garments from her own wardrobe, frequently changing her costume. Conscious of her own beauty and eager to astonish and seduce, she dressed in provocative and excessive versions of current fashion such as, in this image, a very low décolletage, an enormous crinoline, and heavy eye makeup.

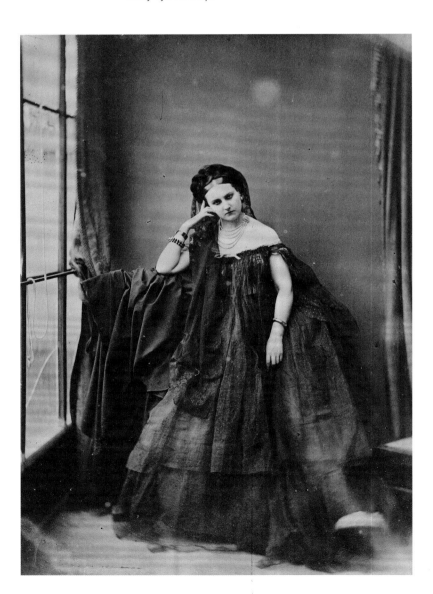

In the December 6, 1874, issue of *La Dernière Mode*, Mallarmé compared the embroidered design on a piece of cloth to language itself:

> Language . . . is put together like a marvelous work of embroidery or lace: not a thread of an idea is lost, it hides itself, but only to reappear a bit later on, united to another; it all comes together in a design, either complex or simple but ideal, and which memory retains forever.[26]

It is the instantaneous impression or sensation of beauty, a moment caught forever in memory, that luxurious fabrics and intricately wrought language both have the ability to evoke. Mallarmé's association of poetic language and its immediate effects recalls the Impressionists' impulse to capture the momentary effects of light with their swift brushstrokes. This correspondence in artistic ideology is not a surprise: in addition to Manet, Mallarmé was a close friend of Monet and Pierre-Auguste Renoir, among others. Overlap between Mallarmé's writing and the preoccupations of these artists manifests itself throughout *La Dernière Mode*. For instance, a number of the locations that interested the Impressionist painters are referenced in travel columns in the periodical, such as the beaches of Normandy, the western countryside outside of Paris, and the Gare Saint-Lazare.[27] In another passage linking art to fashion, Mallarmé listed an inventory of silks and cashmeres from Lyon, luxuriating in the sumptuousness of the words themselves: "Lyon offers us its *fayes* and its failles, its *poults-de-soie*, its satins, its velvets comparable to no others, its gauzes and its tulles, its crêpes de chine."[28] What should one make of these materials, he asked rhetorically, immediately offering the response: "Above all, masterpieces."[29] Likening dresses to "masterpieces," Mallarmé—like Zola in his description of the displays of laces, silks, and other luxury feminine wares in his fictional department store, Au Bonheur des Dames—elevated women's clothing, employing vocabulary typically used for artworks to refer to haute couture.

Although empirical evidence of the journal's actual circulation is scant, some facts are clear: *La Dernière Mode* survived mere months under Mallarmé's direction; in early 1875, the poet was summarily dismissed by the paper's financial

FIG. 4. "Toilette for the City: Toilette for Important Visits," title page of *La Dernière Mode*, October 18, 1874.

backers; and in May of that year, the periodical filed for bankruptcy.[30] Although the venture was a personal disappointment, Mallarmé looked back on the months that he spent writing *La Dernière Mode* with great nostalgia.[31] Years later he wrote in a letter to the poet Paul Verlaine: "I once . . . tried to write all by myself about toilettes, jewels, furniture, even the theater and dinner menus, a magazine, *La Dernière Mode*, of which the eight or ten issues that appeared still serve, when I undress them from their dust, to make me dream for a long time" (fig. 4).[32] Mallarmé's use of the term *undress*, a charming play on words, was a clever way to refer to a magazine about garments. It also signals the lasting importance of fashion in his writing, long after the final issue of *La Dernière Mode* was produced.

For Mallarmé, fashion evoked the dreams that were central to the Symbolist aesthetic that he helped to pioneer. However, as we have seen, authors used fashion to evoke numerous facets of modernity throughout the century: from Balzac, who chose a fabric boutique as the opening site for his epic *Comédie humaine*; to Baudelaire, for whom the transience of fashion was a useful metaphor to define the ephemeral qualities of the modern moment. That fashion remained important and relevant to authors throughout the nineteenth century is a testament to its crucial role in the literature of modernity.

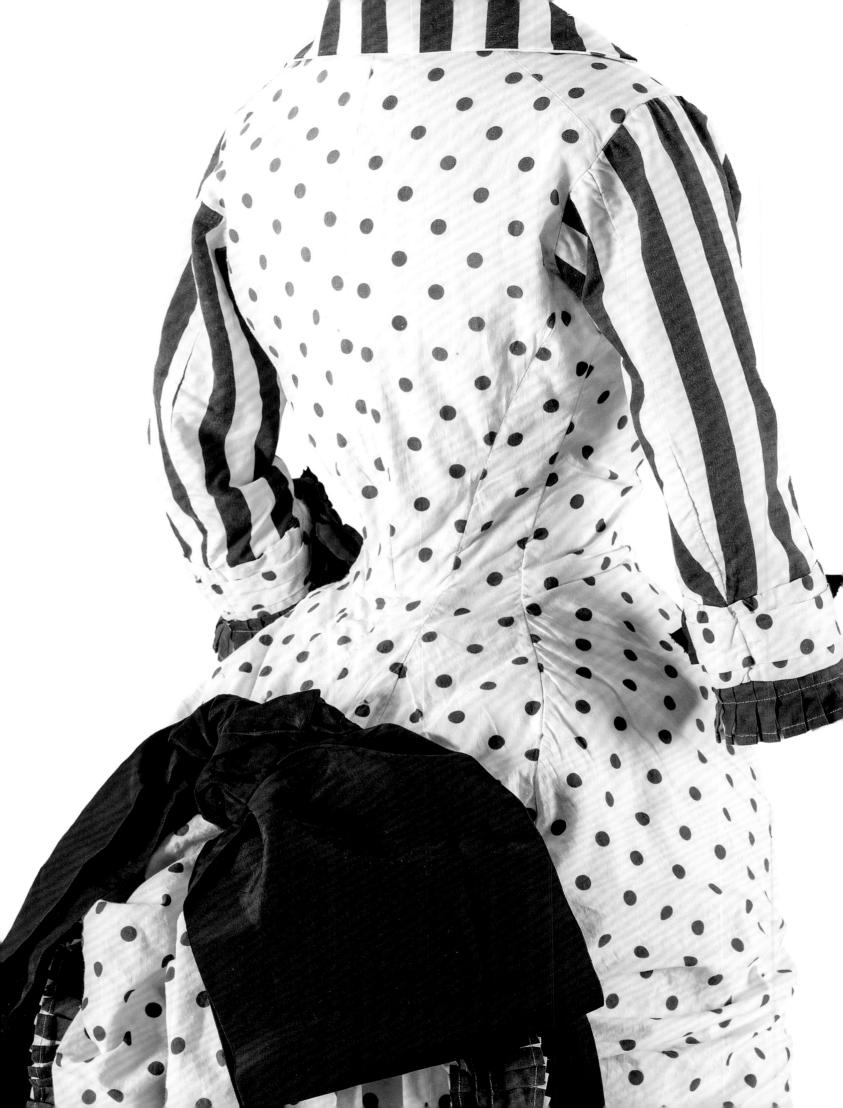

Who Creates Fashion?

Françoise Tétart-Vittu

During the second half of the nineteenth century,
there were many players in the business of fashion in Paris,
from the producers of raw materials to the extremely varied
clientele who transmitted the newest styles to their social circles,
and the *dessinateurs industriels* (industrial designers),
industrial artists, and fashion illustrators who designed
and depicted the articles of fashion.

Corset and crinoline makers, for example, fashioned the latest silhouettes, which were featured in the outfits invented by *dessinateurs industriels*. In turn, these designers proposed their sketches to ready-to-wear manufacturers and dressmakers, and supplied ideas to major trendsetters like those at the specialized counters of department stores. Fashion illustrators and artists also took up these styles in their work, spreading images of Parisian fashionability and modernity throughout Europe and the world.

The notion of a fashion industry dates to the mid-eighteenth century, when both dressmakers and customers from the provinces of France and other countries counted on Parisian suppliers to choose fabrics and embroidery or lace designs for them, provided that these were "the most

fashionable."[1] In the ensuing years, the French word *mode* (fashion) was replaced by *nouveauté* (novelty), which came to mean anything new in the realm of fashion—from trimmings and baubles, to dresses and fabrics.[2] By the nineteenth century, Parisian shops became the unchallenged suppliers of fashionable articles, selling everything necessary to outfit the stylish Parisienne. They were soon imitated in the provinces by both dressmakers and clients.

PRODUCING FABRIC AND PATTERNS: THE INDUSTRIAL DESIGNER

Before a fashionable dress could be made, its fabric had to exist—from heavyweight silk for the winter,

FIG. 1. STEINBACH KOECHLIN & CIE. Print for a summer dress, 1864.
Musée de l'Impression sur Étoffes, Mulhouse.

to patterned cotton muslin for the summer. This fabric was created in a factory by order of its director, whose choice depended on such elements as the quality of yarn available and its price. But more than anything, he relied on the flair of the designers in his workroom. Sent from Lyon or Alsace to Paris, their mission was to determine what Parisians on the boulevards were wearing and what was on display in the windows of wholesale houses. Written in the margins of the sample books of the Koechlin factory are the commentaries of some of these industrial spies.[3] They noted whenever a fabric was displayed in the windows of certain stores along the boulevards between the rue Montmartre and the rue de la Chaussée d'Antin in the quartier de l'Opéra, as well as the choices of wholesalers in the rues Sentier or Jeuneurs, away from the commercial center. Their observations were used to determine what fabric patterns would be likely to please the Parisian market, which served not only as the authority on fashionable taste, but also as an indicator of the likelihood of selling certain fabrics in large quantities to other markets, a potentially even more lucrative proposition. Though some patterns were judged unwearable, the designers admitted that they were necessary to outfit certain women with eccentric tastes.

The fabrics woven or printed in factories were termed *à disposition de motif* (arranged so that the prints or motifs would be fully visible) and *robes à volants* (gathered, ruffled), and they were the leading items in stores from 1845 until about 1875, when polonaise dresses became so popular that

these older styles were abandoned. Textile manufacturers wove a length of fabric to serve as a reference for the cutting process, with one part intended for the bodice of the dress, and bands of material for ruffles grouped at the other end. The work of sewing the dress was thus quite simple for the buyer—department stores, dry-goods stores in the provinces of France and abroad, and even some boutiques (Charles Frederick Worth might have sold this type of dress kit from 1858 to 1870, before he had in-house dressmakers)—who ordered fifteen or nineteen meters of material from a newspaper, along with a small lithographed pattern showing the sleeves, bodice, and panels positioned on the material (see fig. 1). In addition, an illustration of a figure wearing the dress was included, allowing the seamstress to see the effect produced by the finished outfit. Sometimes the illustration gave two alternatives for how the garment could be cut out and finished.[4]

This production process was highly successful with foreign buyers, especially those in Boston, Philadelphia, and New York, and it is indisputable that the magnificent finery worn on October 18, 1860, for the grand ball given in honor of the Prince of Wales at the New York Academy of Music was of this type.[5] Women also frequently purchased the summer and swimming costumes (with short, buttoned jackets or boleros in light cotton or linen) that the companions of painters wore so often for outings to the country between 1863 and 1870; they either made these themselves or had them made by their dressmakers.[6] The *confections* (ready-made

apparel) available at the specialized counters of department stores, including short capes, overcoats, and dressing gowns in printed fabric, as well as the *mi-confectionnées* (trimmed but not fully sewn together garments) such as walking and summer dresses, were also sold in this manner.[7]

Around 1854 sample dresses were furnished by factories to serve as promotional pieces for large stores; beginning in 1864–66, such models became ubiquitous in clothing stores of all types in Paris and the provinces. These dresses were featured in the large poster advertisements displayed in ready-to-wear departments, in catalogues, and in the inset lithographs that appeared in fashion magazines and were reproduced in the foreign press. They carried the manufacturer's pattern number, the name of the store, the department within the store, and a description (see fig. 2).[8] Using the same advertising principles, firms producing embroidery or machine-made lace created dresses in kits, already embroidered and trimmed, and sold these in department stores.[9] Although these dresses were considered expensive, according to *La Mode Illustrée* in 1869, "they don't measure up to solid colors, for an embroidered dress paralyzes the imagination of the seamstress."[10]

During these years, one of the most fashionable fabric choices for Parisian women was black silk, which was employed not for mourning, but as a supreme mark of elegance—both because the dyeing process had to be of very high quality to ensure that the color did not veer toward green or yellow, and because the fabric set off the pale beauty of young women (see cats. 21–24). Black silk was sold in all department stores, each of which had its own exclusive version in taffeta or faille that could be used for walking outfits (see cat. 22) or elegant afternoon or evening dresses such as one worn by Madame Charpentier in 1878 (cat. 124).[11] All of the faille sold in Paris came from the factory run by the grandsons of Claude-Joseph Bonnet in Jujurieux, whose clients included Paris stores as well as stores in Lyon like that of the Marix brothers (who had counters in establishments in several European cities). Black faille also represented fifty percent of French silk exports; in fact, the leading New York merchant Alexander Turney Stewart in 1865 bought 450 units in a single order.[12]

DESIGNING FASHION: INDUSTRIAL ARTISTS AND FASHION ILLUSTRATORS

The artists who imagined new styles for patterns and outfits were the heirs to the eighteenth-century designers working in manufacturing companies, who had been trained for free in drawing schools.[13] Still included in the category of *dessinateurs industriels* in France's Register of Commerce, their activities nonetheless changed between 1840 and 1860. Rather than designing patterns for prints and embroidery, they began to engage with the ever-widening array of women's clothing in order to create illustrations for fashion houses and department stores. They also furnished lithographed illustrations of models *en blanc*—with face and hands colored but with a simple silhouette of a dress that the manufacturer or fabric dealer could complete with the fabrics he had to sell. These were intended for use by the representatives of fabric merchants like the Marix brothers, who completed each small illustration with additional pages where they glued samples of the fabrics for the outfit in several colors. From

FIG. 2. "Grands Magasins du Louvre. Dealer in *indiennes, muslins and organdies. Spring season 1869. Percale dress, exclusive,*" 1869. Galliera, musée de la Mode de la Ville de Paris.

GRANDS MAGASINS DU LOUVRE

Comptoir des Indiennes Mousselines et Organdi

Saison de Printemps 1869

ROBE PERCALE

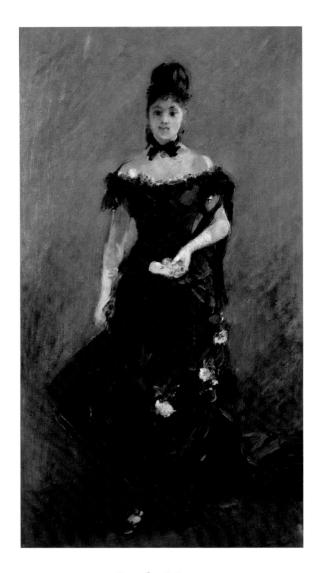

CAT. 21 Berthe Morisot
(FRENCH, 1841–1895)
Figure of a Woman, also called
Before the Theater, 1875

Oil on canvas
57 × 31 cm (22 ½ × 12 ¼ in.)
Private collection

Although Morisot could afford the latest fashions, it is not known how she selected her dresses: did she create them in consultation with a dressmaker, or purchase them from a visionary couturier like Charles Frederick Worth? The black dress the model wears in this painting reveals Morisot's personal involvement with fashion as she wears it herself in photographs by Charles Reutlinger (cats. 23, 24). The bodice, worn off the shoulder in the painting, has the same fit and proportion, and the shirred edge and long bows are clearly represented. Even the shoes and ribbon around the model's neck are the same as in the photograph. Only the change from black lace gloves to plain white gloves and the addition of scattered flowers differentiates the ensemble from the look she chose for her own portrait.

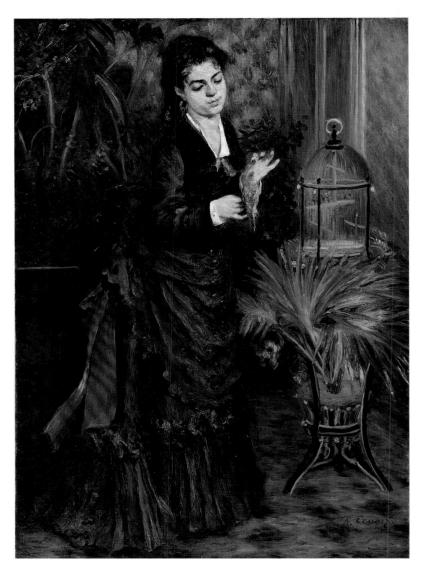

CAT. 22 Pierre-Auguste Renoir (FRENCH, 1841–1919)
Woman with Parrot, 1871

Oil on canvas
92.1 × 65.1 cm (36 ¼ × 25 ⅝ in.)
Solomon R. Guggenheim Museum, New York

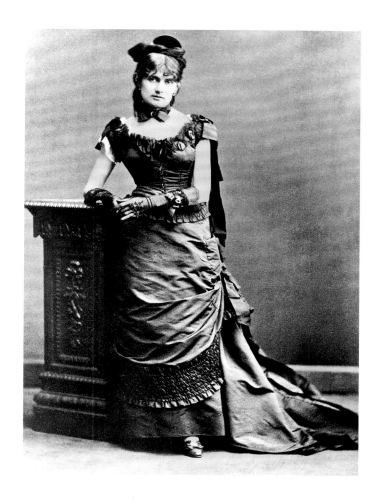

CAT. 23 Charles Reutlinger
(GERMAN, 1816–AFTER 1880)

Berthe Morisot, c. 1875

Musée Marmottan Monet, Paris

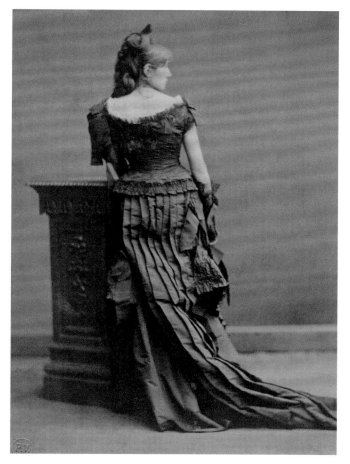

CAT. 24 Charles Reutlinger
(GERMAN, 1816–AFTER 1880)

Berthe Morisot Seen from Behind, c. 1875

Musée Marmottan Monet, Paris

these illustrations, which were intended to show off fabrics, artists created more complex models—veritable studies for the dresses and coats sold to the couture houses and department stores whose catalogues they illustrated—much like the "designer-artists" who illustrated fashion magazines.

Suit and dress designers took advantage of the widespread use of lithography. The medium allowed them to save time in production (over the use of engraving) and publish their own designs, which were carefully painted in gouache, given a handwritten and then lithographed signature and a number on the back, and sometimes stamped with the artist's address. The best known of these designers were Émile Mille, Charles Pilatte, and Léon Sault. Pilatte worked during the years 1860–78, and a large number of his illustrations for dresses survive in museum and library collections. Mille created the publications *L'Élégance Parisienne* (1867) and *Paris-Mode* (1869), including seven engraved plates colored in watercolor per month. Reproduction of these fashion plates was not allowed, and twelve life-size patterns were available each year for forty francs. Sault was an embroiderer who took out a patent in 1864 for movable trimmings on dresses; in 1866 he created the journal *Aquarelle-Mode*, which was delivered with four in-folio pages in French, Italian, English, and German describing a model and complete with black-and-white lithographs of the same design that depicted the outfit from the front, back, and profile. For three francs, a paper pattern would also be supplied, and for five francs, the ensemble would be put together in muslin. On November 8, 1869, Sault announced to his clients that he had available "an immense selection of unpublished watercolors, outfits for balls, receptions and town wear and a large number of ready-to-wear items for the price of 15 francs (5 for subscribers). These watercolor compositions become the property of the buyer."[14]

In addition to his own publications, Sault offered his services as an organizer for twenty or so fashion magazines and put together catalogues such as the special-edition album published for the World's Fair of 1867 for Les Grands Magasins du Louvre with twelve plates of outfits adapted to the twelve months of the year.[15] By 1879 Sault was circulating *La Femme du Foyer Revue de la Mode Illustrée,* a weekly that offered twelve fashion watercolors and

twenty-four patterns a year. Its competitor, Henry Petit's *Mode de Style, Recueil de Toilettes de Grand Luxe*—a supplement to *Salon de la Mode, Moniteur Illustré de la Famille* in 1879—had twenty-eight patterns in a life-size format. In December 1876, A. Albert's *Journal des Modistes et Lingères* was still delivering "fashion documents, 6 plates, each divided into 12, for a total of 72 designs for 6f 50." Some establishments specialized in mail-order sales for a very precise foreign market, especially the United States. Madame Demorest began to publish her patterns in *Frank Leslie's Ladies Gazette* in 1854 and ended up sending out three million paper patterns by 1876 in *Madame Demorest's Mirror of Fashions.* She was followed by Butterick in 1873 and later by *Harper's Bazaar* and *McCall's*.[16]

The variety of ways a particular style and fabric could be illustrated was essential to the spread of fashion, since it not only was the source of international textile advertising, but also influenced every level of production of women's clothing, from finished objects and patterns to ideas for designs and proposals for clients. In Paris stores of any legitimate size published circulating newsletters announcing special sales and produced albums that turned into catalogues. These were inserted into notable fashion journals and thus distributed to a wide audience around the city. The department store Villes de France, for example, created a booklet called *Tarif*; among its pages was an offer to send lithographed plates of the latest fashions and their prices to anyone who requested them. In the years 1865–70, stores such as Le Tapis Rouge, Le Coin de Rue, Le Bon Marché, and Les Grands Magasins du Louvre distributed illustrated catalogues depicting women wearing new styles, which were fitted out with attractive names, reference numbers, materials, and prices. All of these publications were printed in large runs.[17] Some stores even published a notice announcing a catalogue "embellished with 125 fashion illustrations, currently being printed (1st run, official printing 600,000 copies)."[18]

The expansion of stores gave rise to the creation of specialized catalogues, such as those by Les Grands Magasins du Louvre for hats in 1876 and men's clothing in 1879. In addition to these special editions, each store maintained privileged ties with the magazines that featured its catalogues and took out full-page ads for the special sales that it held in April and October.[19] Stores that enjoyed

FIG. 3. ALEXANDRE LACAUCHIE (FRENCH, ACTIVE 1833–1846). Fashion plate from the album of the Compagnie Lyonnaise, 1858–59. Galliera, musée de la Mode de la Ville de Paris.

FIG. 4. PAUL LACOURIÈRE. *Journal des Demoiselles,* May 1, 1880. Lithograph. Department of Special Collections, Charles E. Young Research Library, University of California, Los Angeles.

a certain renown indulged in the luxury of color lithographs ordered from fashion specialists like Alexandre Lacauchie, whose beautiful full-page plates appeared in albums covered in moiré and stamped with gold lettering, containing lists of dresses, coats, and court dresses (fig. 3).[20] This sort of advertising was relayed in such publications as *Actualité* and *La Vie Moderne* for Les Grands Magasins du Louvre and *L'Art et la Mode* for Le Bon Marché.[21]

What differentiated these industrial artists from the illustrators of women's fashion magazines was their deliberate choice to highlight just the outfits, with no surrounding decor or only a very succinct evocation of it, rather than illustrating a genre scene with women dressed to carry out the activities of wealthy bourgeois ladies, such as those who inspired Paul Cézanne's paintings *The Promenade* and *The Conversation* (cats. 25, 27), in which images from the fashion journal *La Mode Illustrée* were subtly yet dramatically altered (cat. 26, fig. 5). In *The Conversation*, Cézanne added two top-hatted gentlemen, subverting the typically female universe pictured in fashion plates.[22]

The most important thing for industrial artists was to show the details of the clothing; their fashion plates resembled the elaborate sketches of costume designers for the theater and were accompanied by patterns. The pattern was the essential milestone in spreading changing styles and providing a guide to assembling and sewing, not only for professional seamstresses but also for individuals who owned a sewing machine.[23] A dress worn by the elegant young Prospérie de Fleury Bartholomé (cats. 28, 29) was partly machine-made and partly hand-sewn. Although we do not know who made this dress, it corresponds to the summer fashions of 1880 and is very similar to a polka-dotted foulard dress that appears in a drawing, accompanied by a pattern, in the May 1880 issue of the *Journal des Demoiselles* (fig. 4). The hand-sewn bodice, with no lining or stays but instead an up-turned bust structure very loosely held in place without cutting into the fabric, contrasts with the elaborate pleating of the striped cotton skirt, which seems to be at least partially machine-sewn. The multitiered white dress in James Tissot's *Portrait* (cat. 30) may also have been hand-sewn and perhaps designed especially for the artist, since it appears in other canvases on other sitters (see cat. 52 and fig. 2, p. 116).

CAT. 25 Paul Cézanne (FRENCH, 1839–1906)

The Promenade, 1871

Oil on canvas
56.5 × 47 cm (22 ¼ × 18 ½ in.)
Private collection

CAT. 26 Imprimerie Gilquin Fils

(FRENCH, ACTIVE 19TH CENTURY)

"Toilettes by Madame Fladry,"

La Mode Illustrée, May 7, 1871

Steel engraving with hand coloring
Sheet: 36.7 × 25.7 cm (14 ⁷⁄₁₆ × 10 ⅛ in.)
Private collection

CAT. 27 Paul Cézanne (FRENCH, 1839–1906)
The Conversation, 1870–71

Oil on canvas
92 × 73 cm (36 ¼ × 28 ¾ in.)
Private collection, courtesy Galerie
Bernheim-Jeune, Paris

When Cézanne began painting fashionable women of his day, he did so not by painting figures outdoors, *sur le vif* (on the spot), but by referencing fashion illustrations. The silhouettes in this painting indicate that these dresses were absolutely up-to-date and true to the fashion plate on which they were based (fig. 5); Cézanne has simplified the trimmings, removing certain pleated flounces, lace, and fringe, just as a customer might when having her dressmaker create a custom design based on a published image. But Cézanne has also added two men to the background, an unusual intrusion into the female realm typically depicted in fashion illustrations. His painting thus subverts and transforms the fashion plate genre into a more ambiguous image of modern life.

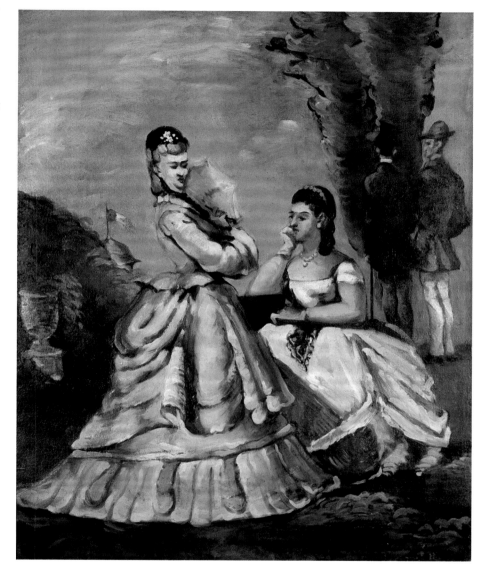

FIG. 5. *La Mode Illustrée*, July 31, 1870, pl. 31.

CAT. 28 Albert Bartholomé
(FRENCH, 1848–1928)

In the Conservatory, c. 1881

Oil on canvas
233 × 142.5 cm (91 ¾ × 56 ⅛ in.)
Musée d'Orsay, Paris

It is not known who made Madame Bartholomé's fashionable summer dress, but it combines elements of structure and tailoring with controlled draping and copious, precise pleating. The tiered, columnar skirt combined with the polonaise bodice fit snugly to the waist and hips accentuates the new long, narrow line. The dress is very similar to patterns that appeared in several fashion periodicals of the day. These enabled dressmakers and individuals with access to sewing machines to create their own trendy outfits. Remarkably, this dress survives (cat. 29). It was preserved by the painter in memory of his wife, who died shortly after the portrait was completed.

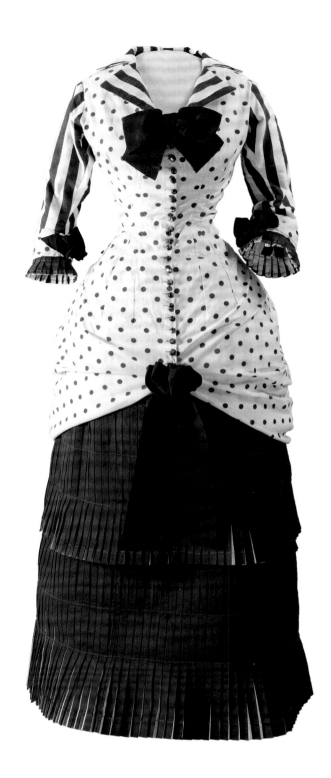

CAT. 29 Summer dress worn by Madame Bartholomé
in the painting *In the Conservatory*, 1880

French
White cotton printed with purple dots and stripes
Musée d'Orsay, Paris

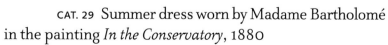

Oil on canvas
91.4 × 50.8 cm (36 × 20 in.)
Tate

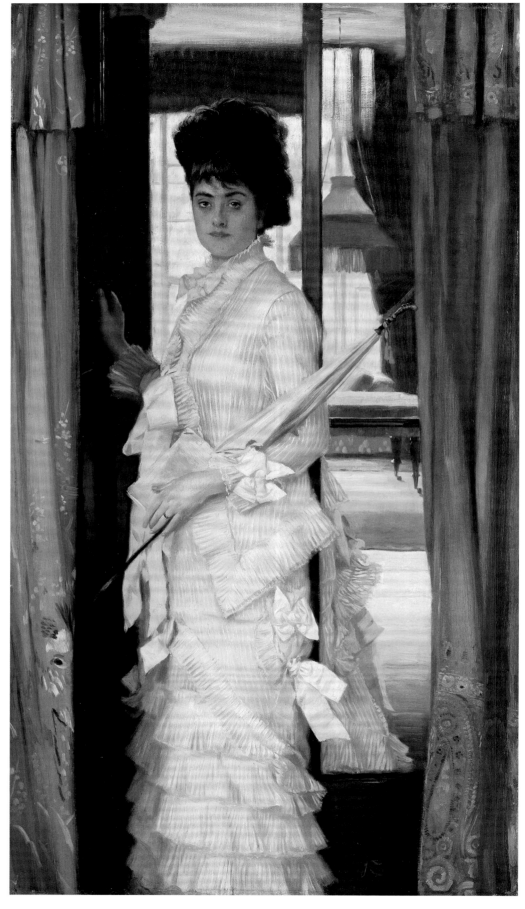

Likewise, in Pierre-Auguste Renoir's genre scene *The Couple* (cat. 31)—for which his friend Frédéric Bazille and Renoir's mistress, Lise, posed—the bright striped dress with an apron trimmed with what was probably machine-made lace speaks to the combination of hand-sewn and machine-made work. Given Lise's talents as a seamstress, the dress is probably her own concoction.

During the period 1865–85, the growth of the fashion press, the industry of precut patterns, and mail-order sales allowed Parisian fashions to spread internationally virtually uncontested. From the 1830s on, English and German magazines featured technical illustrations of the lower halves of dresses or sleeve shapes drawn from French illustrations, along with groupings of figures taken from various Parisian magazines, but these were only shown with the intention of informing readers of the *modes variés* (real trends) from Paris. As of 1835, almost all magazines included diagrams on the back of illustrations, indicating how to take accurate measurements (see fig. 6). Their inevitable complement was a printed pattern grouping the various elements of an ensemble, differentiated only by the type of line used. With these patterns, it was no longer necessary for dressmakers to use the muslin dress pieces[24] or sample dresses[25] that large firms had been sending to their foreign correspondents since the 1820s or presenting in short-term rented showrooms.

These muslin samples were not abandoned, however, and the celebrated establishment Gagelin-Opigez, on the rue de Richelieu, had been since 1851 the most important exporter of models to be reproduced (up to seven thousand at the time of the World's Fair of 1867).[26] Certain famous couturiers, who were able to buy watercolors by artists such as Leduc, Pilatte, or Sault to show their clients as possible creations, then had them reproduced by the illustrators of fashion magazines with captions like "Outfit by Madame X" to advertise a dress that did not yet exist but that the dressmaker could produce.[27] Worth and Madame Hermentine du Riez also proposed patterns for clothing or dresses based on the illustrated designs in the journal *Le Printemps*.

THE CUSTOMER

Fashion designers created patterns for factories, stores, and large couture houses, all of which circulated their work through agents, the press, and mail-order catalogues. The brokers who supplied fashion items to clients far from Paris sometimes also created their own publications. The firm Simons, Baudrais and Co. of New York, for example, published *Paris Messenger*—a monthly founded in 1874 and written in English, with a print run of 15,000—and worked with many well-known establishments. Others, like the store founded in Boston by Mrs. L. P. Hollander, had agents in Paris to provide ready-to-wear clothing or place orders. Some of these brokers supplied outfits under their own names.[28] Women who did not frequently travel ordered their clothing from firms in Paris, stores in their towns, or local seamstresses, but a rich American client who toured the European capitals knew exactly what she was going to buy from couturiers and department stores.[29] Some French dressmakers also came to their clients, like the Duluc sisters and their artistic director, Félicien Rops, who was more than ready to undertake transatlantic trips to cities on the East Coast.

FIG. 6. "Measurements to be given, or how to take measurements for buying by mail," *Catalogue Maison du Bon Marché, Main Patterns for Women's Garments*, Summer 1869. Bibliothèque Forney, Paris.

The Couple, 1868

Oil on canvas
105 × 75 cm (41 ⁵⁄₁₆ × 29 ½ in.)
Wallraf-Richartz-Museum &
Fondation Corboud, Cologne

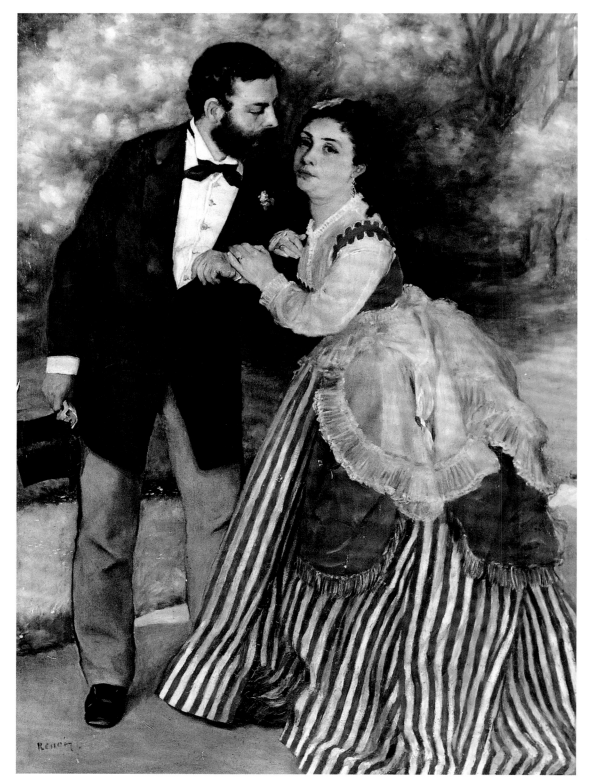

The sketchy background of this portrait-like genre scene suggests that Renoir painted the work in his studio and not en plein air. The man holding a top hat cuts an incongruous figure in the countryside, as does the woman's sumptuous silk dress of red and gold stripes—vibrant (or to some, garish) colors newly available through aniline (chemical) dyes. The dress is *à la polonaise*, with three rounded flaps overlaying the skirt. The topmost polonaise is white and hooked into the skirt; the second is red and forms part of the bodice. The white polonaise seems to be trimmed with machine-made lace, but the rest of the dress was likely handmade. In this period, professional seamstresses and ordinary women with access to sewing machines frequently combined ready-made and handmade components to produce highly individualized styles such as this one.

FIG. 7 Zouave jacket, 1866. Wool and silk. Museum of London.

French women also consumed fashion in various ways. Some wealthy women, including Empress Eugénie herself, designed their own clothing and had it made by their dressmakers.[30] The former countess Eugénie de Montijo brought several Spanish-inspired styles into vogue, including the bolero (see fig. 7), such as that seen in Tissot's *Portrait of Mademoiselle L.L.* (cat. 118). The fashion trendsetter Pauline de Metternich, in contrast, was habitually associated with the House of Worth. Indeed, she recalled that "those men [Worth and Bobergh], very desirous of numbering me among their clients, begged me to have a dress made by them and said that I had only to say how much I wanted to spend on it."[31] Her role as a "jockey" did not prevent her from also being dressed by Madame Maugas, like her friend Mélanie de Pourtalès. The artist Marie Bashkirtseff and salon hostess Nina de Villard de Callias (see cat. 15), two women who were crazy about fashion and art, were always ready to buy magnificent outfits. Nina, at the height of her splendor in 1863–64, wrote to her friend Louise:

> I bought myself a dress at the Compagnie Lyonnaise [a department store]: it was expensive, but it's dazzling. That's the only place where you can find chiffons that are

about decent; mine has a white background with adorable life-size pansies scattered here and there; for the evening, bare-shouldered with a gold sash and velvet pansies in my hair, daytime with a Zouave jacket.[32]

Similarly, Marie dressed in Worth and ran "to exhaust myself at Le Bon Marché" when she was not satisfied with her art classes at the Académie Julian.[33]

Since no details are given in their personal papers, we do not know how Berthe Morisot and Méry Laurent—both of whom loved dressing well and had enough money to buy from the most famous couturiers in Paris—chose their dresses. It is probable that they picked out fabric in stores and had it made up by their regular dressmakers, sometimes sacrificing to buy something really exceptional from one of the fashion houses. The wardrobes of these ladies, as transmitted in the paintings made by their Impressionist friends, seem to have contained many summer dresses in printed muslin or lightweight silk, which would have been comfortable to wear both inside and in the garden.

From fabric production to purchase by the client, fashion was created by numerous actors, including designers conceiving fabrics, directors of purchases at department stores placing orders, and store managers requesting industrial designers to enhance the dresses that they planned to sell. Dressmakers and famous couturiers applied the same tactics as those used in department stores—in particular, exportation to merchants in the provinces and abroad. Between 1860 and 1870, Worth sold fabrics made exclusively for him and used seamstresses working from home (*confectionneuses en chambre*). This system allowed for fast production (fifteen days at maximum), which enabled him to dress rich foreign customers visiting Paris. The customers' desire for authentic Parisian fashion became so predominant that labels were present in every creation produced by stores or seamstresses, who added their names and addresses on a ribbon inside the bodice. The establishment of copyright in the 1880s meant that Parisian fashion and fashion houses would maintain their international dominance and renown for the next one hundred years.

Édouard Manet
The Parisienne

Françoise Tétart–Vittu

THE PARISIENNE IN 1874

The year 1874 was a seminal one for fashion. Pierre–Auguste Renoir painted *The Parisienne* (cat. 32), and between September 6 and December 20, Stéphane Mallarmé published eight issues of *La Dernière Mode*.[1] At the same time, the Union Centrale des Beaux–Arts Appliqués à l'Industrie devoted its fourth exhibition to the Musée Historique du Costume at the Palais de l'Industrie, with 6,000 works from 250 private and public lenders spread over 12 rooms.[2] One of the organizers, Auguste Racinet, went on to produce the major encyclopedia *Costume historique*, which appeared in installments from 1874 to 1886.[3] This lively interest in clothing was particularly focused on women's dress, which, in its modern form, was linked to Parisian elegance, the result of a literary and artistic current that brought together contemporaries like Charles Baudelaire, Constantin Guys, Mallarmé, and Félicien Rops. Though of different artistic sensibilities, they viewed women, art, and fashion as exemplary of "that fleeting modernity" emphasized by Camille Lemonnier, a friend of Rops and Alfred Stevens.[4]

THE GENESIS AND EVOLUTION OF THE PARISIENNE

The specific type of Parisienne characteristic of the years 1863–69 initially had the same slight air of rascality as the cocottes drawn by Paul Hadol, Mars (Maurice Bonvoisin), and Bertall (Albert d'Arnoux) in the magazine *La Vie Parisienne*,[5] and the same dramatic aspect as Rops's *Parisienne*, who appears in the guise of the Goncourt brothers' character Manette Salomon (fig. 6, p. 51).[6] But in 1874, Renoir's *Parisienne*, wearing a fancy blue day dress, and Stevens's *Paris Sphinx* (1875/77; Koninklijk Museum voor Schone Kunsten, Antwerp), in printed muslin, instead evoked elegant, distinguished feminine figures. By the following year, the terms *la mode* and *Parisienne* were assimilated into the French vocabulary, concretized in the fashionable black day dress of Édouard Manet's *Parisienne* (cat. 33) and in an essay published by Charles Blanc, *L'Art dans la parure et dans le vêtement* (Art in Ornament and Dress), in which he developed his ideas on how the art of dressing was associated with the infallible taste of the Parisian woman.

The new Parisienne was a woman of fashion, who might also be a woman of the world; she might be a member of *la grande bourgeoisie*, an actress, or a kept woman. Regardless of her position, she was always turned out in a correct and flattering manner. From Nina de Callias (see cat. 15) to Valtesse de La Bigne and Méry Laurent, Parisiennes were fashionable, chic, and beautiful women who moved freely in the artistic circles of Paris.

THE PARISIENNE AND THE FASHION INDUSTRY

During the period 1865–85, painters were often in contact with women who made a living from fashion for aesthetic, personal, and economic reasons. Indeed, from the late eighteenth century onward, women working in the fashion trade were repeatedly used as models by illustrators and painters of genre scenes featuring Parisian women.[7]

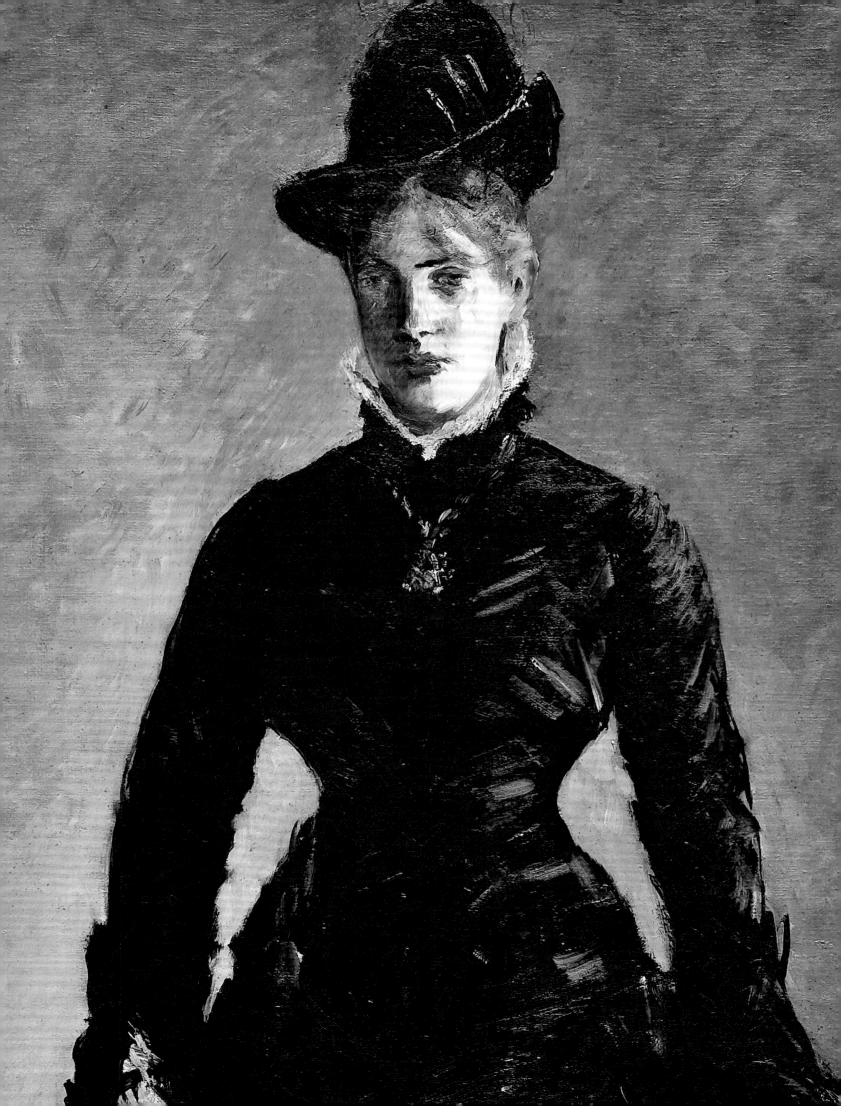

CAT. 32 Pierre-Auguste Renoir
(FRENCH, 1841–1919)

The Parisienne, 1874

Oil on canvas
163.2 × 108.3 cm (64 5/16 × 42 11/16 in.)
National Museum Wales, Cardiff

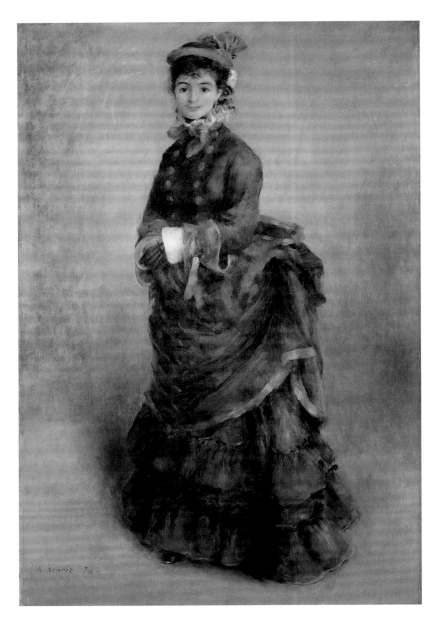

In Paris it was the most natural thing in the world for a young woman who worked during the week, went dancing at public balls on Sunday, and relaxed with students and painters on the banks of the Seine in the summer to become first a model and then a companion for an artist.[8] Norbert Goeneutte, Claude Monet, Renoir, and Rops all married couturiers.[9]

Fashionable dresses became indispensable in the studio, joining exotic bric-a-brac and an assortment of old weapons. Stevens, for example, often used the same dresses or variations of them in multiple paintings and attached great importance to the clothing that he borrowed or bought from friends, as well as the garments passed on to him that had once been worn by famous, elegant women, such as Princess Metternich. Méry Laurent, the mistress of the rich Doctor Evans, Empress Eugénie's American dentist, possessed outfits by Charles Frederick Worth that her friend Manet found exquisite; in *Autumn (Méry Laurent)* (1881; Musée des Beaux-Arts, Nancy), he painted her in a fawn-colored pelisse in front of a Japanese robe borrowed from Antonin Proust.[10] The significance of fashion in artistic circles was immediately conveyed to the public by those who popularized new fashions—industrial designers, illustrators, and publishers of journals that were intended to provide ideas to milliners, dressmakers, and fashion houses.[11]

By the 1880s, the Parisienne—synonymous with fashion—was a definitively established archetype. She lived in an apartment that positively shouted *artiste*—overloaded with objets d'art from many different periods, as well as a profusion of plants and fabrics—and moved in the circles that patronized the salons of Louise Abbéma, Juliette Adam, Marie Bashkirtseff, Sarah Bernhardt, Madeleine Lemaire, and Princess Mathilde. She also diligently frequented painting salons—those of independent painters as well as those sponsored by La Bodinière or the Galerie Georges Petit.[12] At the official Salon, she found herself hard-pressed to resist commissioning a portrait by a well-known society painter like Léon Bonnat, Alexandre Cabanel, or Jules Lefèbvre of herself wearing a gown by a famous dressmaker, an essential element of any portrait of a lady.

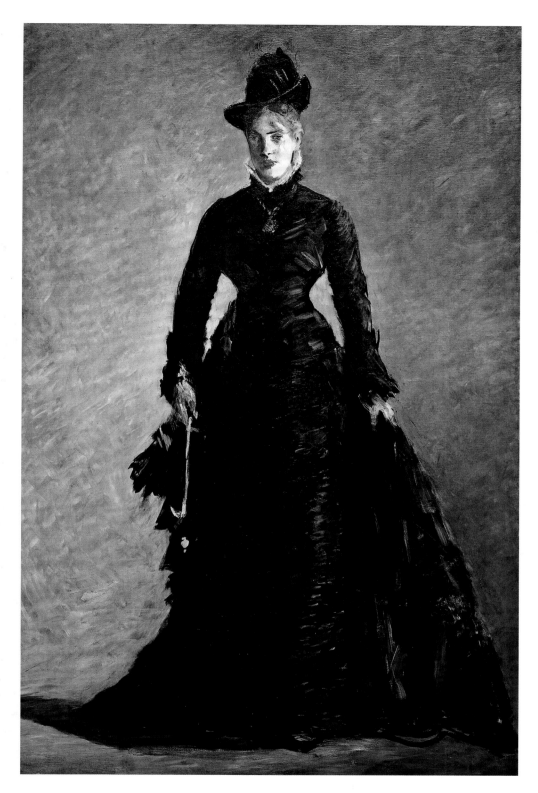

CAT. 33 Édouard Manet (FRENCH, 1832–1883)

The Parisienne, c. 1875

Oil on canvas
192 × 125 cm (75 ⅝ × 49 ¼ in.)
Nationalmuseum, Stockholm

FASHION JOURNALS, ART, AND THE PARISIENNE

This interest in dresses was quickly seized upon by critics, who made it difficult for artists to avoid being considered costumers rather than painters. As reviewers of the Salon quipped: "The Carolus-Duran Line of Velvets" and "Now Available at the House of Béraud, Guaranteed Colorfast Fabrics."[13] In August 1881, a magazine embodying this craze appeared: *L'Art et la Mode* was a deluxe revue created by the group of prestigious personalities surrounding the department store magnate and modern art collector Ernest Hoschedé and the Viscountess de Peyronny, a society columnist and the daughter of the artist François-Auguste Biard.[14] In the first issue of the journal, published in August 1881—which illustrated *Her Majesty, the Parisienne* (fig. 1), a commission by Stevens featuring a green dress draped in lace flounces, after a photograph

FIG. 1. ALFRED STEVENS (BELGIAN, 1823–1906).
Her Majesty, the Parisienne, 1880. Reproduced by Desjardins in *L'Art et la Mode* 1 (August 1881).

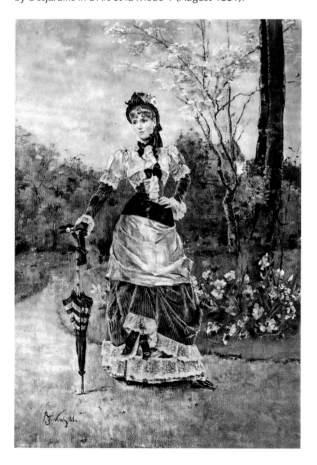

of a dress by Worth—the close, indeed symbiotic, relationship between painter and costumer is apparent.[15] The publication's interest in fashion directly echoed that seen in the painting exhibitions where Stevens's peers, particularly his female collaborators, showed their work. The artists Giuseppe De Nittis, Goeneutte, and Léonie Mesnil selected the plates for *L'Art et la Mode*, and the articles were sprinkled with illustrations, ornamental lettering, drawings, and texts discussing the Salon exhibition and society painters such as Louis Leloir, Madeleine Lemaire, Henri Pille, and Georges Rochegrosse. The journal's satirical contributors also described outfits worn to the theater or to receptions and criticized the latest oddities in fashion.

During this period, the stage increasingly provided inspiration for art. Many periodicals were created to illustrate the elegant toilettes worn to theatrical premieres, including *Le costume au théâtre et à la ville* (Theatrical and Street Costume; 1885–88), founded by the designer Eugène Mesplès and Charles Bianchini, a couturier and costumer at the Opéra.[16] Indeed, one chronicler noted enthusiastically that the costumes worn by the great singer Adelina Patti in *Linda* had "an eminently artistic character and if I were a painter, I would like to make of them the most adorable genre paintings."[17] Artistic dress was also the business of the great actress Sarah Bernhardt, a painter and sculptor who had studied under Stevens. She was painted as Pierrot by De Nittis and was a friend of the society artists Abbéma and Charles Chaplin. The actress's dresses for *The Sphinx*, *Froufrou*, and *The Lady of the Camellias*—for which she wore "a skirt submerged in lace painted with a profusion of camellias by [Georges] Clairin, over white satin"—exemplified the voluntary marriage of painting and fashion.

The Viscountess de Peyronny sang the praises of the dresses "painted by our artists," noting, "You can judge how attractive and also how valuable a dress may be when its trim is signed Madrazo, Madeleine Lemaire, Chaplin or De Nittis."[18] Critics hastily turned away from their previous negative responses to the focus on fashion in art, pointing out that women were colorists who matched primary hues with complementary shades—nasturtium and turquoise, sulfur yellow and garnet red, pearl gray

FIG. 2. JEAN BÉRAUD (FRENCH, 1849–1935).
L'Art et la Mode 7 (January 12, 1884), p. 81.

FIG. 3. CHARLES-ALEXANDRE GIRON (SWISS, 1850–1914). *Woman with Gloves,* also called *The Parisienne,* c. 1883. Oil on canvas; 200 × 90 cm (78 ¾ × 35 ⁷⁄₁₆ in.). Musée du Petit-Palais, Paris.

and china pink. They added that it was necessary to have a feel for color in the same way that one has a feel for the expressive silhouette when dressing oneself, and that "any really inspired woman must spend one day a month in the studio of a real painter: Baudry, Cabanel, Carolus-Duran, Madrazo."[19] This point of view persevered throughout 1880–90 and is reflected in the illustrations of Henri de Montaut and Jean Béraud ("who will sketch for you the profile of a Parisian woman in five minutes" [see fig. 2]), in *L'Art et la Mode,* as well as images in *La Vie Élégante* from 1882, the outfits imagined for *La Mode de Style,* and the haute couture designs of Jean-Philippe Worth, the son of Charles Frederick Worth.[20]

The essentially urban elegance of the Parisienne seems to contradict the Impressionist vision of the world, which emphasized intimate interior scenes or those set in the great outdoors. While artists like Manet and Renoir evoked elegant women on the Parisian street, however, they were not trying to reproduce fashion plates. Indeed, their goals differed from those of Stevens, as well as Abbéma, Mary Cassatt, and Berthe Morisot, with all their practical knowledge of how fabrics look and feel. Nor did they endeavor to portray dresses in detailed splendor in the manner of Bonnat, Cabanel, or Auguste Toulmouche. Yet there is no doubt that, from the late 1860s to about 1880, the woman and her dress were these painters' favorite inspiration: Renoir liked the transparency of muslins on a pastel background or blue faille set against blue backgrounds, De Nittis made Tissot's precise details softer, and Charles Carolus-Duran evoked Manet's touch. Clearly influenced by these precedents, in 1883 Charles Giron painted a woman he had met in Ville d'Avray, portraying her as such a staple of elegant fashion that she was later called *The Parisienne* (fig. 3). With this work, Giron joined Renoir and Manet in the celebration of the Parisienne, though this creature had, since their original depictions of her a decade before, increasingly become a woman bathed in elegance and expensive fabrics rather than a modern woman on the go.

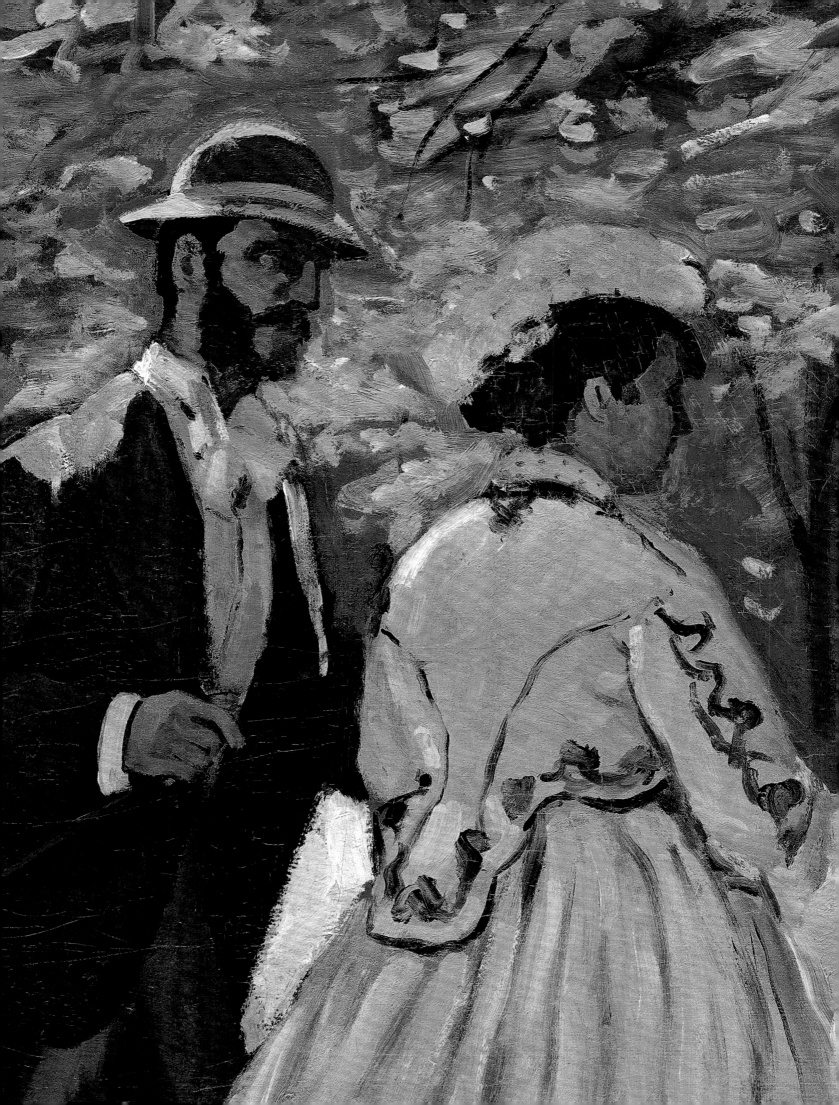

Fashion en Plein Air

Birgit Haase

THE POWER OF DRESS

In 1867 Émile Zola described the motto of the painters of the *nouvelle peinture*—the Parisian artistic avant-garde of the Second Empire (1852–70), whose stated aim was to develop a new manner of combining landscape and figures in plein air painting—as "the dream all painters have: putting life-size figures into a landscape."[1]

The ground for this style had been prepared three decades earlier by the artists of the Barbizon School, who left their studios for the forest of Fontainebleau near Paris, expressing the yearning of urbanites for nature through their *paysages intimes*, which they painted in part en plein air. Their works influenced progressive painters like Gustave Courbet, who strove for an immediate, sensual absorption in reality. For Courbet, however, this did not mean the reproduction of impressions from nature: instead, his works, all of them created in the studio, are distinctive for their dark tones and suggested critique of society. In the Salon of 1857, Courbet's *Young Ladies on the Banks of the Seine* (cat. 34) caused a stir because the bourgeois public decoded the two young women stretched out on the river's bank as prostitutes. Such an interpretation was supported by the women's lascivious poses and glances, as well as the realistic portrayal of their contemporary clothing—or lack thereof. The woman in the background is dressed but shows her ankles and too much décolletage, while the one in the foreground appears in just her undergarments. A top hat, visible in the rowboat in the background, indicates the scandalous presence of a male companion. It was above all this violation of socially determined dress codes that made the scene offensive to contemporary viewers.

Six years later, in 1863, Édouard Manet provoked a similar scandal in the Salon des Refusés with his *Luncheon on the Grass* (fig. 1). The depiction of undressed women in the company of fully

CAT. 34 Gustave Courbet **(FRENCH, 1819–1877)**
Young Ladies on the Banks of the Seine, 1856–57

Oil on canvas
174 × 206 cm (68 ½ × 81 ⅛ in.)
Petit Palais, Musée des Beaux-Arts de la Ville de Paris

Though fully accessorized with shoes, stockings, gloves, and a cashmere shawl, the woman in the foreground wears only her corset, petticoats, and chemise; her missing dress implies that she has undressed in public. This dishabille, brazenly on display for the viewer, coupled with her provocative attitude, was even more shocking to the public than if she had been fully nude. Despite Courbet's beautifully rendered details— embroidered shawl, lace, and sheer layers of fabric—critics of this Realist scene were fixated on the morality of the image. The woman and her companion were assumed to be prostitutes, a theory made all the more compelling by the presence of a man's top hat in the rowboat at the water's edge.

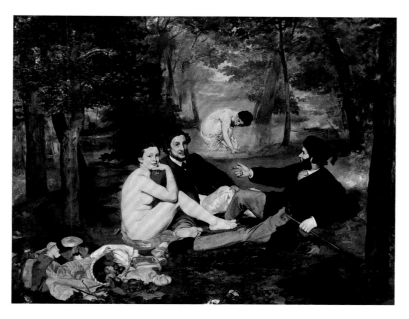

FIG. 1. ÉDOUARD MANET (FRENCH, 1832–1883).
Luncheon on the Grass, 1863. Oil on canvas; 208 × 264.5 cm
(81 ⅞ × 104 ⅛ in.). Musée d'Orsay, Paris.

dressed men in a forest clearing referred back to
prototypes from Renaissance painting, but Manet
transferred the motifs of such works to his own
time.[2] What so infuriated the conservative public
was exactly this updating of a subject taken from
the past. Through the ambitious format of a history
painting, and with comparatively bright, richly
nuanced colors, the artist seemed to be upgrading
the disreputable atmosphere of the Parisian demi-
monde. The key to such a reading was primarily
Manet's depiction of contemporary clothing. The
two gentlemen pose in casual attire, suitable for a
sojourn in the country. The discarded wardrobe of
the model, Victorine Meurent—a summer dress
made of a blue dotted fabric, a white chemise, and
a straw hat with a wide brim—is arranged in the
left foreground as a still life, while the bathing
woman in the background wears a loose chemise.
As in Courbet's picture, it is through the details
of the clothing that Manet's scene, theatrically
arranged and meticulously executed in his studio,
can be seen as part of the *vie moderne*.

　　The artistic representation of contemporary
fashion in modern painting had been by this time
a central topic in a lively aesthetic discourse for
about two decades. In 1845 Charles Baudelaire had
coined the famous motto "the heroism of modern
life," and during the ensuing decades, the French art

world, under his guidance, took up the search for
"the painter of modern life."[3] In this context, the
contemporary "lady of fashion" increasingly became
of interest to artists.[4] During the 1860s and 1870s,
the depiction of fashionably attired women as
representatives of modern life was one of the main
challenges for contemporary painters in France,
who wished to create a discriminating style of plein
air figure painting that reflected a decidedly modern
perception of the environment characterized by a
fundamentally urban way of looking. In this respect,
Zola counted the young Claude Monet as among
the most significant representatives of the *nouvelle
peinture* because

> he loves our women—their parasol [*sic*],
> their gloves, their clothes, and right down
> to their false hair and their rice powder—
> everything that makes them daughters of
> our civilization. . . . Like a true Parisian,
> he takes Paris to the country: he can't paint a
> landscape without putting dressed–up ladies
> and gentlemen into it. Nature appears to
> lose its interest for him as soon as it no
> longer bears the imprint of our customs.[5]

In 1887 Monet himself wrote to a friend, the art
critic and collector Théodore Duret: "I am working
as hard as ever and at new endeavors, plein air
figures, as I understand them, done like landscapes.
This is an old dream that is agitating me constantly,
that I wanted to make real just once. But it is
difficult."[6] It seems likely that Monet was referring
to his figure paintings of 1887, but he may also have
had in mind those of the previous year, including
Study of a Figure Outdoors (Facing Right) (cat. 135).

MONET'S *LUNCHEON ON THE GRASS*

The "old dream" began with a group of figure
paintings by Monet from the mid–1860s—all called
Luncheon on the Grass—which he conceived as the
ambitious manifesto for a style of painting that was
modern in form as well as content. The final version
of this colossal, life–size picture, meant for exhibi-
tion at the Salon of 1866, remained incomplete;
just two large fragments have survived (cats. 38, 39).
Information about this monumental project may be

gleaned from Monet's diverse preparatory drawings and studies, among them a diligently detailed study in oil of the overall composition, at least part of which was probably painted outdoors (fig. 2). This work represents both an homage and a challenge to Courbet's large figure paintings and particularly to Manet's painting of the same title. In contrast to his predecessors, Monet avoided any kind of historicizing, eroticizing, or mannered features. Instead, he designed a decidedly contemporary version of a

picnic of elegantly dressed Parisians set in the forest of Fontainebleau. It was his aim to represent a scene of present-day life in the open air, presumably recorded as it was being observed.

The novelty of such an intent is reflected in the painted study *Bazille and Camille*, which shows an elegant couple in a sunny clearing (cat. 35). The rapid, concise brushwork and the daring bright-dark contrasts suggest that the picture was painted directly in nature.[?] This work exhibits a

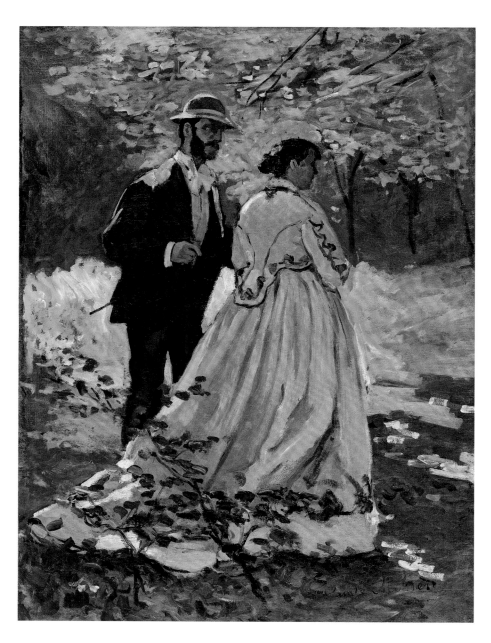

CAT. 35 Claude Monet (FRENCH, 1840–1926)
Bazille and Camille (Study for "Luncheon on the Grass"), 1865

Oil on canvas
93 × 68.9 cm (36 ⅝ × 27 ⅛ in.)
National Gallery of Art, Washington, D.C.

In this study for *Luncheon on the Grass*, the exaggerated lights and shadows and the merging of figures into the landscape presage Monet's Impressionist style. Camille's white walking dress, highly fashionable but worn casually and without a crinoline, becomes almost gray beneath the shadows. Her companion, Monet's friend Frédéric Bazille, wears a melon hat and a dark, open suit jacket atop a white shirt with crisp cuffs and a cravat, a leisurely but elegant outfit appropriate for the country. Taking cues from fashion illustrations, the figures make no contact with the viewer and are shown walking so that their fashions are patently on display.

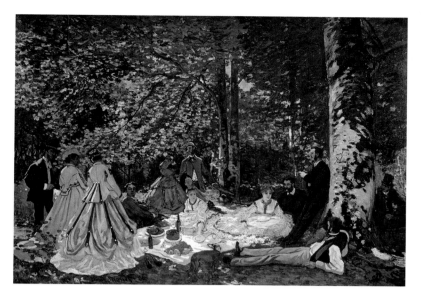

FIG. 2. CLAUDE MONET (FRENCH, 1840–1926).
Luncheon on the Grass (Study), 1865/66. Oil on canvas;
130 × 181 cm (51 ³/₁₆ × 71 ¼ in.). Pushkin State Museum
of Fine Arts, Moscow, inv. 3307 / W.62.

FASHION TAKES A VACATION

This remark points to a specifically modern leisure behavior. Supported by the expansion of railway travel, summer sojourns throughout the near and more remote environs of Paris became one of the new habits of the members of urban society, who had adopted a traditionally aristocratic way of living and adjusted it to accommodate their needs. The "flight to the country," however, implied a perpetuation of the urban way of life and fundamentally urban fashions. Even so, concessions in fashion were made as a result of the typically modern acceleration of movement in space and time. New, informal *petits costumes* afforded their wearers greater freedom of movement.[10] Since the beginning of the 1860s, when trailing skirts came into vogue even for promenade outfits, fashion magazines increasingly reported on a both pragmatic and "gracious-looking style of lifting one's dresses."[11] Indeed, some of the fashionably trailing crinoline skirts could be gathered and thereby shortened by means of integrated pulling devices. The effect is demonstrated in contemporary fashion illustrations: in an etching by Anaïs Toudouze, published in an 1864 issue of *La Mode Illustrée*, the woman on the right wears a beige and black ensemble consisting of a mantle, a short bolero jacket, and a flaring skirt that has been lifted above a decoratively ornamented petticoat (fig. 3).

Extant pieces allow us to understand how an effect like this could be obtained. The shape, colors, and trimmings of a three-part summer dress (fig. 4) demonstrate striking parallels to the ensemble shown in the fashion illustration. This dress is made from a robust, light-brown linen; the trimmings, which outline the fashionable silhouette, consist of decorative black passementerie.[12] While the short bolero and broad waistbelt enclose the upper body above a slightly raised waistline, the skirt, composed of fourteen panels of cloth cut diagonally on one side, features a shape characteristic of the waning Second Empire: a flattened front and wide, flaring back. The considerable quantity of material could be gathered by the wearer according to her preference by means of an arrangement of strings. To this purpose, long, narrow ribbons—called *tirettes* (literally, "little pulls") or *pages*—were attached to the skirt's inside along all vertical seams; their upper ends were tied to buttons loosely fastened

formal modernism that surpasses anything Monet had painted heretofore, corresponding deeply with the topical depiction of contemporary clothing. A friend of Monet, the painter Frédéric Bazille, posed as a correctly dressed country gentleman in a suit with a dark jacket, stands diagonally behind Monet's companion, Camille Doncieux, the view of her slightly turned back displaying her fashionably elegant garment. With broad brushstrokes, Monet captured the garment's defining shape and drapery by varying the darkness of its shaded parts and succinctly pointing out details and textures. The bright promenade dress with darkly contrasting soutache embroidery consists of a tight-fitting short jacket and a skirt, worn here without the customary crinoline, but with a long train with voluminous folds.[8]

A comparable extant day dress dating to the first half of the 1860s (cat. 36) consists of a tight-fitting, high bodice that imitates the contemporary shape of a short, open bolero jacket worn over a fully buttoned vest. This is complemented by a wide crinolined skirt that extends to the floor without a train. Similar to a slightly later seaside ensemble (cat. 37), the day dress is made of white cotton piqué with a black edging and soutache embroidery; piqué was a sturdy, comfortable fabric that contemporary fashion magazines recommended as especially suited "for a sojourn in the country or in seaside resorts."[9]

American
White cotton piqué embroidered with black soutache
The Metropolitan Museum of Art, New York

Clean and tailored in shape, the distinctive, high-contrast character of this dress comes from its elaborate soutache embellishment, whereby flat, narrow braid is stitched to the surface of a fabric. This type of trimming was often used in military uniforms and reinforces the masculine influences in this ensemble. The wide bell shape of the skirt is supported by a crinoline of connected metal hoops. Crinolines replaced layered petticoats in the late 1850s and provided lightweight sculpting for the period's ever-increasing skirt dimensions. The light crinoline, paired with the dress's sturdy, breathable cotton piqué, was recommended for comfort while walking by the seaside or in the country.

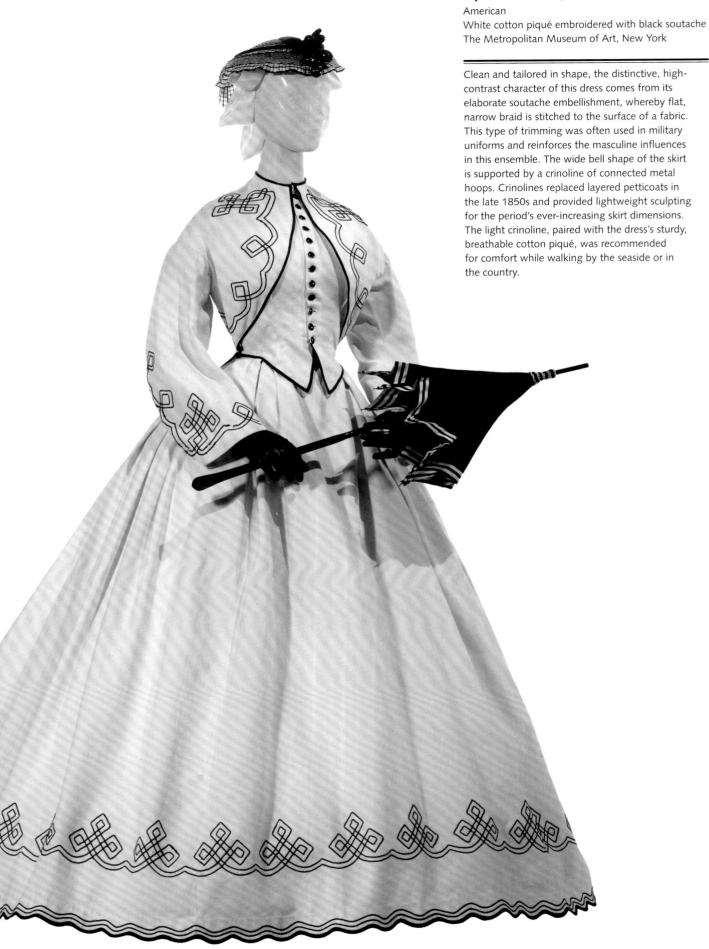

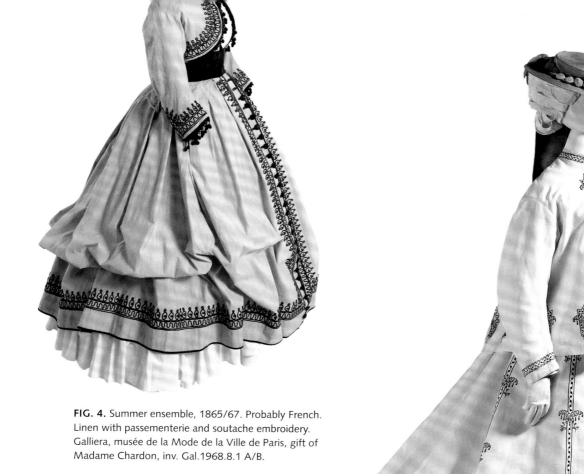

FIG. 4. Summer ensemble, 1865/67. Probably French. Linen with passementerie and soutache embroidery. Galliera, musée de la Mode de la Ville de Paris, gift of Madame Chardon, inv. Gal.1968.8.1 A/B.

CAT. 37 Woman's three-piece seaside ensemble, 1864/67

French
Cotton, plain weave with supplementary warp, and cotton, machine embroidery
Los Angeles County Museum of Art

FIG. 3. ANAÏS TOUDOUZE (FRENCH, 1822–1899).
La Mode Illustrée 5 (July 10, 1864). Galliera, musée de la Mode de la Ville de Paris.

above small openings in front and back of the waist-line. Pulling the buttons raised the skirt's hem.

It is significant that Monet depicted this modern variant of female "leisure wear" in his artistic manifesto of plein air painting. In the oil study for *Luncheon on the Grass* (fig. 2), he repeated the figure study from *Bazille and Camille* with very few changes on the picture's left edge and supplemented it with a third figure, who stands diagonally in front of Camille. This female figure, seen from behind, serves primarily to present a fashionable promenade ensemble to best advantage: the sand-colored outfit with blue ribbons consists of a close-fitting *paletot* and a decoratively raised overskirt. The extant fragments of the final painting, executed in the studio the following winter, testify to further significant changes (cats. 38, 39). Among other considerations, Monet reacted to a trend in contemporary fashion by replacing the bright ensemble and its soutache work with a stone-gray *petit costume* comprising a rather short, raised overskirt and trimmings in brilliant aniline red.[13] The painter paid tribute to the growing importance and accelerating change of what was already in vogue during the Second Empire by making these specifically modern details the central focus of his artistic representation of a passing moment of present-day life.

CAPTURING THE FASHIONABLE

In Monet's *Luncheon on the Grass* canvases, the short-lived fashion of the day—itself a symptom of the time—expresses, according to avant-garde aesthetics, the idea of the fleetingness of modern perception. Thus one can detect in the painting, in terms of both form and content, the influence of contemporary fashion illustrations, a decidedly modern, ephemeral medium that by way of an impersonal elegance represented the pictorial world of the *vie moderne*.[14] The conventions of the genre are reflected both in Monet's depiction of fashionably dressed figures en plein air and in the different poses of the men and women, presenting summertime clothes from a variety of viewpoints. Individual characteristics recede in favor of an ostentatious presentation of garments and the resultant distanced manner of perception. It was obviously the depiction of contemporary ladies' fashion en

CAT. 38 Claude Monet **(FRENCH, 1840–1926)**
Luncheon on the Grass (left panel), 1865–66
Oil on canvas
418 × 150 cm (164 ⅝ × 59 in.)
Musée d'Orsay, Paris

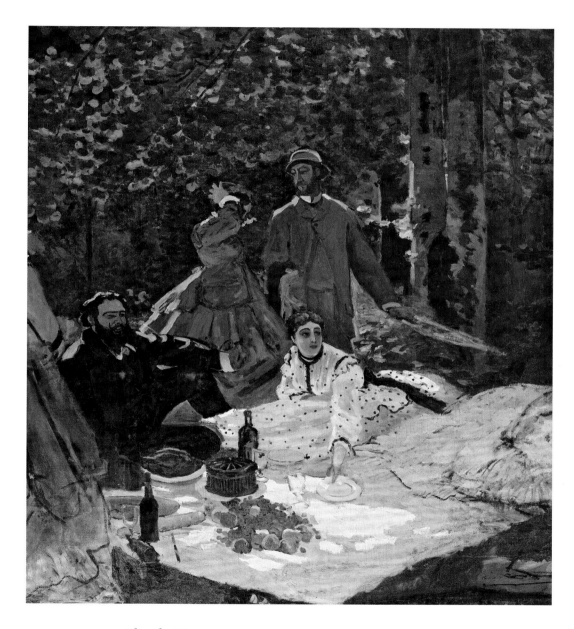

CAT. 39 Claude Monet **(FRENCH, 1840–1926)**
Luncheon on the Grass (central panel), 1865–66
Oil on canvas
248.7 × 218 cm (97 ⅞ × 85 ⅞ in.)
Musée d'Orsay, Paris

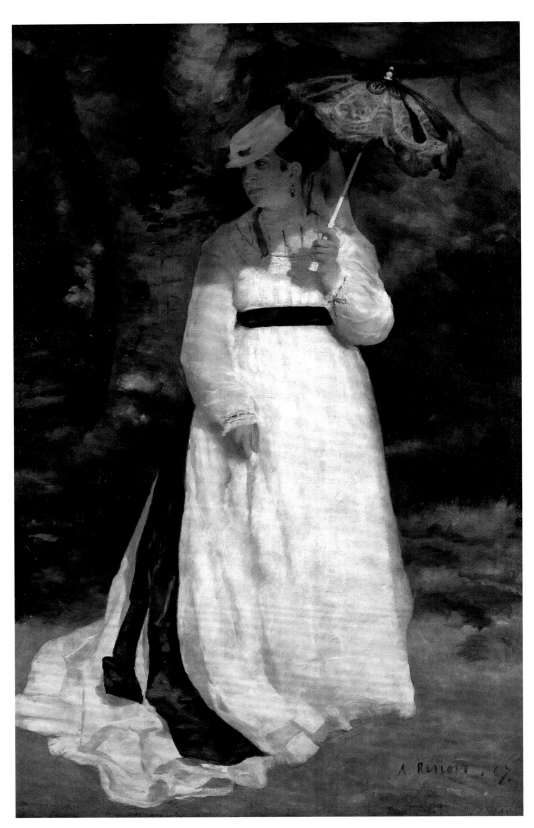

CAT. 40 Pierre-Auguste Renoir
(FRENCH, 1841–1919)
Lise—The Woman with the Umbrella, 1867

Oil on canvas
184 × 115.6 cm (72 7/16 × 45 1/2 in.)
Museum Folkwang, Essen

Here Renoir portrayed his nineteen-year-old companion, Lise, as a charming young Parisienne, dressed for the country in an informal, but fashionable, sheer muslin day dress, worn without crinoline and simply adorned with a long black waist sash and small ribbons at the cuffs and décolletage. Her ample white skirt proved ideal for the study of the effects of sunlight and the colored reflection of foliage on fabric, while her black lace umbrella and tipped (porkpie) hat cast shadows across her face and shoulders. Described by critics at the 1868 Salon as the "sister" to Monet's *Camille* (cat. 16), this full-length portrait exemplifies a type of modern woman, not the woman herself.

CAT. 41 Parasol, 1860/69

French
Black silk lace, ivory silk faille, and taffeta
with carved ivory handle
The Metropolitan Museum of Art, New York

CAT. 42 Dress, c. 1864

American
Bleached linen tarlatan dress with
matching sash
Museum of the City of New York

plein air that was central to the painter's and the public's interest and that became the touchstone of artistic modernism.

This was true also of other representatives of the *nouvelle peinture*, such as Pierre-Auguste Renoir. Zola counted him, along with Monet and Bazille, among the most important painters—those who were truly invested in expressing the reality of modern life, including the modern appearance of their contemporaries.[15] The critic arrived at this estimation above all on the basis of the picture with which Renoir first provoked public attention in the Salon of 1868, *Lise—The Woman with the Umbrella* (cat. 40). The young artist presented his companion, Lise Tréhot, at life size, in bright sunlight before a suggested forest landscape, like an elegant fashion figurine with a self-contained, statuesque appearance. As in a fashion illustration, but magnified, the summarily painted surrounding environment looks like a stage set, while the viewer's attention is directed entirely at the frontally depicted young woman in her contemporary summer outfit. Renoir defined the white muslin dress with its high black sash, the stylish little hat, and the dainty lace parasol (see cat. 41 for a similar style) with broad, fluid brushstrokes.

Contemporary opinion considered gowns made of delicate white muslin, which allowed the skin of the arms and décolletage to shimmer through the fabric (see cat. 42), appropriate for a summertime sojourn in the open; the absence of a broad crinoline here further underlines the modish informality of the dress. The sunlight, subdued only at the top of Lise's head by the dainty parasol that shades her face, makes the white fabric of her dress appear radiant, barely broken by delicate blue shadows, highlighting the effect of light in nature, which contemporaries recognized as the specific modern quality of this picture.[16] This implies that the painter consciously employed his model's contemporary wardrobe in the interest of his artistic avant-gardism. The emphasis on the dress is accentuated by the fact that Lise, her head turned to the side, refuses eye contact with the observer and hence appears psychologically distanced or impersonally typified. The foregrounding of her contemporary clothes and the withdrawing of her face turn Lise into an embodiment of the Parisienne, the ideal image of contemporary womanhood that since the first half of the

nineteenth century had been synonymous with fashion and modernity.[17] It is precisely this perspective that is mirrored in Zola's characterization of Lise as "one of our women, or one of our mistresses rather, painted with great truthfulness and successful innovation in the modern way."[18]

Three years later, Renoir attained success at the Salon with *Lise on the Banks of the Seine—Bather with Griffon Terrier* (cat. 43), whose subject and composition are complementary to but at the same time quite different from *Lise—The Woman with the Umbrella*. In the later painting, Lise is rendered as a monumental standing nude in a copse of willow trees by the bank of the Seine. She has shed her clothes in order to take a bath in the company of a fully dressed female companion and a small dog. This subject—"legitimized" by stylistic borrowing from Greek antiquity as well as references to works by Courbet, and probably executed in the artist's studio—appears, when compared to *Lise—The Woman with the Umbrella*, much more traditional in form and content. The scene acquires a "modern touch" again primarily through the depiction of contemporary clothing. The clothing is not, however, the painting's central focus. Even so, it seems as if the discarded striped summer dress and shirt, decorated with lace and red bows, have left their "imprint" on Lise's body, which is shaped according to the contemporary ideal, with descending shoulders, full breasts, a slim waist, and ample thighs.[19] In its immediate, real presence, this undressed body à la mode evokes Manet's portrayal of Victorine Meurent in *Luncheon on the Grass* (fig. 1); its artistic handwriting, however, remains more reticent. That Renoir made a conscious concession to the conservative taste of the Salon's public is obvious from a comparison with the smaller *Promenade*, also of 1870 (fig. 5). Although the composition and narrative style that define this representation of a fashionably dressed couple taking a walk follow the conventions of genre paintings acceptable to the Salon, the painterly technique is highly innovative compared to *Lise on the Banks of the Seine*, a painting that Renoir intended to succeed in the Salon. By dispensing with the painstaking execution of details, Renoir's loose, short brushstrokes impart the impression of scintillating sunlight falling through leaves, focusing attention on the radiant whiteness of the fashionable summer dress, which is defined by colorful shadows.[20]

Lise on the Banks of the Seine—
Bather with Griffon Terrier, 1870

Oil on canvas
184 × 115 cm (72 ⁷⁄₁₆ × 45 ¼ in.)
Museu de Arte de São Paulo Assis Chateaubriand, São Paulo

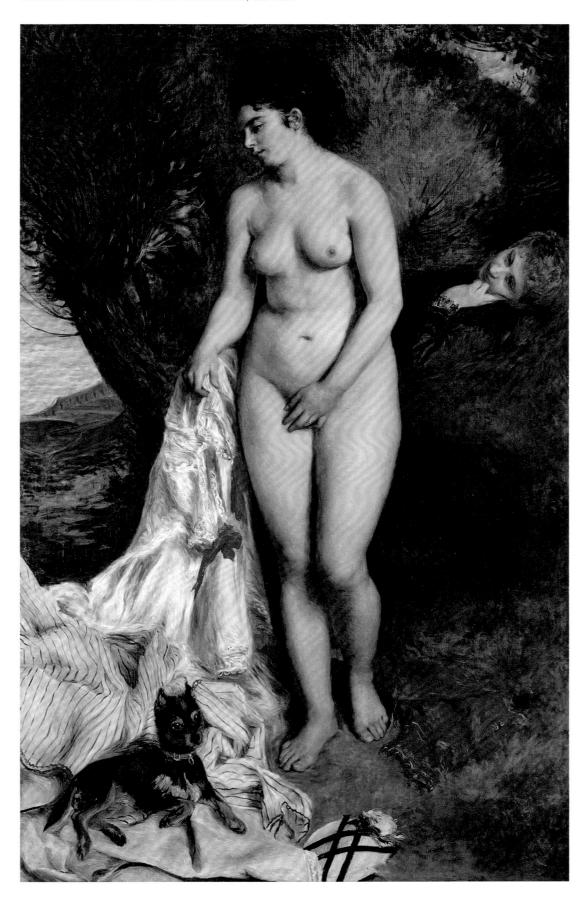

CAT. 44 Pierre–Auguste Renoir
(FRENCH, 1841–1919)

The Swing, 1876

Oil on canvas
92 × 73 cm (36 ¼ × 28 ¾ in.)
Musée d'Orsay, Paris

The relaxed, informal clothing worn by the two men, the little girl, and Jeanne on the swing reflects the intimacy of this garden setting. Jeanne's princess-style dress has no waist seam breaking its long, slender line, while a row of bright blue bows down the center echoes its lithe silhouette. Renoir's effort to record the effect of sunlight shining down through a canopy of leaves onto the group of figures was derided by critics, who called his stippled, kaleidoscopic use of color "impressionistic hail."

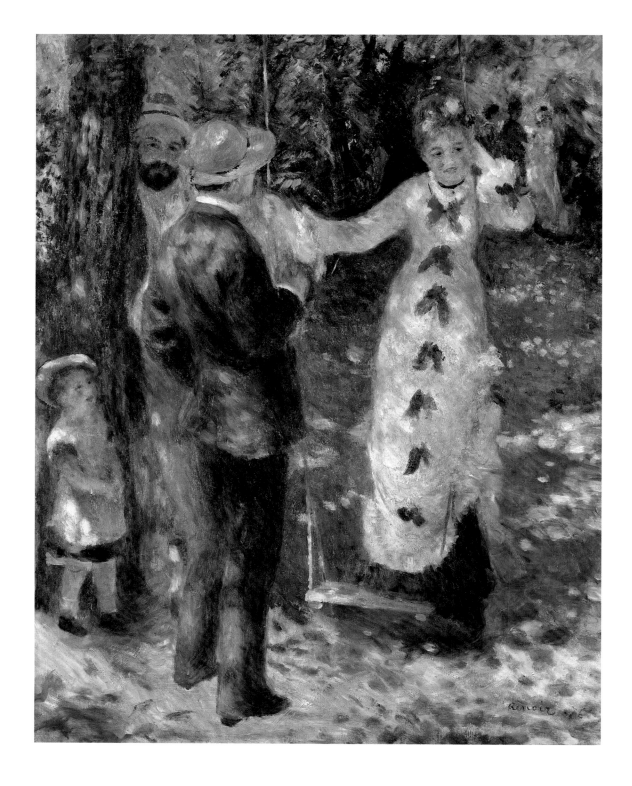

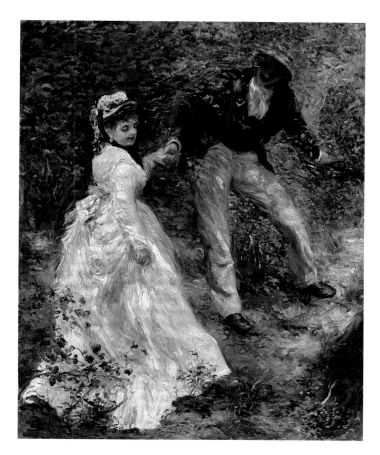

FIG. 5. PIERRE-AUGUSTE RENOIR (FRENCH, 1841–1919).
The Promenade, 1870. Oil on canvas; 80 × 64 cm (31 ½ × 25 ³/₁₆ in.).
The J. Paul Getty Museum, Los Angeles.

Renoir evoked a similar light effect in *The Swing,* painted six years later and presented in 1877 at the third Impressionist group exhibition (cat. 44). In an enchanted park terrain behind the painter's studio in Montmartre, Jeanne, a young workingwoman from the neighborhood, stands on a swing, lost in thought, while two men and a little girl vie for her attention. With soft brushstrokes of radiant color, Renoir captured the scene in the vibrating sunlight under the trees; its cheerful, festive ease evokes representations of *fêtes galantes* from the Rococo period. The center of the painting is marked by Jeanne's formal dress, which follows the high-fashion style of the "close-fitting line."[21] In its fit and cut, the princess-style dress of white muslin retraces the contours of a body shaped by a cuirass corset.[22] The vertical silhouette is empha-sized by a sequence of blue bows running down the front, which harmonize in color with the petticoat visible beneath the raised hem. Stylistically similar outfits appear in contemporaneous paintings by the highly successful society painter James Tissot (see cats. 30, 52). But a comparison reveals characteristic differences, both in content—while Tissot preferred the effect of high-end fashion, Renoir depicted the style's working-class version—and especially in form. In place of the precise, copiously detailed depictions of the Salon painter, the Impressionist's brushwork seems to dissolve the dress into a web of loose brushstrokes and colored dots. These dots, above all, ignited the indignation of contemporary critics, who felt reminded of splattered grease.[23]

The representation of contemporary fashion, demanded by Baudelaire as proof of artistic modernism and realized by avant-garde painters in programmatic and often scandalous works, was established by the 1870s as an accepted subject of modern as well as popular art. Increasingly, the specifically impressionistic handwriting that Monet, Renoir, and other representatives of the *nouvelle peinture* developed during the following years became the principal standard by which to judge avant-garde art. In this endeavor, the integration of fashionably dressed figures into landscapes suffused with light was at first the special strength of the Impressionists. Only slowly did attention shift from the depersonalizing effect of contempo-rary garments toward the dematerializing effect of radiant sunlight, from the transience of short-lived fashion to the mutability of atmospheric phenomena. Eventually, figures appeared ever more strongly as elements of nature, and began to fuse with it and turn into those "plein-air figures . . . done like landscapes," whose portrayal Monet still considered an artistic challenge as late as the mid-1880s (see cat. 135). He and his comrades, as avant-garde representatives of the emerging Impressionist movement, laid the foundation for this during the 1860s, when they sought in progres-sive paintings the representation of current ladies' fashion as an expression of the timeliness and ephemeral nature of a moment in the *vie moderne.*

Claude Monet
Women in the Garden

Birgit Haase

In the spring of 1866, Claude Monet began work on a large group portrait set in the garden of a house he had rented in Ville d'Avray, southwest of Paris. Two years later, Émile Zola described *Women in the Garden* (cat. 45), which had meanwhile been rejected by the Salon, as one of the young painter's most characteristic works capturing the *vie moderne*:

> A painting of figures, women in light-colored summer dresses, gathering flowers as they walk the paths of a garden; the sun falling directly on the astonishingly white skirts; the soft shade of a tree cuts like a large gray sheet across the paths and the sunlit skirts. Nothing could be stranger as an effect. It takes a singular love of one's times to dare such a tour de force—materials cut in two by shadow and sun, well-dressed ladies in a flower garden carefully combed by the rake of a gardener.[1]

Zola considered the painting modern on the basis of both content and form, corresponding to Monet's artistic intention of creating a manifesto of avant-garde figure painting en plein air.[2] As he had done in the incomplete *Luncheon on the Grass* (cats. 38, 39), the artist painted life-size figures in the midst of nature. It was his intention to capture on canvas a fleeting moment of contemporary life outside his studio, in natural light and according to practices until then customary only for painted sketches. In order to visualize his ambitious aims, Monet, as a "painter of modern life" in Charles Baudelaire's sense, relied above all on the representation of currently fashionable garments.

"I practiced effects of light and color that were contrary to those people were used to,"[3] Monet said, remembering, about thirty years later, his work on the painting. He reconstructed the visible world through light and color and thereby called forth an effect of brightness and optical immediacy that shocked his contemporaries. Committed to the technique of sketching en plein air, Monet worked with large brushes in quick, broad strokes directly in front of his subject. The intensive light of the afternoon sun—which falls diagonally into the garden in a wide swath, its radiance penetrating even the shade—defines the whole scene. Large, opaquely applied stretches of color of a partially rough texture crystallize, complemented by accents placed with nearly graphic clarity. Even shadows appear as unalloyed color values.

No less trendsetting than Monet's painting style, and most closely connected with it, was his choice of the relatively unpretentious subject of four young women in a garden among deep-green shrubbery and flowering rosebushes. They are arranged in various postures around a small tree whose slender trunk establishes the central axis between the group on the left and the fourth idler on the right. The figures, and the picture's entire structure, are defined primarily by the summery, bright gowns with tight-fitting, high-waisted bodices, half-length *paletots*, and widely undulating crinoline skirts typical of the contemporary fashion of the waning Second Rococo period. The use of similar colors for the dresses—modulated by the immaterial, transformative power of the light—accentuates the two-dimensionality of the group. Monet's search for a sensual representation of current fashions is characteristically combined here

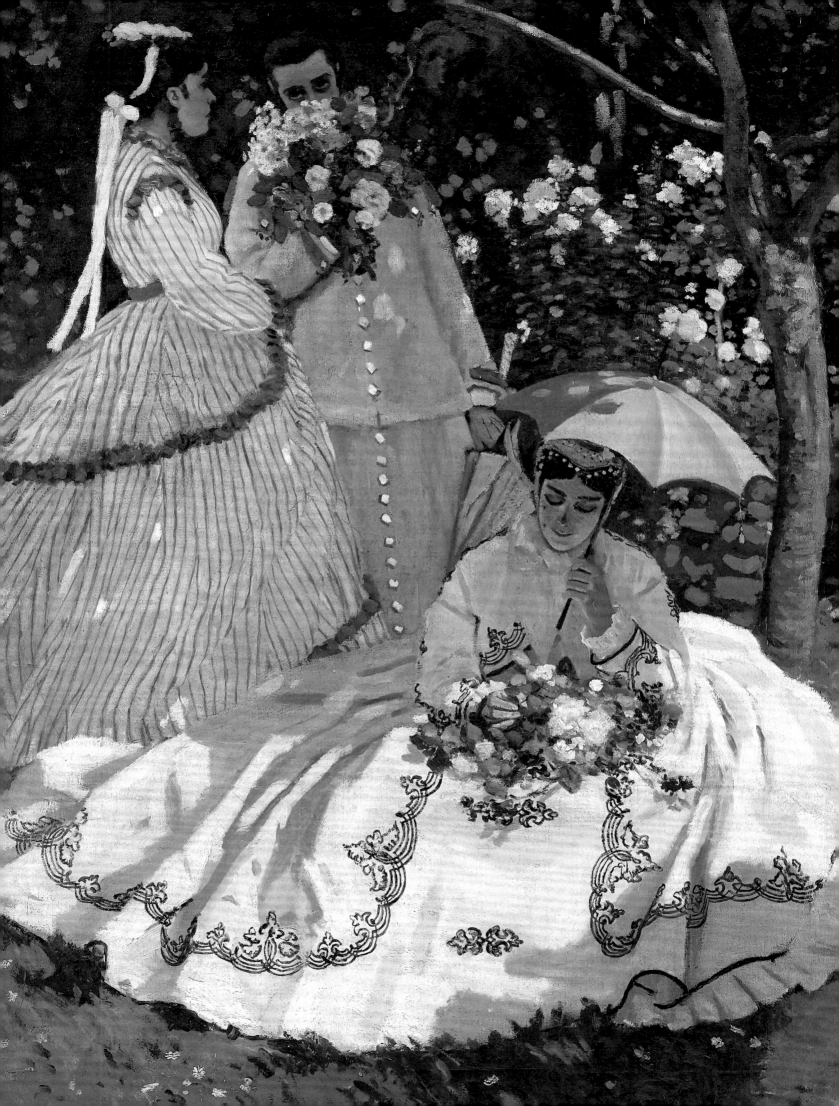

CAT. 45 Claude Monet (FRENCH, 1840–1926)

Women in the Garden, 1866

Oil on canvas
255 × 205 cm (100 ⅜ × 80 ¹¹⁄₁₆ in.)
Musée d'Orsay, Paris

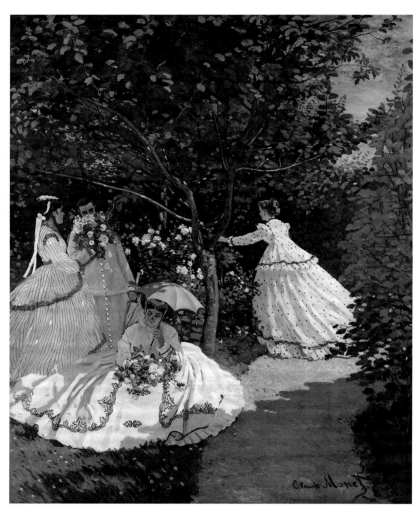

selected only brightly nuanced gowns, showing them from somewhat more advantageous angles and in combination with different accessories than in the previous painting. Even so, they can be unequivocally identified as identical.[7]

We may assume, then, that these garments actually did exist, which raises the question of their provenance. The conjecture that Monet borrowed them in Paris, or even that he had a supply of currently fashionable garments in his studio, is rather improbable in view of his precarious financial situation at the time.[8] Interestingly, clothes that resemble those used by Monet in *Luncheon on the Grass* and *Women in the Garden* repeatedly appear in sketches by Eugène Boudin from the mid-1860s.[9] It is probable that Boudin used the fashionably attired mistress of his former disciple as a model during their (attested) work together on the coast of Normandy; in this case, the depicted apparel might have belonged to her. Camille, who had grown up in well-established bourgeois circumstances and to whose elegance and fashion sense numerous paintings from the 1860s and 1870s testify, probably had a relatively plentiful, fashionable wardrobe around 1865.[10] The fact that this wardrobe may have been supplemented with at most a few accessories after Camille's breach with her family during the first years of her illegitimate liaison with Monet may be one reason that Monet depicted the same dresses repeatedly. This also aligned with the tradition of preserving clothing for as long as possible by taking meticulous care of garments and imaginatively varying the basic elements by adding or subtracting trims and accessories. In *Women in the Garden*, Camille and Monet combined dresses from earlier years with different accessories and presented them from varying perspectives. Their inspiration may well have been contemporary fashion engravings, whose stylistic influences are unmistakable in the painting. The individual characterization of the women

with his artistic awareness of the decorative effect of the painting's surface.[4]

In this methodically well-calculated arrangement, Monet deviated from the principle of an immediate depiction of nature in favor of portraying a carefully selected subject in a deliberate, conscientious composition.[5] The mere fact that he was limited to one single model implies that the figures were consciously arranged: his companion at the time and later his wife, Camille Doncieux, consecutively posed for each of the four women.[6] Monet varied both her posture and her outward appearance according to the requirements of the intended composition. In this the painter and his model made use of garments that had also been put to service in *Luncheon on the Grass* (fig. 2, p. 89; cats. 38, 39). For *Women in the Garden*, they

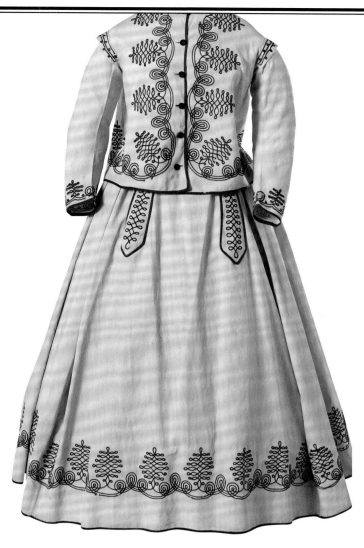

FIG. 1. Promenade ensemble, 1865/67. Probably French. Cotton with soutache braid. Galliera, musée de la Mode de la Ville de Paris, gift of the Société de l'histoire du costume, inv. Gal.1920.1.2298.

details executed under a uniformly subdued studio light—that the uncompromising modernism of *Women in the Garden*, which was painted predominantly outdoors, is illuminated. Monet intensified the formal affinities of his painting with the medium of fashion prints—and at the same time far surpassed this model. He did so by creating a flat, decorative pictorial effect through figures that stand out against their background as clearly delineated silhouettes; in their garments, the shapes, materials, trimmings, designs, and colors of contemporary ladies' fashion come alive. With energetic brushstrokes of an unmistakably calculated colorfulness, he achieved a subtle, sensual representation of the fabrics, encouraging Zola to assign him the first rank among the "painters of modern life" in 1868.[13]

The figures in *Women in the Garden* appear as ideal female representatives of the *vie moderne*, and a closer examination of their clothing shows how serious Monet was about representing an immediate, real impression. The skirt that is spread across the grass in the painting's foreground, the flounce of the crinoline petticoat visible beneath its hem, signifies a stylistic motif characteristic of the fading Second Empire: an amplitude of fabric necessitated by the considerable width of the hem. This is also suggested by the compact, cone-shaped contour of the sand-colored dress in the background.[14] An extant ensemble of similar silhouette and colors (fig. 1), a *petit costume* of beige cotton, consists of a hip-length, loose "sack *paletot*" and a cone-shaped crinoline skirt. It differs from its painted counterpart only in its trimmings: the continuously intertwining threads of the soutache embroidery were highly prized in promenade dresses because of their decorative effect and fascinating "exotic-military" connotation.[15] In *Women in the Garden*, such embroidery is featured on the foreground ensemble, in which Camille had posed a year earlier for *Bazille and Camille* (cat. 35). The dress was updated with new accessories: a yellow *capote* with a wide chin ribbon and an elegant parasol.

No less contemporary are the striped dress on the left and the dotted ensemble on the right, the "smoothed" triangular silhouette of their skirts presented to especially good effect—a feature

recedes in favor of an ostentatious display of garments. Their psychological isolation—caused by the repeated depiction of the same model—the reduced gestures and facial expressions, and the artificial configurations in poses of calculated casualness also correspond to the representational conventions of contemporary fashion illustrations.[11]

Even before Monet, other painters of his generation recognized the potential of these fashion plates as prototypes and used them in their art. James Tissot, in his painting *The Two Sisters* (cat. 4), showed young girls in fashionable dresses posing in half shadow, a subject akin to Monet's garden painting.[12] But it is through comparison with Tissot's painting—with its consciously affected sensibility of colors, refined elegance, and faithful depiction of

FIG. 2. Promenade dress, 1865/67. French or English. Taffeta with vertical stripes (lancé) in satin weave of two different shades of green. Museum für Kunst und Gewerbe, Geschenk der Stiftung zur Förderung der Hamburgischen Kunstsammlungen, Hamburg, inv. 1986.15.St.358.

referred to as absolutely modern in fashion magazines of 1866/67. The striped dress particularly highlights this contemporary silhouette, which is further emphasized by the dainty headdress with long ribbons cascading down Camille's back. A similar extant promenade dress made of eggshell silk taffeta features narrow green woven stripes and color-coordinated decorations (fig. 2). Its tight bodice, slightly raised waistline, and crinoline skirt—flat in front and swaying out in back—is in keeping with the predominant silhouette of 1866.[16] Details of cut and trimming accentuate the characteristics of ideal beauty that favored a broad, descending shoulder line, luscious bust, slender waist, and shapely posterior. The allusion to the overskirt of the eighteenth-century *robe à la française*, highly in vogue during the Second Empire, was incorporated

with a strikingly modern graphic clarity through the addition of green velvet ribbons. Iodine green or methyl green, developed in 1865/66, was one of the new synthetic aniline dyes that were regarded as a sign of modernism at the time.[17]

In contrast to this extant promenade dress, Camille's green striped gown—as well as her dress with black dots—was made of soft, translucent muslin. Contemporary fashion magazines recommended this fabric for light, airy summer dresses, preferably in bright colors with a spare use of contrasting colors for decoration. Especially popular—in both the fashion world and among the artists of the *nouvelle peinture*—was the dazzling white made possible in the nineteenth century through modern techniques of textile finishing. In *Women in the Garden*, Monet's bright palette, dominated by ceruse, reflects what Edmond Duranty later singled out as one of the fundamental innovations of Impressionism: the discovery of the "decolorizing effect" of bright sunlight.[18] Fashion-conscious ladies valued white fabrics for the advantageous effect they had on the complexion. Beyond that, in bourgeois society white suggested ethical values. It symbolized virginal purity, noble tenderness, and gentility. By lending to women both the ethereal appearance held in high esteem at the time and an aura of "luxurious simplicity," white signified an exclusive lifestyle.[19] In order to preserve the moral purity of such attire, the wearer had to move cautiously, shunning physical work and dirty environments. Consequently, white dresses both occasioned and expressed a leisurely, refined existence, revealing a feminine ideal that also underlies *Women in the Garden*.

While it was in a forest glade that Monet arranged his picnic companions the year before, in *Luncheon on the Grass*, he now posed the fashionably dressed Camille in a suburban garden outside Paris, which had been laid out according to the bourgeoisie's taste. This change of setting corresponded with an evolving attitude toward nature that was shaped by the city, one that understood the cultivated landscape of a park as the stage of social life, a "salon en plein air," where it was of the highest importance to see and be seen and where a modish wardrobe was essential. Citydwellers' perceptions of the rural landscape

were changing as an increasingly mobile society ventured out to the countryside around Paris. Monet showed himself indebted to this trend, taking, as Zola put it, "Paris with him out into the country" and demonstrating in his paintings a "special preference for a nature fashioned by humans in the modern style."[20] With *Women in the Garden*, he dedicated himself for the first time explicitly to the bourgeois "urbane idyll" of the garden as an arena of fashionable representation.[21]

That ladies' fashion was in this context considered neither excessive nor unsuitable is illustrated by numerous contemporary pictures of similarly attired ladies en plein air. Rather, there existed an analogy between idealized nature and an artificial wardrobe. In *Women in the Garden*, the carefully shaped ornamental garden represents urbane sophistication as much as the women's ensembles, which were a product of evolving technologies and a burgeoning consumer culture. Virginia Spate argued that the fashionable image of these women is a close analogy to Monet's modern, urban, distanced manner of perception, stating, the "*Women in the Garden* . . . are represented simply as lovely, up-to-date objects."[22] Resembling the flowers that surround them, the brightly dressed women, as embodiments of Parisian chic, are defined entirely by their outward appearances, treated as luxury items in an aesthetic refuge. Their carefully depicted outfits, whose restrictive forms and delicate materials make any physical movement difficult, turn them into status symbols of a passive, decorative character. Their idleness—emphasized rather than veiled by their ladylike occupation with flowers—further intensifies this impression.

Monet's portrayal mirrors a patriarchal image of womanhood, characteristic of the bourgeoisie at this time, that cherished the looks, demeanor, and surroundings of a woman as manifestations of her husband's or lover's socioeconomic prestige.[23] As in other figural images from the second half of the 1860s, Monet demonstrated his debt to the mentality of a *bon bourgeois*, perhaps using Camille's fastidious wardrobe to express his own social pretensions.[24] Monet's fashionably elegant women, seen in a carefully tended garden evoke an ideal world without labor that was informed by the lifestyle of an aristocratic past.

Monet's depiction of holiday leisure in nature refers to the pictorial genre of *fêtes champêtres*, initiated during the Rococo period by Antoine Watteau. Monet's modernized, middle-class "earthly paradise" set in a pleasure garden replaced the ideal aristocratic landscape; the four young women in fashionable garb figure as Graces of the *vie moderne* in a bourgeois Arcadia. This highlights the fact that the "pictorial reality" presented in *Women in the Garden* is, in the final analysis, an illusion—a seemingly real representation of the bourgeois dream of a never-ending sunny holiday.

Monet in no way depicted a moment of contemporary life; rather, he presented something desired as real. He designed a world that is related to reality but fictive—an *allégorie réelle* in which he acted as *grand couturier* for Camille. Her fashionable wardrobe served as both a symbol of the *vie moderne* and a means to give visual expression to a desirable standard of living. Monet's focus on bright summer ensembles gave him the opportunity to establish the effect of sunlight as relatively independent of the picture's motif, according to the style of progressive painting en plein air. In his depiction of the dresses, the artist was primarily interested in capturing an *effet éphémère* balanced between *observation* and *réflection*.[25] In this manner, he created a congenial interpretation of his subject in keeping with the Baudelairean leitmotif opposing nature and art that dominated the second half of the nineteenth century and can be found in both the era's progressive painting and women's fashion. *Women in the Garden* is thus a key work in this complex interplay of Impressionism, fashion, and modernity.

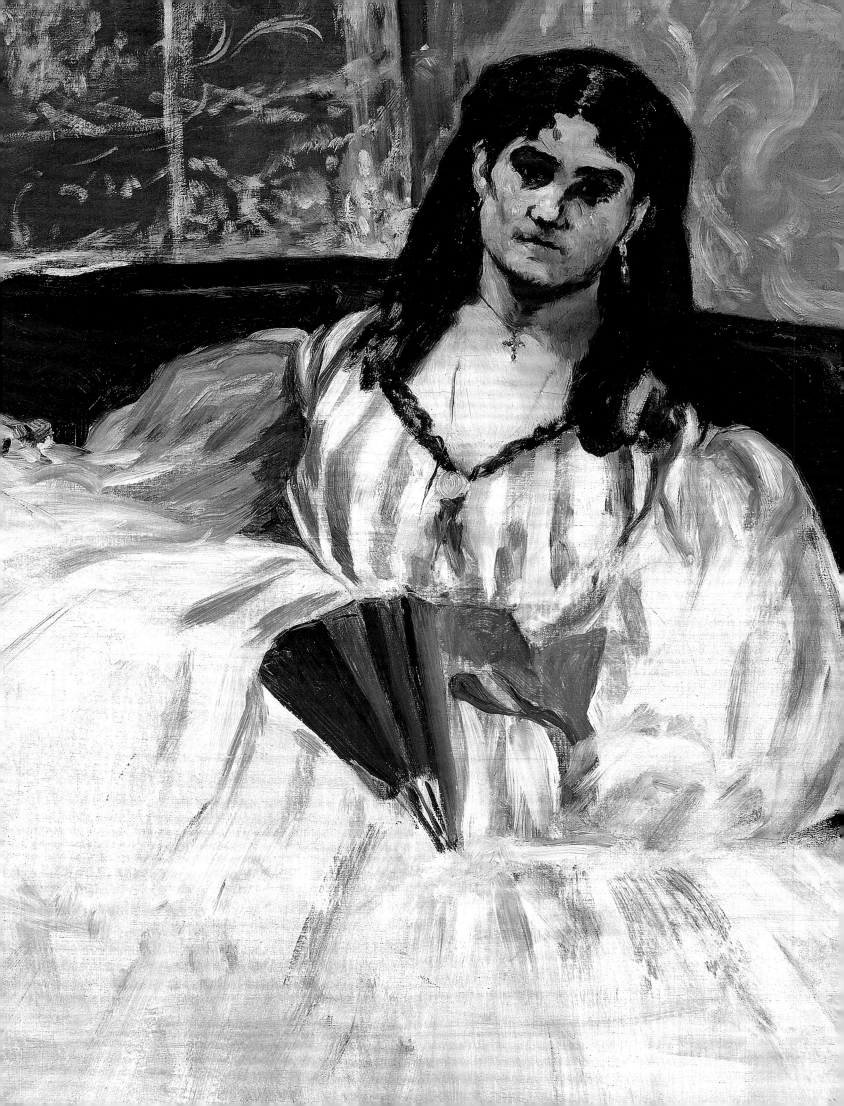

Fashion and Intimate Portraits

Justine De Young

All portraiture is intimate. It invites careful examination of the faces, bodies, and clothes of figures that can neither leave nor turn away. Likewise, to paint a portrait requires intimacy.

A painted portrait attests to long minutes, stretching into longer hours, spent studying an individual's features and dress. Even the language used to describe the process, "capturing a likeness," implies something taken and, by extension, something given up. Yet despite the inevitable intimacy of the process, many portraits feel opaque—an apparently accurate transcription of the sitter's exterior appearance and nothing more.

The best portraits create a sense of another's presence across time; in the words of Charles Baudelaire, "Everything—from costume and coiffure down to gesture, glance and smile (for each age has a deportment, a glance and a smile of its own)—everything, I say, combines to form a completely viable whole."[1] Moving beyond the details of dress, manners, posture, and poise, such portraits hint at the sitter's personality and seem animated by a unique intelligence. Impressionist portraits,

in particular, achieve this lively effect; their lack of formality translates into a feeling of naturalness.[2]

While conventional portraiture of the 1860s and 1870s had an artificial, deliberately studied air—featuring women standing in their best evening dresses, framed by opulent interiors—Impressionist portraits of women in diaphanous *robes d'intérieur* (morning or afternoon dresses worn only among close friends and family) exude a sense of private informality. Even those pictures with generic titles are so carefully observed and specific that one feels in the presence of an individual, not just a type. The immediacy and casualness of the scenes impart a sense of intimacy and familiarity. They lull the viewer into accepting the truthfulness of the moment, its apparent lack of artifice (which, of course, is itself artfully constructed).

Especially prevalent among the Impressionists' subjects were women seen casually lounging, dressed

not for the public but for resting comfortably at home. Such scenes were pointedly not chic—or not solely so—instead representing relaxed moments of everyday life. The women depicted are observed not by *le monde*, the fashionable outside world, but by family and intimate friends. They exist in private, seemingly protected spaces, not posing so much as pausing. The painters of these portraits captured quiet, quotidian moments of contemplation of actual, not ideal, women. The women wear simple, everyday dresses, likely from their own wardrobes and made in consultation with their local dressmakers, rather than the more elaborate high fashion seen in public settings like Pierre-Auguste Renoir's *Loge* (cat. 12). Unlike the women depicted in fashion plates or in fashionable genre pictures, these sitters are most often shown alone and unoccupied. Modeled by family and friends, Impressionist portraits challenge conventions of portraiture, while also experimenting with new pictorial strategies.

FIG. 1. ANAÏS TOUDOUZE (FRENCH, 1822–1899). *Le Follet* 23, 272 (May 1869), pl. 705. New York Public Library.

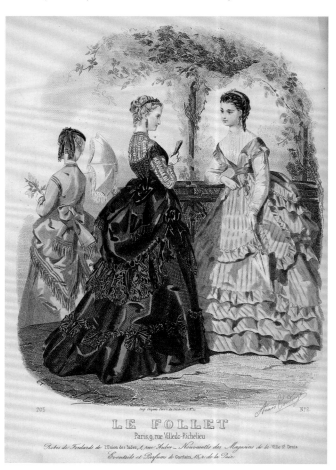

As nineteenth-century poet and critic Stéphane Mallarmé highlighted in his essay "Les Impressionnistes et Édouard Manet" (1876), the Impressionists sought to capture real, transitory light effects, not the steady indirect northern light of the studio favored by artists for centuries:

> Manet and his school use simple colour, fresh, or lightly laid on, and their results appear to have been attained at the first stroke, that the ever-present light blends with and vivifies all things. As to the details of the picture, nothing should be absolutely fixed in order that we may feel that the bright gleam which lights the picture, or the diaphanous shadow which veils it, are only seen in passing, and just when the spectator beholds the represented subject, which being composed of a harmony of reflected and ever-changing lights, cannot be supposed always to look the same, but palpitates with movement, light and life.[3]

One finds this harmony of light and diaphanous shadow especially in paintings of domestic interiors, which indeed seem animated by the free play of direct sun and shade. The unusual poses and lighting effects amplify the challenges of painting women's clothing—often monochromatic black or white dresses. These colors, of course, offered the greatest test of artists' abilities to render nuances of light and dark, sun and shadow, on various fabrics. This interest in the "harmony of reflected and ever-changing lights" distinguishes the work of Manet and the Impressionists from contemporaries like Charles Carolus-Duran, whose *The Lady with the Glove* (cat. 19) captures a transitory moment, but in the more traditional, steady light of the studio.

Black presented a particular challenge: how to record gradations of tint in the absence of color. Notably, by the 1860s, it had become quite common to wear black, especially in the afternoon, when many intimate portraits by Impressionists like Edgar Degas and Berthe Morisot were set. In the late 1860s and early 1870s, low-bodiced silk dresses with short, flat sleeves—to which transparent black sleeves could be attached or over which a separate fitted bodice of grenadine (a thin, gauzelike fabric) or tulle could be worn (see cat. 46)—were particularly

CAT. 46 Black dress, 1863/65

English
Black net over black slightly corded silk taffeta
Manchester City Galleries

All black, with a high, round neckline of net over a low silk
décolletage, vertical ribbon work, and lace-trimmed sheer
sleeves, this dress represented the height of fashion when
it was made. Layered over the highly valued pale skin
of a lady, its diaphanous dark surfaces would have offered
a rewarding challenge for painters. That black garments had
again come to epitomize chic sophistication and modernity
benefited the widow. Her enforced mourning wardrobe was
now a stylish advantage.

à la mode. Thus, not all women in black should be
assumed to be in mourning, as an 1869 fashion
plate in *Le Follet* (fig. 1) of an elegant black silk day
dress elaborately edged in lace attests. Degas's
1869 portrait *Madame Théodore Gobillard* (cat. 47)
incorporates these popular fashion trends: Yves
Gobillard wears a black gown with attached gauzy
sleeves and a button-front chemisette, which fills in
the low neckline of her dress and could have been
removed for evening wear. Likewise, the woman in
Morisot's *Interior* (cat. 48) wears a sheer tulle or net
bodice opened *en coeur* in the front over her black
taffeta dress. These elegant styles fell out of favor in
the mid-1870s, when the large number of women
actually in mourning for lost loved ones after the
Franco-Prussian War and Paris Commune of 1870–
71 made the look too funereal for everyday wear.

The melancholy possibilities of black are well
captured in Degas's quiet and enigmatic portrait of
Gobillard, Morisot's eldest sister. Her face visible
only in profile, Gobillard gazes thoughtfully, almost
solemnly, off to the right. Her black eyes appear
focused, not vague—an impression reinforced by
the stillness of her other features and the paleness
of her skin. Mary Cassatt later praised the unfin-
ished portrait as one of Degas's "finest": "It is much
in the style of a Vermeer and quite as interesting,
very quiet and reposeful. It is a beautiful picture.
A woman in black seated upon a sofa against the
light[—]the model was a sister of Berthe Morisot[—]
not handsome, but a Degas!"[4] The work was
the culmination of an extended series of studies and
sittings conducted in the Morisots' rue Franklin

CAT. 47 Edgar Degas (FRENCH, 1834–1917)
Madame Théodore Gobillard, 1869

Oil on canvas
55.2 × 65.1 cm (21 ¾ × 25 ⅝ in.)
The Metropolitan Museum of Art,
New York

Degas painted this portrait of Yves Gobillard, oldest sister of Berthe Morisot, in the living room of the sisters' Paris home in 1869. The domestic setting is implied by Gobillard's bare head and the absence of jewelry. Her sheer black afternoon dress, popular at the time, suggests neither mourning nor sensuality. Typically these stylish black dresses had low-cut bodices and short sleeves, and were worn with detachable, sheer long sleeves (as here) or beneath separate gauzy bodices that could be removed for evening wear. Gobillard's silk dress features thinly veiled décolletage, worn with a face-framing button-front chemisette, and dropped shoulders.

home in 1869. The domestic setting is confirmed by the sitter's lack of jewelry, hat, and gloves—accessories that were expected for visits outside of one's own home. Yves had married two years earlier but was on an extended visit to her parents in Paris when Degas asked her to pose for him.

The artist sketched Gobillard in the ground-floor living room of her family's house, with the green of their garden visible through the open window behind her head.⁵ His sketches demonstrate

the careful compositional planning that went into the work, revealing his experiments with the placement and orientation of Gobillard's head. In the final portrait, Degas created an unusual feeling of intimacy and distance. Gobillard's proximity to the front of the picture plane places the viewer close to her, like an intimate friend, but her placid self-assurance and apparent ignorance of our presence forestall any sense of exchange. Absent too is the sensuality one might expect from her drop-

CAT. 48 Berthe Morisot
(FRENCH, 1841–1895)

Interior, 1872

Oil on canvas
60 × 73 cm (23 ⅝ × 28 ¾ in.)
Collection of Diane B. Wilsey

The subject of this painting sits in an upstairs parlor of the artist's home, formally dressed as she waits to receive an afternoon visitor. Her black silk dress with long, sheer sleeves and décolleté bodice was a popular afternoon style for chic bourgeois women from the late 1860s to the early 1870s. Although the same style, fabric, and color were worn for mourning, in this instance, the woman's ensemble, combined with her elegant coiffure and golden jewelry, suggests instead her participation in contemporary fashion.

shouldered gown of black silk with transparent sleeves; Degas did not play up the transparency or hint at the sexuality that a lightly veiled décolletage might suggest. Indeed, Gobillard's dress is painted not to reveal the body, but to frame the face; the gown's barely delineated, soft blackness contrasts with the yielding whiteness of the loosely sketched furniture.

Painted three years later, Morisot's *Interior* resembles Degas's portrait of her sister in many respects. Both center on women in black afternoon dresses with transparent sleeves, who are seated in elegant bourgeois interiors; indeed, the setting here is again the Morisot home, though now, according to Anne Higonnet, the upstairs parlor or *petit salon*, where Morisot often painted.[6] Both women appear in the foreground, with their hands clasped in their laps and their feet and lower skirts cut off by the frame edge. Their profiles bisect the canvas, and a burst of greenery behind them sets

off their brunette hair. Soft light filters into the room through gauzy curtains, and the women gaze thoughtfully off into the distance.

The similarities end there, however. Morisot's painting depicts not a casual day at home, but instead an afternoon call. Where Gobillard leans informally on an overstuffed sofa, the central figure in *Interior* sits more properly in an ebonized and gilded chair with a lavender cushion. Whether the unknown woman in black is making a call or awaiting a visitor, she is clearly dressed for a formal visit. While the black dress with a sheer tulle or net bodice resembles the dress worn by Gobillard, this woman's outfit is accessorized with a gold bracelet, earrings, and a locket on a thin black ribbon tied at her throat. In contrast to Gobillard's loosely piled updo, with curls cascading down her neck, and the long braids of the woman in gray at the window of *Interior*, the central figure of this painting wears a more formal coiffure adorned with a black ribbon.[7] The profusion of plant life is not the Morisot garden, but rather an enormous bronze jardiniere that brings the garden inside. Notably, a muted still-life painting lies propped against the planter, and it is on this picture within the picture that Morisot signed the work.

Where Gobillard appears focused, the woman in *Interior* seems reflective, almost lost in reverie. As Higonnet so aptly remarked, this introspection powerfully affects our perception of the figure: "Behind Morisot's women's reserve we sense a life all the more intense because it is withheld."[8] So while *Interior* ostensibly features a more social encounter, recording the ritual of the afternoon call, the moment depicted and the composition of the scene cast us in an inescapable and almost uncomfortable intimacy with the central woman in black, whose thoughts nonetheless remain unknowable. A similar sense of reserve emanates from the downwardly directed gaze of the mother in Morisot's *On the Balcony* (cat. 77), which shifts the two background figures from *Interior,* modeled by Gobillard and her daughter, onto the garden terrace of the Morisot home.[9] The *robe de soie noire*, with its bustle and tiered flounces, now appears on a more surely maternal figure, who stands at the railing with her pinafore-clad daughter. Here the jaunty pink parasol, recorded with only a few quick strokes of paint, makes clear—as does the gold jewelry in *Interior*—that the woman's black dress is not a mourning

dress. As elsewhere, the focus is not on the Parisian skyline visible in the distance or the lush plant life hinted at by the touches of red and pink at right; instead, this is an almost psychological portrait of the inward-turned thoughts and apparent disconnect of the female figure.

Degas and Morisot were not alone in their use of intimate acquaintances as models. Indeed, Morisot's friend and later brother-in-law, Manet, also relied on family—and famously on Morisot herself—to pose for his vividly recorded slices of Parisian life, like *The Balcony* (cat. 76) and *Repose* (cat. 120). But before this, Manet painted his wife, Suzanne, as a vision in white (cat. 49). Suzanne initially appeared alone, sunlit and radiant, staring out at the painter and viewer. Between 1873 and 1875, the artist reworked the picture to include the profile of Suzanne's son, Léon, reading, as well as the planter at left—two solid, darker notes that balance, but also divert attention from, Suzanne and Manet's experimentation with the effects of light in the work.[10] When Manet exhibited the altered work in 1880, it was under the title *La Lecture*, or *Reading*, which shifted the focus from Suzanne to Léon as the subject.[11] The painting clearly began, however, as a carefully rendered portrait of the thirty-five-year-old Suzanne, lit *à contre-jour*. The canvas is a study of white on white; the filmy fabric of Suzanne's white muslin dress (compare cat. 51), which both conceals and reveals, finds its counterpoint in the transparent layers of curtains draped in front of the illuminated window. The whites of her sun-dappled skirt echo those of the scallop-edged curtains, which reveal glimpses of a plant-filled balcony beyond.

The image is so exquisite that it is tempting to imagine that Manet's friend and frequent defender Émile Zola was inspired by the 1880 exhibition of *Reading* in his description of the great white sale at the fictional Au Bonheur des Dames department store:

> There was nothing but white, yet it was never the same white, but all the different tones of white, competing together, contrasting with and complementing each other, achieving the brilliance of light itself. . . . In the transparency of the curtains the white took wing, in the muslins and laces it attained the freedom of light, and the tulles were so fine

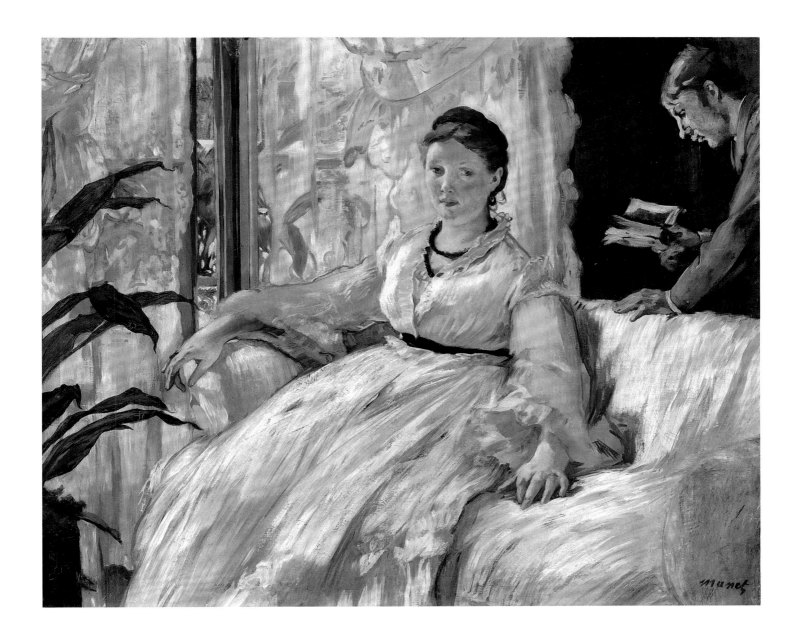

CAT. 49 Édouard Manet (FRENCH, 1832–1883)
Reading, 1865 (reworked 1873/75)
Oil on canvas
61 × 73.2 cm (24 × 28 ¹³⁄₁₆ in.)
Musée d'Orsay, Paris

CAT. 50 Édouard Manet (FRENCH, 1832–1883)

Lady with Fan, 1862

Oil on canvas
90 × 113 cm (35 ⁷⁄₁₆ × 44 ½ in.)
Museum of Fine Arts, Budapest

Manet created this painted sketch of his friend Charles Baudelaire's former mistress Jeanne Duval in 1862. Duval reclines awkwardly on a divan, her strange posture accentuated by the expanse of her crinoline skirt, which has been exaggerated beyond the reality of fashion. Duval is depicted here as a middle-aged invalid, but her gauzy white summer dress reveals an awareness of contemporary style. Wearing multiple pieces of jewelry, holding a green fan, and gazing out from darkly shadowed eyes, she exhibits the artifices of femininity that Baudelaire expressed admiration for in his writing.

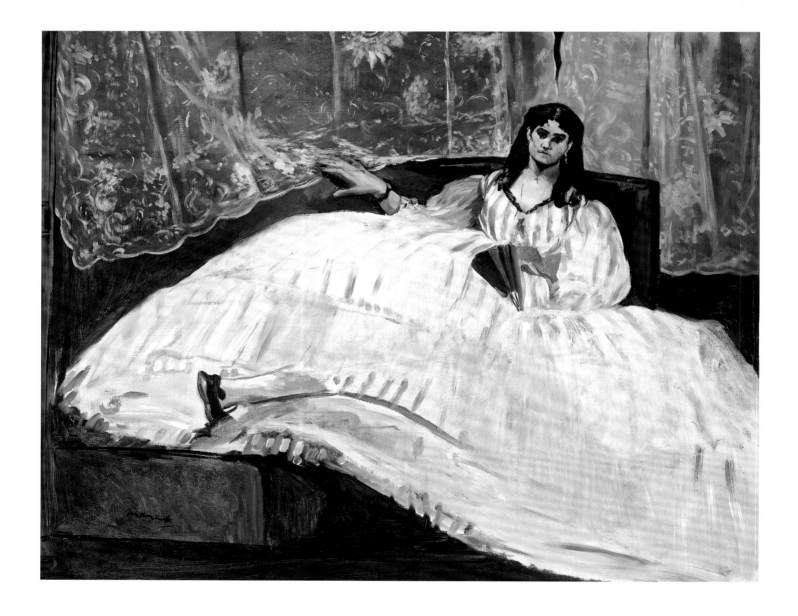

CAT. 51 Women's morning dress, c. 1865
European
Cotton and muslin
Los Angeles County Museum of Art

that they seemed to be the ultimate note, dying away into nothing.[12]

Indeed, just as Zola's words evoke the visual spectacle of the cascading white linen cunningly arranged to entice the consumer, Manet's picture seems to be an exploration in paint of the multifarious ways white can seduce the eye.

At the center of the picture are the luminous Suzanne and her magnificent white gown. Suzanne's dress is in many ways a translation of the black dress of the woman in Morisot's *Interior*. The sheer bodice is crossed *en coeur* in the front and belted over another white muslin bodice with short, flat sleeves. Here the white is set off by touches of black—from the black of her thin belt, to the double strand of jet beads around her neck,

her pendant earrings, and the thin ribbon in her hair. White muslin dresses with transparent sleeves, contrasting belts, and long sashes were very fashionable summer wear in the 1860s, as reflected in James Tissot's *The Two Sisters* (cat. 4), exhibited at the 1864 Salon, and Renoir's portrait of his companion, *Lise—The Woman with the Umbrella*, exhibited at the 1868 Salon (cat. 40).[13] Manet himself painted a similar dress in his 1862 portrait *Lady with Fan* (cat. 50). This work also juxtaposes a transparent lace curtain and the model's white striped dress. But where Baudelaire's mistress, Jeanne Duval, is dwarfed by her expansive crino-lined skirt, Suzanne is clearly the dominant force in *Reading*. The lesser amplitude of her skirt is in keeping with the shrinking silhouette of the crino-line over the course of the 1860s, but also likely due

CAT. 52 James Tissot (FRENCH, 1836–1902)

July: Specimen of a Portrait, c. 1878

Oil on fabric
87.5 × 61 cm (34 ⁷⁄₁₆ × 24 in.)
The Cleveland Museum of Art

Known for his fashionable scenes of society women, Tissot used the same costumes in different canvases throughout his career. In this portrait, the artist's mistress Kathleen Newton poses in a tiered white summer dress that first appears in a painting dated 1874. Here Kathleen wears the dress without the petticoats that originally supported it, perhaps because she is indoors or because that would no longer have been the height of fashion, as styles were shifting toward a longer, slimmer silhouette. Exhibited in 1878 at the Grosvenor Gallery in London, this painting garnered praise not for its documentation of fashion, but for Tissot's skilled manipulation of light and shadow.

FIG. 2. JAMES TISSOT (FRENCH, 1836–1902).
Seaside, c. 1878. Oil on canvas; 86 × 60 cm
(33 ⁷⁄₈ × 23 ⁵⁄₈ in.). Private collection.

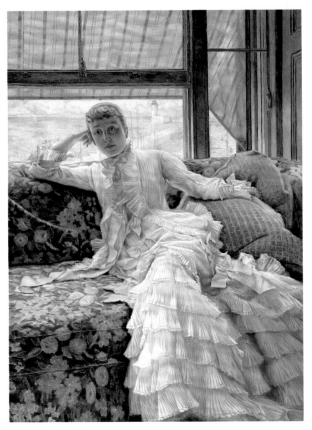

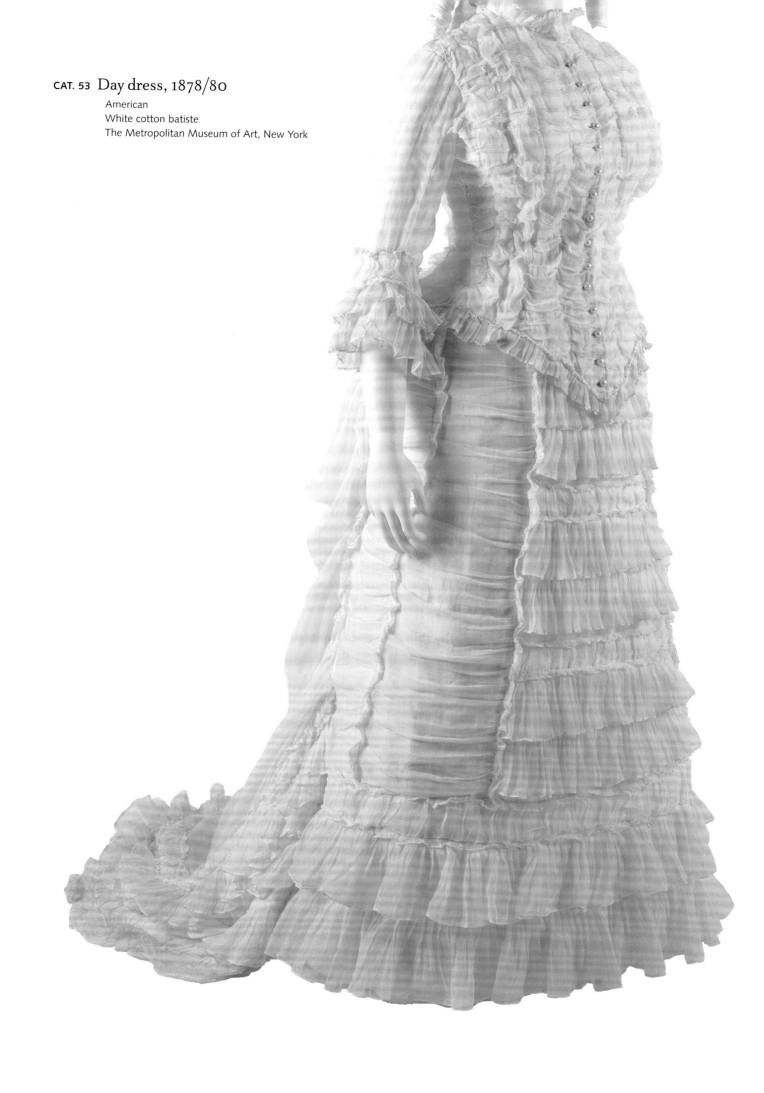

CAT. 53 Day dress, 1878/80
American
White cotton batiste
The Metropolitan Museum of Art, New York

CAT. 54 Édouard Manet (FRENCH, 1832–1883)

Madame Édouard Manet on a Blue Sofa, 1874

Pastel on brown paper, laid down on canvas
49 × 60 cm (19 ⁵⁄₁₆ × 23 ⁵⁄₈ in.)
Musée d'Orsay, Paris

to the fact that she is not wearing the hooped underskirt such fashions demanded. Her dress is clearly one that could be worn out of doors—as the Tissot and Renoir portraits attest—but in the privacy of her home, a woman could dispense with the hat, parasol, and crinoline that would be expected in public. The fact that she has done so in this portrait adds to the intimacy of the moment, which Suzanne's calm, deliberate gaze emphasizes. She does not smile, as one might expect, but instead patiently and directly faces us; only her fingertips betray any movement. The small gestures of her hands evoke touch and prompt the viewer to imagine the texture of the fabric beneath her fingertips.

The same interest in the play of light and texture is seen in James Tissot's hybrid portrait and genre scene *July: Specimen of a Portrait* (cat. 52).

Tissot's companion, Kathleen Newton, posed for the picture, but while her face is more impassive than Suzanne's, one similarly cannot help but imagine the feel of the overstuffed velvet pillow on which her left hand rests. Sumptuous cascades of pleated flounces and yellow satin ribbon run riot down the front of her dress. The sinuous line of her hip and left leg is visible through the filmy fabrics. Like Suzanne, she wears a summer frock without the customary petticoats or padded bustle that would have been expected had she ventured out of doors. Indeed, the full skirts of the figures with red and white parasols at the water's edge remind us of this point. The emphasis of the painting is on the intimacy of this warm summer afternoon at the seaside. We are cast in close proximity to Newton—able to see out, but shielded from outside views by

FIG. 3. PIERRE-AUGUSTE RENOIR (FRENCH, 1841–1919).
Portrait of Madame Claude Monet, 1872. Oil on canvas;
53.3 × 71.8 cm (21 × 28 ¼ in.). Calouste Gulbenkian Foundation, Lisbon.

the sunlit striped canopy. We can feel a soft breeze coming through the open window, smell the salty sea air, and hear the gentle crashing of the waves on the sand below. That the woman's dress is no longer highly fashionable for the period is beside the point.

Tissot, like Manet in *Reading*, explored effects of light, transparency, opacity, and the seemingly endless nuances of white, but in *July* unusually cast Newton's face nearly completely in shadow, instead highlighting her white muslin dress with the canopy-filtered sunlight. When the painting was exhibited at the Grosvenor Gallery in London in 1878, the *Observer* particularly praised Tissot's handling of light and color:

> Few artists have so much audacity in the choice of singular effects of light and colour, still fewer have the skill that would justify such a choice; and if we would select a single example in illustration of what has been said, we may point to the figure of a lady in a muslin costume, sitting up on a couch in front of an open window, to which the painter has given the title of "July" (no. 34). This is really a very accomplished study of the accepted conditions of light and air, and a very skillful rendering of their effect upon local colour.[14]

Tissot moved to London in 1871, after having fought to defend Paris during the Franco-Prussian War, and continued to paint scenes of fashionable life, but now with elegant Londoners rather than chic Parisiennes as his subject.[15] London certainly offered a more hospitable audience for his characteristic modern-life genre pictures than war-ravaged Paris, where the arts administration and Salon jury were seeking to promote patriotic and serious subjects, rejecting the sort of superficial, sophisticated paintings produced by Tissot and others before the war.[16] We know from Tissot's notes that the setting for *July* was the Albion Hotel, built in 1760 and well positioned near the sandy shores of Viking Bay in Ramsgate.[17]

While working in England, Tissot developed a favored repertoire of subjects—whether from personal inclination or to suit public tastes. Shipboard, boating, and harborside pictures featuring pretty women became his stock-in-trade. What becomes clear upon even a brief perusal of his works of this period is that he developed a favored set of dresses as well. The white striped muslin summer dress worn by Newton in *July* (compare cat. 53) appears in works by Tissot as early as 1874, long before Newton entered his life.[18] He painted the dress, or slight variations of it, at least seven times. In his 1876 portrait of Miss Lloyd (cat. 30), the same tiers of pleated flounces and sunny yellow bows appear on a brunette model. This repetition did not deter collectors, however, and a copy of *July* was commissioned, again featuring Newton, though now with a more touristic view of the waterside pier and Ramsgate lighthouse in the distance, which befits its more generic title, *Seaside* (fig. 2). The other striking difference between the two pictures is the color and style of Newton's hair; ironically, it is the copy that is truer to reality, with Newton's characteristic blond hair pulled tightly around her head in a bun with a fringe of bangs in the front. According to X-radiography and a recent examination by conservators, the slightly frizzy mop of red hair piled atop Newton's head in *July* was a later alteration to the work, almost certainly done by another artist.[19]

While Manet, Morisot, and Tissot may have abstracted portraits of family and friends into genre scenes of modern life for exhibition, they also created many intimate portraits that were more deliberately private and never shown publicly

it seems just as likely to have been inspired by the informal series of portraits exchanged by the Impressionists at this time.[21] In particular, it strikingly parallels Renoir's 1872 portrait of Camille Monet on a sofa (fig. 3), which Manet doubtless would have seen while painting alongside Claude Monet in Argenteuil in 1874. In Renoir's closely cropped portrait of his friend's wife, Camille lounges on a white sofa, loosely grasping the popular bourgeois newspaper *Le Figaro* in her right hand, but again deliberately engaging the viewer and painter with an impassive yet relaxed stare. The intimacy of the scene is further heightened by her informal dress, in this case a blue silk peignoir with gold embroidery panels down the front.

A peignoir—derived from the word *peigner*, meaning "to comb the hair"—was, as the origins of the word imply, a woman's loose-fitting dressing gown without a waist seam, which was worn only at home among family and the closest of friends. Peignoirs—casual, comfortable, and often in soft colors—became increasingly popular in the nineteenth century for informal dress, as they did not require a corset, crinoline, or bustle and were often worn only with a chemise and petticoat.[22] Including peignoir-clad figures became de rigueur in modern-life scenes. Renoir's charming *Woman at the Piano* (cat. 55) features the model Nini Lopez wearing a white muslin peignoir—her delicate pink skin shimmers beneath the translucent fabric that veils her body. The transparency and unusual vantage point are obvious when the work is compared to Alfred Stevens's straight-on treatment of a more demure *Eva Gonzalès at the Piano* (cat. 11). Tissot's 1866 portrait of the Marquise de Miramon (cat. 7) shows her in a particularly elegant rose-colored velvet peignoir, which creates a sense of casual intimacy and aristocratic negligence. Manet's *Young Lady in 1866* (cat. 9) features his favorite model, Victorine Meurent, in a pale-pink peignoir unbuttoned slightly at the top to reveal the lace of her chemise. The contrast between the informality of the peignoir and the fashionable silhouette of the day is made obvious in Manet's *The Balcony* (cat. 76), which juxtaposes the seated Morisot in a pagoda-sleeved peignoir, clearly at home, with the violinist Fanny Claus, wearing a newly fashionable short walking dress with crinoline and gloves, hat, and *bottines* (short walking boots), dressed to go out.

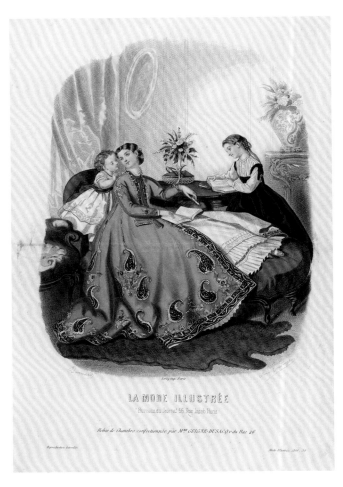

FIG. 4. ANAÏS TOUDOUZE (FRENCH, 1822–1899).
La Mode Illustrée 39 (September 23, 1866). Schlesinger Library, Radcliffe Institute, Harvard University.

during their lives. One work of such relaxed informality is Manet's 1874 pastel portrait of Suzanne reclining casually with her feet up on a brilliant blue sofa (cat. 54). While the interest here is no longer in transparent, filmy fabrics, Suzanne's focused gaze again engages the viewer directly, as it did in *Reading*. This is thought to be Manet's first pastel portrait, a medium he adopted only in the 1870s and employed almost exclusively for portraits of women. Suzanne is pictured either before or after an afternoon stroll, wearing a gray mantelet (cape) and white flounced promenade dress with white stockings and black satin shoes.[20] A floppy straw hat rests on her head, the long black velvet ribbons, normally used to secure it under her chin, trailing down the front of her bodice.

While Suzanne's pose—resting on her elbow, with left hand on her lap—is often compared to that of the scandalous *Olympia* (1863; Musée d'Orsay, Paris), a Salon sensation of nearly a decade earlier,

CAT. 55 Pierre–Auguste Renoir
(FRENCH, 1841–1919)

Woman at the Piano, 1875/76

Oil on canvas
93.2 × 74.2 cm (36 ¾ × 29 ¼ in.)
The Art Institute of Chicago

The model in this picture, probably Nini Lopez, wears a sheer white peignoir, a type of loosely cut indoor garment worn without restrictive underwear such as corsets or crinolines. Soft and comfortable, peignoirs were quite popular in the 1870s, when fashion dictated that street dresses be tight and constricting. To wear a peignoir was, however, to be in dishabille, so this type of garment was only worn among intimates, in the privacy of one's home. Aside from the unusual vantage point of this scene, Renoir's treatment of the woman at the piano would not have been out of place in a nineteenth-century fashion illustration.

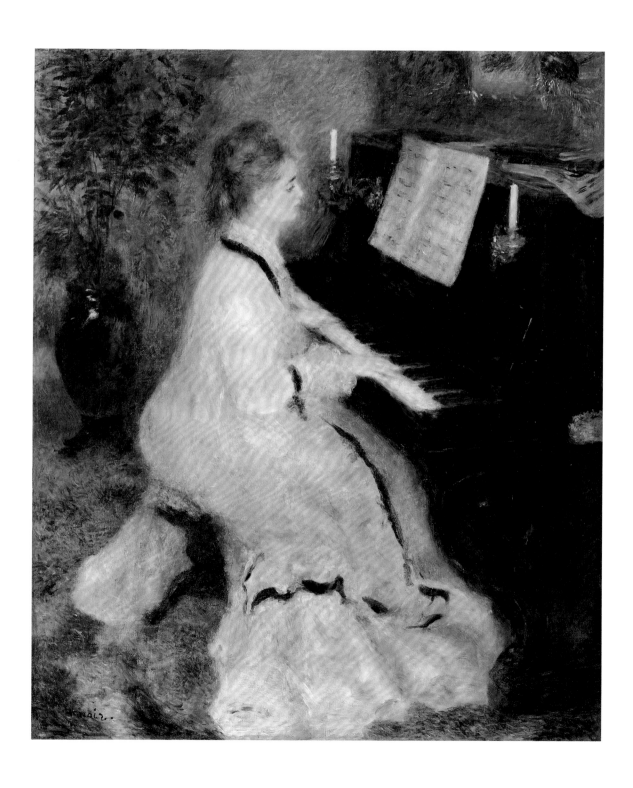

CAT. 56 Berthe Morisot (FRENCH, 1841–1895)

Woman with a Fan. Portrait of Madame Marie Hubbard, 1874

Oil on canvas
50.5 × 81 cm (19 ⅞ × 31 ⅞ in.)
Ordrupgaard, Copenhagen

Peignoirs or *robes de chambre* also featured in the fashion plates of the day, such as a September 1866 *La Mode Illustrée* plate featuring a woman reclining on a chaise longue in a blue cashmere *robe de chambre* surrounded by her four- and ten-year-old daughters (fig. 4). Comparing the fashion plate by Anaïs Toudouze, one of the premier fashion illustrators of the day, with Renoir's portrait of Camille Monet in a similar pose and sumptuous blue peignoir highlights the different interests of the Impressionists and fashion-plate artists. In the plate, every detail of the lavish setting is carefully recorded—from the somewhat incongruous bear-skin rug to the elegant marble-topped console table supporting an enormous vase of flowers. The plate is overloaded with signs of contented domesticity; the mother gently inclines her head toward her younger daughter, while the ten-year-old serenely reads at her mother's feet. The mother's skill at beautifying herself and her home is evident not only in her elegant toilette and the multiple flower arrangements, but also in the embroidered chair in the foreground, her embroidery work basket on the side table attesting to her handicraft skills.

In both Renoir's and Manet's portraits of artists' wives, one finds none of these decorative or domestic cues; the focus is clearly on the face and demeanor of the individual depicted. In such intimate portraits, there are no distractions. The background of Manet's picture features bare mustard-yellow walls, blue overstuffed furniture, and little else. Renoir's setting is even more sketchily rendered, with only the suggestion of a side table and perhaps a bowl evident at the right. These are scenes of casual intimacy among adults, but they carry none of the provocative allure or suggestiveness of the boudoir, as lounging women on sofas so often do.[23] By resisting the conventions of the fashion plate and the libidinous tradition of the reclining temptress, Manet and Renoir created portraits of refreshing directness and compelling interest.

Morisot's 1874 portrait of one of her closest friends, Marie Hubbard (cat. 56), evinces a similar relaxed atmosphere and intimate mise-en-scène.[24] Hubbard is dressed informally in a white peignoir of dotted Swiss voile (semisheer, ultra-thin cotton) over a white cotton chemise and petticoat, white stockings, and marigold-colored mules.[25] In contrast to the bourgeois interiors of Morisot's other works,

the setting is only roughly sketched; Madame Hubbard reclines rather than lounges, propped up with two lace-edged pillows on a periwinkle daybed. As in Manet's *Reading*, the filmy transparency of her dress and the diffuse light filtering into the scene allowed Morisot to experiment with rendering the entire spectrum of whites and the play of light and shade. The black and gold fan, with its touches of red and green, seems to sparkle in the sun, while unpredictable highlights play across Hubbard's body and even her face—the lower half of which is startlingly illuminated in contrast to her darker brow. The painting is more closely cropped and more loosely finished than even Renoir's portrait of Camille Monet, with the soles of Hubbard's heels grazing the frame and the rest of the room fading literally to gray. We get the same feeling of intelligent reserve portrayed in *Interior,* but, ironically, while Hubbard is alone (unlike the woman in Morisot's *Interior*), she does not seem isolated. Our immediate proximity and Hubbard's deliberate alertness create a sense of communion, which obviates the potential for ennui or melancholy.

What made Impressionists like Degas, Manet, Morisot, and Renoir so avant-garde among other nineteenth-century artists was their willingness to blur the lines between the public and the personal, to transcend genres and conventions. Often featuring women from the artists' own lives, their paintings transform everyday life into art, blending portraiture and genre painting, and all the while explore effects of light and shade, close cropping, and unconventional poses to create vividly real vignettes. As we look at these intimate portraits, Baudelaire's admonition in "Le peintre de la vie moderne" (The Painter of Modern Life) seems apt: "However much we may love *general* beauty, as it is expressed by classical poets and artists, we are no less wrong to neglect *particular* beauty, the beauty of circumstance and the sketch of manners."[26] It is that "particular beauty"—intensely alive and incredibly present—that animates these Impressionist portraits even today.

Édouard Manet

Nana

Valerie Steele

"The satin corset may be the nude of our era," suggested Édouard Manet.¹ This paradoxical statement almost certainly alludes to his painting *Nana* (cat. 57), which depicts the actress Henriette Hauser dressed only in an ice–blue satin corset, filmy white lingerie, blue silk stockings, and high-heeled shoes. A fully clothed gentleman in a top hat and evening suit sits nearby, watching her. The scene appears to depict an actress in her dressing room being visited by an admirer, presumably a lover. Refused entry to the 1877 Salon and called an "outrage to morality," *Nana* has often been compared to Manet's scandalous modern nude *Olympia* (1863; Musée d'Orsay, Paris).

When *Nana* was first displayed, following its rejection from the Salon, in the window of Giroux et Cie, a dealer in objets d'art and luxury items whose windows attracted a great deal of public attention,² reviewers seized upon Hauser's attire—what one critic called her "elegant dishabille"—as central to the picture's meaning.³ Contemporaries agreed that the subject's colorful satin corset and silk lingerie marked her as a courtesan. Utilizing the language of fashion journalism, the periodical *La Vie Parisienne* described *Nana* as "a little illustration of the outfit for intimacy. Corset by Madame X . . . Lingerie by Madame Y."⁴ The same blue corset, silky lingerie, and model also appear in Manet's *Before the Mirror* (cat. 58), in which the woman is alone and shown from behind, pulling on one of the laces of her corset. Manet's biographer, Beth Archer Brombert, suggested that *Before the Mirror* "seems to be a preparatory oil sketch for *Nana* and may have been the subject Manet [originally] had in mind: a woman at her toilette."⁵ Indeed, the absence

of a man in *Before the Mirror* is the work's most significant difference from *Nana* and is largely responsible for the dramatically different interpretations of the central figure in the two paintings. A tradition of images showing women at their toilette existed in both high art, such as Berthe Morisot's *Woman at Her Toilette* (cat. 59), and popular visual culture, including corset advertisements.

It is notable that Manet specified a satin corset when describing "the nude of our era" and that he portrayed a blue satin corset in both *Nana* and *Before the Mirror*. To understand the significance of Hauser's attire and Manet's enigmatic statement, it is necessary to consider the history of the corset, its relationship to other items of lingerie, and their relationship to fashion. Hauser's ultra-fashionable, colorful corset is an important reason why contemporaries identified her as a woman of the demimonde. Fashion was closely associated with modernity and, therefore, with "the nude of our era."

The naked human body is central to the history of Western art. The female nude, in particular, is a recognized artistic genre. Historically, the nude has often been explicitly contrasted with images of women clothed in contemporary fashionable dress. Consider, for example, Francisco de Goya's naked and clothed *majas* (fig. 1), which have sometimes been compared to Manet's *Olympia* and *Nana*. If you look closely at the nude *maja*'s body, it is easy to see the physical effects of an invisible corset, raising and separating her breasts and stiffening her spine. As Anne Hollander pointed out in her pioneering book *Seeing through Clothes*, fashion invariably stylizes the body, so that even

CAT. 57 Édouard Manet
(FRENCH, 1832–1883)

Nana, 1877

Oil on canvas
150 × 116 cm (59 1/16 × 45 11/16 in.)
Hamburger Kunsthalle

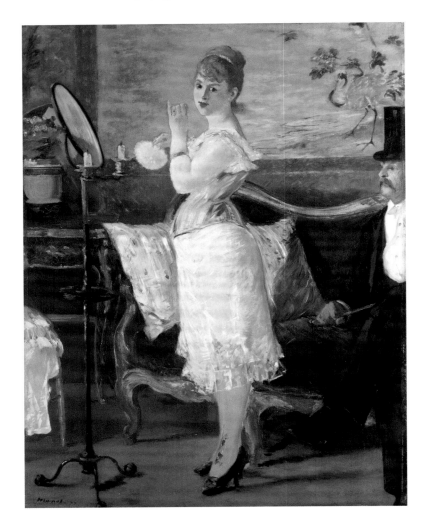

representations of naked people are subtly
(or not so subtly) influenced by the way they
look dressed.[6]

Between the naked and the clothed is a
third, liminal category—underwear—which may
be characterized as a type of secret, sexual clothing
hidden underneath external fashionable dress,
in close proximity to the naked body. There are
two types of lingerie: soft and hard. The corset,
precursor to both the girdle and the brassiere, falls
into the second category, providing a structured
foundation for outer clothing. Over several centuries,
the changing shape of the corset corresponded

directly to the changing shape of female
fashionable dress.

The corset originated in the early sixteenth
century in Spain as a laced bodice that was
attached to a hooped skirt. Within a few decades,
it had incorporated rigid strips of whalebone, horn,
or buckram. From the courts of Spain and Italy, this
new fashion spread to France and other European
countries, where it was valued for creating erect
posture and a slender waist. From the beginning,
corsets were not without their critics. "To get a slim
body, Spanish style, what tortures do women not
endure," observed the writer Michel de Montaigne,
". . . if only they may hope for an increase in their
beauty."[7]

Early corsets were known as "whalebone
bodies"—*corps à la baleine*—an expression that
blurred the distinction between fleshy bodies
and the clothes that covered and shaped them.
As Peter Brooks felicitously put it, "The corset
is a body, one that 'embraces' and gives form to the
body, and in turn takes its shape from the body."[8]
Although based on the shape of the female body,
the corset gave it an idealized and stylized form:
erect and firm, with a slender waist and sexually
dimorphic curves. Indeed, the corset molded the
body into a shape corresponding to the current
silhouette of fashionable dress. As waists
lengthened in the 1870s, for example, corsets
also became longer, moving down from the waist
over the abdomen. Technological developments
in the manufacture of corsets, such as the steam-
molding process invented in 1868, may have
contributed to this new silhouette. By the time
Manet painted *Nana,* the fashionable corset was
shaped like an hourglass, curving out over the
stomach and hips, emphasizing the relative
slenderness of the waist, and pushing the breasts up.

By 1855 some ten thousand workers in
Paris specialized in the production of corsets, and
in 1861 it was estimated that more than one million
corsets were sold annually there. The majority were
mass-produced, made of sturdy materials such
as cotton twill with metal boning (see cat. 60), and
sold for between three and twenty francs. But there
were also custom-made corsets in silk with genuine
whalebone stays that cost from twenty-five to
sixty francs (see cat. 61), and lace-trimmed luxury

corsets that cost up to two hundred francs.[9] The majority were white or off-white, as were other cotton or linen undergarments, like chemises (a precursor of the slip), corset covers (see cat. 62), and drawers (underpants; see cat. 63).

In the mid-nineteenth century, fashionable dress might be colorful and luxurious, but underwear tended to be relatively plain, made of cotton or linen, and white in color. "A woman's chemise is . . . the white symbol of her modesty," declared one French doctor in 1861.[10] In the later nineteenth century, however, one of the most striking characteristics of fashion was the "elaboration" of women's undergarments, which

CAT. 58 Édouard Manet (**FRENCH, 1832–1883**)
Before the Mirror, 1876

Oil on canvas
92.1 × 71.4 cm (36 ¼ × 28 ⅛ in.)
Solomon R. Guggenheim Museum, New York

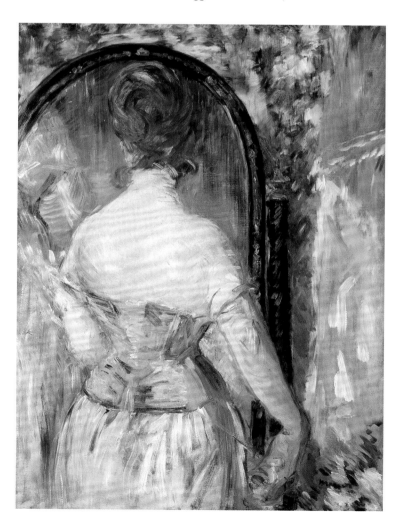

were increasingly made of silk, muslin, and fine percale, coquettishly trimmed with lace and ribbons. Dress historians agree that "the great epoch of underwear" occurred between about 1890 and 1910, when the international women's fashion press continuously elaborated on the "enthralling subject" of women's lingerie.[11]

But already by the 1870s and 1880s, the seductive qualities of lingerie and corsets were receiving increasing attention within the demimonde. "The aristocracy of vice is recognizable today by its lingerie," wrote Joris-Karl Huysmans in his review of Manet's *Nana*. "Silk is the trademark of courtesans who rent out at a high price."[12] Likewise, although satin was a fashionable material—and during his brief career as fashion editor of *La Dernière Mode* in 1874, Manet's friend the poet Stéphane Mallarmé sometimes used the pseudonym Mademoiselle Satin—it also carried erotic connotations. Émile Zola's novel *Nana* (first serialized in 1879), a notorious literary portrayal of the modern prostitute, includes a prostitute named Satin, and in *Au bonheur des dames* (The Ladies' Paradise; 1883), the lingerie on display in a department store is described as looking "as if an army of pretty girls had undressed as they went from department to department, down to their satiny skin."[13]

Just as they launched many other new fashions, courtesans and actresses were the first to wear conspicuously luxurious lingerie. Nana is every inch the fashionable demimondaine, spearheading the new fashion for corsets made from luxury materials like satin in colors such as blue, pink, and red. She also wears a silk chemise with lacy straps, a lace-trimmed silk petticoat, and a pair of silk drawers. (Drawers, which to some seemed improperly masculine, were a relatively new and still somewhat controversial addition to the female wardrobe when Manet made this painting.) It is unclear whether the blue bows just barely visible above her knees decorate her drawers or her garters, but her fashionable, racy blue silk stockings have a pattern on the front and her high-heeled shoes are also decorated with embroidery. As Huysmans observed, "Intelligent and corrupted as she is, [Nana] has understood that the elegance of stockings and slippers is . . . one of the most

CAT. 59 Berthe Morisot (FRENCH, 1841–1895)

Woman at Her Toilette, 1875/80

Oil on canvas
60.3 × 80.4 cm (23 ¾ × 31 ⅝ in.)
The Art Institute of Chicago

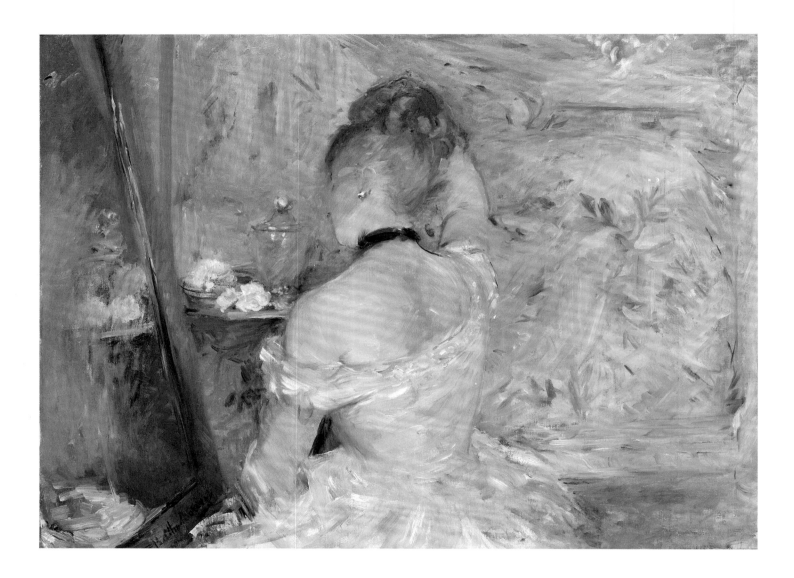

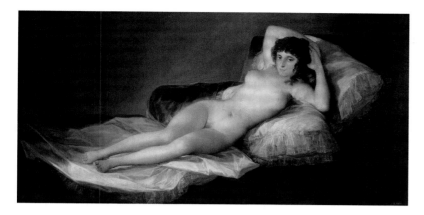

FIG. 1. FRANCISCO DE GOYA (SPANISH, 1746–1828).
Nude Maja, 1797/1800. Oil on canvas; 97 × 190 cm (38 × 75 in.).
Museo del Prado, Madrid.

FIG. 2. ÉDOUARD MANET (FRENCH, 1832–1883).
Woman Fastening Her Garter, 1878–79. Pastel on canvas;
55 × 46 cm (21 ⅝ × 18 ⅛ in.). Ordrupgaard, Copenhagen.

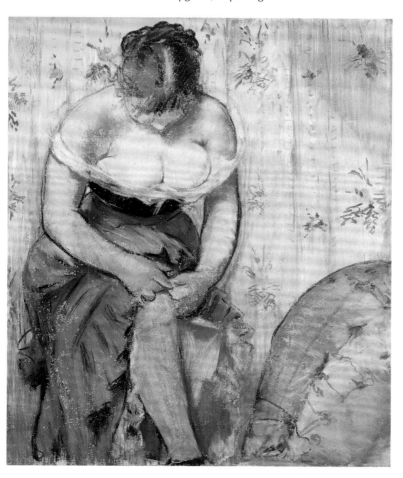

precious adjuncts that expensive whores have invented for overthrowing men."[14]

Even as silk and satin began to become more popular fabric choices for underwear, color continued to be controversial. "Color in the secret clothing of women is an entirely modern taste," observed one French writer, who associated it with "the nervousness that torments our imagination, . . . the dulling of our sensations, [and] . . . the unceasing unsatisfied desire that causes us to suffer . . . and that we apply to all manifestations of our feverish life."[15] "The proper and virtuous woman wears a white satin corset, never a colored corset," declared Henri de Montaut in one of a series of centerfolds on corsets and lingerie published during the 1880s in *La Vie Parisienne*. White satin was "flexible, shimmering, soft against the body."[16] Like the woman who wore it, a white satin corset was elegant and seductive, but still decent. A corset of "tea-rose"-colored satin, on the other hand, was described as "very elegant and extremely becoming. Evidently designed to be seen and . . . looked at!"[17]

The flowering of luxurious and erotic lingerie did not occur in a vacuum. According to the prolific fashion writer Octave Uzanne, the elegance of lingerie grew in proportion to the increasing "simplicity" of women's daytime apparel, including the popularity of "the English-style tailored suit," as well as "the democratic uniform created by all the department stores."[18] Lingerie sometimes seemed to be the last repository of erotic femininity in the age of the New Woman.

A host of literary and visual sources demonstrates that the corset in particular carried multiple meanings. Manet's pastel *Woman Fastening Her Garter* (fig. 2) depicts a woman in a corset, chemise, and petticoats. As she leans forward to fasten the garter holding up her blue stocking, her breasts swell upward, reminding us that the corset functioned as a precursor to the Wonderbra. Eugène Chapus, author of *Manuel de l'homme et de la femme comme il faut* (Manual of the Elegant Man and Woman; 1862), bluntly stated, "A woman in a corset is a lie, a falsehood, a fiction, but for us this fiction is better than the reality."[19] "Before and After the Corset," a centerfold in *La Vie Parisienne*, compared the "flawed" reality of most female bodies with the idealized version produced by

CAT. 61 Corset, c. 1877

American
White cotton sateen and lace
The Metropolitan Museum of Art, New York

CAT. 60 Worcester Corset Company
(AMERICAN, 1861–1950)

Corset, c. 1880

Light blue cotton sateen
The Metropolitan Museum of Art, New York

CAT. 63 Drawers, c. 1890

French
White plain weave cotton and lace
The Metropolitan Museum of Art, New York

CAT. 62 Corset cover, c. 1880

American
White plain weave cotton
The Metropolitan Museum of Art, New York

CAT. 64 Henri Gervex (FRENCH, 1852–1929)

Rolla, 1878

Oil on canvas
176 × 221 cm (69 ⁵/₁₆ × 87 in.)
Musée d'Orsay, Paris

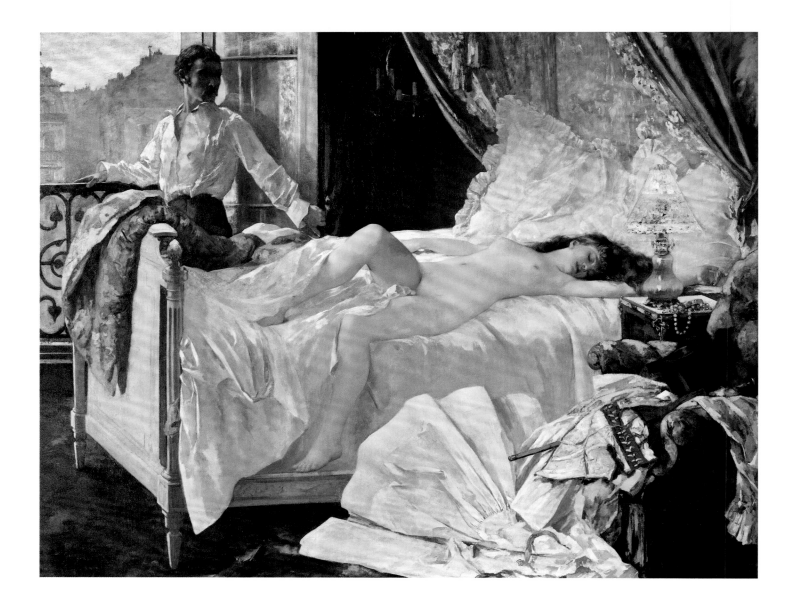

corsetry.[20] Yet attitudes were already evolving at the end of the nineteenth century. The fashion for luxurious, seductive lingerie and corsets coexisted with a new vogue for athletic underwear and boneless sport corsets. *La Vie Parisienne*'s "Les Corsets" of January 15, 1881, had as its central figure a "very well-made woman," who is "able to do without" a corset and wears instead a pale-pink silk maillot.[21]

As the art historian Lynda Nead pointed out, "The classical, high-art tradition of the female nude plays on the idea of wholeness and contained form."[22] Whereas Titian's *Venus of Urbino* (1538; Galleria degli Uffizi) was seen to present an idealized image of the goddess of love, Manet's modern nude *Olympia* aroused controversy both because Manet's formal painterly language was unconventional and because viewers objected to Victorine Meurent's individualized corporeality. She looked like a thin, dirty, insolent prostitute. It is also relevant that Manet's model in *Olympia* is not, in fact, naked. She wears earrings, a bracelet, a locket hanging from a ribbon tied around her throat, and one shoe, specifically a mule, a style of backless, high-heeled shoe associated with the intimacy of interiors, particularly the boudoir. Posing for Manet's *Nana*, Hauser also appears in a transitional state, neither fully dressed nor completely undressed. Her corset contains the fullness of her flesh, like the *cuirasse esthetique* of a classical male nude, while its satin mimics the softness of her skin. Within only a few decades, the corset would become internalized through diet and exercise, resulting in a new cultural ideal of femininity.

When Manet's painting was first displayed in 1877, a poem was published in a contemporary journal with this stanza:

> More than nude, in her chemise,
> the *fille* shows off
> Her charms and the flesh that tempts.
> There she is.
> She has put on her satin corset and
> is getting dressed
> Calmly, near a man, who has come
> to see her.[23]

Clearly Manet was not alone in associating corsets and lingerie with erotic nudity, since for the poet, too, Nana was "more than nude, in her chemise," her flesh especially tempting precisely because she has "put on her satin corset." A cartoon, "The New Temptation of Saint Anthony," published in *Le Rire* in 1895, also conveys this idea. In the first of four scenes, Saint Anthony ignores a naked woman. He begins to look up as she puts on a lacy chemise, dark stockings, and high-heeled shoes. He stares avidly as she puts on her corset, and after she has put on a pair of lace-and-ribbon-trimmed drawers, he leaps to his feet with pleasure.

But the appeal of lingerie also turns on the transition, the movement between dress and undress. Henri Gervex's painting *Rolla* (cat. 64) caused a scandal not because of its classically beautiful nude, but because of the pile of clothing next to the bed: her pink dress and stiff white petticoat, punctuated by a rose-colored garter and a red corset, splayed open to reveal its white lining. Protruding from underneath her corset is her lover's cane, revealing the speed with which she must have taken off her clothes. This little still life enacts a striptease, which shocked the public. Years later Gervex recalled that it was Edgar Degas who had suggested painting "the dress she's taken off" and "a corset on the floor." When the Salon ordered the painting removed, Degas triumphantly declared, "You see . . . they understood that she's a woman who takes her clothes off."[24] Ultimately, *Nana* does not demonstrate that the satin corset was more sexually potent than the naked body, but rather that the corset drew its erotic charm from the naked body it covered and accentuated. It was the movement between dress and undress—and, of course, the idea of a woman who takes her clothes off for a man—that aroused and scandalized viewers.

An Ideal of Virile Urbanity

Philippe Thiébaut

Publications devoted to men's fashions and their history—
a research subject very much in vogue during the last fifteen years—
make hardly any reference to Impressionist paintings,
whereas the Impressionist vision of women's fashions
has given rise to numerous studies, among them one by Marie Simon[1]
and the remarkable catalogue published on the occasion of the
exhibition presented in 2005 at the Kunsthalle, Bremen.[2]

Nonetheless, in *Fabric of Vision*, Anne Hollander broached the question of Impressionism's contribution to our understanding of men's fashions.[3] In particular, she carried out a subtle analysis of one of the variations of Gustave Caillebotte's famous *The Pont de l'Europe* (1876–77; Kimbell Art Museum, Fort Worth), which features three males in profile.[4] In another foray into the subject of male fashion in Impressionist paintings, Aileen Ribeiro lingered on the male figure dressed in black and white in the background of Pierre-Auguste Renoir's *The Loge* (cat. 12).[5] She pointed to Charles Baudelaire's famous speech about "the outer skin of the modern hero,"[6] Charles Blanc's comments on the expressiveness of the way hair is cut and beards and mustaches trimmed,[7] and the witty *Guide sentimental de l'étranger dans Paris* (Sentimental Guide to Paris

for Foreigners), compiled in 1878 for visitors to the Exposition Universelle.[8] The author of this imposing manual was obviously addressing a male audience, and it establishes a record of how the Parisian male of the late 1870s dressed or should have dressed:

> All of coquetry's light is on Woman; we are the lining of the jewelry box against which the eternal diamond stands out. . . . Civilized Man, from the point of view of his clothing, is nothing more than the accompanist of Woman; he allows her to sing the symphony of white, pink, and green as a solo, with all the modulations and half-tones of color that industry has introduced, like sharps and flats.[9]

CAT. 65 Top hat, 1875/1900

American
Black silk
The Metropolitan Museum of Art, New York

CAT. 66 Suit, 1867/68

American
Brown wool broadcloth
The Metropolitan Museum of Art, New York

CAT. 67 Imprimerie Lamoureux
(FRENCH, ACTIVE 19TH CENTURY)

"Six Men, a Woman, and a Boy in Day Dress,"
Le Progrès: Modes de Paris pour
l'Académie Européenne des Modes, 1868

Lithograph with hand coloring
Sheet: 32 × 49 cm (12 ⅝ × 19 ¼ in.)
The Metropolitan Museum of Art, New York

FIG. 1. HENRI FANTIN-LATOUR (FRENCH, 1836–1904).
Studio in the Batignolles, 1870. Oil on canvas; 204 × 273.5 cm
(80 ⁵⁄₁₆ × 107 ¹¹⁄₁₆ in.). Musée d'Orsay, Paris.

The options for bold dress for the "accompanist" were singularly limited during the second half of the nineteenth century, at least until the 1890s.[10] Indeed, color in male dress disappeared, supplanted by plain, dark shades, and ordinary cloth replaced velvet, silk, and brocade. The habit of adapting the same outfit to different uses was also acquired in this period. The Parisian man of the world—once out of his dressing gown—lived in two sets of clothing: his daytime outfit and evening clothes.[11] Indeed, in a declaration that would remain relevant until World War I, Baron de Mortemart de Boisse in 1857 stated: "Town dress for men is something familiar to everyone; one has only to open one's eyes. One knows that it would be as ridiculous to go out in the morning in evening dress, as to arrive at someone's reception in a redingote."[12]

The general lines and silhouette of male dress during this period were unusually stable. Even twenty years later, the statements reported in the January 1867 issue of the *Journal des Modes d'Hommes* (Journal of Men's Fashions) were still valid:

> Take a close look at a very elegant man, one following the style of our period, dressed in a *paletot* sack coat, and examine in detail the various parts of his outfit, from the bottom up: two straight pipes contain his legs until they join a wider pipe; from this two annexes

jut, still in pipe-shape, to enclose the arms, and crowning the edifice is a gutter pipe, to which we give the name of hat.[13]

Tailors, dispirited by the invasion of black clothes (see cat. 67), devoted themselves to the one thing left for them to promote: the necessity of good cut to show the male body to advantage. As the tailor Humann[14] explained:

> Fashion has its reason for existing for this alone—that it is the *free* expression of the taste of the day, but it becomes the ridiculous or *licentious* expression of bad taste as soon as it breaks free of the rules governing the proportions of the human body. This means that a waist that is too long or too short— even though it may conform to the require- ments of fashion—is no less in bad taste, an exaggeration that will make the man seem disproportioned or even disjointed. This situation differs from variations in fashion that are compatible with good taste, that is, harmonious in their proportions and unity as a whole.[15]

Despite the conventions inherent in the genre, fashion illustration constituted a strong testament to this statement. By portraying a particular silhouette, profile, or pose ad nauseam, it disseminated the concept of a morphological ideal, as well as one of virile urbanity. Through fashion illustrations, a canon emerged: The body had to be straight, the torso wide, the waist narrow, and the stomach perfectly flat, all without the use of a corset, the wearing of which—so popular with dandies of the Romantic period—had been abandoned. The chest was thrown out, an effect that could be achieved with a perfectly starched shirt bib. Legs must be long, but whether calves were thick or thin was of no importance, since the disappearance of breeches in favor of trousers meant that they were no longer visible. The more ample cut of trousers also dissi- mulated the crotch. At the same time, the range of fabrics that could be used for casual, travel, or "seasonal" trousers was quite wide, allowing a number of possibilities for striped, checked, and houndstooth patterns. The upper body was strapped tight—"pinched," to take up an expression dear to Émile Zola—in a dark frock coat or a

CAT. 68 Henri Fantin-Latour
(FRENCH, 1836–1904)

Édouard Manet, 1867

Oil on canvas
117.5 × 90 cm (46 5/16 × 35 7/16 in.)
The Art Institute of Chicago

Here, Fantin-Latour painted his friend Manet as he wanted to be revealed: wearing an expertly tailored frock coat over a fitted waistcoat with an elegant golden watch chain and a crisply starched white shirt, enhanced by a blue cravat. The impractically tall silk top hat, kid leather gloves, and silver-tipped walking cane reveal that this carefully constructed and sartorially flawless outfit was intended to identify Manet as an impeccably groomed and fashionable gentleman-flaneur, not a rebellious outsider.

redingote, sometimes double-breasted and with tails that could vary in length.[16] The short jacket that appeared at the beginning of the Third Republic was worn only when vacationing. During this period, the *paletot*—a sort of short overcoat derived from the sailor's peacoat—also firmly established itself. Appreciated for its roominess (it had no waist), comfort, neutrality, and ability to conceal, it enjoyed unequivocal success with a bourgeois clientele.[17] But whether he wore a frock coat, a redingote, or a *paletot*, a man was judged above all on the impeccability of his cuffs, shirt collar—upright or

turned down—and tie, still rather wide even if the ways of knotting it had become fewer and less intricate. Feet were encased in ankle boots with heels that varied in height, the very soft crease of the trouser legs just breaking over the shoes. The head was covered in a top hat of black silk. Cane, umbrella, and gloves completed the outfit of a gentleman preparing to leave the house. Responding to these strictures of male fashion, Baron de Mortemart de Boisse recommended: "As to form, éman may impress by his dress; but deep down, his worth derives only from himself. He must recommend

himself by his wits and not by his apparel, by his aptitudes and not by the price of his clothes."[18]

The Circle of the Rue Royale, painted by James Tissot in 1868 (cat. 73), illustrates the entire range of male attire and the ways that gentlemen carried themselves at the end of the Second Empire. Here the conventions of fashion illustration were not entirely avoided, and the aristocrats in the frieze—improbable mannequins for the most fashionable clothing stores—were deprived of life. The grouping of men in *Studio in the Batignolles*, painted two years later by Henri Fantin-Latour (fig. 1), is more natural, and the artist seems to have been more at ease in interpreting the figures' modern dress. Their clothing was not used as an element of characterization, and a certain uniformity of dress reigns over this gathering of friends centered around the figure of

FIG. 2. PIERRE-AUGUSTE RENOIR (FRENCH, 1841–1919). *Dance in the City*, 1883. Oil on canvas; 180 × 90 cm (70 ⅞ × 35 ⁷⁄₁₆ in.). Musée d'Orsay, Paris.

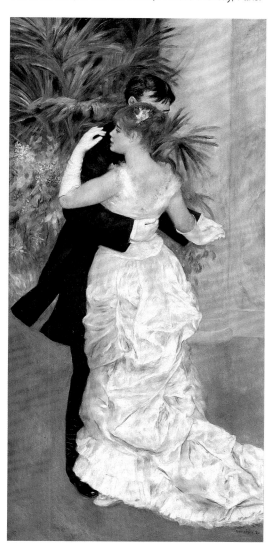

Édouard Manet, who is set apart by the light-colored trousers that he was so fond of.[19] His visitors divide themselves into two groups: those wearing *paletots* (Otto Scholderer, Renoir, and Claude Monet) and those wearing frock coats (Jean Astruc, Zola, Manet, and Frédéric Bazille).

As early as the 1860s, two Impressionists—Manet and Bazille—were looked upon as men of elegance, preoccupied with their appearance. Manet can be considered the typical well-dressed city dweller. The young George Moore, arriving in Paris in 1872 to enroll in Alexandre Cabanel's studio, recounted the strong impression made on him by Manet's natural elegance the first time they met at the Nouvelle Athènes café:

> Although essentially Parisian by his birth and by his art, he had in his physiognomy and his manners something that made him resemble an Englishman. Perhaps it was his clothes—his outfits with their elegant cut—and his way of carrying himself. His way of carrying himself! . . . those square shoulders swinging from side to side when he crossed the room, and his slender waist, and that face, that nose, that mouth.[20]

It was indeed a fine bourgeois fellow, confident of his appearance, who posed in 1867 for Fantin-Latour's three-quarter-length portrait of him (cat. 68). One is struck by the impeccable cut of his frock coat, which shows the natural curve of his shoulder, revealing the cuffs of his shirtsleeves and the front pockets of his waistcoat, where a watch and its chain are tucked.

As for Bazille, whose beautiful checked trousers played a major role in *Studio in the Batignolles*, the state of his clothing preoccupied him so much that it came out in letters to his parents, who lived in Montpellier. Not only do these letters furnish precious information about the personality of the young man, but they also contribute to our understanding of the male wardrobe and its upkeep—laundering, sewing buttons, and patching—during the Second Empire. These were all worries for a single man, as Bazille's letter to his parents from March 1863 makes abundantly clear:

> My shirts are completely falling apart. I have only two or three in a presentable state;

CAT. 69 James McNeill Whistler
(AMERICAN, 1834–1903)

*Arrangement in Flesh Color and Black:
Portrait of Theodore Duret*, 1883

Oil on canvas
193.4 × 90.8 cm (76 ⅛ × 35 ¾ in.)
The Metropolitan Museum of Art, New York

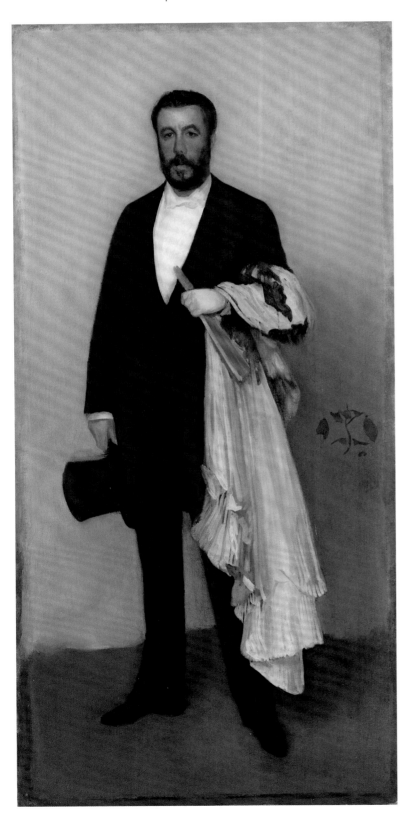

I'm saving them for the days when I go to the Mamignards.[21] Some will really have to be made for me; if Mama orders them, I'd like them without collars, I bought myself some detachable collars, they're more fashionable and they allow me to make the same shirt last longer. My socks are hardly in better shape, I've bought a few pairs but I'll need more soon.[22]

Questions of caring for a wardrobe paled in importance, however, when compared to the cut of his clothes. Discussing a little black redingote and a dressy pair of trousers, Bazille asked his mother to transmit directions to the tailor who had the young man's measurements on record: "I ask that the trousers should be quite long, please, and the sleeves of the coat a bit short and not tight at the shoulders."[23] Some of the clothing he needed could instead be purchased in stores stocking fashionable articles. Indeed, with the arrival of nice weather, Bazille asked his mother to choose "a dressy pair of trousers and a light frock coat for everyday . . . an ordinary waistcoat and several white waistcoats" for him at Au Prophète, the largest clothing store in Montpellier.[24]

Rendering images of modern life was among the primary objectives of the *nouvelle peinture*, and the Impressionists—whether they worried about their personal elegance or not—could not avoid the representation of contemporary male clothing, even if, as the writer Edmond About stated, what the bourgeois wore lacked cruelly in the picturesque.[25] Since dress tended toward uniformity, artists focused their efforts on transposing the male silhouette and gestures. Edmond Duranty expressed the necessity of such a shift very well:

What we need is that special note of the modern individual, in his clothes, in the middle of his social routines, at home or in the street. The data becomes singularly penetrating: this is fitting the pencil with a flaming torch, it's the study of moral reflections on physiognomies and clothing, the observation of man in the privacy of his apartment, of that special trait stamped on him by his profession, the gestures it causes him to make, cross sections of the aspects of his life that allow him to grow best and

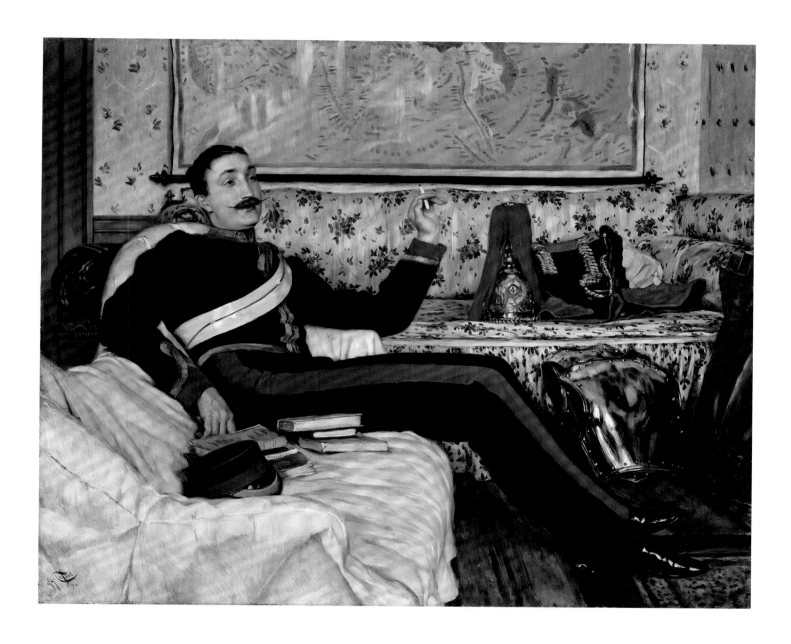

CAT. 70 James Tissot **(FRENCH, 1836–1902)**

Frederick Gustavus Burnaby, 1870

Oil on panel
49.5 × 59.7 cm (19 ½ × 23 ½ in.)
National Portrait Gallery, London

The popular Fred Burnaby, soldier and adventurer, was 6 feet 4 inches tall and regarded as the strongest man in the British Army. Tissot painted him posing casually but still clad in the regulation uniform (trousers with a broad red stripe, and a white leather pouch belt) of a captain of the Royal Horse Guards, an English cavalry regiment. Burnaby wears his "at-ease" stable dress uniform. His more formal full-dress tunic, parade helmet, and cuirass rest nearby. The stack of books and the map on the wall emphasize Burnaby's interest in exploration. He wrote best-selling accounts of his travels through Asia and was the first man to fly a hot-air balloon solo across the English Channel.

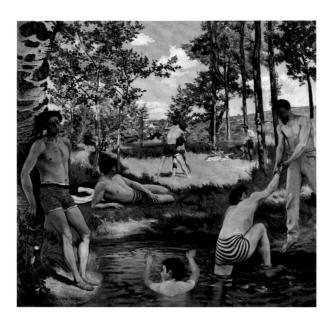

FIG. 3. FRÉDÉRIC BAZILLE (FRENCH, 1841–1870). *Summer Scene*, 1869. Oil on canvas; 160 × 160.7 cm (63 × 63 ¼ in.). Harvard Art Museums/Fogg Museum, Cambridge, Massachusetts, gift of Mr. and Mrs. F. Meynier de Salinelles, 1937.78.

cause him to stand out most. With a back, we want a temperament to be revealed, an age, a social state; with a pair of hands, we must express a judge or a merchant; by a gesture, a whole string of feelings. . . . The way he carries himself will teach us that this person is going to a business meeting, and that other is returning from a tryst.[26]

The Impressionists all but ignored society receptions, and depictions of black evening dress are thus rare in their paintings. Though such outfits appear in representations of loges, as well as in *Dance in the City* by Renoir (fig. 2), large, full-length figures wearing this type of evening dress are unusual. James McNeill Whistler's depiction of Theodore Duret (cat. 69) is an exception, one that was inspired by the artist's quest for subtle chromatic arrangements. In this work, the black of Duret's suit—which does not take into consideration the different textures of the materials—is juxtaposed against the brilliant area of white where his shirt front, waistcoat, and tie come together, and the pink domino suggests that he is going to or coming from a masked ball at the Opéra.

Portrayals of military men were also rare in the work of the Impressionists, unlike that of Tissot, who liked representing officers parading in salons,

including the intrepid Colonel Frederick Gustavus Burnaby, famous for holding his audiences spellbound by recitals of his exotic adventures (cat. 70). The absence of military men from Impressionist paintings can perhaps be attributed to the fact that military service in France only became universal in 1872.[27] Aside from specifically military scenes and events, uniforms first made an appearance in representations of everyday life during the 1880s, before becoming commonplace in the 1890s.

For the Impressionists, representations of urban activities offered just one view of modernity. Zola strongly emphasized this point in 1868 when describing Monet: "Like a true Parisian, he takes Paris to the country: he can't paint a landscape without putting dressed-up ladies and gentlemen into it. Nature appears to lose its interest for him as soon as it no longer bears the imprint of our customs."[28] The Impressionists explored with unparalleled delight the world of boaters, especially those who were not seeking physical exercise, but instead "a pleasure of a rather coarse kind," to use an expression from the *Grand dictionnaire universel du XIXe siècle* (Universal Dictionary of the 19th Century; 1866–76).[29] Manet, Monet, and Renoir reveled in the spectacle offered by the disparate, cosmopolitan crowd that swarmed the outdoor dance halls and restaurants in the suburbs of Paris, pairing off into ephemeral couples for the length of a sunny afternoon spent on the banks of the Seine at Argenteuil, Chatou, or Bougival. Whether courting in a skiff or flirting on a dock, boaters were recognizable by the white or striped maillots they wore, their characters at once vulgar and erotic, as gleefully emphasized in literature of the period.[30]

Gustave Caillebotte, in contrast, favored genuine athletes, even amateurs devoid of any spirit of competition. Like Bazille's astonishing *Summer Scene* (fig. 3), Caillebotte's paintings of swimmers yield substantial information about the different types of men's swimming costumes in use at the time. Some wear outfits covering their whole bodies, down to mid-thighs or knees: one-piece striped suits, or navy blue suits composed of a tunic and pants that stop at the knees, sometimes held together by a belt. Others have simple striped or solid-colored shorts. The zebra-striped knits winding around the torsos and loins of boaters and bathers are proof of the growth of the textile industry through the production of knitted fabric.[31]

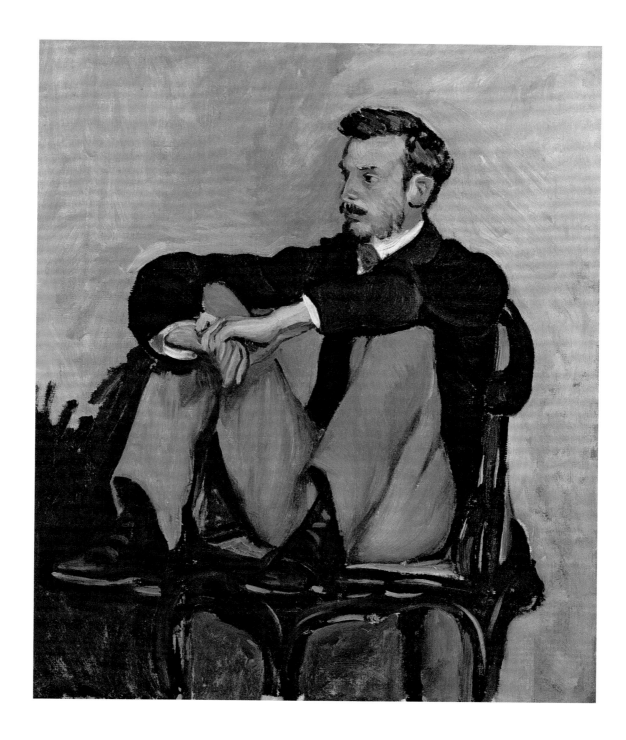

CAT. 71 Frédéric Bazille (FRENCH, 1841–1870)

Pierre–Auguste Renoir, 1867

Oil on canvas
61.2 × 50 cm (24 × 19 ¹¹⁄₁₆ in.)
Musée d'Orsay, Paris, on deposit to the
Musée Fabre, Montpellier

In Bazille's portrait, Renoir is rakishly posed but respectably dressed, his posture adding interest to an outfit that is indistinguishable from that of other society men. His boots have elastic inserts, an innovation of the nineteenth century that enabled men and women to pull their boots on without closures. These boots and his coordinating, but not matching, coat and pants were all appropriate for daytime. Although Paris was the center of women's fashion, London dictated taste in menswear. As the decorative trimming of women's clothing escalated, supported by the established luxury industries of Paris, men's garments became more sober and focused on fit and the precise details championed by British tailors.

The adherents of the *nouvelle peinture*, which privileged pictorial fact over anecdotal figuration, were dependent on the good will and availability of models in order to ensure their freedom. They were preoccupied by the delicate artistic problem of translating onto canvas the dark carapace of men's clothing. Zola was probably remembering the "long hours of posing" for Manet in 1868 when he wrote of the relentlessness of the hero of *L'Oeuvre* (The Masterpiece; 1886), Claude Lantier, in transposing onto canvas the black velvet jacket of his comrade and childhood friend Pierre Sandoz, who agreed to pose so that the painter would not have to pay a model.[32] The Impressionists, despite their differences in personality and fortune, painted each other time and again—Renoir represented Bazille (1867; Musée d'Orsay, Paris), Monet (1872; Musée Marmottan Monet, Paris), and then Alfred Sisley (1875–76; Art Institute of Chicago); and Edgar

FIG. 4. EDGAR DEGAS (FRENCH, 1834–1917).
Ludovic Halévy and Albert Boulanger-Cavé Backstage at the Opéra, 1879. Distemper and pastel; 79 × 55 cm (31 ⅛ × 21 ¹¹⁄₁₆ in.). Musée d'Orsay, Paris.

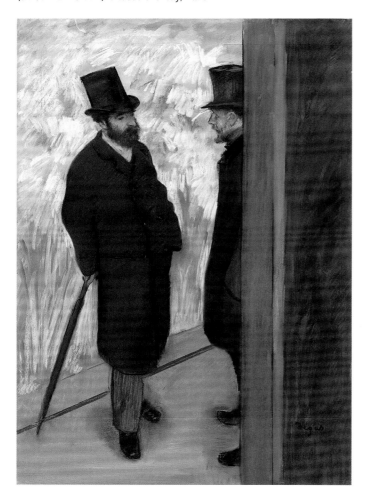

Degas depicted Manet sprawled across a sofa listening to his wife play the piano (1869; Kitakyushu Municipal Museum of Art). Bazille's compelling portrait of Renoir captures him in an unstable position, sitting in a caned armchair with his knees drawn up to his chest and his arms wrapped around them (cat. 71). Renoir appears as a symbol of the free-spirited, relaxed artist, despite being dressed in an entirely respectable and conventional way, in a black frock coat, light gray trousers without cuffs, a white shirt (the looseness of the brushstrokes making it impossible to see if the collar is upright or turned down), a blue tie, and ankle boots.

This reliance on friends as models went beyond portrait painting. In 1865 Bazille agreed to pose for four of the male figures in Monet's *Luncheon on the Grass* (fig. 2, p. 89), who appear as elegant silhouettes in semicasual summer clothes (Bazille was apparently wearing one of those striped percale shirts referred to as *de fantaisie* and considered "artistic" by fashion illustrations). The attentiveness of these figures to their female companions means that they avoid the contented discourtesy that emanates from the solitary figure of Victor Jacquemont, searching for a spot to sit and read his newspaper.[33] Degas also continually asked his friends to ape poses for his masterful genre scenes, whose spontaneity was not without ambiguity. The two figures wearing redingotes and top hats in conversation in the wings of a theater are no other than the eminent Ludovic Halévy and Albert Boulanger-Cavé, brought together to evoke a chance encounter between connoisseurs of dance girls (fig. 4). In *Portraits at the Stock Exchange* (cat. 81), it is the consultation of a financial document that brings together and isolates two men—one of them the financier Ernest May—in the middle of the chaotic agitation so characteristic of this milieu.

In contrast, Caillebotte demonstrated a particular interest in male solitude. He masterfully suggested idleness, boredom, and reverie in his silhouettes of men viewed from behind as they stand before a window or lean against a balcony, pausing in their wanderings around spacious, comfortable apartments to observe the spectacle of life in the street. In *Portrait of a Man* (cat. 72), the scene is set around an older model, who is silhouetted against the light of an open window, the very image of withdrawal into himself. In Caillebotte's *At the Café* (cat. 74), the expressionless man with his hands

Portrait of a Man, 1880

Oil on canvas
82 × 65 cm (32 ¼ × 25 ⁹⁄₁₆ in.)
The Cleveland Museum of Art

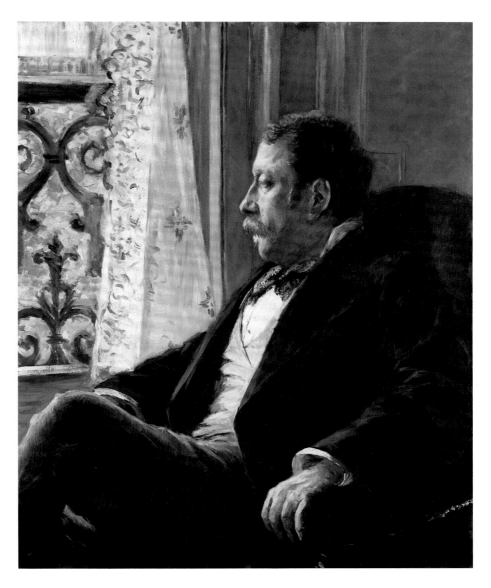

deep in his pockets, who occupies the center of the composition, has none of the distinction of his predecessors. His dress—upright collar (open too far at the neck), hat pushed too far back on his head, trousers wrinkled across the thighs—stance, and massive nonchalance denote a social status below that of the clients seated at the tables reflected in the mirror. He does not belong to the category of men-about-town strolling the Paris boulevards, sporting gloves, canes, and top hats—fundamental accessories for any elegant man.

Fashionable clothing and accessories imposed a certain silhouette on their wearers and influenced hand gestures. In particular, the vogue for cigars and cigarettes shaped the paintings of the Impressionists. Cigars invaded Europe at the time of the Napoleonic wars and rapidly became a symbol of the bourgeoisie, since in this period,

aristocrats and high-placed churchmen still took snuff. Cigarettes—which enjoyed a first wave of popularity during the Crimean War (1853–56) before undergoing a spectacular increase in consumption starting in 1870—were more emblematic of the intellectual world and emancipation movements.[34] The Impressionists reflected these new pleasures and the gestures associated with them. Smokers were numerous in their works, from Manet's elegant cigar lovers, to Renoir's depictions of robust young people puffing on cigarettes after a country picnic.[35]

All of these images demonstrate the ability of the Impressionists to depict the everyday behavior and dress of the Parisian man. Despite the difficulties caused by the uniformity of cut and color of men's clothing, they were able to capture the essence of the modern male.

James Tissot
The Circle of the Rue Royale

Guy Cogeval and Stéphane Guégan

Little by little however, M. Tissot has moved closer to us, and step by step, painting to painting, he has arrived at the modern world.

—Théophile Gautier[1]

There is a delightful paradox in including James Tissot in a discussion of fashion and the Impressionists. His tight, shimmering canvases are as hostile to the untidy brushwork of the Impressionist style as the painter himself was to the group's strategies. In 1874 he resolutely kept himself at a distance from their first collective event and, in the end, respected only Edgar Degas, Giuseppe De Nittis, Édouard Manet, and James McNeill Whistler among the leading lights of the *nouvelle peinture*. He shared these artists' taste for narrative complexity and psychological indecisiveness, capturing contemporary mores carefully and ironically, with nuances of mood and humor, and without ever turning a blind eye to them or looking down on them.

It is becoming increasingly evident that Tissot's contribution to the representation of Parisian modernity in the 1860s was fundamental. Peopled with ladies in extravagant outfits and impeccably attired dandies, his entire universe cries out compellingly about the obsessive representation of the fashions of the period. In Tissot's world, clothing speaks to the social condition at its very essence—the appetite for power, the burden of seduction, and the desire to impose one's will on others by any and all means. This was the artist's response to the dual components of modernity, as Gérald Froidevaux defined it, from Charles Baudelaire's time on: "Fashion seems to promise the revelation not only of what constitutes modern beauty, but also of the disturbing dynamism of

values and significations, which, in the modern period, dominate the whole of social interaction."[2] If Tissot appears more lively than Alfred Stevens or Auguste Toulmouche, artists with whom he is often compared, it is because his painting is a marvelous elaboration—with a formal invention that is often ignored—of the spell cast by fashion when it is defined as "the most typical expression of bourgeois society, but also as an attempt at subverting its order."[3] The society painter is also the painter who explores its demons and hidden vices.

We should bear in mind that Tissot's style was profoundly conditioned by the clothing trade.[4] Like Henri Matisse and Édouard Vuillard a few decades later, Tissot was connected to the budding clothing industry through both of his parents and his birthplace in Nantes. His fascination as a child— and probably also an adolescent—with the magic of textiles marked his painting from the moment he crossed the threshold of the Paris Salon. Like Degas he was trained by a disciple of Jean-Hippolyte Flandrin—the mediocre Louis Lamothe, a professor at the École des Beaux-Arts. An admirer of the Neoclassical painter Jean-Auguste-Dominique Ingres, Tissot was first known for his archaeological reconstitutions of the late Middle Ages, characterized by a rather rigid aspect adopted from the Flemish and German Primitives, as well as the Belgian painters who created pastiches of their work, including Henri Leys. Yet these evocations of melancholic couples or Johann Wolfgang von Goethe's *Faust* (1808) are more than simple vignettes of an outdated Romanticism. The silent, taut canvases—demanding more from the viewer than they give—bring the past to the present with a frenzy that the painter would soon

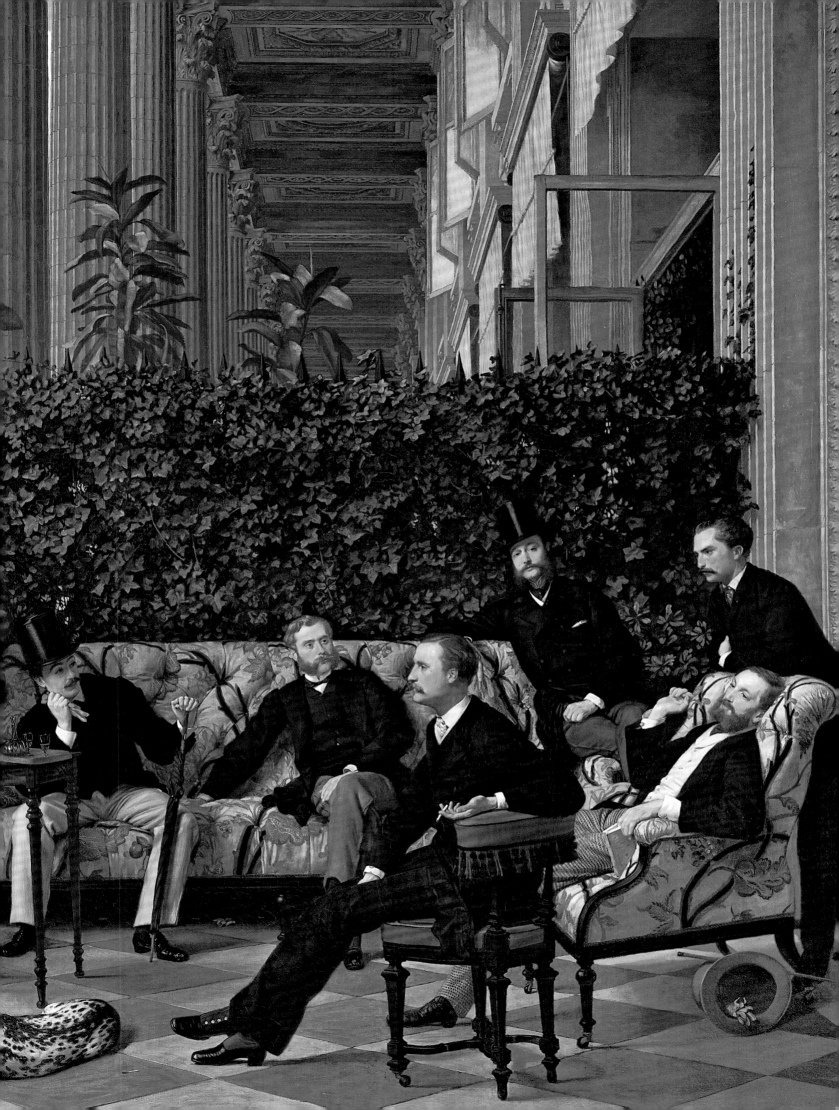

use to capture the contemporary world in all its historicity.

This turnaround occurred after Tissot's first trip to Venice and the scandal of the first Salon des Refusés—a significant moment for the new Realist wave in art. As a result, in 1864 the artist—abandoning the slit doublets, slashed tights, and furred short capes of his early paintings—plunged into the very latest fashions. In keeping with the winds of modernity blowing throughout the period, he sent two snapshots of contemporary life to the exhibition. These are more than portraits; they resolutely break free from the generic definition to which their settings, depth of focus, and narrative potential seem to link them. Critics recognized their common references to fashion plates and the illustrated

FIG. 1. JAMES TISSOT (FRENCH, 1836–1902).
Leaving the Confessional, 1865. Oil on canvas; 115.4 × 69.2 cm (45 ⁷⁄₁₆ × 27 ¼ in.). Southampton Art Gallery and Museums.

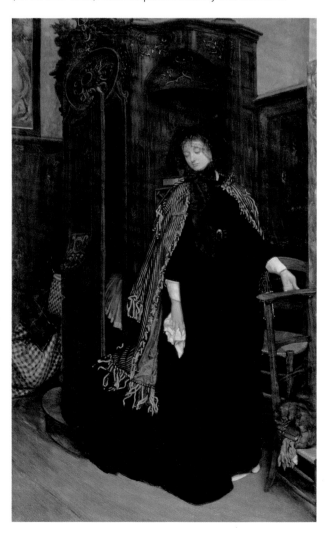

press, as well as the resemblance of Tissot's *The Two Sisters* (cat. 4) to Gustave Courbet's *Young Ladies on the Banks of the Seine* (cat. 34) and James McNeill Whistler's *Symphony in White, No. 1: The White Girl* (fig. 1, p. 26). Théophile Gautier also noted:

> Today in painting what is being mostly sought is what are called touches: one does a white touch, a gray touch, a yellow touch, that is, predominance is given in the painting to a specific note. Thus M. Hébert . . . used a blue touch; as for M. Tissot, he put an apple green touch in his charming canvas entitled *The Two Sisters.*[5]

But the greatness of a painting is defined by its capacity to transcend its sources and become both prescriptive and performative. Based on this rubric, fashion historian Marie Simon remarked on the intermediary position of Tissot's *Portrait of Mademoiselle L.L.* (cat. 118) between the engravings it recalls and the plates it prefigures.[6] In this first foray into modernity, Tissot's intent was to mark his territory immediately and strongly, to seduce and disarm. From the name of the young woman, presented with joyful assonance, to her haughty disregard, the portrait is far from the bourgeois conventions that it both resembles and rejects. The influence of Ingres's skillful lines and sharp colors also plays into this image of effrontery. The reference to fashion plates, which typically show very sedate representations of young women under the Second Empire, does not affect the force of this "portrait." Mademoiselle L.L. sits on the edge of a little table, a less-than-appropriate pose reminiscent of those assumed by *amazones*. Her head is sensually bent to enhance the mouth, and her eyes are as inappropriate as her pretty hands with exaggeratedly long fingers. We see Tissot's passion for red in Mademoiselle L.L.'s famous bolero. Evoking both bullfighting and the Crimean War, this garment, as well as the Greuzian empty cage and drawing folder, highlight the painting's overall ambiguity. Modern down to the pink slipper peeking out from under her black dress, the mysterious L.L.—who supposedly posed for Degas in the same period—compels the viewer to see her limitless independence.[7] Free of patronymic,

including the great—and their sporadic virtue. In short, the artist had become a painter à la mode.

Between 1865 and 1866, Tissot secured his entry into an aristocratic world, backed mostly by arranged and lucrative weddings.[10] In *The Marquis and Marquise de Miramon and Their Children* (cat. 1), he emphasized the dandy, rider, and member of the Jockey Club (as indicated by his riding whip) René de Cassagne de Beaufort, Marquis de Miramon. In this work, the couple's two children, Léon and Geneviève, born after 1860, were deliberately positioned: Tissot placed the little girl in her mother's arms and the male heir by his father's side. Obeying the rules of a traditional "conversation piece," he contrasted feminine frivolity with the sobriety of the master, and the split pear with the heraldic dog, creating a composition redolent of a chateau existence spent between terrace and wooded acres. Because of the nobility of the sitters, the painting was exhibited on the walls of the prestigious Cercle de l'Union Artistique, far from the crowded Salon and near the portrait of the Baronne Nathaniel de Rothschild by Jean-Léon Gérôme. According to the critic Léon de Lagrange:

> Mr. Tissot has ventured a large format for a family portrait. Mr. the Marquis de M., his wife and his two children are grouped quite naturally on the terrace of a park. The young woman is charming with her baby in her arms. The other child doesn't exist enough. In general, this painting doesn't show enough strength, it is almost reduced to shades of gray, interrupted, but not warmed, [there are] some touches of bright colors that are insufficient to create some relationship between stronger tones.[11]

This painting also illuminates the English tropism of a painter who very early on gave himself a British first name as a symbol of his devotion to the new painters from the other side of the Channel, the great discovery of the World's Fair of 1855.

For the dashing Tissot, a highly paid painter and great lover of women, 1867 was a year of consecration in many respects; this is confirmed by the large-format portrait of Tissot by Degas that portrays him as a dandy (fig. 2). Tissot established

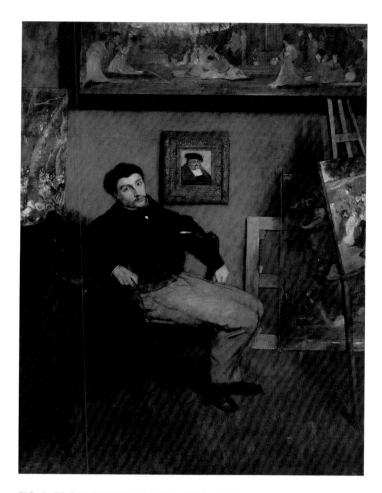

FIG. 2. EDGAR DEGAS (FRENCH, 1834–1917).
James-Jacques-Joseph Tissot, 1867/68. Oil on canvas; 151.4 × 111.8 cm (59 ⅝ × 44 in.). The Metropolitan Museum of Art, New York.

matrimonial ties, and profession, nothing yet imprisons her.

Dated very precisely "February 1864," Tissot's painting underlines the passing of time and consequently takes on the value of a manifesto of the new school of painting. Within only a few months, the artist would become a fashionable painter, attracting the attention of critics and interest from clients who lived by, and for, etiquette. By the end of the Second Empire, the voluble, ambitious Tissot indeed aroused debate at the Salon but won the votes of those with the most prestige.[8] At the Salon of 1866, where Tissot won a medal, Gautier recorded his notoriety and compared his *Leaving the Confessional* (fig. 1) to the vignettes in *La Vie Parisienne*, one of the jewels of the illustrated fashion press.[9] As this painting playfully suggests, Tissot had become the painter of all ladies—

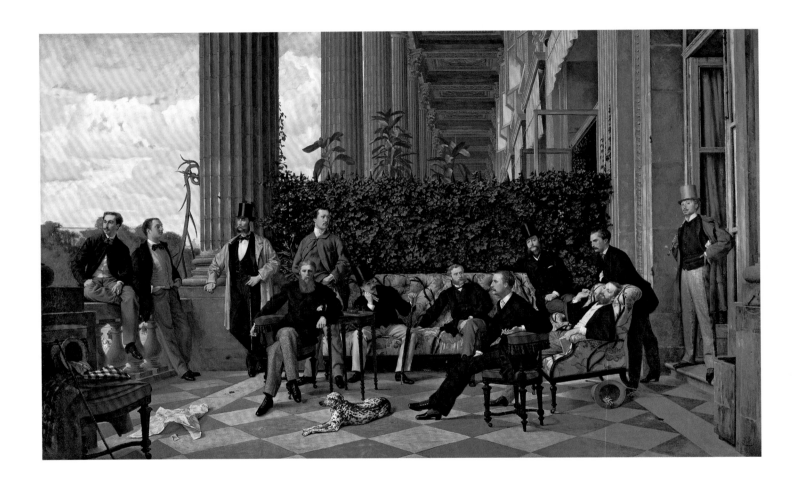

CAT. 73 James Tissot (FRENCH, 1836–1902)

The Circle of the Rue Royale, 1868

Oil on canvas
175 × 281 cm (68 ⅞ x 110 ⅝ in.)
Musée d'Orsay, Paris

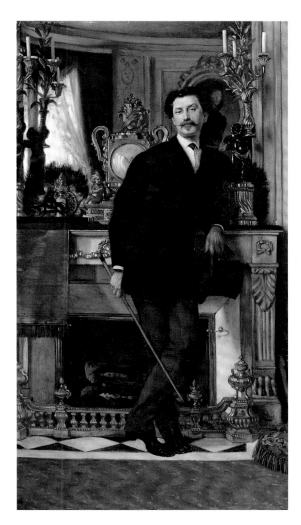

FIG. 3. JAMES TISSOT (FRENCH, 1836–1902).
Portrait of Eugène Coppens de Fontenay, 1867. Oil on canvas;
69.8 × 39.1 cm (27 ½ × 15 ⅜ in.). Philadelphia Museum of Art,
purchased with the W. P. Wilstach Fund, 1972.

himself at 64, avenue de l'Impératrice (now the
avenue du Bois de Boulogne), and he exhibited
two paintings at the Salon and two others at the
Exposition Universelle. If we were to compare his
situation during this period with the generally
unfavorable reception of his friend Manet, who
was then attempting to appropriate a more socially
acceptable iconography than that of his *tableaux
à scandale* (*Luncheon on the Grass* [fig. 1, p. 87] and
Olympia [1863; Musée d'Orsay], for example),
the contrast would be most eloquent.[12] In 1867
Tissot embarked on two significant undertakings:
he painted a portrait of the aristocratic Eugène
Coppens de Fontenay (fig. 3), one of the distin-
guished members of the Jockey Club, and he also

painted (probably on commission) *The Circle of the
Rue Royale* (cat. 73). Originally of Royalist persua-
sion, the fashionable circle became, fifteen years
later, more diverse in its political leanings.[13] Around
the Marquis de Miramon (who probably played a
crucial role in the collective commission of the
work) and the Baron Hottinguer, the artist grouped
eleven other eminent members of this very closed
club, which was predominantly favorable to
Napoléon III. Although the old aristocracy is still
present in this image, the men are largely railway
barons and military officers, illustrating the fusion
of industry and the sword—an exact allegory of
the Second Empire—a principle that broke with the
political tenets (Legitimist and Orléanist) of the
Jockey Club. The newspaper thrown on the ground,
a copy of *Le Constitutionnel*, represents the rejection
of the liberal monarchy and serves as a symbol
of the aesthetic modernity that Tissot advocated.
The seated man on the right side of the picture,
Edmond de Polignac, who holds the *Vie de Louis XVII*
in his left hand, is an incarnation of those still
dreaming of a monarchy. Above him the figure of
Gaston de Gallifet, as tensed as a sword, carries the
energy of the empire. The result is a dual incarna-
tion of arrogantly relaxed gentry in a large panoramic
scene that recalls the collective portraits of the
seventeenth century.

But there is no question here of a preoccupa-
tion with either the viewer or the vulgar. Ignoring
any hint of elevated conversation, the canvas
emphasizes instead the accessories of distinguished
virility, as it was embodied at the time in fashion
illustrations—top hats and canes with lines as
clean as those of the well-cut overcoats.[14] The artist
also took advantage of the setting of columns and
windows of the architecture by Gabriel. In other
words, Tissot and Manet each painted their own
Balcony (cats. 73, 76), whose occupants are meant
to simultaneously capture viewers' interest and
disorient their gaze. Tissot's image of well-dressed
prominent citizens confirms the implicit byword
of the *peintre-couturier* (fashion portraitist): in
seeking the perfect unity between the body and its
clothing, we clothe ourselves so as to better expose
ourselves. It is no surprise then that fashion designers
from Charles Frederick Worth to Vivienne Westwood
have saluted Tissot as a colleague and a rival.[15]

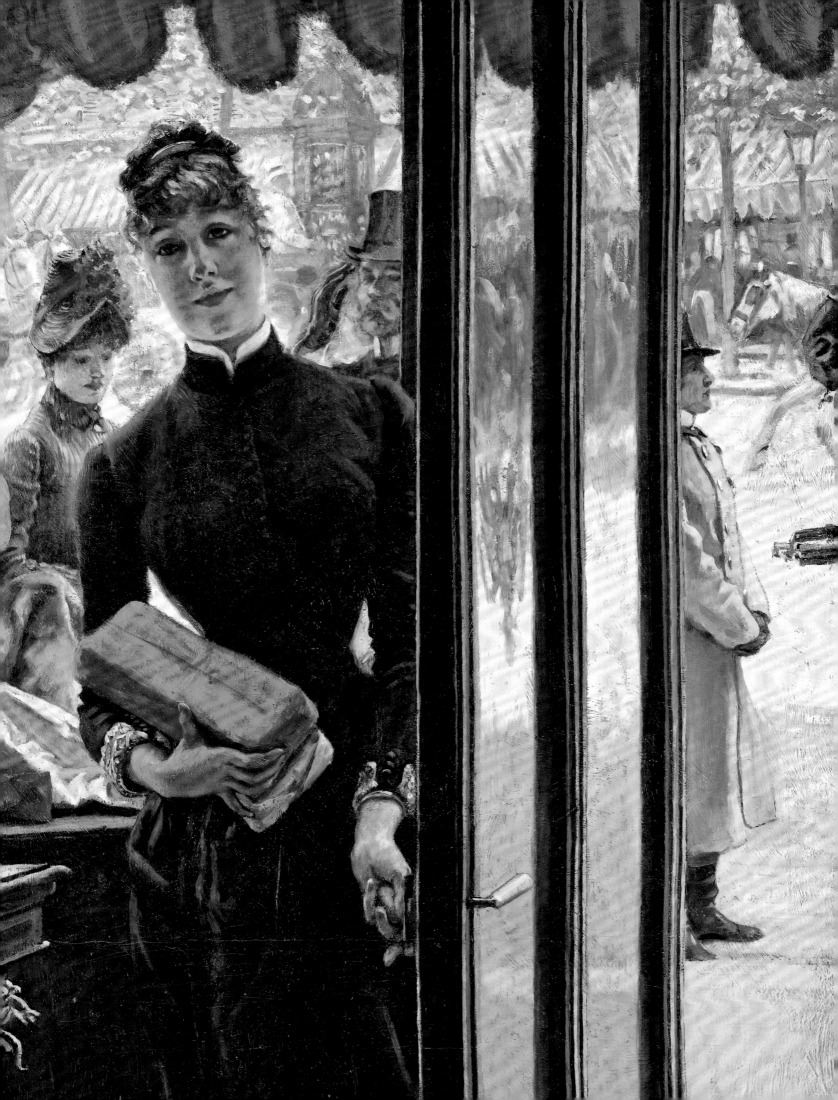

Looking Through, Across, and Up

The Architectural Aesthetics of the Paris Street

David Van Zanten

Until recently, the administration overseeing the street lines of Paris allowed builders—as long as they respected the laws of building height—the liberty of placing balconies, cornices and entablatures as they saw fit. . . .

The result has been a serious lack of harmony between the various constructions belonging to the same complexes. . . .

The overall order of the city has suffered from this lack of harmony, and the duty of the town councilors was to remedy it.

It was in order to attain this goal that I ordered the insertion of a clause in contracts for the sale of land belonging to the city, obliging buyers to give the facades of houses in each parcel the same principal lines, so that balconies would be continuous, and cornices and roofs would be *as much as possible* on the same level.

This measure is so essential to the architectonic effect, that to this end, I propose its extension to all reconstruction of buildings undertaken, either when a new street is put through, or in the case of a simple realignment. . . .

I myself will examine with interest the various studies which you must present in response.

—Baron Georges-Eugène Haussmann[1]

FIG. 1. JEAN BÉRAUD (FRENCH, 1849–1935).
Paris Street Scene, c. 1910. Oil on canvas; 24.1 × 38.1 cm
(9 ½ × 15 in.). Wadsworth Atheneum Museum of Art, Hartford.

There are few urban architectural projects so universally praised today as the Haussmannian transformation of Paris (1853–70). In less than two decades, the unstoppable prefect of the Seine opened the city with a new kind of street— a broad boulevard with ample sidewalks, usually shaded with lines of trees and framed by tall apartment houses balanced on broad sheets of plate glass—as well as gorgeous new public buildings.[2]

This world is brought to life in the society paintings of Giuseppe De Nittis, a friend of Edgar Degas, and Jean Béraud, who rendered views of well-dressed crowds enjoying broad, tree-shaded streets. These spaces may or may not have absolutely existed; in Béraud's elegant, tiny *Paris Street Scene* (fig. 1), he seems to have dropped a boulevard into an irregular spatial configuration, with an elegant club building added at the vanishing point. Illustrators, constrained by reality, showed these new spaces with few such comfortable viewpoints, shooting off instead in all directions at "steam's own speed" (see figs. 3, 4).[3] The well-to-do Impressionist Gustave Caillebotte explored the tension of Paris's radiating canyons in his large canvases *The Pont de l'Europe* (1876; cat. 80) and *Paris Street; Rainy Day* (1877; cat. 93). But he increasingly became more interested in creating smaller panels that looked across these spaces or directly down from above, especially from his own fourth-floor apartment in the quartier de l'Opéra. In *Man on the Balcony* (1880; private collection), we look out on the treetops of a

boulevard as though we might step weightlessly onto a silent leaf carpet instead of the echoing cobbles of the street.[4]

Haussmann's new cityscape was realized through the intervention of the *commissaires voyers* (or *architectes voyers*) of the twelve arrondissements of Paris, following the revised Plan of Paris administered by the architect Eugène Deschamps.[5] That plan was approved by the Fourth Commission of the Conseil Municipal in charge of *voirie* (streets) and the architects of the Conseil des Bâtiments Civils, and its implementation was controlled by the 1852 ruling that building permits would be bestowed only after drawn house plans were submitted to the city.[6] Projections like balconies could not exceed 1.5 meters in depth, and a subcommittee of the Conseil des Bâtiments Civils was created to judge specific cases.

An observant young American woman, Frances Willard (soon to become Dean of Women at Northwestern University in Evanston, Illinois) spent 1868–69 in Paris with a friend, boarding with the widow of the *architecte voyer* of the 13th arrondissement, Louis-Alfred Perrot.[7] She kept a careful diary, and early in her stay, she made these comments on the late Monsieur Perrot's *fonction*:

> Antoinette [Madame Perrot] told us about Monsieur Perrot—that he was the architect of the 13th arrondissement of Paris (Gobelins). That no one could make the least alteration in his house—even to put in a window, or a pane of glass, without his permission. We told her how in "free America" every man chose the material, and style that suited him and no one dared molest. She thought it, evidently, a liberty not to be envied, and said we must have all sorts of odd looking streets as a result. Paris is to be beautiful—that is decreed, and no one is permitted to interfere with his private tastes or ignorances [*sic*].[8]

AFLOAT ON PLATE GLASS

The apartment building at 72, boulevard de Sébastopol, designed by the successful private architect François Rolland and illustrated in Adolphe Lévy's 1870 *Maisons les plus remarquables*

de Paris (The Most Significant Houses of Paris; see fig. 2), was a typical unit in this huge construction scheme. Lévy's unusual cross section shows the building's novel structure. The street facades are composed of fifty centimeters of solid masonry, the interior partitions made of thin wood, and the back and party (shared) walls constructed from rough stonework and stuccoed.[9] A vaulted coal cellar stands two stories below the street; five stories of apartments rise above with a mansard for servants; and, in between these, two stories of open space supported by iron posts and beams create an unencumbered commercial zone with virtually no walls, large openings between the floors, a glass skylight across the courtyard, and plate glass to the street across the first floor. François Loyer traced this remarkable new paradigm of Paris street architecture to the facades promulgated in 1860 around the quartier de l'Opéra, a district of fashionable boutiques and painting galleries, by the architect Charles Rohault de Fleury.[10] These were noted and depicted with

some wonder and enthusiasm in popular journals like *L'Illustration* and *Le Monde Illustrée*.[11]

Impressionist café scenes like Caillebotte's *At the Café* (cat. 74) adopted this new architectural language, playing with the illusion-creating confrontation of long mirrors and plate-glass walls.[12] James Tissot's carefully observed *Shop Girl* (cat. 75) uses the nearly invisible glass plane between the shop interior and the boulevard to raise the social play of capitalist interactions to a sort of frozen ballet. The viewer becomes the wealthy customer just leaving the store (whose coachman is visible outside the door), ushered out by one shopgirl while another puts away boxes; the only disruption (one of glances across glass surfaces) is a well-dressed man staring in at her through the shop window. In Charles Baudelaire's 1869 short story "Les yeux des pauvres" (The Eyes of the Poor), a sheet of plate glass serves as the fundamental intermediary between the bourgeoisie and the working class—contentment amid blazing gaslight and mirrors within, and dumb fascination without.[13]

FIG. 2. FRANÇOIS ROLLAND (FRENCH, 1806–1888). "Lateral Cross Section of 72, Boulevard de Sébastopol," c. 1860. From Adolphe Lévy, *Les maisons les plus remarquables de Paris*, vol. 1 (Moniteur des Architectes, 1870), pl. 27.

THE BALCONY: LOOKING ACROSS THE STREET

The issue of the Haussmannian surface highlights the relationship between what is in front of and what is behind the solid limestone walls of the apartments surprisingly balanced above plate-glass walls, and how the inside and the outdoors are connected by the architectural feature that Haussmann sought above all to control: the balcony. The struggle between the balcony and the formal facade is ancient, fought already during the Italian Renaissance, when the revival of classical design coincided with the stripping of facades of their medieval (and Middle Eastern) wooden lookouts. Édouard Manet's *The Balcony* (cat. 76) seems to show the balcony's traditional wooden slats falling away, leaving a place of bald, uneasy self-presentation. Haussmann opposed the balcony's tendency to break through the facade, demonstrated in Caillebotte's quartier de l'Opéra paintings and Berthe Morisot's *On the Balcony* (cat. 77). In the latter, a woman and her daughter look out from their home across the slopes of Passy, the Seine River, and Vaugirard, eastward toward the Dome of the Invalides, suggesting that their vantage

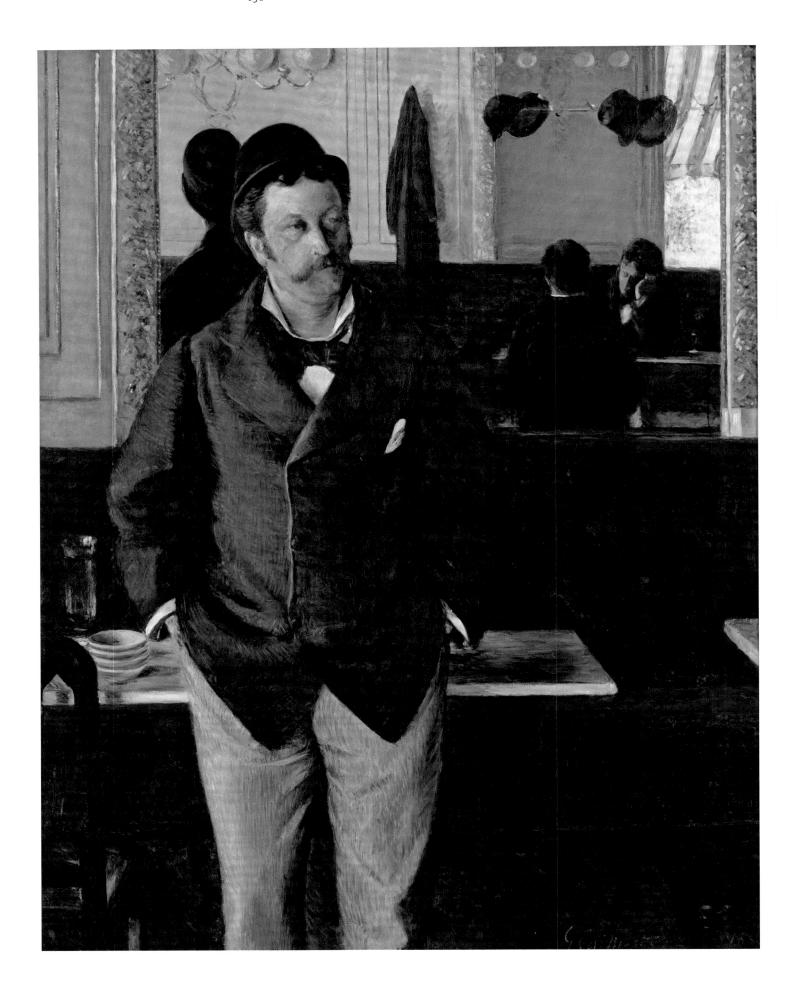

VAN ZANTEN Looking Through, Across, and Up

CAT. 74 Gustave Caillebotte
(FRENCH, 1848–1894)

At the Café, 1880

Oil on canvas
153 × 114 cm (60 ¼ × 44 ¹⁵⁄₁₆ in.)
Musée d'Orsay, Paris, on deposit to
the Musée des Beaux-Arts, Rouen

Caillebotte's male model wears a dark, melon-shaped
hat. In contrast to the other patrons, who are visible
in the mirror's reflection, seated and with their own hats
hung on hooks, he stands in front of a mirror, hands
inside the pockets of his rumpled outfit. Although this
model appears in other paintings as a bourgeois man
of leisure (cat. 72), here his small derby, fashionable
years earlier, and general crudeness of manner and dress
caused critics to label him a "barfly," an unsophisticate
who spent time in cafés and drinking establishments.

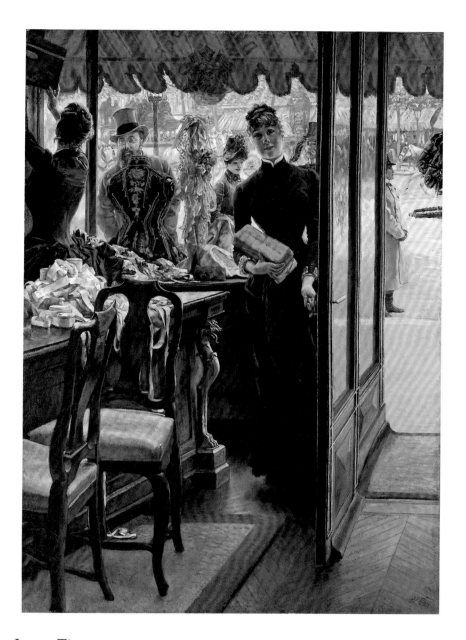

CAT. 75 James Tissot **(FRENCH, 1836–1902)**
The Shop Girl from the series *Women of Paris*, 1883–85

Oil on canvas
146.1 × 101.6 cm (57 ½ × 40 in.)
Art Gallery of Ontario, Toronto

This painting, from Tissot's series *Women of Paris*,
depicts a young woman working in a Parisian shop,
perhaps a *magasin de nouveauté*, where shoppers could
buy accessories and trims like the silk ribbons piled
on the table. Shopgirls were a symbol of modernity,
representing fashion, mass consumption, and the new
public roles women played in urban life. Like the goods
for sale in stores, shopgirls were also on display.
They dressed fashionably thanks to advances in mass
production and the cutting-edge fashion publications
readily available throughout Paris.

CAT. 76 Édouard Manet
(FRENCH, 1832–1883)

The Balcony, 1868–69

Oil on canvas
170 × 124.5 cm (66 ¹⁵⁄₁₆ × 49 ¹⁄₁₆ in.)
Musée d'Orsay, Paris

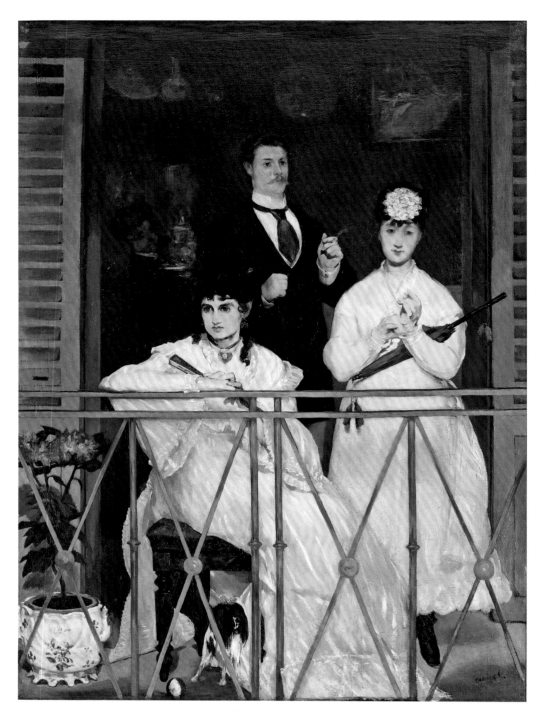

Manet's use of a balcony setting, coupled with the clothing in which he attired the female figures, confused some contemporary critics. Both of the women are shown as if on display, in daytime-appropriate pristine white gowns, which can be seen in their entirety through the open metalwork of the railing. But the woman on the left, artist Berthe Morisot, is seated and focused on the spectacle of the street, while Fanny Claus is portrayed standing, as if about to go out, with gloves, hat, and parasol—accessories only necessary outside the home. Moreover, Morisot's relaxed dress with pagoda sleeves suggests an intimate gathering, whereas Claus's shorter walking dress would usually have been reserved for being out in public. The women's clothing thus echoes the indeterminate, simultaneously private yet public space of the balcony.

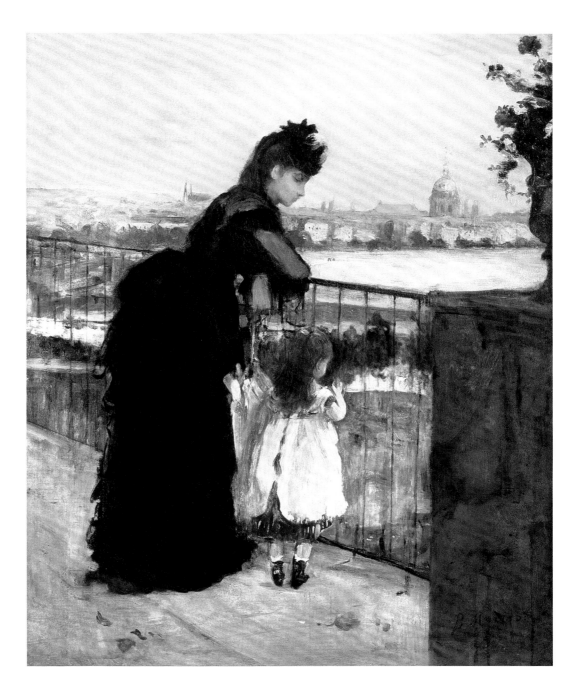

CAT. 77 Berthe Morisot **(FRENCH, 1841–1895)**

On the Balcony, 1872

Oil on canvas
60 × 50 cm (23 ⅝ × 19 ¹¹⁄₁₆ in.)
Private collection

Leaning on a railing at the edge of a private balcony, a woman and young girl observe Georges-Eugène Haussmann's Paris. Occupying this intermediate space, they are dressed appropriately for appearing in public. The little girl—the artist's niece, Bichette (Paule Gobillard)—wears the dress and pinafore that were customary for little girls, while her mother, Yves Gobillard, is stylishly dressed for a promenade in a black walking dress accessorized with a forward-tilting hat and pink parasol. The composition of the scene may have been inspired by contemporary fashion plates: showing Bichette turned away from the viewer makes the details on the back of her pinafore visible, and placing Yves in profile emphasizes her fashionable bustle.

In the Loge, 1878

Oil on canvas
81.3 × 66 cm (32 × 26 in.)
Museum of Fine Arts, Boston

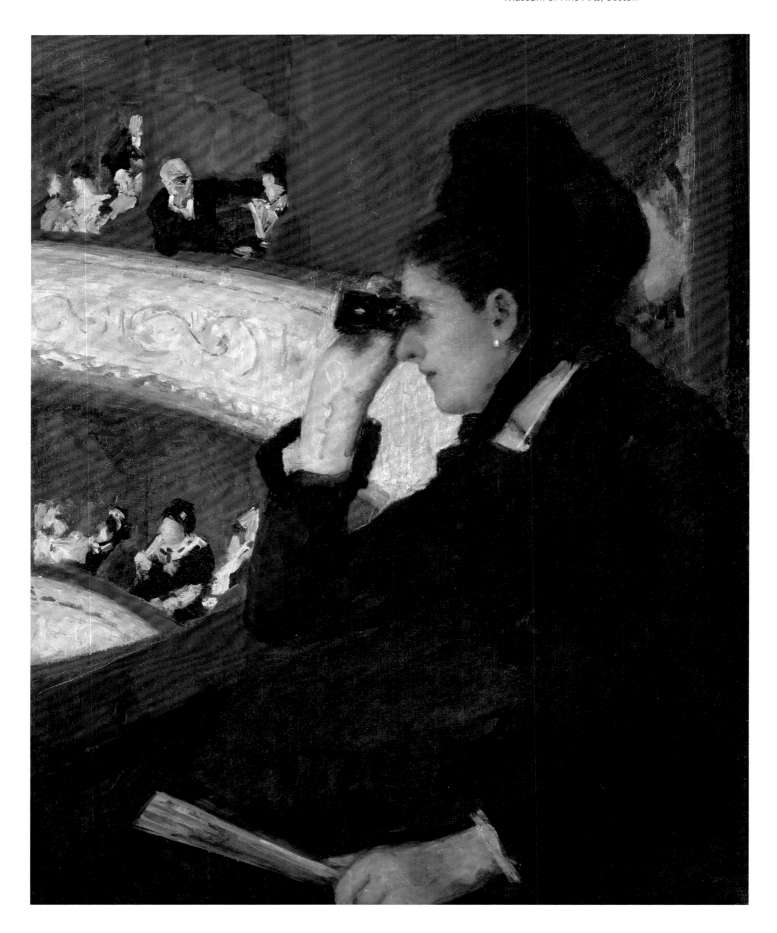

FIG. 3. FÉLIX THORIGNY (FRENCH, 1824–1870).
"New Fountain on the Boulevard de Sébastopol,"
Le Monde Illustrée 4, 175 (August 18, 1860), p. 109.

FIG. 4. GABRIEL-ÉMILE WIBAILLE (FRENCH, 1802–AFTER 1857).
"Place de l'Étoile," *Le Monde Illustrée* 1, 1 (April 1, 1857), p. 5.

point has expanded from a balcony to an observatory.

Caillebotte's and Morisot's balconies are for seeing rather than being seen, unlike Manet's *tableau* (for which Morisot herself modeled), which is closer to a theater box, also often called a *balcon*,[14] like that depicted in Mary Cassatt's *In the Loge* (cat. 78). Cassatt's subject levels her opera glasses across the space—at other *balcons*, not down at the stage. This is reminiscent of the Impressionist views that look across street spaces rather than up and down them, as do contemporary illustrators' views, including the woodcuts in *L'Illustration* and *Le Monde Illustrée* by artists like Félix Thorigny (see fig. 3). The Impressionist street became a public interior, like a theater space, where the two meanings of *balcon* merge into one.

THE HAUSSMANNIAN BOULEVARDSCAPE

If the Haussmannian street was potentially a kind of interior space, just what sort was it? The first issue of the journal *Le Monde Illustrée* (founded with government support to crimp the market of the pioneering publication *L'Illustration*), published on April 1, 1857, is dominated by an unusual aerial view of the place de l'Étoile (fig. 4) drawn by Gabriel-Émile Wibaille. Under construction since 1855, the place de l'Étoile served as the locus of the development of the city's western extension.[15] What had been planned in 1853 as two echoing hemicycles fitted tightly around the central arch with an intervening ring of over-scaled statues of the marshals of France was now broken into separate blocks reaching back to an annular street and divided by twelve broad boulevards radiating out across the city. As the streets widened and achieved a clean, geometric form, they began to match the framing blocks of houses in a tense equality of mass and void, once again blending exterior and interior.

According to Michaël Darin, the radiating boulevards shown in Wibaille's illustration vary in width—seventy meters for the major axial Champs-Elysées and avenue de Neuilly; thirty-six for the secondary axial avenues de Wagram and du Roi de Rome; forty for the avenues de l'Impératrice, de Josephine, de Friedland, and Essling just off the major axis; and thirty-six for the remaining four

FIG. 5. EUGÈNE-EMMANUEL VIOLLET-LE-DUC (FRENCH, 1814–1879). *Entretiens sur l'architecture,* vol. 2 (Morel, 1872), pl. 36.

FIG. 6. LOUIS BONNIER (FRENCH, 1856–1946). "Comparison of Haussmann's (left) and Bonnier's (right) Modified Street Envelopes," *Conférences faites dans l'hémicycle de l'École Nationale des Beaux-Arts les 22 et 29 octobre 1902 sur les règlementes de voirie* (C. Schmid, 1903), figs. 11–12.

streets just off the minor axis.[16] This is because the silhouette of the central Arc de Triomphe itself broadens and narrows as the viewer moves around it.[17] Indeed, as one rides around the inner annular street at the Étoile, the Arc de Triomphe flashes into view in slowly widening, then narrowing, then widening glimpses. Interwoven with the vertical axes of the straight boulevards, the buildings surge forward and fall back as one proceeds.[18] In his early novel of Haussmannization, *La curée* (The Kill; 1871–72), Émile Zola's pair of lovers sensuously wheels through the new boulevards of Paris in an open carriage, just as Jean-François de Bastide's similar pair had proceeded coquettishly from room to room in his erotic *Petite maison* (The Little House; 1753) one hundred years before. It is less that the discipline of the interior had been extended into the street than that the street became fantasized as formerly only the interior could be.

THE THINNING OF THE FACADE

Although Haussmann championed a smooth stone surface for the upper building facades of his new Paris, his parallel insistence on minimal projections seemed to argue for a continuous, fragile plane. Eugène-Emmanuel Viollet-le-Duc's model *maison de rapport* (apartment building) facade, published in the 1872 fascicle of his *Entretiens sur l'architecture* (fig. 5), shows just such a continuous surface of glistening terracotta sheets held in place by a web of iron flanges, the whole balanced on a firm iron girder above the continuous glass shop windows, emblazoned "Nouveautés en étoffes," on the building's ground floor.[19] Zola also featured such a facade in his *Au bonheur des dames* (The Ladies' Paradise; 1883), in which a department store expands step by step until, in the final scenes, it breaks through to the newly cut (fictional) rue du Dix-Décembre, rising in an explosion of colored tile, glass, and metal (which would actually have been legally impossible in the 1860s, when the novel is set): "It was in its fresh gaiety, a vast architectural development in polychrome materials, highlighted in gold, announcing the bustle and flash of the commerce within, attracting the eyes like a giant window display aflame with the brightest of colors."[20] This crescendos at the skyline:

Les terrasses, telles qu'elles sont actuellement et telles qu'elles pourront être aux beaux jours prochains.
LA MAISON AUX JARDINS SUSPENDUS

FIG. 7. HENRI SAUVAGE (FRENCH, 1873–1932).
"26, rue Vavin," *L'Illustration* 3708 (March 21, 1914), pp. 220–21.

But as the displays grew higher, the tones became even more brilliant. The frieze of the ground floor paraded mosaics—a garland of red and blue flowers, alternating with marble plaques. . . . Finally, at the very top, the entablature displayed itself as the fiery flowering of the entire facade, its mosaics and porcelains reappearing in the warmest of colors, the zinc gutters serrated and gilded, and resting above them a whole population of statues, representing large industrial cities and manufacturing centers, their delicate profiles silhouetted in bright sunshine.[21]

This fictional building can be likened in its color and intricacy to the interior of the Opéra Garnier, which was said to have been designed to set off patrons' gowns.[22]

THE WEIGHTLESSNESS OF THE NEW PARIS

We began by quoting Haussmann describing the architectual consistency that he imposed on the Paris cityscape and sketching the administration that he created to carry this out. That administration evolved as, after Hausmann, the politicians grew weaker and the architects, the critics, and even the artists became more engaged. In 1880 and 1884, the strictures of Second Empire *voirie* were loosened. In 1896 a committee was established by the city to rethink the aesthetics of the cityscape,

with Louis Bonnier as secretary. In 1898 it produced a report that in 1902 resulted in a law enabling much greater three-dimensionality and variety in street walls—a new dispensation Bonnier publicized in drawings, articles, pamphlets, public appearances, and finally in the buildings themselves (fig. 6). The theater of these changes was, first, the rue Réaumur, cut in the 1890s, and in fact, Zola's rue du Dix-Décembre of *Au bonheur des dames*.[23] Bonnier founded a "concours de façades" in 1898 for just the rue Réaumur, then (starting in 1899) for all of Paris, which recognized Hector Guimard's famous Castel Beranger. The full expression of these new standards was the boulevard Raspail, cut during the years just after 1900.[24] Bonnier, brother-in-law of Pierre-Auguste Renoir's close friend Ferdinand Deconchy, explained,

> When you think that rental property is just about the only kind of construction in common use in our newly created streets . . . and if you add to that fact the obligation of the builder to follow the meticulously defined and extremely severe laws governing how far any portion of a building can project out of the street line, you are no longer surprised at the flatness or monotony of appearance that is so criticized in the large apartment buildings of our times. [My proposal] would make room for a considerable number of possibilities that would oblige architects to find different, relatively unexpected, solutions. Art would profit as much as hygiene.[25]

In 1911 this new streetscape was brought to fruition in the apartment block at 26, rue Vavin by the architect Henri Sauvage. A cascade of balconies, meant to be treated as aerial gardens that blend with the interiors through floor-to-ceiling glazed openings, covers the facade on every floor in brilliant white-glazed tile (touched with occasional color accents).[26] Finally the facade wall is gone, replaced (Sauvage imagined) by a cascade of foliage (fig. 7). The street is no longer a theater space for frank self-presentation, as in Manet's *Balcony*, but rather an embowered stack of bourgeois gardens falling back, floor by floor, to let in the sun.

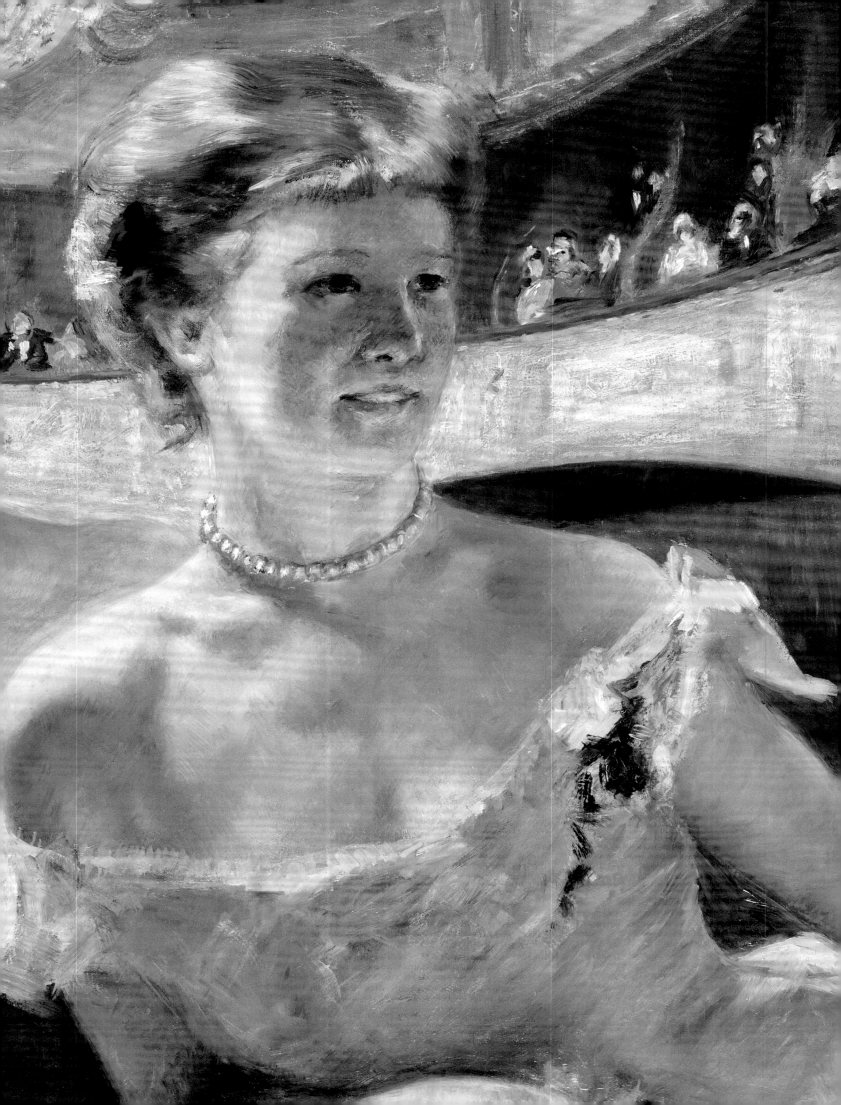

Spaces of Modernity

Gloria Groom

The French capital achieved its iconic status,
which it retained well into the twentieth century,
precisely because it managed to construct spaces and
enliven places for the cultures and performances of fashion.

—John Potvin[1]

THE STREETS OF PARIS AS A FASHION PARADE

Writing from Paris in her diary on the last day of 1868, the young American Frances Willard noted her admiration for "the brilliant shop-windows and the almost equally dazzling costumes of 'tout le monde' upon the wide pave [*sic*]," concluding that "Paris is indeed the consummate flower of taste and wealth and fashion. To walk its streets one hour is a lesson in life worth miles of travel—months of hardship."[2] Paintings of people walking in the city proliferated in the 1860s and 1870s, created by artists like Jean Béraud, who specialized in modestly scaled scenes of fashionable people experiencing the boulevards and radiating intersections of Paris as if on a stage, aware that they are being watched (see fig. 1).[3] Béraud turned these public spaces, the realm of the flaneur, into arenas for social interaction.[4] In his *Church of Saint-Philippe-du-Roule, Paris* (cat. 79), exhibited at the Salon in 1877, he depicted fashionable male and female Parisians on the rue du Faubourg Saint Honoré, which had recently become a trendy shopping street. Indeed, though the flaneur continued to enjoy unrestricted access to the city, by the last third of the century, women were increasingly the consumers of the new Paris.[5]

The inhabitants of the streets of Paris were the subjects of two monumental compositions by Gustave Caillebotte shown in 1877 at the Third Impressionist Exhibition. Both featured the newly completed residential districts in Baron Georges-Eugène Haussmann's quartier de l'Europe, with fashionable women front and center: arm in arm with a male escort in *Paris Street; Rainy Day* (cat. 93); and interacting with men in a more puzzling way in *The Pont de l'Europe* (cat. 80). Although the latter

FIG. 1. JEAN BÉRAUD (FRENCH, 1849–1935).
Place de l'Europe, c. 1875. Oil on canvas; 48.3 × 73.6 cm
(19 × 29 in.). Private collection.

CAT. 79 Jean Béraud (FRENCH, 1849–1935)
The Church of Saint-Philippe-du-Roule, Paris, 1877

Oil on canvas
59.4 × 81 cm (23 ⅜ × 31 ⅞ in.)
The Metropolitan Museum of Art, New York

work shares the same elements as Béraud's small painting of the nearby intersection, the fashions in each distinguish them. In Béraud's anecdotal scene, the top-hatted man's gaze falls upon the single woman at center who calls to her little dog and is obviously dressed more coquettishly than his own female companion. The significance of their interaction is one of many anecdotal details— the carriages, the boy in white carrying a bouquet at left, the child twisting away from her mother at right—of dress and manners portrayed by Béraud.

Caillebotte's near-life-size figures also mirror street life but, at the same time, present a much more ambiguous statement on fashion and manners. In *The Pont de l'Europe*, the lone female glances knowingly at the flaneur (probably a self-portrait of the artist), who appears to look back at her, or perhaps at the worker in a cap and smock ahead of him. Another male, identifiable as a worker by his unfitted jacket and cap, walks in the opposite direction. Preparatory drawings and X-radiography of this canvas suggest that Caillebotte played with fashion, identity, and meaning—changing the flaneur's bowler to a top hat, adjusting his relationship to the woman (from couple to propositioner), and adding more ruffled flounces to her dress and parasol—before arriving at this scene, in which members of distinct social classes occupy the same stage.[6] Many scholars have offered suggestions about the artist's intentions, pointing out that Caillebotte, who lived a few blocks away, would have been sensitive to the fact that the bridge itself had recently been erected by working-class men like those he included. This composition— along with other images of men at work, including *Floor Scrapers* (1876; Musée d'Orsay, Paris) and *House Painters* (1876; private collection)— might also reflect his identification as one of the "industrious rich," the *artiste-ouvrier* who embraced Republican ideals.[7]

Although both of Caillebotte's paintings received generally positive reviews, the elegant couple in *Paris Street* was criticized as being too "big and boring," lacking the anecdotally piquant quality of figures in works by Giuseppe De Nittis and Béraud.[8] Interestingly, *The Pont de l'Europe*, which hung in the same room at the Impressionist exhibition as *Paris Street*, was less challenging to viewers. The critic Jacques (Arsène Houssaye) saw it as more "impressionist" and "more truthful

CAT. 80 Gustave Caillebotte (**FRENCH, 1848–1894**)

The Pont de l'Europe, 1876

Oil on canvas
124.7 × 180.6 cm (49 ⅛ × 71 ⅛ in.)
Association des Amis du Petit Palais, Geneva

The striding flaneur is probably a self-portrait of the artist. It is impossible to tell what he is gazing at, but his confident stride and fashionable attire attest to his active participation in contemporary urban life. The woman to his left exhibits all the requisite attributes of the Parisienne: a parasol and a black walking ensemble whose skirt she lifts slightly to reveal the tips of her boots, their red bows coordinated with those on her veiled bonnet. The relationship between the man and woman cannot be discerned from the painting, but this is precisely where the painting's modernity lies: in its depiction of the ambiguous relationships and social mingling made possible by the city's recently widened boulevards and intersections.

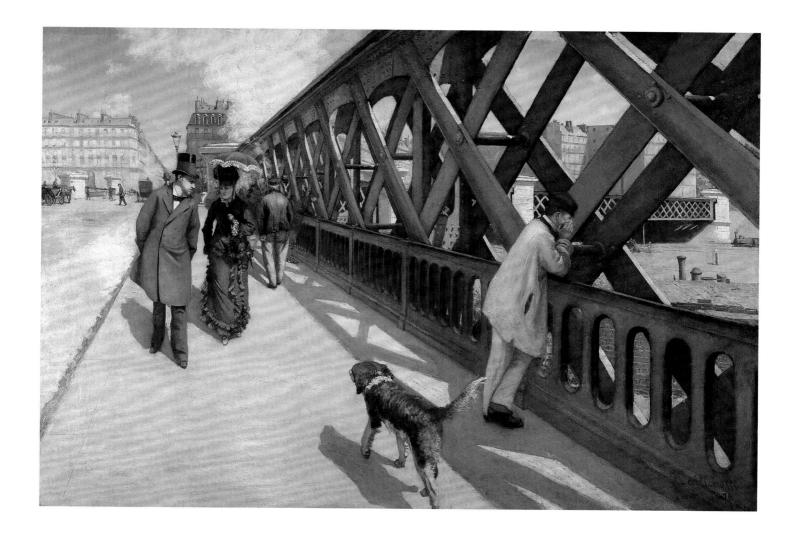

CAT. 81 Edgar Degas (FRENCH, 1834–1917)
Portraits at the Stock Exchange, 1878–79

Oil on canvas
100 × 82 cm (39 ⅜ × 32 ¼ in.)
Musée d'Orsay, Paris

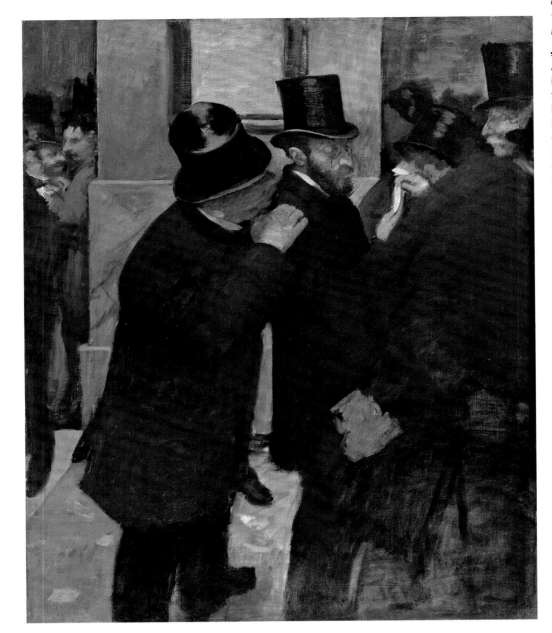

A crowd of black top hats and seemingly indistinguishable dark sack coats reveals the uniformity and simplicity of the businessman's wardrobe. Degas shows bankers and investors in plain, sober clothing that emphasizes their practicality, professionalism, and membership in a certain social group. Small variations exist in the details of the men's garments (in the color, trim, and collar styles, for example) but the overall effect is of homogenous, serious, sober masculinity. This genre scene, which includes a portrait of the banker and collector Ernest May (at center), demonstrates the importance placed on conformity and the expression of professional rather than personal identity in male dress.

and at the same time more graceful" than *Paris Street*.⁹ He was untroubled by the flaneur's untoward gesture, which countered the prevailing conduct rules advising men to distance themselves from single women so as not to be seen as propositioning or following them. Nor did he comment on the potentially awkward interaction between bourgeois and worker.¹⁰ In contrast to the "big and boring figures" of its companion piece, *The Pont de l'Europe*, like Béraud's vignettes of city life, showed an acceptable mixing of society, while also providing a more readily accessible

and popular stereotype of male–female interactions on the street.

If the street compositions of Béraud and Caillebotte highlight fashion and the social mixing so prevalent on the streets of Paris, the same cannot be said of Edgar Degas's *Portraits at the Stock Exchange* (cat. 81), shown at the Fourth Impressionist Exhibition, in 1879. Although Degas routinely walked the city before working, his important scenes of urban life—the exquisitely aristocratic *Place de la Concorde* (fig. 2), or the view outside the Bourse in *Portraits at the Stock Exchange*—lack any social

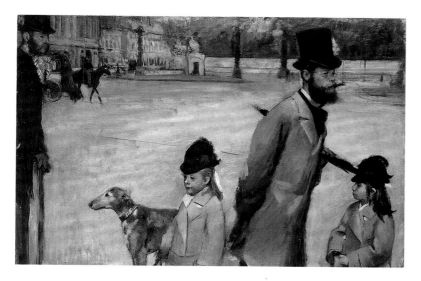

FIG. 2. EDGAR DEGAS (FRENCH, 1834–1917). *Place de la Concorde,* also called *Viscount Lepic and His Daughters Crossing the Place de la Concorde,* 1875. Oil on canvas; 78.4 × 117.5 cm (30 ⅞ × 46 ¼ in.). The State Hermitage Museum, Saint Petersburg.

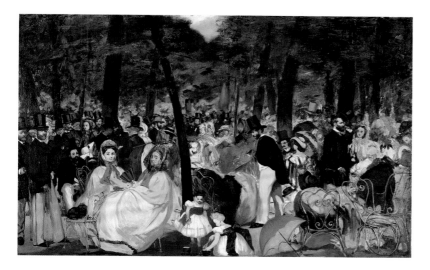

FIG. 3. ÉDOUARD MANET (FRENCH, 1832–1883). *Music in the Tuileries Gardens,* 1862. Oil on canvas; 76.2 × 118.1 cm (30 × 46 ½ in.). National Gallery, London, NG 3260.

ambiguity.[11] Following Edmond Duranty's dictum to show people in their professions, *Portraits at the Stock Exchange* depicts bankers and investors, including the thirty-four-year-old Ernest May, a collector and admirer of Degas, furtively whispering tips and speculations on the sidewalk and street in front of the Bourse, the Paris stock exchange.[12] It is also possible that in this painting Degas was commenting on businessmen like May, whose engagement with the art world represented another kind of speculative enterprise.[13] In this exclusively male bastion of the city, filled with members

of a particular social set—the upper class and its aspirants—Degas painted fashion as uniform. The top hats are indistinguishable; only the shades of sack coats and *paletots* and the details of braided trim demonstrate differences in taste and style. Although not descriptive from a photographic or Realist viewpoint, the sartorial codes in Degas's claustrophobic view from the street parallel those explicitly described in Émile Zola's two novels about the rise and fall of the speculator Aristide Saccard— *La curée* and *L'Argent* (The Kill and Money; both 1891). Both use fashion as a complementary theme to the story of fortunes made and lost at the Bourse, with women (and their wardrobes) playing a parallel role as victims or beneficiaries.[14]

Degas was unusual in his decision to show the business of art as part of modern life.[15] In revisionist histories of Impressionism, the spaces of modernity are understood to be fictions, largely seen from the viewpoint of the flaneur. Impressionist paintings frequently mirror the lifestyles of those who collected the artists' work without alluding to the business that made those pursuits possible. Focused on the new boulevards leading out from the city center, Caillebotte, Degas, Édouard Manet, Claude Monet, and Pierre-Auguste Renoir ignored the areas of industrial activity to the west and north, and the most impoverished areas to the east.

PARKS, GARDENS, AND BALCONIES

The *jardin public* or public park was an extension of the boulevard. During the Second Empire, the elaboration of green spaces in the city exemplified Napoléon III's desire to create a new social order "to offer new forms of entertainment (the racetrack rather than the opera), and to create new modes of display for the bourgeoisie to naturalize its modern rites and forms of identity."[16] Manet's portrait of modern society *Music in the Tuileries Gardens* (fig. 3) addresses the appropriateness of dress to place— in this case, a once-royal park with stringent dress codes.

More prevalent in Impressionist paintings, however, were private gardens, which offered a view of modern life outdoors but allowed for a more controllable fiction. In 1874 Manet exhibited a large canvas entitled *The Railway* at the Salon (cat. 82).

CAT. 82 Édouard Manet (FRENCH, 1832–1883)

The Railway, 1873

Oil on canvas
93.3 × 111.5 cm (36 ¾ × 43 ⅞ in.)
National Gallery of Art, Washington, D.C.

Here Manet uses dress to define the different stages of women's lives. The girl, the child of Manet's friend Alphonse Hirsch, wears a summery white dress trimmed with lace and a wide blue plaid sash. Her dress has the shorter skirt of childhood, with pantalettes peeking out at her knees. As she grew up, her hem would drop and it would no longer be considered seemly to expose her arms and shoulders, except at the most formal of occasions. Seated next to the young girl, Manet's favorite model, Victorine Meurent, clearly plays the role of a companion, not a mother, since her hair flows over her shoulders in a style reserved for youth. The sort of nautical blue dress with minimal white trim that she wears was deemed appropriate for strolling, shopping, and visiting.

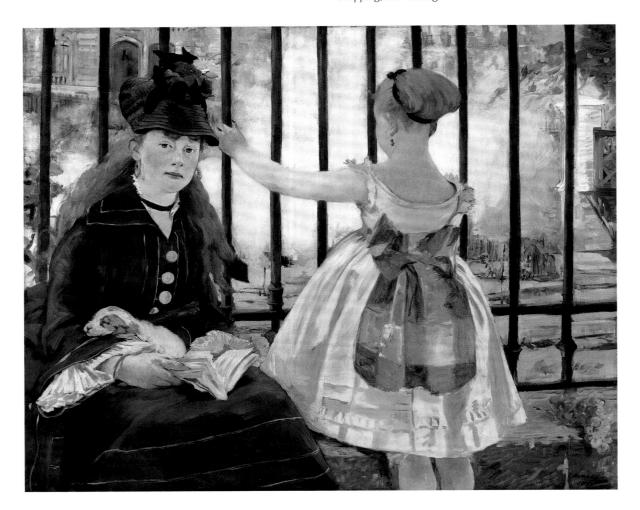

His favorite model, Victorine Meurent, posed with the daughter of his friend Alphonse Hirsch in Hirsch's garden overlooking railroad tracks. Yet this setting was simply an urban pretext, a recognizably Parisian backdrop, to allow Manet to portray his favorite model and detail her splendid blue spring walking dress (perhaps made of twill or light wool), with trendy large gold buttons on the bodice, and matching hat. Given Manet's strong feelings about

fashion, he might have selected or provided for Victorine's blue suit, perhaps to set off the lightweight white summery dress worn by her young companion. By showing her with hair falling down on her shoulders, he suggests that she is a sister or young governess rather than a mother. Likewise, in *Woman Reading* (cat. 122), Manet relied on earlier studies of the backyard of his Bellevue home to paint a studio-created fiction of a woman

Camille Monet on a Garden Bench, 1873

Oil on canvas
60.6 × 80.3 cm (23 ⅞ × 31 ⅝ in.)
The Metropolitan Museum of Art, New York

Even in this relaxed country setting, Monet painted Camille as a fashionable urban Parisienne. Wearing a basque bodice with large cuffs and a flounced, crinolined skirt, Camille accessorized her elegant ensemble with white gloves and a parasol, topping it off with a stylish bonnet. Some scholars have speculated that the sober colors and velvet trim of her formal, restrained attire may indicate that she is in mourning. It is also possible, however, that the recently married Monet wanted Camille's rich, dark fabrics to express her bourgeois respectability.

fashionably dressed—with a fichu, black suit, kid gloves, and black hat—and drinking a mug of beer at an outdoor café.[17]

When Monet painted *Camille Monet on a Garden Bench* (cat. 83), one of his rare plein air works made after the 1860s, he posed her with a gentleman resembling Manet in the backyard garden of his home in the suburbs. Although Monet's many paintings of Camille often show her outdoors in bright, light-reflective frocks, here—perhaps in keeping with the restrained elegance typical of Manet's Parisiennes—he emphasized her haute-bourgeois sobriety. The ensemble, similar to a velvet and damask dress advertised in *La Mode Illustrée* in March of the same year, consists of a tiered and layered underskirt, a velvet-trimmed overskirt, a jacket with deep velvet cuffs, and a matching bonnet and parasol.[18] Leaning over the bench, the male figure is of secondary importance, but his striped trousers, frock coat, and silk top hat are, like the woman's outfit, potent signifiers of wealth and social class. The fashionable silhouette of the female in the background

(presumably a nurse), however, is reduced to a series of white and blue strokes, the details of her dress obliterated by the translation of raking sunlight into paint. She is similar to the female in the background of a contemporary work by Monet, *The Lunch: Decorative Panel* (fig. 4), in which the domestic setting—the enclosed garden of the artist's Argenteuil house—is clearly legible. While several of Monet's compositions from the 1870s painted at Argenteuil feature the artist's house and garden, in *Camille Monet on a Garden Bench*, the prominent placement of the bench in the ordered garden suggests a public park—a rarer subject in Monet's Impressionist years—and the fiction of an elegantly dressed bourgeois couple taking a pause from their stroll.

For female artists, parks were easily accessible spaces for observing modern life, but it was the private interior, or the in-between spaces of balconies and terraces, that provided a natural protective perch from which to experiment with light effects while retaining control over the environment. In Berthe Morisot's *On the Balcony*

FIG. 4. CLAUDE MONET (FRENCH, 1840–1926).
The Lunch: Decorative Panel, c. 1874. Oil on canvas;
160 × 201 cm (63 × 79 ⅛ in.). Musée d'Orsay, Paris,
bequest of Gustave Caillebotte.

(cat. 77), a mother and daughter look out from the railed terrace along the end of the Morisot family's rue Franklin home. Although Morisot's choice of view, overlooking the formerly barren expanse of the Trocadéro hill (which had been landscaped in 1867 for the Exposition Universelle), recognizes the impact of urban change, the painting speaks to intimate relationships within a private space in the still-rural neighborhood of Passy.[19] The sketchy skyline, from which the Baroque dome of the Invalides rises, provides a historical backdrop for the figures of Morisot's sister and niece, who represent modern motherhood. This is a conversation piece carefully set up by the artist to suggest a spontaneous expression of modern life, and as such it shares a similar intention with Monet's *Camille Monet on a Garden Bench*. In both works, fashion and the poses and settings found in fashion plates allowed the artists to experiment with color, light, and their personal styles.[20]

Balconies and windows provided Mary Cassatt and Morisot, as well as Caillebotte, Degas, and Manet, with a field of experimentation for transcribing the light refracting off fabrics and models in interiors, as well as the new stone masonry that had transformed the modern city. Manet's portrait of his wife, *Reading* (cat. 49), contrasts the metal railway bridge glimpsed through the window with the lace curtains, soft cushioning, and gauzy white dress of Madame Manet. Outside are signs of urban transport and action, while inside are soft, transparent fabrics and inactivity. In both *Reading* and Caillebotte's *Interior*, or *Interior, Woman at a Window* (fig. 5), the reading man is of secondary importance to the woman and window. In Caillebotte's composition, however, the woman is not comfortably ensconced within the interior but rather dressed for the street and turned away from the viewer. Like German Romantic paintings, which frequently show women looking longingly onto the landscape beyond, this work highlights the woman's gaze, which falls on the advertisements and shop names that appear on the buildings across the street and below her window.

SHOPPING PARIS

While Caillebotte's view implicitly suggests commercial activity by directing our gaze to the shops at street level, in the decades of the Impressionists' most intense engagement with modern life, it was not shops but *grands magasins*, or department stores, that dominated the cityscape with their particularly lavish architecture. Thus, shopping became part of the experience of walking. As Nancy Forgione pointed out, women could go out unescorted as long as they were moving.[21] One of the reasons women could occupy the streets unchaperoned (at least during the day) was to window-shop.[22] Both the bourgeoisie and shopgirls on limited incomes could study fashion through department store and boutique displays that simulated luxury.

Although little was written about male shopping, the flaneur surely could not have remained immune to the dazzling displays characterizing Paris from the seventeenth century onward. In 1878 the young Italian Edmondo De Amicis found Paris to have a museum-like quality, with its reflections of glass and gilt:

> Ah! Here is the burning heart of Paris. Here is splendor at its height: this is the metropolis of metropolises, the open and lasting palace of Paris, to which all aspire and everything tends. Here the street becomes a square, the sidewalk a street, the shop a museum,

FIG. 5. GUSTAVE CAILLEBOTTE (FRENCH, 1848–1894).
Interior, also called *Interior, Woman at a Window*, 1880.
Oil on canvas; 116 × 89 cm (45 ¹¹⁄₁₆ × 35 in.). Private collection.

FIG. 6. "Exhibition of the Société des Aquarellistes
Français at the Galerie Georges Petit, rue de Sèze, in 1882,"
L'Illustration, February 25, 1882.

L'EXPOSITION DES AQUARELLISTES A LA NOUVELLE SALLE DE LA RUE DE SEZE

the café a theatre, beauty, elegance, splendor, dazzling magnificence, and life a fever. . . . Windows, signs, advertisements, doors, facades, all rise, widen and become silvered, gilded and illuminated. . . . It seems like one immeasurable hall of an enormous museum, where the gold, gems, laces, flowers, crystals, bronzes, all the masterpieces of industry, all the seductions of art, all the finery of riches, and all the caprices of fashion are crowded together and displayed in a profusion which startles, and a grace which enamors. The gigantic panes of glass, the innumerable mirrors, the bright trimmings of wood which extend halfway up the edifices, reflect everything.[23]

In the following year *La Vie Moderne* published a similar observation by the flaneur Nodier on the temptations of store displays:

The shops on the boulevard Montmartre and the boulevard des Italiens seemed to rival each other in the attractiveness of their displays. How beautiful these things were. What a succession of wonderful goods. In which fairy tale was he strolling by? . . . Wasn't this department store interesting, with all its delicate laces, its brocades, its Indian shawls, all the art of Lyon, Mechlin and Cashmere? Can one keep an indifferent eye before such a spectacle?[24]

Both of these breathless descriptions pertain to the commercial district around the Opéra and the avenues of the Italiens, Capucines, and Madeleine, the same neighborhood where the internationally renowned painting dealers Paul Durand–Ruel and Georges Petit had galleries. The latter's luxury gallery on the rue de Sèze (off the boulevard des Capucines) would become the alternative exhibition space for Monet and Renoir (see fig. 6), and the offices of *La Vie Moderne* on the nearby boulevard des Italiens also promoted the Impressionists and neighboring retailers beginning in 1879.[25]

In 1883 *La Vie Moderne* praised the publication of Zola's *Au bonheur des dames* (The Ladies' Paradise), which glorified the department store's increasing preeminence. Like restaurants, operas, and boulevards, which allowed people to see

fashion on parade, department store displays promoted a style of living that featured changing merchandise and up-to-date fashions for a wider public. The *grands magasins*, whose openings, expansions, and seasonal sales were featured in tourist guides, played an important role in modernity, but were rarely, if ever, depicted by the Impressionists or other painters of modern life.[26] Instead, this much-written-about structure—whose characteristic two-story glass rotunda inspired the moniker *cathédrales des temps modernes*—was conspicuously absent from Impressionist compositions.

Even Cassatt and Morisot excluded this feminine pastime from their repertoire, perhaps because they were unable to imagine or allow themselves to be seen in a department store, depending instead on more elite dressmakers and smaller boutiques for their own clothing and painted fashions.[27] Degas, with his paintings of *modistes* and their clients, also focused on the small millinery shops that he may have visited with Cassatt.[28] In her essay "Why the Impressionists Never Painted the Department Store," Aruna D'Souza posited several reasons for the absence of department store imagery in the Impressionists' repertoire, most significantly that the *grands magasins* exposed the "anxieties of the Impressionists to the commercialization of art."[29] Françoise Tétart-Vittu seconds this explanation, concluding that as the Impressionists themselves were fighting for recognition by merchandising their wares in alternative exhibitions or through auctions, they wanted to escape associations with the commercial culture of shopping (see p. 214 in this volume).[30] Another reason the Impressionists distanced themselves from the subject of the department store may have been that many sold paintings of a Realist, conservative, and anti-Impressionist vein, thus promoting a type of work that conflicted with the Impressionist aesthetic and way of marketing themselves. This would help to explain why not only the Impressionists but also Alfred Stevens, James Tissot, Auguste Toulmouche, and many other artists specializing in images of modern life avoided this symbol of middle-class culture altogether. Although these artists experienced the new consumer culture, they chose to focus on leisure entertainments in which fashion, but not its acquisition, featured prominently.[31] Paradoxically, while department stores like Le Bon

FIG. 7. GIUSEPPE DE NITTIS (ITALIAN, 1846–1884).
In the Grandstands, left panel of *Race at the Bois de Boulogne*, 1881. Pastel on canvas; 196 × 106 cm (77 ⅛ × 41 ¾ in.). Galleria Nazionale d'Arte Moderna, Rome.

Marché and Les Grands Magasins du Louvre took on growing real estate and product lines, they also constructed smaller rooms, alcoves, and boudoirs within their larger stores in order to evoke the bourgeois "home" and appeal to individual rather than public tastes.

FASHION ON DISPLAY

According to Nemo,[32] writing for *La Vie Moderne*, to be Parisian and in society (*mondain*) was to be a participant in its rituals: in the winter, theater, balls, parties, and concerts; in the spring, races; and in the summer, bathing at beaches.[33] While there were no fashion shows per se until the later nineteenth

century, these activities offered opportunities to display fashion in everyday life. Department stores announced *expositions des modes* at different seasons, and couturiers made sure that their clothing appeared on the wealthy or celebrated. The Bois de Boulogne, a venue for riding on horseback or in carriages, was an unofficial fashion show.[34] Renoir's monumental *Riding in the Bois de Boulogne* (1873; Hamburger Kunsthalle), rejected at the Salon of 1873, was a blatant attempt to tap into the high fashion world by depicting his bourgeois client Madame Darras bedecked in a riding habit with veil. Manet painted several images of the *amazones* of the Bois de Boulogne, including the comely *Young Woman in a Round Hat* (cat. 127), a variation on the horsewoman theme, with a parasol substituted for a riding crop.

Like horseback and carriage riding, the horse races at the Hippodrome de Longchamp, also in the Bois de Boulogne, offered opportunities for displaying fashion.[35] Giuseppe De Nittis's large pastel triptych *Race at the Bois de Boulogne* (fig. 7) shows a woman wearing the new cuirass bodice (slim at the hips and without a bustle) in a popular

silvery lavender. For his subject, he drew directly from Béraud's 1881 series of graphic illustrations of the Grand Prix commissioned by *Le Figaro* (see fig. 8) to illustrate an article stressing fashion over sport. Both Degas and Manet were also frequent visitors to the races, the former concentrating on the horses and jockeys and the latter on the spectacle of the crowds in the stands. Their paintings diverged from De Nittis's and Béraud's more detailed representations of well-heeled spectators. Manet's *The Races at Longchamp* subverted fashion statements to focus on the race itself (fig. 9). The triangular silhouettes of the crinolined dresses and *paletots* are identifiable through the shorthand brushstrokes with which the artist whipped up the spectators, showing them as if seen from the viewpoint of the jockeys passing by.

A few years later, Degas made a different fashion statement when depicting horseracing. In *Woman with Binoculars* (cat. 84), a single female wearing a lemony summer dress with trendy "bishop" sleeves and skin-colored gloves intently observes the scene before her, perhaps a sporting event. Although Degas did not show the object of her scrutiny, we know from another painting, *At the Racetrack* (fig. 10), that she was originally paired with a male figure (resembling Manet) and placed in front of horses with jockeys. While the artist made many drawings of this model, he painted her out of the final composition, which was known as *The Racetracks (The Jockeys)* until 1960, when layers of overpaint were removed, revealing the woman with binoculars. In this "recuperated Degas,"[36] the fashionable figures seem almost staged, as if in a photographic studio, with the horses and jockeys serving as a painted backdrop to set off their dark elegance.[37] In the smaller painting, the force of Degas's lone observer is greater; her face blocked by her binoculars, her impact stems from both her unself-conscious gesture and her bright dress with matching bonnet and multiple lace-trimmed flounces (datable to 1874–75), which denote assured elegance, stylishness, and wealth.[38]

In 1874, a year or so before Degas painted *Woman with Binoculars* (cat. 84), empowering his subject with the gaze usually reserved for men looking at women, James Tissot exhibited *The Ball on Shipboard* at the Royal Academy (cat. 85).[39] His goal seems to have been to show a mix of young women and older men, whose similar but not necessarily

FIG. 8. JEAN BÉRAUD (FRENCH, 1849–1935). "The Weighing of the Jockeys in front of the Grandstands," *Le Figaro*, June 12, 1881.

Devant les Tribunes de l'Enceinte du Pesage.

CAT. 84 Edgar Degas (FRENCH, 1834–1917)
Woman with Binoculars, 1875/76

Oil on cardboard
48 × 32 cm (18 ⅞ × 11 ⅞ in.)
Staatliche Kunstsammlungen Dresden,
Galerie Neue Meister

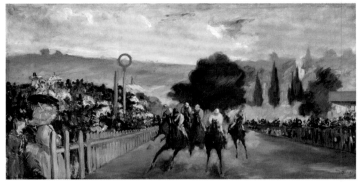

FIG. 9. ÉDOUARD MANET (FRENCH, 1832–1883).
The Races at Longchamp, 1866. Oil on canvas;
43.9 × 84.5 cm (17 ¼ × 33 ¼ in.). The Art Institute of Chicago,
Potter Palmer Collection, 1922.424.

FIG. 10. EDGAR DEGAS (FRENCH, 1834–1917).
At the Racetrack, c. 1868. Oil on panel; 45.7 × 36.8 cm
(18 × 14 ½ in.). Private collection.

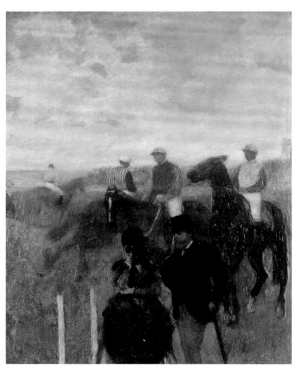

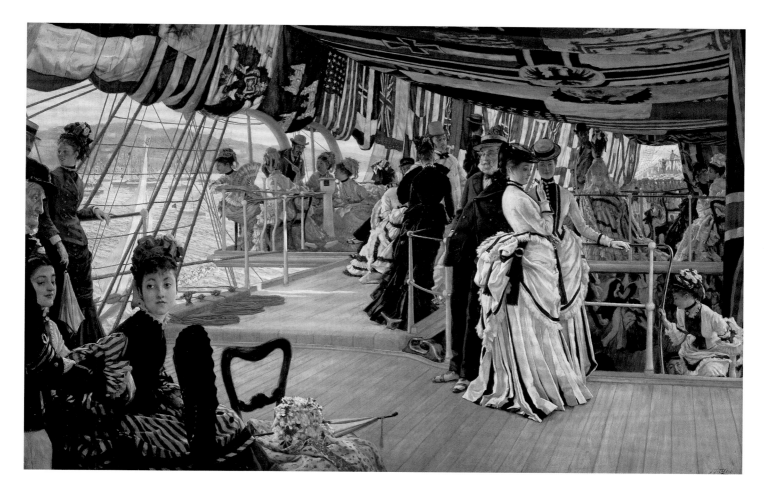

CAT. 85 James Tissot **(FRENCH, 1836–1902)**
The Ball on Shipboard, c. 1874

Oil on canvas
84.1 × 129.5 cm (33 ⅛ × 51 in.)
Tate

The Ball on Shipboard is Tissot's commentary on London's upwardly mobile society. Tissot lived and worked in the city after fleeing Paris during the Commune. Paris's economic depression created new wealth in London, as well as access to Parisian fashion and opportunities for social climbing. Tissot's satirical scene illustrates vulgar social strivers, complex dress codes, and the role of appearance in a society in which purchasing fashionable clothes was one way to obtain social status.

FIG. 11. LÉON DU PATY (FRENCH, ACTIVE 1869–1880).
"At the Salon, Evening," *La Vie Moderne*, July 3, 1879.

equal social standings were expressed through fashion. The central females do not interact but instead strike poses to show off the fabrics, cuts, and silhouettes of their dresses, and the men function as the secondary accessories often featured with women in fashion plates. Some dresses are à la mode, such as the one worn by the woman right of center with the exaggerated bustle, and others, such as the deep-blue silk walking dress, are the dernier cri. The gaggle of women at the back, who wear identical, vaguely eighteenth-century light-turquoise dresses, are less recogniz-ably stylish. The repetitive quality of the dresses and the fact that they show more décolletage than was admissible for a daytime event made the women suspect or, as one author put it, from "other classes."[40] Critics found *The Ball on Shipboard* vulgar, with "no pretty women, but a set of rather more showy than elegant costumes, some few graceful, but more ungraceful attitudes, and not a lady in a score of female figures."[41] Tissot, the son of a tailor and a seamstress, had an intimate knowledge of fashion and a flair for painting all varieties of fabrics, furs, laces, and rugs, among other signs of material wealth. His use of fashion was problematic, however, causing his paintings

to be hailed as elegant but enigmatic, symptomatic of fashion but also caricaturing its inherent superficiality.

NIGHTTIME ENTERTAINMENTS: FASHION ILLUMINATED

The idea of night light and, correspondingly, night life was directly linked to innovations in lighting inaugurated at the Exposition Universelle in 1878.[42] "Illumination discourse," as Hollis Clayson labeled it in her groundbreaking research on the effect of the new electric light, was largely embraced by those who wanted to extend the effects of daylight into the evening.[43] As a result of this greater illumination, the Salon was able to stay open later and became a destination point for women and families (see fig. 11). In *La Vie Moderne* René Delorme suggested that the evening Salon's success was getting people out at night during the uneventful post–Opéra season. To further encourage more public activity, he suggested that the city construct a lighted, glass-domed gallery to supplant the narrow *passages* (covered arcades) and offer an opportunity for strolling the boulevards after dark:

> [The glass-domed street] was missing in Paris. We understood it when we went to the Salon, in the evening, our actual passages are ridiculous. From its basement, *La Vie Moderne* looks out contemptuously at the passage des Princes [and] the passage des Panoramas, neither of which has the height of our great sewage system. The passages Verdeau and Jouffroy are only hallways. . . . What we need, in the heart of Paris, is a large and beautiful glass gallery. A domed boulevard. . . . Paris wants and deserves better and more. We need to finish the boulevard Haussmann, and to cover up the portion between the boulevard des Italiens and the rue Taitbout. It's a real project and a good one. The success of the evenings at the Salon proves it. Let's ask a member of the City Council to write a proposal to whomever is in charge.[44]

Although images of people walking the boulevards at night abounded in the popular press, and despite

CAT. 86 Berthe Morisot **(FRENCH, 1841–1895)**

Young Woman in a Ball Gown, 1879

Oil on canvas
71 × 54 cm (28 × 21 ⁵⁄₁₆ in.)
Musée d'Orsay, Paris

Surrounded by floating impressions of flowers, which also adorn the front of her gown, Morisot's seated young woman almost blends into the background of this painting. Her white gloves are barely visible against her pale complexion and the décolletage of her cuirass bodice. Dressed according to the latest fashion in evening wear, this refined young woman appears strikingly similar to the women in a fashion plate from an 1880 issue of the *Journal des Demoiselles* (cat. 87). Her style communicates youth, trendy elegance, and active participation in public life, portraying her as a typical modern woman.

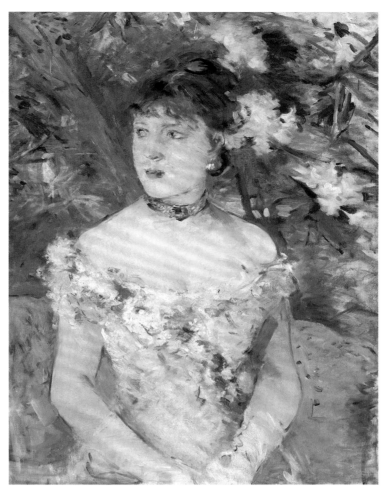

CAT. 87 "Two Women in Evening Dresses,"
Journal des Demoiselles, 1880

Steel engraving with hand coloring
Sheet: 24.8 × 17.8 cm (9 ¾ × 7 in.)
The Metropolitan Museum of Art, New York

The young ladies in this 1880 fashion plate from the *Journal des Demoiselles* are styled very similarly to the subject in Morisot's painting from the previous year, *Young Woman in a Ball Gown* (cat. 86). In the illustration, both young women wear luxurious evening gowns in the elongated silhouette popular from around 1876 to 1883. Their dresses feature sleeveless cuirass bodices with decorated plastron front panels; off-the-shoulder, décolleté necklines; and long, narrow skirts draped horizontally with apron-style overskirts. Like Morisot's young woman, these figures have coiffures fashioned with curled bangs and adorned with flowers, suggesting the painter paid careful attention to the ideal modes shown in contemporary fashion magazines.

CAT. 88 Mary Cassatt (AMERICAN, 1844–1926)
Woman with a Pearl Necklace in a Loge, 1879

Oil on canvas
81.3 × 59.7 cm (32 × 23 ½ in.)
Philadelphia Museum of Art

With this painting, Cassatt entered boldly
into Impressionism, as one critic noted when
he saw this work at the Fourth Impressionist
Exhibition. Cassatt's use of unconventional
colors to achieve the effect of the reflected,
artificial indoor lighting of the theater
prompted some critics to call her subject's skin
dirty. The young woman's formal décolleté
evening gown is tastefully accessorized
with a single strand of pearls, a corsage,
and a flower in her hair. The fan in her gloved
hand completes her decorous ensemble,
but her relaxed posture and half-smile
demonstrate that she is actively—indeed
unself-consciously—enjoying her evening.

CAT. 89 Charles Frederick Worth
(ENGLISH, 1825–1895)

Ball gown, c. 1886

Ice blue satin, ice blue uncut ribbed
velvet, cream lace, ice blue chiffon,
ice blue ball fringe, ice blue beads,
artificial flowers, ice blue silk plush
Museum of the City of New York

Worth, the premier couturier of his day,
was often the source of new fashion
trends and silhouettes that were then
introduced to society by Empress Eugénie
and later, in the 1870s and 1880s, by
his many European and American clients.
Here, ice blue ribbed velvet is combined
with luminous satin to create a gown
of subtle and ethereal contrasts. Lace and
flowers frame the shoulders and beaded
fringe trims the edge of the overskirt;
it would have trembled with every subtle
movement of the wearer. A special room
in Worth's atelier, the "salon de lumière,"
was lit first by candlelight, later by gas
lamps, and eventually by electric fixtures,
so clients could preview how the fabrics
and colors they selected would look
under artificial light.

CAT. 90 Jean Béraud (FRENCH, 1849–1935)

A Ball, 1878

Oil on canvas
65 × 117 cm (25 ⅝ × 46 ¹⁄₁₆ in.)
Musée d'Orsay, Paris

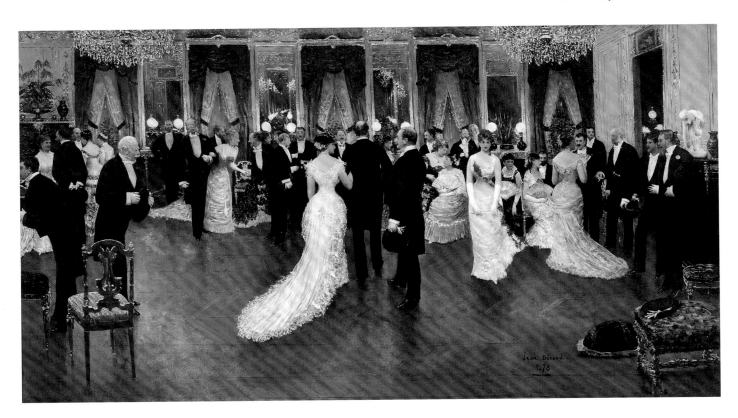

increased nocturnal illumination, the Impressionists and their circle painted only institutions of night-time entertainment and not the street experience.

Morisot's *Young Woman in a Ball Gown* (cat. 86), shown at the Fifth Impressionist Exhibition, suggests the experience of an opera or ball. The model's upswept chignon, jeweled collar, décolleté, off-the-shoulder gown, and white kid gloves are the uniform of an evening out. The upholstered sofa and garden backdrop, however, seem to have been literally dropped in, reminding us that the scene is a fiction. Morisot's painting speaks to a domestic (or studio) conception and does not depend on a recognizable public setting, unlike Renoir's *The Loge* (cat. 12) or Cassatt's *Woman with a Pearl Necklace in a Loge* (cat. 88). In both of these works, the setting of the theater box, a comfortable inner sanctum amidst a larger public spectacle, underscores the reading of the Parisienne and nightlife.[45]

Cassatt exhibited *Woman with a Pearl Necklace* at the Fourth Impressionist Exhibition, in 1879. She may have painted the sitter in her studio, but her ability to translate the gaslit interior, sensations

of light on skin, and the mirrored reflection of gilt-trimmed balconies suggests an observed experience that belies the studio setup. Although her model's open expression and fidgety, excited posture suggest she is new to the theater, her fashion adheres closely to the highly controlled culture of the theater box. She is an ingenue wearing a wide décolleté gown, bows at the shoulders, and real or artificial flowers at the neckline. Her decorative fan has an expensive mother-of-pearl handle, and her kid gloves are perfectly fitted. She wears suitably understated jewelry, signaling her youth and unmarried status.[46] The sense of immediacy in Cassatt's painting is analogous in spirit, if not in palette and technique, to that of Renoir's *The Loge* and his even more compellingly "modern" painting *Acrobats at the Cirque Fernando (Francisca and Angelina Wartenberg)* (1879; Art Institute of Chicago), which shows circus performers posing in the controlled light of his studio.

Although also based on observed experience, Béraud's contemporary portrayal of a society ball, exhibited at the Salon of 1878 (cat. 90), appears ponderous compared to the vitality and freedom suggested by Cassatt's painting. Women in white

and men in black are self-consciously posed across the expansive ballroom. The frieze of black figures punctuated by the pastel ball dresses with languid trains speaks to the popularity of these form-fitting, mermaid-style dresses, a model invented by Charles Frederick Worth. When this work was exhibited, however, Béraud's loose handling and simplified outlines struck one reviewer as showing an "'Impressionist' technique" and a scene of *la vie mondaine* (high society) "so spiritual and so animated, it is a true challenge with its lit lamp posts, its well-dressed women and its men dressed in black suits."[47] Béraud's emphasis on the black-and-white evening wear rarely shown in Impressionist scenes of modernity was also criticized as monotonous, dreary, and inappropriate for decorative and ornate interiors. Referring especially to Charles Garnier's Opéra, Delorme opined:

> A black suit is ugly, two black suits are even more so. But nothing compares to the ugliness of the reunion of several thousand black suits. I have sometimes wondered which inexplicable oddity has made our generation wear this funerary costume in the gorgeous decor of the palace of Charles Garnier. The staircase of the Opéra, with its gold, its marble, its onyx appeals for a grand costume that our mundane uniform will never grant.[48]

When the Impressionists painted theater or opera boxes, they limited their focus to one or two figures, without describing the occasion or architectural setting. Part of the popular appeal of Béraud's fashionable gathering was that it included aristocrats, politicians, and *grandes dames* who were recognizable to visitors and reviewers of the Salon. This was not true of Tissot's depiction of a couple entering a society ball painted the same year (cat. 91). Although the background includes equally well-dressed guests, the subject of the painting is the social climber, whose rapacious eye scans the crowd, while her older consort looks determinedly ahead. In this version of the composition, Tissot featured the recently divorced Kathleen Newton in the title role. Her garish orange and yellow ruffled gown, with a high neck topped off with a ribboned hat more appropriate to day wear, was considered démodé by 1878 and even more out of

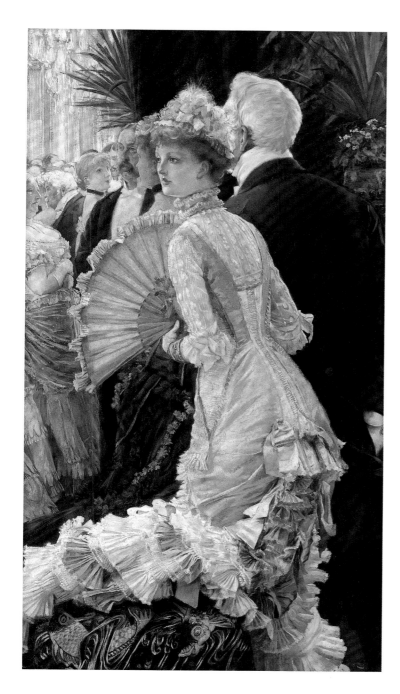

CAT. 91 James Tissot **(FRENCH, 1836–1902)**

Evening, 1878

Oil on canvas
90 × 50 cm (35 ⁷⁄₁₆ × 19 ¹¹⁄₁₆ in.)
Musée d'Orsay, Paris

The golden yellow gown worn by Tissot's English mistress Kathleen Newton, with its tight princess bodice and low, abundantly flounced and pleated train, was hailed as "worthy of Worth"; one critic predicted its pleasing trims and colors would be an inspiration to dressmakers. Its lace sleeves and high neck worn with a hat are an unusual choice that would have been thought more appropriate as an evening ensemble than for a ball, where typically women wore low décolletage and bared their arms. In contrast to Newton's body-skimming dress, the matron to the left wears a bustle gown, a style that was popular several years earlier, perhaps because the newer—and ultimately short-lived—princess silhouette was only flattering to the young and slender.

CAT. 92 James Tissot (FRENCH, 1836–1902)

The Circus Lover from the series *Women of Paris*, 1885

Oil on canvas
147.3 × 101.6 cm (58 × 40 in.)
Museum of Fine Arts, Boston

In this painting, the female spectators wearing the choicest fashions are as much on display as the performers. The small hats perched atop the heads of the two women in the foreground are of a style often embellished and amplified with feathers, bows, and stuffed birds. The high necklines, gloves, and fans comprising the ensembles suggest respectability; however, by depicting a crowd of vivacious, unescorted women blatantly gazing at male performers and directly confronting the viewer, Tissot hinted at the changing role of the newly emboldened Parisienne.

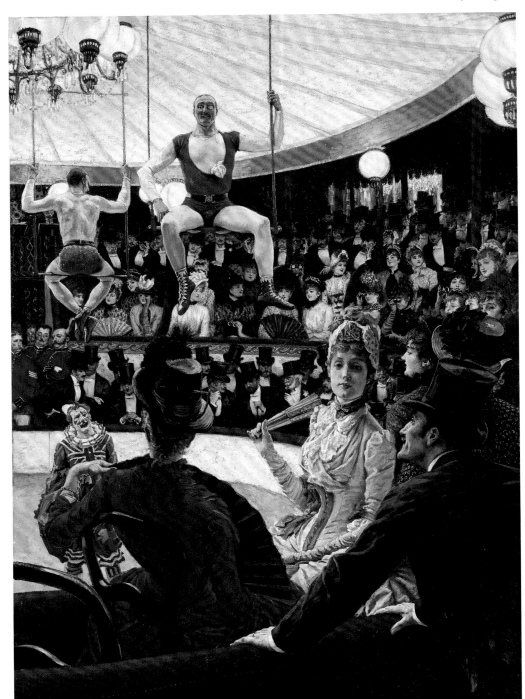

fashion in 1883–85, when the artist repeated and expanded the composition, showing a more generalized female model. Tissot intended these canvases to be a painted parallel to an etched series entitled *Women of Paris* that illustrates short stories by Guy de Maupassant, Zola, and other leading authors of the day. Exhibited in 1885 at the Galerie Sedelmeyer in Paris, the series was criticized for showing Parisiennes who were not even French (see cat. 92). It was seen as an Anglophile's caricature of women pretending to be French.[49] The women were deemed vapid, and the garishness of Tissot's palette and highly descriptive style were compared to colored photographs and other cheap reproductions.[50] Was Tissot, known for his exquisite fashions and enigmatic but elegant females, making a statement about modern women, no longer confined to the domestic sphere, or was this series a tongue-in-cheek poke at the Parisienne, who felt bound to display herself in the public arena?

The balls and other social events imaged by Béraud and Tissot were not subjects with which the Impressionists were familiar, and while they painted boulevards, parks, and squares, they did not focus on the commercial center of Paris, which by the 1870s encompassed the shops and department stores radiating out from Garnier's Opéra. By the 1880s, in fact, the excitement of Haussmann's urban experiment, so enthusiastically embraced by Paris's visitors and more ambiguously expressed in the paintings of the Impressionists, had worn off. Walking the city or consuming its modern entertainments continued to engage progressive artists, but the depiction of fashion was not as central to the evocation of those experiences for Post-Impressionist painters.

Along with this increasing disinterest in the city, the Impressionists turned away from depicting its most paintable denizens: the flaneur and Parisienne. Zola's early assessment of Monet as a "true Parisian" who could not paint a landscape without including well-dressed men and women was no longer applicable. With Camille's death in 1879, Monet increasingly left Paris to paint new topographical challenges that had nothing to do with fashion and the Parisienne. By the 1880s, Caillebotte too had left Paris entirely and refocused his art on the property around his home at Gennevilliers. Manet's series of fashionable Parisiennes begun around 1879–80 was divorced

from the urban backdrop of racetracks, bars, cafés, and gardens found in his paintings from the 1870s. And Renoir's expanded social circle by 1879 provided exposure to, and portrait commissions from, ultra-fashionable clients, which made it unnecessary for him to reimagine fashion for fictions of modern life.

The fashion industry, which had allowed fashion to trickle down to the middle class and become a generator of new ideas in the intellectual circles of Paris, had fulfilled Zola's prophesies in *Au bonheur des dames* but at the same time had been neutralized by its own success—a phenomenon implicit in Georges Seurat's massing of similarly attired women in *A Sunday on La Grande Jatte—1884* (cat. 137).[51] Indeed, by the last decade of the century, a completely new style and paradigm emerged for depicting Paris and reimagining the Parisienne, whose "fashioning" would be taken up by the artists and decorators of Art Nouveau.

Gustave Caillebotte
Paris Street; Rainy Day

Aileen Ribeiro

A new art, just as noble as the old, a completely
modern art, suitable to the needs of our time.
—Joris-Karl Huysmans[1]

If any one painting can be said to sum up the
modern city during the second half of the nine-
teenth century, a good candidate would be Gustave
Caillebotte's vast and audacious *Paris Street; Rainy
Day* (cat. 93). Here we do not see the sunny, mellow,
pleasurable scenes of Paris depicted by Caillebotte's
contemporaries, but rather the gritty reality of a
gray, rainy day in the new bourgeois Paris created
by Georges-Eugène Haussmann. The prefect of
the Seine was hired by Napoléon III at the begin-
ning of his reign to make the capital a modern city,
with wide boulevards, parks and public spaces,
large theaters, hotels, shops, and impressive
residential areas.[2] The site of Caillebotte's painting
was identified by Kirk Varnedoe as the carrefour
created by the intersecting rues de Moscou,
Turin, Saint-Pétersbourg, and—in the center of
the canvas—Clapeyron, a quartier typical of late
Haussmannization and familiar to the artist, who
lived close by on the rue de Miromesnil. This
was the Paris that Caillebotte loved, "the outsized
scale of its spaces and the inhuman regularity of
its architecture."[3]

With its wide-angle perspective, odd
convergences, and disparity of scale, as well as
the looming building that dominates the scene
(presumably with shops on the ground floor,
although they cannot be identified),[4] the phrase
"étrange-exact"—applied by Joris-Karl Huysmans
to Edgar Degas's work—seems singularly
appropriate to *Paris Street; Rainy Day*.[5] The painting
is a depiction of modern life—both personal

(the attractive couple in the right foreground) and
impersonal (the dark uniformity of the pedestrians
with their umbrellas)—as clothing and architecture
come together in muted, somber colors. In his
book *L'Art dans la parure et dans le vêtement*
(Art in Ornament and Dress; 1875), Charles Blanc,
art critic and cofounder of the *Gazette des Beaux-
Arts*, claimed that both architecture and dress—
particularly that of men but also women's practical
everyday wear—were governed by similar rules,
such as symmetry, repetition (variety had charm but
"repetition has more grandeur"), and economy of
decoration.[6] These features of modern life, however,
often created a sense of alienation and isolation.
The predominant darkness of outdoor clothing
was linked to the grayness of buildings and streets,
and created a tendency for people to merge into
their surroundings, lose their individuality, and
retreat into their own private worlds. The over-
whelming sense of grayness in modern life was
frequently alluded to by contemporaries; "in our
cities," said Gabriel Prévost, "the street is gray . . .
gray also are the walls which have been battered
by hail, rain and snow; the paving stones are gray,
and also the air full of mist and fog." "In such
a gray climate," he continued, "all colors worn in
the streets become subdued and muted."[7] For this
reason, Caillebotte gave a bluish tint to some of the
clothes in his painting, both softening the harshness
of the prevailing blackness of menswear and
accurately reflecting how clothing merged into the
prevailing grayness of this kind of urban atmosphere.

This is the subject of *Paris Street; Rainy Day*,
probably begun in the fall of 1876 and completed in
the spring of the following year, when it was shown
at the Third Impressionist Exhibition. While many

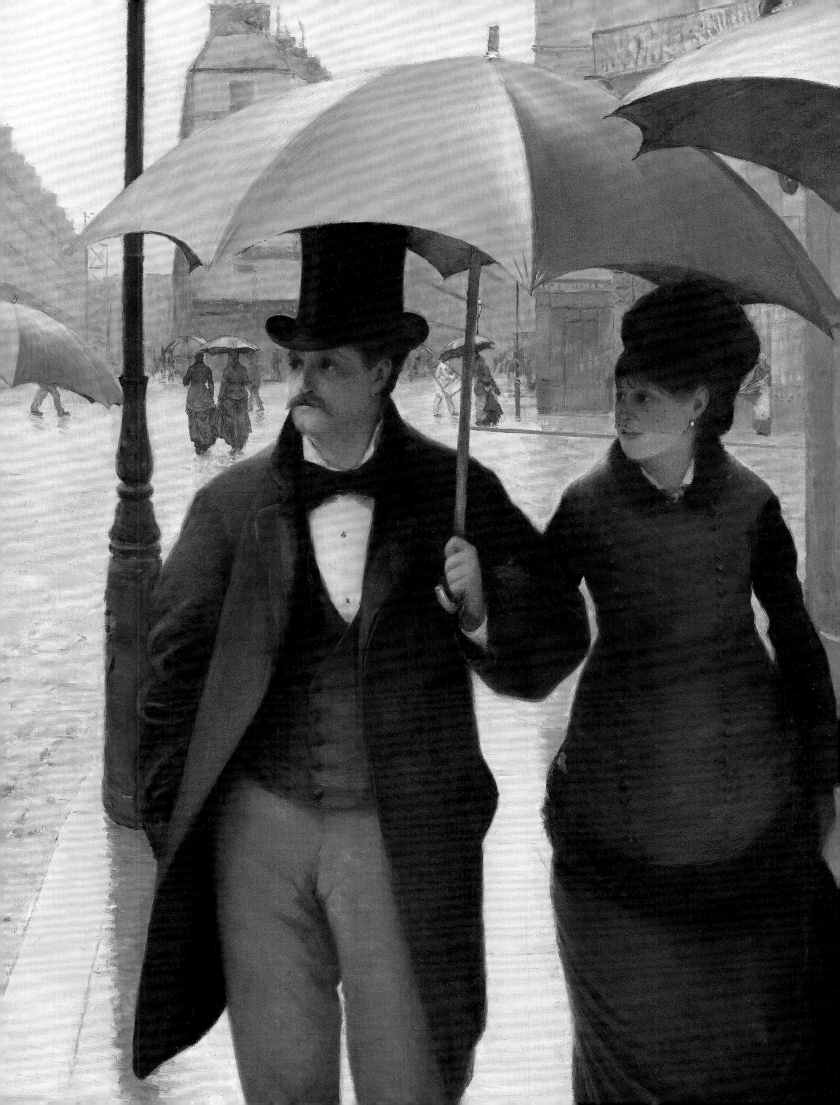

CAT. 93 Gustave Caillebotte (FRENCH, 1848–1894)

Paris Street; Rainy Day, 1877

Oil on canvas
212.2 × 276.2 cm (83 ½ × 108 ¾ in.)
The Art Institute of Chicago

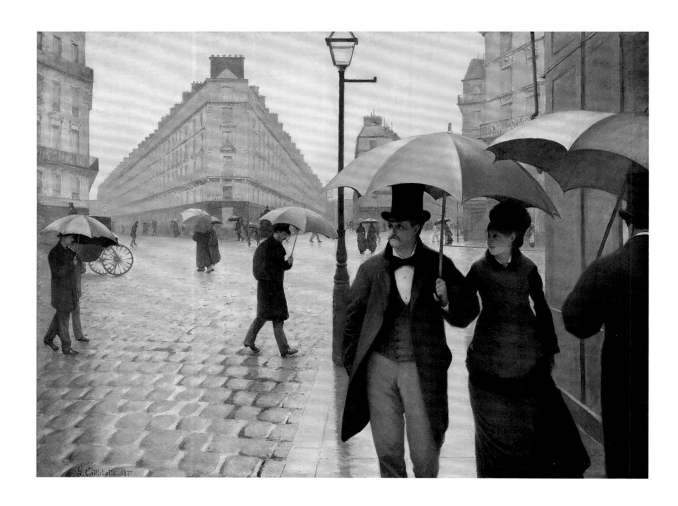

critics found the painting too gray, large, and impersonal; disliked the way the streetlamp cut the picture in half; and disapproved of the fact that the two main figures were cut off at the knees, the journal *Le Radical* admired the central characters with their "modern costume, modern faces."[8] Émile Zola also found much to praise, declaring the couple "very real" and Caillebotte an artist "who shows the finest courage and who does not hesitate to treat modern subjects on a life-sized scale."[9] Modern subjects, of course, were de rigueur for the *nouvelle peinture* and for the Impressionist artists whom Caillebotte first joined in 1876 at their second exhibition, but both contemporaries and later

critics saw him more as a social realist than as a true Impressionist. From a wealthy bourgeois family (he was able to support less well-off artists and promote their work),[10] Caillebotte was drawn to Realist writers like Zola and to the ways in which photography could both depict and exaggerate the realities of the modern city. It seems highly probable that he used photography in the preparation of *Paris Street; Rainy Day*.[11]

Apart from the architecture and the two main figures, the most eye-catching aspect of the scene is the umbrellas, which create a sense of decorative unity in the large canvas. The umbrellas seem to be identical, made of waterproof gray silk stretched

over a curved steel frame; inexpensive, and even slightly flimsy, they look as if the artist ordered them in bulk. Even *Le Radical* suggested that they had been bought from a department store such as Les Grands Magasins du Louvre or Le Bon Marché.[12] The umbrella—like the dark masculine clothes— is a functional symbol of Baudelairean equality; as E. M. Forster wrote ironically in *Howards End* (1910), "The angel of Democracy had arisen . . . proclaiming, 'All men are equal—all men, that is to say, who possess umbrellas.'"[13] Most writers saw the umbrella as a sign of protective anonymity amid the bustle and clamor of urban life; it creates a space around the person carrying it, enclosing and protecting him or her from other people as well as the weather.[14] If care is not taken, however, collisions with others carrying umbrellas can easily occur, especially on narrow sidewalks; the umbrella of the man on the far right of *Paris Street; Rainy Day* seems about to crash into the one held by the elegant young couple.

Although the painting is filled with umbrellas, is it really raining in the scene? This was a question that exercised the minds of some critics of the painting. "The open umbrellas are all of a uniformly silvery tint," said Roger Ballu in *La Chronique des Arts et de la Curiosité*, "yet the rain is nowhere to be seen." *Le Petit Journal* even wondered if the white reflections suggested snow, although "there is not a single flake on people's clothing."[15] Caillebotte's title for his painting was *Rue de Paris, temps de pluie*, which encompasses both the idea of rain and the presence of rain in the air in the form of fine drizzle—difficult to see but persistent enough to make the paving stones shiny and slightly slippery. If the form of precipitation was actually a light drizzle, the people depicted in the composition may be unsure if it has stopped raining, or may wish to protect their clothes and silk top hats from moisture and raindrops dripping from buildings and shop fronts. This is the sort of speculation that writers like Georges Rivière rightly dismissed; he declared in *L'Impressioniste* that if there was no rain, his fellow critics were naive to complain about its lack, for the painting was a "study of atmosphere and light."[16] Michael Fried offered the less plausible argument that raindrops would "break the absorptive mood that Caillebotte has summoned and maintained."[17]

The question of rain is just one of the many aspects of the painting that make the viewer stop and wonder, but the main puzzle surely relates to the unidentified man and woman who dominate the right side. Well dressed, they are a personable pair and thus immediately attract the viewer's notice; as Blanc commented, "To adorn a person or thing is not simply to cause them to be seen, it is to cause them to be admired; it is not simply to draw attention to them, it is to lead the spectator to regard the object or person beautified with feelings of pleasure."[18] They seem an unlikely couple. The woman is a bourgeoisie, dressed with muted elegance. Her self-contained neatness contrasts with her companion's expansiveness and careless grace, his coat lying open despite the weather. An artist-flaneur (as perhaps Caillebotte saw himself in the 1870s), he seems mentally disengaged from his companion and looks as though he might be happier on his own. The flaneur (a term defined in the 1830s), needing to pass unnoticed as an observer of city life, was essentially solitary; usually a dandy, with wit and more aesthetic taste than an upper-class man, he displayed the same "aloof manner [and] fastidious dress."[19]

CLOTHING THE PAINTING

Everywhere, behind the practical rationality of consumption and behaviour in dress, lurk meaning and social values.
—Philippe Perrot, *Fashioning the Bourgeoisie: A History of Clothing in the Nineteenth Century*[20]

Early in the twentieth century, the sociologist Georg Simmel noted the tension between the uniformity of fashion and the need for differentiation, for a sense of the individual. Looking at the uniformity of middle-class men's dress in general in the later nineteenth century, and specifically in *Paris Street; Rainy Day*, we can appreciate Simmel's comment, "Fashion is imitation of a given pattern . . . it leads the individual onto the path that everyone travels."[21] The men in the painting (apart from the workman carrying a ladder in his loose white smock and light trousers) all wear dark coats and trousers, with just a glimpse of white linen at the neck; they are all

middle class—appropriately so, as Caillebotte was described by Huysmans as the painter of the bourgeoisie.[22]

John Carl Flügel, in his book *The Psychology of Clothes* (1930), described the "great masculine renunciation" of menswear in the nineteenth century, suggesting that—in the words of Blanc—"man abandons colour to women; he himself becomes colourless and sombre."[23] Flügel attributed this dramatic change in masculine appearance to the "new social order" created by the French Revolution and the resultant need for clothing that expressed "the common humanity of all men," which could be best achieved by "greater uniformity of dress" and "greater simplification."[24] The notion of the "great masculine renunciation" is something of an exaggeration—lighter colors were available for a range of informal occasions—but it is true to say that men became more conservative in their dress, less prone to adopt the frequent changes that characterized female fashion, and—as Penelope Byrde noted—"visually less arresting." She explained, "Men do not necessarily aim to be self-effacing . . . in their dress, but some of the traditional masculine ideals such as self-control when expressed in dress, lead to understatement and subtlety."[25]

FIG. 1. RENÉ MAGRITTE (BELGIAN, 1898–1967).
Golconde, 1953. Oil on canvas; 80 × 100.3 cm
(31 ½ × 39 ½ in.). The Menil Collection, Houston.

By the mid-nineteenth century, both middle- and upper-class men had adopted a uniform dominated by dark hats and coats, a trend that continued well into the twentieth century. In René Magritte's 1953 *Golconde* (fig. 1), men wearing black bowler hats and black coats (replicating the artist's own appearance) fall from the sky like huge raindrops. The clothing in Magritte's painting, like that in Caillebotte's, symbolizes the world of the professional worker, of practicality and the sartorial safety of the tribe. Blanc stated that menswear should indicate status, gravity, stability, symmetry, and freedom of movement (see cat. 94).[26] Compared to the complexities of contemporary female dress, which was prone to exaggeration and bodily distortion, men developed clothing that was, as Anne Hollander said, more natural and related to the shape of the body, expressing "a confident adult masculinity . . . the modern look of carefully simplified dynamic abstraction that has its own strong sexual appeal."[27] Although her words are applicable to menswear in general, Hollander referred to the suit, coat (jacket), waistcoat, and trousers, which had been the main items in the masculine wardrobe since the late seventeenth century and, by the time Caillebotte painted *Paris Street; Rainy Day*, were plain and somber in color and predominantly made of woollen fabrics. Alternatives to the suit included a range of jackets that did not match the trousers. Among the preliminary sketches for *Paris Street; Rainy Day* are images of men in jackets known as university coats (a style from England popular with young men), which are cut away sharply at the front, as well as the loose, unstructured jackets worn by artisans and working men. All these gave way in the final work to the longer overcoat, a garment that added unity and gravitas to the scene.

Functionality and comfort were essential attributes of good tailoring, as the *Journal des Tailleurs* commented in 1877: "The general aspect of modern costume may be described as easy fitting, without extreme tightness, and with an idea of comfort which is not carried to a point of exaggeration."[28] But as the same tailoring manual observed, comfort should not be emphasized to the extent that a man's appearance might be thought slovenly: "Men say they study *comfort*, but appropriateness

FIG. 2. GUSTAVE CAILLEBOTTE (FRENCH, 1848–1894).
Preliminary study for the couple in *Paris Street; Rainy Day*,
1877. Graphite and charcoal on buff paper; 47 × 30 cm
(18 ½ × 11 ¹³⁄₁₆ in.). Private collection.

should also be studied," and they should note, for example, that on some occasions a more formal coat, the frock coat (redingote), should be worn in preference to the looser overcoat (which enabled men to walk with their hands in their pockets).²⁹ The frock coat was a formal, structured coat, fitted to the figure, and usually with a seam at the waist, but the most popular style, especially for walking outdoors, was the overcoat or *paletot*. Of varying lengths (it was originally a square-cut loose jacket), the *paletot* was a practical woollen coat, usually single-breasted and simple in shape; it was the "ideal product of democratic leveling," for such a uniform garment could hide other, possibly inferior, clothes.³⁰ Such coats "occupy the principal place among the choice of garments," and they could be dark in color, like those worn by the majority of men

in Caillebotte's painting, or in "light colours, the various shades of gray, grayish brown, olive gray, mouse color" for the warmer months.³¹ The coat of the artist-flaneur in *Paris Street; Rainy Day* is open (and, curiously, lacks buttons or buttonholes), providing a contrast to the dark coats and trousers of his fellow pedestrians. The rest of his outfit is thus revealed—a white shirt, a black cravat knotted in a bow, a waistcoat cut across at the waist, and gray trousers, fairly narrow in cut, that fasten with a fly front, a style in general use by the 1870s. His clothing is a harmonious series of grays, the white shirtfront and glossy black of the top hat a counter-point to the rest of his outfit. Blanc claimed that in the work of great masters such as Titian, Rembrandt, and Van Dyck, the brightness of linen had to be "softened" by warm glazes and tints; in contemporary paintings, however, linen, highly starched and "distressing to the eye," had to be largely covered up by a completely fastened waistcoat.³² Caillebotte's elegant flaneur obeyed this dictum, his double-breasted waistcoat fully buttoned over a stiffened shirtfront fastened with gold studs.

In any portrait (and this is surely one), the head plays the most important role; the man's refined features, with a slightly haughty and melancholy expression, seem appropriate for a flaneur. Blanc noted that the expression was formed through the choice of facial hair—particularly the moustache, "a sign of a manly temperament"—but that it had to be natural, not like the pointed moustaches popular in the Second Empire, which had to be kept in place with "the use of a cosmetic, easily detected and soon melted."³³ The hat was de rigueur for men and ought to be—claimed Blanc—like architecture, with "some dominant dimension capable of being grasped at first sight." This is certainly true of the gleaming silk top hat that Caillebotte depicted in his painting, though it was a style deplored by Blanc, who thought it broke the rules of harmony, its "frightful cylindrical shape . . . altogether at variance with the spherical form of the head."³⁴ Aesthetics apart, there were practical problems with the top hat; "absurd and hideous," it was, according to Prévost, of no use in the rain and wind, and it made it difficult for a man to move his head with ease.³⁵ In a sense this was the point of the top hat: it was an art to wear it with a certain style and self-confident

CAT. 94 Frock coat and trousers, c. 1876
American
Black wool broadcloth
Kent State University Museum

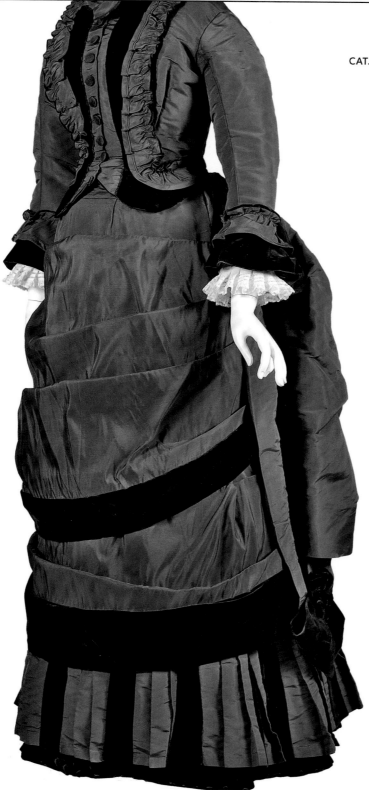

CAT. 95 Blue walking dress, 1873/74

Possibly American
Deep blue silk taffeta and velvet
Kent State University Museum

The sober colors and restrained trimmings
of this walking dress would have made
it an ideal uniform for the modernizing
city of the 1870s. Unlike the vibrant
colors worn indoors, the deep blue of
the silk and black of the velvet accents
would have made the dress blend in
with the gray buildings and streets. The
symmetrical, vertical rows of self-fabric
ruching on the jacket front and the simple
black bands bordering the *tablier* reflect
a sleek, urban aesthetic. As cities grew
and increasing numbers of bourgeois
women found walking a necessary and
desirable activity, outdoor dresses that
did not train fashionably grew more
popular because they were much easier
to keep clean.

FIG. 3. *Les Modes Parisiennes*, 1876. British Museum.

FIG. 4. ÉDOUARD MANET (FRENCH, 1832–1883).
Isabelle Lemonnier, c. 1880. Oil on canvas; 81.9 × 73 cm
(32 ¼ × 28 ¾ in.). Dallas Museum of Art.

authority. As Philippe Perrot stated, it remained in fashion for so long because it incorporated "both bourgeois propriety, through its stiffness and funereal sobriety, and aristocratic bearing, because it made any physical activity completely impossible."[36] It was the one feature of a man's appearance that did not conform to the rationality and comfort of the rest of his clothing.[37]

Caillebotte saw the streets of Paris as mainly (though not exclusively) a masculine world; middle- and upper-class women did not often walk in the streets and rarely did so on their own. Etiquette manuals suggested that women should particularly avoid walking in the streets in bad weather, as dresses were difficult to control on windy days and to clean when it rained. For this reason, women were encouraged to wear practical fabrics in dark colors and simple styles; according to the December 1876 issue of the *Journal des Modes*, women should blend into their surroundings, "dressed in unnoticeable colors like the stone of the walls and the dust on the pavement."[38] But simple styles of dress were only relatively so, as fashion dictated complex arrangements of back drapery that had to be lifted decorously to avoid dirty streets, as the small female figures on either side of the flaneur's head in *Paris Street; Rainy Day* do. In October 1876, the *Journal des Modes* admired the gracefulness of dresses with trains, declaring fashion privileged over practicality: such costumes were "not fit for the street; but Fashion has not to think of the street." The following spring, the magazine stated more sympathetically that fashion was "made for the rich, and the rich drive in carriages. They do not know the little miseries of walking through muddy streets with a long skirt to hold up, an umbrella . . . purse and parcels maybe, to carry all at the same time."[39] A constant refrain in the contemporary fashion press was the inconvenience of such long, complex skirts in inclement weather; it was unclean to let the train trail on the ground but awkward to hold it up. It was fine, according to the *Journal des Modes*, to use both hands to raise the skirt, but "this cannot be done if the right hand be required for a gentleman's arm, or . . . an umbrella."[40]

Given the problems of deportment presented by skirts, women were urged by fashion journals and conduct books to study their movements in a

looking glass before leaving home. By the mid-1870s, women had begun to adopt a streamlined look in their dress, wearing long, close-fitting cuirass bodices and skirts that draped fairly close around the legs, as in Caillebotte's preliminary, full-length sketch of the couple (fig. 2).[41] At home, declared Prévost, women could be more imaginative in their clothes and dress to please themselves, but outdoors their appearance belonged to others, so they should adopt the sober costume best suited to the streets.[42] Blanc stressed that the "dignity of female dress is increased by everything which allows uniformity to predominate, whilst relieving it by slight variations";[43] thus, the woman's brown wool two-piece outfit, a *toilette de promenade*, is enlivened by a double row of buttons down the front, black velvet sleeves, and fur at the collar, cuffs, and hips. Fur was fashionable for both dresses and coats and jackets (and also appeared in Caillebotte's painting in the form of a matching fur toque, which gives the woman height like her companion's top hat), illustrated in fashion plates (see fig. 3) and portraits (see fig. 4). Auguste Challamel's *Histoire de la mode en France* (History of Fashion in France; 1881), noting the vogue for modest fur-trimmed woollen costumes in muted, neutral colors, attributed the general trend for fur partly to the Russo-Turkish War of 1877–78.[44] Blanc thought that the most important part of a woman's dress was the bodice, which best showed off her figure; Caillebotte may have agreed, as he chose to cut off his couple at the knees, wishing also perhaps to emphasize the graceful curve of the band of fur on the woman's hips, and perhaps, with a touch of eroticism, to hint at the body beneath the dress.[45]

The aim of a woman of fashion, as expressed in etiquette books, was to "bring her toilette into harmony . . . with her character, mood, age, face, complexion, and the color of her eyes"; it was generally accepted that a modest woman, especially outdoors, would be conscious of her age and status, and discreet in her demeanor, clothes, and accessories.[46] It was regarded as vulgar to wear too much jewelry in the street; thus, unobtrusive earrings were the rule, like the small pearls that draw attention to the ear, soft cheek, and graceful jawline of Caillebotte's young bourgeoisie. Makeup, too, must be discreet; as Huysmans noted,

respectable women did not wear the obvious paint of actresses and the demimonde, but simply face powder.[47] The small spotted veil of Caillebotte's central woman offers no protection against the weather or the male gaze;[48] it does not pretend to hide the face but acts as a foil to the complexion, "making more conspicuous what there is an appearance of wishing to conceal."[49]

Edmond Duranty's famous 1876 pamphlet *La nouvelle peinture* (The New Painting) stressed the importance of real observation in art; a back could express a person's temperament, age, and status, and hands in the pockets could reflect eloquence itself.[50] While Caillebotte's concerns, as Varnedoe remarked, were limited to his immediate experience—that of modern urban life, with its "depersonalization, detachment, and individual isolation"[51]—his treatment of such themes was remarkable for its almost surreal intensity.[52] The artist could, said Prévost, "add something here, remove something there, following his caprice or his imagination; he can sacrifice a detail in his composition or simplify the whole to set off a particularly successful detail."[53] It is this process of selection, of the heightened artistic imagination, that Caillebotte engaged in when he painted *Paris Street; Rainy Day*, exaggerating the architecture of his scene to an almost sinister degree, with dizzying perspectives, an almost tangible feeling of rain and mist, and life-size figures in elegant attire, at variance with the buttoned-up men and bundled-up women who move around and behind them. The artist sensed how important clothing was to suggest the way people lived and demonstrate their individual isolation, but at the same time underline the uniformity of appearance and behavior demanded by modern urban life. As Robert Herbert noted: "We should not be surprised that fashion and art shared certain features. Many artists deliberately cultivated fashion in their paintings," for it was the most obvious signifier of modernity.[54] Clothing, Challamel suggested, indicates the spirit of the period, an aspect of the picture of civilization.[55]

10289

Photography, Fashion, and the Cult of Appearances

Elizabeth Anne McCauley

Everyone poses
For his cause;
It's only a question of daring.
That's life;
A mania:
To pose and make pose.

— Ernest Mayer[1]

One's appearance is the dominant passion of the French.

—Varvara Rimsky-Korsakow[2]

A few months after the French photographer Félix Nadar opened a newly enlarged, ambitious studio at 35, boulevard des Capucines in 1861, he staged a celebratory photograph of the facade of his business (fig. 1). While showcasing staff members gathered on the roof, fiacres parked along the curb, and an ostentatious gaslit sign applied across the two top stories of the building—where Nadar had installed his offices, dressing rooms, and glazed sitting areas—the photograph also captured the studio's neighbors on the first two floors: À la Ville de Sedan,

Manufacture de Vêtements, a production area and salesroom with finished dresses, fabrics, and men's clothing; Au Corah des Indes, a retailer of scarves named after a popular Indian silk; and a saddlery with rows of leather goods. The portraits that Nadar sold—increasingly in the form of tiny cartes de visite of famous entertainers, journalists, and artists—thus competed with other alluring commodities that called out from behind the newly enlarged glass showcases along Paris's main commercial thoroughfare.

198

FIG. 1. FÉLIX NADAR (FRENCH, 1820–1910). *View of Nadar's Studio at 35, Boulevard des Capucines*, c. 1861. Albumen print from collodion-on-glass negative. Bibliothèque Nationale de France, Paris.

The juxtaposition of commercial photographs and clothing retailers presented in this image is emblematic of the heightened visibility that both achieved during the reign of Napoléon III (1852–70), when Parisian life was refocused on a court that welcomed international diplomats, nobility, celebrities, and parvenus, while encouraging technological improvements and more democratized creature comforts. Photographs, available since 1851 as glossy sheets of albumenized paper printed from finely grained, collodion-on-glass negatives, by definition depicted the contemporary material world before the lens. Their selling points were their guaranteed resemblance to nature and the truth of their details. Thus, they were ideal for recording new buildings, manufactured goods, engineering feats, and, most important, people—loved, emulated, profiled in the daily press, and, in the case of criminals or freaks, marveled over and feared. If modernity as conceptualized by the likes of Charles

Baudelaire was all about speed, secularism, and contemporaneity, then photography was the paradigmatic modern medium.

As a system of signification whereby individuals indicated their real or desired rank, sexual interests, taste, profession, and social cohesion, clothing had seen rapid changes in styles and an explosion of consumer choices since the first fashion magazines and engraved and etched illustrations appeared in the late eighteenth century.[3] Mechanization—which led to the development of the sewing machine, improved textile production, machine-made lace and trims, and faster modes of transportation—lowered prices and allowed more people to purchase items that looked like the expensive, handmade wares still crafted by private dressmakers and tailors. To distinguish themselves from the masses of new consumers, aspiring elites had to develop connoisseurship of cuts, fabrics, and finishes; become early adopters of styles; or create original, striking combinations of individualized accessories or trims. The close, detailed looking encouraged by albumen prints matched the critical physiognomic examination necessary to make character judgments based on the fine points of clothing, hairstyle, makeup, and deportment. In an urban society where, as the Russian beauty Varvara Rimsky-Korsakow observed, appearance was everything, what better means to reveal rapidly transforming exteriors than rapidly exposed photographs?

The appearances that mattered during the Second Empire were those of celebrities, a new type of public person that included not only members of the court, but also entertainers, courtesans, and occasionally geniuses from the arts, music, and literature. Traditionally, there had been a visibility gap between entertainers, whose success depended on their physical merits seen onstage, and political and social elites, who were hidden from the public aside from glimpses in open-air carriages or private boxes at the opera. After carte de visite portraits took off in the late 1850s, elites signed away (or sold) the rights to their images to commercial photographers.[4] For the modest cost of one franc, middle-class consumers could study the faces of Empress Eugénie, Princess Pauline de Metternich (known as the "best-dressed monkey" in Paris because of her simian features), and the emperor's cousin Princess Mathilde Bonaparte; they could also

examine the silks, satins, lace trims, and toques that elites donned for their portrait sittings.

Although Empress Eugénie consciously selected French textiles for the ample crinolines that she wore on public occasions and in pictures in an effort to encourage national production (see fig. 2), there is no evidence that photographs of notable women were intended to sell clothing during the Second Empire.[5] Indeed, fashion photography had to await the Belle Epoque— perhaps because of the difficulty of reproducing photographs in magazines (which continued to use hand-tinted engravings or lithographs), or because of the limited marketing capacities of artisanal dressmakers. Given that firms that sold furniture, locomotives, and other machinery had begun to create photographic albums of albumen prints for

traveling salesmen to carry in the 1850s, the lag of photographic marketing in the clothing industry may also be attributed to the limited appeal of totally repeatable products and to the success of celebrity portraits as unofficial advertisements for clothing that could subsequently be copied by dressmakers. In addition, drawn fashion plates showing stereotypically pretty faces, tiny hands and waists, and graceful gestures allowed consumers to project themselves as the wearers of the clothing, whereas photographs of actual women in the latest fashions, with all their physical particularities, prevented this identification. One can posit that it took a certain learned indifference to the "reality effect" of the photograph (and the cultivation of professional "models" who possessed ideal beauty) for viewers to disregard the identity of the woman donning the clothes and see her as the equivalent of an inanimate prop or mannequin.

The commercial photographic portraits of Parisian notables, whose exploits filled newspaper gossip columns, functioned less as intentional advertisements for dressmakers than as lessons in how outfits should be put together and the ways they should be worn. Posing in a photographic studio was a learned behavior; the problem was that the studio was an oddly artificial place, without any real motives for emotion or social interaction. Unlike acting on a theatrical stage, in a studio there was no live crowd to please; one performed only for the photographer. There was similarly no story to tell and, in single-figure portraits, no one with whom to interact. As in sittings for painted portraits, which lasted for a period of weeks or even months, models had to show their physical traits to best advantage. But, unlike painted portraits, in photographs the assumption of a graceful attitude and pleasant face had to be immediate and motionless, as little retouching was possible. The best sitters were thus those who had practiced striking pictorial "attitudes" in public; the worst and least self-aware had to have their limbs and gazes manipulated by the photographer, who shaped the body like a sculptor while chatting to give them some reason to look interested or animated.

Nineteenth-century photographic portraits were by definition interior views dependent on natural lighting.[6] Studios installed on the top stories of buildings featured large expanses of glass overhead and along one side, with screens that rolled

FIG. 3. ANDRÉ-ADOLPHE-EUGÈNE DISDÉRI (FRENCH, 1819–1889). *Countess de Meyendorff* [six views] *and Her Mother, Baroness de Meyendorff* [two views], 1858. Uncut sheet of cartes de visite; albumen print from collodion-on-glass negative; 20 × 23.2 cm (7 ⅞ × 9 ⅛ in.). Musée d'Orsay, Paris, PHO 1995-20-80.

CAT. 96 André-Adolphe-Eugène Disdéri
(FRENCH, 1819–1889)

Beresford from Demi-Monde I 56, 1867

Albumen silver print from glass negative
18.4 × 24.8 cm (7 ¼ × 9 ¾ in.)
The Metropolitan Museum of Art, New York

down to control light and prevent direct sunlight from hitting the model. Additional portable screens were used to bounce light off the side of the face farthest from the light source. Diffused northern light was considered best for photographing, and spring and fall were the preferred seasons, as they lacked strong contrasts of light and shadow, over-heating in the rooftop studio in the summer, and darkness and cold in the winter. Although photo-graphic amateurs occasionally made distant shots of figures in landscapes, the difficulties of exposing green foliage and pale skin at the same time and of controlling outdoor light kept commercial portrait photographers inside throughout the nineteenth century. This contrasted with the shift taking place within avant-garde French figure painting, in which figure groupings studied under dappled sunlight in the 1860s became a defining trait of Impressionism.

In an effort to improve the aesthetic results of photographs for a bourgeois public more comfortable behind a counter than at a ball, photographers included sections in the manuals they published that detailed what to wear for a portrait and how to position the hands and head. Plaids and stripes were generally considered to distract from the face, as was excessive jewelry; blues, which would appear white in the final print, were to be avoided, as were dark greens, which would appear black. The face looked best in a three-quarters view, and the hands needed to be held near the plane of the face to remain in focus. As André-Adolphe-Eugène Disdéri, the inventor of the carte de visite, emphasized, the goal was to establish a simple stance, without a twisted neck or unbalanced limbs, and to adjust the pose and setting based on the demands of each sitter. If sitters were short, their heads should be placed nearer to the top of the frame; if they were fat, they should stand before dark backgrounds to make their heads seem smaller.⁷ Placing trains in profile or advancing slightly toward the camera and directing ladies to attend to a plant, study a book, or adjust their hat in a mirror (see fig. 3 and cat. 96), Disdéri set the standard for graceful, full-length views that emphasized voluminous layers of fabric over homely facial features.

As the props, poses, placement of the sitter, and lighting of carte de visite portraits became largely standardized by the 1860s, with each opera-tor claiming signature characteristics, those artists who still produced painted portraits inevitably had

FANTAISIES PHOTOGRAPHIQUES (PAS CHEZ NADAR!), — par MARCELIN (suite).

— Saisissez-moi bien : il faudra me prendre au moment où, en me voyant sortir des Folies-Nou-
velles, une jeune dame s'écrie : — Ah! qu'il est donc bien, ce monsieur!

FIG. 4. MARCELIN (ÉMILE-MARCELIN-ISIDORE PLANAT, FRENCH, 1829–1887). "Photographic Fantasies," *Petit Journal pour Rire* 130 (1858), p. 3.

to address the changing expectations of their more wealthy clients, who had seen themselves in cartes and consequently had a more acute sense of how they wanted to appear in prestigious oil paintings.[8] When the young painter Claude Monet was hired in 1868 to make a portrait of the wife of Le Havre businessman Louis Joachim Gaudibert, he seems to have drawn from, rather than rejected, the popular carte de visite formula (cat. 97). Whether he used a photograph as an aide-memoire, aped a *profil perdu* pose he had seen in fashion plates and cartes, or ceded to the demands of his patrons is unknown, but he produced a composition in which the expensive dress (see cat. 98) and imported shawl (see cat. 99) upstage the woman's largely invisible face. Moreover, the motif of departure—Marguerite Gaudibert puts on a glove and dons the black hat on the table next to the fragile roses—echoes that of countless cartes. Even the pale-blue background curtain, rose-patterned carpet, and strong frontal lighting flattening her left cheek and the rear wall suggest the contrivance of a photographic studio rather than the actual haute-bourgeois setting, the Château des Ardennes–Saint-Louis, owned by notary Eugène Marcel, the father of the young sitter.[9] The effect, as in Monet's earlier full-length view of his future wife, Camille, exhibited in the

1866 Salon (cat. 16), is one of theatrical display for the viewer, an awkward combination of an elegant pose and costume with a rugged facture that reveals Monet's inexperience with the portrait genre.

Painters were not the only ones to unconsciously (or even consciously) assimilate the poses and general layout of carte de visite portraits. The public was also directed to look at extant images to improve their performance before the lens. Alexandre Ken, a Parisian carte de visite photographer, proposed placing a photo album in the waiting room of a photographer's studio: "In thumbing through it and examining the portraits exposed, in questioning the artistic value of each one of them, the sitter can appreciate and seize the poses and expressions that fit him the best."[10] This imitation of stances, however, further confounded the visible differences between a well-educated, sophisticated person and a "poseur," arousing a certain anxiety over the veracity of photographs that found expression in caricature. For example, in an 1858 issue of the *Petit Journal pour Rire*, Marcelin (Émile-Marcelin-Isidore Planat) depicted a showy gent with a striped vest, smoking cigar, puffed-out chest, and rakish top hat commanding an abashed photographer to capture him "at the moment when, seeing me get out of the Folies-Nouvelles, a young woman cries out, 'Oh, what a swell guy he is, this monsieur!'" (fig. 4).[11] Another comic sketch, published in *Le Figaro* on May 27, 1860, describes an Englishman visiting Disdéri's studio in need of one hundred cartes de visite in various poses. The photographer assures him that the sitting will take ten minutes and he can have the cartes in eight days. Exclaiming that he is leaving for Calcutta that evening, the Englishman catches sight of four portraits of Hippolyte Lucas, Ponson du Terrail, Etienne-Marie Mélingue, and (possibly) Luigi Lablache (respectively, a well-known entomologist, writer, actor, and musician, who each got a puff in the story), which he thinks look somewhat like him. "I'll take twenty-five of each!" he cries, and leaves happily with pictures that fulfill his self-image.[12]

Although such stories playing on the flexibility of likenesses and the social aspirations of vulgar people (including the English) flattered the Parisian readers of comic papers (who would, of course, never themselves behave so stupidly), they exposed the extent to which superficiality and social climbing threatened to bring down the

CAT. 97 Claude Monet (FRENCH, 1840–1926)
Madame Louis Joachim Gaudibert, 1868

Oil on canvas
217 × 138.5 cm (85 ⁷⁄₁₆ × 54 ⁹⁄₁₆ in.)
Musée d'Orsay, Paris

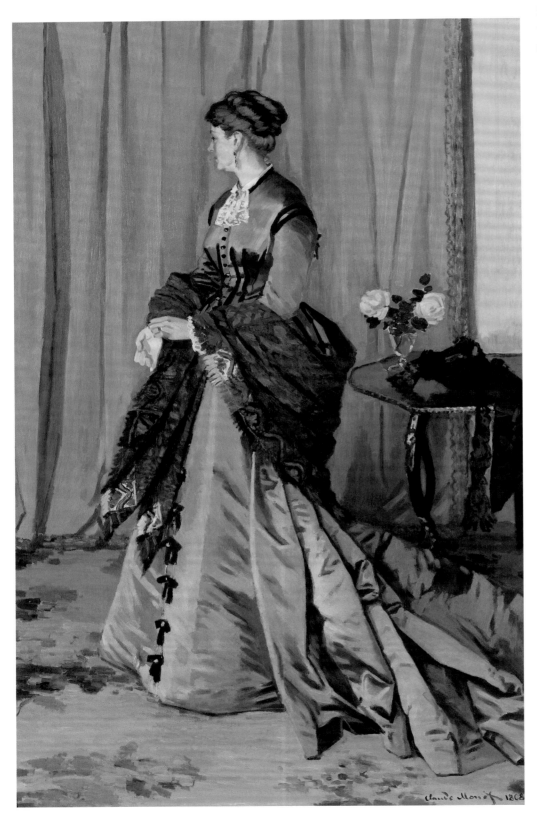

Standing at the center of a bourgeois interior, surrounded by a sumptuous curtain, plush carpet, and other ornate furnishings, Madame Louis Joachim Gaudibert turns her face away from the viewer. Reminiscent of contemporary fashion plates and cartes de visite, this full-length view does not present Madame Gaudibert's personality, but rather portrays her as a fashionable Parisienne. The composition emphasizes her hairstyle and outfit, stylishly accessorized with a glove, golden jewelry, and a luxurious cashmere shawl. Her burnished silk dress, adorned with lace and bows down the front, has an overflowing train that spills over a flat-front crinoline. This abundance of costly fabric, an indication of the subject's wealth and social standing, is highlighted by the woman's unconventional posture.

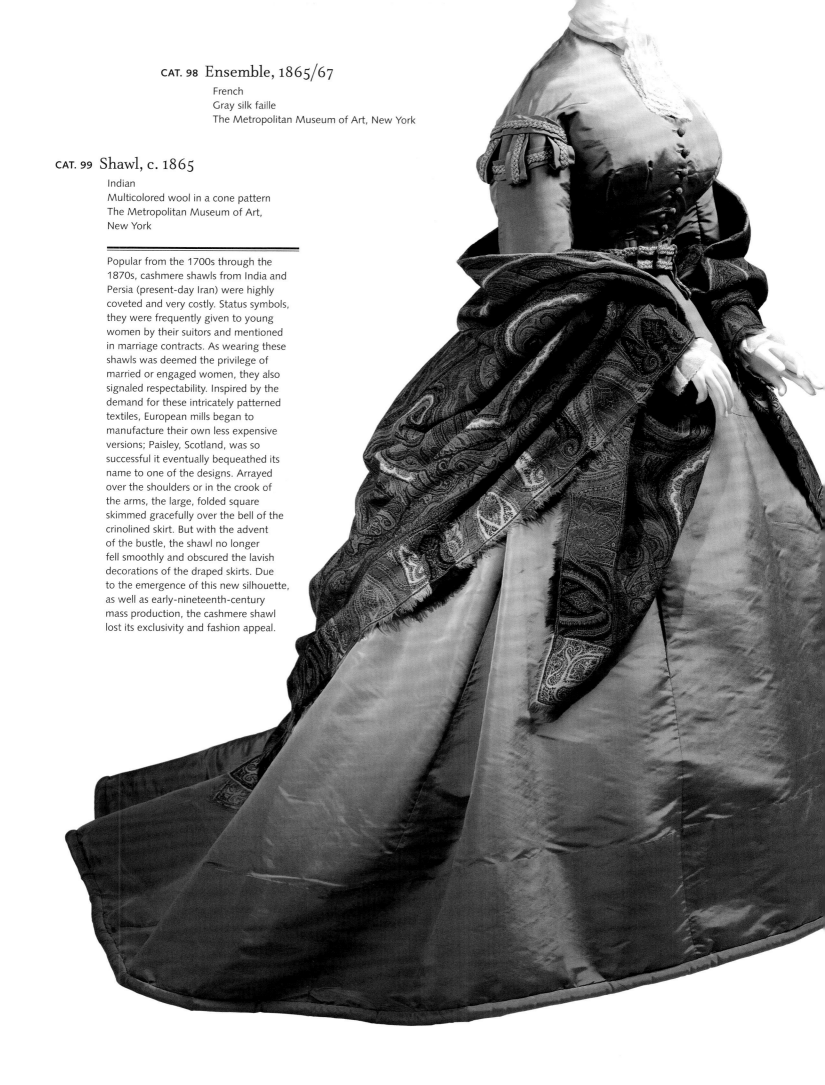

CAT. 98 Ensemble, 1865/67

French
Gray silk faille
The Metropolitan Museum of Art, New York

CAT. 99 Shawl, c. 1865

Indian
Multicolored wool in a cone pattern
The Metropolitan Museum of Art,
New York

Popular from the 1700s through the 1870s, cashmere shawls from India and Persia (present-day Iran) were highly coveted and very costly. Status symbols, they were frequently given to young women by their suitors and mentioned in marriage contracts. As wearing these shawls was deemed the privilege of married or engaged women, they also signaled respectability. Inspired by the demand for these intricately patterned textiles, European mills began to manufacture their own less expensive versions; Paisley, Scotland, was so successful it eventually bequeathed its name to one of the designs. Arrayed over the shoulders or in the crook of the arms, the large, folded square skimmed gracefully over the bell of the crinolined skirt. But with the advent of the bustle, the shawl no longer fell smoothly and obscured the lavish decorations of the draped skirts. Due to the emergence of this new silhouette, as well as early-nineteenth-century mass production, the cashmere shawl lost its exclusivity and fashion appeal.

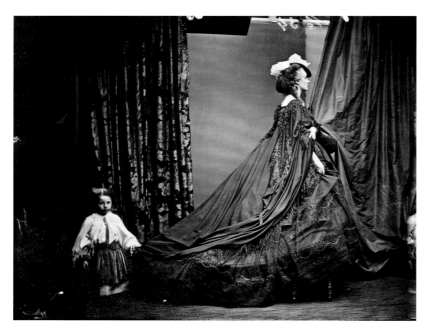

FIG. 5. PIERRE-LOUIS PIERSON (FRENCH, 1822–1913).
Countess Castiglione with Her Son [Alba], 1863–65.
Modern print by Christian Kempf, enlarged from one
of four images on the original collodion-on-glass negative;
24 × 30 cm (9 7/16 × 11 13/16 in.). Musée d'Unterlinden,
Colmar, Mayer et Pierson Archive.

traditional values of honesty, constancy, hard work, and decorum that conservatives, aristocrats, and much of the bourgeoisie defended. The leveling effect of photographic portraits, which reduced all people to the same format with similar poses and equivalent props, upset the refined Goncourt brothers, who complained in 1860 that one would be hard-pressed to say if Rigolboche (Marguerite Badel, a cancan dancer), the Italian Republican Giuseppe Garibaldi, or Jules Léotard (a trapeze artist and originator of the suit that bears his name) occupied Paris the most at present.[13] Another comic anecdote published the following year describes two "rigolboches" (now a slang term for loose women) standing in front of a photographer's window and complaining that their portraits are being displayed next to those of their dress- and corset-makers.[14] The humor, of course, derives from the descent of celebrity portraits down the social scale, so that women of ill repute mimic the outrage that aristocrats express at the prominent display of images of vulgar entertainers.[15]

No one better represented the excessive emphasis on expensive finery and the use of photography to promote a decadent culture of "posing" during the late nineteenth century than Virginia Oldoini, the Countess de Castiglione, a married Italian with a conveniently tolerant husband. Notorious for her designer gowns and beauty, she arrived in Paris in 1855 and became one of the many lovers of Napoléon III. By 1856 she discovered the newly incorporated studio of Mayer et Pierson, which had photographed the imperial family. Over the course of three different periods—1856–57, 1861–67, and after 1893— she frequented the studio for some four hundred portraits, bringing along changes of clothing and her young son (born in 1855) to serve as a page and occasional model in his own right (see fig. 5).[16] Whereas other wealthy women sat on multiple occasions for photographic portraits that commemorated the costumes that they contrived for the famous fancy-dress balls held at the Opéra and royal palaces, Castiglione made the portrait studio the site of dramatic, narcissistic self-fashioning. Few of her pictures circulated as celebrity cartes: they were made for her, her lovers, and her distinguished friends, and she clearly choreographed them, since they are unlike any other images made by Mayer et Pierson or Pierre-Louis Pierson, who later took over the studio. The liberties that Castiglione took before the lens—from lifting her skirts to reveal her bare feet to simulating scenes of drunkenness, prayer, or depression—approximated the varied poses of professional actresses and singers. But rather than wearing stage costumes, the countess drew upon her extensive wardrobe of ball gowns, which in effect functioned like particularly elaborate theatrical costumes.

Demimondaines who operated on the fringes of polite society and whose reputations had to be constantly reasserted since they did not depend on inherited wealth or titles were among the first to rebel against the types of poses described in photographic manuals, which rapidly became prosaic and uninteresting. When one sees cartes with men doffing their hats, sitting astride chairs, smoking cigars, pretending to drive hobbyhorses, and clowning around in the studio, or women raising their skirts, wearing male clothing (see fig. 6), gazing coyly at the camera, or showing only a back view of a dress, one can safely surmise that the subjects are entertainers, journalists, or trendsetters like Castiglione. At a time when etiquette manuals advised that men should tip their hats to acquaintances on the street and not make large

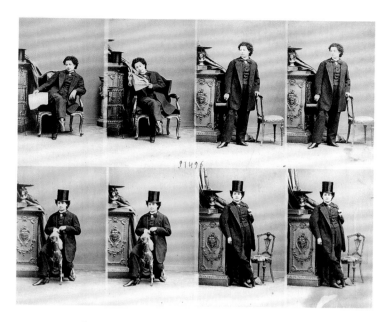

FIG. 6. ANDRÉ-ADOLPHE-EUGÈNE DISDÉRI (FRENCH, 1819–1889).
Madame Berthier, 1862. Uncut sheet of cartes de visite; albumen
print from collodion-on-glass negative; 20 × 23.5 cm (7 ⅞ × 9 ¼ in.).
Musée d'Orsay, Paris, PHO 1995-25-48.

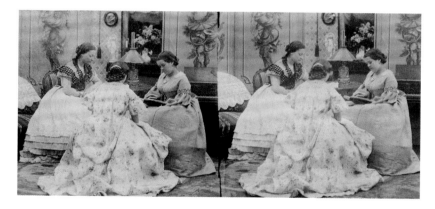

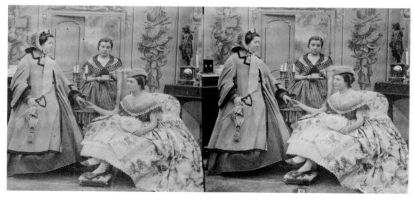

FIG. 7. LAMICHE FILS ET AUGÉ (FRENCH, ACTIVE 1857–1866).
Women in Interior, 1862. Albumen prints from collodion-on-glass
negatives. Bibliothèque Nationale de France, Paris.

gestures with their arms or put both hands in their pockets,[17] and young ladies were instructed not to stretch out on an armchair, lean on a table, or cross their legs,[18] these postures appeared in photographs as jokes or ways of literally thumbing one's nose at the public. Such outrageous behavior became chic, rather than boorish, when done as a conscious violation of politeness. Fashionable Parisians had to learn how to read the difference.

While portrait photographs functioned as the primary means for the famous and fashionable to distribute their likenesses, other types of photographs introduced in the 1850s also demonstrated how the well-to-do passed their leisure hours. Stereoscopic views, which consisted of two images mounted next to one another that optically melded into a seemingly three-dimensional picture when viewed through a stereopticon, became popular parlor amusements by 1855. In the form of albumen prints mounted on cardboard, which were much cheaper than stereo daguerreotypes, the stereoscopic format encompassed landscapes, architectural monuments, occasionally still lifes, erotica, and, particularly in France, staged views of actors and actresses in interiors that were adapted from the theater. Issued in series by Parisian firms including Furne fils et Tournier, Lefort, Block, Jouvin, Billon, and Raudnitz, these scenarios used mirrors and doorways into antechambers to add depth to their views and featured subjects such as men playing cards, women reading and taking tea in a salon, drinking parties in cafés and private clubs, and groups waiting for a train or at the races (see fig. 7). The walls, furniture, and towering mountain peaks or railroad quays seen in the backgrounds may have been trompe-l'oeil painted flats, but the women's traveling or evening gowns and men's frock coats represented the latest in fashionable gear. Stereo consumers were literally immersed in dramatic situations that they had seen performed on the vaudeville stage or read about in comic and high-life magazines such as *La Vie Parisienne*, *Le Journal Amusant*, or *Le Figaro*.[19]

Not everyone was pleased with the prominence given to the celebrities of the European capitals or the insidious expansion of the photographic industry that largely commemorated their possessions, faces, and haunts. Baudelaire, who in 1863 was enchanted by late-eighteenth-century fashion plates, which he believed represented the

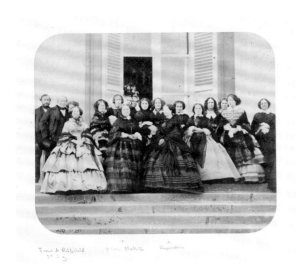

FIG. 8. ÉDOUARD DELESSERT (FRENCH, 1828–1898).
Empress Eugénie and Her Ladies-in-Waiting at Compiègne,
October/November 1856. Albumen print from collodion-
on-glass negative; 15.3 × 17.6 cm (6 × 6 ¹⁵⁄₁₆ in.). Bibliothèque
Nationale de France, Paris.

amusing, titillating, fleeting first course to the
divine cake that was eternal beauty,"[20] as early as 1859
had found photography mechanical, debased,
unimaginative, and a slave to truth.[21] The difference
for him lay in the creativity and whimsy of costume
versus the reproductive qualities of photography
as a medium (despite the fact that the subject matter
of photographs was often the flaneur culture that
he extolled). True fashionability was characterized
by originality in putting together an ensemble,
whereas photography, because it had in his eyes
become industrialized and bourgeois, might be seen
as the equivalent of ready-to-wear uniformity.

This fine distinction was, however, atypical.
Most social critics of imperial rule and the photog-
raphers and academic artists it supported lumped
together the medium and the world it recorded.
Photography itself had become a fad for Bonapartist
amateurs. Céleste Baroche, whose husband, Jules,
held various ministerial positions under Napoléon
III, described endless days of shooting pigeons
and rabbits and racing horses at Compiègne,
interrupted when "an amateur artist, M. [Édouard]
Delessert, photographed a group of women in the
midst of which was the Empress. Then the men had
their turn! Once the prints were pulled, everyone
without exception, found themselves ugly!" (fig. 8).[22]
Photography was not only practiced by the beau
monde as an amusement, but was also continuously

plugged in the same columns that dropped the names
of expensive dressmakers, jewelers, hatmakers,
and perfumers. Viscountess de Renneville (Olympe
Descubes de Lascaux), who wrote fashion columns
for *L'Artiste*, *Le Moniteur de la Mode*, and other papers,
was one of many professional journalists who
puffed photography in columns devoted to "Modes
de la Saison." "Go, Madame, put on a pair of boots,
a chimney hat, a cigar in your mouth, a lorgnette
in your left eye, and be photographed by Disdéri as
an example of an elegant fashion type of 1855,"
she naughtily exclaimed, before praising his works
as exhibiting the seal of genius.[23]

For painters embarking on portraits and
genre scenes, the emulation of photography
and current fashion was a pitfall to be avoided if one
wanted to make serious works of art. The philoso-
pher P. J. Proudhon, despite his admiration for the
Realist painter Gustave Courbet, argued:

> A portrait . . . must have, if it's possible, the
> exactitude of a photograph, but, more than a
> photograph, it must express life, the habitual,
> intimate thought of the subject. While
> unthinking light, instantaneous in its action,
> can only give a rapidly interrupted image
> of the model, an artist, more skillful than
> light because he reflects and feels, can imbue
> a prolonged sentiment in the face.[24]

The same point was made in reviews of the Salons
of the 1850s and 1860s: while acknowledging the
progress that the photographic industry had
recently made, Edmond About concluded in 1857
that "the most beautiful photographs, even if they
were colored by the sun in person, would obtain
less success in a public exhibition than the
idealized paintings of M. [Édouard] Dubufe and
M. Winterhalter."[25] Victor de Laprade, in a
discussion of portraits published in 1861, found
that the daguerreotype demonstrated the distance
that separated, "even considering the question of
resemblance, a true portrait from the mathematical
reproduction of the forms of a head in all their
details."[26] Art does not reproduce only visible beauty
and truth, he believed, but a beauty and truth
superior to facts.[27]

Contemporary dress posed as much of a
problem for painters as did the assertive details of a
photographed face. If a portrait should be a timeless

likeness, could the ridiculous cut and accessories of the moment be made eternally attractive? Baudelaire, while acknowledging the funereal aspect of contemporary male dress, famously claimed in his 1846 Salon review extolling the heroism of modern life that a colorist could make something of a black frock coat, white tie, and gray ground.[28] Ernest Chesneau, in his remarks on the Salon of 1863, similarly observed:

> The nineteenth century is not as ugly as people claim. Our women's toilettes are charming, light, quivering, undulating around the body, caressing the breasts. As for men's clothing, people criticize its sobriety and drabness; but it's worth repeating that there are no colors in nature, only light. Let a great painter, not a so-called colorist, but a luminist (if I dare coin a phrase), attack modern life, and if he's really a painter, if he doesn't have merely a vague desire to succeed, if he doesn't scorn his subject, if he's audacious and has a bit of genius, he will make a masterpiece of our black suits, overcoats, dresses and shawls, with the clothing of men and women in the nineteenth century.[29]

Too much attention to the specifics of contemporary clothing in portraits and genre painting, however, inspired charges of materialism akin to those leveled at photography. The socialist critic Théophile Thoré, who advocated art that celebrated the simple nobility of lower-class life, in his 1861 Salon review of portraits attacked "la mode" for imposing a uniformity of the body and face, which

> denatures personal originality, erases partic-ularities and eccentric traits, adds angles where there were none, files down the points that exist . . . whitens the skin, blackens the hair . . . tightly binds the shoulders, puffs out the elbows, elongates the fingers, straightens the feet, and squeezes the waist. . . . This is seen in all periods, but especially in periods of decadence.[30]

Such loss of personal expressiveness in favor of fashionability, as encoded in the body, was similarly remarked upon by Victor Fournel in a critique of the bourgeois "portraituromanie" of the 1850s. Taking fashion plates as their models, sitters in inexpensive portraits and the daguerreotypes that replaced them insisted on frontal stances, full lighting, and décolleté dresses, and assumed affected poses. Fournel, fatigued and amused by such portraits, ironically advised: "Take as much care with the dress as the face, render with scruples the color, the design, the cut, the flowers, the richness; surpass yourself in the laces, the gauze, the jewels, and you will be a great painter!"[31] For Jules Castagnary (another defender of Courbet and the Realist movement), excessive attention to fabric and clothing was the downfall of the portraitist Charles Carolus-Duran in the Salon of 1872; drowning the sitters of his two exhibited portraits in silk, the artist made them look like fatted calves covered with ornaments or billboards before the House of Worth.[32]

Attacks on both photography and fashion during the Second Empire and even into the Third Republic hinged on their seeming superficiality and substitution of short-lived values for personal qualities. Clothing hid and falsified the body, puffing it out with wires, pads, ruffles, and pleats; photographs erased the telling gait, laugh, smell, and caressing gaze of a lover frozen in sepia. And yet both were intimately tied to the fabric of lives increasingly experienced in fragments and motion. As Edmond Duranty, a critic of the timeless standards of art and defender of the newly dubbed "Impressionistes" in 1876, railed:

> Farewell to the human body, treated like a vase, with an eye for the decorative curve. Farewell to the uniform monotony of bone structure, to the anatomical model beneath the nude. What we need are the special characteristics of the modern individual, in his clothing, in the middle of social situations, at home, or on the street.[33]

In an era of change, photography and fashion fueled each other and found admirers among those who exalted the brash, the surprising, and the seemingly unique personal vision that, despite the leveling effect of expanding consumer capitalism, held the promise of human autonomy and individuality.

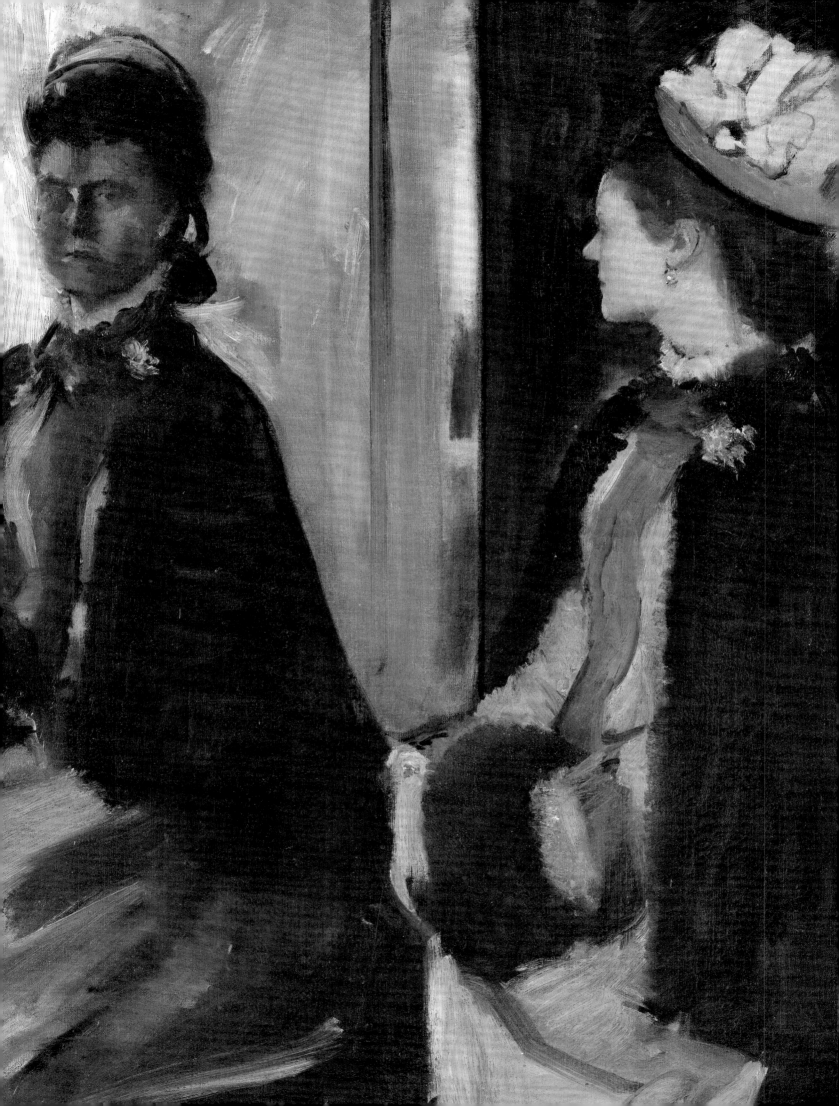

Shops versus Department Stores

Françoise Tétart-Vittu

Émile Zola's theory about the deep-seated opposition
between the boutique and the department store—
described in 1883 in his *Au bonheur des dames* (The Ladies' Paradise)—
has created some confusion over the role of both entities
in the fashion world of the mid-nineteenth century.

In truth, however, the writer greatly simplified
and shifted the authentic details he noted during
his research on Parisian business activity, applying
these to his fictionalized account of the Rougon-
Macquart family, which was set much earlier, in
1864–69.[1] Indeed, far from being in direct conflict
with the department store, the shop actually
represented an earlier stage in its development.
The evolution of department stores was above all
an economic development linked to financial and
urban change: the transformation of Paris through
the construction of wide thoroughfares and train
stations in the years 1840–60 pushed commercial
activity west, from the Palais Royal toward the
new Opéra, the Madeleine-St. Augustin, and finally
the Rond-Point des Champs-Elysées at the end
of the century. By the mid-1850s, the development

of large tracts of real estate became possible, and
department stores—which had grown proportion-
ately and were sometimes located next to hotels[2]—
became part of the new centers of activity in Paris.[3]

Prior to the nineteenth century, Parisian
shops achieved fame because of the quality of their
work, produced by craftsmen recognized as masters
by their guilds. Yet the shops' physical aspect was
not always luxurious, and it was only at the end of
the eighteenth century, when wood paneling and
mirrors began to be used as decoration, that the
shops themselves—or at least the most famous among
them—became a subject of praise (see fig. 1). This
exteriorization of wealth occurred alongside the
creation of the *Almanach du commerce* in 1798 and
the official promotion of the products of industry at
trade fairs that took place periodically from 1799 on.

Supplement

FIG. 1. Denis Diderot and Jean Le Rond d'Alembert. "Haute Couture," plate 429 from *Encyclopédie, ou Dictionnaire raisonné des sciences, des arts et des métiers* (1751–72).

FIG. 2. Les Grands Magasins du Louvre, 1877. From Bernard Marrey, *Les Grands Magasins* (Librairie Picard, 1979).

The turn of the nineteenth century marks the beginning of commerce in *nouveautés* (fashion articles). Notions sellers—who sold everything needed for dressmaking, including fabric, ribbons, trims, and other accessories—created shops specializing in fabric for clothing, accessories, shawls, laces, short capes, and, eventually, ready-made dresses and outerwear such as coats, fichus, and *visites* (short capes with long panels in front, which were fashionable in 1883–88). By 1812 the word *boutique* had become old-fashioned, replaced by the term *magasin*. The *magasin* maintained the same devotion to artistry as the boutique, however, draping garlands along its facade or artfully displaying clothing behind ever larger store windows lit by gaslight like miniature stages.[4] The merchandise published by the Abbé de la Mésangère, the director

of the *Journal des Dames et des Modes* (1798–1810), which advertised the merchants in Paris with the most beautifully decorated shops, was not limited to fashion. In fact, the only fashion merchants featured in the publication were shop owner Mademoiselle Bertin and *lingère* (linen draper) Mademoiselle Lebeuf, who sold linen household items, including undergarments. La Mésangère's journal included a series of engraved plates showing the facades of shops.[5]

Over the following years, thanks particularly to the creation between 1811 and 1839 of twenty-five covered arcades that allowed people to linger in front of the artistically decorated store windows of Paris, fashion shops became more visible at street level, though until around 1890, the shops of tailors, milliners, and dressmakers were just as likely to be located on higher floors as on street level. During the same period, store interiors also became more beautifully appointed. In her *Chroniques parisiennes* from 1837–44, Madame de Girardin described the luxury of Madame Beaudrant's establishment, which featured Boulle-style cabinets with glass windows where she displayed her hats.[6] Even shops dealing in smaller, less expensive fashion novelties—like ribbons, trims, and accessories—sought the look of luxury: tables made of exotic woods replaced counters, and baubles were displayed on upholstered backgrounds and stands, protected under glass in Louis XV–style display cases. In the years 1865–75, the ostentatious presentation of merchandise spread to the vast window displays of new department stores such as La Grande Maison de Blanc and Les Grands Magasins du Louvre, which, like hotels and railway stations, took advantage of metal framing structures, a decrease in the price of plate glass, and the invention of the elevator (see fig. 2).[7]

In fact, department stores, with their emphasis on sumptuous and richly decorated interiors, were not so different from the large, specialized fashion houses (the future purveyors of haute couture) that remained above street level. Located on the "noble" floor of a new building or a former private mansion, and reached by a graceful staircase, these *maisons* consisted of a series of comfortably furnished rooms: the waiting room, its walls hung with the portraits of famous clients or medals won at international trade shows, where customers could sit and look over the style

CAT. 100 Edgar Degas (FRENCH, 1834–1917)

Madame Jeantaud at the Mirror, c. 1875

Oil on canvas
70 × 84 cm (27 ⁹⁄₁₆ × 33 ¹⁄₁₆ in.)
Musée d'Orsay, Paris

Her small hat perched toward the back of her head, Madame Jeantaud pauses to catch her reflection in the mirror. The unusual angle at which she is shown permits viewers to appreciate her graceful dolman, her fur muff, and the ribbons and flowers piled on her hat. Married women never appeared in public with bare heads, so their choice of hat was paramount. In fact, headwear became so important in the nineteenth century that multiple boutiques could be found on the same street, each endeavoring to create a signature look based on the rapidly changing trends. Degas did not specify whether Madame Jeantaud is frequenting a hat shop or simply looking in the mirror at home before an outing.

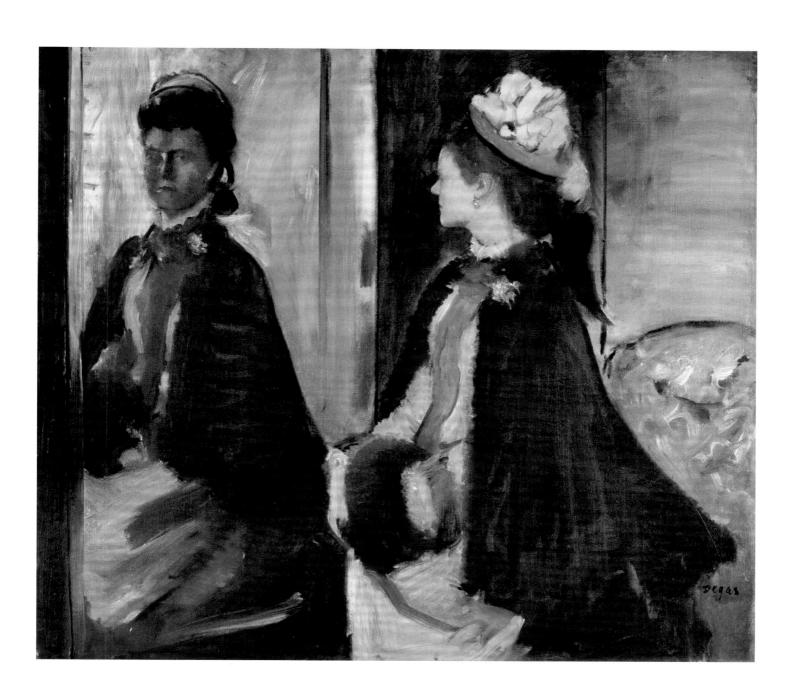

offered by the house or illustrated in fashion magazines; the show room; a fitting room; and rooms devoted to various individual accessories, such as lingerie or hats.[8]

Despite the notable characteristics of various types of fashion establishments, in his numerous depictions of millinery shops, Edgar Degas did not fully describe the space of the store. In *Madame Jeantaud at the Mirror* (cat. 100), for example, the woman pauses before a mirror to give herself a final look before venturing outside, muff in hand. Although the space could be a domestic interior, it is also possible that she is in an interior similar to that in *At the Milliner's* (cat. 101), which depicts either a specialized boutique or one of the intimate spaces within a larger department store.

Like department stores, which grew by purchasing multiple buildings (see fig. 2; fig. 3, p. 201), the large fashion houses moved higher and higher in their buildings, occupying more floors and eventually taking over neighboring buildings as well. This was true of the venerable linen and lingerie establishment Doucet, founded in 1840 at 17, rue de la Paix, with a display window on each side of the door to the building (see fig. 3), featuring the *chemiserie* (haberdasher) Doucet et fils for men on

CAT. 101 Edgar Degas (FRENCH, 1834–1917)

At the Milliner's, 1882

Pastel on pale gray wove paper (industrial wrapping paper), laid down on silk bolting
76.2 × 86.4 cm (30 × 34 in.)
The Metropolitan Museum of Art, New York

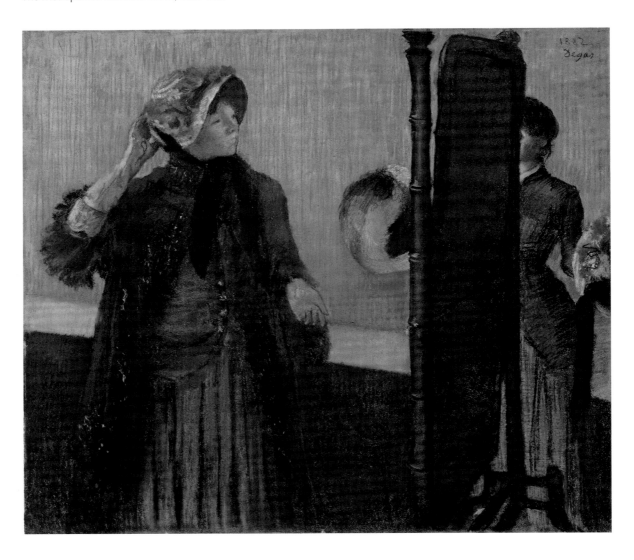

Wood engraving
40.5 × 29.8 cm (15 ¹⁵⁄₁₆ × 11 ¾ in.)
Private collection

FIG. 3. Facade of the House of Doucet, rue de la Paix, and listing of the various stores within, c. 1850.

the left, and the clothing, linen, and lace shop of Madame Doucet for women on the right. In 1869 Édouard Doucet ceded the shirt business on the first floor to Pilzer and Harson in order to devote himself to ladies' couture under the name Madame Doucet; he did, however, keep the upper floors of the building in order to advertise the specialties of the house. In 1878, in anticipation of the Exposition Universelle held in Paris later that year, the Duluc sisters, specializing in couture, moved

to the most beautiful floor of a building on the rue Mosnier, where they advertised their particular specialties in large letters across the balcony. After 1895–1900, however, these second- and third-floor shops became less desirable, and direct access to the street became necessary as an affirmation of a shop's celebrity. Once at street level, all the great fashion houses—Beer, Cheruit, Raudnitz, Rouff, and Worth—decorated their windows to entice passersby, who could hardly fail to notice the famous name painted or engraved on a plaque, or even emblazoned on the facade of the building.

Department stores constantly copied fashion houses and other deluxe establishments. Even those east of the city, far from the elegant part of town, like À La Ville de Saint Denis on the rue du Faubourg Saint Denis or Au Grand Marché Parisien on the rue Turbigo, emphasized luxury. In fact, these larger entities focused on a non-working-class, bourgeois clientele, allowing any woman from the lower rungs of the bourgeoisie, or even just a competent housewife, to buy fabric and notions to sew clothing with a trendy silhouette that would approximate a luxury item. This same middle-class woman could also buy ready-made garments in all Parisian department stores beginning around 1865. In 1870–80 department stores were very serious about their obligation to offer an imitation of the luxury for which Parisian fashion was renowned; they often alluded to it directly, insisting on the elegance of the styles they offered. *La Paix* advertised in 1869 "ravishing outfits that are every bit as desirable as those of Worth," shown in a "Renaissance salesroom, with artfully carved paneling framing enormous mirrors in Venetian glass."[9]

Given the importance of both large and small stores to the modern landscape of Paris, one may wonder why Realist and Impressionist painters did not focus on them as a theme, especially when they were so present in literature. Impressionists were interested in outdoor light and the constantly changing effects of shadow, particularly in the country, but also on city streets. The artificial light of the theater and *cafés-concerts*—its effects on fabric and the flesh revealed by low-cut necklines, and its reflections in mirrors and gilding—also fascinated them, but shops were barely represented at all in their art. Degas made a few scenes of milliners trimming hats and customers trying on hats (cats. 101, 103, 105), and toward the end of

FIG. 4. EVA GONZALÈS (FRENCH, 1849–1883).
Interior of the Milliner's, 1882–83. Oil on canvas; 38 × 46 cm
(15 × 18 ⅛ in.). The Cheryl Chase and Stuart Bear Collection.

FIG. 5. PROSPER LAFAYE (FRENCH, 1806–1883).
"Interior of the Saint Joseph Shops," 1845. Reproduced in
L'Illustration 112 (April 19, 1845), p. 120.

Marie Simon noted that the picturesque quality of stores did not seem to interest the Impressionists, despite remarks by Edmond Duranty, who in 1876 in *La nouvelle peinture* (The New Painting) pointed to stores dealing in fashion as a possible subject for the modern painter. Likewise, Joris-Karl Huysmans claimed in 1880 that "all modern life must be studied more: balls, the lives of family, craftsmen and the bourgeoisie, stores."[10] While independent painters like the Impressionists, and even those whose work was welcomed at official Salons and society gatherings, painted the new spaces of Paris, they preferred the intimacy of private gardens or interior scenes, with friends or companions as models. These artists perhaps wanted to differentiate themselves from the widespread images of industrial publicity found in store catalogues, lithographs of manufacturers' designs for couture houses, and above all fashion engravings made by talented illustrators like the Colin sisters, Jules David, and Guido Gonin, whose compositions included scenes of women in every aspect of bourgeois life. The timid attempt by the painter Prosper Lafaye at the Salon of 1845 to capture an interior scene at the Magasins Saint-Joseph (fig. 5) produced no imitators, since popular illustrated magazines like *L'Illustration*, *Le Journal Amusant*, and *La Vie Parisienne* thoroughly satisfied any appetite for engravings of facades and announcements of sales and new store openings. These views of consumer culture would later be echoed in the paintings *The Storefront of the Couturier Doucet* (fig. 6) and *Workers Leaving the House of Paquin* by Jean Béraud (1906; Musée Carnavalet). In these, however, the emphasis is on the fashionable men and women on the streets of Paris rather than on the shops themselves.

The definition and relationship of fashion, art, and modernity is subject to discussion. Félicien Rops—for whom, as an artist and fashion designer, the terms were essential—wrote to his friend the Belgian writer Edmond Picard on the topic on March 18, 1878:

> Above all, I wish to paint our era. When I say that a painter must be of his times, I believe that he must especially paint character before painting outfits and accessories. I will never be persuaded that a lady (in a yellow dress)

his career, Édouard Manet, who was friends with a number of wealthy and fashionable notables, painted Méry Laurent as if at a boutique musing over which hat to acquire (cat. 104). Eva Gonzalès showed a fitting at a store that might be either a milliner's or dressmaker's shop. Far from a finished painting, this small-scale sketch was not even exhibited during her lifetime (fig. 4). A decade later, James Tissot depicted a young shopgirl as part of his series *Women of Paris* (1883–85), seen as if photographed from the rear of the store against the light coming in from the window (cat. 75).

CAT. 103 Edgar Degas (FRENCH, 1834–1917)

At the Milliner's, 1882

Pastel on paper
67 × 52 cm (26 ⁷⁄₁₆ × 20 ½ in.)
Musée d'Orsay, Paris

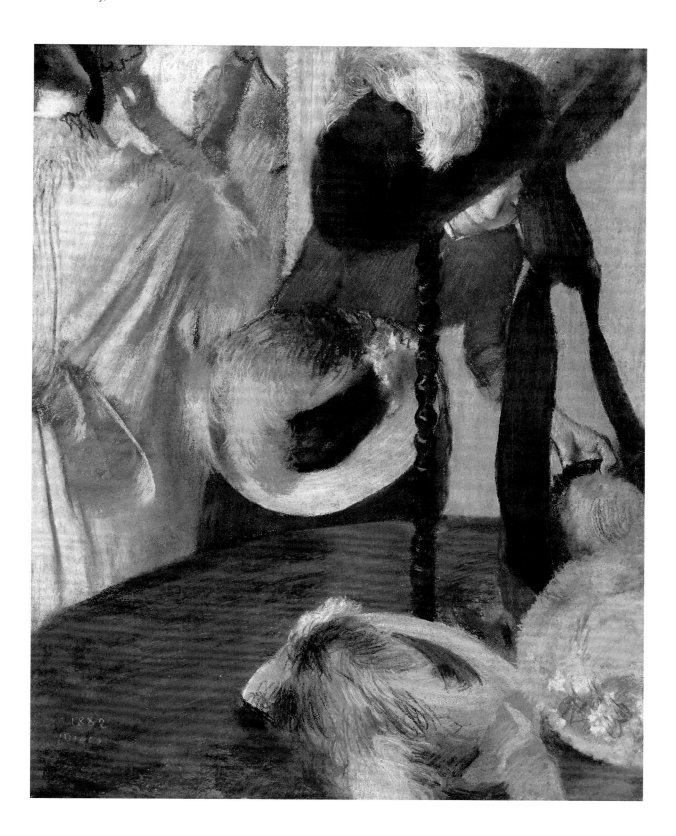

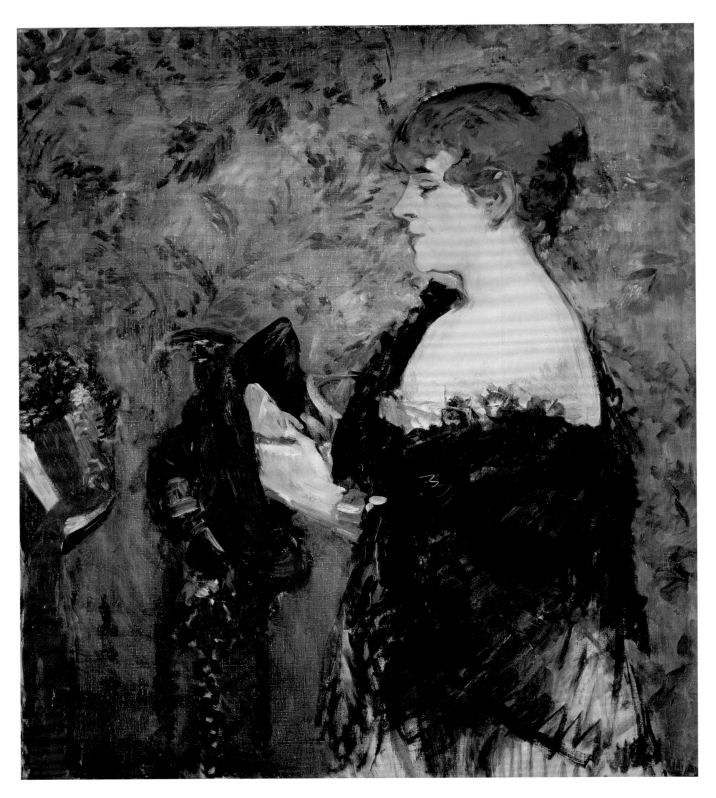

CAT. 104 Édouard Manet **(FRENCH, 1832–1883)**

At the Milliner's, 1881

Oil on canvas
85.1 × 73.7 cm (33 9/16 × 29 1/16 in.)
Fine Arts Museums of San Francisco

FIG. 6. JEAN BÉRAUD (FRENCH, 1849–1935).
The Storefront of the Couturier Doucet, c. 1899. Oil on panel;
36 × 44.5 cm (14 ³/₁₆ × 17 ½ in.) Madame M. Roche, Paris.

reading a letter, a demoiselle (in a blue dress) contemplating a Japanese figurine, that any fine person (in a velvet dress) admiring herself in a mirror, constitutes the most palpitating and most interesting aspects of modernity—all the more so as there is not one of them who was captured on canvas unawares, but rather each was brought to the studio at one hundred *sous* a session and dressed in the yellow, blue, pink, white, or velvet dress to represent the Society Lady for those who have never seen one. On the other hand, I allow that the dresses are marvels of execution—but modern life, modernity—where is it?[11]

These remarks, apparently aimed at the paintings of Alfred Stevens, speak to Rops's desire for painters to do more than show a woman as an object. He alluded to the need for artists to picture a woman as an active rather than passive participant, by extension illustrating her role in procuring a dress and objects that define her. Rops himself never depicted a woman in the role of consumer as an answer to his quest for "modern life, modernity." In this he was like the Impressionists, most of whom stayed away from this aspect of modern life. Only at the end of the century, in fact, could one admire a sumptuous representation of the interior of Le Bon Marché in a triptych by Félix Vallotton, who in 1898 finally paid homage to the lively colors and picturesque quality of fabric and perfume counters that were to remain so much a part of the department store culture (fig. 7).

FIG. 7. FÉLIX VALLOTTON (SWISS, 1865–1925).
Le Bon Marché, 1898. Oil on board (triptych); 70 × 50 cm
(27 ⁹/₁₆ × 19 ¹¹/₁₆ in.); 70 × 100 cm (27 ⁹/₁₆ × 39 ³/₈ in.);
70 × 50 cm (27 ⁹/₁₆ × 19 ¹¹/₁₆ in.). Private collection.

Edgar Degas
The Millinery Shop

Gloria Groom

The source of ornament. Think of a treatise on ornament for women or by women, based on their manner of observing, of combining, of selecting their fashionable outfits and all things. On a daily basis they compare, more than men, a thousand visible things with one another.

—Edgar Degas[1]

Edgar Degas's observations on women's ability to choose their dresses and accessories from a variety of possibilities presaged his active interest and participation in shopping. Indeed, he is known to have accompanied the artist Mary Cassatt and Madame Émile Straus (the cousin of his friend Daniel Halévy) on visits to dressmakers and millinery shops in the late 1880s and early 1890s.[2] Acutely attentive to women's fashion in general, he was most intrigued by the chapeau. The essential crown and status symbol of any respectable woman, the hat represented an independent accessory that nonetheless must be matched to her visage and outfit—an ornament to be admired, acquired, and above all held and tried on.[3] Unlike dresses, which could be all but manufactured—and, by the 1870s, made from how-to kits following basic patterns available in magazines—hats, even those in *grands magasins* (department stores), where they were displayed in separate rooms, were individualized and expensive (cats. 109–11). This fashion statement inspired Degas to create some seventeen pastels and four oil paintings. Apart from a "modiste" exhibited in 1876 at the Second Impressionist Exhibition (still unidentified), his works on the millinery theme can be divided into two categories: those made around 1879 to 1886 showing interchanges between customers and milliners; and

those dating from the 1890s through 1910, which were often reworked from earlier subjects and from which bourgeois clients were largely excluded.[4]

LOOKING BENEATH THE SURFACE OF *THE MILLINERY SHOP*

The Art Institute of Chicago's *The Millinery Shop* (cat. 105) is Degas's largest and only "museum scale work" on this subject.[5] In this nearly square canvas, a milliner, seated at an angle beside a table of hats on wooden stands, studies the unresolved shape of a hat that is not completely decorated. She and the five hats on display to her right are depicted from a slightly elevated viewpoint, suggesting "the experience of encountering fashionable hats in a show window or inside the shop."[6] The prominent pentimenti indicate that the composition evolved during the working process, with Degas scraping down and painting over many areas of the canvas. X-radiography of the work (fig. 1) shows that changes to the original composition relate closely to a series of pastels (now lost; see fig. 2). In two of these works, in addition to holding a hat, the woman wore a broad round hat and was clearly a customer.

Much has been written about this painting and others in which Degas blurred or skewed expectations of social types through costume and posture. Recent examinations using infrared reflectography (IRR) and X-radiography show that the figure in the Art Institute's canvas shifted position a number of times: two heads in three-quarter profile—depicted from a higher vantage point and set lower in the scene—are visible, contrasting with the final composition, in which the head is in profile

CAT. 105 Edgar Degas **(FRENCH, 1834–1917)**

The Millinery Shop, 1879/86

Oil on canvas
100 × 110.7 cm (39 ⅜ × 43 ⅝ in.)
The Art Institute of Chicago

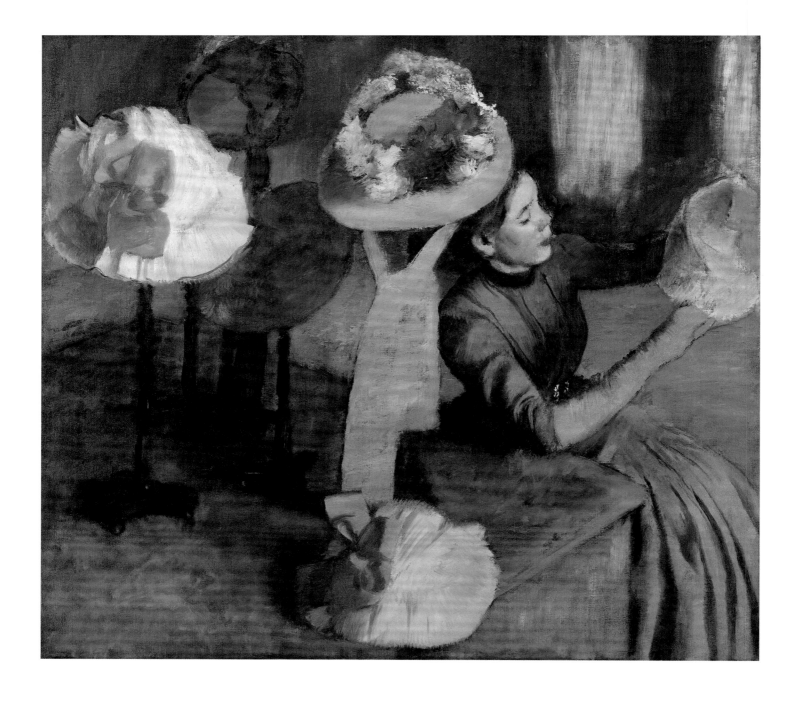

FIG. 1. X-radiograph image of *The Millinery Shop* showing Degas's original composition.

FIG. 3. Overlay of IRR image of *The Millinery Shop* and *At the Milliner's*, showing the correspondence between the original composition of the painting and the pastel.

FIG. 2. EDGAR DEGAS (FRENCH, 1834–1917).
At the Milliner's, 1882–86. Pastel; 40 × 60 cm (18 ⅛ × 23 ⅝ in.).
Location unknown, formerly Aubert Collection.

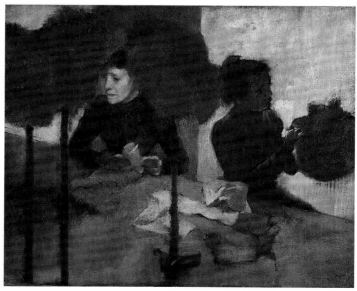

FIG. 4. EDGAR DEGAS (FRENCH, 1834–1917).
The Milliners, c. 1882. Oil on canvas; 60 × 74.9 cm (23 ⅝ × 29 ½ in.).
The J. Paul Getty Museum, Los Angeles, 2005.14.

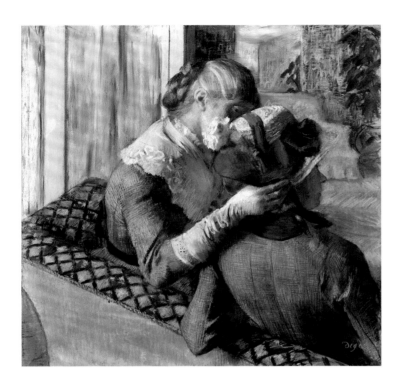

CAT. 106 Edgar Degas (FRENCH, 1834–1917)
At the Milliner's, 1881

Pastel on five pieces of wove paper, backed with paper,
and laid down on canvas
69.2 × 69.2 cm (27 ¼ × 27 ¼ in.)
The Metropolitan Museum of Art, New York

the woman's olive dress, painted to suggest wool or another rich fabric, with its fur-trimmed collar and belt with silver buckle, is not obviously the garment of a *petite commerçante*.[9] Nor is the nature of her elbow-length glove unanimously agreed upon: For some it is a sewing glove or mitt and thus a clear indication of her status as an employee. And yet it appears to be a kid glove rather than one of the cotton gloves used by milliners to protect hats from oil.[10] It is thus not so dissimilar from the suede gloves worn by the young bourgeois lady who helps position her friend's chapeau in *At the Milliner's* (cat. 106).[11] Even the woman's lack of hat is not a definitive indicator of her social status, and the disembodied hats, the largest and most finished of which hovers directly above her head, suggest her association with, if not appropriation of, this symbol of bourgeois status and decorum. Perhaps the more compelling argument for seeing the seated female in *The Millinery Shop* as an employee rather than a visitor is her concentrated focus on the hat itself—an expression that Degas exaggerated through her pursed lips, which seem to be holding a pin.[12]

IMAGING THE *MODISTE*

Unlike the series of bathers that Degas exhibited at the 1886 Impressionist exhibition, which was described as showing a peephole view from a male perspective,[13] the two pastels that he showed the same year on the millinery theme treat the business of hat-making and selling through the lens of the intimate relationships between producers, sellers, and consumers.[14] Degas was keenly aware of the "Béraud trap"—the risk of being overly narrative— and Degas's pastels of a milliner and her client (cat. 101), and a milliner and her apprentice (fig. 5), were considered Realist subjects and "nothing new" by reviewers of the 1886 exhibition.[15] They were read as representing the Parisian milliner and reflecting the morality and economic plight of this type of woman.

Like the danseuse and laundress, the milliner was considered ripe for moral ruin, since her wages were low and the prospect of making more money on the side was a very real temptation. Milliners

and appears higher on the canvas.[7] The IRR image most clearly shows features related to the figure in what was likely its second position. An overlay (fig. 3) with the outlines of the pastel drawing formerly in the Aubert Collection rescaled and laid over the IRR image shows a very close correspondence between these early designs and the pastel.

Equally noticeable in the X-radiograph and IRR images are changes in costume, indicating that the sleeve of the woman's dress was once trimmed with lace. The hat that she examines in the final composition was also much larger and more fully decorated. These changes suggest the stages in Degas's painting process, as he switched the woman from customer to milliner, although the details of this transformation remain ambiguous. In *The Milliners* (fig. 4), Degas painted over the original "customers," with their lace fichus and hats, with dark brown, making their transition to workers much clearer than in *The Millinery Shop*.[8] The Chicago composition subverts an easy reading:

were doubly suspect, as were shopgirls (*femmes de comptoir*), because they catered to the moneyed classes and were constantly reminded of the luxury goods that they handled and promoted but could not afford. Eunice Lipton and Hollis Clayson described the milliner as a "tart" and cited contemporaries like Gustave Coquiot, who called Degas's milliners "a very delightful group of Parisian coquettes."[16] But the anonymous *Mémoires d'une modiste écrits par elle-même* (Memoirs of a Shopgirl Written by Herself), published in 1866, paints a bleaker picture of their status, underscoring the helplessness of modistes, who were often victims of shops' wealthy owners or other male predators.[17] Whereas women employed in dressmaking establishments were among the highest paid of female workers,[18] modistes, as the critic Geffroy described the "anemic and ragged" figures of two pastels exhibited in 1886, "are surely those who earn two francs per day, composing hats at twenty louis, waiting to deliver them."[19]

Unlike Degas, for whom the millinery shop was a recurring subject over thirty years, Pierre-Auguste Renoir rarely ventured into this thematic territory. His unusual 1877 pastel of a smiling milliner (cat. 107) defies any negative social reading. Framed by the hats on display through the plate-glass window, the milliner (also called *trottin* or apprentice) is shown leaving the store on her way to deliver the hatbox she holds. The rose in her hair matches the blossom on her bodice and serves as a substitute headdress for the ornately decorative hats she helps create but cannot own. Yet she is presented as a young woman enjoying the freedom of the street, outside the workroom or fitting area, and without a relationship to labor.[20] Although Renoir was deeply interested in women's hats — suggesting to Madame Charpentier that he study them (along with dresses) "from life from all angles" for a special section for *La Vie Moderne*—the work of the modiste was a less compelling subject for him.[21]

ARTICLES DE PARIS

Beginning in 1879, Degas used the term *articles* to denote the similarity between the accessories—gloves, hats, and fans—sold in the arcades and boutiques of Paris and the small, undemanding

works that he made for easy revenue.[22] In his millinery shop paintings, he equated the hat shop or *atelier de modiste* with the artist's studio. Both represented the factory where hats and artwork—*articles de Paris*, or confected goods—were made to satisfy a specific market.[23] A decade earlier, in a letter to his favorite model of the time, Emma Dobigny, he mentioned having put out his shop sign, referring to his studio as an "établissement de bouillon," and by extension to himself as a merchant of *bouillon* or a small shopkeeper of remaindered or returned items.[24] Degas's reference to shop signs and to his *établissement* made it clear that he aligned himself with small merchants. Indeed, there is no evidence to suggest that his shopping trips with Cassatt and Straus included stops at the *grands magasins,* where males far outnumbered female shop clerks.

Although the most notable millinery shops were located in the rue de la Paix in the quartier de l'Opéra, the stores Degas depicted were never specified by name or identifiable imagery. In paintings like *At the Milliner's* (cat. 106), the understated elegance of the decor and light-filled windows suggest that the setting may be an exclusive boutique above ground level, while the more spartan setting of *The Millinery Shop* (cat. 105) suggests a smaller boutique or even the work area of a hat shop. Unlike the art of Renoir—or later the photographer Eugène Atget, who showed window dressings with hats as seen from store exteriors—Degas's *The Millinery Shop* and *The Milliners* show a view from the street set within the window frame, focusing on the creation of hats rather than the finished products. As in representations of artists' studios, where finished paintings occupy the same space as unfinished canvases (usually with one nearly finished work on an easel), *The Millinery Shop*'s ornately executed and only partially finished hats exist side by side and are deftly arranged so that the scene is inviting to both male and female viewers.[25] In *The Milliners*, an earlier composition visible in an X-radiograph shows a table laden with decorated hats; this was painted over sometime before 1905 and replaced by the ribbons and trims in the finished composition, the elements of assembly and work.

Douglas Druick was the first to equate Gustave Caillebotte's provocative refashioning of raw materials (meat) to the hero of Émile Zola's

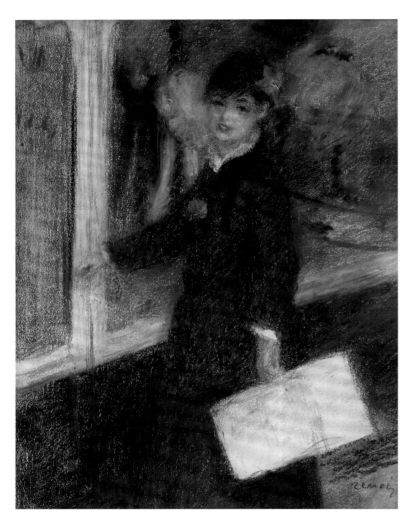

CAT. 107 Pierre-Auguste Renoir
(FRENCH, 1841–1919)

The Milliner, 1877

Pastel on paper
53.3 × 41.3 cm (21 × 16 ¼ in.)
The Metropolitan Museum of Art, New York

novel *Le ventre de Paris* (The Belly of Paris; 1873), Claude Lantier, who artfully arranges store windows so that they create a desire to consume.[26] A similar metaphor equating artist and *étalagiste* (window dresser) is suggested by Eva Gonzalès's milliner-*apprêteuse* or trimmer (fig. 6), who is equally artful as she selects from her drawer the artificial flowers and ribbons that will be used for her hats, perhaps those on the stand and table to her right. The pink and blue flowers in the drawer harmonize with the blue of her dress, all of which are set against pale blue wallpaper decorated with a gold floral pattern. Her role as an active participant in the fashioning of a hat links her to the painter applying paint to his canvas. As Ruth Iskin pointed out in her extensive study of Degas's hat shops, the milliner and artist have a common goal: "Each represents a different expertise, but both require careful looking."[27] They are linked by the artistry (milliners considered themselves artists) and connoisseurship they bring to their work.[28] Degas often conflated the elements of hat-making with painting, and finished hats with artworks. On July 14, 1882, he sold the pastel now known as *At the Milliner's* (cat. 103) to Durand-Ruel under the title *Hats Still Life*.[29] In this and other such works—*A Woman Seated beside a Vase of Flowers (Madame Paul Valpinçon?)* (1865; The Metropolitan Museum of Art, New York), *Woman with a Vase of Flowers* (1872; Musée d'Orsay, Paris), *Diego Martelli* (1879; Museo Nacional de Bellas Artes, Buenos Aires), and *Woman Bathing in a Shallow Tub* (1886; Musée d'Orsay, Paris)—the still lifes are obvious, sometimes even foregrounded, but like the hats in the scenes of millinery shops, always embedded in a genre scene.

HATS AND OTHER FASHION FETISHES

The connection between composing a painting and making a hat was not unique to Degas, and by the time of his millinery series, men, especially among the vanguard (including Édouard Manet, Stéphane Mallarmé, and Zola), had become increasingly interested in the representation of fashion commodities.[30] In his recollections of Manet's keen interest in shopping, Antonin Proust wrote: "He spent a whole day in rapture before the

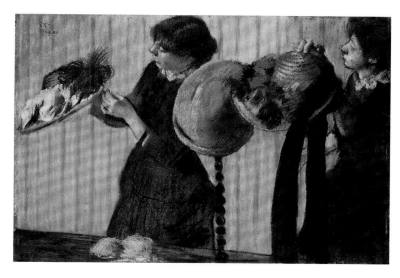

FIG. 5. EDGAR DEGAS (FRENCH, 1834–1917).
Little Milliners, 1882. Pastel on paper; 48.9 × 71.8 cm
(19 ¼ × 28 ¼ in.). The Nelson-Atkins Museum of Art,
Kansas City, acquired through the generosity of an
anonymous donor, F79-34.

FIG. 6. EVA GONZALÈS (FRENCH, 1849–1883).
The Milliner, c. 1887. Pastel and watercolor on canvas;
45 × 37 cm (17 ¹¹⁄₁₆ × 14 ⁹⁄₁₆ in.). The Art Institute of Chicago,
Olivia Shaler Swan Memorial Collection, 1972.362.

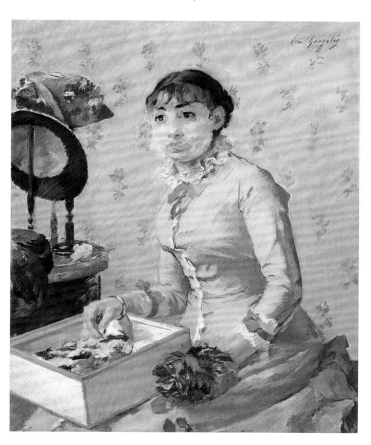

materials unrolled in front of him by Madame
Derot. The next day it was the hats of a famous
modiste, Madame Virot, that fired his enthusiasm.
He wanted to compose a toilette for Jeanne, who
became the actress Mademoiselle Demarsy."[31]
The tactile experience—both electric and erotic—
of the encounter between the artist's or consumer's
hand and an object, a recurring metaphor in Zola's
Au bonheur des dames (The Ladies' Paradise; 1883),
describes Degas's own attraction to feminine fash-
ion. According to Paul Gauguin, the artist went
"into ecstasies before the milliner's shops in the rue
de la Paix, the charming laces, those famous
touches by which our Parisian women drive you into
buying an extravagant hat."[32]

Edmund de Waal's family memoir, *The Hare
with Amber Eyes* (2010), inspired by his relative
Charles Ephrussi—a collector of works by Degas
and the other Impressionists, as well as Japanese
art—offers a poetic description of the pleasures of
touching and handling tiny netsuke; his words are
reminiscent of the language used by both Proust and
Gauguin to describe the Impressionists' passion for
textiles, trims, and hats.[33] De Waal described the act
of accessing the netsuke: "But the vitrine—as opposed
to the museum's case—is for opening. And that
opening glass door and the moment of looking, then
choosing, and then reaching in and then picking up
is a moment of seduction, an encounter between a
hand and an object that is electric."[34] It is a descrip-
tion easily likened to entering an artist's studio,
where works could be held up for scrutiny, or a shop,
in which the hats were intended to be handled.

Interestingly, Degas's images of fashionably
dressed women looking at and figuratively consum-
ing works in picture galleries (cats. 125, 126)
were made in the same period as his most intense
engagement with the subject of milliners. Framed
and behind glass, the hats in his paintings of store
windows are reminiscent of his scenes set in galler-
ies: both represent untouchable objects of desire
and aesthetic consumption. Degas painted an
intimate encounter, which, like the opened case of
the netsuke, represents the "moment of seduction,"
when both milliner and customer participate in the
handling of the object of desire.

A recurring visual syntax for advertising
hats, hairstyles, corsets, and other ingredients in

feminine toilettes was the repetitive grid (see cat. 108). In Iskin's words, these representations, "severing an item from its human context," point to the fetishistic properties of fashion that were encouraged by the *grands magasins*, with their many specialized departments, each with its own "look."[35] Zola's *Au bonheur des dames*, whose publication in 1883 coincided with Degas's interest in the millinery theme, acknowledges this new paradigm and the demise of the specialty boutique, such as the umbrella and walking stick business run by the novel's fictional Bourras, who rails against Octave Mouret and his managers at the Bonheur des Dames: "The scoundrels are creating departments of flowers, millinery, perfume, shoes and I don't know what else."[36] Instead of going from one shop to another, hours were now spent roaming the departments within the multilevel *magasin*. Epitomizing this new female form of flaneurism is Zola's Madame Marty, whose mania for buying frivolous and unnecessary articles at the department store nearly ruins her husband. Zola offered a vivid picture of her shopping frenzy, which involved,

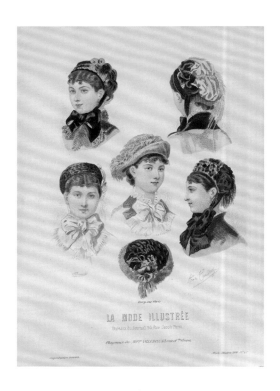

CAT. 108 Anaïs Toudouze **(FRENCH, 1822–1899)**
"Six Hats," *La Mode Illustrée* 42 (December 19, 1880)
Steel engraving with hand coloring
36 × 25 cm (14 ¼ × 10 in.)
Private collection

CAT. 109 Hat, 1885/90
American
Dark brown silk velvet and brown silk faille trimmed with light brown silk brocade ribbon
The Metropolitan Museum of Art, New York

CAT. 110 Bonnet, 1887
French
Lavender straw and silk ribbon trimmed with purple silk velvet and artificial thistles
The Metropolitan Museum of Art, New York

CAT. 111 Hat, 1887
French
Brown silk velvet trimmed with ostrich feathers and gold metallic thread
The Metropolitan Museum of Art, New York

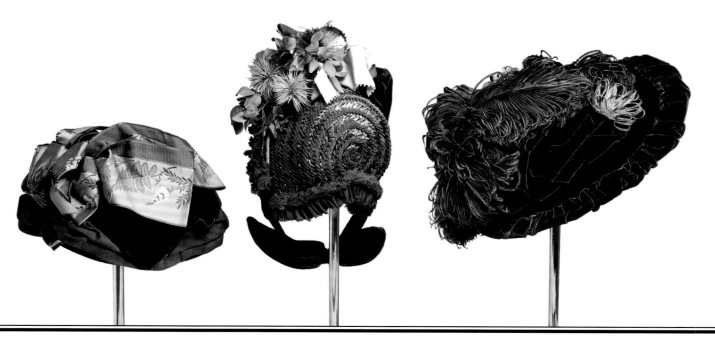

CAT. 112 Eva Gonzalès (FRENCH, 1849–1883)

The White Slippers, 1879/80

Oil on canvas, laid down on panel
23 × 32 cm (9 ¹⁄₁₆ × 12 ⁵⁄₈ in.)
Vera Wang

spending an hour in the new millinery department, installed in a new salon on the first floor, having cupboards emptied for her, taking hats from the rosewood stands with which two tables were decked, and trying them all on with her daughter—white hats, white bonnets, white toques. Then she had gone downstairs again to the shoe department at the far end of one of the galleries, beyond the ties, a department which had been opened that very day. She had ransacked the showcases, seized with morbid desire at the sight of white silk mules trimmed with swansdown and shoes and boots of white satin with high Louis XV heels.[37]

Eliciting Madame Marty's "morbid desires" were the shoes displayed in glass cases. Unlike hats, which could be individualized and made to order, shoes were ready-made in generic styles. Gonzalès's paintings of white satin slippers and the pump popularized by Louis XV (cats. 112, 113) play to the fetishistic fascination surrounding this part of the wardrobe, which, in contrast to hats, was erotic because it clothed a part of the body that was never intended to be fully exposed.[38] In many of the Impressionists' intimate portraits (see pp. 107–23 in this volume), a mule or slippers dangling from the couch heightened the informal dishabille of the sitter. Although Gonzalès's paintings rarely showed her subjects' shoes peeking out from below their

CAT. 113 Eva Gonzalès **(FRENCH, 1849–1883)**

The Pink Slippers, 1879/80

Oil on canvas, laid down on panel
26 × 35 cm (10 ¼ × 13 ¾ in.)
Private collection, courtesy of Galerie
Hopkins, Paris

CAT. 114 Henri Charles Guérard
(FRENCH, 1846–1897)

The Assault of the Shoe, 1888

Etching, with open bite, in light red and black
on cream laid paper
Image/plate: 16.7 × 25.2 cm (6 9/16 × 9 15/16 in.);
sheet: 19.9 × 28.1 cm (7 13/16 × 11 1/16 in.)
The Art Institute of Chicago

CAT. 115 Henri Charles Guérard
(FRENCH, 1846–1897)

The Assault of the Shoe, 1888

Etching, with open bite, in black on cream
wove paper
Image/plate: 16.7 × 25.4 cm (6 9/16 × 10 in.);
sheet: 35.5 × 49 cm (14 × 19 5/16 in.)
The Art Institute of Chicago

CAT. 116 Edgar Degas (FRENCH, 1834–1917)
Mademoiselle Marie Dihau, 1867–68

Oil on canvas
22.2 × 27.3 cm (8 ¾ × 10 ¾ in.)
The Metropolitan Museum of Art, New York

CAT. 117 Edgar Degas (FRENCH, 1834–1917)
The Jet Earring, 1876–77

Monotype printed in black ink on
white wove paper
Plate: 8.2 × 7 cm (3 ¼ × 2 ¾ in.);
sheet: 18 × 13.2 cm (7 ¹⁄₁₆ × 5 ³⁄₁₆ in.)
The Metropolitan Museum of Art, New York



anonymity, and as in Manet's paintings of Méry Laurent and Jeanne Demarsy (cat. 104; fig. 2, p. 258), Marie is a mannequin, simply advertising the accoutrements of travel.

Degas's series of fifteen small monotypes of women focusing on striped bodices, headdresses, and jewelry are more elusive nods to the fashion industry. In *The Jet Earring* (cat. 117), the technique— the result of drawing with greasy ink on a metal plate that is then pressed onto a paper surface for a one-off (monotype)—bears the artist's touch, but the subject itself, a close-up of the back of a woman's head, is indifferent and even more anonymous than traditional depictions of hair and headpieces in fashion magazines, such as Mallarmé's fashion plate in *La Dernière Mode* illustrating the complicated "Virgil" hairdo, "an enchanting style for a dinner-party" (fig. 6). Degas's version is more overtly nonrepresentational; it is objectlike, fetishized, and more still life than portrait.[41]

The admiration Degas expressed for the hand-wrought, his identification with the artisan, and his recognition of art as a commodity are most profoundly expressed in his millinery shop paintings, which are complex and evolved in meaning and style over time. Expressive of his appreciation of both women who create (milliners) and women who make aesthetic choices (clients), they also show the artist's equation of carefully arranged handmade objects with artists who arrange compositions and colors. Like the picture frame— a functional and ornamental commodity that Degas fervently believed was the artist's responsibility to conceive, select, and procure in order for it to harmonize and support the work of art—the hat played an essential role in balancing and completing a feminine ensemble.[42] His paintings and pastels of the millinery shop can be seen as his most accessible metaphor for the creative process and, indirectly, the fashion industry.[43]

FIG. 6. STÉPHANE MALLARMÉ (FRENCH, 1842–1898). "The Virgil," *La Dernière Mode*, October 18, 1874.

dresses, she seems to have had a personal association with shoes.[39] The date given for her painting of the white slippers suggests a possible link to her marriage to Henri Charles Guérard in 1879, while the pink pumps also appeared in an earlier painting entitled *The Harpist* (1873/74; private collection).[40] The personalized totemic potency of this fashion statement is evident in a series of six lithographic prints entitled *The Assault of the Shoe*, which Guérard created five years after Gonzalès's death (cats. 114, 115). In these works, the pink silk pumps star in a sartorial saga as a shoe citadel besieged by Lilliputian Chinese men.

The erotic charge of footwear can be compared to other fetishistic or sartorial separations of commodity from content. Degas's painting of the professional singer and instrumentalist Marie Dihau (cat. 116) highlights her fashion accessories, which together indicate a woman outfitted with travel necessities—carpeted travel bag, hat, and jewelry—but reveals little about her personality or physiognomy. The profile view accentuates her

Fashion and the Press

Justine De Young

By the mere inspection of a woman's exterior appearance,
another woman, if she has intelligence and the habit,
will know what class she belongs to, what was her education,
what society she has seen. She will even discern her tastes,
her character, if she takes the trouble to observe;
often her manner of arranging her shawl, of putting on her hat,
of fastening her gloves reveals an entire existence.

—Countess Dash[1]

While dress has been linked to character and social status in popular discourse since the Renaissance, it was not until the Realists and then Impressionists embraced the painting of modern life and portraiture and genre subjects overtook the Paris Salon that art critics had frequent occasion to critique painting in those terms.[2] The idea that fashion revealed a person's character was pervasive in the 1860s; what one wore was believed not only to reflect one's morality, but also to affect it. In 1866 Madame de Simiane warned the young readers of the *Magasin des Demoiselles*: "Extravagance in dress leads to extravagance in manners and in speech, the same way that ruin leads to ruin. Fashion, you must understand, exercises a great influence over morals."[3] Henri Nadault de Buffon, in his *Notre*

ennemi le luxe (Luxury, Our Enemy; 1869), similarly explained, "If costume reveals the taste of a person, it is also an exact mirror of their morality."[4] This view also pervades Charles Baudelaire's famous essay "Le peintre de la vie moderne" (The Painter of Modern Life; 1859), in which he claimed that a courtesan's "over-ornate shoe would be enough to betray her for what she is, if the somewhat unnecessary extravagance of her whole toilette had not done so already."[5] Dressing fashionably and in good taste thus became one of the central concerns of a bourgeois woman's daily life, as not merely her appearance but also her reputation was at stake.

Not surprisingly these beliefs influenced art and Salon criticism of the period. Art critics

CAT. 119 "Woman in an Outdoor Dress with a Woman in a White Muslin Dinner Dress from *Les Modes Parisiennes,*" *Peterson's Magazine,* August 1865

Steel engraving with hand coloring
Sheet: 19 × 14.2 cm (7 ³⁄₈ × 5 ⁵⁄₈ in.)
The Metropolitan Museum of Art, New York

The bright red, embellished bolero jacket and voluminous dark skirt worn by the woman in the foreground of this fashion plate are remarkably similar to the ensemble in *Portrait of Mademoiselle L.L.* (cat. 118) painted by Tissot the previous year. Whereas the painted version portrays a unique individual, this image focuses on displaying the fashionable elements of dress—high belted waistlines, crinolines, drop earrings, and white blouses worn under skirt and jacket separates—characteristic of the period.

CAT. 118 James Tissot **(FRENCH, 1836–1902)**
Portrait of Mademoiselle L.L., 1864

Oil on canvas
124 × 99.5 cm (48 ¹³⁄₁₆ × 39 ³⁄₈ in.)
Musée d'Orsay, Paris

Tissot's young woman posed unconventionally on a tabletop is both fashionable and full of personality. Her expansive black skirt is worn without a crinoline, though it is certainly wide enough to accommodate one. She has paired it with a bolero jacket, a Spanish-style trend likely inspired by the Empress Eugénie, but the bold, highly saturated red of the jacket conveys the young woman's own self-assurance, and the sliver of blue stocking below her skirt hints at intellectual pursuits. While her ensemble is strikingly similar to the one in the 1865 fashion plate shown below (cat. 119), her direct gaze and singular attitude display a character not often found in contemporary fashion plates.

FIG. I.—OUT-DOOR DRESS.—The skirt is of black alpaca, trimmed down the front with black velvet, edged with crimson braid. Black velvet belt and jet buckle. Jacket of crimson cashmere, trimmed with black. Black hat of the Scotch form.
FIG. II.—DINNER DRESS OF WHITE MUSLIN, trimmed with blue.

FIG. 1. CHARLES VERNIER (FRENCH, 1831–1887).
The Contrast, c. 1870. Color lithograph. University of
Sussex Library, Brighton.

tried to discern the fashionability as well as the
moral character of the modern women depicted
in portraits and genre scenes of everyday life.
In James Tissot's 1864 *Portrait of Mademoiselle L.L.*
(cat. 118), the young woman wears a full black skirt
and vibrant red bolero. She perches on the edge
of a table piled high with books and a thin trace of
blue is visible between her skirt and ivory shoe,
which prompted Théophile Thoré to remark:
"She has perhaps bluestockings hidden beneath
the long drapery of her black skirt. In any case she
wears a shocking red vest, much too red."[6] *Bas bleus*,
or bluestockings, were associated with women who
had literary aspirations or careers. The derogatory
term is thought to have come from the prioritization
of comfort over fashion—namely, the choice to
wear warm blue wool stockings rather than the
black silk ones dictated by fashion.

Rather than show the unnamed Mademoiselle
L.L. seated decorously and smiling prettily, Tissot
presented her as calmly intelligent and reserved.
Despite the posy of flowers and the exuberantly
floral wallpaper behind the figure, the cumulative
effect of the portrait—with a photograph tucked
in the mirror, the portfolio on the chair, and the
haphazard pile of loose sheets or drawings on the
table—is reminiscent of the intellectual disorder of
Édouard Manet's 1868 depiction of Émile Zola
(Musée d'Orsay, Paris), not a demure fashion plate.
Ironically, while *bas bleus* were assumed to dress
unfashionably, Mademoiselle L.L. wears a popular
style of the time, as one can see in an 1865 *Les Modes*

Parisiennes fashion plate (cat. 119). Her bolero was
in keeping with the vogue for Spanish fashions after
Napoléon III's marriage to the Spanish countess
Eugénie de Montijo, who set trends for much
of the Second Empire.[7] Mademoiselle L.L.'s bolero
is not just red, however, but "too red," evoking
perhaps the threat of revolution rather than the
fashionability of its wearer. Extremes of any sort
were considered revelatory of a woman's character.

Likewise, Claude Monet and Pierre-Auguste
Renoir, in their full-length portraits of their fash-
ionably dressed lovers, *Camille* (cat. 16) and *Lise—
The Woman with the Umbrella* (cat. 40), found their
subjects' social status and, by implication, morality
questioned when the paintings were exhibited
at the Salon. Even friendly critics like Zola said of
Renoir's portrait, "This is one of our wives, or
rather one of our mistresses, painted with great
truthfulness."[8] What it is about *Lise* and *Camille* that
makes them more likely to be mistresses than wives
is left to the viewer to discern. The artists' decision
to include the women's first names, rather than hide
their identities by calling them *Mademoiselle C* or
Mademoiselle L (as Tissot did), likely contributed to
this impression. Dressing too fashionably could
also be a sign of questionable morality, as attested
to by the most discussed paintings in the 1868 Salon,
Charles Marchal's *Penelope* (c. 1868; The Metropolitan
Museum of Art, New York) and *Phryne* (c. 1868;
location unknown), which cast the ideal wife and
ideal whore in modern clothing.[9] Phryne's ultra-
fashionable black evening dress, like Camille's
couture-inspired gown, was interpreted by many as
a sign of her sexual availability rather than simply
her fashionability.[10]

Charles Carolus-Duran paid attention to
these reactions when creating his own full-length
portrait of his wife in modern dress for the next
year's Salon, carefully calibrating the dress, pose,
and presentation of the work to ensure its success—
and respectability (cat. 19). Unlike Monet and
Renoir, Carolus-Duran designated his painting in
the Salon catalogue as a portrait and hid his wife's
identity, as was customary, with three stars, titling the
painting *Portrait of Madame* ***. In Carolus-Duran's
painting, Pauline Croizette stands in the entry hall
of a bourgeois apartment and looks out at the viewer,
pulling lightly on the pinky of her pearl-gray glove,
its mate already lying cast off on the ground. *Portrait
of Madame* *** is a performance by Croizette, who

Repose, c. 1871

Oil on canvas
148 × 113 cm (59 ⅛ × 44 ⅞ in.)
Museum of Art, Rhode Island School of
Design, Providence

When Manet exhibited this painting of
his artist friend Berthe Morisot at the Salon
of 1873, critics and public alike found
Morisot's slouch, exposed foot, undone
top button, and seemingly disengaged
expression unattractive and unfeminine.
Her controversial appearance, combined
with Manet's unconventional painting style,
agitated viewers, provoking negative reviews
and caricatures (see fig. 3). It did not help
that in 1873, about two years after the
painting was made, Morisot's simple white
day dress with its dainty embroidered
flowers was already out of fashion,
replaced by a more elaborately decorated
and cumbersome style.

plays the part of the fashionable and flirtatious
Parisienne, artfully dropping one of her gloves so
that it can be gallantly retrieved by the onlooker.
Unlike Camille and Lise, Croizette wears a black silk
day dress, an elegant mainstay of the bourgeois
closet.[11] With its sophisticated mastery of, but not
excessive indulgence in, the fashions of the day,
Portrait of Madame ***, served, in the eyes of Horace
de Viel-Castel, as a reproach to the demimonde of
fashionable but disreputable women of Paris:

> Voilà the perfect elegance that the demi-
> monde will never attain, because, despite

their impudence, one smells their misery, the
double baseness of their origins and their spirit
and the vicious vulgarity of all their days; they
believe they have never accumulated enough
silks, laces and trinkets . . . to hide their poor
depravity and to attract the eye of the passerby.[12]

Women thus had a fine line to walk; to dress unfash-
ionably risked charges of intellectualism, whereas
to dress too fashionably risked charges of immorality.
This complex calculus would become even more
complicated when France plunged into war with
Prussia in 1870.

The Franco-Prussian War understandably brought most art production and changes in fashion to a halt. Under the Second Empire, Paris had frequently been represented as a chic Parisienne, but during the war, allegories cast the city as a woman in mourning. In Charles Vernier's *The Contrast* (fig. 1), Paris is presented before the war in a low-bodiced, flounced evening gown, her crown jauntily tipped forward on her head; Paris during the siege is portrayed by a much more somber figure, dressed all in black.[13] Pierre Puvis de Chavannes's two allegories of Paris painted during the war, *The Balloon* (fig. 2) and *The Pigeon* (1871; Musée d'Orsay, Paris), feature Paris in similarly starkly simple, unembellished black dresses. Like Vernier's Paris, Puvis's city has set fashion aside; she wears no crinoline, and her dress falls simply around her hips. This recasting of Paris as a serious, plainly dressed woman should be seen as part of the larger movement away

from fashion during the war, encouraged even by fashion journals, which stressed the traditional feminine virtues of charity and devotion in place of coquetry and fashionability.[14] This ambivalence about fashion would indelibly impact the signification and interpretation of paintings depicting modern dress created in the 1870s. After the Franco-Prussian War, belief in the correspondence between fashion and morality grew even stronger, and in the immediate aftermath of the Paris Commune, writers like Gaston de Cambronne wrote fervently of their hopes for a new sort of "true dress, whose decency is its most beautiful ornament."[15]

There was no consensus and little satisfaction around the representation of modern women in the Salon of 1872, the first held after the war and Commune. The fashionable Parisiennes of the 1860s who had peppered the walls of earlier Salons were now considered inappropriate subjects for art. In the press, artists were urged to embrace serious subjects and to act as soldiers:

> Art is a soldier; it also has its battles to fight as armies do. It must help regenerate our spirits and remake a vigorous and strong France. Art must produce grand and virile works, worthy of the task that we all are undertaking, worthy of the terrible times that we have gone through and of the future we await.[16]

FIG. 2. PIERRE PUVIS DE CHAVANNES (FRENCH, 1824–1898). *The Balloon*, also called *The Invaded City of Paris Entrusts Its Appeal to France to the Air*, 1870. Oil on canvas; 136.7 × 86.5 cm (53 13/16 × 34 1/16 in.). Musée d'Orsay, Paris.

The new French government—headed by Marshal Patrice de MacMahon—was dedicated to the "'reestablishment of moral order,' a politically loaded phrase that announced the social conservatism of [MacMahon's] government, as well as its religious and militaristic character."[17] Charles Blanc, head of the Beaux-Arts Administration, sought to fulfill MacMahon's mandate through strict jurying of the Salon. The government made it clear that it disliked landscape and genre subjects and would only support history painting in the grand style.[18] Few of the Impressionists found their works accepted in the 1872 Salon; those who did avoided fashionable modern-life subjects. Berthe Morisot's pastel of her pregnant sister, Edma Pontillon, won acceptance, while her more chic, yet somber *Interior* (cat. 48) did not. Madame Pontillon's obvious maternity was likely more welcome as a

model for French femininity after the war than the ennui and isolation portrayed in *Interior*.[19]

In the Salon of 1873, it would be Manet's depiction of Morisot herself that would prompt a negative reaction from critics.[20] In *Repose* (cat. 120), painted c. 1871, the elegant Morisot, clad in white muslin, reclines casually on an overstuffed sofa. She leans on one elbow with one leg tucked beneath her; a dainty foot emerges from the billows of her airy white day dress, edged in sketchily rendered yellow roses.[21] Her tiny waist is highlighted by her thin black belt and the amplitude of her bustle, which adds fullness to her right hip due to her position. Her expression is pensive and distant; its opacity makes it tempting to see a parallel between her emotional state and the charged and stormy Japanese print above her head. Neither the painting nor Morisot's expression was aligned with societal expectations for art or feminine behavior at the time, but the negative reaction at the Salon was likely also due to Morisot's idleness and somber chic—or rather lack of chic. Her dress's simplicity, while fashionable when the work was painted, was out of step with the tiered flounces and heavy ornamentation of gowns in 1873.

Although public discourse may have been calling for a rejection of fashion, to actually do so was seen as a threat—a rejection of traditional feminine concerns and roles. While Manet's loose and gestural painting technique was undoubtedly bold and objectionable, deeper concerns seem to underlie criticisms like that offered by Théophile Silvestre in *Le Pays*: "Dull, sickly creature, wretchedly dressed, her arms as skinny as a wire; from her sullen face to her little foot, she could not be more poor, thin, or in a worse mood."[22] Indeed, the work's divergence from expected norms of comportment, dress, and artistic rendering was so shocking that *Repose* apparently attracted a "restive and suspicious" crowd at the Salon and became a favorite target of caricaturists.[23] One exploited Morisot's unbalanced position and the stormy scene above her head in a caricature titled "Seasickness" (fig. 3). Her relaxed slouch was at odds with the stiff, formal posture expected of women of the time; coupled with the casual dishabille suggested by her partially unbuttoned bodice, it discomfited critics and the public.

While Morisot's dress seems to embody the simplicity and lack of ornamentation called for after the war, she was considered "wretchedly dressed" in light of the contemporary enthusiasm for ostentation, seen in works like Renoir's *The Loge* (cat. 12), exhibited at the First Impressionist Exhibition in 1874.[24] The woman's black-and-white striped gown, with its lace-trimmed bodice and ruffled sleeves, has none of the simplicity of line of Morisot's dress. The occasion is, of course, quite different—an evening at the theater rather than an afternoon at home—and the dress speaks to that shift with its low-cut bodice and more striking color contrast. While Morisot may have been too plainly dressed for 1873 critics, Renoir's subject was too extravagantly attired for those of 1874. In Jean Prouvaire's review of the picture, he expressed his firm belief that "the 'tart' in black and white in [*The Loge*] will attract attention by her reprehensible charm and by the light and joyful luxury of the fabrics."[25] Prouvaire's disdain for the luxurious fabrics and the joy he attributed to them recalls Viel-Castel's earlier reproach of the demimonde's mania for acquiring new toilettes to attract clientele and fill an implied void.

Prouvaire seems to have believed that any interest in fashion led inexorably toward prostitution, as became clear when he cast Renoir's demure *Parisienne* (cat. 32), also exhibited at the 1874 show, as merely a younger version of the woman

FIG. 3. BERTALL (ALBERT D'ARNOUX, FRENCH, 1820–1882). "Seasickness, by Manet," *L'Illustration* (May 24, 1873).

in *The Loge*. Within the corpus of nineteenth-century Parisienne images, Renoir's stands out as a particularly meek and naive example, lacking entirely the flirtatious elegance of Carolus-Duran's 1869 portrait. Renoir did not outline his Parisienne's small waist, choosing instead to emphasize the intricate folds and ruffles of her brilliant blue skirt. His decision to dress his model in patriotic "bleu de France" and title the work *The Parisienne* makes it tempting to read the painting as an attempt to redeem or revalorize the fashionable figure in postwar Paris.

Despite her demure dress and demeanor, however, Renoir's *Parisienne* was read by critics in sexualized terms. Prouvaire exemplified this reaction:

> She guards herself carefully so as to not show her legs. One can barely make out the tip of her boot, which peeks out like a little black mouse. The hat, almost on the ear, is daringly coquettish, but the dress does not reveal enough of her body. Nothing is more irritating than locked doors. Is it a portrait, this painting? It is to be feared so. The face, bizarrely old-fashioned and yet childish, smiles a false smile. But there is something naive about her.[26]

Prouvaire was annoyed by the painting's refusal to accede to the Parisienne's signature sexiness; the model's dress is too buttoned-up given her presumed character, and she pretends to possess a respectability that she actually lacks. In his review, he links her fate to that of the woman in *The Loge*: "The cheeks whitened with pearl powder, the eyes animated with a blandly passionate look, you will soon be like her, gold lorgnette in hand, attractive and useless, delightful and stupid."[27] This sort of moralizing condescension was a regular feature of art criticism both before and after the war.

Not all women, however, were subject to this kind of judgment in the press, as revealed by the critical reaction to another painting by Renoir only four years later: his portrait *Madame Georges Charpentier and Her Children*, exhibited at the 1879 Salon (cat. 124). Having begun collecting works by Renoir a few years earlier, Georges Charpentier, a successful publisher, commissioned this large group portrait in 1878.[28] Madame Charpentier, here dressed in a chic black gown, frequently held

literary salons attended by authors including Gustave Flaubert, Edmond de Goncourt, Guy de Maupassant, and Zola, who were all published by her husband. In the portrait, she sits in the Japanese-style drawing room or perhaps boudoir of the Charpentiers' rue de Grenelle home. Not only her elegant dress with a train, but also the decor testifies to her fashionable taste.[29] Her three-year-old son, Paul, sits beside her, dressed like his sister, Georgette, who is comically seated on the back of their large and apparently dutiful black-and-white Newfoundland, Porthos.[30] Paul's long hair and feminine dress were in keeping with conventions of the time.[31]

Renoir had exhibited smaller individual portraits of Madame Charpentier and Georgette at the Third Impressionist Exhibition in 1877 to largely positive reviews, but he decided to submit this grand family portrait to the 1879 Salon instead (cat. 124). Through her network of artistic and literary contacts, Madame Charpentier apparently arranged to have the work hung in a favorable spot at the Salon, where it attracted a great deal of notice.[32] Critics praised Renoir's deft use of color in the portrait, but frequently criticized his loose treatment of the figures. The presence of the two children and the bourgeois domesticity of the scene, compounded by the restrained sophistication of Madame Charpentier's dress, made any aspersions on her morality impossible. Critics were not prevented from inferring her character, however; one, for example, wrote that she was clearly "a pretty woman, gracious, of a rich and agreeable nature, who knows how to arrange things tastefully."[33] Of course, while the Salon catalogue listed the portrait anonymously as *Mme G . . . C . . . et ses enfants,* her identity was well known to at least some of the critics; F.-C. de Syène identified the portrait in *L'Artiste* as depicting "the family of an editor known by the entire world and beloved of all men of letters."[34] So such praise of Madame Charpentier and the relative restraint of the critics should perhaps in part be credited to their desire to curry favor with the esteemed publisher rather than a reformed mindset.

Charpentier was not only a prominent publisher of naturalistic literature, but in 1879 he also created a weekly journal, *La Vie Moderne,* that chronicled the artistic, social, and literary life of Paris. Moreover, he exhibited Impressionist works

CAT. 121 Henri Fantin-Latour (FRENCH, 1836–1904)
Édouard Manet, 1867/80

Black crayon with touches of charcoal on
cream wove paper
39.9 × 31.1 cm (15 ¾ × 12 ¼ in.)
The Art Institute of Chicago

In 1880, when Manet was given an exhibition at the
offices of publisher Georges Charpentier's journal
La Vie Moderne, the weekly printed an article about
the artist, accompanied by some sketches and a
lithographic reproduction of Fantin-Latour's portrait of
Manet. The painting on which the printed image was
based was first shown at the Salon of 1867, where
audiences were surprised to see Manet portrayed in a
conventional tailored suit and black silk top hat, holding
a walking stick (cat. 68). The 1880 article recounted
the artist's prolonged misrepresentation as an eccentric
bohemian, and included the lithograph to affirm Manet's
respectable taste in dress and his bourgeois character.

in an associated gallery by the same name. *La Vie
Moderne*, which frequently published articles
by Renoir's brother, unsurprisingly had nothing
but praise for the 1878 Charpentier family portrait,
remarking that "readers of *La Vie Moderne* know
as well as I do the original and fine talent of
M. Renoir."[35] Émile Bergerat, the journal editor
and gallery director, argued in the first issue that
society was too prone to read morality in dress:
"Perhaps it is also time to show that not all elegant
women are necessarily adventuresses, not all
great ladies trollops, and that the love of the interior
is not the exclusive attribute of the poor classes."[36]
Despite this editorial view, the connection between
clothing and character underlies many of *La Vie
Moderne*'s articles.

What better artist to exhibit at the galleries
of *La Vie Moderne* than the consummate flaneur
Manet, who showed twenty-five new paintings and
pastels there in April 1880? In conjunction with
the exhibition, the journal published a celebratory
article about Manet accompanied by a few sketches
by the artist and a lithograph of Henri Fantin-
Latour's 1867/80 portrait of Manet (cat. 121).
In the painting, Manet appears as a well-dressed
bourgeois, wearing an informal black sack coat
and vest, dove-gray trousers, a white shirt, and a
blue tie (cat. 68). The correctness of his dress
extends to his accessories—from his traditional
black top hat to his kidskin gloves and silver-tipped
cane. When it was exhibited at the 1867 Salon,
this justly celebrated portrait startled critics, who
had imagined a bohemian rather than bourgeois
artist in light of his infamous paintings. The 1880
La Vie Moderne profile of Manet reminds the
reader of this long-running misconception:
"For a long time, it has been popular to represent
Manet as a wild vagabond, with an untidy beard,
long hair, eccentrically dressed, with a pointed
cap with wide wings, one of the hats of the
revolutionaries of 1830."[37] Tellingly, it was not just
feminine dress that was expected to reveal charac-
ter; Manet's shocking and unconventional art
conditioned critics to expect his dress to reflect his
disregard for artistic tradition. In reality, he dressed
like everyone else: "We know today that Édouard
Manet wears a short and neatly trimmed beard,
that his hair is of a reasonable length, that he shops
like everyone else at the tailor next door, and, more
uniquely, is a man of perfect education, excellent

CAT. 122 Édouard Manet **(FRENCH, 1832–1883)**

Woman Reading, 1879/80

Oil on canvas
61.2 × 50.7 cm (24 1/8 × 20 in.)
The Art Institute of Chicago

Manet was praised by critics for his skill in conjuring accurate and realistic portrayals of modern people wearing the correct dress, displaying the proper attitude, and occupying the appropriate milieu for their socioeconomic status. Here he depicts a woman wearing a street dress, matching felt hat, and kid gloves, an ensemble suitable for a public outing and befitting the subject's age and social status. Seated near a table with a glass of beer as she peruses an illustrated journal, the young woman appears to be spending her afternoon at an outdoor brasserie. In fact, the scene was probably staged inside Manet's studio.

CAT. 123 Pierre-Auguste Renoir **(FRENCH, 1841–1919)**
Young Woman Reading an Illustrated Journal, c. 1880
Oil on canvas
46.3 × 55.9 cm (18 ¼ × 22 in.)
Museum of Art, Rhode Island School of Design, Providence

manners, with a cultivated spirit and amiable character."[38]

The article goes on to praise Manet for the reality of his artworks: "Manet's innovation in art is first of all his manner of placing figures and objects in their proper atmosphere, his scrupulous search for exactly the correct milieu. One always knows, in looking at his works, where, when, during what era and what time they were made."[39] Manet's *Woman Reading* (cat. 122), painted around the time of the 1880 *La Vie Moderne* exhibition, presents a particularly strong example of the artist's apparent realism.[40] This dynamic picture depicts a young woman seated in a café or—in light of the mug of beer—more likely a brasserie in the afternoon. She is in street dress, wearing a black felt hat, kidskin gloves, and an elaborate gray ruff; her hair is cut fashionably with a fringe of bangs. She holds an illustrated journal, which is attached to a wooden rod to prevent patrons from removing it from the premises. Behind her is a briskly rendered patchwork of red and green touches hinting at flowers, which suggests an outdoor setting. Ironically, of course, this verisimilitude was achieved not *sur place* but in Manet's studio. These effects were contrived to create an impression of instantaneity and exactness, and the model was a frequent patron of the Nouvelle Athènes, a café favored by Manet, adding to the realism of the staging.[41] One *Vie Moderne* critic remarked of Manet's works: "All these people live, breathe and pulsate with life; they are of flesh and bone."[42] He was, of course, not content to leave it there, seeing in Manet's careful delineation of costume not mere chic, but character: "Each one is of her race, of her time and her milieu; the women of the world are true women of the world, the tarts are true tarts, the urchins true urchins!"[43]

Whether inspired by Manet's *Woman Reading*, his patron Charpentier's journal, or merely a moment from everyday life, Renoir also depicted a young woman—in this case his future wife, Aline Charigot—reading an illustrated magazine around this time (cat. 123). As in Manet's painting, the model's head is set against a flurry of quick, colorful marks.[44] In Renoir's depiction, the magazine is equally if not more prominent than the model herself, who relaxes in a red armchair. Where Manet indicated the journal cover with a few sketchy brushstrokes of black with hints of yellow and blue, Renoir chose to show an interior double-page illustration with an almost theatrical quality. The loosely rendered characters on the page lie in direct contrast to the smooth porcelain of Charigot's face, her tenderly recorded profile, and her brilliant red hair. She wears no hat or gloves, and by the unself-conscious way she leans back in the chair, we can tell she is at home. We peer over her shoulder, intruding on a private moment; the close cropping of the picture and compressed space amplify the intimacy of the scene. Had a nineteenth-century critic reviewed the picture, he likely would have had a litany of comments about her lower-class status, lack of sophistication, or implied sensuality.

Or perhaps not. *La Vie Moderne* may not have lived up to its standard of believing "not all elegant women are necessarily adventuresses," but there were voices of dissent. The critic Jules Castagnary as early as 1868 staked out a contrarian position: "A woman at her work table is not necessarily virtuous, however simple her dress. Likewise, a woman at her dressing table is not necessarily a courtesan, however luxurious her dress may be."[45] This seems eminently reasonable today but was the minority position in the nineteenth century. We have become so accustomed to looking at Impressionist paintings from a twenty-first-century perspective that it bears remembering that the expectations of nineteenth-century viewers were quite different and the stakes for the artists and the women they depicted much higher. Fashion was no frivolous concern for the nineteenth-century woman; it was a vital part of her identity—and painters and the press treated it as such. Indeed, as Manet himself remarked: "The latest fashion, you see, is absolutely necessary for a painter. It's what matters most."[46]

Pierre-Auguste Renoir
Madame Georges Charpentier and Her Children

Sylvie Patry

At the Salon of 1879, Pierre–Auguste Renoir, who admitted that he "has never been so happy," saw his career take a turn for the better thanks to *Mme G . . . C . . . et ses enfants* (as the painting was called in the accompanying catalogue; cat. 124).[1] This unprecedented success can be partly explained by the identity of the model, whom the press immediately recognized and revealed.[2] Posing here with her children Paul (seated on the sofa) and Georgette, Marguerite Charpentier was, since 1871, the wife of the famous Georges Charpentier. In 1872, Georges took over the direction of the Librairie Charpentier, the publishing house created by his father, which he quickly developed. In addition to signing on the young Émile Zola, whose Rougon–Macquart series was published there and who served as its literary director, he also took on Gustave Flaubert, Edmond de Goncourt, Alphonse Daudet, and most of the writers known as naturalists.[3] With them Georges established close relationships; for example, Zola was named godfather of the Charpentiers' son, Paul.[4] Renoir's portrait can be seen as directly linked to the editorial ventures of the Charpentier family, down to the Newfoundland dog, Porthos, a gift from one of their writers.[5]

In 1878, when Renoir painted the portrait of Marguerite and her children, the fortune of the Charpentier publishing house was at its peak thanks to the prodigious success of *L'Assommoir* (1877), the seventh title in the Rougon–Macquart series. A year later Charpentier launched the journal *La Vie Moderne* and began to hold temporary art exhibitions in its offices. Renoir had his first one-man exhibition there in June.

MARGUERITE, "SALON WOMAN"

A level-headed woman, Marguerite (fig. 1) played an important role in the rise and management of the publishing house. According to her husband's associate, Maurice Dreyfous, "she deserves a special place in the gallery of women who left their mark on the world of Literature and Ideas in the third quarter of the nineteenth century. Among her many assets, she had the good fortune to be pretty and seemingly both intelligent and good—smarter than she appeared and kinder than she looked."[6]

FIG. 1. *Marguerite Charpentier*, c. 1875. Private collection.

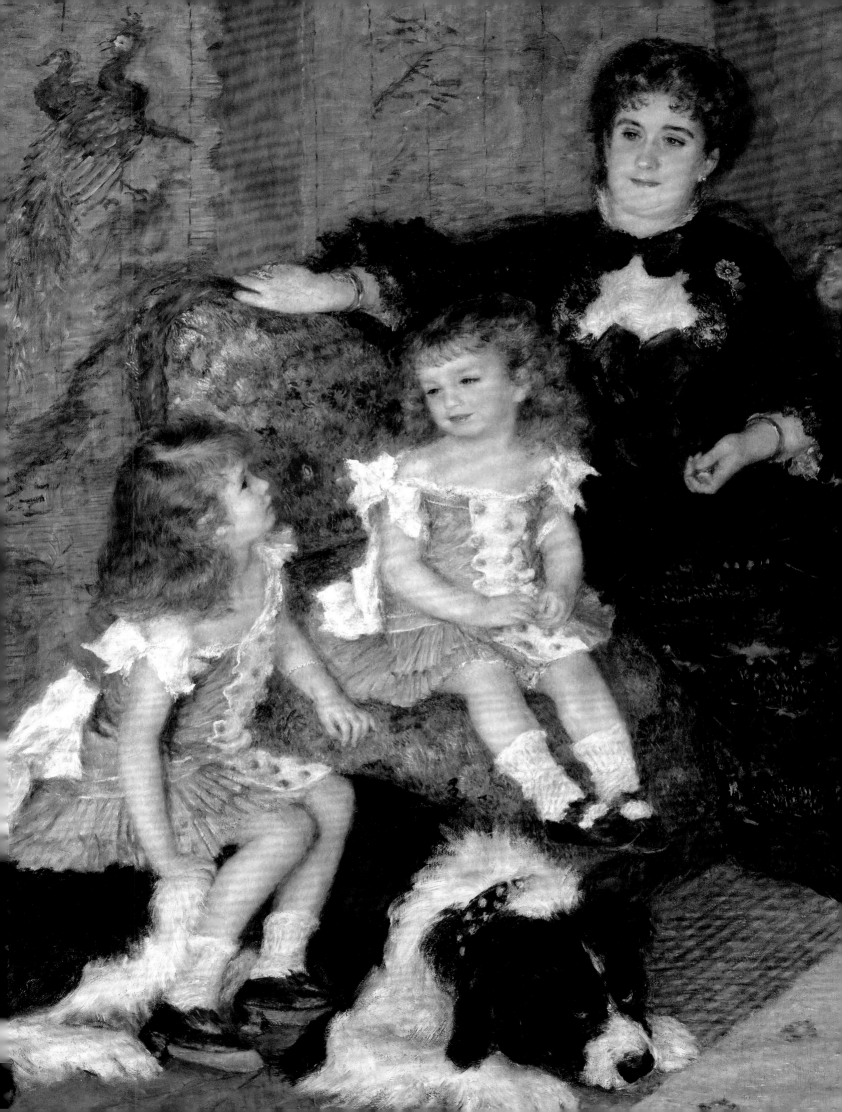

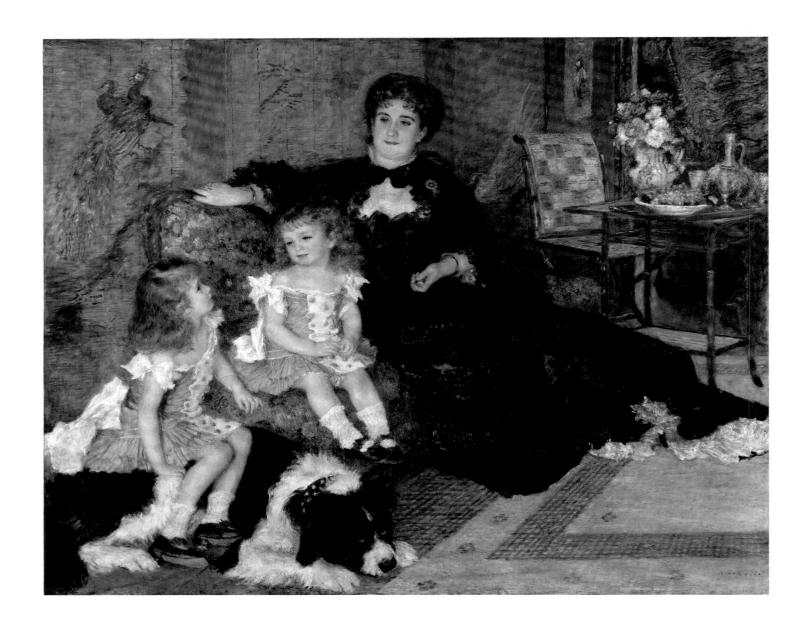

CAT. 124 Pierre–Auguste Renoir

(FRENCH, 1841–1919)

Madame Georges Charpentier and Her Children, 1878

Oil on canvas
153.7 × 190.2 cm (60 ½ × 74 ⅞ in.)
The Metropolitan Museum of Art, New York

It is thus to her that Flaubert addressed his pleas for the publication of his *La légende de Saint-Julien l'hospitalier* (The Legend of Saint Julian the Hospitaller) and recommended that Charpentier publish his protégé, Guy de Maupassant.[7] When the company's finances began to falter in the early 1880s, it was Marguerite who offered financial advice to her husband.[8] Even Zola was inspired by Marguerite for the character of the society lady, Madame Deberle, in *Une Page d'amour* (A Love Episode), the hit of 1878.

Most important was Marguerite's role as hostess of a salon attended by the elite of the literary world, by actors and artists such as Renoir, Gustave Caillebotte, Charles Carolus-Duran, Edgar Degas, Jean-Jacques Henner, Édouard Manet, and Claude Monet, as well as by politicians including Georges Clemenceau, Jules Ferry, Léon Gambetta, and Eugène Spuller.[9] Two of the three additional portraits that Renoir sent to the Salon of 1879 (the 1877 oil *Jeanne Samary*, Pushkin State Museum of Fine Arts, Moscow; and the 1878 pastel *Paul Charpentier*) had

a direct connection to the Charpentier household.[10] The Charpentier salon and publishing house were so identified with the naturalist artists and writers and Republican circles that one can spot a reference to Marguerite in an article that appeared in the fashion magazine *La Mode Illustrée*, criticizing the new type of "Salon Woman": "Is it necessary to add that she's a realist and that she pities all dissidents of this new art? A realist in literature as well as in painting, she feels close to writers who aren't able to produce beautiful things and therefore talk about that which is ugly with a skill that attracts her. . . . The ideal? What could that be? What matters to her are new words and the use of these words—a violent and colorful language—to produce new effects. Isn't she herself a walking neologism?"[11]

A modern salon woman indeed, Marguerite was interested in the daring *nouvelle peinture* embodied by Renoir's brilliantly colored portrait. She and her husband were among the first known collectors of the Impressionist group, acquiring several paintings by Renoir—*The Fisherman*, *The Dahlia Garden*, and *Woman's Head*—in the first Impressionist sale of 1875.[12] Over the next years they bought works by Monet and, shortly before Manet's death, purchased the artist's large-scale modern history painting, *The Combat of the Kearsage and the Alabama* (1864; Philadelphia Museum of Art).[13]

The sale of their collection on April 11, 1907, included works by Degas, Paul Cézanne, Guiseppe De Nittis, Marcellin Desboutin, Henri Fantin-Latour, Camille Pissarro, Pierre Puvis de Chavannes, and Alfred Sisley, as well as the academy-sanctioned artists Henner and Alfred Philippe Roll.[14] It was with Renoir, however, who considered himself the Charpentiers' "court painter," that they had the closest relationship.[15] Georges Charpentier and Renoir might have met each other at the restaurant Fournaise or other *guinguettes* (suburban open-air taverns) that the publisher liked to frequent, or through Maurice Dreyfous, who was responsible for Charpentier taking on Zola in 1872 and served as the intermediary between Marguerite and Renoir.[16] Between 1876 and 1880 Renoir worked on a variety of projects for his new patrons, including illustrated menus, portraits of their children, and decorative panels (see fig. 2) for the staircase leading from the offices to the family apartment.[17] The latter show a

FIG. 2. PIERRE-AUGUSTE RENOIR (FRENCH, 1841–1919).
Man on a Staircase (Edmond Renoir) and *Woman with a Fan*,
c. 1876. Oil on canvas; each 168 × 65 cm (66 ⅛ × 25 ⅝ in.).
The State Hermitage Museum, Saint Petersburg.

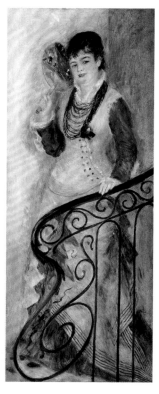

couple welcoming visitors and has often been said to be a representation of the hosts. According to some scholars, the woman bears a certain resemblance to Marguerite and carries a fan, alluding to the vogue for Japonisme that is so apparent in *Madame Georges Charpentier and Her Children*.[18] Renoir also painted a smaller portrait of Marguerite, whose success at the Third Impressionist Exhibition in 1877 may have encouraged the Charpentiers to commission the larger painting.

RENOIR'S CONVERSATION PIECE: A PORTRAIT OF TASTE AND FASHION

If the size of *Madame Georges Charpentier and Her Children* is ambitious, its composition and the choice of the black dress evoke the large-scale portraits of mothers and children by Rubens, Van Dyck, and, according to art historian Roger Fry, Gainsborough.[19] It is also a manifesto of modern portraiture, in which the model, in keeping with Duranty's admonishment in *La nouvelle peinture* (The New Painting; 1876), is represented not just by her clothes, but by her surroundings, too.[20] As Edmond Renoir, the artist's brother and a journalist for *La Vie Moderne*, commented, it was Renoir's immersion in his models' world that made his work special, remarking that for *Madame Georges Charpentier and Her Children*, he painted her home "without moving her furniture from the place it occupies every day, without doing anything to enhance one or the other part of the painting."[21] Renoir represented her in the family's little Japanese living room, even though, like Flaubert (who is said to have exclaimed "Why Japan? Because it's chic! It's chic!") he complained that Marguerite put "Japanese objects every-where."[22] Among these objects are painted screens, possibly a *kakemono* (a hanging scroll), and exported bamboo furniture.[23] Like the "knickknacks" accumulated by Zola's Madame Deberle (inspired by Madame Charpentier) in *Une page d'amour*, these typify the widespread enthusiasm for Japan in the 1870s.[24] In addition to the Charpentiers' passion for all things "chic," which Flaubert predicted would "ruin the Charpentier publishing

house," they had a "taste for the exotic, mixed with modern fashion."[25]

Considering black the "queen of colors,"[26] Renoir had already exploited the theme of the black dress in *Woman with Parrot* (cat. 22) and *Portrait of Madame Georges Hartmann* (1874; Musée d'Orsay, Paris), in which the dress was so important that the painting was sometimes called *La dame noire*.[27] Marguerite's stylishness is further enhanced by the extreme elegance of her children, who are dressed identically in embroidered white silk reception dresses, according to the custom of the time. Marguerite herself is dressed for receiving guests or going to dinner or the theater.[28] She wears a black summer or winter dress with a train, which was "strictly limited to evenings," according to *La Mode Illustrée*, which issued impassioned pleas for women to abandon the train in favor of short dresses for day.[29] Peeking out from the train are the white flounces of the supporting underskirt, which, according to Marcel Proust, is "a passage of paint-ing comparable to the most splendid of Titians," and gives "the most striking impression of elegance since the great paintings of the Renaissance" to the woman he called a "ridiculous little bourgeois."[30] Renoir's touch of white, which brings the darks into balance, was perplexing to some, including Michel Drucker, one of Renoir's biographers, who wondered, "What on earth is this lace flounce at the very end of Madame Charpentier's long skirt; who can say that this charming woman, who is a little short, didn't choose that trick, or was it Renoir who preferred to light up this corner of his rather dull painting?"[31]

Clearly, in the Charpentier portrait, Renoir put fashion's dictates in the service of his artistic imagination. Balancing accurate representation and painterly delectation, he lingered over the rendering of the décolletage trimmed by the white edges of the undergarments and joined at the neckline with a knotted bow, a chic and original detail noted by Flaubert.[32] Here Renoir suggests the transparency of Chantilly lace on the skin (fig. 3). Marguerite has pinned a daisy-shaped brooch on her bodice—a reminder of her first name (*marguerite* means daisy in French) and of her father's profession as an official jeweler to the Second Empire, creator of Eugénie and Napoléon III's imperial crowns.[33]

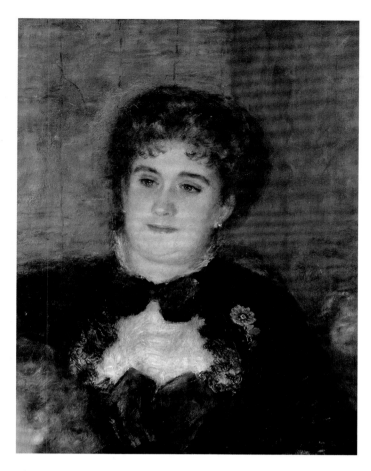

FIG. 3. Detail of the Chantilly lace at Madame Charpentier's neck in *Madame Georges Charpentier and Her Children* (cat. 124).

Marguerite's dress has traditionally been indentified as a gown by Charles Frederick Worth, which would link her to her mother and their family tradition of elegance, and reiterates the association of the famous dressmaker with Impressionism, a connection noted by critics of Berthe Morisot's work as early as the 1874 exhibition.[34] While the attribution to Worth remains unclear, the dress was undoubtedly the work of a renowned fashion house. It invites comparison to creations by the House of Roger, and also to a plate from the November 1878 issue of *La Mode Illustrée* (fig. 4), which shows what appears to be a similar dress with square neckline, narrowed silhouette, and train, and was published two weeks after the probable completion of the painting.[35] But Renoir's imprecise rendering makes it impossible to ascribe the dress to a particular couturier or to match plate to painting. The dress, like the fashion plate, has all the qualities of a visiting dress or dinner toilette, especially the ruffles of lace banding over the layers of tiered pleating across the front of the skirt. The separate basque bodice, rather than the continuous princess lined silhouette shown in the fashion plate, suggests a slightly earlier style.[36]

In Renoir's painting, the expression of light, brilliant colors, and liberated brushwork are put in service of rendering the fabric and cut of Marguerite's outfit. Renoir's subtle touches of gray on the black dress, which seem "as if they were erased by a linen stamp," interpret the decorative sashes, bordered with black lace, that gather the skirt in at the front.[37] The basque bodice with its two big black silk bows, knotted in double rosettes, recalls the Louis XV style—not surprising since Marguerite loved the eighteenth century and sometimes dressed up as Marie Antoinette—and probably inspired Renoir, a great admirer of Watteau and Boucher.

Renoir's intimate knowledge of fashion came from his family, which included tailors and dressmakers. His father was a tailor, his mother as a seamstress, and his oldest sister, Lisa, was a dressmaker who, in 1864, married Charles Leray, a fashion illustrator. Another brother, Victor, was a tailor in Paris, who married a dressmaker, and moved to Saint Petersburg, as did numerous French tailors of the period. Renoir himself, before

FIG. 4. ANAÏS TOUDOUZE (FRENCH, 1822–1899).
"Toilettes by Madame Fladry, hat by Madame Deloffre,"
La Mode Illustrée, November 10, 1878. Steel engraving
with hand coloring; 36.4 × 25.5 cm (14 5/16 × 10 in.).
The Metropolitan Museum of Art, New York, The Library
of the Costume Institute, purchased with income from
the Irene Lewisohn Bequest.

embarking on a career as a porcelain painter at
the end of the 1850s, was advised by his family
to become a fashion plate designer. In 1879, with
the complicity of Madame Charpentier, Renoir
almost realized that ambition when he suggested
that the last page of *La Vie Moderne* be dedicated
to the "fashion of the week": "I will take care of
precise drawings as soon as I get back to Paris. . . .
One can make arrangements with milliners and
dressmakers. Hats one week, dresses the next.
I'll go to their premises to make the drawings from
life from all angles."[38] Although he made illustrations
for *La Vie Moderne,* sometimes for his brother's
stories and essays, he made no fashion illustrations—
even though in the fifth issue of the journal, Ernest
d'Hervilly launched a fashion column whose first
topic was hats, one of Renoir's favorite accessories.[39]

In addition to the brilliant coup represented
by the joint launch of *La Vie Moderne* on April 10,
1879, and *Madame Georges Charpentier and Her
Children* at the Salon of May 1879, there were other
connections between the painting and the journal.
In the first issue, the editorial boasts that it will
cover the taste for "modern life" in all its aspects.
This notion is echoed in a poem by Théodore
de Banville, himself one of Renoir's models: "Artist,
now you can paint life / Modern, quivering, avid,
insatiate, / Beautiful of quiet pain and severity; /
Because your spirit is thirsty with truth."[40] The rest
of the poem encouraged artists to paint "women
in particular," which paralleled the review's own
plea in favor of mothers—a plea that can be seen as
echoing the elements characterizing *Madame Georges
Charpentier and Her Children*:

> Reader, this is Modern Life. Do what nobody
> has ever dared to do; say what nobody has
> ever dared to say; show what nobody has ever
> dared to see, this is how we want to be useful
> and this is where we want to be different.
> We won't hesitate, for example, to give
> important space to family life whose quiet
> happiness cannot be denied by even the most
> skeptical, . . . Equally audaciously, we will
> encourage mothers to be proud of being
> maternal; [we will] treat of domestic issues
> and things of the home. . . . Perhaps it is also
> time to show that not all elegant women are

necessarily adventuresses, not all great ladies trollops, and that the love of the interior is not the exclusive attribute of the poor classes.[41]

La Vie Moderne's defense of maternity and childhood is linked to philanthropic ideas common to Madame Charpentier (who founded a day-care center) and to Renoir, who in 1876 suggested that Marguerite finance a *pouponnat*, or preschool, to help the malnourished and neglected children he saw living in Montmartre.[42]

Along with *La Vie Moderne*'s emphasis on the new idea of bourgeois privacy, so wonderfully expressed by the Charpentier portrait, was its goal to promote all forms of creation, breaking down the hierarchy between the fine and decorative arts, even going so far as to recommend that "one exhibit at the Salon a dress, a rug, a piece of furniture, and . . . a jury would give them a medal."[43] Renoir is not one of these "well-dressed gentlemen who dress their dolls in outfits copied from fashion plates," such as James Tissot, Alfred Stevens, and Auguste Toulmouche, mocked by Zola and Huysmans for being "étoffistes"—"fabric makers."[44] For Renoir, fashion mattered as much as other everyday objects, because both reveal the best (the eighteenth century) or the worst (the industrial arts of his century) of the spirit or social organization of their time.[45] This is why Proust felt that Renoir, more successfully than a Pierre-Auguste Cot or a Charles Chaplin, faithful reporters of contemporary taste, expressed "the poetry of an elegant home and the beautiful dresses of our time."[46] Though integrating the latest fashions, Renoir manages to escape from fashion reportage and instead gives a timeless dimension to his portrait by not singling out specific styles and accessories that might render *Madame Georges Charpentier and Her Children* démodé—a mistake Durand-Ruel warned Renoir to avoid.[47]

The painting remained in the Charpentiers' salon until 1907, and thanks to Marguerite's intervention it was exhibited several times. Writing to her in 1886, Renoir noted, "They're going to take your portrait down [for the Galerie Georges Petit] since this is the only reason why they accepted my application in the first place."[48] The success of the painting, and Marguerite's continued efforts on its behalf, were also a source of irritation for the artist, who tired of the work, and once exclaimed, in reference to the painting, "Madame Charpentier, put her in the Louvre and leave me alone!"[49]

While Renoir expressed doubts about his abilities, admitting to Durand-Ruel before an exhibition, "I don't know if this is good or bad," the dealer deemed *Madame Georges Charpentier and Her Children* one of Renoir's successes.[50] His faith in the painting was especially evident at the time of the Charpentier sale on April 11, 1907. A month earlier Durand-Ruel had written to William Church Osborne, a trustee of The Metropolitan Museum of Art, New York, and Fry, then a curator at the museum, about this "absolute masterpiece."[51] The dealer placed bids on the museum's behalf, which, in turn, acquired *Madame Georges Charpentier and Her Children* for the unprecedented sum of nearly 92,400 francs.[52] It was thus that The Metropolitan Museum of Art purchased its first Impressionist painting.

Changing Silhouettes

Helen Burnham

That beautiful woman who, unknown to herself,
is enclosed in a network of inflexible parallels like
a bird in its cage—an invisible trelliswork of horizontal
and vertical lines confines the free play of her beauty.

—Charles Blanc, *L'Art dans la parure et dans le vêtement*[1]

By the late 1870s and 1880s, a growing number of women were actively engaged in public life; as a result, they wore new styles of clothing appropriate for outings in the city and suburbs. Whether viewing paintings in the Musée du Louvre, singing in a Parisian church, or strolling on the island of La Grande Jatte, they appeared in daytime ensembles that, while often luxurious, tended to be relatively sleek and unadorned. This is especially true of the antecedents of the tailored female suit: garments, progressive in design and sensibility, that evolved to accommodate new roles for women. With their clear proportions and bold silhouettes, these dresses—and the women who wore them—became ideal subjects for artists exploring new avenues for the representation of modern life in the late Impressionist era.

The curve of Mary Cassatt's back in a trim jacket and the line of her outstretched right arm and tightly furled umbrella are the focus of one of Edgar

Degas's most expressive and rigorously organized images—an 1879 etching reworked in pastel around 1885 (cat. 125).[2] The nearly abstract shape created by Cassatt's figure, dress, and fur- or feather-trimmed hat is a key element in this unusual composition. It provides a counterpoint to the sharply angled lines of the parquet floor, wainscoting, paintings, and frames that make up the contrasting rhythms of a gallery at the Louvre. It also suggests a great deal about Cassatt or, more accurately, Degas's perception of his friend and fellow artist.[3] He gave her a fashionable silhouette that suits her persona as an ambitious artist, while tracing her arresting stance and gesture.

Many years later, Cassatt wrote to her friend Louisine Havemeyer to confirm that it was she who had posed in the Louvre, leaning on her umbrella—a slightly masculine accessory to match the dandy-like panache of her elegant posture.[4] When she met Degas sometime in 1877, she had a recognizable

Mary Cassatt at the Louvre: The Paintings Gallery, 1885

Pastel over etching, aquatint, drypoint, and crayon
voltaïque, on tan wove paper
Plate: 30.5 × 12.7 cm (12 1/16 × 5 in.);
sheet: 31.3 × 12.7 cm (12 3/8 × 5 3/8 in.)
The Art Institute of Chicago

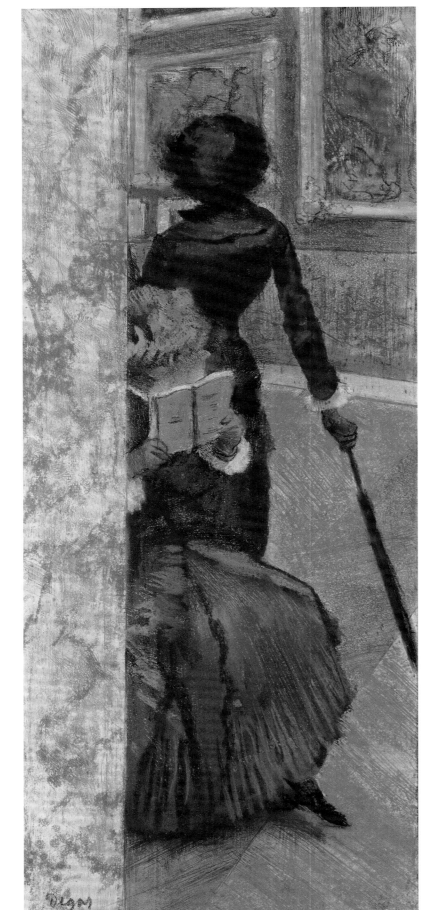

"tall and tailored" style that included "fine fabrics and elegant jewelry."[5] She was interested in fashion, observing the modern rituals of dress in Paris and within her circle of family and friends, and carefully selecting clothing for herself.[6] Her chic apparel in Degas's pastel is precisely fitted to her body to form the sheathlike silhouette characteristic of 1879–80, when the bustle essentially disappeared.[7] Its energetic lines suggest agility and movement.[8] Almost certainly a walking dress (*robe de promenade*), her attire is composed of a skirt and jacket with a cuirass bodice, a shawl collar, and lustrous fabric that reflects the light in the gallery, such as a silk plain weave, faille, or fine wool.

Versions of the walking dress and its close cousins the visiting dress, traveling dress, and day dress were worn by women at all levels of society: fashionable women, including Princess Alexandra of Wales; working women; bourgeois women; and, eventually, the progressive New Woman and suffragettes. The more suitlike of these dresses were sometimes made by tailors or included tailored elements.[9] They had stylistic affinities to sporting clothes, especially the riding habit known as the *amazone*, and carried with them some of the connotations of that apparel and eponymous cultural type.[10] The term *amazone* was applied to aristocratic, unconventional, professional women as well as, of course, to horseback riders. These associations, however, were by no means translated to every woman who wore a tailored dress. Nor did newly popular "masculine" accessories such as the umbrella and tailored jacket necessarily send a gender-bending message to observers. The impact of these clothes was based on who wore them and in what context. Peculiarities of body type, fit, posture, and personality all played into the impression rendered by such dresses.

Degas was especially interested in capturing idiosyncrasies of the human figure in the late 1870s and early 1880s, depicting his subjects in physical states that suggested deeper psychological, biological, and social truths—often rendered, as Jean Boggs described, as "bold, self-contained

Portraits in a Frieze, 1879

Pastel on paper
50 × 65 cm (19 ¹¹/₁₆ × 25 ⅝ in.)
Private collection

The two women on the left wear walking suits with tight cuirass jackets and narrow skirts that are tied back. These ensembles exemplify the more tailored, less ornamented direction in which the female silhouette was evolving. The third figure is dressed in a less fashionable but more practical manner, with baggy sleeves and fuller skirt; her determined look and defiant pose suggest her independence from traditional female coquetry. Unlike previous masculine trends in women's clothing, like the Zouave jacket, which was adorned with trims and braids, the garments worn by all three women are almost austere. In cut and ornament they reflect women's changing roles.

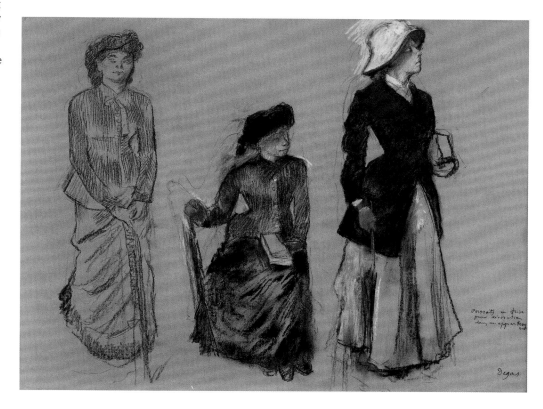

forms, which have expressive silhouettes."[11] Around this time, he sketched three women in charcoal and pastel for a work he described as "portraits in a frieze for the decoration of an apartment," which was shown at the Sixth Impressionist Exhibition, in 1881 (cat. 126).[12] Cassatt may have been the model for one or more of the figures, possibly those in the center and on the right, although scholars have never been able to precisely identify the women portrayed. Perhaps they were intended to be anonymous actors in a collection of images of modern femininity, arrayed in a new conception of the domestic mural.[13] Yet they are unusually quirky for such a display: these unidealized women look with interest and puckish self-assurance at the world around them, carry books, and wear dresses as practical as they are fashionable.

The two women on the left wear very similar apparel; indeed, they may be wearing the same outfit—seen from different perspectives—consisting of a walking suit with a striped cuirass bodice buttoned up the front, above a tubular skirt, with the fabric tied back toward the rear and a pleated

ruffle at the hem. They both carry umbrellas and wear large hats, possibly trimmed with ostrich feathers. These clothes were very much in fashion in 1878–80, but the women's poses are unconventional, seemingly spontaneous and uniquely personal, especially in comparison to contemporary fashion plates (see fig. 1). The woman on the right, who also appears alone in an etching of about 1879, combines an intent posture with eccentric apparel. Her skirt is rather wide; her jacket is a little loose, especially in the sleeves, suggesting that it might be an example of the ready-made outerwear available at department stores; and her hat seems out of step for the period. She carries what appears to be a parasol, which Degas highlighted with a few pink strokes of pastel. She looks like a grown-up version of the artist's *Little Dancer—Aged Fourteen* (1880/82, cast c. 1920–23; The Metropolitan Museum of Art, New York, and others) and might be a bohemian or a bluestocking who has constructed a jaunty outfit well matched to a day of reading, strolling, and visiting, if not the rules of high fashion.[14]

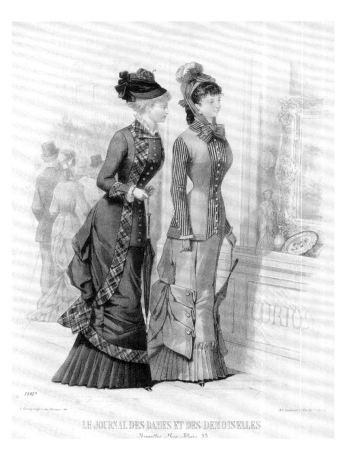

FIG. 1. *Le Journal des Dames et des Demoiselles,* 1878.

Édouard Manet also painted women in modes suggestive of particular social types, though his models nonetheless defy easy categorization. He claimed to have succeeded in representing the women of the Third Republic, and his "naturalist" series of this period includes a number of bust-length views of women, mostly dressed for outings, whose apparel and physiognomy range from fashion plate chic to unique approximations of *la dernière mode*.[15] His *Young Woman in a Round Hat* (cat. 127) is an example of the latter. She is arranged in semi-profile, as if in a fashion plate, but her costume is less clearly defined than those in fashion journals. This work is sometimes grouped with Manet's paintings of female riders, but the woman is not wearing the typical attire of an *amazone*.[16] Her small black hat, probably made of felt, is plausibly equestrian, as are her stiff white collar and the blue shade of her bodice, but the panels of decorative contrasting fabric at her neck, as well as her bracelets and parasol, with its fancy gold head or *bequille*, are more in keeping with an outfit for strolling. This mix of fashionable elements, many of them derived

from menswear—perhaps a source of the confusion over her identity as an *amazone*—complements an unusually sturdy face and imposing sideways gaze, which is partially obscured by her veil and the strangely dark shadow beneath it, an aspect of the painting that viewers tend to find disconcerting.[17] Has the woman's vision, and thereby her power, been blocked or mediated by her veil? Why did Manet choose to represent this woman in a state of limbo between staying in and going out? Though this painting has been understood simply as "one of Manet's finest" portraits, it is also capable of raising difficult questions about the artist's perception of women and, more broadly, the complicated state of bourgeois femininity.[18] Manet presented a lack of clarity in matters of dress that captured the disconcerting nature of fashion at a time when its ability to transform and disguise identity was one of its more troubling characteristics.[19]

Manet's painting of the actress Jeanne Demarsy is less a portrait than an embodiment of fashionable spring (fig. 2). "She is not a woman," wrote Maurice du Seigneur in his review of the Salon of 1882, where the painting was shown, "she is a bouquet, truly a visual perfume."[20] In contrast to *Young Woman in a Round Hat*, Jeanne wears an ultrafeminine floral day dress, comparable to period costumes and dresses depicted in fashion plates.[21] Her frilly accessories include a bonnet trimmed with lace, silk flowers, and ribbons and a lacy parasol. Despite the abundance of adornments and trappings, this is highly structured work. Little thought or feeling registers in Jeanne's pretty face, the preferred facial type of the moment. She is set apart from the background as if in low relief, with the contour of her bust line, her parasol, and the dark ribbon at her neck creating a shape that Manet repeated in related prints and drawings. Her static silhouette has less to do with the expression of character than with the controlled presentation of an impersonal ideal.[22] A linear convention similar to the profile views in fashion plates, early Renaissance portraiture, and Japanese ukiyo-e woodblock prints, it contributes to Jeanne's personification as a beauty, a springtime Parisienne.[23] In her flowery dress, set against a verdant yet shallow background, she becomes something of an icon within a planar decorative scheme, not unlike the more abstract and intensely silhouetted female subjects that would

CAT. 127 Édouard Manet (FRENCH, 1832–1883)

Young Woman in a Round Hat, 1877/79

Oil on canvas
54.6 × 45.1 cm (21 ½ × 17 ¾ in.)
The Henry and Rose Pearlman Foundation, on long-term loan
to the Princeton University Art Museum

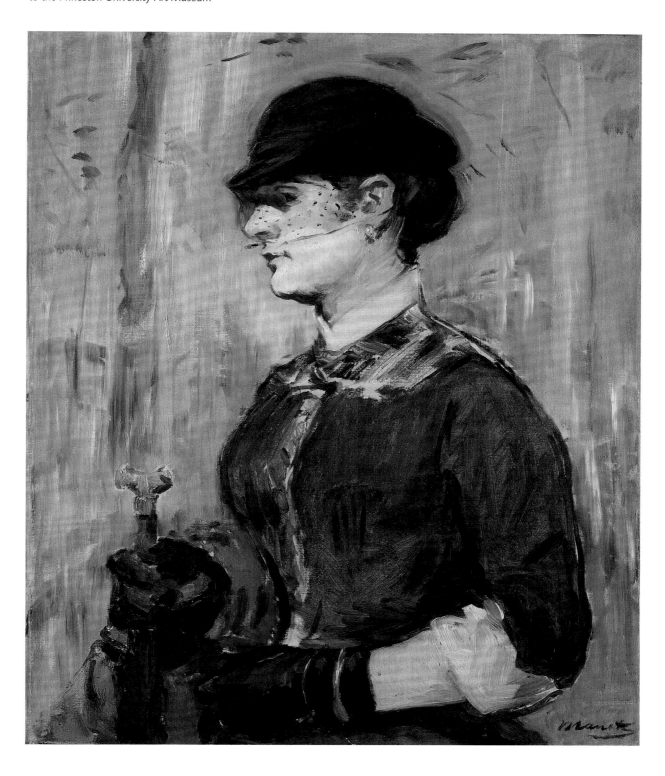

FIG. 2. ÉDOUARD MANET (FRENCH, 1832–1883).
Spring (Jeanne), 1881. Oil on canvas; 73 × 51 cm
(28 ¾ × 20 1/16 in.). Private collection.

FIG. 3. ÉDOUARD VUILLARD (FRENCH, 1868–1940).
Woman in a Striped Dress, 1895. Oil on canvas; 65.7 × 58.7 cm
(25 7/8 × 23 1/8 in.). National Gallery of Art, Washington, D.C.,
collection of Mr. and Mrs. Paul Mellon, 1983.1.38.

soon characterize the work of a younger generation of painters (see fig. 3).

In the 1880s, a greater sense of compositional order and increased attention to principles of design marked the work of many painters, who looked to new artistic theories as well as the French classical tradition. The young painter Jacques-Emile Blanche, a member of Degas's social circle, demonstrated the important role of fashion in the move toward a more stable and harmonious aesthetic in his 1887 pastel portrait of a woman (cat. 128).[24] His subject is presumably the wife of Henri Wallet, to whom the pastel is dedicated.[25] She wears luxurious clothing suitable for a promenade, and her hair, with a fashionable fringe curled with an iron around her face, coordinates with the hues of her tall hat and skirt. Her jacket or *paletot*, perhaps velvet or a rich wool with soutache embroidery, curves over a chestnut skirt embellished with lines of darker brown. The elegant colors of Madame Wallet's attire, while certainly the latest style (see cat. 129), also serve to unify the composition, lending further stability to an already orderly image.

Madame Wallet appears in semiprofile against a simple ground, a format that was, by the mid-1880s, standard for portraiture of women, at which Blanche excelled. This format was also conducive to combining the features of a particular person with those of an ideal type. Madame Wallet's upright posture, set parallel to the picture plane and perpendicular to her bustle; her clearly defined silhouette; the neutral background; and her unified apparel combine with the semiprofile view to give her more of a symbolic presence than, for example, Manet's *Young Woman in a Round Hat*. Yet with her gentle if aloof sideways glance, she retains enough personality to avoid becoming, like Jeanne, a fixed type.

The prominent bustle of Madame Wallet's skirt came into fashion around 1883, along with a greater abundance of fabric in the skirt, as exemplified by the dress worn by Mrs. Andrew Carnegie at the reception following her return from her honeymoon in 1887 (cat. 130) and a c. 1886 dress by the couturier Charles Frederick Worth (cat. 131). Worth had a strong relationship with the Lyon silk industry and commissioned specialized fabrics for his dresses. He is said to have reintroduced the bustle, often integrated into the skirt itself, at the

CAT. 128 Jacques–Emile Blanche
(FRENCH, 1861–1942)

Portrait of a Woman, also called
Portrait of Madame Henri Wallet, 1887

Pastel on canvas
129 × 64 cm (50 ¾ × 25 ¼ in.)
Musée d'Orsay, Paris

Fashionably dressed for a promenade, a visit,
or perhaps a shopping excursion, Madame
Wallet's dark *paletot* with tone-on-tone soutache
embroidery is sculpted to fit over the projecting
bustle of this period, sometimes called a *strapontin*
(after a type of chair) or shelf bustle. Although
women wearing this highly tailored style were
often portrayed in silhouette to emphasize the
prominence of the bustle and the alluring curve it
created with the lower back, the look appeared
decidedly vertical from the front. The slim jacket,
the skirt with its fullness pulled to the back, and the
high feather-trimmed toque perched on the head
all elongated the figure, while the sober colors
complemented this less frivolous, masculine look.

CAT. 129 E. Gaillard (FRENCH, ACTIVE 19TH CENTURY),
Abel Goubaud (FRENCH, ACTIVE 19TH CENTURY),
Jules David (FRENCH, 1808–1892), and Imprimerie
Honoré Lefèvre (FRENCH, ACTIVE 19TH CENTURY)
"The Latest Fashions, Expressly Designed and Prepared for
Le Moniteur de la Mode," *Le Moniteur de la Mode*, March 1, 1887

Lithograph with hand coloring
Sheet: 39.5 × 26.6 cm (15 ⁹⁄₁₆ × 10 ½ in.)
The Metropolitan Museum of Art,
New York

FIG. 4. *La Mode Illustrée* 21 (May 24, 1885), p. 165.

FIG. 5. ALFRED GREVIN. "I Bet That Does Not Cost Him More Than Twenty-Five Cents a Meter," *Journal Amusant*, October 23, 1886.

beginning of the 1880s in order to stimulate the silk industry in France. As the bustle evolved, fashion plates began to emphasize the profile view and its dramatic silhouette, since this perspective gave the most information about the new styles (see fig. 4).[26] So did caricatures, which highlighted the more excessive versions of this mode (see fig. 5), sometimes called *strapontins* after a type of chair— a reference to the shape of these extraordinary protuberances.

A bustle typical of the early years of the 1880s appears in Pierre-Auguste Renoir's *The Umbrellas* (fig. 6; see also cat. 132). The woman on the right and her two smartly attired children were painted around 1881.[27] The mother's ensemble consists of a rich blue jacket in velvet or plush, a wool skirt accented by a floral corsage, a hat adorned with bright feathers, gray kid gloves, and two fine bracelets; her children wear similarly elegant attire, including bonnets trimmed with feathers, lace, flowers, and ribbons.[28] The clothes and the colorful, soft, painterly manner in which they were rendered stand in contrast to the more severe apparel, modified palette, and linear treatment of the majority of figures and umbrellas in the painting, which were completed later in the 1880s. These elements create one of the most structured compositions in Renoir's oeuvre, in which carefully arranged geometric forms bring to life the rhythms of a busy city street in the rain. His style changed as he painted this work, becoming more methodical and precise, and his choice of clothing complemented that shift. The forward-facing woman on the left without a hat or umbrella, for example, dons a simple ensemble in keeping with the artist's new sense of order. Probably a milliner's assistant or *modiste*, she also provides an interesting contrast of fortune and class with the woman on the right, which her lack of hat in public (a breach of custom associated with lower-class and sexually available women) and remarkably plain attire reinforce.

Henry Lerolle, a painter and patron of the arts, exhibited his masterpiece, *The Organ Rehearsal* (1885; The Metropolitan Museum of Art, New York), at the same 1886 exhibition in New York where *The Umbrellas* had its first American viewing; around the same time, Lerolle painted a reduced version entitled *The Rehearsal in the Choir Loft* (cat. 133).[29] The Galerie Durand-Ruel organized the exhibition, *Works in Oil and Pastel by the Impressionists of Paris,*

FIG. 6. PIERRE-AUGUSTE RENOIR (FRENCH, 1841–1919).
The Umbrellas, 1881/85. Oil on canvas; 180.3 × 114.9 cm
(71 × 45 ¼ in.). National Gallery, London.

tonality of these day dresses (see cat. 133)—probably made of wool and possibly tailor-made—unadorned with the exception of the highlighted hat decorations, unifies the figures with their surroundings, also painted in shades of brown, gray, and yellow.[34] The women seem at ease in the choir loft and in their clothes. The singer's posture suggests that she is consumed by her song and not by fashionability; she stands upright without stiffness or artificiality. The naturalism of her pose and those of her companions, as well as the large scale of the painting, convinced many viewers that they were witnessing a rehearsal. In New York, visitors in 1887 "often spoke low before it, as if waiting for the organ to play and the voice of the singer to be heard."[35]

Lerolle's rational organizational scheme, traditional to some and forward-thinking to others, appealed to both conservative and avant-garde critics.[36] It provided a stark contrast to paintings displaying typical characteristics of Impressionism, such as Claude Monet's *Study of a Figure Outdoors (Facing Right)* (cat. 135), a kind of nostalgic tribute to his first wife, Camille, who appeared in a similar pose, dress, setting, and style some ten years earlier in *Woman with a Parasol—Madame Monet and Her Son* (1875; National Gallery of Art, Washington, D.C.).[37] *The Organ Rehearsal* impressed admirers, such as the artist Maurice Denis, who later praised his friend Lerolle and his "canvases of personal inspiration, where modern dress, an unexpected composition, a simplified system of values and distinguished grays, gave a new note, a poetry of our time."[38] The work is convincingly of the moment, yet it is also organized, still, clear, "poetic," and durable—as opposed to the quick, fleeting, and spontaneous qualities of Monet's Impressionism.

The appreciation of order and harmony in painting found a counterpart in contemporary discussions of fashion. Numerous examples of the interest in enduring rules of dress, principles that outlasted the vicissitudes of seasonal changes in style, appeared in fashion magazines and journals. Keen to establish regularity among these highly mutable cultural phenomena, writers proposed solutions to resolve the confusion of *la toilette*—the difficulty men had in reading women's fashion as a result of the profusion of different styles—in the form of "truths" and diagrams. As *L'Art et la Mode* reported, in a decidedly tongue-in-cheek

although critics were quick to note that Lerolle's work "belonged to an altogether different genre."[30] The painting was fastidiously prepared through a process that involved drawing a grid on the ground layer in order to transfer a preparatory study to the canvas.[31] The figures, including the artist's wife and her sisters, one of whom is the singer, are carefully arranged within the horizontals and verticals delineating the architecture of Paris's St. François-Xavier church. Indeed, the singer's face is directly in the center of the composition, where a network of lines precisely frames her face, seen in strict profile.[32]

In a guide to the Salon of 1885, the first time *The Organ Rehearsal* was exhibited, the clothing in it was described as "a young woman in somber green, with large hat decorated with yellow feathers," as well as a woman in "a brown dress" and another in "black, with yellow flowers on her hat."[33] The dark

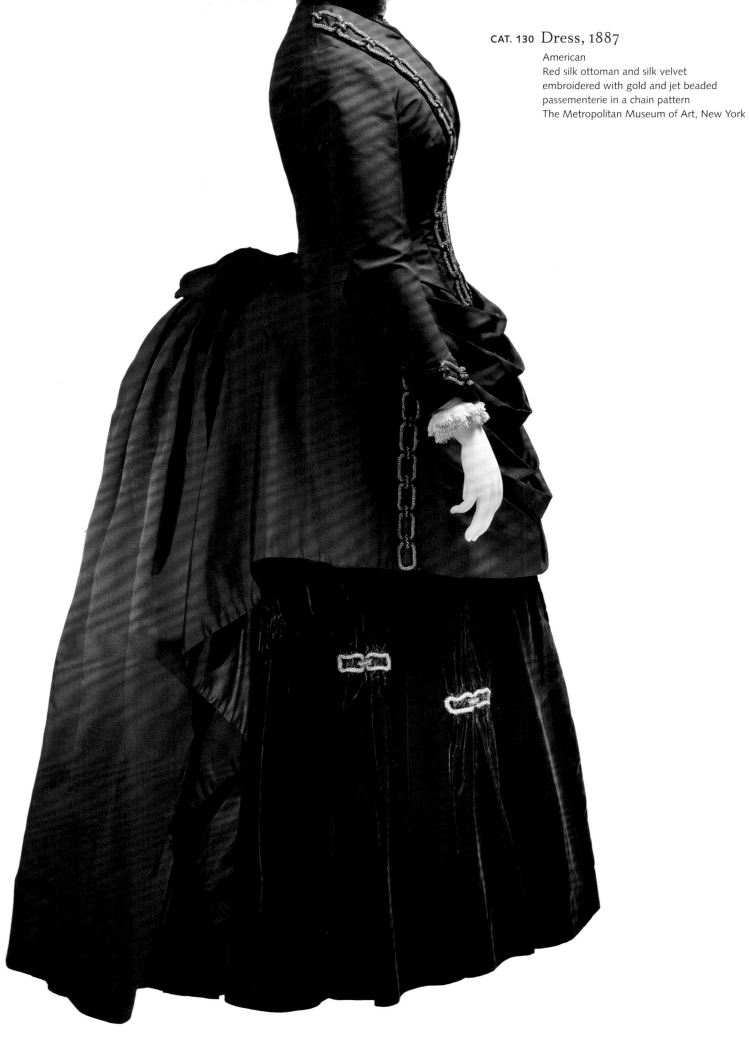

CAT. 130 Dress, 1887
American
Red silk ottoman and silk velvet
embroidered with gold and jet beaded
passementerie in a chain pattern
The Metropolitan Museum of Art, New York

Charles Frederick Worth
(ENGLISH, 1825–1895)

Day dress, c. 1886

Dress: dark brown silk damask in a
starburst pattern; skirt: light brown
silk satin with dark brown silk
and gold metallic passementerie
The Metropolitan Museum of Art,
New York

In 1883 the bustle returned with a vengeance.
No longer the soft, feminine, high-waisted,
lace-trimmed pouf of the late 1860s and early
1870s, this "hard" shape supported by a wire
cage was visually angular and clean, made in
heavier fabrics and rich, dark colors. The look
was accentuated by a low front waist, a high
neckline, and tight sleeves. This silhouette was
certainly a reaction to the frilled and flounced
fishtail gown of the previous years whose
tight, tied-back skirt trailed on the ground
even during the day, making it difficult to
wear. Worth may have reintroduced the bustle
(which required yards of fabric to cover the
extreme rear protrusion) to stimulate the
French silk industry in Lyon, as he had done
many years before by making Empress Eugénie
a dress of Lyon brocade.

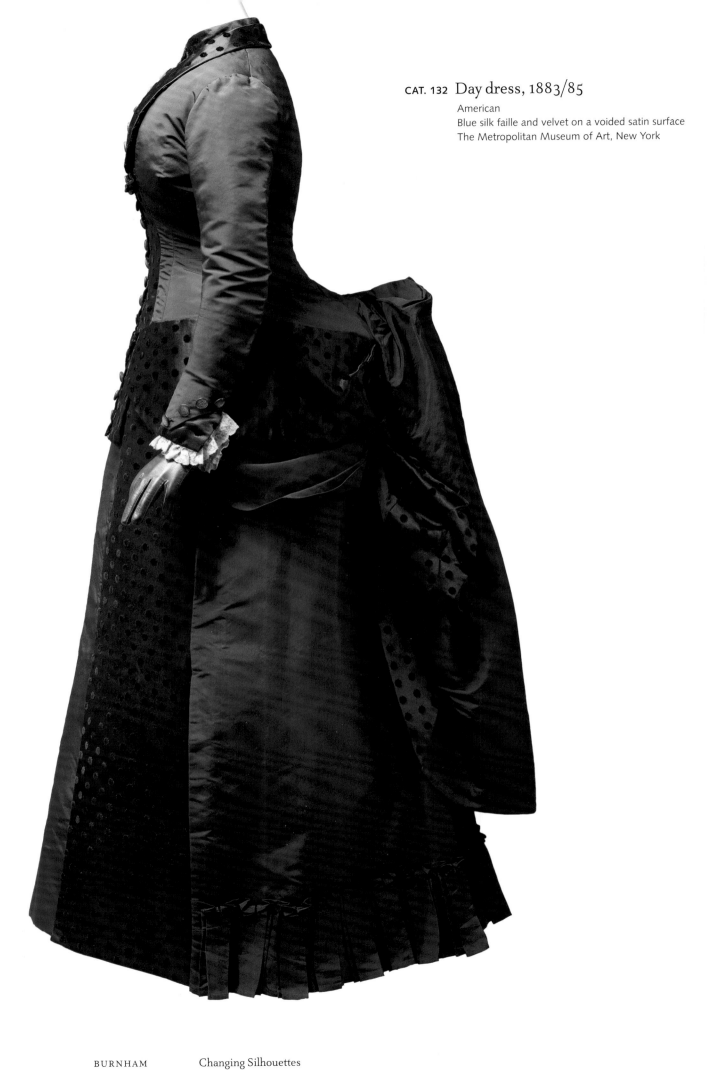

The Rehearsal in the Choir Loft, c. 1885

Oil on canvas
101.6 × 152.4 cm (40 × 60 in.)
Private collection

At the Salon of 1885, Lerolle showed a larger version of this painting entitled *The Organ Rehearsal* (1885; The Metropolitan Museum of Art, New York) which is more than twice the size of this work. Both versions of the composition reflect the artist's personal interest in music, religion, and family (his family members are gathered at left). Exhibiting their bourgeois status, the figures in this work are dressed simply and soberly, but fashionably, although the bare head of the woman seated in the foreground would have been unconventional for a church service. The central figure—wearing a shelf-like bustle and feather-adorned headdress commonly found in fashion plates (see cat. 134)— is Marie Escudier, the artist's sister-in-law.

CAT. 134 Imprimerie P. Lacourière–Falconer (FRENCH, ACTIVE 19TH CENTURY)
"Two Women in Afternoon Dresses,"
Journal des Demoiselles et Petit Courrier des Dames Réunis, 1884

Steel engraving with hand coloring
Sheet: 26.5 × 18.2 cm (10 ⅜ × 7 ⅛ in.)
The Metropolitan Museum of Art, New York

Introduced in the mid-1880s, the bustle was a prominent mass extending at a nearly ninety-degree angle from the wearer's natural waist. Day dresses, like those worn by the women in this 1884 fashion plate, consisted of tightly fitted bodices styled with long sleeves and high necks. Skirts were cut shorter and wider than their predecessors; combined with the absence of trains, this allowed women to walk more easily and provided glimpses of their shoes beneath simple, unadorned hems. The tall crowns of hats were amplified with plumage. In this illustration and Henry Lerolle's c. 1885 painting *The Rehearsal in the Choir Loft* (cat. 133), the fashionable female silhouette of the period appears as a vision of exaggerated proportions.

CAT. 135 Claude Monet (FRENCH, 1840–1926)

Study of a Figure Outdoors (Facing Right), 1886

Oil on canvas
130.5 × 89.3 cm (51 3/8 × 35 1/8 in.)
Musée d'Orsay, Paris

BURNHAM Changing Silhouettes

FIG. 7. CHARLES BLANC. *L'Art dans la parure et dans le vêtement* (Renouard, 1875), p. 77.

CAT. 136 Georges Seurat (FRENCH, 1859–1891)
Study for "A Sunday on La Grande Jatte," 1884

Oil on canvas
70.5 × 104.1 cm (27 ¾ × 41 in.)
The Metropolitan Museum of Art, New York

tone, in 1882 Professor Catallucci gave a lecture on "the art of dressing women and geometry" during which he "drew a woman, in the center of which he placed triangles, squares, and other geometric figures. He demonstrated the proportionality that must exist between different parts of the body."[39] As silly as the professor's discourse might have appeared to some members of his audience, he had prestigious company in his quest to apply mathematics to the study of clothing. In 1875 Charles Blanc, one of the most renowned writers on aesthetics of his day, published a lengthy treatise on personal adornment that featured diagrams of such principles as amplitude (an "axiom of geometry")—similar in appearance to a simplified dressmakers' pattern (fig. 7).[40] Blanc believed, "In spite of the innumerable varieties which comprise the art of dressing, that art is subject, like all the others, to three invariable conditions of beauty, which are order, proportion, and harmony."[41]

The desire to institute a diagrammatic regularity in dress seems to have found its greatest artistic proponent in Georges Seurat. His *A Sunday on La Grande Jatte—1884* features visitors to an island in the Seine near Paris; their apparel is depicted in nearly geometric shapes, seen mostly in profile or from the front (cats. 136, 137).[42] Throughout the composition, these shapes are repeated and varied in size, amplitude, and color, contributing to the scene's overarching pictorial unity. Seurat may never have read Blanc's *L'Art dans la parure et dans le vêtement* (Art in Ornament and Dress; 1875), but his appreciation of the writer's 1867 theory of painting is well documented, and to some extent, the dress in *La Grande Jatte* appears to exemplify Blanc's call to order for dress as well as art.[43] Yet Seurat's approach to fashion also deviated from this model in significant ways.[44] His treatment of apparel in *La Grande Jatte* differentiated one figure from another, often in exaggerated and jarring ways, contributing to a sense of disharmony among the members of his great cast of characters.[45]

This is particularly true of one of the painting's most fashionable and contentious figures: the prominent woman on the right. While she shares basic features with many members of the crowd, she is also patently and, to some observers outrageously, identifiable as a uniquely fashionable creature. She wears the most modern walking dress of 1885–86, which consists of a closely fitted

CAT. 137 Georges Seurat **(FRENCH, 1859–1891)**
A Sunday on La Grande Jatte—1884, 1884–86,
painted border, 1888/89

Oil on canvas
207.5 × 308.1 cm (81 ¾ × 121 ¼ in.)
The Art Institute of Chicago

"breastplate"[46] bodice with a small waist, made to seem all the more narrow by her pronounced bustle and voluminous skirt, with a pleated underskirt and folds of fabric in an apronlike or *tablier* formation in front and a cascading waterfall of drapery over the bustle. Other chic details include the buff kid gloves pulled up to or above the edge of her sleeves; the parasol with a ribbon at the handle; and the decorative band of contrasting fabric along the lower edge of her skirt.[47] She wears a hat not unlike that worn by her dapper male companion and a crisp, slightly masculine collar, which might be a fringe of lace or a more tailored strip of unadorned white linen.

At least one observer in Seurat's time and numerous critics since have called this figure a cocotte or kept woman.[48] Cocottes were members of the demimonde, the segment of Parisian society known for launching the latest styles of dress. Demimondaines "risk[ed] ridicule . . . to introduce fashion" in public spaces, where they could not only attract but also court attention.[49] Good taste generally dictated a certain reserve in fashion for the more respectable classes, which tended to favor restrained versions of the fashions illustrated in magazines and worn first by courtesans.[50] Demimondaines, who were sometimes called *singesses* (female monkeys), were also known to be accompanied by little dogs, who offered an entrée for flirtation with male admirers.[51] It is possible that Seurat's fashionable woman was simply wealthy enough to buy a stylish ensemble and was not necessarily part of the demimonde,[52] but if this is the case, she is nonetheless assertively fashion-forward, provoking attention with her extremely stylish clothing. This fact, in addition to the impossibility of identifying her with absolute clarity, would have been sufficient cause to find her and her male companion "scandalous."[53]

The evolution of Seurat's treatment of the woman's silhouette gives us a sense of the importance he attached to this form, one of the most telling indications of her status and a crucial element in his composition. Scientific analysis and close observation of the painting's surface reveal the adjustments Seurat made from an 1884 oil sketch (cat. 136) to the initial stages of the final painting and then within the final painting itself, probably during the period 1885–86.[54] He broadened the figure, enhanced her bust line, and amplified her bustle (see fig. 19, p. 209). In the final painting, her bustle expanded twice, rendering her ever more obviously fashionable.[55] By contrast, the woman fishing on the left of the painting had a more prominent bustle in the oil sketch than she does in the final painting.[56] This figure is the closest in profile to the cocotte or *promeneuse* (promenader) on the right and has likewise been identified, though somewhat less convincingly, as a prostitute.[57] That Seurat included these two like figures only to emphasize the variations between them—small and large, light and dark, less and more fashionable, relatively at ease and awkwardly, perhaps even comically, on display—is unsurprising. A similar juxtaposition occurs between the clothing and accessories of the *promeneuse* and her male companion. The boulevardier, whose only distinguishing features are his monocle, flower boutonniere, and cigar, is echoed and ultimately overshadowed by his female counterpart, the fashionable woman who strolls in her tailored apparel, an object of fascination and a participant in the modern scene.[58]

Fashion's changing silhouettes featured prominently in art of the late 1870s and 1880s, contributing to the evolving styles of painters and helping to identify their subjects as individuals and types. Structured apparel was among the most forward-looking of the period, signaling the development of tailored styles as well as the evolution of women's roles in the public sphere. It was progressive, yet it could also be seen as a form of protection, however attractive, for its wearers. The buttoned-up styles of walking dresses provided a kind of chic uniform with which to meet the exciting but potentially troubling aspects of public life. Seurat's *promeneuse* and her dress speak to the paradox of dressing for public view: she both encourages attention and is stiffly ill at ease in her prominent role; and her dress is forbiddingly constrained yet also outrageously tantalizing. That painters chose to focus on such fashions speaks not only to an interest in representing the reality of modern life, but also to affinities among aesthetics, painting, and dress, as Blanc might have argued. Indeed, the emergence of the tailor-made suit for women and the move toward a more structured aesthetic in the work of numerous artists during this period may be seen less as a coincidence than as a reflection of a broader desire to institute some control over the unruly phenomena of urban life; to display reassuring evidence of a new order; and, in some cases, to test its limits.

Key Dates in Fashion and Commerce, 1851–89

Françoise Tétart-Vittu and Gloria Groom

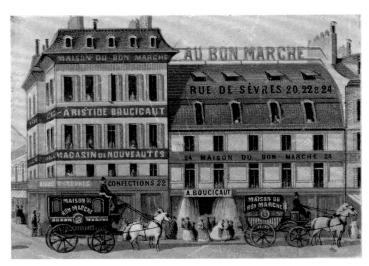

SINGER'S SEWING MACHINE.---Fig. 1.

FIG. 1. Wood engraving of the Singer sewing machine of 1851. From "The Sewing Machine," *The Scientific American*, July 25, 1896, p. 73.

1851 **MAY 1** The Great Exhibition opens in the Crystal Palace in Hyde Park, London. The Gagelin boutique in Paris, located at 53, rue de Richelieu (also known as Opigez & Chazelle, after the names of its directors), wins the only medal for France in the category of Upper Clothing at the Great Exhibition, probably for designs made by Charles Frederick Worth (1825–1895). The previous year, Gagelin had allowed Worth to start a dressmaking department.

Gagelin becomes the only silk mercer to offer ready-made clothes when Worth creates ready-made muslin dress samples for his patrons. The clients choose a style, then Worth matches it to an appropriate fabric.

Although sewing machines had existed since the late eighteenth century, machinist Isaac Merritt Singer (1811–1875) made dramatic improvements in their practicality and ease of operation, and with New York lawyer Edward Clark (1811–1882) introduces a professional sewing machine (fig. 1). I. M. Singer & Co. will later become the Singer Manufacturing Company.

1852 Founded as a small shop in 1838 by Aristide Boucicaut (1810–1877), Le Bon Marché is enlarged to become the first department store in France, with a specially designed building on the corner of rue de Sèvres and rue du Bac in Paris (fig. 2).

FIG. 2. Le Bon Marché, 1869. Engraving. Musée Carnavalet, Paris P.M.V.P/Michel Toumazet.

1853 **MAY** Octave-François Opigez-Gagelin inherits Gagelin from his father, F.-O. Opigez, and forms a new partnership with employees Ernest Walles and Charles Frederick Worth.

Emperor Napoléon III (1808–1873) marries the Spanish countess Eugénie de Montijo (1826–1920), who soon becomes a fashion leader. Fond of sports, Eugénie forges her own style. When not in her official role, she is usually seen wearing a black skirt and a red shirt called a "Garibaldi," named for the Italian revolutionary Giuseppe Garibaldi. In addition to her dressmaker, Mademoiselle Palmyre, at the Tuileries Palace, Empress Eugénie would come to rely on the top seamstress at the House of Worth for her more extraordinary dresses and masked-ball costumes beginning in 1859.

1855 Inauguration of the department store Au Louvre with 50,000 visitors on its first day. It will later (1863) become Les Grands Magasins du Louvre (fig. 3).

The Exposition Universelle is held on the Champs-Elysées, Paris, with an emphasis on industrial exhibits. The dressmaking firm Gagelin (also known at that time as Opigez-Gagelin & Cie) wins the Grand Prize medal for its ready-to-wear dresses; France is the only country to offer ready-made clothes.

First known existence of paper patterns, known as "des modèles reproducteurs" (models for reproduction) at Opigez-Gagelin & Cie.

FIG. 3. Les Grands Magasins du Louvre, color lithograph, 1866. Bibliothèque Nationale de France, Paris, Estampes et Photographie, Va 232 c.

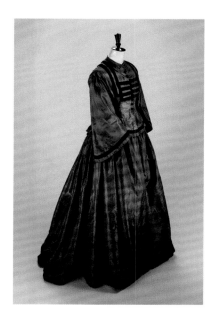

FIG. 4. Silk dress, c. 1862, dyed with Perkin's original aniline mauve dye. Science Museum, London.

1856 In an attempt to resolve patent disputes and avoid expensive litigation, the American sewing machine companies unite as the Sewing Machine Trust. Members include Wheeler and Wilson Manufacturing Co., I. M. Singer & Co., Grover and Baker Sewing Machine Co., and Elias Howe.

Opening of the Bazar Parisien (later to be called Bazar de l'Hôtel de Ville, or BHV), on the rue de Rivoli, where it still exists today.

Madame Roger, Empress Eugénie's official seamstress, opens a boutique at 25, rue Louis le Grand near the Opéra.

Eighteen-year-old English chemist William H. Perkin (1838–1907) accidentally discovers a way to mass-produce a purplish color using by-products of coal tar (see fig. 4). Following his discovery of mauveine—the first synthetic organic dye—many new aniline dyes appear (some developed by Perkin himself), and factories producing them are constructed across Europe.

1858 **JULY 1** Charles Frederick Worth leaves Opigez–Gagelin & Cie to establish, with the Swedish draper's clerk Otto Gustaf Bobergh (1821–1882), the dressmaking shop Worth & Bobergh, at 7, rue de la Paix. For their foreign customers, mostly Americans, Worth establishes the custom of sewing brand labels into bespoke garments (see fig. 5), although it is not until 1884, when haute couture emerges, that designer branding becomes widespread.

FIG. 5. Worth & Bobergh label on an evening dress, 1866/67. Stamped in gold on petersham ribbon waist stay. Museum of the City of New York, 62.190.1a–c.

1859 Following a French victory in a bloody battle on June 4th in the town of Magenta, Italy, during the Franco–Austrian War (also known as the Second War of Italian Unification), a new red dye developed by chemist Edward Chambers Nicholson (1827–1890) is given the name magenta and catapulted into fashion.

1860 **JANUARY 23** Adoption of a free-trade treaty between Great Britain and France. On the British side, this agreement reduced import taxes on wine and also on "articles de Paris et de Lyon," meaning, in particular, fashionable items produced by the highly skilled, labor-intensive fashion industry.

The department store Le Bon Marché launches home delivery carriages, which advertise the name of the store on their sides (fig. 6).

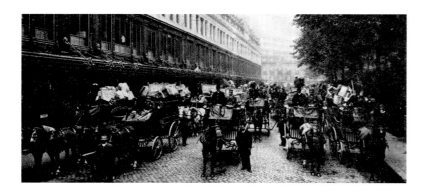

FIG. 6. Delivery of merchandise to and from Paris and the suburbs by Le Bon Marché, 1889. Bibliothèque historique de la Ville de Paris.

1862 The International Exhibition is held in South Kensington, London. Gagelin, despite Charles Frederick Worth's departure four years earlier, is awarded a first-class medal with a remarkable selection of Japanese textiles and objects that were a novelty at the time.

1863 The department store Au Louvre is renamed Les Grands Magasins du Louvre. It is one of the models, along with Le Bon Marché, that Émile Zola will use as the prototype in his novel *Au bonheur des dames* (see 1883 below). Expansion and reopening of the department store À la Place Clichy.

First listing of the couturier Émile Pingat (1820–1901) in the *Bottin du commerce* (directory of commerce, an early yellow pages) as "E. Pingat, Hudson and Company, 30, rue Louis le Grand, near the Opéra." A rival to Worth as a designer and as a tastemaker, the dressmaker Pingat (see fig. 7) also specializes in outerwear, such as opera coats, jackets, and mantles.

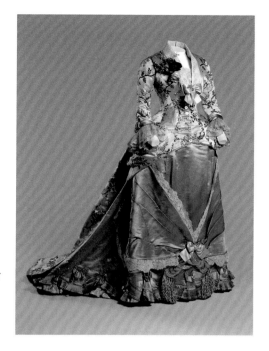

FIG. 7. ÉMILE PINGAT (FRENCH, 1820–1901). Dinner dress, 1878. Silk brocade, lace, and silk satin. Chicago History Museum, gift of Mr. Albert J. Beveridge III. 1976.270.1a–b.

1864 Charles Frederick Worth is listed in the directory of commerce as an official purveyor to Empress Eugénie.

1865 MAY 11 Jules Jaluzot (1834–1916) launches the department store Au Printemps at the corner of boulevard Haussmann and the rue de Provence (fig. 8). He is the first to sell an exclusive black silk for dresses known paradoxically as "Marie-Blanche."

FIG. 8. Au Printemps department store, boulevard Haussmann and rue de Provence, 1865.

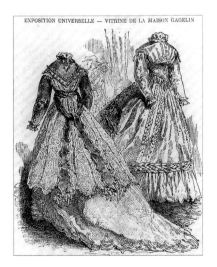

1867 At the Exposition Universelle in Paris, Gagelin exhibits its ready-made dresses on mannequins in cases (see fig. 9 for its designs). Other boutiques show fabrics as well as ready-to-wear garments, although luxury design shops, like the House of Worth, do not exhibit.

Elias Howe's sewing machine wins a gold medal at the Exposition.

FIG. 9. The Gagelin showcase at the 1867 Exposition Universelle, presenting a dress chosen by the Austrian empress, in a style called "Eugénie" or "princess style." From *La Vie Parisienne*. Bibliothèque historique de la Ville de Paris.

1868 Creation of the Chambre Syndicale des Confectionneurs et des Tailleurs pour Dames, the first union for seamstresses and dressmakers. In 1910 it will become the Chambre Syndicale de la Couture Parisienne.

The store À la Ville de Saint Denis, on the rue du Faubourg Saint Denis near the Gare de l'Est (fig. 10), offers 20,000 paper patterns of all the models prepared by their dressmaking workshop.

FIG. 10. The department store À la Ville de Saint Denis, Paris. From *Le Monde Illustré*, 1878.

Following the phenomenon of department stores in Paris and New York—including the opening of Macy's (1858), A. T. Stewart's "Iron Palace" (1862), and B. Altman and Co. (1865)—in Chicago, Field, Leiter and Co. opens in a six-story building at the northeast corner of State and Washington Streets. It will become Marshall Field and Co. in 1881 and will remain Marshall Field's until the firm's acquisition by Macy's, Inc., in 2005.

Emergence of new technological developments in the manufacture of corsets, such as the steam-molding process, that, after 1876, allowed corsets to be produced in the longer, hip-covering "princess-line" style.

1869 **SEPTEMBER 9** Due to great success, the second expansion of Le Bon Marché by Aristide Boucicaut (1810–1877) and his wife, Marguerite (1816–1887) begins.

Opening of the department store À la Paix on the rue du Dix-Décembre (in 1870, the street is renamed the rue du Quatre-Septembre).

August Destory patents his sewing machine for boots.

Gustave Janet (1829–?) launches the magazine *La Mode Artistique* with color lithograph fashion plates.

1871 During the siege of Paris, many designers, including Worth and Madame Maugas, organize ambulances for the men protecting the city. Department stores remain open, but some, like Les Grands Magasins du Louvre (located on the rue de Rivoli) and Pygmalion (on the rue Saint-Denis) are damaged by fires.

Due to the Franco-Prussian War, *Le Moniteur de la Mode* is issued in Brussels by the associated publication *Le Journal des Dames et des Demoiselles* and each issue features hand-colored fashion prints. The wood engravings of *La Mode Illustrée* are printed in Berlin for the newspaper *Victoria*. Distributed weekly, *La Mode Illustrée* becomes one of the most popular French fashion periodicals.

FIG. 11. *La Mode Miniature* 1 (July 7, 1872).

1872 Newlyweds Ernest Cognacq (1839–1928) and Marie–Louise Jay (1838–1925) launch the department store La Samaritaine, near the Pont–Neuf. They will continue to expand La Samaritaine throughout the rest of the century until it eventually becomes the largest department store in Paris. It will close its doors in 2005.

Publication of *La Mode Miniature* by Adolphe Goubaud, a weekly illustrated fashion magazine (see fig. 11) that measured only 12.1 by 15.2 centimeters (4 ¾ by 6 inches).

1874 An exhibition on historic costumes at the Union Centrale des Beaux Arts Appliqués à l'Industrie comprises over 6,000 garments from numerous institutions and collectors.

Symbolist poet Stéphane Mallarmé (1842–1898) launches the illustrated fashion magazine *La Dernière Mode*, written entirely by him and subscribed to mostly by the members of his intellectual circle (see fig. 12).

The embroiderer and dress trimmer Léon Sault creates the Agence Générale de la Mode, Cabinet de Dessins de Figurines de Mode et de Journaux Specialisés Pour Couturiers.

Beginning of the expansion of La Samaritaine department store.

FIG. 12. Cover of *La Dernière Mode* 2 (September 20, 1874).

1875 Aristide Boucicaut, owner of the department store Le Bon Marché, opens an in–store gallery of fine arts for painting and sculpture exhibitions. According to Émile Zola, Boucicaut exhibited second–rate contemporary artists.

1876 **MAY 6** John Wanamaker opens his eponymous dry good emporium and clothiers in Philadelphia in a former railroad station. Wanamaker's will often be called the "Grand Depot." In 1896 he will purchase the former A. T. Stewart department store building in New York and open the first Wanamaker's outside Philadelphia.

Ernest Hoschedé (died 1891), one of the first and most enthusiastic collectors of Impressionist work, especially that of Claude Monet, whom he commissioned in 1876 to paint four decorative panels for the Château de Rottembourg (including *Turkeys*; fig. 13), is made director of the store La Compagnie des Indes, specializing in imported cashmeres and silks.

The Sewing Machine Trust (see 1856 above) is dissolved, and the competition among the dominant manufacturers intensifies.

FIG. 13. CLAUDE MONET (FRENCH, 1840–1926). *Turkeys*, 1877. Oil on canvas; 174 × 172.5 cm (68 ½ × 67 ¹⁵⁄₁₆ in.). Musée d'Orsay, Paris, RF 1944 18.

1877 Death of Aristide Boucicaut, founder of Le Bon Marché. His widow and son assume control of the store, which then had a workforce of 1,800 employees.

1878 At the Exposition Universelle, Paris, a new silhouette is introduced. It is known as the "mermaid" style for its frilled and flounced fishtail train and tight, tied-back skirt, shaped by a low, small bustle, or *tournure*, in the back.

Dressmaker Émile Pingat introduces evening cloaks called *visites*, for which he will become famous (see fig. 14).

FIG. 14. ÉMILE PINGAT (FRENCH, 1820–1901). Evening cloak, 1885–89. Brooklyn Museum Costume Collection at The Metropolitan Museum of Art, gift of the Brooklyn Museum, 2009, anonymous gift in memory of Mrs. John Roebling, 1970, 2009.300.484.

1880 The department store Le Palais de la Nouveauté (see fig. 15), founded by Jacques François Crespin (1824–1888), is the first to offer all of its items for sale on credit.

Creation of the newspaper *L'Art et la Mode* by a group of artists at the invitation of Ernest Hoschedé. It will feature short items and illustrations on fashion by the Impressionists and other celebrated painters of the day (see fig. 16).

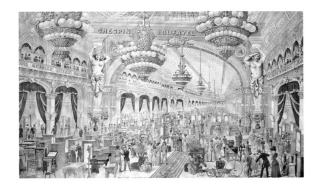

FIG. 15. H. Laas. Le Palais de la Nouveauté. Bibliothèque Nationale de France, Paris, Estampes et Photographie.

FIG. 16. *L'Art et la Mode* 42 (September 15, 1883), pp. 8–9.

1881 Opening of the Parisian store of the English dressmaker Charles Poynter Redfern (1853–1929) at 242, rue de Rivoli. He becomes known for dressing Alexandra, the Princess of Wales (1844–1925) when he is named Dressmaker by Royal Appointment in 1888.

1882 Édouard Manet (1832–1883) paints *In the Conservatory* (1878–79; Nationalgalerie, Staatliche Museen zu Berlin), his friend Jules Guillemet and his fashionable wife. Guillemet would go on to open the fashion boutique Aux Montagnes Russes, at 19, rue du Faubourg Saint Honoré, in 1883.

The Union Centrale des Beaux Arts Appliqués à l'Industrie and the Société du Musée des Arts Décoratifs merge to form the Union Centrale des Arts Décoratifs. Located on the rue de Rivoli, it is dedicated to the collection of decorative arts, textiles, and costume. In 1905, this group will create the Musée des Arts Décoratifs.

Closing of the department store La Paix on the rue du Quatre-Septembre (fig. 17).

FIG. 17. "Grands Magasins de la Paix," c. 1879. Bibliothèque Nationale de France, Paris, Estampes et Photographie, Va 236 e.

1883 *Au bonheur des dames*, a novel by Émile Zola, which was published serially in *Le Gil Blas* between December 17, 1882 and March 1, 1883, is released in book form by the Librairie Charpentier in Paris (see fig. 18). Based on extensive research on the department stores Le Bon Marché and Les Grands Magasins du Louvre, it is the first work to describe this new cultural phenomenon, including the life of the employees, the strategies of merchandising, the rise to power of a store owner, and the demise of the independent boutique.

Etienne Poussineau, known simply as Félix (1841–1930), a dressmaker at 15, rue du Faubourg Saint Honoré, hires the future fashion designer Jeanne Lanvin (1867–1946), as a milliner's apprentice.

FIG. 18. The first page of the manuscript of Émile Zola's *Au bonheur des dames*. Bibliothèque Nationale de France, Paris, Manuscrits, NAF 10275, folio 1.

1884 Creation of the Chambre Syndicale de la Haute Couture Française to protect the rights of seamstresses—including providing for their insurance and pensions.

Access to credit allows more people to purchase sewing machines; competition helps keep prices low and improves the fashion industry. For the first time, a local labor union (composed of independent tailors and seamstresses) acquires its own machines.

Manufacturing of ready-made clothing spreads to many areas of France.

Founding of the fashion house of Ernest Raudnitz at 23, rue Louis le Grand. It is especially popular among American customers.

1885 **MAY 23** Alfred-Hippolyte Chauchard (1821–1909) retires from the directorship of Les Grands Magasins du Louvre. The fortune Chauchard made from the department store allows him to acquire a significant collection of Barbizon paintings, most of which are now in the Musée d'Orsay, Paris.

The House of Rouff, at 13, boulevard Haussmann, becomes one of the most famous fashion shops in Paris. On its label Rouff uses a signature, copying Worth's innovation.

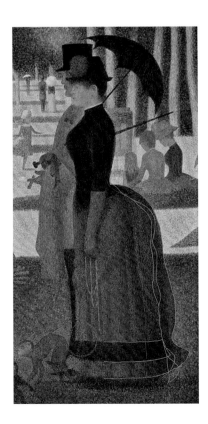

1886 Georges Seurat (1859–1891) completes *A Sunday on La Grande Jatte— 1884* (cat. 137), which is shown in the last Impressionist exhibition. In his final campaign on the painting, Seurat increases the size of the bustle to reflect the fashion trends of that year, when the dimension of the bustle reached its apogee (fig. 19).

FIG. 19. Detail of *A Sunday on La Grande Jatte—1884* (cat. 137), showing Seurat's three different depictions of the bustle.

1887 Completion of the construction of the Marshall Field's wholesale store on Franklin Street between Quincy and Adams Streets in Chicago (fig. 20).

Expansion of Le Bon Marché to include seventy-four different sales counters.

FIG. 20. Henry H. Richardson, architect (1838–1886). Marshall Field's wholesale store, Chicago, 1885–87 (now demolished).

1888 Georges Jules Dufayel (1855–1916) assumes ownership of the department store Le Palais de la Nouveauté. In 1890 he will change its name to Grands Magasins Dufayel.

1889 At the Exposition Universelle in Paris, the exhibitors include forty-six department stores and shops specializing in fashion, attesting to the extraordinary international growth and pervasive presence of fashion in contemporary life.

Checklist of the Exhibition

Works are listed in chronological order and, within each year, in alphabetical order by artist's last name. Works with no known artist or maker appear after those by named artists, alphabetically by title.

French titles are given where they differ substantially from the English.

Significant early exhibitions are given where applicable; they include exhibitions that occurred during an artist's lifetime and major posthumous exhibitions, such as memorial exhibitions mounted shortly after an artist's death.

In addition to the cartes de visite and fashion plates shown in the body of the catalogue (listed individually below), a broader selection of both, as well as of department store catalogues, from the collection of The Metropolitan Museum of Art was shown in New York and Chicago. For a number of examples, see the appendices.

This checklist has been revised to reflect changes made to the exhibition since the first printing of the catalogue.

— 1840 —

HONORÉ DAUMIER (FRENCH, 1808–1879).
It's Amazing! I've Had Four of Just These Sizes in My Life . . . , February 7, 1840. Lithograph with hand coloring, second state of two; image: 24.8 × 19.2 cm (9 ¾ × 7 ⁹⁄₁₆ in.); sheet: 36.3 × 27.8 cm (14 ⁵⁄₁₆ × 10 ¹⁵⁄₁₆ in.). The Metropolitan Museum of Art, New York, The Elisha Whittelsey Collection, The Elisha Whittelsey Fund, 1962, 62.650.258.

NEW YORK, CHICAGO
NOT IN CAT.

— 1847 —

CONSTANTIN GUYS (FRENCH, 1802–1892).
Reception, 1847/48. Pen and brown ink with brush and watercolor, over graphite, on ivory laid paper; 17.8 × 19.7 cm (7 ¹⁄₁₆ × 7 ¹³⁄₁₆ in.). The Art Institute of Chicago, Olivia Shaler Swan Memorial Collection, 1933.524.

CHICAGO
CAT. 18

— 1856 —

GUSTAVE COURBET (FRENCH, 1819–1877).
Young Ladies on the Banks of the Seine (*Les demoiselles des bords de la Seine (été)*), 1856–57. Oil on canvas; 174 × 206 cm (68 ½ × 81 ⅛ in.). Petit Palais, Musée des Beaux-Arts de la Ville de Paris, PPP00377.

Significant early exhibitions: 1857: Paris, Salon, no. 620 (*Les Demoiselles des bords de la Seine (été)*). 1867: Paris, Rond-Point de l'Alma, *Exposition des Oeuvres de M. G. Courbet*, no. 8 (*Les Demoiselles des bords de la Seine*). 1873: Vienna, Association de l'Art autrichien.

PARIS, NEW YORK, CHICAGO
CAT. 34

PIERRE-LOUIS PIERSON (FRENCH, 1822–1913).
Woman Leaning on Her Elbow, 1856/57. Albumen silver print from glass negative; 11.1 × 7.6 cm (4 ⅜ × 3 in.). The Metropolitan Museum of Art, New York, David Hunter McAlpin Fund, 1975, 1975.548.31.

NOT IN EXHIBITION
CAT. 20

— 1860 —

CONSTANTIN GUYS (FRENCH, 1802–1892).
Woman with a Muff, 1860/64. Pen and brown ink with brush and watercolor, over traces of graphite, on cream wove card; 23 × 17 cm (9 ¹⁄₁₆ × 6 ¾ in.). The Art Institute of Chicago, Olivia Shaler Swan Memorial Collection, 1933.523.

CHICAGO
NOT IN CAT.

Parasol, 1860/69. American or European. Black silk lace, ivory silk faille, and taffeta with tortoiseshell handle. The Metropolitan Museum of Art, New York, gift of Mrs. Henry G. Bartol, 1938, C.I.38.44.8.

NEW YORK, CHICAGO
NOT IN CAT.

Parasol, 1860/69. French. Black silk lace, ivory silk faille, and taffeta with carved ivory handle. The Metropolitan Museum of Art, New York, gift of Mrs. Walter Kernan, 1975, 1975.215.3.

NEW YORK, CHICAGO
CAT. 41

— 1862 —

ÉDOUARD MANET (FRENCH, 1832–1883).
Lady with Fan (*La Maîtresse de Baudelaire*), 1862. Oil on canvas; 90 × 113 cm (35 ⁷⁄₁₆ × 44 ½ in.). Museum of Fine Arts, Budapest, 368.B.

Significant early exhibitions: 1865: Paris, Martinet.

NEW YORK, CHICAGO
CAT. 50

Day dress, 1862/64. American. White cotton piqué embroidered with black soutache. The Metropolitan Museum of Art, New York, gift of Chauncey Stillman, 1960, C.I.60.6.11a, b.

NEW YORK, CHICAGO
CAT. 36

— 1863 —

JAMES TISSOT (FRENCH, 1836–1902).
The Two Sisters, also called *Portraits in a Park*, 1863. Oil on canvas; 210 × 136 cm (82 ½ × 53 ⁹⁄₁₆ in.). Musée d'Orsay, Paris, gift of Albert Bichet, 1904, RF 2788.

Significant early exhibitions: 1864: Paris, Salon, no. 1860 (*Les Deux soeurs; portrait*).

PARIS, NEW YORK, CHICAGO
CAT. 4

Black dress, 1863/65. English. Black net over black slightly corded silk taffeta. Manchester City Galleries, 1940.295/2.

NEW YORK, CHICAGO
CAT. 46

— 1864 —

JAMES TISSOT (FRENCH, 1836–1902).
Portrait of Mademoiselle L.L., 1864. Oil on canvas; 124 × 99.5 cm (48 ¹³⁄₁₆ × 39 ⅜ in.). Musée d'Orsay, Paris, RF 2698.

Significant early exhibitions: 1864: Paris, Salon, no. 1861 (*Portrait de Mlle L. L. . . .*).

PARIS, NEW YORK, CHICAGO
CAT. 118

Dress, c. 1864. American. Bleached linen tarlatan dress with matching sash. Museum of the City of New York, gift of Misses Braman, 47.83.1a, b.

NEW YORK, CHICAGO
CAT. 42

Woman's three-piece seaside ensemble, 1864/67. French. Cotton, plain weave with supplementary warp, and cotton, machine embroidery. Los Angeles County Museum of Art, purchased with funds provided by Suzanne A. Saperstein and Michael and Ellen Michelson, with additional funding from the Costume Council, the Edgerton Foundation, Gail and Gerald Oppenheimer, Maureen H. Shapiro, Grace Tsao, and Lenore and Richard Wayne, M.2007.211.944a–c.

CHICAGO
CAT. 37

— 1865 —

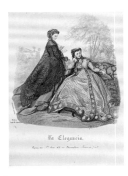

HÉLOÏSE LELOIR (FRENCH, 1820–1873).
"Two Women Outdoors," *La Elegancia* (Barcelona),
1865/66. Lithograph with hand coloring;
sheet: 29.5 × 21.9 cm (11 ⅝ × 8 ⅝ in.).
The Metropolitan Museum of Art, New York, gift of
Mrs. H. J. Bernheim, 1958, 58.646.15(19).

NOT IN EXHIBITION
CAT. 3

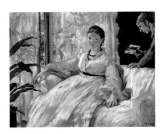

ÉDOUARD MANET (FRENCH, 1832–1883).
Reading, 1865 (reworked 1873/75). Oil on canvas;
61 × 73.2 cm (24 × 23 ¹³⁄₁₆ in.). Musée d'Orsay,
Paris, bequest of the Princess Edmond de Polignac,
RF 1944 17.

Significant early exhibitions: 1880: Paris, La Vie
Moderne, *Oeuvres nouvelles d'Edouard Manet*, no. 10
(*La Lecture*). 1884: Paris, École Nationale des
Beaux-Arts, *Exposition des oeuvres de Édouard Manet*,
no. 46 (*La Lecture*).

PARIS
CAT. 49

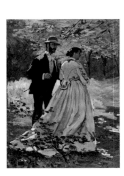

CLAUDE MONET (FRENCH, 1840–1926).
*Bazille and Camille (Study for "Luncheon on the
Grass")*, 1865. Oil on canvas; 93 × 68.9 cm
(36 ⅝ × 27 ⅛ in.). National Gallery of Art, Washington,
D.C., Ailsa Mellon Bruce Collection, 1970.17.41.

PARIS, NEW YORK, CHICAGO
CAT. 35

CLAUDE MONET (FRENCH, 1840–1926).
Luncheon on the Grass (left panel), 1865–66.
Oil on canvas; 418 × 150 cm (164 ⅝ × 59 in.).
Musée d'Orsay, Paris, gift of Georges Wildenstein,
1957, RF 1957 7.

PARIS, NEW YORK, CHICAGO
CAT. 38

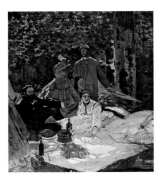

CLAUDE MONET (FRENCH, 1840–1926).
Luncheon on the Grass (central panel), 1865–66.
Oil on canvas; 248.7 × 218 cm (97 ⅞ × 85 ⅞ in.).
Musée d'Orsay, Paris, acquired as a payment in kind,
1987, RF 1987 12.

PARIS, NEW YORK, CHICAGO
CAT. 39

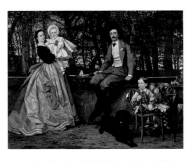

JAMES TISSOT (FRENCH, 1836–1902).
*The Marquis and Marquise de Miramon and Their
Children*, 1865. Oil on canvas; 177 × 217 cm
(69 ¹¹⁄₁₆ × 85 ⁷⁄₁₆ in.). Musée d'Orsay, Paris, RF 2006 22.

Significant early exhibitions: 1866: Paris, Exposition
de l'Union Artistique.

PARIS, NEW YORK, CHICAGO
CAT. 1

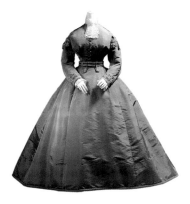

Ensemble, 1865/67. French. Gray silk faille.
The Metropolitan Museum of Art, New York,
gift of Mrs. Alfred Poor, 1958, C.I.58.4.4a–e.

NEW YORK, CHICAGO
CAT. 98

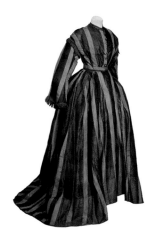

Promenade dress, 1865/68. English. Alpaca and silk
fringe. Manchester City Galleries, 1946.152/2.

NEW YORK, CHICAGO
CAT. 17

Shawl, c. 1865. Indian. Multicolored wool in a cone
pattern. The Metropolitan Museum of Art, New York,
gift of Miss F. L. Schepp, 1955, C.I.55.16.3.

NEW YORK, CHICAGO
CAT. 99

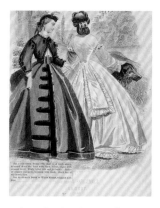

"Woman in an Outdoor Dress with a Woman in a White Muslin Dinner Dress from *Les Modes Parisiennes*," *Peterson's Magazine*, August 1865. Steel engraving with hand coloring; sheet: 19 × 14.2 cm (7 ⅜ × 5 ⅝ in.). The Metropolitan Museum of Art, New York, Woodman Thompson Collection, The Irene Lewisohn Reference Library at The Metropolitan Museum of Art, FP.19.1865.

NEW YORK, CHICAGO
CAT. 119

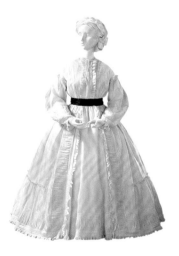

Women's morning dress, c. 1865. European. Cotton and muslin. Los Angeles County Museum of Art, purchased with funds provided by Suzanne A. Saperstein and Michael and Ellen Michelson, with additional funding from the Costume Council, the Edgerton Foundation, Gail and Gerald Oppenheimer, Maureen H. Shapiro, Grace Tsao, and Lenore and Richard Wayne, M.2007.211.667.

NEW YORK, CHICAGO
CAT. 51

— 1866 —

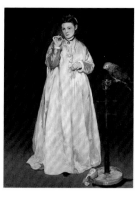

ÉDOUARD MANET (FRENCH, 1832–1883).
Young Lady in 1866 (also called *La Femme au perroquet*), 1866. Oil on canvas; 185.1 × 128.6 cm (72 ⅞ × 50 ⅝ in.). The Metropolitan Museum of Art, New York, gift of Erwin Davis, 1889, 89.21.3.

Significant early exhibitions: 1866: Paris, the artist's studio (no cat.). 1867: Paris, avenue de l'Alma, *Catalogue des Tableaux de M. Édouard Manet*, no. 15 (*Jeune dame en 1866*). 1868: Paris, Salon, no. 1659 (*Une Jeune femme*). 1872: London, Durand-Ruel, *Fifth Exhibition of the Society of French Artists*, no. 49. 1884: possibly Paris, École Nationale des Beaux-Arts, *Exposition des oeuvres de Édouard Manet*, no. 39 (*Une jeune femme*).

PARIS, NEW YORK, CHICAGO
CAT. 9

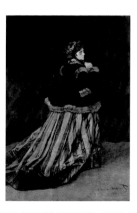

CLAUDE MONET (FRENCH, 1840–1926).
Camille, 1866. Oil on canvas; 231 × 151 cm (90 ¹⁵⁄₁₆ × 59 ½ in.). Kunsthalle Bremen, Der Kunstverein in Bremen, 298–1906/1.

Significant early exhibitions: 1866: Paris, Salon, no. 1386 (*Camille*). 1868: Le Havre, *Exposition maritime internationale*, no. 856 (*Camille*). 1899: Paris, Galerie Georges Petit, *Tableaux par P.-A. Besnard, J.-C. Cazin, C. Monet, A. Sisley, F. Thaulow, et de Poteries par E. Chaplet*, no. 60 (*La Femme à la robe verte*). 1901: Berlin, Paul Cassirer, *Dritte Kunstausstellung der Berliner Secession*, no. 181. 1902: Brussels, Salon (*9e Exposition de la Société des Beaux-Arts*), no. 122. 1904: Weimar, *Monet, Manet, Renoir et Cézanne*, no. 22. 1906: Bremen, *Internationale Kunstausstellung*, no. 241.

NEW YORK, CHICAGO
CAT. 16

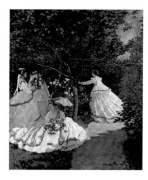

CLAUDE MONET (FRENCH, 1840–1926).
Women in the Garden, 1866. Oil on canvas; 255 × 205 cm (100 ⅜ × 80 ¹¹⁄₁₆ in.). Musée d'Orsay, Paris, RF 2773.

Significant early exhibitions: 1867: Submitted but not accepted at Salon. 1867: Paris, Chez Latouche, 34, rue Lafayette (*Printemps*). 1924: Paris, Georges Petit, *Monet*, no. 1.

PARIS, NEW YORK, CHICAGO
CAT. 45

JAMES TISSOT (FRENCH, 1836–1902).
Portrait of the Marquise de Miramon, née Thérèse Feuillant, 1866. Oil on canvas; 128.3 × 77.2 cm (50 ⁹⁄₁₆ × 29 ¹⁵⁄₁₆ in.). The J. Paul Getty Museum, Los Angeles, 2007.7.

Significant early exhibitions: 1867: Paris, Exposition universelle, no. 589 (*Portrait de Mme la marquise de M****).

NEW YORK, CHICAGO
CAT. 7

Sample from the Marquise de Miramon's peignoir, 1866. Silk, velvet; 12.4 × 32.5 cm (4 ⅞ × 12 ¹³⁄₁₆ in.). The J. Paul Getty Museum, Los Angeles, U.2007.71867.

NEW YORK, CHICAGO
CAT. 8

— 1867 —

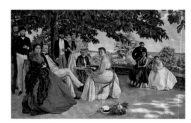

FRÉDÉRIC BAZILLE (FRENCH, 1841–1870).
Family Reunion, 1867. Oil on canvas; 152 × 230 cm
(58 ⅞ × 90 ⁹⁄₁₆ in.). Musée d'Orsay, Paris, acquired with
the participation of Marc Bazille, brother of the artist,
1905, RF 2749.

Significant early exhibitions: 1868: Paris, Salon, no. 146
(*Portraits de la famille*).

PARIS, NEW YORK, CHICAGO
CAT. 2

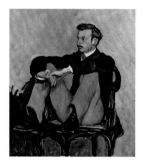

FRÉDÉRIC BAZILLE (FRENCH, 1841–1870).
Pierre-Auguste Renoir, 1867. Oil on canvas;
61.2 × 50 cm (24 × 19 ¹¹⁄₁₆ in.). Musée d'Orsay, Paris,
on deposit to the Musée Fabre, Montpellier, DL 1970 3.

PARIS, NEW YORK, CHICAGO
CAT. 71

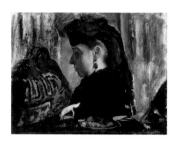

EDGAR DEGAS (FRENCH, 1834–1917).
Mademoiselle Marie Dihau, 1867–68. Oil on canvas;
22.2 × 27.3 cm (8 ¾ × 10 ¾ in.). The Metropolitan
Museum of Art, New York, H. O. Havemeyer
Collection, bequest of Mrs. H. O. Havemeyer, 1929,
29.100.182.

PARIS, NEW YORK, CHICAGO
CAT. 116

**ANDRÉ-ADOLPHE-EUGÈNE DISDÉRI (FRENCH,
1819–1889).** *Beresford from Demi-Monde I 56*, 1867.
Albumen silver print from glass negative; image:
18.4 × 24.8 cm (7 ¼ × 9 ¾ in.); album page:
26.2 × 34.8 cm (10 ⁵⁄₁₆ × 13 ¹¹⁄₁₆ in.). The Metropolitan
Museum of Art, New York, Gilman Collection,
gift of the Howard Gilman Foundation, 2005,
2005.100.588.2.54.

NOT IN EXHIBITION
CAT. 96

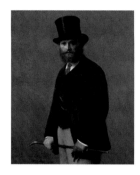

HENRI FANTIN-LATOUR (FRENCH, 1836–1904).
Édouard Manet, 1867. Oil on canvas; 117.5 × 90 cm
(46 ⁵⁄₁₆ × 35 ⁷⁄₁₆ in.). The Art Institute of Chicago,
Stickney Fund, 1905.207.

Significant early exhibitions: 1867: Paris, Salon, no. 571
(*Portrait de M. M. . . .*). 1871: London, International
Exhibition, 1511. 1889: Paris, Exposition universelle
internationale, no. 339 (*Portrait de Manet*). 1906: Paris,
L'École des Beaux-Arts, *Exposition de l'oeuvre de
Fantin-Latour*, no. 8 (*Portrait de Manet*).

PARIS, NEW YORK, CHICAGO
CAT. 68

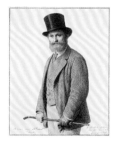

HENRI FANTIN-LATOUR (FRENCH, 1836–1904).
Édouard Manet, 1867/80. Black crayon with touches
of charcoal on cream wove paper; 39.9 × 31.1 cm
(15 ¾ × 12 ¼ in.). The Art Institute of Chicago,
Clarence Buckingham Collection, 1967.595.

CHICAGO
CAT. 121

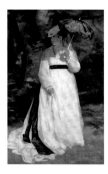

PIERRE-AUGUSTE RENOIR (FRENCH, 1841–1919).
Lise—The Woman with the Umbrella, 1867.
Oil on canvas; 184 × 115.6 cm (72 ⁷⁄₁₆ × 45 ½ in.).
Museum Folkwang, Essen, G 144.

Significant early exhibitions: 1868: Paris, Salon, no.
2113 (*Lise*). 1869: possibly Paris, Charpentier's. 1901:
Berlin, Kunstausstellung der Berliner Secession, no. 204.

PARIS, NEW YORK, CHICAGO
CAT. 40

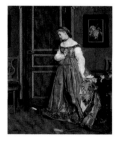

ALFRED STEVENS (BELGIAN, 1823–1906).
Hesitation (Madame Morteaux ?), c. 1867. Oil on
panel; 55.5 × 43.2 cm (21 ⅞ × 17 in.). The Art Institute
of Chicago, Mr. and Mrs. Martin A. Ryerson Collection,
1933.1178.

Significant early exhibitions: 1867: Paris, Exposition
universelle, no. 125 (*Innocence*).
1900: Paris, École des Beaux-Arts, *Exposition de
l'oeuvre d'Alfred Stevens*, no. 127 (*Hésitation*).

CHICAGO
NOT IN CAT.

Suit, 1867/68. American. Brown wool broadcloth.
The Metropolitan Museum of Art, New York, gift of
Miss Jeanne Devereaux, 1951, C.I.51.114a–c.

NEW YORK, CHICAGO
CAT. 66

— 1868 —

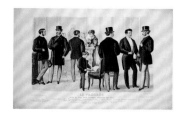

IMPRIMERIE LAMOUREUX (FRENCH, ACTIVE 19TH CENTURY). "Six Men, a Woman, and a Boy in Day Dress," *Le Progrès: Modes de Paris pour l'Académie Européenne des Modes*, 1868. Lithograph with hand coloring; sheet: 32 × 49 cm (12 ⅝ × 19 ¼ in.). The Metropolitan Museum of Art, New York, The Irene Lewisohn Reference Library, Woodman Thompson Collection, FP.49.1868.

NEW YORK, CHICAGO
CAT. 67

ÉDOUARD MANET (FRENCH, 1832–1883). *The Balcony*, 1868–69. Oil on canvas; 170 × 124.5 cm (66 ¹⁵/₁₆ × 49 ¹/₁₆ in.). Musée d'Orsay, Paris, bequest of Gustave Caillebotte, 1894, RF 2772.

Significant early exhibitions: 1869: Paris, Salon, no. 1616 (*Le Balcon*). 1869: Brussels, *Exposition générale des beaux-arts*, no. 754 (*Le balcon*).

PARIS
CAT. 76

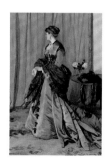

CLAUDE MONET (FRENCH, 1840–1926). *Madame Louis Joachim Gaudibert*, 1868. Oil on canvas; 217 × 138.5 cm (85 ⁷/₁₆ × 54 ⁹/₁₆ in.). Musée d'Orsay, Paris, acquired thanks to an anonymous Canadian gift, 1951, RF 1951 20.

Significant early exhibitions: 1925: Paris, *Cinquante ans de peinture français*, no. 46 (*Portrait de Mme G . . .*).

PARIS, NEW YORK, CHICAGO
CAT. 97

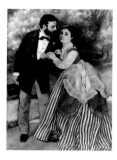

PIERRE-AUGUSTE RENOIR (FRENCH, 1841–1919). *The Couple*, 1868. Oil on canvas; 105 × 75 cm (41 ⁵/₁₆ × 29 ½ in.). Wallraf-Richartz-Museum & Fondation Corboud, Cologne, WRM 1199.

Significant early exhibitions: 1869: possibly Paris, Charpentier's. 1904: Berlin, Paul Cassirer, VII, Jahrgang. III Ausstellung, no. 51.

PARIS, NEW YORK, CHICAGO
CAT. 31

JAMES TISSOT (FRENCH, 1836–1902). *The Circle of the Rue Royale*, 1868. Oil on canvas; 175 × 281 cm (68 ⅞ × 110 ⅝ in.). Musée d'Orsay, Paris, RF 2001 53.

PARIS, NEW YORK, CHICAGO
CAT. 73

— 1869 —

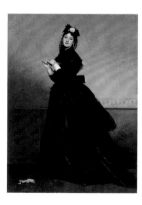

CHARLES CAROLUS-DURAN (FRENCH, 1837–1917). *The Lady with the Glove*, 1869. Oil on canvas; 228 × 164 cm (89 ¾ × 64 ⁹/₁₆ in.). Musée d'Orsay, Paris, RF 152, RF 2756.

Significant early exhibitions: 1869: Paris, Salon, no. 843 (*Portrait de Mme . . *). 1878: Paris, Exposition Universelle, no. 302 (*La dame au gant*).

PARIS, NEW YORK, CHICAGO
CAT. 19

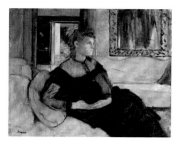

EDGAR DEGAS (FRENCH, 1834–1917). *Madame Théodore Gobillard*, 1869. Oil on canvas; 55.2 × 65.1 cm (21 ¾ × 25 ⅝ in.). The Metropolitan Museum of Art, New York, H. O. Havemeyer Collection, bequest of Mrs. H. O. Havemeyer, 1929, 29.100.45.

Significant early exhibitions: 1876: Paris, 11, rue Le Peletier, *2e exposition de peinture*, Apr. 1–30, no. 39 (*Portrait de femme [ébauche]*).

PARIS, NEW YORK, CHICAGO
CAT. 47

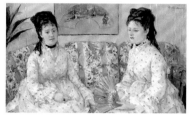

BERTHE MORISOT (FRENCH, 1841–1895). *The Sisters*, 1869. Oil on canvas; 52.1 × 81.3 cm (20 ½ × 32 in.). National Gallery of Art, Washington, D.C., gift of Mrs. Charles S. Carstairs, 1952.9.2.

PARIS, NEW YORK, CHICAGO
CAT. 10

— 1870 —

PAUL CÉZANNE (FRENCH, 1839–1906). *The Conversation*, 1870–71. Oil on canvas; 92 × 73 cm (36 ¼ × 28 ¾ in.). Private collection, courtesy Galerie Bernheim-Jeune, Paris.

PARIS
CAT. 27

EDGAR DEGAS (FRENCH, 1834–1917).
Sulking, c. 1870. Oil on canvas; 32.4 × 46.4 cm
(12 ¾ × 18 ¼ in.). The Metropolitan Museum of Art,
New York, H. O. Havemeyer Collection, bequest of
Mrs. H. O. Havemeyer, 1929, 29.100.43.

Significant early exhibitions: 1896: Paris, Durand-Ruel,
Degas. 1915: New York, M. Knoedler & Co., *Loan
Exhibition of Masterpieces by Old and Modern
Painters*, Apr. 6–24, no. 25 (*The Dispute*).

PARIS, NEW YORK, CHICAGO
CAT. 5

PIERRE-AUGUSTE RENOIR (FRENCH, 1841–1919).
*Lise on the Banks of the Seine—Bather with Griffon
Terrier*, 1870. Oil on canvas; 184 × 115 cm
(72 ⁷⁄₁₆ × 45 ¼ in.). Museu de Arte de São Paulo Assis
Chateaubriand, São Paulo, 95 P.

Significant early exhibitions: 1870: Paris, Salon,
no. 2405 (*Baigneuse*). 1913: Paris, Bernheim-Jeune,
Renoir, no. 4 (*La Baigneuse au griffon*).

NOT IN EXHIBITION
CAT. 43

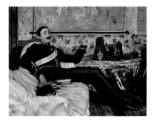

JAMES TISSOT (FRENCH, 1836–1902).
Frederick Gustavus Burnaby, 1870. Oil on panel;
49.5 × 59.7 cm (19 ½ × 23 ½ in.). National Portrait
Gallery, London, purchased, 1933, NPG 2642.

Significant early exhibitions: 1872: London,
International Exhibition, no. 1282
(*M. le Colonel * * ** *).

PARIS, NEW YORK, CHICAGO
CAT. 70

— 1871 —

PAUL CÉZANNE (FRENCH, 1839–1906).
The Promenade, 1871. Oil on canvas; 56.5 × 47 cm
(22 ¼ × 18 ½ in.). Private collection.

Significant early exhibitions: 1903: Berlin, Siebente
Kunstausstellung der Berliner Secession, no. 36
(*Zwei Frauen im Garten*). 1907: Paris, Grand Palais,
Salon d'Automne, *Exposition rétrospective d'oeuvres
de Cézanne*, no. 30 (*Les deux promeneuses*).

PARIS, NEW YORK, CHICAGO
CAT. 25

**IMPRIMERIE GILQUIN FILS (FRENCH, ACTIVE 19TH
CENTURY).** "Toilettes by Madame Fladry," *La Mode
Illustrée*, May 7, 1871. Exhibited in New York: Steel
engraving with hand coloring; sheet: 36.9 × 26.2 cm
(14 ½ × 10 ¼ in.). The Metropolitan Museum of Art,
The Library of the Costume Institute, purchased with
income from the Irene Lewisohn Bequest. Exhibited in
Chicago: Steel engraving with hand coloring; sheet:
36.7 × 25.7 cm (14 ⁷⁄₁₆ × 10 ⅛ in.). Private collection.

NEW YORK, CHICAGO
CAT. 26

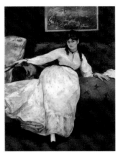

ÉDOUARD MANET (FRENCH, 1832–1883).
Repose, c. 1871. Oil on canvas; 148 × 113 cm
(59 ⅛ × 44 ⅞ in.). Museum of Art, Rhode Island School
of Design, Providence, bequest of Mrs. Edith
Stuyvesant Vanderbilt Gerry, 59.027.

Significant early exhibitions: 1873: Paris, Salon, no. 998
(*Le Repos*). 1884: Paris, École Nationale des Beaux-
Arts, *Exposition des oeuvres de Édouard Manet*, no. 56
(*Portrait de Mlle Éva Gonzalès*). 1895: New York,
Durand-Ruel, *Manet*, no. 1.

NEW YORK, CHICAGO
CAT. 120

BERTHE MORISOT (FRENCH, 1841–1895).
On the Balcony (*Femme et enfant au balcon*),
1871/72. Watercolor with touches of gouache over
graphite on off-white paper; 20.6 × 17.3 cm
(8 ⅛ × 6 ¹³⁄₁₆ in.). The Art Institute of Chicago,
gift of Mrs. Charles Netcher in memory of Charles
Netcher II, 1933.1.

CHICAGO
NOT IN CAT.

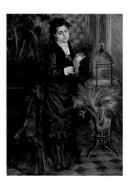

PIERRE-AUGUSTE RENOIR (FRENCH, 1841–1919).
Woman with Parrot, 1871. Oil on canvas; 92.1 ×
65.1 cm (36 ¼ × 25 ⅝ in.). Solomon R. Guggenheim
Museum, New York, Thannhauser Collection, gift,
Justin K. Thannhauser, 1978, 78.2514.68.

Significant early exhibitions: 1913: Paris, Bernheim-
Jeune, *Renoir*, no. 2 (*La Femme à la perruche*).

NEW YORK
CAT. 22

287

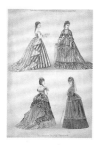

"The Latest French Fashions," *The Queen, The Lady's Newspaper and Court Chronicle*, 1871. Lithograph; sheet: 42.7 × 28.4 cm (16 13/16 × 11 3/16 in.). The Metropolitan Museum of Art, New York, The Elisha Whittelsey Collection, The Elisha Whittelsey Fund, 63.608.6.

NEW YORK, CHICAGO
CAT. 13

— 1872 —

CONSTANTIN GUYS (FRENCH, 1802–1892).
Three-Quarter Length Portrait of a Woman, 1872/73. Pen and brown ink, with brush and gray wash, over graphite, on ivory wove paper; 28.8 × 19.6 cm (11 5/16 × 7 3/4 in.). The Art Institute of Chicago, gift of Robert Allerton, 1924.802.

CHICAGO
NOT IN CAT.

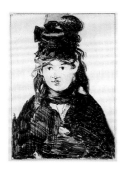

ÉDOUARD MANET (FRENCH, 1832–1883).
Berthe Morisot in Black, 1872–74. Exhibited in New York: Lithograph on chine collé, second state of two; image: 24.9 × 17.6 cm (9 13/16 × 6 15/16 in.); sheet: 40 × 30.2 cm (15 3/4 × 11 7/8 in.). The Metropolitan Museum of Art, New York, Harris Brisbane Dick Fund, 1923, 23.21.22. Exhibited in Chicago: Lithograph in black with scraping on gray chine, laid down on ivory wove paper; plate: 20.4 × 14.2 cm (8 1/16 × 5 5/8 in.); primary support: 24.1 × 17.4 cm (9 1/2 × 6 7/8 in.); secondary support: 42.2 × 31.5 cm (16 5/8 × 12 7/16 in.). The Art Institute of Chicago, Charles Deering Collection, 1927.4210.

NEW YORK, CHICAGO
NOT IN CAT.

BERTHE MORISOT (FRENCH, 1841–1895).
Interior, 1872. Oil on canvas; 60 × 73 cm (23 5/8 × 28 3/4 in.). Collection of Diane B. Wilsey.

Significant early exhibitions: 1896: Paris, Durand-Ruel, *Berthe Morisot (Madame Eugene Manet) Exposition de son oeuvre*, Mar. 5–23, no. 51 (*Intérieur*).

PARIS, NEW YORK, CHICAGO
CAT. 48

BERTHE MORISOT (FRENCH, 1841–1895).
On the Balcony (*Femme et enfant au balcon*), 1872. Oil on canvas; 60 × 50 cm (23 5/8 × 19 11/16 in.). Private collection.

NEW YORK, CHICAGO
CAT. 77

— 1873 —

ÉDOUARD MANET (FRENCH, 1832–1883).
Lady with Fans (*Portrait of Nina de Callias*), 1873. Oil on canvas; 113 × 166.5 cm (44 1/2 × 65 9/16 in.). Musée d'Orsay, Paris, bequest of Mr. and Mrs. Ernest Rouart, RF 2850.

Significant early exhibitions: 1884: Paris, École Nationale des Beaux-Arts, *Exposition des oeuvres de Édouard Manet*, no. 77 (*La dame aux éventails*).

NEW YORK, CHICAGO
CAT. 15

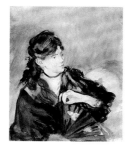

ÉDOUARD MANET (FRENCH, 1832–1883).
Berthe Morisot, 1873/74. Watercolor over traces of graphite on off-white wove paper; 20.9 × 16.8 cm (8 1/4 × 6 5/8 in.). The Art Institute of Chicago, Helen Regenstein Collection, 1963.812.

CHICAGO
NOT IN CAT.

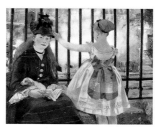

ÉDOUARD MANET (FRENCH, 1832–1883).
The Railway, 1873. Oil on canvas; 93.3 × 111.5 cm (36 3/4 × 43 7/8 in.). National Gallery of Art, Washington D.C., gift of Horace Havemeyer in memory of his mother, Louisine W. Havemeyer, 1956.10.1.

Significant early exhibitions: 1874: Paris, Salon, no. 1260 (*Le chemin de fer*). 1884: Paris, École Nationale des Beaux-Arts, *Exposition des Oeuvres de Édouard Manet*, no. 68 (*Le chemin de fer*).

CHICAGO
CAT. 82

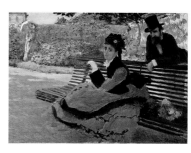

CLAUDE MONET (FRENCH, 1840–1926).
Camille Monet on a Garden Bench (*Le Banc*), 1873. Oil on canvas; 60.6 × 80.3 cm (23 7/8 × 31 5/8 in.). The Metropolitan Museum of Art, New York, The Walter H. and Leonore Annenberg Collection, gift of Walter H. and Leonore Annenberg, 2002, bequest of Walter H. Annenberg, 2002, 2002.62.1.

Significant early exhibitions: 1903: Berlin, Paul Cassirer, *Siebenten Kunstaustellung der Berliner Secession*, no. 142 (*Auf der Bank*).

NEW YORK
CAT. 83

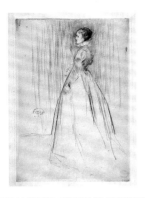

JAMES MCNEILL WHISTLER (AMERICAN, 1834–1903). *The Velvet Dress*, 1873. Drypoint, fourth state of five; plate: 23.3 × 15.7 cm (9 3/16 × 6 3/16 in.); sheet: 30.8 × 20.8 cm (12 1/8 × 8 3/16 in.). The Metropolitan Museum of Art, New York, gift of Miss G. Louise Robinson, 1940, 40.3.1.

NOT IN EXHIBITION
NOT IN CAT.

Blue walking dress, 1873/74. Possibly American. Deep blue silk taffeta and velvet. Kent State University Museum, Silverman/Rodgers Collection, 1983.1.126a, b.

NEW YORK, CHICAGO
CAT. 95

ARTIST UNKNOWN (FRENCH, ACTIVE 19TH CENTURY). *Two Young Ladies in a Garden*, 1873–74. French. Etching and drypoint; image: 15.2 × 10.6 cm (6 × 4 3/16 in.); plate: 23.8 × 15.9 cm (9 3/8 × 6 1/4 in.); sheet: 30 × 23.7 cm (11 13/16 × 9 5/16 in.). The Metropolitan Museum of Art, New York, gift of Edith P. Blasé, 44.91.860.

NOT IN EXHIBITION
NOT IN CAT.

— 1874 —

JEAN-BAPTISTE-CAMILLE COROT (FRENCH, 1796–1875). *Lady in Blue*, 1874. Oil on canvas; 80 × 50.5 cm (31 1/2 × 19 7/8 in.). Musée du Louvre, Paris, acquired thanks to the annuity from the gift of Maurice Audéoud, with the participation of the children of Henri Rouart, 1912.

PARIS, NEW YORK, CHICAGO
CAT. 6

ÉDOUARD MANET (FRENCH, 1832–1883). *Madame Édouard Manet on a Blue Sofa*, 1874. Pastel on brown paper, laid down on canvas; 49 × 60 cm (19 5/16 × 23 5/8 in.). Musée d'Orsay, Paris, RF 4507.

PARIS
CAT. 54

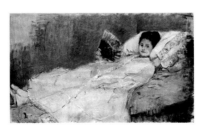

BERTHE MORISOT (FRENCH, 1841–1895). *Woman with a Fan. Portrait of Madame Marie Hubbard*, 1874. Oil on canvas; 50.5 × 81 cm (19 7/8 × 31 7/8 in.). Ordrupgaard, Copenhagen, 200 WH.

NEW YORK, CHICAGO
CAT. 56

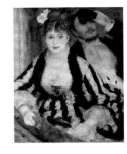

PIERRE-AUGUSTE RENOIR (FRENCH, 1841–1919). *The Loge*, 1874. Oil on canvas; 80 × 63.5 cm (31 1/2 × 25 in.). The Samuel Courtauld Trust, The Courtauld Gallery, London, P.1948.SC.338.

Significant early exhibitions: 1874: Paris, Galerie Nadar, 35, boulevard des Capucines, *Première exposition*, Apr. 15–May 15, no. 142 (*La Loge*). 1892: Paris, Durand-Ruel, *A. Renoir*, no. 63 (*La Loge*). 1899: Paris, Durand-Ruel, *Monet, Pissarro, Renoir, Sisley*, no. 74 (*La Loge*). 1900: Paris, Grand Palais des Champs-Elysées, Exposition Internationale Universelle, *Centennale de l'Art français*, no. 562 (*La Loge*). 1904: Brussels, La Libre esthétique, *Exposition des Peintres Impressionnistes*, no. 128. 1905: London, Grafton Galleries, *Pictures by Boudin . . . etc.*, no. 251.

PARIS, NEW YORK, CHICAGO
CAT. 12

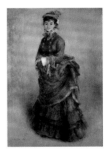

PIERRE-AUGUSTE RENOIR (FRENCH, 1841–1919). *The Parisienne*, 1874. Oil on canvas; 163.2 × 108.3 cm (64 5/16 × 42 11/16 in.). National Museum Wales, Cardiff, NMW A 2495.

Significant early exhibitions: 1874: Paris, Galerie Nadar, 35, boulevard des Capucines, *Première exposition*, Apr. 15–May 15, no. 143 (*Parisienne*). 1892: Paris, Durand-Ruel, *A. Renoir*, no. 106 (*La Dame en bleu*).

NOT IN EXHIBITION
CAT. 32

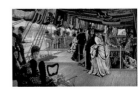

JAMES TISSOT (FRENCH, 1836–1902). *The Ball on Shipboard*, c. 1874. Oil on canvas; 84.1 × 129.5 cm (33 1/8 × 51 in.). Tate, presented by the Trustees of the Chantrey Bequest 1937, N04892.

Significant early exhibitions: 1874: London, Royal Academy, no. 690 (*The Ball on Shipboard*).

PARIS, NEW YORK, CHICAGO
CAT. 85

— 1875 —

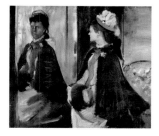

EDGAR DEGAS (FRENCH, 1834–1917).
Madame Jeantaud at the Mirror, c. 1875. Oil on canvas; 70 × 84 cm (27 ⁹⁄₁₆ × 33 ¹⁄₁₆ in.). Musée d'Orsay, Paris, bequest of Jean Edouard Dubrujeaud subject to usufruct in favor of his son Jean Angladon-Dubrujeaud, 1970, RF 1970 38.

Significant early exhibitions: 1912: St. Petersburg, *Centennale d'Art Français*, no. 176. 1917: Zurich, *Französische Kunst*, no. 89.

PARIS
CAT. 100

EDGAR DEGAS (FRENCH, 1834–1917).
Woman with Binoculars, 1875/76. Oil on cardboard; 48 × 32 cm (18 ⅞ × 11 ⅞ in.). Staatliche Kunstsammlungen Dresden, Galerie Neue Meister, purchased from the collection of Woldemar von Seidlitz, Dresden, 1922, no. 2601.

Significant early exhibitions: 1897: Dresden, *Internationalen Kunst-Austellung*, May–June, no. 122. 1907: Dresden, *Moderne Kunstwerke aus Privatbesitz*, no. 16.

PARIS, NEW YORK, CHICAGO
CAT. 84

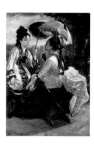

MARCELLIN GILBERT DESBOUTIN (FRENCH, 1823–1902). *The Conversation*, 1875/79. Oil on canvas; 55.5 × 38 cm (21 ¹³⁄₁₆ × 14 ¹⁵⁄₁₆ in.). The Art Institute of Chicago, Mr. and Mrs. Lewis Larned Coburn Memorial Collection, 1935.71.

CHICAGO
NOT IN CAT.

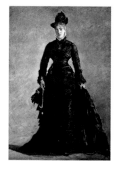

ÉDOUARD MANET (FRENCH, 1832–1883).
The Parisienne, c. 1875. Oil on canvas; 192 × 125 cm (75 ⅝ × 49 ¼ in.). Nationalmuseum, Stockholm, bequest 1917 of bank director S. Hult, managing director Kristoffer Hult, director Ernest Thiel, director Arthur Thiel, director Casper Tamm, NM 2068.

PARIS, NEW YORK, CHICAGO
CAT. 33

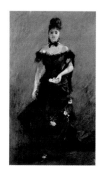

BERTHE MORISOT (FRENCH, 1841–1895).
Figure of a Woman, also called *Before the Theater* (*Femme en noir*, also called *Avant le théâtre*), 1875. Oil on canvas; 57 × 31 cm (22 ½ × 12 ¼ in.). Private collection.

Significant early exhibitions: 1876: Paris, Galerie Durand-Ruel, 11, rue Le Peletier, *2e exposition de peinture*, Apr. 1–30, no. 178 (*Figure de femme*). 1892: Paris, Boussod, Valadon et Cie., *Exposition de Tableaux, Pastels et Dessins par Berthe Morisot*, no. 6 (*Femme en noir*).

PARIS, NEW YORK, CHICAGO
CAT. 21

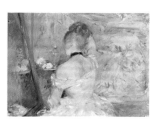

BERTHE MORISOT (FRENCH, 1841–1895).
Woman at Her Toilette, 1875/80. Oil on canvas; 60.3 × 80.4 cm (23 ¾ × 31 ⅝ in.). The Art Institute of Chicago, Stickney Fund, 1924.127.

Significant early exhibitions: 1880: Paris, 10 rue des Pyramides, *5me exposition de peinture*, Apr. 1–30, no. 115 (*Femme à sa toilette*).

PARIS, NEW YORK, CHICAGO
CAT. 59

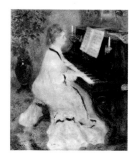

PIERRE-AUGUSTE RENOIR (FRENCH, 1841–1919).
Woman at the Piano, 1875/76. Oil on canvas; 93.2 × 74.2 cm (36 ¾ × 29 ¼ in.). The Art Institute of Chicago, Mr. and Mrs. Martin A. Ryerson Collection, 1937.1025.

Significant early exhibitions: 1876: Paris, Galerie Durand-Ruel, 11, rue Le Peletier, *2e exposition de peinture*, Apr. 1–30, no. 219 (*Femme au piano*).

PARIS, NEW YORK, CHICAGO
CAT. 55

CHARLES REUTLINGER (GERMAN, 1816–AFTER 1880). *Berthe Morisot*, c. 1875. Photographic negative. Musée Marmottan Monet, Paris.

NEW YORK, CHICAGO
CAT. 23

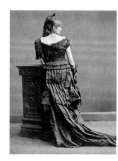

CHARLES REUTLINGER (GERMAN, 1816–AFTER 1880). *Berthe Morisot Seen from Behind*, c. 1875. Photograph. Musée Marmottan Monet, Paris.

NEW YORK, CHICAGO
CAT. 24

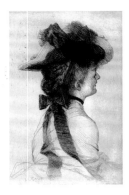

JAMES TISSOT (FRENCH, 1836–1902).
The Rubens Hat, 1875. Etching printed in brown ink on wove paper; plate: 25.4 × 16.3 cm (10 × 6 ⁷⁄₁₆ in.); sheet: 40.6 × 27 cm (16 × 10 ⅝ in.). The Metropolitan Museum of Art, New York, Harris Brisbane Dick Fund, 1924, 24.13.8.

NEW YORK, CHICAGO
NOT IN CAT.

Top hat, 1875/1900. American. Black silk. The Metropolitan Museum of Art, New York, gift of Miss Ruth Catlin, 1941, C.I.41.24.5a.

NEW YORK, CHICAGO
CAT. 65

— 1876 —

ALBERT BARTHOLOMÉ (FRENCH, 1848–1928), EDGAR DEGAS (FRENCH, 1834–1917), JEAN BAPTISTE ÉDOUARD DETAILLE (FRENCH, 1848–1912), LUCIEN DOUCET (FRENCH, 1856–1895), JEAN LOUIS FORAIN (FRENCH, 1852–1931), JEAN-LÉON GÉRÔME (FRENCH, 1824–1904), EDMOND DE GONCOURT (FRENCH, 1822–1896), AND EUGÈNE LAMBERT (FRENCH, 1825–1900). Folding fan, 1876/95. Thick tan wove paper with bamboo supports, with ivory laid paper note laid down and folded with fan; 40 × 70.2 cm (15 ¾ × 27 ⅝ in.). The Art Institute of Chicago, obj. 152059.

CHICAGO
NOT IN CAT.

FÉLIX BRACQUEMOND (FRENCH, 1833–1914).
The Terrace of the Villa Branca, 1876. Etching, seventh state of eight; plate: 26.5 × 36.3 cm (10 ⁷⁄₁₆ × 14 ⁵⁄₁₆ in.); sheet: 34.5 × 49.8 cm (13 ⁹⁄₁₆ × 19 ⅝ in.). The Metropolitan Museum of Art, New York, gift of David Keppel, 1922, 22.1.20.

NOT IN EXHIBITION
NOT IN CAT.

GUSTAVE CAILLEBOTTE (FRENCH, 1848–1894).
The Pont de l'Europe, 1876. Oil on canvas; 124.7 × 180.6 cm (49 ⅛ × 71 ⅛ in.). Association des Amis du Petit Palais, Geneva.

Significant early exhibitions: 1877: Paris, 6, rue Le Peletier, *3e exposition de peinture*, Apr. 1–30, no. 2 (*Le Pont de l'Europe*). 1894: Paris, Durand-Ruel, *Exposition rétrospective d'oeuvres de G. Caillebotte*, no. 6 (*Le Pont de l'Europe*).

CHICAGO
CAT. 80

EDGAR DEGAS (FRENCH, 1834–1917).
The Jet Earring, 1876–77. Monotype printed in black ink on white wove paper; plate: 8.2 × 7 cm (3 ¼ × 2 ¾ in.); sheet: 18 × 13.2 cm (7 ¹⁄₁₆ × 5 ³⁄₁₆ in.). The Metropolitan Museum of Art, New York, anonymous gift, in memory of Francis Henry Taylor, 1959, 59.651.

NEW YORK, CHICAGO
CAT. 117

ÉDOUARD MANET (FRENCH, 1832–1883).
Before the Mirror, 1876. Oil on canvas; 92.1 × 71.4 cm (36 ¼ × 28 ⅛ in.). Solomon R. Guggenheim Museum, New York, Thannhauser Collection, gift, Justin K. Thannhauser, 1978, 78.2514.27.

Significant early exhibitions: 1880: Paris, La Vie Moderne, *Oeuvres nouvelles d'Edouard Manet*, no. 8 (*Devant la glace*).

NEW YORK, CHICAGO
CAT. 58

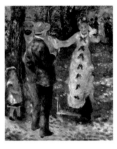

PIERRE-AUGUSTE RENOIR (FRENCH, 1841–1919).
The Swing, 1876. Oil on canvas; 92 × 73 cm (36 ¼ × 28 ¾ in.). Musée d'Orsay, Paris, bequest of Gustave Caillebotte, 1894, RF 2738.

Significant early exhibitions: 1877: Paris, 6, rue Le Peletier, *3e exposition de peinture*, Apr. 1–30, no. 185 (*La Balançoire*). 1883: Paris, Durand-Ruel, *Oeuvres de P.-A. Renoir*, Apr. 1–25, no. 28 (*La Balançoire*). 1892: Paris, Durand-Ruel, *A. Renoir*, May, no. 23 (*La Balançoire*). 1917: Barcelona, Palau de Belles Artes, *Exposició d'art francès contemporani*, Apr.–July, no. 823.

PARIS, NEW YORK, CHICAGO
CAT. 44

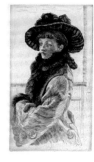

JAMES TISSOT (FRENCH, 1836–1902).
Mavourneen, 1876. Drypoint and etching on cream laid paper; plate: 37.2 × 20.5 cm (14 ¹¹⁄₁₆ × 8 ⅛ in.); sheet: 43.2 × 34.4 cm (17 ¹⁄₁₆ × 13 ⁹⁄₁₆ in.). The Art Institute of Chicago, Charles Deering Collection, 1927.5522.

CHICAGO
NOT IN CAT.

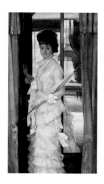

JAMES TISSOT (FRENCH, 1836–1902).
Portrait, 1876. Oil on canvas; 91.4 × 50.8 cm
(36 × 20 in.). Tate, purchased 1927, N04271.

Significant early exhibitions: 1877: London, Grosvenor
Gallery, no. 18 (*A Portrait*).

PARIS, NEW YORK, CHICAGO
CAT. 30

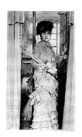

JAMES TISSOT (FRENCH, 1836–1902).
Portrait of Miss L . . . , or *A Door Must Be Either Open
or Closed*, 1876. Drypoint on laid paper, only state;
plate: 38.8 × 21.6 cm (15 ¼ × 8 ½ in.); sheet:
48.8 × 33.5 cm (19 ³/₁₆ × 13 ³/₁₆ in.). The Metropolitan
Museum of Art, New York, Harris Brisbane Dick Fund,
1924, 24.73.1.

CHICAGO
NOT IN CAT.

Frock coat and trousers, c. 1876. American.
Black wool broadcloth. Kent State University Museum,
gift of Mary E. Crawford Croxton, 1986.41.2a, b.

NEW YORK, CHICAGO
CAT. 94

— 1877 —

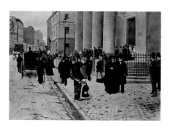

JEAN BÉRAUD (FRENCH, 1849–1935).
The Church of Saint-Philippe-du-Roule, Paris, 1877.
Oil on canvas; 59.4 × 81 cm (23 ⅜ × 31 ⅞ in.).
The Metropolitan Museum of Art, New York, gift of
Mr. and Mrs. William B. Jaffe, 1955, 55.35.

Significant early exhibitions: 1877: Paris, Salon, no. 173
(*Le Dimanche, près de Saint-Philippe-du-Roule*). 1893:
New York, American Fine Arts Society, loan exhibition,
Feb. 13–Mar. 26, 1893, no. 45, lent by S. P. Avery, Jr.

NEW YORK, CHICAGO
CAT. 79

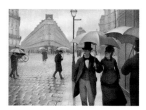

GUSTAVE CAILLEBOTTE (FRENCH, 1848–1894).
Paris Street; Rainy Day, 1877. Oil on canvas; 212.2 ×
276.2 cm (83 ½ × 108 ¾ in.). The Art Institute of
Chicago, Charles H. and Mary F. S. Worcester
Collection, 1964.336.

Significant early exhibitions: 1877: Paris, 6, rue Le
Peletier, *3e exposition de peinture*, Apr. 1–30, no. 1
(*Rue de Paris; Temps de pluie*). 1894: Paris, Durand-
Ruel, *Exposition retrospective d'oeuvres de G.
Caillebotte*, no. 47 (*Une Rue de Paris; effet de pluie*).

PARIS, NEW YORK, CHICAGO
CAT. 93

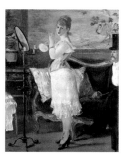

ÉDOUARD MANET (FRENCH, 1832–1883).
Nana, 1877. Oil on canvas; 150 × 116 cm
(59 ¹/₁₆ × 45 ¹¹/₁₆ in.). Hamburger Kunsthalle.

Significant early exhibitions: 1877: Paris, Giroux,
boulevard des Capucines (exhibited in Giroux's
shop window).

PARIS
CAT. 57

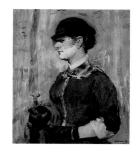

ÉDOUARD MANET (FRENCH, 1832–1883).
Young Woman in a Round Hat, 1877/79.
Oil on canvas; 54.6 × 45.1 cm (21 ½ × 17 ¾ in.).
The Henry and Rose Pearlman Foundation,
on long-term loan to the Princeton University Art
Museum, L.1988.62.14.

NEW YORK, CHICAGO
CAT. 127

PIERRE-AUGUSTE RENOIR (FRENCH, 1841–1919).
The Milliner, 1877. Pastel on paper; 53.3 × 41.3 cm
(21 × 16 ¼ in.). The Metropolitan Museum of Art,
New York, The Lesley and Emma Sheafer Collection,
bequest of Emma A. Sheafer, 1973, 1974.356.34.

CHICAGO
CAT. 107

Corset, c. 1877. American. White cotton sateen and
lace. The Metropolitan Museum of Art, New York,
gift of David L. Andrews, 1976, 1976.254.3i, j.

NEW YORK, CHICAGO
CAT. 61

— 1878 —

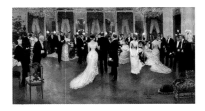

JEAN BÉRAUD (FRENCH, 1849–1935).
A Ball, 1878. Oil on canvas; 65 × 117 cm (25 ⅝ × 46 ¹/₁₆ in.). Musée d'Orsay, Paris, RF 1994 15.

Significant early exhibitions: 1878: Paris, Salon, no. 178 (*Une Soirée*).

PARIS, NEW YORK, CHICAGO
CAT. 90

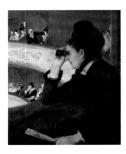

MARY CASSATT (AMERICAN, 1844–1926).
In the Loge, 1878. Oil on canvas; 81.3 × 66 cm (32 × 26 in.). Museum of Fine Arts, Boston, The Hayden Collection, Charles Henry Hayden Fund, 10.35.

Significant early exhibitions: 1881: New York, Society of American Artists. 1893: Paris, Durand-Ruel, *Exposition de tableaux, pastels et gravures de Mary Cassatt*, no. 13 (*La Loge*). 1895: New York, Durand-Ruel, *Exposition of Paintings, Pastels, and Etchings by Miss Mary Cassatt*, no. 5 (*Dans la loge*). 1903: New York, Durand-Ruel, *Exhibition of Paintings and Pastels by Mary Cassatt*, no. 1 (*Dans la loge*). 1909: Boston, St. Botolph Club, no. 24 (*Dans la loge*). 1926: The Art Institute of Chicago, *Catalogue of a Memorial Collection of the Works of Mary Cassatt*, Dec. 21, 1926–Jan. 24, 1927, no. 1 (*At the Opera*). 1928: Pittsburgh, Carnegie Institute, *A Memorial Exhibition of the Work of Mary Cassatt*, Mar. 15–Apr. 15, no. 2 (*At the Opera*).

PARIS, NEW YORK, CHICAGO
CAT. 78

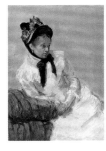

MARY CASSATT (AMERICAN, 1844–1926).
Portrait of the Artist, 1878. Watercolor and gouache on wove paper, laid down to buff-colored wood-pulp paper; 60 × 41.1 cm (23 ⅝ × 16 ³/₁₆ in.). The Metropolitan Museum of Art, New York, bequest of Edith H. Proskauer, 1975, 1975.319.1.

Significant early exhibitions: 1895: New York, Durand-Ruel, *Exposition of Paintings, Pastels, and Etchings by Miss Mary Cassatt*, no. 35 (*Jeune femme assise*). 1926: The Art Institute of Chicago, *Catalogue of a Memorial Collection of the Works of Mary Cassatt*, Dec. 21, 1926–Jan. 24, 1927, no. 33 (*Woman Leaning on Her Right Hand*). 1928: Pittsburgh, Carnegie Institute, *A Memorial Exhibition of the Work of Mary Cassatt*, Mar. 15–Apr. 15, no. 28 (*Self Portrait*).

NEW YORK
CAT. 14

EDGAR DEGAS (FRENCH, 1834–1917).
Portraits at the Stock Exchange, 1878–79. Oil on canvas; 100 × 82 cm (39 ⅜ × 32 ¼ in.). Musée d'Orsay, Paris, bequest subject to usufruct in 1923 by Ernest May, RF 2444.

Significant early exhibitions: 1879: Paris, 228, avenue de l'Opéra, *4me exposition de peinture*, Apr. 10–May 11, no. 61 (*Portraits à la Bourse*). 1880: Paris, 10, rue des Pyramides, *5me exposition de peinture*, Apr. 1–30, no. 35 (*Portraits à la Bourse*).

PARIS, NEW YORK, CHICAGO
CAT. 81

HENRI GERVEX (FRENCH, 1852–1929).
Rolla, 1878. Oil on canvas; 176 × 221 cm (69 ⁵/₁₆ × 87 in.). Musée d'Orsay, Paris, bequest of M. Bérardi, 1926, LUX 1545.

Significant early exhibitions: 1878: Paris, Salon (*Rolla* was accepted and then removed one month before the opening because of the perceived impropriety of its subject matter). 1878: Paris, M. M. Bague et Cie, 41, rue de la Chaussé d'Antin, Apr.–July.

PARIS, CHICAGO
CAT. 64

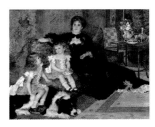

PIERRE-AUGUSTE RENOIR (FRENCH, 1841–1919).
Madame Georges Charpentier and Her Children, 1878. Oil on canvas; 153.7 × 190.2 cm (60 ½ × 74 ⅞ in.). The Metropolitan Museum of Art, New York, Catharine Lorillard Wolfe Collection, Wolfe Fund, 1907, 07.122.

Significant early exhibitions: 1879: Paris, Salon, no. 2527 (*Portraits de Mme G. C. . . . et de ses enfants*). 1886: Brussels, Palais des Beaux-Arts, *Troisième exposition annuelle des XX*, no. 2 (*Mme Charpentier et ses deux enfants*). 1886: Paris, Georges Petit, *5e Exposition Internationale de Peinture et de Sculpture*, cinquième année, no. 124 (*Portrait de Mme G. C. et ses Enfants*). 1892: Paris, Durand-Ruel, *Exposition A. Renoir*, no. 110 (*Portrait*). 1900: Paris, Bernheim-Jeune, *Exposition A. Renoir*, no. 17 (*En Famille*). 1901: Paris, Petit Palais, *Exposition de l'enfance*, no. 1111 (*Mme Charpentier et ses enfants*). 1904: Brussels, La libre esthétique Brussels, Musée Moderne, *Exposition des peintres impressionnistes*, no. 129 (*Portrait de Mme Charpentier et de ses enfants*).

PARIS, NEW YORK, CHICAGO
CAT. 124

JAMES TISSOT (FRENCH, 1836–1902).
Evening (Le Bal), 1878. Oil on canvas; 90 × 50 cm (35 ⁷/₁₆ × 19 ¹¹/₁₆ in.). Musée d'Orsay, Paris, bequest of William Vaughan, 1919, RF 2253.

Significant early exhibitions: 1878: London, Grosvenor Gallery, no. 33 (*Evening*).

NEW YORK, CHICAGO
CAT. 91

JAMES TISSOT (FRENCH, 1836–1902).
July: Specimen of a Portrait, c. 1878. Oil on fabric;
87.5 × 61 cm (34 7/16 × 24 in.). The Cleveland Museum
of Art, bequest of Noah L. Butkin, 1980.288.

Significant early exhibitions: 1878: London, Grosvenor
Gallery, no. 34 (*July [Specimen of a Portrait]*).

PARIS, NEW YORK, CHICAGO
CAT. 52

**JAMES MCNEILL WHISTLER (AMERICAN,
1834–1903).** *The Toilette*, 1878. Exhibited in
New York: Lithotint, with scraping and incising, on a
prepared half-tint ground, second state of five; image:
25.7 × 16.4 cm (10 1/8 × 6 7/16 in.); sheet: 30.8 ×
19.7 cm (12 1/8 × 7 3/4 in.). The Metropolitan Museum
of Art, New York, gift of Paul F. Walter, 1984,
1984.1119.2.

NOT IN EXHIBITION
NOT IN CAT.

Day dress, 1878/80. American. White cotton batiste.
The Metropolitan Museum of Art, New York, purchase,
Irene Lewisohn Trust Gift, 1993, 1993.42a, b.

NEW YORK, CHICAGO
CAT. 53

— 1879 —

MARY CASSATT (AMERICAN, 1844–1926).
Woman with a Pearl Necklace in a Loge, 1879. Oil on
canvas; 81.3 × 59.7 cm (32 × 23 1/2 in.). Philadelphia
Museum of Art, bequest of Charlotte Dorrance Wright,
1978, 1978-1-5.

Significant early exhibitions: 1879: Paris, 228, avenue
de l'Opéra, *4me exposition de peinture*, Apr. 10–May
11, no. 49 (*Femme dans une loge*). 1893: Paris,
Durand-Ruel, *Exposition Mary Cassatt*, no. 4 (*Au
théâtre*). 1895: New York, Durand-Ruel, *Exposition of
Paintings, Pastels, and Etchings by Miss Mary Cassatt*
no. 5 (*Dans la loge*). 1908: Paris, Durand-Ruel,
Tableaux et pastels par Mary Cassatt, no. 8
(*Au Théâtre*).

PARIS, NEW YORK, CHICAGO
CAT. 88

EDGAR DEGAS (FRENCH, 1834–1917).
Mary Cassatt at the Louvre: The Etruscan Gallery,
1879–80. Softground etching, drypoint, aquatint, and
etching, third state of nine; plate: 26.8 × 23.2 cm
(10 9/16 × 9 1/8 in.); sheet: 43.2 × 30.5 cm (17 × 12 in.).
The Metropolitan Museum of Art, New York,
Rogers Fund, 1919, 19.29.2.

NEW YORK
NOT IN CAT.

EDGAR DEGAS (FRENCH, 1834–1917).
The Millinery Shop, 1879/86. Oil on canvas;
100 × 110.7 cm (39 3/8 × 43 5/8 in.). The Art Institute of
Chicago, Mr. and Mrs. Lewis Larned Coburn Memorial
Collection, 1933.428.

PARIS, NEW YORK, CHICAGO
CAT. 105

EDGAR DEGAS (FRENCH, 1834–1917).
Portraits in a Frieze, 1879. Pastel on paper; 50 × 65 cm
(19 11/16 × 25 5/8 in.). Private collection.

Significant early exhibitions: 1879: Paris, 228, avenue
de l'Opéra, *4me exposition de peinture*, Apr. 10–May
11, no. 67 (*3 portraits en frise, essai de decoration*).

NOT IN EXHIBITION
CAT. 126

EVA GONZALÈS (FRENCH, 1849–1883).
The Pink Slippers, 1879/80. Oil on canvas, laid down
on panel; 26 × 35 cm (10 1/4 × 13 3/4 in.).
Private collection, courtesy of Galerie Hopkins, Paris.

PARIS, NEW YORK, CHICAGO
CAT. 113

EVA GONZALÈS (FRENCH, 1849–1883).
The White Slippers, 1879/80. Oil on canvas, laid down
on panel; 23 × 32 cm (9 1/16 × 12 5/8 in.). Vera Wang.

PARIS, NEW YORK, CHICAGO
CAT. 112

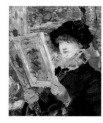

ÉDOUARD MANET (FRENCH, 1832–1883).
Woman Reading (La Lecture de l'illustré), 1879/80.
Oil on canvas; 61.2 × 50.7 cm (24 1/8 × 20 in.).
The Art Institute of Chicago, Mr. and Mrs. Lewis Larned
Coburn Memorial Collection, 1933.435.

Significant early exhibitions: 1880: Paris, La Vie
Moderne, no. 10. 1884: Paris, École Nationale des
Beaux-Arts, *Exposition des oeuvres de Édouard Manet*,
no. 92 (*Tête de femme*).

PARIS, NEW YORK, CHICAGO
CAT. 122

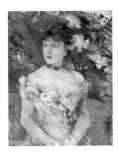

BERTHE MORISOT (FRENCH, 1841–1895).
Young Woman in a Ball Gown, 1879.
Oil on canvas; 71 × 54 cm (28 × 21 ⁵⁄₁₆ in.).
Musée d'Orsay, Paris, RF 843.

Significant early exhibitions: 1880: Paris, 10, rue des Pyramids, *5me exposition de peinture*, Apr. 1–30, no. 120 (*Portrait*). 1887: Paris, Georges Petit, *Exposition Internationale de Peinture et de Sculpture*, sixième année, no. 95 (*Jeune fille au bal*).

PARIS, NEW YORK, CHICAGO
CAT. 86

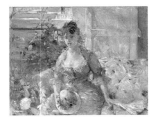

BERTHE MORISOT (FRENCH, 1841–1895).
Young Woman Seated on a Sofa, c. 1879.
Oil on canvas; 80.6 × 99.7 cm (31 ¾ × 39 ¼ in.).
The Metropolitan Museum of Art, New York, partial and promised gift of Mr. and Mrs. Douglas Dillon, 1992, 1992.103.2.

NEW YORK
NOT IN CAT.

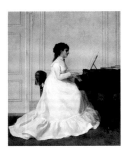

ALFRED STEVENS (BELGIAN, 1823–1906).
Eva Gonzalès at the Piano, 1879. Oil on canvas; 54.9 × 45.4 cm (21 ⁵⁄₈ × 17 ⁷⁄₈ in.). The John and Mable Ringling Museum of Art, the State Art Museum of Florida, Florida State University, Sarasota, Florida, SN 438.

Significant early exhibitions: 1883: Amsterdam, Exposition internationale d'Amsterdam, Aug. (possibly exhibited).

PARIS, NEW YORK, CHICAGO
CAT. 11

Bonnet, 1879/84. American. Straw trimmed with light brown silk tulle and orange silk velvet bows. The Metropolitan Museum of Art, New York, gift of Mrs. Charles D. Dickey, Mrs. Louis Curtis, Jr., and Mr. S. Sloan Colt, 1957, C.I.57.15.12.

NEW YORK
NOT IN CAT.

— 1880 —

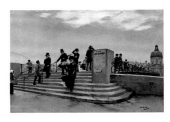

JEAN BÉRAUD (FRENCH, 1849–1935).
A Windy Day on the Pont des Arts, 1880/81.
Oil on canvas; 39.7 × 56.5 cm (15 ⁵⁄₈ × 22 ¼ in.).
The Metropolitan Museum of Art, bequest of Eda K. Loeb, 1951, 52.48.1.

Significant early exhibitions: 1895: New York, Madison Square Garden, Fair in Aid of Educational Alliance and Hebrew Technical Institute, Dec. 1895, no. 39 (*A Windy Day*).

NEW YORK
NOT IN CAT.

GUSTAVE CAILLEBOTTE (FRENCH, 1848–1894).
At the Café, 1880. Oil on canvas; 153 × 114 cm (60 ¼ × 44 ¹⁵⁄₁₆ in.). Musée d'Orsay, Paris, on deposit to Musée des Beaux-Arts, Rouen, RF 1943 70/D.946.1.

Significant early exhibitions: 1880: Paris, 10, rue des Pyramids, *5me exposition de peinture*, Apr. 1–30, no. 6 (*Dans un café*).

PARIS, NEW YORK, CHICAGO
CAT. 74

GUSTAVE CAILLEBOTTE (FRENCH, 1848–1894).
Portrait of a Man, 1880. Oil on canvas; 82 × 65 cm (32 ¼ × 25 ⁹⁄₁₆ in.). The Cleveland Museum of Art, bequest of Muriel Butkin, 2009.157.

PARIS, NEW YORK, CHICAGO
CAT. 72

PIERRE-AUGUSTE RENOIR (FRENCH, 1841–1919).
Young Woman Reading an Illustrated Journal, c. 1880.
Oil on canvas; 46.3 × 55.9 cm (18 ¼ × 22 in.).
Museum of Art, Rhode Island School of Design, Museum Appropriation Fund, 22.125.

Significant early exhibitions: 1886: New York, American Art Association, no. 259 (*Woman Reading*) (possibly this painting).

PARIS, NEW YORK, CHICAGO
CAT. 123

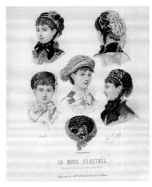

ANAÏS TOUDOUZE (FRENCH, 1822–1899).
"Six Hats," *La Mode Illustrée* 42 (December 19, 1880). Steel engraving with hand coloring; 36 × 25 cm (14 ¼ × 10 in.). Private collection.

CHICAGO
CAT. 108

WORCESTER CORSET COMPANY (AMERICAN, 1861–1950). Corset, c. 1880. Light blue cotton sateen. The Metropolitan Museum of Art, New York, Brooklyn Museum Costume Collection at The Metropolitan Museum of Art, gift of the Brooklyn Museum, 2009; gift of E. A. Meister, 1950, 2009.300.3110a–c.

NEW YORK, CHICAGO
CAT. 60

Corset cover, c. 1880. American. White plain weave cotton. The Metropolitan Museum of Art, New York, gift of Mrs. Stephen Hurlbut, 1979, 1979.331d.

CHICAGO
CAT. 62

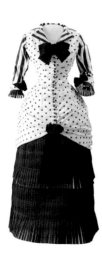

Summer dress worn by Madame Bartholomé in the painting *In the Conservatory*, 1880. French. White cotton printed with purple dots and stripes. Musée d'Orsay, Paris, gift of the gallery Charles and André Bailly, 1991, ODO 1991 1.

PARIS, NEW YORK, CHICAGO
CAT. 29

Hat, c. 1880. American or European. Straw trimmed with dark red silk velvet, ivory cotton organdy, and artificial leaves. The Metropolitan Museum of Art, New York, purchase, Irene Lewisohn Bequest, 1971, 1971.242.8.

NEW YORK, CHICAGO
NOT IN CAT.

"Two Women in Evening Dresses," *Journal des Demoiselles*, 1880. Steel engraving with hand coloring; sheet: 24.8 × 17.8 cm (9 ¾ × 7 in.). The Metropolitan Museum of Art, New York, The Irene Lewisohn Reference Library, Woodman Thompson Collection, FP.41.1880.

NEW YORK, CHICAGO
CAT. 87

— 1881 —

ALBERT BARTHOLOMÉ (FRENCH, 1848–1928). *In the Conservatory*, c. 1881. Oil on canvas; 233 × 142.5 cm (91 ¾ × 56 ⅛ in.). Musée d'Orsay, Paris, gift of the Société des Amis du Musée d'Orsay, 1990, RF 1990 26.

Significant early exhibitions: 1881: Paris, Salon, no. 92 (*Dans la serre*).

PARIS, NEW YORK, CHICAGO
CAT. 28

EDGAR DEGAS (FRENCH, 1834–1917). *At the Milliner's*, 1881. Pastel on five pieces of wove paper, backed with paper, and laid down on canvas; 69.2 × 69.2 cm (27 ¼ × 27 ¼ in.). The Metropolitan Museum of Art, New York, The Walter H. and Leonore Annenberg Collection, gift of Walter H. and Leonore Annenberg, 1997, bequest of Walter H. Annenberg, 2002, 1997.391.1.

Significant early exhibitions: 1905: London, Grafton Galleries, and Paris, Durand-Ruel, *Pictures by Boudin, Cézanne, Degas, Manet . . .* , Jan.–Feb., no. 65 (*At the Milliner's*).

NEW YORK
CAT. 106

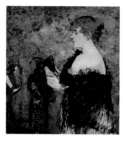

ÉDOUARD MANET (FRENCH, 1832–1883). *At the Milliner's* (*La modiste*), 1881. Oil on canvas; 85.1 × 73.7 cm (33 ⁹⁄₁₆ × 29 ¹⁄₁₆ in.). Fine Arts Museums of San Francisco, Museum purchase, Mildred Anna Williams Collection, 1957.3.

NEW YORK, CHICAGO
CAT. 104

HENRY SOMM (FRENCH, 1844–1907). *Japonisme*, 1881. Drypoint; plate: 24.1 × 31.9 cm (9 ½ × 12 ⁹⁄₁₆ in.); sheet: 27.4 × 36.6 cm (10 ¹³⁄₁₆ × 14 ⁷⁄₁₆ in.). The Metropolitan Museum of Art, New York, purchase, Harry G. Friedman bequest, 1966, 67.539.201.

NEW YORK, CHICAGO
NOT IN CAT.

— 1882 —

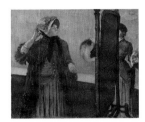

EDGAR DEGAS (FRENCH, 1834–1917).
At the Milliner's, 1882. Pastel on pale gray wove paper (industrial wrapping paper), laid down on silk bolting; 76.2 × 86.4 cm (30 × 34 in.). The Metropolitan Museum of Art, New York, H. O. Havemeyer Collection, bequest of Mrs. H. O. Havemeyer, 1929, 29.100.38.

Significant early exhibitions: 1886: Paris, 1, rue Laffitte, *8me exposition de peinture*, May 15–June 15, no. 14 (*Femme essayant un chapeau chez sa modiste*). 1892: London, Mr. Collie's Rooms, *A Small Collection of Pictures by Degas and Others*, Dec. 18, 1891–Jan. 8, 1892, no. 19 (*Chez la modiste*). 1892: Glasgow, Institute of the Fine Arts, *31st Exhibition of Works of Modern Artists*, Feb. 2–Mar., no. 562 (*Chez la modiste*).

NEW YORK
CAT. 101

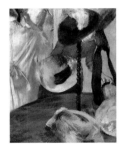

EDGAR DEGAS (FRENCH, 1834–1917).
At the Milliner's, 1882. Pastel on paper; 67 × 52 cm (26 7/16 × 20 1/2 in.). Musée d'Orsay, Paris, RF 52075.

PARIS
CAT. 103

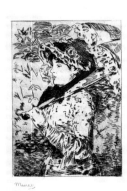

ÉDOUARD MANET (FRENCH, 1832–1883).
Jeanne: Spring (Le Printemps), 1882. Etching on blue laid paper, only state; plate: 15.7 × 11.4 cm (6 3/16 × 4 1/2 in.); sheet: 37 × 24.4 cm (14 9/16 × 9 5/8 in.). The Metropolitan Museum of Art, New York, 21.76.30.

NOT IN EXHIBITION
NOT IN CAT.

CHARLES FREDERICK WORTH (ENGLISH, 1825–1895). Evening dress, c. 1882. Cream silk satin and net embroidered with pink artificial roses and green leaves. The Metropolitan Museum of Art, New York, Brooklyn Museum Costume Collection at The Metropolitan Museum of Art, gift of the Brooklyn Museum, 2009; gift of the Princess Viggo in accordance with the wishes of the Misses Hewitt, 1931, 2009.300.635a, b.

NEW YORK
NOT IN CAT.

Bonnet, 1882. American. Straw trimmed with purple silk satin. The Metropolitan Museum of Art, New York, gift of Mrs. Robert S. Kilborne, 1958, C.I.58.67.29.

NEW YORK, CHICAGO
NOT IN CAT.

— 1883 —

ALBERT BARTHOLOMÉ (FRENCH 1848–1928).
The Artist's Wife Reading, 1883. Pastel and charcoal on wove paper, laid down on blue wove paper, laid down on stretched canvas; 50.5 × 61.3 cm (19 7/8 × 24 1/8 in.). The Metropolitan Museum of Art, New York, Catharine Lorillard Wolfe Collection, Wolfe Fund, 1990, 1990.117.

NEW YORK
NOT IN CAT.

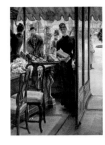

JAMES TISSOT (FRENCH, 1836–1902).
The Shop Girl from the series *Women of Paris*, 1883–85. Oil on canvas; 146.1 × 101.6 cm (57 1/2 × 40 in.). Art Gallery of Ontario, Toronto, gift from Corporations' Subscription Fund, 1968, 67/55.

Significant early exhibitions: 1885: Paris, Galerie Sedelmeyer, *Exposition J.-J. Tissot: Quinze Tableaux sur la Femme à Paris*, Apr. 19–June 15, no. 14 (*La Demoiselle de magasin*). 1886: London, Arthur Tooth and Sons, *Pictures of Parisian Life by J. J. Tissot*, no. 5 (*The "Young Lady" of the Shop*).

PARIS, NEW YORK, CHICAGO
CAT. 75

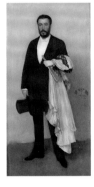

JAMES MCNEILL WHISTLER (AMERICAN, 1834–1903). *Arrangement in Flesh Color and Black: Portrait of Theodore Duret*, 1883. Oil on canvas; 193.4 × 90.8 cm (76 1/8 × 35 3/4 in.). The Metropolitan Museum of Art, New York, Catharine Lorillard Wolfe Collection, Wolfe Fund, 1913, 13.20.

NEW YORK
CAT. 69

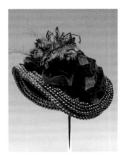

Bonnet, 1883. French. Dark red silk velvet and glass beads trimmed with feathers. The Metropolitan Museum of Art, New York, gift of Mrs. Francis Howard and Mrs. Avery Robinson, 1953, C.I.53.68.4.

NEW YORK, CHICAGO
NOT IN CAT.

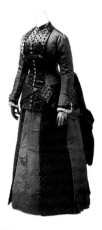

Day dress, 1883/85. American. Blue silk faille and velvet on a voided satin surface. The Metropolitan Museum of Art, New York, gift of Anne L. Maxwell, in memory of her mother, Julia H. Lawrence, 1989, 1989.246.1a, b.

NEW YORK, CHICAGO
CAT. 132

— 1884 —

IMPRIMERIE P. LACOURIÈRE-FALCONER (FRENCH, ACTIVE 19TH CENTURY). "Two Women in Afternoon Dresses," *Journal des Demoiselles et Petit Courrier des Dames Réunis*, 1884. Steel engraving with hand coloring; sheet: 26.5 × 18.2 cm (10 ⅜ × 7 ⅛ in.). The Metropolitan Museum of Art, New York, The Irene Lewisohn Reference Library, Woodman Thompson Collection, FP. 43.1884.

NEW YORK, CHICAGO
CAT. 134

GEORGES SEURAT (FRENCH, 1859–1891).
Study for "A Sunday on La Grande Jatte," 1884.
Oil on canvas; 70.5 × 104.1 cm (27 ¾ × 41 in.).
The Metropolitan Museum of Art, New York, bequest of Sam A. Lewisohn, 1951, 51.112.6.

NEW YORK
CAT. 136

GEORGES SEURAT (FRENCH, 1859–1891).
A Sunday on La Grande Jatte—1884, 1884–86, painted border, 1888/89. Oil on canvas; 207.5 × 308.1 cm (81 ¾ × 121 ¼ in.). The Art Institute of Chicago, Helen Birch Bartlett Memorial Collection, 1926.224.

Significant early exhibitions: 1886: Paris, Maison Dorée, 1, rue Laffitte, *8me Exposition de peinture*, May 15–June 15, no. 175 (*Un Dimanche à la Grande-Jatte (1884)*). 1886: Paris, rue des Tuileries, *IIème Exposition de la Société des Artistes Indépendants*, Aug. 21–Sept. 21, no. 353 (*Un Dimanche à la Grande-Jatte—1884*). 1887: Brussels, Musée de l'Art Modern, *IVe exposition annuelle de XX*, Feb., no. 1 (*Un dimanche à la Grande-Jatte. 1884*). 1892: Paris, *VIIIème Exposition de la Société des Artistes Indépendants* (retrospective exhibition incorporated into larger salon), Pavillon de la Ville de Paris, Mar. 19–Apr. 27, no. 1082 (*Un Dimanche à la Grande-Jatte, 1884, (1886) prêté* [lent by] *Mme Seurat*).

CHICAGO
CAT. 137

GEORGES SEURAT (FRENCH, 1859–1891).
Woman Walking with a Parasol (Study for "A Sunday on La Grande Jatte"), 1884. Conté crayon on cream laid paper; 31.7 × 24.1 cm (12 ½ × 9 ½ in.). The Art Institute of Chicago, bequest of Abby Aldrich Rockefeller, 1999.8.

CHICAGO
NOT IN CAT.

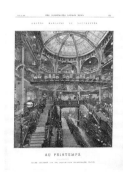

"At Le Printemps," *Illustrated London News*, October 18, 1884. Wood engraving; 40.5 × 29.8 cm (15 ¹⁵⁄₁₆ × 11 ¾ in.). Private collection.

NEW YORK, CHICAGO
CAT. 102

— 1885 —

JOHN LEWIS BROWN (FRENCH, 1829–1892).
Fan: The Races at La Marche, 1885. Lithograph printed in five colors on ivory wove paper, mounted on fan armature; 38 × 75 cm (15 × 29 ⁹⁄₁₆ in.). The Art Institute of Chicago, gift of Douglas Druick, 1994.818.

CHICAGO
NOT IN CAT.

EDGAR DEGAS (FRENCH, 1834–1917).
Mary Cassatt at the Louvre: The Paintings Gallery, 1885. Pastel over etching, aquatint, drypoint, and crayon voltaïque, on tan wove paper; plate: 30.5 × 12.7 cm (12 ¹⁄₁₆ × 5 in.); sheet: 31.3 × 12.7 cm (12 ⅜ × 5 ⅜ in.). The Art Institute of Chicago, bequest of Kate L. Brewster, 1949.515.

Significant early exhibitions: 1905: London, Grafton Gallery, no. 49.

CHICAGO
CAT. 125

HENRY LEROLLE (FRENCH, 1848–1929).
The Rehearsal in the Choir Loft, c. 1885. Oil on canvas; 101.6 × 152.4 cm (40 × 60 in.). Private collection.

Significant early exhibitions: 1885: Paris, Salon, no. 1563 (*A l'Orgue*). 1886: New York, National Academy of Design, *Works in Oil and Pastel by the Impressionists of Paris*, May 25–June 30, no. 29 (*The Organ*). 1886–87: New York, The Metropolitan Museum of Art, *Loan Collection of Paintings and Sculpture*, Nov. 1886–Apr. 1887, no. 137 (*The Organ*).

NEW YORK, CHICAGO
CAT. 133

JAMES TISSOT (FRENCH, 1836–1902).
The Circus Lover from the series *Women of Paris*,
1885. Oil on canvas; 147.3 × 101.6 cm (58 × 40 in.).
Museum of Fine Arts, Boston, Juliana Cheney Edwards
Collection, 58.45.

Significant early exhibitions: 1885: Paris, Galerie
Sedelmeyer, *Quinze Tableaux sur la Femme à Paris*,
Apr. 19–June 15, no. 11 (*Les Femmes de sport*). 1886:
London, Arthur Tooth and Sons, *Pictures of Parisian
Life by J. J. Tissot*, no. 7 (*The Amateur Circus*).

PARIS, NEW YORK, CHICAGO
CAT. 92

Hat, 1885/90. American. Dark brown silk velvet and
brown silk faille trimmed with light brown silk brocade
ribbon. The Metropolitan Museum of Art, New York,
gift of Mrs. Frances Craver Northam, 1946, C.I.46.98.1.

NEW YORK, CHICAGO
CAT. 109

— 1886 —

CLAUDE MONET (FRENCH, 1840–1926).
Study of a Figure Outdoors (Facing Right) (*Essai de
figure en plein-air; Femme à l'ombrelle tournée vers la
droite*), 1886. Oil on canvas; 130.5 × 89.3 cm
(51 ⅜ × 35 ⅛ in.). Musée d'Orsay, Paris, gift of
Michel Monet, son of the artist, 1927, RF 2620.

Significant early exhibitions: 1891: Paris, Durand-Ruel,
Exposition Claude Monet, May, no. 21 or 22 (*Essai de
figure en plein air*).

PARIS, NEW YORK, CHICAGO
CAT. 135

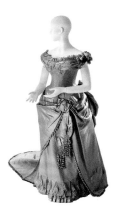

**CHARLES FREDERICK WORTH (ENGLISH,
1825–1895).** Ball gown, c. 1886. Ice blue satin, ice
blue uncut ribbed velvet, cream lace, ice blue chiffon,
ice blue ball fringe, ice blue beads, artificial flowers,
ice blue silk plush. Museum of the City of New York,
32.12.a, b.

CHICAGO
CAT. 89

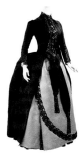

**CHARLES FREDERICK WORTH (ENGLISH,
1825–1895).** Day dress, c. 1886. Dress: dark brown
silk damask in a starburst pattern; skirt: light brown silk
satin embroidered with dark brown silk and gold
metallic passementerie. The Metropolitan Museum of
Art, New York, Brooklyn Museum Costume Collection
at The Metropolitan Museum of Art, gift of the
Brooklyn Museum, 2009; gift of Mrs. William E. S.
Griswold, 1941, 2009.300.664a, b.

NEW YORK, CHICAGO
CAT. 131

— 1887 —

JACQUES-EMILE BLANCHE (FRENCH, 1861–1942).
Portrait of a Woman, also called *Portrait of Madame
Henri Wallet*, 1887. Pastel on canvas; 129 × 64 cm
(50 ¾ × 25 ¼ in.). Musée d'Orsay, Paris, RF 43327.

NEW YORK, CHICAGO
CAT. 128

**E. GAILLARD (FRENCH, ACTIVE 19TH CENTURY),
ABEL GOUBAUD (FRENCH, ACTIVE 19TH
CENTURY), JULES DAVID (FRENCH, 1808–1892),
AND IMPRIMERIE HONORÉ LEFÈVRE (FRENCH,
ACTIVE 19TH CENTURY).** "The Latest Fashions,
Expressly Designed and Prepared for *Le Moniteur de la
Mode*," *Le Moniteur de la Mode*, March 1, 1887.
Lithograph with hand coloring; sheet: 39.5 × 26.6 cm
(15 ⁹⁄₁₆ × 10 ½ in.). The Metropolitan Museum of Art,
New York, The Elisha Whittelsey Collection, The Elisha
Whittelsey Fund, 1953, 53.664.22.

NEW YORK, CHICAGO
CAT. 129

GEORGES SEURAT (FRENCH, 1859–1891).
Still Life with Hat, Umbrella, and Clothes on a Chair,
1887. Conté crayon and white gouache on paper;
31 × 23.8 cm (12 ³⁄₁₆ × 9 ⅜ in.). The Metropolitan
Museum of Art, New York, bequest of Walter C. Baker,
1971, 1972.118.235.

NEW YORK
NOT IN CAT.

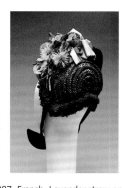

Bonnet, 1887. French. Lavender straw and silk ribbon
trimmed with purple silk velvet and artificial thistles.
The Metropolitan Museum of Art, New York,
gift of Mrs. James G. Flockhart, 1968, C.I.68.53.17.

NEW YORK, CHICAGO
CAT. 110

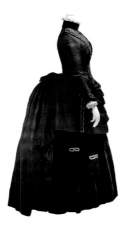

Dress, 1887. American. Red silk ottoman and silk velvet embroidered with gold and jet beaded passementerie in a chain pattern. The Metropolitan Museum of Art, New York, gift of Mrs. James G. Flockhart, 1968, C.I.68.53.6a, b.

CHICAGO
CAT. 130

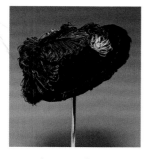

Hat, 1887. French. Brown silk velvet trimmed with ostrich feathers and gold metallic thread. The Metropolitan Museum of Art, New York, gift of Mrs. James G. Flockhart, 1968, C.I.68.53.18.

NEW YORK, CHICAGO
CAT. 111

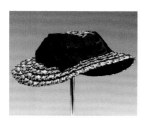

Hat, c. 1887. American or European. Light and dark brown straw and purple silk faille trimmed with purple silk ribbon. The Metropolitan Museum of Art, New York, gift of Mrs. Charles D. Dickey, Mrs. Louis Curtis, Jr., and Mr. S. Sloan Colt, 1957, C.I.57.15.8.

NEW YORK
NOT IN CAT.

— 1888 —

HENRI CHARLES GUÉRARD (FRENCH, 1846–1897). *The Assault of the Shoe*, 1888. Etching, with open bite, in light red and black on cream laid paper; image/plate: 16.8 × 25.2 cm (6 ⅝ × 9 ¹⁵⁄₁₆ in.); sheet: 25 × 36 cm (9 ⅞ × 14 ³⁄₁₆ in.). The Art Institute of Chicago, restricted gift of Anne Searle Bent, 2009.660.

NEW YORK, CHICAGO
NOT IN CAT.

HENRI CHARLES GUÉRARD (FRENCH, 1846–1897). *The Assault of the Shoe*, 1888. Etching, with open bite, in light red on cream wove paper; image: 11 × 21 cm (4 ⁵⁄₁₆ × 8 ¼ in.); plate: 16.6 × 25.2 cm (6 ⁹⁄₁₆ × 9 ¹⁵⁄₁₆ in.); sheet: 34.4 × 49.2 cm (13 ⁹⁄₁₆ × 19 ⅜ in.). The Art Institute of Chicago, restricted gift of Anne Searle Bent, 2009.661.

CHICAGO
NOT IN CAT.

HENRI CHARLES GUÉRARD (FRENCH, 1846–1897). *The Assault of the Shoe*, 1888. Etching, with open bite, in black on cream wove paper; image: 16.7 × 25.4 cm (6 ⁹⁄₁₆ × 10 in.); sheet: 35.5 × 49 cm (14 × 19 ⁵⁄₁₆ in.). The Art Institute of Chicago, restricted gift of Anne Searle Bent, 2009.662.

CHICAGO
CAT. 115

HENRI-CHARLES GUÉRARD (FRENCH, 1846–1897). *The Assault of the Shoe*, 1888. Etching, with open bite, in light red and black on cream laid paper; image/plate: 16.7 × 25.2 cm (6 ⁹⁄₁₆ × 9 ¹⁵⁄₁₆ in.); sheet: 19.9 × 28.1 cm (7 ¹³⁄₁₆ × 11 ¹⁄₁₆ in.). The Art Institute of Chicago, restricted gift of Anne Searle Bent, 2009.663.

NEW YORK, CHICAGO
CAT. 114

— 1890 —

Drawers, c. 1890. French. White plain weave cotton and lace. The Metropolitan Museum of Art, New York, gift of Mrs. Jan Juta, 1950, C.I.50.23.3.

CHICAGO
CAT. 63

— 1894 —

FÉLIX VALLOTTON (SWISS, 1865–1925). *The Milliner*, 1894. Woodcut in black on ivory wove paper; image: 18 × 22.6 cm (7 ⅛ × 8 ¹⁵⁄₁₆ in.); sheet: 25.1 × 32.8 cm (9 ⅞ × 12 ¹⁵⁄₁₆ in.). The Art Institute of Chicago, Joseph Brooks Fair Memorial Collection, 1947.460.

NOT IN EXHIBITION
NOT IN CAT.

— 1912 —

JEAN-EUGÈNE-AUGUSTE ATGET (FRENCH, 1857–1927). *Boulevard de Strasbourg (Corsets)*, 1912. Gelatin silver printing-out paper print; 22.9 × 18 cm (9 × 7 ⅛ in.). The Art Institute of Chicago, Julien Levy Collection, gift of Jean and Julien Levy, 1975.1130.

CHICAGO
NOT IN CAT.

Fashion Plates

This is a representative selection of fashion plates from the collection of The Metropolitan Museum of Art, New York. Although fashion plates first circulated at the end of the eighteenth century in England and France, they were most popular from c. 1850 to 1900, when fashion photography replaced them. Usually set into fashion magazines, they provided consumers throughout Europe access to the latest (usually French) styles in clothing, accessories, and hair. Artists also referred to them for trends in fabrics and silhouettes. Characteristically, fashion plates showed vignettes of the bourgeoisie engaged in various activities, clad in appropriate clothing. Many fashion plates carried captions describing the fashions depicted, along with the names and addresses of the dressmakers, boutiques, or department stores where they could be obtained.

1. MONNIN (FRENCH, ACTIVE 19TH CENTURY), IMPRIMERIE MOINE (FRENCH, ACTIVE 19TH CENTURY), AND AN UNKNOWN ARTIST (FRENCH, ACTIVE 19TH CENTURY). "Two Women Wearing Coats," 1863–64. Steel engraving with hand coloring; sheet: 34.8 × 25.6 cm (13 11/16 × 10 1/16 in.). The Metropolitan Museum of Art, New York, gift of Mrs. H. J. Bernheim, 1958, 58.646.20.

2. ILLMAN BROTHERS ENGR. (AMERICAN, ACTIVE 19TH CENTURY). "Five Women in Day and Evening Dresses around a Piano, from 'The New Song,' Les Modes Parisiennes," Peterson's Magazine, September 1876. Steel engraving with hand coloring; sheet: 22 × 28.8 cm (8 5/8 × 11 3/8 in.). The Metropolitan Museum of Art, New York, The Irene Lewisohn Reference Library, Woodman Thompson Collection, FP.33.1876.

3. UNKNOWN ARTIST (FRENCH, ACTIVE 19TH CENTURY). "Two Women in Day Dresses with a Young Girl," Modes de Paris: Journal des Demoiselles et Petit Courrier des Dames Réunis, 1873. Steel engraving with hand coloring; sheet: 22.5 × 17.8 cm (8 7/8 × 7 in.). The Metropolitan Museum of Art, New York, The Irene Lewisohn Reference Library, Woodman Thompson Collection, FP.32.1873.

4. ÉMILE PRÉVAL (FRENCH, ACTIVE 19TH CENTURY). "Woman Looking through a Telescope, with a Man and a Dog," Les Modes Parisiennes, 1863. Steel engraving with hand coloring; sheet: 27 × 20 cm (10 1/2 × 7 3/4 in.). The Metropolitan Museum of Art, New York, The Irene Lewisohn Reference Library, Woodman Thompson Collection, FP.1.1863.

5. ILLMAN BROTHERS ENGR. (AMERICAN, ACTIVE 19TH CENTURY). "Six Women at the Beach from Les Modes Parisiennes," Peterson's Magazine, August 1870. Steel engraving with hand coloring; sheet: 19 × 26.5 cm (7 3/8 × 10 1/2 in.). The Metropolitan Museum of Art, New York, The Irene Lewisohn Reference Library, Woodman Thompson Collection, FP.25.1870.

6. GILQUIN ET DUPAIN IMPRIMERIE (FRENCH, ACTIVE 19TH CENTURY). "Seven Men and a Woman in Day Dress and Outerwear," Modes Européennes, Organe de l'Académie Universelle des Tailleurs, September 1861. Steel engraving with hand coloring; sheet: 37.7 × 53 cm (14 7/8 × 21 in.). The Metropolitan Museum of Art, New York, The Irene Lewisohn Reference Library, Woodman Thompson Collection, FP.51.1861.

7. UNKNOWN ARTIST (FRENCH, ACTIVE 19TH CENTURY). "Two Women in a Garden," La Mode Illustrée, 1865. Steel engraving with hand coloring; sheet: 30.4 × 22.8 cm (12 × 9 in.). The Metropolitan Museum of Art, New York, The Irene Lewisohn Reference Library, Woodman Thompson Collection, FP 15.1865.

8. ANAÏS TOUDOUZE (FRENCH, 1822–1899). "Two Women in Evening Dresses," La Mode Illustrée, 1877. Steel engraving with hand coloring; sheet: 26.8 × 19.2 cm (10 1/2 × 7 5/8 in.). The Metropolitan Museum of Art, New York, The Irene Lewisohn Reference Library, Woodman Thompson Collection, FP.35.1877.

9. ALBERT ÉDITEUR, IMPRIMERIE LEROY, AND LAURE NOËL (FRENCH, 1827–1878). "Le Coquet" Journal des Modes Spécial pour Couturières, July 1, 1869. Steel engraving with hand coloring; sheet: 28.1 × 39.6 cm (11 1/16 × 15 9/16 in.). The Metropolitan Museum of Art, New York, gift of Mrs. H. J. Bernheim, 1958, 58.646.18.

1

2

3

LES MODES PARISIENNES

LES MODES PARISIENNES PETERSON'S MAGAZINE

Modes Européennes

LA MODE ILLUSTRÉE

LE COQUET

Cartes de Visite

This is a representative selection of cartes de visite, or visiting cards, by the Parisian photographer André–Adolphe–Eugène Disdéri (French, 1819–1889). All (with the exception of the one to the immediate right) are in the collection of The Metropolitan Museum of Art, New York. In 1854, Disdéri patented this type of small photograph, along with a method for making eight separate negatives on a single plate, which greatly reduced production costs. Usually an albumen print measuring a little more than two by three inches, individual "cartes" were mounted on thick card stock so that they could be traded with friends and visitors. "Cartomania" was so intense that it led to the publication and eager collection of cartes of prominent people (especially actresses), which in turn gave consumers information on contemporary fashion and how to wear it.

All cartes de visite are albumen silver prints from glass negatives.

1. Untitled carte de visite, 1859. 19.9 × 23.2 cm (7 ⅞ × 9 ⅛ in.). The Art Institute of Chicago, restricted gift of Helen Harvey Mills in honor of Katherine Bussard, 2006.314.

2. *Monsieur and Madame Musard from Demi-Monde II 57*, 1860. The Metropolitan Museum of Art, New York, Gilman Collection, gift of The Howard Gilman Foundation, 2005, 2005.100.588.3, p. 91.

3. *Héloise from Demi-Monde II 57*, 1863. The Metropolitan Museum of Art, New York, Gilman Collection, gift of The Howard Gilman Foundation, 2005, 2005.100.588.3, p. 22.

4. *Gabrielle; Gutierrez de Estrada from Demi-Monde II 57*, 1867. The Metropolitan Museum of Art, New York, Gilman Collection, gift of The Howard Gilman Foundation, 2005, 2005.100.588.3, p. 10.

5. *Berthe from Demi-Monde I 56*, 1862. The Metropolitan Museum of Art, New York, Gilman Collection, gift of The Howard Gilman Foundation, 2005, 2005.100.588.2, p. 78.

6. *Cora Pearl from Demi-Monde I 56*, 1862. The Metropolitan Museum of Art, New York, Gilman Collection, gift of The Howard Gilman Foundation, 2005, 2005.100.588.2, p. 26.

7. *Madame Surrivan from Demi-Monde II 57*, 1866. The Metropolitan Museum of Art, New York, Gilman Collection, gift of The Howard Gilman Foundation, 2005, 2005.100.588.3, p. 139.

8. *Beresford from Demi-Monde I 56*, 1867. The Metropolitan Museum of Art, New York, Gilman Collection, gift of The Howard Gilman Foundation, 2005, 2005.100.588.2, p. 53.

9. *Gabrielle from Demi-Monde II 57*, 1867. The Metropolitan Museum of Art, New York, Gilman Collection, gift of The Howard Gilman Foundation, 2005, 2005.100.588.3, p. 11.

1

2

3

4

5

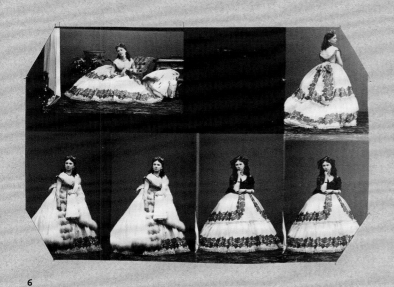

6

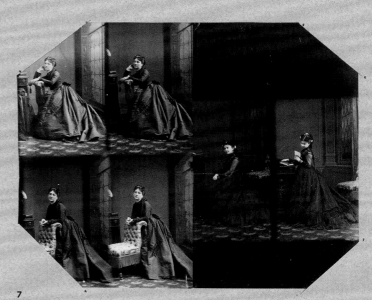

7

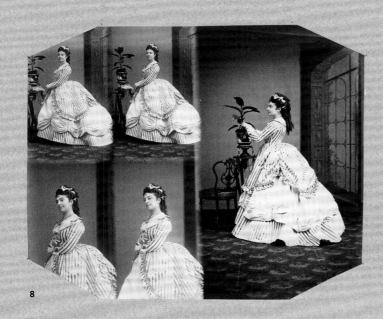

8

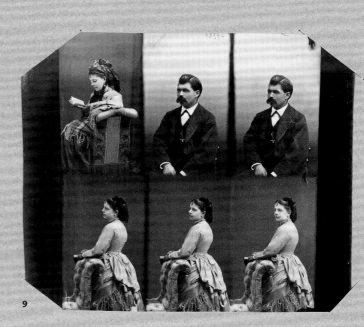

9

Notes

Frequently cited works are listed in short form; for full citations, consult the Selected Bibliography.

CHAPTER 1

Tinterow, "The Rise and Role of Fashion in French Nineteenth–Century Painting"

The author thanks Laura Corey and Susan Stein for their invaluable assistance.

1 "Ce qu'il nous faut, c'est la note spéciale de l'individu moderne, dans son vêtement, au milieu de ses habitudes sociales, chez lui ou dans la rue." Duranty 1876, p. 24, quoted in Moffett 1986, pp. 43–44.

2 "La réalité de l'homme et de l'habit trans-figurée par la magie des ombres et des lumières, par ce soleil, poésie des couleurs qui tombe de la main du peintre?" Edmond and Jules de Goncourt, entry for Nov. 12, 1861, in Goncourt and Goncourt 1956, p. 985, quoted in Tinterow and Loyrette 1994, p. 132.

3 "Les peintres qui aiment leur temps du fond de leur esprit et de leur coeur d'artistes." Zola 1959, p. 130.

4 "Nous nous trouvons en face de la seule réalité, nous encourageons malgré nous nos peintres à nous reproduire sur les toiles, tels que nous sommes avec nos costumes et nos moeurs." Ibid., p. 129.

5 "Gravures de mode banales et inintelligentes." Ibid., p. 130.

6 "Une des conséquences les plus saillantes du mécénat bourgeois." Léon Rosenthal, *Du romantisme au réalisme; essai sur l'evolution de la peinture en France de 1830 à 1848* (H. Laurens, 1914), p. 23, quoted in Tinterow and Loyrette 1994, p. 183.

7 "La toilette est l'expression de la société. . . . La toilette est, tout à la fois, une science, un art, une habitude, un sentiment." Balzac 2000, pp. 147–53.

8 "Presque tous les portraits sont des chefs d'oeuvre, mais ses tableaux sont bien ennuyeux." Frédéric Bazille to his parents, May 1867, in Bazille 1992, p. 140 (letter 93), quoted in Tinterow and Loyrette 1994, p. 186.

9 "M. Ingres est encore seul de son école. Sa méthode est le résultat de sa nature, et, quelque bizarre et obstinée qu'elle soit, elle est franche, et pour ainsi dire involontaire. Amoureux passionné de l'antique et de son modèle, respectueux serviteur de la nature, il fait des portraits qui rivalisent avec les meilleures sculptures romaines." Charles Baudelaire, "Salon de 1846," in Baudelaire 1975, vol. 2, p. 460.

10 Ribiero 1999, p. 13.

11 "Oui, dit Manet, la femme de Second Empire, cela n'a pas été fait et cependant elle a été le type d'une épôque." Antonin Proust, "Édouard Manet: Souvenirs," *La Revue Blanche* 8, 90 (Mar. 1, 1897), p. 206.

12 "Le type de la bourgeoisie de 1825 à 1850." Ibid., quoted in Tinterow 1994, p. 207.

13 Iskin 2007, p. 198.

14 Ibid., p. 223.

15 "Une vraie toilette vaut un poème. Il y a un goût, un choix dans la pose et le reflet de chaque ruban satiné, dans les soies roses, dans le doux satin argenté, dans la mauve pâle, dans la douceur des couleurs tendres, attendries encore par des enveloppes de guipure, par des bouillons de tulle, par des ruches qui frissonnent; les épaules, les joues ont une teinte charmante dans ce nid moelleux de blondes et de dentelles. C'est toute la poésie qui nous reste, et comme elles l'entendent!" Taine 1867b, p. 27. The translation is from Taine 1888, pp. 24–25.

16 "Les revues illustrées en sont pleines; ce sont presque des gravures de mode; le costume s'y étale dans toutes ses exagérations. . . . l'artiste ne tient pas compte de la déformation du corps humain; ce qui lui plaît, c'est l'élégance du moment, le luisant des étoffes, la correction des gants, la perfection du chignon. . . . Nombre de portraits, dans nos expositions annuelles, ne sont que le portrait d'une robe." Taine 1867a, pp. 71–72. The translation is from Taine 1974, p. 80.

17 ". . . en marchant derrière Fortuny, tout un virtuosisme d'arpèges, de trilles, de chiffons, de crêpons, qui ne procèdent d'aucune loi d'observation, d'aucune pensée, d'aucun vouloir d'examen. Ils ont chiffonné, maquillé, troussé la nature, l'ont couverte de papillotes. Ils la traitent en coiffeurs, et la préparent pour une opérette. L'industrie, le commerce tiennent une part trop considérable dans leur affaire." Duranty 1876, p. 13, quoted in Moffett 1986, p. 41.

18 "On ne me persuadera jamais qu'une femme qui lit une lettre dans une robe bleue, qu'une dame qui regarde un éventail dans une robe rose, qu'une fille qui lève les yeux au ciel pour voir s'il pleut, dans une robe blanche, constituent des côtés bien intéressants de la vie moderne. . . . Dix photographies d'album me donneront la dose de modernité incluse là dedans, d'autant que la dame, la demoiselle et la fille *ne sont pas prises sur le fait*, mais sont amenées à cent sous la séance, dans l'atelier, pour revêtir les sousdites robes et représenter la vie moderne." Joris-Karl Huysmans, "Le Salon de 1879," in Huysmans 1883, pp. 31–32.

19 The quote reads, in full: "What I'm most passionate about, much much more than all the rest in my profession—is the portrait, the modern portrait. I seek it by way of colour, and am certainly not alone in seeking it in this way. I WOULD LIKE, you see I'm far from saying that I can do all this, but anyway I'm aiming at it, I *would like* to do portraits which would look like apparitions to people a century later. So I don't try to do us by photographic resemblance but by our passionate expressions, using as a means of expression and intensification of the character our science and modern taste for colour." (Ce qui me passionne le plus, beaucoup beaucoup davantage que tout le reste dans mon métier—c'est le portrait, le portrait moderne. Je le cherche par la couleur et ne suis certes pas seul à le chercher dans cette voie. Je VOUDRAIS, tu vois je suis loin de dire que je puisse faire tout cela mais enfin j'y tends, je *voudrais* faire des portraits qui un siècle plus tard aux gens d'alors aparussent comme des apparitions. Donc je ne nous cherche pas à faire par la ressemblance photographique mais par nos expressions passionnées, employant comme moyen d'expression et d'exaltation du caractère notre science et goût moderne de la couleur.) Vincent van Gogh to his sister Willemien van Gogh, June 5, 1890, *Vincent van Gogh: The Letters*, accessed June 19, 2012, http://vangoghletters.org/vg/letters/let879/letter.html.

20 "The women here with their elegant head-dresses, their Grecian beauty, and their shawls with pleats like you see in the early masters, remind one of the processions on Greek urns. . . . At any rate, here is one source for a beautiful modern style." (Les femmes sont ici avec leur coiffure élégante, leur beauté grecque, leurs châles formant plus comme les primitifs, sont, dis-je, des défilés grecs. . . . En tout cas il y a ici une source de beau style modern.) Paul Gauguin to Émile Bernard, late Oct. or early Nov. 1888, Arles, in *Correspondance de Paul Gauguin: Documents, Témoignages*, ed. Victor Merlhès (Fondation Singer-Polignac, 1984), p. 270, quoted in Ives and Stein 2002, p. 63.

Tinterow, "Édouard Manet: *Young Lady in 1866*"

1 Tinterow 2003, p. 971. The theory of the five senses was first posited in Connolly 1973, pp. 25–27: "Indeed, one of the few parrots to appear as the sense of hearing is that in Manet's *Woman with a Parrot* [*Young Lady in 1866*; cat. 9], where it is joined by the invitingly peeled orange, the fragrant violets, the fingered ribbon and a monocle, to constitute an essay on the five senses."

2 See Hansen 2005, pp. 37–38.

3 "D'un rose faux et louche, la robe ne laisse pas deviner le corps qu'elle recouvre." Théophile Gautier, "Salon de 1868." *Le Moniteur Universel*, May 11, 1868; reprinted in Tabarant 1931, p. 150. Unless otherwise noted, all translations are by Marie-Caroline Dihu.

4 "L'intention de M. Manet était, on doit le supposer, d'engager un dialogue symphonique, une sorte de duo, entre la robe rose de la jeune femme et les teintes rosées de son visage. Il n'y est nullement parvenu, car il ne sait pas peindre la chair; la nature l'intéresse peu; les spectacles de la vie ne l'émeuvent pas." Paul Mantz, "Salon de 1868, II," *L'Illustration*, June 6, 1868, p. 362; reprinted in Tabarant 1931, p. 150.

5 "La robe rose tendre s'harmonise délicieusement avec un fond couleur de perle fine. . . . La tête, bien qu'elle soit de face et dans la même lumière que l'étoffe rose, on n'y fait guère attention: elle se perd dans la modulation du coloris." Bürger 1870, pp. 532–33.

6 "Je ne parlerai pas du tableau intitulé:

Une jeune dame. On le connaît, on l'a vu à l'Exposition particulière du peintre. Je conseille seulement aux messieurs habiles qui habillent leurs poupées de robes copiées dans des gravures de mode, d'aller voir la robe rose que porte cette jeune dame; on n'y distingue pas, il est vrai, le grain de l'étoffe, on ne saurait y compter les trous de l'aiguille; mais elle se drape admirablement sur un corps vivant; elle est de la famille de ces linges souples et grassement peints que les maîtres ont jetés sur les épaules de leurs personnages. Aujourd'hui, les peintres se fournissent chez la bonne faiseuse, comme les petites dames." Émile Zola, "Mon salon," *L'Événement Illustré,* May 10, 1868; reprinted in Zola 1959, p. 124.

7 An X-radiograph of *Young Lady in 1866* shows that the dress was initially about two inches wider on each side and longer along the bottom, indicating Manet's concern over silhouette. Thanks to Charlotte Hale for bringing this to my attention.

8 Juliet Wilson-Bareau, correspondence with the author, Oct. 26, 2011.

9 "La comtesse n'avait pas fait attention à l'entrée du tilbury. Rastignac se retourna brusquement et vit la comtesse coquettement vêtue d'un peignoir en cachemire blanc, à nœuds roses, coiffée négligemment, comme le sont les femmes de Paris au matin. Elle embaumait. Elle avait sans doute pris un bain, et sa beauté, pour ainsi dire, assouplie, en semblait plus voluptueuse. Ses yeux étaient humides. L'œil des jeunes gens sait tout voir; leurs esprits s'unissent aux rayonnements de la femme comme une plante aspire dans l'air les substances qui lui sont propres. Eugène senti donc la fraîcheur épanouie des mains de cette femme sans avoir besoin d'y toucher. Il voyait, à travers le cachemire, les teintes rosées du corsage que le peignoir, légèrement entr'ouvert, laissait parfois à nu, et sur lequel son regard s'étalait par les flexuosités. Les ressources du busc étaient inutiles à la comtesse; la ceinture marquait seule sa taille flexible; son col invitait à l'amour; ses pieds étaient jolis dans ses pantoufles. Quand Maxime prit cette main pour la baiser, alors Eugène aperçut Maxime, et la comtesse aperçut Eugène." Balzac 1869, pp. 48–49.

CHAPTER 2
Groom, "The Social Network of Fashion"

1 De Amicis 1879, pp. 5–6.

2 Ibid., p. 9.

3 Zola 1998b, pp. 297–98.

4 Arsène Houssaye, "Quelques opinions avancées sur la Parisienne," *L'Artiste,* Aug. 1, 1869, p. 147; reprinted in Houssaye 1869, p. 273.

5 Bodt et al. 2009, p. 26, n. 56. See also a review of the Stevens exhibition held at the Royal Museums of Fine Arts of Belgium and the Van Gogh Museum in Sterckx 2010.

6 Théophile Gautier, for example, admired Stevens's painted fictions, which he labeled "Le poème de la femme du monde" (The poem of the society woman). Gautier,

"Autour de l'exposition (8e article), exposition belge," *Le Moniteur Universel,* Sept. 22, 1867, p. 1251; quoted in Simon 1995a, p. 187.

7 Bodt et al. 2009, pp. 20, 22.

8 Higonnet 1990, pp. 22–23. In 1868, around the time of Morisot's introduction to Manet, Stevens painted *The Young Woman* (National Gallery of Ireland), a small portrait of a woman who is thought to be Morisot, which he dedicated to Manet; Lefebvre 2006, p. 35. For Gonzalès, see Grant 1994, p. 180.

9 Bodt et al. 2009, p. 163. Painter and Morisot scholar Bill Scott has been an enormous source of information for me. But both he and Anne Higonnet believe that it may be impossible to identify Morisot's dressmakers. Higonnet, e-mail correspondence with the author, Nov. 1, 2011.

10 "Si vous le permettez, j'enverrai chercher dimanche matin la toilette de Mademoiselle Gonzalès." Sainsaulieu and Mons 1990, p. 12. This implies that it was a special dress for the occasion rather than the visiting dress she would otherwise have been wearing to come to his studio. Unless otherwise noted, all translations are by Marie-Caroline Dihu.

11 Renoir's father and brother, Léonard-Victor, were both tailors; his mother was a seamstress; and his brother-in-law, Charles Letay, was a fashion illustrator. White 1984, p. 30.

12 "Le grand homme de la famille." Lecadre 1995.

13 Of course, both Morisot and Gonzalès would have been excluded from café society.

14 Carolus-Duran (who painted Monet's portrait in 1867 [Musée Marmottan Monet, Paris]) and the painter of the infamous *Rolla* (cat. 64), Henri Gervex, also felt at home in these circles. The latter, a friend of Renoir, was sufficiently engaged with the future Impressionists to have facilitated the acceptance of Monet's *Camille* to the Salon of 1866.

15 Translated in Moffett 1986, p. 42. Carolus-Duran's break with Monet's circle and adoption by haute-bourgeois society is borne out in Arsène Houssaye's weekly articles in the *New York Tribune,* for which he was a foreign society correspondent. A collection of these from Dec. 1874 to May 1875 was published as *Life in Paris* in 1875, and reprinted in 1879 and 1881. A keen observer of this interregnum era, the writer described the forced gaiety between governments and cited the salon of "Citizen Rattazzi, now the loveliest widow of the two worlds dazzling with diamonds" attended by Carolus-Duran and the aristocracy. Houssaye 1881, Dec. 8, 1874, pp. 13–15.

16 See Waller 2006, pp. 124–25. Waller called Duranty's essay one of the first and most important attempts to provide a theoretical explication of the Impressionist project.

17 Ibid., p. 125.

18 Compare, for example, Paul Cézanne's experiments in fashion painting based on

plates from *La Mode Illustrée* (cats. 25–27; fig. 5, p. 71) to his many portraits of his model and future wife, Hortense, whom he met while she was working as an artist's model in Paris in Apr. 1869 and whose love of fashion was thought to be extreme— to the degree that it is said she stopped at her dressmaker when she traveled from Paris to Aix-en-Provence upon learning of her husband's final illness. By the time she arrived, Cézanne was already dead. Cachin 1996, p. 346.

19 "Mon Salon, IV: Les Actualistes," *L'Événement Illustrée,* May 24, 1868; translated in Distel 2010, p. 385, n. 5.

20 Butler 2008, p. 108.

21 Lise's father was county postmaster and then a tobacconist/lemonade seller in Paris. For Lise as a seamstress, see Distel 2010, p. 71. Collins 2001, p. 526, makes no mention of Lise as a seamstress, but she is depicted sewing in *Lise Bending* (1866; Dallas Museum of Art). The white dress Lise wears in the painting submitted to the Salon of 1868 appears in *Portrait of Lise,* or *Lise Holding a Bouquet of Wildflowers* (1867), which was sold at Christie's on June 24, 2008; Daulte 1971, no. 32.

22 Iskin 2007.

23 See ibid., pp. 87–88, 240, n. 96, for Mary Cassatt's role in Degas's works on the millinery shop and Paul Gauguin's remembrances of Degas's love of going to the rue de la Paix, where many millinery shops and other boutique designer stores were located. For information on dress patterns, see Tiersten 2001, pp. 201–02. See also De Young 2009, pp. 76, 82–83. De Young suggested that fashion patterns appeared as early as the 1860s.

24 Corot's *Lady in Blue* (cat. 6) was not seen by anyone but a handful of his intimates and was not exhibited publicly until the Exposition Universelle of 1900; thus, we cannot know how it would have fared among contemporary critics. It depicts an unusual fashion, even for a transitional garment; even stranger is the fact that in the original conception (seen in X-radiography) the model wore dark lace gloves, which the artist later painted out. Hansen 2005, pp. 64–65.

25 "La modernité, mon jeune ami, la modernité!! – Il fallait aller chez une vraie dame, si l'on voulait peindre une dame! . . . Non, le peintre moderne n'est pas seulement un excellent 'couturier,' comme le sont malheuresement la plupart de ceux qui, sous prétexte de modernité, enveloppent un mannequin de soies variées; non, l'on ne fait pas du contemporain en louant un modèle qui sert indifféremment à personnifier les hautes dames et les basses filles, et c'est à ce point de vue surtout que les impressionnistes de talent sont, selon moi, très supérieurs aux peintres qui exposent aux expositions officielles." Huysmans 1923, pp. 42–43.

26 This is true despite the titles of the paintings (which use the sitters' first names), which undermined the respectability that the scale of the works suggested.

27 See Sotheby's, New York, *Impressionist and Modern Art*, sale cat. (Sotheby's, Nov. 3, 2008), lot 55.

28 Nini would disappoint her mother by marrying a minor actor; see Claerbergen and Wright 2008, pp. 32–33; Collins 2001, p. 329. Only the very wealthy had clothes designed by couturiers, and only the very poor made their own clothes. Bourgeois women designed their outfits from head to toe, going from specialized boutiques to their dressmakers for multiple fittings. Higonnet 1990, p. 16.

29 For Marguerite Charpentier, see "Fashion and the Press," pp. 239–40 in this volume; "Pierre-Auguste Renoir: *Madame Georges Charpentier and Her Children*," pp. 244–51 in this volume; and De Young 2009, p. 91.

30 Fashion historian Aileen Ribeiro believes the dress in *The Loge* must have existed. It has been compared to Worth fashions, yet the actual dress has not been identified in fashion plates or advertisements. Ribeiro, e-mail correspondence with the author, June 24, 2008.

31 Claerbergen and Wright 2008, pp. 28–34.

32 Andrée modeled for Degas in *Absinthe Drinkers* (1876; Musée d'Orsay, Paris), wearing an outfit Degas invented, according to Druick et al. 1988, p. 396. She may also appear in Degas's *Women in Street Clothes* and as the model for the right-hand figure in *Portraits in a Frieze* (cat. 126). She was the model for Manet's *The Plum* (1878; National Gallery of Art, Washington, D.C.), Henri Gervex's *Rolla* (cat. 64), and at least three paintings by Renoir (*At the Café* [1878; private collection], *After the Luncheon* [1879; Städel-Museum, Frankfurt], and *Luncheon of the Boating Party* [1880; Phillips Collection, Washington, D.C.]). See Collins 2001, p. 44.

33 According to Nancy Mowll Mathews, Cassatt tried to get her American friends to branch out from the usual Worth and Doucet venues to the smaller (female) dressmakers. I am grateful to Mathews for her insights on Cassatt's relationship to fashion. Mathews, e-mail correspondence with the author, Feb. 18, 2012.

34 This recollection of Degas's passion for fashion comes from Antonin Proust: "He spent a whole day in rapture before the materials unrolled by Madame Derot. The next day it was the hats of a famous *modiste*, Madame Virot, that fired his enthusiasm. He wanted to compose a *toilette* for Jeanne [Mlle Demarsy]." (Il passa une journée en extase devant des étoffes que déroulait Mme Derot. Le lendemain, c'étaient les chapeaux d'une modiste célèbre, Mme Virot, qui l'enthousiasmaient. Il voulait composer une toilette pour Jeanne.) Quoted in Moreau-Vauthier 1903; translated in Simon 1995a, p. 142.

35 "A un recueil qui veut étudier la Mode comme un art." Mallarmé 1933, p. 50.

36 *La Dernière Mode* cost about four times as much as *La Mode Illustrée*. The merchandise and recipes the journals featured also had different price points.

37 This occurred when he moved to the rue de Rome, where Manet also lived. See Harent and Leinen 2005, p. 65.

38 Manet kept this painting in his studio without ever exhibiting it during his lifetime. Musée d'Orsay 2000, pp. 16, 83.

39 Houssaye was a particular friend of Hector de Callias, with whom he collaborated at *L'Artiste*, and was a witness at the wedding. Pakenham 2000, pp. 53–54. Of his collection, Houssaye wrote, "Remember well, then, the names of Renoir and Monet. I have in my collection the *Camille* of M. Monet and an early *Bather* by M. Renoir which one day, I will give to the Luxembourg when that museum will open its doors to all opinions of the brush." (Donc, retenez bien le nom de M. Renoir et le nom de M. Monet. J'ai dans ma galerie la Femme à la robe verte de Monet et une première *Baigneuse* de Renoir que je donnerai un jour au musée du Luxembourg quand le musée du Luxembourg ouvrira sa porte à toutes les opinions du pinceau.) From a letter quoted in Karl Bertrand, "Le Salon de 1870: Peinture," *L'Artiste*, June 1870, pp. 319–20; quoted in Sloane 1951, p. 202.

40 Houssaye 1881, p. 141 (Mar. 22, 1875). For more of Houssaye's remarks on fashion, see Houssaye 1881, pp. 64, 187.

41 "Dans l'antiquité comme au moyen âge, une robe durait longtemps. Les historiens rapportent que les robes de galas reparaissaient à toutes les grandes fêtes, on portait la robe de sa mère et de son aïeule. Aujourd'hui, nos reines et nos courtisanes ne portent leurs robes qu'une fois; elles se croiraient déshonorées si elles ne changeaient pas tous les jours d'habit." Houssaye 1875, vol. 3, p. 222.

42 Bodelsen 1968.

43 Although Hoschedé had early on embraced the Impressionists, his publication was careful to appeal to more conservative tastes. In the 1881 issue of *L'Art et la Mode*, readers were encouraged to "spend one day a month in the studio of a real painter: Baudry, Cabanel, Carolus Duran, Madrazo." (Tout femme bien inspirée doit passer un jour par mois dans l'atelier d'un vrai peintre, Baudry, Cabanel, Carolus Duran, Madrazo.) Simon 1995a, p. 131.

44 Ibid., p. 136

45 This was a one-time experiment that was not customary until the twentieth century. See McCauley, "Fashion, Photography, and the Cult of Appearances," p. 313, n. 5 in this volume.

46 It was distinguished as a more serious and family-oriented publication than the more risqué *La Vie Parisienne*, noted for its racier illustrations and coverage of entertainment. This mirrored the way Renoir's *Madame Georges Charpentier and Her Children* (cat. 124) was seen as a reflection of the morality of the sitter, whose choices in fashion reflected her superior tastes. See "Pierre-Auguste Renoir: *Madame Georges Charpentier and Her Children*," pp. 248–51 in this volume.

47 Breward 1999; Lehmann 2000.

48 He purchased Renoir's study for *The Loge* for 220 francs and sold it in 1912 to Bernheim-Jeune. Bodelsen 1968, p. 334. It was most recently sold at Sotheby's, London, Feb. 5, 2008.

49 They started to collect art destined for the store, the adjacent picture gallery, and their apartments. In the beginning, they collected the work of the Impressionists, but then they sold most of their collection (excepting several works by Boudin, Degas, and Monet) to buy eighteenth-century paintings. Boime 1979; translated in Carter et al. 1976, p. 17.

50 Lehmann 2009, pp. 68–69.

Groom, "Claude Monet: *Camille*"

1 For this chapter, the author is especially indebted to Mary Gedo's recent monograph; see Gedo 2010. Monet had exhibited two seascapes at the Salon of 1865, each measuring three by five feet. See Gedo 2010, p. 24.

2 Monet's aunt may have been responding to negative reports sent to her by Auguste Toulmouche, a cousin by marriage, about the artist's prolonged trips away from Paris to paint en plein air. See Lecadre 1995. For Gustave Courbet's role in encouraging the artist to paint something smaller and more commercial for the Salon, see Gedo 2010, pp. 30, 40, 49–50.

3 Those portraits all depicted women, and two were also painted by female artists: no. 499, *Jannina* (Mlle Donnier); no. 841, *Berthe* (Mme Gomier); no. 1115, *Diane* (Charles Lapostolet); no. 1386, *Camille* (Monet); no. 1422, *La Petite Amie* (Édouard-Joseph Moulinet); nos. 1720, *Carmella*, and 1721, *Marthe* (both by Jules-Émile Saintin); and no. 1748, *Carmella* (Henri-Guillaume Schlesinger). Two of these paintings depicted a subject named Carmella, suggesting the use of the same model. The work entitled *Diane* might refer to a mythological inspiration, and Saintin's *Marthe* indicates a biblical influence. Only one of the titles from this group, *The Girlfriend*, suggests the artist's intimate connection to his model.

4 Gedo 2010, p. 45. See also Spate 1992, pp. 38–39.

5 Charles Blanc, "Salon de 1866, 1ér article," *Gazette des Beaux-Arts* 20, 6 (June 1866), pp. 497–520.

6 Bürger 1870, pp. 285–86; translated in Gedo 2010, p. 40.

7 For the differing accounts of how long Monet worked on *Camille*, see Gedo 2010, p. 43.

8 "Voyez la robe. Elle est souple et solide. Elle traîne mollement, elle vit, elle dit tout haut qui est cette femme." Zola 1959, pp. 69–73. Unless otherwise noted, all translations are by Marie-Caroline Dihu.

9 "Je venais de parcourir ces salles si froides et si vides, las de ne rencontrer aucun talent nouveau, lorsque j'ai aperçu, cette jeune femme, traînant, sa longue robe en s'enfonçant dans le mur. Comme s'il y avait eu un trou." Ibid.

10 Hansen 2005, p. 73.

11 "À la demarche de Camille, à la façon provocante dont elle foule le trottoir, on devine sans peine que Camille n'est pas une femme du monde, mais une 'Camille.'" Léon Billot, "Fine Arts Exhibition," *Journal du Havre*, Oct. 9, 1868; translated in Wildenstein 1999, p. 73.

12 See Félix Y, *La Vie Parisienne* (May 5, 1866); translated in Tucker 1995, p. 24, n. 12. The caricature is illustrated in Hansen 2005, p. 267.

13 See, for example, Simon 1995a, Steele 1998, Hansen 2005, Burnham 2007, and Iskin 2007.

14 Roskill 1970, p. 395, n. 22. Ruth Butler also suggested that Camille introduced Monet to fashion-plate imagery. Butler 2008, p. 109.

15 Haase also brings up the possibility that Camille posed for some of Eugène Boudin's paintings, since they show similar styles of dresses. See Haase, "Claude Monet: *Women in the Garden*," p. 102 in this volume.

16 See Gedo 2010, p. 237, n. 11. Camille had only a modest dowry at the time of her marriage to Monet in 1870, and her family did not own a building but rented a modest apartment. See also Butler 2008, p. 166, for information on the unresolved legal dispute over Doncieux's will. Butler stated that Camille's father was a merchant in Lyon and suggested that M. Doncieux had something to do with the textile industry. She saw Camille's fashion sense as stemming from her father's profession, fashion plates, and department stores (ibid., pp. 96, 108–09).

17 See also Frances Willard's 1869 diary, in which she reported going to Les Grands Magasins du Louvre and buying a "pretty spring mantle—black cashmere trimmed with satin, for forty-eight francs—not a bit cheaper or prettier than I could have procured at 'Palmer's' in Chicago." Willard, Mar. 9, 1869, *Diary #2*, p. 17, transcribed by Carolyn DeSwarte Gifford. Frances E. Willard Journal Transcriptions, Series 55/43, Northwestern University Archives, Evanston, Illinois. For the price of a studio at the time, see Tucker 1995, p. 227, n. 13.

18 In a letter to his mother written after Jan. 15, 1866, Bazille mentioned that he was working on a large painting of a young man and woman: "What is so terribly difficult is the woman. She has a green satin dress that I rented." (Ce qui est horriblement difficile c'est la femme, il y a une robe de stain vert, que j'ai louée.) Bazille to his mother, Jan. 15, 1866, in *Correspondance*, ed. Didier Vatuone (Les Presses du Languedoc, 1992), p. 120. Translated in Hansen 2005, p. 34. See also Butler 2008, p. 110.

19 Françoise Tétart-Vittu, e-mail correspondence with the author, Jan. 23, 2012. According to Vittu, in 1874 dress fabric from Les Grands Magasins du Louvre cost 6.75 francs per meter, or 135 francs for a dress that required 20 meters of fabric (not counting trims, patterns, and labor). Vittu also believes that machine-made, department-store dresses remained more expensive than handmade ones until later in the century, although this statistic is not unanimously agreed upon by fashion historians; Françoise Tétart-Vittu, in conversation with the author, Nov. 13, 2009. See also De Young 2009, p. 30.

20 Monet also changed her face, body, and pose. For a full report on the conservation work carried out at the Kunsthalle Bremen, see Landgrebe 2005. It is also possible that Monet borrowed the rug from Bazille, who in a letter to his mother written after Jan. 15, 1866 (see n. 18), mentioned having also rented a *tapis* (rug).

21 See Simon 1995a, pp. 51–55, describing a commentator on the ball at the Tuileries in 1866, who referred to a society leader dressed in satin and tulle, with "no crinoline."

22 In Feb. 1868, Rops presented the charcoal drawing "Parisian Type: Bal Mabile" [*sic*] to the Goncourt brothers with the inscription "A MMrs Edmond & Jules de Goncourt après Manette Salomon / Félicien Rops / Paris 67," an allusion no doubt to their novel of the same title, which was written the same year. In this story, a Jewish beauty snares an artist and ends up demanding that he provide her with a bourgeois existence. For the drawing, see Bonnier et al. 1998, pp. 160–61. There is also an etching after the charcoal drawing by Albert Bertrand.

23 "Leurs oeuvres sont vivantes, parce qu'ils les ont prises dans la vie et qu'ils les ont peintes avec tout l'amour qu'ils éprouvent pour les sujets modernes." Zola 1959, p. 130.

24 "La Parisienne n'est pas à la mode, elle est la mode—quoi qu'elle fasse,—quels que soient les barbarismes de sa toilette, — Quand une provinciale passe sur le boulevard, on reconnaît que sa robe est neuve. La robe de la Parisienne a beau sortir, à l'instant même, de chez Worth ou de chez une couturière quelconque, il semble qu'elle ait été portée depuis la veille: la provinciale est habillée par sa robe, la Parisienne habille sa robe. Et comme c'est bien sa robe à elle et non à une autre! La robe s'est assouplie; la robe caresse la femme comme la femme caresse la robe. Si c'est une robe longue, elle la représente dans son caractère sentimental, avec sa traîne paresseuse." Arsène Houssaye, "Quelques opinions avancées sur la Parisienne," *L'Artiste*, Aug. 1, 1869, pp. 154–55.

25 See Iskin 2007, p. 243, n. 10. Iskin made the distinction between the Parisienne, stressing her seductive powers, and the bourgeois chic of the Parisienne, which was connected to the French fashion industry. The fact that the dealer Cadart showed Monet's second version of *Camille* in his store window further underscores art's relationship to fashion and display.

26 "La fille sent la fille et la femme du monde sent la femme du monde." Huysmans 1883, p. 43.

CHAPTER 3
Brevik–Zender, "Writing Fashion from Balzac to Mallarmé"

1 "S'il m'était permis de choisir dans le fatras des livres qui seront publiés cent ans après ma mort, savez-vous celui que je prendrais? . . . Non, ce n'est point un roman que je prendrais dans cette future bibliothèque, ni un livre d'histoire: quand il offre quelque intérêt c'est encore un roman. Je prendrais tout bonnement, mon ami, un journal de modes pour voir comment les femmes s'habilleront un siècle après mon trépas.

Et ces chiffons m'en diraient plus sur l'humanité future que tous les philosophes, les romanciers, les prédicateurs, les savants." Quoted in Flügel 1930, p. 5. Unless otherwise noted, all translations are the author's own.

2 Felski 1995, p. 13.

3 "La modernité, c'est le transitoire, le fugitif, le contingent, la moitié de l'art, dont l'autre moitié est l'éternel et l'immuable." Baudelaire 1975, vol. 2, p. 695.

4 "Ondoyant." Ibid., p. 691.

5 "Geste." Ibid., p. 695.

6 "Vélocité d'exécution." Ibid., p. 686.

7 "La circonstance." Ibid., p. 687.

8 "Si une mode, une coupe de vêtement a été légèrement transformée, si les noeuds de rubans, les boucles ont été détrônés par les cocardes, si le bavolet s'est élargi et si le chignon est descendu d'un cran sur la nuque, si la ceinture a été exhaussée et la jupe amplifiée, croyez qu'à une distance énorme son oeil d'aigle l'a déjà deviné." Ibid., p. 693.

9 "Mouvement rapide." Ibid., p. 686.

10 "La rue assourdissante autour de moi hurlait. / Longue, mince, en grand deuil, douleur majestueuse, / Une femme passa, d'une main fastueuse / Soulevant, balançant le feston et l'ourlet; // Agile et noble, avec sa jambe de statue. / Moi, je buvais, crispé comme un extravagant, / Dans son oeil, ciel livide où germe l'ouragan, / La douceur qui fascine et le plaisir qui tue. // Un éclair . . . puis la nuit!— / Fugitive beauté / Dont le regard m'a fait soudainement renaître, / Ne te verrai-je plus que dans l'éternité? // Ailleurs, bien loin d'ici! trop tard! *jamais* peut-être! / Car j'ignore où tu fuis, tu ne sais où je vais, / Ô toi que j'eusse aimée, ô toi qui le savais!" Baudelaire 1975, vol. 1, pp. 92–93. The translation is from Baudelaire 2003, p. 97.

11 "Hideux, sauvage, abominable, contraire à l'art." Gautier 1858.

12 Gautier's essay does not mention which artists might not have seen the value of depicting modern dress in art, but in 1858, when he wrote the essay, he was known to be friends with the illustrator Gustave Doré and the painter Pierre Puvis de Chavannes, both of whom preferred classical or mythological subjects (and dress) to the representations of modern city dwellers favored by the Impressionists.

13 "Cette santé rougeaude qui est une grossièreté dans notre civilisation." Gautier 1858.

14 "La mode doit donc être considérée comme un symptôme du goût de l'idéal . . . comme une déformation sublime de la nature, ou plutôt comme un essai permanent et

successif de réformation de la nature."
Baudelaire 1975, vol. 2, p. 716.

15 "Un être divin et supérieur." Ibid., p. 717.

16 "Fenêtre ouverte sur l'infini." Ibid.

17 "La passion mystérieuse de la prêtresse."
Ibid.

18 Not all authors shared Baudelaire's praise of
cosmetics. Gustave Flaubert, for example,
used cold cream unfavorably to link his
adulterous protagonist, Madame Bovary,
to a courtesan, while Émile Zola called upon
powders and creams to suggest the inner
(hidden) degradation of corrupt women,
such as his infamous prostitute, Nana.

19 "Tout ce qui orne la femme, tout ce qui sert
à illustrer sa beauté, fait partie d'elle-même."
Baudelaire 1975, vol. 2, p. 714.

20 For an overview of the rise of nineteenth-
century feminism in France, see Fraisse and
Perrot 2002; Waelti-Walters and Hause
1994.

21 Garelick 1998, p. 20.

22 Lehmann 2000, p. 75.

23 This argument was put forth most
emphatically by Roger Dragonetti.
See Dragonetti 1992.

24 "Peindre, non la chose, mais l'effet qu'elle
produit." Mallarmé 1959, p. 137.

25 Lehmann 2000, p. 63.

26 "Une langue . . . est composée à l'égal d'un
merveilleux ouvrage de broderie ou de
dentelle: pas un fil de l'idée qui se perde,
celui-ci se cache mais pour reparaître un peu
plus loin uni à celui-là; tous s'assemblent en
un dessin, complexe ou simple, idéal, et que
retient à jamais la mémoire." Mallarmé
1945, p. 828.

27 Stadler 2001, p. 270.

28 "Lyon nous offre ses fayes et ses failles, ses
poults-de-soie, ses satins, ses velours à nuls
autres pareils, ses gazes et ses tulles, ses
crêpes de Chine." Mallarmé 1945, p. 781.

29 "Ces étoffes: qu'en faire? avant tout des
chefs-d'oeuvre." Ibid.

30 Lecercle 1989, pp. 30–32.

31 Mallarmé was outraged by his forced
departure from the periodical and wrote
several furious letters to friends requesting
that they refrain from writing for the
magazine if approached by his replacement.

32 "J'ai . . . tenté de rédiger tout seul toilettes,
bijoux, mobiliers et jusqu'aux théâtres et
aux menus de dîner, un journal, La Dernière
Mode, dont les huit ou dix numéros parus
servent encore quand je les dévêts de leur
poussière, à me faire longtemps rêver."
Mallarmé 1945, p. 1625.

CHAPTER 4
Tétart–Vittu, "Who Creates Fashion?"

1 "Les plus à la mode." Papers from the
Barbier-Tétart establishment, à la Barbe d'or,
rue des Bourdonnais, Paris, 1755–1795,
Victoria and Albert Library, London,
Msl/1976/4062, No. 86QQ 11 G. See
Boyce 1981.

2 With the growth of commercial establish-
ments, after 1875 nouveautés designated
the silk, cotton, and wool fabrics that manu-
facturers turned out each season with

printed motifs or fantaisies d'armure (inven-
tive woven patterns), but not those in solid
colors. Armure refers to the way warp and
weft intersect in a fabric.

3 These are in the collection of the S.U.D.
Musée de l'Impression sur Étoffes in
Mulhouse.

4 Coleman 1989, p. 11.

5 Already in 1854, Frank Leslie's Gazette of
Paris, London and New York Fashions
mentioned the importation of these dresses.
Two dresses worn at the ball are in the
collection of the City of New York Museum
(no. 39-26a, b and 53640-16a–d). See
Milbank 2000, nos. 204–05.

6 These were sold at the Villes de France for
thirty-five francs in the summer of 1863.
A dress with a paletot jacket of this type
was advertised by Steinbach, Koechlin in
1864; the fabric necessary to create it was
divided into sections for the skirt, bodice,
and jacket and detail. See Bringel and
Jacqué 2009, no. 72. On the robe à disposi-
tion, see Musée de la Mode et du Costume
1992, p. 33.

7 According to Carette 1889–91, Empress
Eugénie sent her to the Louvre to buy
a dressing gown for the empress to wear
while watching over the sickbed of
the prince.

8 A checked cotton dress and dotted
polonaise was labeled "Grands Magasins
du Louvre / Indian Counter muslins and
organdy / 10714 / Spring 1869 / Percale
dress / Exclusively at our store" (Grands
Magasins du Louvre / Comptoir des
indiennes mousselines et organdi / 10714 /
Saison de printemps 1869 / Robe percale /
propriété exclusive) with the Louvre's brand
(a lion lying at the foot of an L) as a water-
mark. See Musée de la Mode et du
Costume 1992, p. 123.

9 For example, a tunic from Printemps carried
the label, "The Laurel / Au Printemps /
Winter Fashions 1872–1873 / Embroidered
outfit partially sewn, delivered with illustra-
tion in a magnificent Swiss-pasteboard box /
The Outfit, 129 F" (Le Laurier / Au Prin-
temps / nouveautés hiver 1872–1873 /
Costume brodé mi-confectionné livré avec
gravure dans une magnifique boite suisse /
Le costume 129 F). See ibid., p. 103, no. 216.
Examples of these types of consignments
also exist in private collections, including an
embroidered dress of white gauze, still in its
own box decorated with gold filets around a
flowered cartouche. The label inside the
dress reads, "E. Billioque, Father & Son and
Faucher, Bordeaux, shawls, cashmere wraps
made in India and France, silk goods, fashion
novelties, outfits, lace, engagement presents,
trousseaux and layettes" (E. Billioque père
fils et Faucher, Bordeaux, châles, cachemires
des Indes et de France, soieries, nouveautés,
toilettes, dentelles, corbeilles de mariage,
trousseaux et layettes).

10 "Elles ne valent pas l'uni car la robe brodée
paralyse l'imagination de la couturière."
La Mode Illustrée, 1869, p. 230.

11 Au Printemps carried Marie-Blanche silk,
and Les Grands Magasins du Louvre had
Paris-Louvre and drap-cyclope.

12 Pansu 2003, pp. 402–09.

13 Musées de la Ville de Paris 1995, pp. 26–30.

14 "Un choix immense d'aquarelles inédites,
toilettes de bal, de réception et de ville et un
grand nombre de confections au prix de 15
francs, (5 pour les abonnés). La composition
de ces aquarelles devient la propriété de
l'acheteur." Tétart-Vittu 1992. Léon Sault's
embroidery firm continued under his son
and still existed in 1910. In 1892 he
launched the new magazine Mode-Charme,
Revue de Tendances.

15 Andia and François 2006, pp. 140–41.

16 This was also the case for the House of
Lassalle, whose labeled outfits are in the
collection of the Musée des Arts Décoratifs
in Paris. Emery 1997, pp. 78–91.

17 In 1863 Les Grands Magasins du Louvre
printed 50,000 copies of its special issue;
in 1865 it doubled the number, and in 1874
it put out 360,000 pages of Nouveautés de
Printemps (Spring Fashions). Lecercle 1989,
pp. 176–79; Syndicat des entreprises 1984.

18 "Illustré, orné de 125 gravures de modes,
est actuellement sous presse (1er tirage,
chiffre officiel 600.000)." "Les Phares de la
Bastille," L'Univers Illustré, Oct. 26, 1878,
p. 687.

19 For example, the Louvre appeared in La
Mode Illustrée in 1874 and the Grands
Magasins de la Place Clichy in Le Salon de
la Mode in May 1881.

20 We know of four albums from the
Compagnie Lyonnaise: 1856–57, 1858–59,
1860–61, and 1861–62. See Musée Galliera
2008, pp. 161–62. The firm still existed in
1900.

21 La Vie Moderne, 1880, p. 720. F. Ambrière,
"Le Bon Marché: Exhibitions and sales.
January, White; February, lace and braiding;
March ready-to-wear exhibition; May, sale
of Summer outfits; June, sales and special
offers for Summer; September, rugs;
December end-of-the-year presents and
sales." (Le Bon Marché: les expositions et
les soldes. Janvier, le blanc; Février, dentelles
et galons; Mars, exposition des confections;
Mai, vente des toilettes d'été; Juin, soldes et
occasions d'été; Septembre, tapis; Décem-
bre, étrennes et soldes.), L'Art et la Mode,
1889, pp. 105–12. I wish to thank Gloria
Groom for bringing this to my attention.

22 Other changes in The Conversation, such
as the prominent tricolor flag at left, can be
discussed in terms of Cézanne's turn to
popular imagery for inspiration, as well
as his desire to express overt political
sentiments. For the meaning of these and
the other paintings drawn from La Mode
Illustrée—including Two Women and Child
in an Interior (c. 1871; Pushkin Museum of
Fine Art, Moscow), see Dombrowski 2006.

23 As a result, specialized magazines
increasingly featured advertisements for
sewing machines and makers of sewing
mannequins. In the quartier Chaussée-
d'Antin-Bourse-Richelieu—a center for
wholesalers, newspapers, and sewing
suppliers—it was even possible to buy
ready-made or made-to-measure
dressmaking dummies that were adjustable
in height.

24 According to *Townsend's Monthly Selection of Parisian Costumes* (1826), "Mrs Rowden: French, Swiss and English costumes are brought out every month in full size paper patterns completely made up so as to serve as correct guide to copy from." In Nov. 1856, *Le Follet* announced an exhibition of the "paper patterns of Winter Fashions by Madame Distribuer of the fg St Honoré—her agent is now ready to forward her cases of fashion: 14 life-size (cloaks, robes, sleeves) in french système, together with plate and complete description. Thomas White 161 Fleet Street."

25 One of these smaller-than-life-size models—a gray town dress trimmed with blue braid (c. 1865)—is in the Chicago History Museum.

26 Musée de la Mode et du Costume 1992, pp. 40–43.

27 See, for example, Charles Pilatte's sketch as reproduced by the illustrator Claudius Compte-Calix in *Les Modes Parisiennes* 1043 (Feb. 21, 1863). Tétart-Vittu 1995a, p. 30.

28 During this period, industrial protection was beginning to be put in place for ready-to-wear garments as a guarantee against counterfeiting, having first been applied to shoes and hats. Labeling became general practice after 1880 no matter the rank of the establishment, and the brand or signature thus became a sign of distinction. For export, the brand of a garment was stamped on its waistband or the lining of the bodice. On Mar. 21, 1884, this protection was applied to ladies' clothing and trimmings. Musée de la Mode et du Costume 1992, pp. 50–52.

29 Jachimowicz 1990.

30 The empress's outfits, which could not be worn too many times for reasons of political and social prestige, were given to the women in charge of her wardrobe, headed by Pepa Pollet, who sold them at a profit in the United States, where, unlike in France, finery was often rented.

31 "Ces messieurs [Worth et Bobergh], très désireux de me compter au nombre de leurs clientes me priaient de bien vouloir faire une robe chez eux et que je n'avais qu'à dire le prix que je voulais y mettre." Metternich-Sándor 1922, pp. 106–07.

32 "Je me suis achetée une robe à la Compagnie Lyonnaise, c'est cher mais c'est étourdissant. Ce n'est que là que l'on trouve des mousselines un peu propres; la mienne est fond blanc avec, de distance en distance, des pensées de grandeur nature adorablement dessinées; pour le soir, décolletée avec une ceinture dorée et des pensées de velours dans les cheveux, le jour avec le zouave." Letter from Nina to Louise D'Alcq; see D'Alcq 1902, pp. 106–07.

33 "S'abrutir au Bon Marché." Diaz 2011.

Tétart–Vittu, "Édouard Manet: *The Parisienne*"

1 Lecercle 1989, p. 163; Lannoy and Terrasse 2003.

2 Union Centrale 1874. The *Gazette des Beaux-Arts* published eight articles on the exhibition, from Oct. 1, 1874, to July 1, 1875.

3 Racinet 1888. See also Tétart-Vittu 2003.

4 "Cette modernité fugitive." Lemonnier 1888.

5 Hadol, a customs officer for the tolls of Paris, drew sketches for magazines on his customs registers. Mars portrayed *cocodettes* and actresses, and Bertall illustrated numerous reviews and put together collections like *La comédie de notre temps* (1874).

6 This etching, dated 1867, was dedicated to the Goncourt brothers by Rops.

7 See, for example, Louis-Marie Lanté's *Les ouvrières de Paris*, published by the *Journal des Dames et des Modes* (1816–24); Paul Gavarni's many *grisettes* in the series *Etudiants de Paris*, published in *Le Charivari* (1839–42), and his illustrations for Louis Huart's *Physiologie de la grisette* (1841) and the chapter on the *grisette* in *Les Français peints par eux-mêmes* (1841); Norbert Goeneutte's *The Fitting* (1878); and the different versions of Stevens's *New Dress* (1874, 1889).

8 See, for example, Gustave Courbet's *Young Ladies on the Banks of the Seine* (cat. 34), Claude Monet's and Renoir's *The Grenouillère at Croissy* (1869; The Metropolitan Museum of Art, New York; 1869; Nationalmuseum, Stockholm), and Renoir's *Luncheon of the Boating Party* (1876; The Phillips Collection, Washington, D.C.).

9 Rops designed dresses for his mistresses, the sisters Léontine (1849–1915) and Aurélie Duluc (1852–1924), from 1867 to 1890. He married Léontine and had a daughter, Claire, with her in 1871. See Tétart-Vittu 1998.

10 See the nuanced analysis of this issue in Simon 1995b, p. 147. See also Harent and Leinen 2005.

11 See Tétart-Vittu, "Who Creates Fashion?," pp. 63–77 in this volume.

12 These galleries featured exhibitions by associations of female painters or French watercolorists.

13 "Maison Carolus Duran, nouveau rayon de velours"; "Maison Béraud, étoffes garanties bon teint." Hadol, "Le Salon comique," *L'Eclipse*, June 9, 1872; "La Boite aux aquarelles, le Bazar de la rue de Sèze," *La Vie Parisienne*, Feb. 16, 1884; quoted in Simon 1995b, pp. 136–37.

14 The Vicomtesse de Peyronny was known as Etincelle, Eliane de Marsy, Vicomte de Létorière, and Duchesse de Maufrigneuse. Widowed in 1890, she then married Baron Double, a famous art collector. She wrote for *Le Figaro* and *La Mode Pratique*.

15 Reproduced in Lefebvre 2006, pp. 42–43, ill. 30–31.

16 Tétart-Vittu 1995b, p. 115.

17 "Un caractère éminemment artistique et si j'étais peintre, j'en voudrais faire les plus mignons tableaux de genre." *L'Art et la Mode* (Apr. 1881), p. 69.

18 "Vous jugez de l'attrait et aussi de la valeur d'une robe dont la garniture peut être signée Madrazo, Madeleine Lemaire, Chaplin ou de Nittis." *L'Art et la Mode* (Aug. 1881), p. 32.

19 "Toute femme bien inspirée doit passer un jour par mois dans l'atelier d'un vrai peintre, Baudry, Cabanel, Carolus Duran, Madrazo." Etincelle, *L'Art et la Mode* (1881), p. 80.

20 *L'Art et la Mode*, Jan. 12, 1884, p. 81.

CHAPTER 5
Haase, "Fashion en Plein Air"

1 "Le rêve que font tous les peintres: mettre des figures de grandeur naturelle dans un paysage." Zola 1959, p. 96. Unless otherwise noted, all French translations are by Jean Coyner.

2 Herbert 1988, pp. 170–73.

3 "L'héroïsme de la vie moderne." Baudelaire 1962b, p. 85. "Le peintre de la vie moderne." Baudelaire 1962a.

4 In 1863 Baudelaire stated that a painter "s'étant imposé la tâche de chercher et d'expliquer la beauté dans la *modernité*, représente volontiers des femmes très parées et embellies par toutes les pompes artificielles, à quelque ordre de la société qu'elles appartiennent." (Having imposed upon himself the task of seeking and trying to explain beauty in *modernity*, [he] often represents very dressed-up women who are made prettier by many artificial means, whatever social class they belong to.) Baudelaire 1962a, p. 494.

5 "Il aime nos femmes, leur ombrelle, leurs gants, leurs chiffons, jusqu'à leurs faux cheveux et leur poudre de riz, tout ce qui les rend filles de notre civilisation. . . . Comme un vrai Parisien, il emmène Paris à la campagne, il ne peut peindre un paysage sans y mettre des messieurs et des dames en toilette. La nature paraît perdre de son intérêt pour lui, dès qu'elle ne porte pas l'empreinte de nos mœurs." Zola 1959, p. 130.

6 "Je travaille comme jamais et à des tentatives nouvelles, des figures en plein air, comme je les comprends, faites comme des paysages. C'est un rêve ancien qui me tracasse toujours et que je voudrais une fois réaliser: mais c'est difficile." Claude Monet to T. Duret, Aug. 13, 1887; quoted in Wildenstein 1979, p. 233, no. 794.

7 See Hansen and Herzogenrath 2005, p. 74.

8 Soutache is narrow, flat decorative braid (a type of galloon) that is stitched in ornamental patterns.

9 "Für das Land oder einen Aufenthalt in Seebädern." *Pariser Damenkleider-Magazin* 16, 7 (July 1863), pp. 103–05. Contemporary fashion illustrations, as well as objects that have been preserved in museum collections, testify to this style's popularity. See Haase 2002.

10 The *petits costumes* of the 1860s had somewhat shortened skirts without trains and/or with gathered upper skirts, mostly worn over a small crinoline. In the early 1860s, the *petit costume* was a relatively new style that was still seen as informal and somewhat daring. On the fashion of the *petits costumes*, see Tétart-Vittu 2008, pp. 104–08; Haase 2012, pp. 41–44.

11 "Graziös aussehende Art des

Kleideraufnehmens." *Pariser Damenkleider-Magazin* 16, 2 (Feb. 1863), p. 22.

12 *Passementerie* is a more elaborate trimming than soutache. It includes tassels, fringes, ornamental cords, pompons, rosettes, buttons, and gimps, among other forms. In this dress, there is soutache embroidery combined with crochet lace, pompons, and buttons.

13 See Haase 2002, pp. 51–52.

14 See Roskill 1970, p. 392; Isaacson 1972, pp. 43–50; Steele 1998, pp. 124–27.

15 See Zola 1959, p. 132.

16 See Hansen and Herzogenrath 2005, pp. 105–07.

17 See Haase 2002, pp. 61–62.

18 "Une de nos femmes, une de nos maîtresses plutôt, peinte avec une grande vérité et une recherche heureuse du côté moderne." Zola 1959, p. 132; translated in Distel 2010, p. 385, n. 5.

19 See Hollander 1978, pp. 161–62.

20 See Hansen and Herzogenrath 2005, p. 143.

21 Apparently, the same dress appears in the left half of Renoir's *Moulin de la Galette* (1876; Musée d'Orsay, Paris). The fashionable ladies' dresses in Renoir's depictions of proletarian or petit-bourgeois milieus indicate that larger segments of the population were able to afford contemporary styles of dress by the second half of the nineteenth century due to increasing democratization, industrialization, and the onset of mass production.

22 A princess-style dress is a sleek dress without a waist seam; its smooth fit is realized through the use of vertical seams and long darts from bust to hip. The cuirass corset is a tight, hip-length, steam-molded corset with curvaceous lines that was worn under sheathlike dresses with cuirass bodices in the 1870s and 1880s. Ambroise Vollard wrote that Renoir had a particular preference for the close-fitting princess dress. He felt it lent to its wearer "such a pretty, shaped line." Vollard 1961, p. 49.

23 See *L'Événement*, Apr. 6, 1877; quoted in Wadley 1987, p. 110.

Haase, "Claude Monet: *Women in the Garden*"

1 "Un tableau de figures, des femmes en toilettes claires d'été, cueillant des fleurs dans les allées d'un jardin; le soleil tombait droit sur les jupes d'une blancheur éclatante; l'ombre tiède d'un arbre découpait sur les allées, sur les robes ensoleillées, une grande nappe grise. Rien de plus étrange comme effet. Il faut aimer singulièrement son temps pour oser un pareil tour de force, des étoffes coupées en deux par l'ombre et le soleil, des dames bien mises dans un parterre que le rateau d'un jardinier a soigneusement peigné." Zola 1959, p. 131.

2 Zola's estimation corresponds to current scholarship, which sees this painting as an "icon of modern art." Gedo 2010, p. 56.

3 "Je m'exerçais à des effets de lumière et de couleur qui heurtaient les habitudes reçues." François Thiébault-Sisson, "Claude Monet: Les Années d'épreuves," *Le Temps* 26 (Nov. 1900).

4 Robert L. Herbert aptly remarked about this painting, "Its modernity can be expressed in an aphorism: the decorative in art becomes an expression of fashion in society." Herbert 1988, p. 177.

5 Contrary to Monet's original intent and despite his later statements, this painting was not made exclusively en plein air. The artist finished it in a studio in Honfleur after extensive revisions as late as the beginning of 1867.

6 See, for example, Isaacson 1967, pp. 144, 146; Roskill 1970, p. 392; Needham 1971, pp. 79, 119; Champa 1973, p. 10; Busch 1981, p. 30; Seitz 1988, p. 22; Gedo 2010, p. 50. Other authors recognize Camille only in the three women portrayed on the left of *Women in the Garden*, including Wildenstein 1974, pp. 35, 150; Maurer 1983, p. 281; Tinterow and Loyrette 1994, p. 429. The red-haired woman in a dotted dress is undoubtedly also Camille, however, posing here, as she did in *Luncheon on the Grass* (fig. 2, p. 89; cat. 39), in a wig.

7 See Haase 2002, pp. 65–66.

8 The exchange of "props" among artist friends may have served as an alternative practice. Around 1866 Monet wrote to the painter Frédéric Bazille: "Je vous envoie par ce commissionnaire une paire de draps qui est à vous ainsi qu'une crinoline." (I send you by this messenger a set of drapes that belong to you, as well as a crinoline.) Quoted in Wildenstein 1974, p. 35, n. 235. This suggests that fashion accessories circulated among artists' studios and were used as shared equipment.

9 See Haase 2002, p. 83.

10 Ruth Butler evaluated Camille's fashion expertise, which derived from the democratization of luxury during the Second Empire, as a central contribution to Monet's depictions of the *vie moderne*. See Butler 2008, pp. 108–09, 123.

11 See Isaacson 1967, pp. 144–47; Roskill 1970, pp. 391–95; Steele 1998, pp. 124–26.

12 See Wentworth 1984, p. 52; Hansen and Herzogenrath 2005, pp. 112–15.

13 "Leurs oeuvres ne sont pas des gravures de mode banales et inintelligentes, des dessins d'actualité pareils à ceux que les journaux illustrés publient. Leurs oeuvres sont vivantes, parce qu'ils sont prises dans la vie et qu'ils les ont peintes avec tout l'amour qu'ils éprouvent pour les sujets modernes." (Their works aren't simple and mindless fashion plates, documentary drawings similar to those published by illustrated newspapers. Their works are alive because they are taken from life itself and because they painted them with all the love they feel for modern subjects.) Zola 1959, p. 130.

14 The ensemble is identical to the *petit costume* depicted from behind in *Luncheon on the Grass*, as is evident from its color, blue ribbons, and lozenge-shaped white buttons. That this correspondence has until now mostly escaped attention can be attributed to the fact that the view of the back of the *paletot*, close-fitting at the waist, in *Luncheon on the Grass* is completely different than the baggy frontal

view in *Women in the Garden*. The vogue for this fashionable, "half-fitting" jacket is confirmed by illustrations and descriptions in contemporary fashion magazines. See Haase 2002, pp. 65, 108–09.

15 See ibid., pp. 122, 271–78.

16 Ibid., pp. 231–38; Hornborstel 1991, pp. 78–79.

17 See Breward 1995, pp. 161–63; Haase 2001, pp. 27–28.

18 "La découverte de ceux d'ici [of Impressionists B. H.] consiste proprement à avoir reconnu que la grande lumière *décolore* les tons, que le soleil reflété par les objets tend, à force de clarté, à les ramener à cette unité lumineuse qui fond ses sept rayons prismatiques en un seul éclat incolore, qui est la lumière." Duranty 1876, p. 30. "Rather, the real discovery of these painters lies in their realization that strong light mitigates color, and that sunlight reflected by objects tends, by its very brightness, to restore that luminous unity that merges all seven prismatic rays into one single colorless beam—light itself." Moffett 1986, p. 42.

19 See Haase 2005, pp. 234–35; Haase 2010, p. 189.

20 "Il emmène Paris à la campagne"; "Claude Monet aime d'un amour particulier la nature, que la main des hommes habille à la moderne." Zola 1959, pp. 130, 132.

21 See Herbert 1988, p. 178; Haase 2002, p. 94.

22 Spate 1992, p. 39.

23 The image of the woman typical of nineteenth-century bourgeois society, as defined by the male gaze, is given its fundamental analysis in Veblen 1899.

24 See Herbert 1988, pp. 178–80; Spate 1992, pp. 11, 22; Haase 2002, pp. 58–60.

25 Monet himself used these two terms early in his career to identify the decisive coordinates of his concept of art. See Monet to Bazille, July 15, 1864; quoted in Wildenstein 1974, p. 420, no. 8. See also Isaacson 1978, pp. 12–18. Stéphane Mallarmé indicated a connection between Impressionism and Symbolism in the poetic credo he formulated in 1864: "Peindre, non la chose, mais l'effet qu'elle produit." (To paint not the thing, but the effect it produces.) That statement could just as well characterize Monet's artistic principles, implying a close affinity to contemporary women's fashion. See Mallarmé to Henri Cazalis, Oct. 1864; quoted in Mallarmé 1959, p. 137.

CHAPTER 6
De Young, "Fashion and Intimate Portraits"

1 Baudelaire 1964, p. 13.

2 For more on the Impressionist redefinition of portraiture, see particularly the essays by Colin Bailey and Linda Nochlin in Bailey 1997. See also Strauber 2006.

3 Quoted in Moffett 1986, p. 31.

4 Quoted in Weitzenhoffer 1986, p. 230.

5 Druick et al. 1988, pp. 149–53.

6 Higonnet 1992, p. 67.

7 Ibid., p. 70.
8 Ibid., p. 116.
9 Stuckey and Scott 1987, p. 45.
10 Cachin et al. 1983, p. 259.
11 Wilson-Bareau 2011, p. 822.
12 Zola 2008, p. 398.
13 Buck 1961, p. 42.
14 "Grosvenor Gallery," *Observer*, May 5, 1878; quoted in D'Argencourt 1999, vol. 2, p. 604, n. 20.
15 For more on Tissot's wartime art and activities, see Clayson 2002.
16 For more on the postwar atmosphere and its effects on Paris, art, and the press, see "Fashion and the Press," pp. 237–39 in this volume.
17 D'Argencourt 1999, vol. 2, p. 600.
18 Ibid., p. 604, n. 19.
19 D'Argencourt 1999, vol. 2, pp. 602–04.
20 Cahn 2008, p. 51.
21 Cachin et al. 1983, p. 366.
22 Schirrmeister 1990, p. 110.
23 Farwell 1990.
24 Higonnet 1992, p. 160.
25 Schirrmeister 1990, p. 112.
26 Baudelaire 1964, p. 1.

Steele, "Édouard Manet: *Nana*"

1 "Le corset de satin, c'est peut-être le nu de notre époque." C. Delaville, "Édouard Manet," *L'Événement*, May 31, 1881, quoted in Brombert 1996, p. 384.
2 Iskin 2007, p. 38.
3 "Très grand négligé." "Le Monde parisien," *Le Soleil*, May 3, 1877; quoted in Clayson 1991, p. 75. Unless otherwise noted, all translations are the author's own.
4 *La Vie Parisienne*, May 12, 1877.
5 Brombert 1996, pp. 384–85.
6 Hollander 1978, p. 91.
7 Quoted in Steele 2001, p. 14.
8 Brooks 1993, p. 45.
9 Perrot 1994, p. 159.
10 Dr. Daumas, "Hygiène et médecine," *Fashion-théorie* (Mar. 1861); quoted in Perrot 1994, p. 150.
11 See Steele 1985, p. 192.
12 Joris-Karl Huysmans, "La *Nana* de Manet," *L'Artiste de Bruxelles*, May 13, 1877; quoted in Clayson 1991, p. 78. See also Armstrong 2002, pp. 229–30.
13 Zola 2008, p. 409. Since Zola's *Nana* was not serialized until 1879, it cannot have influenced Manet's *Nana*. It is true that Zola's character first appeared in his earlier novel *L'Assommoir*, but then she was only fifteen, with "all her teeth and no corset."
14 J. K. Huysmans, "La *Nana* de Manet," *L'Artiste de Bruxelles*, May 13, 1877; quoted in Clayson 1991, p. 78.
15 Pierre de Lano, *L'Amour à Paris sous le Second Empire* (H. S. Empis, 1896); quoted in Perrot 1981, p. 282.
16 "Les Corsets," *La Vie Parisienne*, Jan. 15, 1881, pp. 38–39.
17 "Les Dessous," *La Vie Parisienne*, May 2, 1885, pp. 252–53.
18 "En verité, le luxe des dessous remonte à quarante ans tout au plus; il s'est accentué sensible depuis quinze ans environ avec la simplicité, la sévérité, le 'comme il faut' des robes de dehors. Le genre anglais, façon tailleur, se généralisant dans la toilette extérieure, le contraste des élégances d'intérieur devant s'accroître, pour ainsi dire, en proportion logique. Depuis 1870, l'excentricité a disparu des modes; les femmes de bon ton affectent avec raison une mise presque modeste pour la tenue de ville; ce sont des draps souples et sombres dont toute la correction est dans 'ce je ne sais quoi' de la coupe qui porte le cachet du grand faiseur. Avec la vulgarisation de certains costume fabriqués à la grosse dans les magasins de nouveautés, une grand élégante ne peut échapper à l'uniforme démocratique, crée par tous les 'Au bonheurs des Dames' de la capitale, que par le recherche des vêtements sans apparat, mais dont le style est impeccable et devance d'au moins six ou dix mois les confections des 'warehouses' de la bourgeoisie parisienne." Uzanne 1902, pp. 213–14.
19 "Une femme en corset est un mensonge, une fiction, mais pour nous autres cette fiction est mieux que la réalité." Eugène Chapus, *Manuel de l'homme et de la femme comme il faut* (Librairie Nouvelle, 1855), p. 38, quoted in Perrot 1994, p. 34.
20 "Avant et après le corset," *La Vie Parisienne*, Jan. 5, 1884.
21 "Les Corsets," *La Vie Parisienne*, Jan. 15, 1881.
22 Nead 1992, p. 33.
23 "Plus que nue, en chemise, elle étale, la fille, / Ses appas et sa chair qui tente. La voilà. / Elle a mis son corset de satin et s'habille / Calme, près d'un monsieur, pour la voir venu là." "Nana," *Le Tintamarre* (May 13, 1877), p. 2; quoted in Clayson 1991, p. 75.
24 "Il faut qu'on comprenne que 'ta' femme n'est pas un modèle. Où est la robe qu'elle a quite? Mets donc un corset par terre!" "Tu vois . . . on a compris que c'est une femme qui se déshabille." Ambroise Vollard, *Degas* (Les Éditions G. Crés et Cie., 1924), p. 44. Quoted in Clayson 1991, pp. 83, 87–88.

CHAPTER 7
Thiébaut, "An Ideal of Virile Urbanity"

1 Simon 1995b.
2 Hansen and Herzogenrath 2005.
3 Hollander 2002.
4 Ibid., pp. 130–33.
5 Ribeiro 2008, pp. 46–47.
6 "La pelure du héros moderne." Baudelaire 1975, vol. 2, p. 494.
7 Blanc 1875, pp. 107–14. Art historian, professor, and magazine publisher Blanc was also the administrative director of the Académie des Beaux-Arts from 1848 to 1851.
8 Ulbach 1878, especially the chapter "Paris-Costume."
9 "Toute la lumière de la coquetterie est pour la femme, nous sommes le fond de l'écrin sur lequel se détache l'éternel diamant. . . . L'homme civilisé, au point de vue de l'habillement, n'est plus que l'accompagnateur de la femme; il la laisse chanter seule la symphonie du blanc, du rose, du vert, avec toutes les modulations de demi-teintes que l'industrie a introduites, comme des dièses et des bémols." Ibid., pp. 83–84.
10 Farid Chenoune divided his work on male fashion from the end of the eighteenth century to the 1990s into four parts. The years 1850–1914 were defined by the *paletot* and frock coat. Chenoune 1993.
11 Because of its erudition and the wide scope of views it reflects, Perrot 1981 remains the primary source on the clothing landscape of the nineteenth century.
12 "L'habillement de ville des hommes est connu de tous, il ne s'agit que d'ouvrir les yeux. On sait qu'il serait aussi ridicule de sortir le matin en habit, que d'entrer dans un salon le soir en redingote." Mortemart de Boisse 1857, pp. 33–34.
13 "Considérez bien un monsieur très élégant, suivant le goût de notre époque, vêtu du paletot-sac, et examinez en détail les diverses parties de son costume en partant de la base: deux tuyaux droits contiennent ses jambes et se perdent dans un tuyau collecteur, de celui-ci s'échappent deux annexes, toujours en forme de tuyaux dans lesquels sont renfermés les bras, et pour le couronnement de l'édifice, un tuyau à gouttière auquel nous donnons le nom de chapeau." Thirifocq, "Du costume dans ses rapports avec les moeurs et avec la civilization," *Journal des Modes d'Hommes* 1 (Jan. 1867); quoted in Perrot 1981, p. 56.
14 Humann was one of the most famous Parisian tailors, among the 1,500 in the capital at the end of the Second Empire, with an establishment in the Hôtel de Coigny, 83, rue Neuve-des-petits-Champs. See *Annuaire Almanach* 1870, pp. 1317–22.
15 "La mode a sa raison d'être, par cela même qu'elle est l'expression *libre* du goût du jour, mais elle devient l'expression ridicule ou *licencieuse* du mauvais goût aussitôt qu'elle s'affranchit des règles des belles proportions du corps humain. Ainsi une taille trop longue ou trop courte a beau être conforma aux exigences de la mode, elle n'en est pas moins une exagération de mauvais goût qui fera paraître l'homme disproportionné et même disloqué. Il en est différemment des variations de mode conciliables avec le bon goût, c'est-à-dire avec l'harmonie des proportions et leur unité d'ensemble." "Une visite chez Humann," *La Vie Parisienne*, Mar. 30, 1867, p. 228.
16 Zola used and abused the term "pinched" in his Rougon-Macquart seriesß to describe elegant young people, taking Maxime Saccard as an archetypical example of the son of a parvenu in *La Curée* (The Kill; 1872).
17 On the different ways of wearing the *paletot*, see the plate of caricatures "Études parisiennes—Les Paletots," *La Vie Parisienne*, Dec. 14, 1867.
18 "L'homme, quant à la forme, peut valoir par ses habits; mais il vaut, au fond, que par lui-même. Il doit se recommander par son esprit et non par sa toilette, par ses

aptitudes et non par le prix de ses vêtements." Mortemart de Boisse 1857, p. 35.

19 As Antonin Proust observed: "Manet stood up after having brushed and replaced his top hat on his head. For, in the country as well as in the city, he was invariably dressed in a jacket or a tight-waisted frock coat, a light-colored pair of trousers, and he wore a very high hat with a flat brim." (Manet se leva après avoir brossé et remis sur sa tête son chapeau haut-de-forme. Car, à la campagne comme à la ville, il était invaria-blement vêtu d'un veston ou d'une jaquette serrée à la taille, d'un pantalon couleur claire, et il se coiffait d'un chapeau très élevé à bords plats.) Antonin Proust, "Édouard Manet (Souvenirs)," La Revue Blanche 89, 15 (Feb. 1897), p. 172.

20 "Bien qu'essentiellement Parisien, par la naissance et par l'art, il y avait dans sa physionomie et ses manières quelque chose qui le faisait ressembler à un Anglais. Peut-être était-ce ses vêtements—ses habits à la coupe élégante—et sa tournure. Cette tournure! . . . ces épaules carrées qui se balançaient, quand il traversait la salle, et sa taille élancée, et cette figure, ce nez, cette bouche." Moore 1889, pp. 109–10. These points were confirmed by Antonin Proust, La Revue Blanche 88, 1 (Feb. 1897), p. 125: "With a neat, arched back he moved in a rhythmic way, to which his rolling gait lent a character of particular elegance. No matter what effort he made—exaggerating this gait or affecting the slack speech of the Paris urchin, he could never manage to be vulgar." (Cambré, bien pris, il avait une allure rythmée à laquelle le déhanche-ment de sa démarche imprimait un carac-tère de particulière élégance. Quelque effort qu'il fît, en exagérant ce déhanche-ment et en affectant le parler traînant du gamin de Paris, il ne pouvait parvenir à être vulgaire.)

21 The Mamignards were cousins of the artist's mother living in Paris.

22 "Mes chemises s'en vont tout à fait. Je n'en ai que deux ou trois en état présentable, je les garde pour les jours où je vais chez les Mamignard. Il faudrait bien m'en faire; si maman m'en commande je les voudrais sans col, je me suis acheté des faux cols, ici c'est plus à la mode, et cela me permet de faire durer plus longtemps la même chemise. Mes chaussettes ne sont guère en meilleur état, j'en ai acheté quelques paires, mais j'en manquerai bientôt." Bazille 1992, p. 49.

23 "Je te prie que les pantalons soient bien longs, et les manches de l'habit un peu courtes et ne gênant pas aux épaules." Ibid., p. 52.

24 "Un pantalon habillé et une jaquette légère pour tous les jours . . . un gilet ordinaire et quelques gilets blancs." Ibid., p. 88.

25 Edmond About, "Le Portrait et le genre," Le Temps, June 13, 1867.

26 "Ce qu'il nous faut, c'est la note spéciale de l'individu moderne, dans son vêtement, au milieu de ses habitudes sociales, chez lui ou dans la rue. La donnée devient singulière-ment aiguë, c'est l'emmanchement d'un flambeau avec le crayon, c'est l'étude des reflets moraux sur les physionomies et sur l'habit, l'observation de l'intimité de l'homme avec son appartement, du trait spécial que lui imprime sa profession, des gestes qu'elle entraîne à faire, des coupes d'aspects sous lesquelles il se développe et s'accentue le mieux. Avec un dos, nous voulons que se révèle [sic] un tempérament, un âge, un état social; par une paire de mains, nous devons exprimer un magistrat ou un commerçant; par un geste, toute une suite de sentiments. . . . L'attitude nous apprendra que ce personnage va à un rendez-vous d'affaires, et que cet autre revient d'un rendez-vous d'amour." Duranty 1876, pp. 24–25.

27 According to a law passed on July 27, 1872, all Frenchmen must complete military service. Originally set at five years for draf-tees or one year for volunteers, the length of service increased to five years for all citizens in 1889.

28 "Comme un vrai Parisien, il emmène Paris à la campagne. Il ne peut peindre un paysage sans y mettre des messieurs et des dames en toilette. La nature paraît perdre de son intérêt pour lui, dès qu'elle ne porte pas l'empreinte de nos moeurs." Émile Zola, "Mon salon. Les actualistes," L'Événement Illustrée, May 24, 1868; quoted in Zola 1991, pp. 207–08.

29 "Un plaisir d'une nature un peu grossière." See the article on canotage in Larousse 1867, p. 284.

30 In 1867 Edmond and Jules de Goncourt evoked the boating world in Manette Salo-mon—from the canoes drifting with the current and the arbors of cabarets to the "disheveled siestas" (siestes débraillées). Goncourt and Goncourt 1868, p. 142.

31 See Parrot 2002.

32 "Longues heures de pose." Émile Zola, "Mon salon. Edouard Manet," L'Événement Illustrée, May 10, 1868; quoted in Zola 1991, p. 198.

33 This subject was brilliantly analyzed in Hollander 2002, pp. 130–31.

34 Heydt 2007, p. 36.

35 See, for example, The Luncheon of the Boating Party (1880; Phillips Collection, Washington, D.C.) and After the Luncheon (1879; Städel Museum, Frankfort).

Cogeval and Guégan, "James Tissot: *The Circle of the Rue Royale*"

1 Théophile Gautier, "Salon de 1868," Le Moniteur Universel, May 26, 1868.

2 "La mode semble promettre la révélation non seulement du beau moderne, mais encore de l'inquiétant dynamisme des valeurs et des significations qui domine, à l'époque moderne, l'ensemble de la vie sociale." Froidevaux 1989, p. 58. Unless otherwise noted, all translations are by Jean Coyner.

3 "Comme l'expression la plus typique de la société bourgeoise, mais aussi comme une tentative de subvertir son ordre." Ibid.

4 See Matyjaszkiewicz 1984.

5 "On cherche beaucoup aujourd'hui en peinture ce qu'on appelle des taches: on fait une tache blanche, une tache grise, une tache jaune, c'est-à-dire on donne la prédominance dans le tableau à une note déterminée. Ainsi M. Hébert . . . a fait une tache bleue; M. Tissot, lui, a fait une tache vert-pomme dans sa charmante toile intitulée les Deux soeurs." Théophile Gautier, "Salon de 1864. VII," Le Moniteur Universel, June 17, 1864.

6 Simon 1995b, pp. 109, 185–86. This was one of the first works to shed light on what Simon called "the interplay of reciprocal influences that establishes itself between fashion and painting" at the time of "the new painting." The role of Tissot in this process is clearly underlined in her analysis.

7 See Marshall and Warner 1999, pp. 40–41; Maeder 1999, p. 83.

8 See Stéphane Guégan, "Moderne et anti-moderne: Gautier entre Manet et Tissot," in Actes du colloque Théophile Gautier et le Second Empire, Palais Impérial de Compiègne, Oct. 13–14, 2011 (forthcoming).

9 Théophile Gautier, "Salon de 1866. VI," Le Moniteur Universel, July 21, 1866.

10 See Des Cars 2007, pp. 42–43.

11 "M. Tissot a essayé des grandes proportions pour un portrait de famille. M. le marquis de M . . . , sa femme et ses deux enfants se groupent assez naturellement sur la terrasse d'un parc. La jeune femme est charmante, son bébé dans ses bras. L'autre enfant existe trop peu. En général, la peinture manque de solidité. Elle se réduit presque à un camaïeu grisâtre qu'interrompent, sans l'échauffer, quelques touches vives, insuffisantes pour créer des rapports de tons soutenus." Léon de Lagrange, "Exposition de l'union artistique," Gazette des Beaux-Arts 20 (Apr. 1866), p. 400. This translation is by Marie-Caroline Dihu.

12 See Guégan et al. 2011, pp. 26–43.

13 See Rey 2011, pp. 21–22.

14 For the accessories that "sign" the mascu-linity of the painting, see Garb 1999, pp. 106–07.

16 When Tissot exhibited Evening (cat. 91) at the inauguration of the Grosvenor Gallery in 1878, the painting really pleased the critic from the Times, who declared, "Yellow is predominant in the hair, the fan and the dress that are inspired from the latest fashion of modern dressmakers, a figure worthy of Worth" (Le jaune prédomine dans sa coiffure, sur son éventail et sur sa robe, qui s'inspirent de la toute dernière mode des couturiers modernes, une figure digne de Worth). See Matyjaszkiewicz 1984, p. 198.

CHAPTER 8
Van Zanten, "Looking Through, Across, and Up"

1 "Jusqu'à ces derniers temps, l'administration de la voirie de Paris à laisser aux constructeurs de maisons la faculté de disposer à leur gré, dans la limite de la

hauteur légale, les lignes des balcons, des corniches et des entablements. . . . // Il en résulte un grave défaut d'harmonie entre les diverses constructions des mêmes groupes. . . . // L'ordonnance générale de la ville souffre de ce défaut d'harmonie, et le devoir de l'édilité était d'y remédier. // C'est pour arriver à ce but que j'ai prescrit, dans les contrats de vente des terrains qui appartiennent à la ville, l'insertion d'une clause qui oblige les acquéreurs à donner aux maisons de chaque îlot les mêmes lignes principales de façade, de manière que les balcons continuent, les corniches et les toits soient *autant que possible* sur les mêmes plans. // Cette disposition est tellement essentielle à l'effet architectonique, que je crois à propos de l'étendre à toute reconstruction de maison opérée, soit par suite d'un percement nouveau, soit par suite d'une simple mise à l'alignement. . . . // J'examinerai moi-même avec intérêt les diverses études que vous devrez présenter suivant les cas." *Recueil des Actes* 1876, pp. 167–69.

2 There is an enormous amount of literature on Haussmannian Paris—from Georges-Eugène Haussmann, *Mémoires du baron Haussmann* (Victor-Havard, 1890–93); André Morizet, *Du vieux Paris au Paris moderne* (Hachette, 1932); and David H. Pinkney, *Napoleon III and the Rebuilding of Paris* (Princeton University Press, 1958); to Pierre Pinon, *Atlas du Paris haussmannien* (Parigramme, 2002); and Michaël Darin, *La Comédie urbaine* (InFolio, 2009). See Van Zanten 2010.

3 This phrase, from Charles Dickens's *Dombey and Son* (1846–48), refers to the transformation of Islington by the arrival of the railways. Dickens 1963, p. 251.

4 Kirk Varnedoe focused especially on his city views and problems of perspective in Varnedoe 1987.

5 Eight more arrondissements were added in 1860, for a total of twenty. At this time, the boundaries of the original twelve were redrawn.

6 See Loyer 1987; Thomine 1999; Schoonbaert 2007; and Loir 2009.

7 She later became president of the Women's Christian Temperance Union in 1879.

8 Her diary survives in the library of the Women's Christian Temperance Union, Evanston, Illinois. Frances E. Willard, Jan. 1869, *Diary #1*, p. 54, transcribed by Carolyn DeSwarte Gifford. Frances E. Willard Journal Transcriptions, Series 55/43, Northwestern University Archives, Evanston, Illinois.

9 This is discussed in Viollet-le-Duc 1872, especially p. 310, n. 1, which cites a technical handbook by Ligier.

10 Loyer 1987, p. 170.

11 See, for example, "Transformation de Paris," *Le Monde Illustrée*, Oct. 15, 1859, p. 253; and "La Nouvelle rue de Rivoli," *L'Illustration*, Oct. 28, 1854, p. 301.

12 Varnedoe 1987, pp. 136–39.

13 "Droit devant nous, sur la chaussée, était planté un brave homme d'une quarantaine d'années, au visage fatigué, à la barbe grisonnante, tenant d'une main un petit garçon et portant sur l'autre bras un petit être trop faible pour marcher. Il remplissait l'office de bonne et faisait prendre à ses enfants l'air du soir. Tous en guenilles. Ces trois visages étaient extraordinairement sérieux, et ces six yeux contemplaient fixement le café nouveau avec une admiration égale, mais nuancée diversement par l'âge.

Les yeux du père disaient: 'Que c'est beau! que c'est beau! on dirait que tout l'or du pauvre monde est venu se porter sur ces murs.'—Les yeux du petit garçon: 'Que c'est beau! que c'est beau! mais c'est une maison où peuvent seuls entrer les gens qui ne sont pas comme nous.'—Quant aux yeux du plus petit, ils étaient trop fascinés pour exprimer autre chose qu'une joie stupide et profonde." Baudelaire 1967, pp. 101–02.

14 Académie Française 1835, p. 135.

15 See Westfehling 1974.

16 Darin 2003, pp. 46–49.

17 This was not by chance, according to a letter from Haussmann to Ministre de l'Intérieur Billault explaining the layout of the quarter and the emperor's desires for it: "I have put before the Emperor the studies relative to where the avenue de l'Impératrice might open into the Place de l'Étoile. . . . // All of the principal facade of the Arc de Triomphe will be respectively visible, since it is the projection of its width that has been used as typical for an avenue. The lateral facade itself will be visible on the right, to a distance of nearly 600 meters, or half of the length of the avenue, for a person standing in the axis of the central avenue." (Je viens de placer sous les yeux de l'Empereur des études relatives au débouché de l'avenue de l'Impératrice sur la place de l'Etoile. . . . // Toute la façade principale de l'arc de Triomphe sera géometralement démasquée, puisque c'est sa largeur en projection qui a été prise pour type de l'avenue. La façade latérale elle-même sera découverte, sur la droite, jusqu'à près de 600 m. de distance, c'est à dire jusqu'à moitié longeur de l'avenue, pour une personne placée sur l'axe de la voie centrale.) Haussmann to Ministre de l'Intérieur Billault, Apr. 30, 1855. Archives du Département de la Loire-Atlantique, Nantes, fonds Billault, 20 J 20(11).

18 This sense of unsteadiness appears in the text by Joseph Méry accompanying Wibaille's image in *Le Monde Illustrée*: "Paris has followed the movements of the celestial bodies, from east to west; its civilization, ever progressive, began in the shadow of the Bastille, in the quartier des Tournelles; the Place Royale became its center, and the prophets said to it: You shall go no further. Then the Place Royale became a point on its circumference; civilization, advancing with giant steps, arrived at the Louvre, planting the surveyor's markers of the future. Along the way, it demolished the rundown hovels, the dark crossroads, the wooden cages, the plasterwork stalls, the tombs of the living, and in that fetid limbo where man, his female and his poor little ones, lived on top of one another like savage races, it has given back human dignity to all; it has given everyone air, breath, life and God's sunshine. Thus does civilization know no limits; it is the railroad of thought, and it has stations. // The Arc de Triomphe was once a boundary stone: today it is a station." (Paris suit le mouvement des corps célestes, il va de l'est à l'ouest; sa civilisation, toujours progressive, commence au quartier des Tournelles, à l'ombre de la Bastille; la Place Royale est son centre, et les prophètes lui disent: Tu n'iras pas plus loin. Puis la Place Royale devient un point de la circonférence; la civilisation, marchant à pas gigantesques, arrive au Louvre et plante ses jalons d'avenir. Chemin faisant, elle démolit les masures lépreuses, les carrefours sombres, les cages de bois, les échoppes de plâtre, les tombes des vivants, et, dans les limbes fétides, où l'homme, sa femme et ses pauvres petits s'entassaient comme des races fauves, elle rend à tous la dignité humaine; elle donne à tous l'air, la respiration, la vie et le soleil de Dieu. Ainsi la civilisation n'a plus de bornes; c'est le chemin de fer de la pensée; elle a des stations. // L'arc de Triomphe fut une borne: c'est une station aujourd'hui.) *Le Monde Illustrée*, Apr. 18, 1857, p. 6.

19 See Viollet-le-Duc 1872.

20 "C'était, dans sa fraîcheur gaie, un vaste développement d'architecture polychrome, rehaussée d'or, annonçant le vacarme et l'éclat du commerce intérieur, accrochant les yeux comme un gigantesque étalage qui aurait flambé des couleurs les plus vives." Clausen 1987, pp. 261–69. Zola was aided in his descriptions by the young architect Frantz Jourdain, who later designed the brilliantly polychrome Samaritaine department store.

21 "Mais, à mesure que les étalages montaient, s'illuminaient les tons éclatants. La frise du rez-de-chaussée déroulait des mosaïques, une guirlande de fleurs rouges et bleues, alternées avec des plaques de marbre. . . . Enfin, tout en haut, l'entablement s'épanouissait comme la floraison ardente de la façade entière, les mosaïques et des faïences reaparaissaient avec des colorations plus chaudes, le zinc des chéneaux était découpé et doré, l'acrotère alignant un peuple de statues, les grandes cités industrielles et manufacturières, qui détachaient en plein soleil leurs fines silhouettes." Ibid.

22 Théophile Gautier, "Le Nouvel Opéra: Intérieur," *Le Moniteur Universel*, May 20, 1863.

23 This is the subject of a dissertation being completed by Harry Zirnheld at Columbia University.

24 Bernard Marrey, *Louis Bonnier, 1856–1946*, (Mardaga, 1988), pp. 213ff.

25 "Quand on pense que la maison de rapport est à peu près la seule usitée dans nos rues nouvelles . . . et si l'on ajoute à ce fait l'obligation pour le constructeur de se tenir dans les règles méticuleuses extrêmement sévères quant aux saillies en avant de

l'alignement, on ne s'étonne plus de la platitude et de la monotonie d'aspect tant reprochées aux grandes habitations à loyer de notre époque. Ce système [1902] donnerait lieu à un nombre assez considérable de dispositifs qui obligeraient les architectes à trouver des solutions différentes et relativement imprévues. L'art y gagnerait autant que l'hygiène." Louis-Charles Boileau, "Rapport sur les travaux de la sous-commission du comité technique," Mar. 3, 1898, quoted in Bonnier 1903, pp. 17–20.

26 Loyer and Guéné 1987.

CHAPTER 9
Groom, "Spaces of Modernity"

1 Potvin 2009, p. 2.

2 Frances E. Willard, Dec. 31, 1868, *Diary #1*, p. 152, transcribed by Carolyn DeSwarte Gifford. Frances E. Willard Journal Transcriptions, Series 55/43, Northwestern University Archives, Evanston, Illinois.

3 Garb 1998, p. 88.

4 Pollock 1988, pp. 73, 80. See also Wolff 1988, p. 117.

5 See Edmond de Goncourt's 1860 lament, "Social life is going through a great evolution. I see women, children, households, families in this café [Eldorado]. The interior is passing away. Life turns back to become public." (La vie sociale y fait une grande évolution qui commence. Je vois des femmes, des enfants, des ménages, des familles dans ce café. L'intérieur va mourir. La vie menace de devenir publique.) Goncourt, journal entry dated Nov. 18, 1860, in *Edmond de Goncourt, Journal des Goncourt: Mémoires de la vie littéraire*, vol. 1 (G. Charpentier et Cie, 1888), p. 346, quoted in Steele 1998, p. 140, n. 9. For a brief summary of the flaneur, see Sagraves 1995, p. 88.

6 Recent X-radiographs of *The Pont de l'Europe* suggest that the dress once had a simpler silhouette without flounces. My thanks to Oscar Ghez, director of the Musée du Petit Palais, Geneva, for sharing this information.

7 For the origins of this expression, which may have been Caillebotte's own, see Sagraves 1995, p. 99, n. 36.

8 Leon de Lora (pseudonym for Louis de Fourcaud) criticized *Paris Street; Rainy Day* in comparison to the work of De Nittis. Ibid., p. 90, n. 50.

9 Ibid., p. 96.

10 Compare this to the moralizing of Frances Willard, who, upon seeing a drunk man, wrote curtly in her diary, "It was the blouse, not the broadcloth [a sign of a gentleman] that covered the back of the inebriate." Her prudery was nondiscriminatory; in the same diary entry, she concluded that "other pleasures—no less fatal—attract the better class of Frenchmen." Willard, Feb. 8, 1869, *Diary #2*, p. 45, transcribed by Carolyn DeSwarte Gifford. Frances E. Willard Journal Transcriptions, Series 55/43, Northwestern University Archives, Evanston, Illinois.

11 Forgione 2005, p. 673.

12 For Ernest May, see Distel 1990, pp. 223–29.

13 See Groom, "Edgar Degas: *The Millinery Shop*," pp. 222–23 in this volume.

14 In *La Curée*, Zola described how Aristide Rougon arrived in Paris penniless with his wife and, after several permutations, changed his last name to Saccard, "a name with which to go to prison or become a millionaire." (Oui, un nom à aller au bagne ou à gagner des millions.) Zola 1984, p. 65. For Zola's use of fashion and couturiers to express the social trajectory of Renée Saccard, see Lehman 2009, pp. 61–65. Unless otherwise noted, all translations are the author's own.

15 For Degas's view of art making, see Groom, "Edgar Degas: *The Millinery Shop*," pp. 223–24 in this volume.

16 Some of these parks, however, were more diverse than others. The Tuileries, a royal park, had stringent dress codes, allowing only appropriately well-dressed people to enter. See Thomas 2006, p. 34.

17 Wilson-Bareau 2011, p. 822.

18 See Colin Bailey's insightful commentary on the painting in Stein and Miller 2009, pp. 59–69. Bailey noted the ongoing speculation about the identity of the gentleman caller but explained that in old age Monet remembered that he was "simply a neighbor from Argenteuil" (ibid., p. 60). He added, "An early suggestion that the model for the gentleman caller was Berthe Morisot's husband, Eugène Manet, is intriguing" (ibid., p. 68, n. 4).

19 The artist Édouard Vuillard, who moved to Passy in 1906, found it still too rural, returning to the Batignolles district by 1909. See Groom 1993, pp. 169–72.

20 This is a different reading than that offered by Griselda Pollock in *Vision and Difference*, which argues that a woman's view could not be as expansive as a man's and compares this work to Manet's view of the fairground, *Exposition Universelle, 1867* (1867; Nasjonalgalleriet, Oslo). Pollock 1988, pp. 86–87.

21 Forgione 2005. For American Frances Willard, the moral outrage was walking bareheaded, not necessarily without a male escort: "Took a return omnibus at the Madeleine after dark—came from Panthéon here much later without fear. Madame says it is nonsense—the impression that ladies can not go out unattended in Paris. Certain to have masculine gender is always pleasant but when not practicable let well-behaved ladies go by themselves without fear." Willard, Dec. 26, 1868, *Diary #1*, p. 149, transcribed by Carolyn DeSwarte Gifford. Frances E. Willard Journal Transcriptions, Series 55/43, Northwestern University Archives, Evanston, Illinois.

22 During her year in Paris, Frances Willard frequently made shopping excursions with her friend Kate Jackson, noting on Dec. 24, 1868, "the gay shops on the rue de Rivoli-Rue de la Paix—and many others. Jewelry and dolls the principal attractions—though both are rivaled by the display of confectionary." She also targeted specific items

(a fur throat protector, a silk-trimmed mantle, and a spring ensemble) at the department store Au Bon Marché. Willard, Dec. 24, 1868, *Diary #1*, p. 147, transcribed by Carolyn DeSwarte Gifford. Frances E. Willard Journal Transcriptions, Series 55/43, Northwestern University Archives, Evanston, Illinois.

23 De Amicis 1879, pp. 10–11.

24 "Les boutiques du boulevard Montmartre et du boulevard des Italiens semblaient multiplier les séductions sur son passage. Que de belles choses entassées dans les vitrines. Quel défilé de produits merveilleux. Dans quel conte de fées se promenait-il donc? . . . Ce magasin de nouveautés n'était-il intéressant aussi, avec ses dentelles délicates, ses tissus brochés, ses châles indiens, tout l'art de Lyon, de Malines et de Cachemire? Pouvait-on passer indifférent devant ce spectacle?" Les Secrétaires de la Rédaction, "L'Art mobilier: Ateliers et vitrines," *La Vie Moderne* 1, 1 (Apr. 10, 1879), p. 16.

25 Beginning in the 1880s, Georges Petit invited Impressionist painters to exhibit at his yearly Expositions Internationales and held important retrospectives for Monet, Camille Pissarro, Renoir, Alfred Sisley, and James McNeill Whistler. Distel 1990, pp. 36–40. *La Vie Moderne* held one-man exhibitions for Manet, Monet, Renoir, and Sisley in its offices in 1879 and 1880. Ward 1996, p. 51. Beginning in 1880, *La Vie Moderne* published a weekly "Gazette du Chic" supporting its favorite boutiques and designers in the commercial district of the quartier de l'Opéra.

26 Starting in the 1870s, Baedeker featured the Bon Marché along with Paris's main monuments as tourist attractions. See Marcheti 2009, p. 172. For Zola, see Jean Noutous, "Histoire anecdotique de la semaine: Gros et menus faits," *La Vie Moderne* 5, 10 (Mar. 10, 1883), pp. 150–51.

27 Morisot scholar and artist Bill Scott observed: "Denis Rouart once told me a Morisot sketch (not in the old nor new catalogue) had been auctioned in Paris (probably sometime between his mother's death in 1965 and 1972) where Morisot painted a dress she wanted her dressmaker to make for her. I have never seen it (I learned about this around 1974–75) nor saw the catalogue." Bill Scott, e-mail correspondence with the author, Sept. 19, 2010. To date, I have not been able to track this sketch down.

28 Iskin suggested that Degas's millinery paintings of the 1880s could have taken place in the intimate alcoves within large department stores or small boutiques, citing Zola's descriptions of "secluded alcoves" in *Au bonheur des dames*. See Iskin 2007, p. 89.

29 D'Souza 2006, p. 132.

30 See ibid. "Already uneasy about negotiating their reputation as 'independents'—and, paradoxically, increasingly reliant on that label to generate sales—it is not unlikely that many modern life painters were eager to avoid a too-close association with the world of shopping."

31 See ibid., p. 130.

32 This pseudonym was no doubt a reference to the captain of the Nautilus in Jules Verne's futuristic *Vingt mille lieues sous les mers* (Twenty Thousand Leagues Under the Sea), published in 1870.

33 "Si vous êtes Parisien et du monde; si l'hiver vous courez les théâtres, les soirées, les raouts, les concerts spirituels et ceux qui ne le sont pas; si vous suivez les courses au printemps; si l'été vous excursionnez dans les villes d'eau et sur les plages, je prévois votre réponse: vous allez avoir un de ces haussements dédaigneux d'épaules qui semblent dire: 'Voilà un Monsieur qui pose de singulières questions!'" Nemo, "Actualités," *La Vie Moderne* 2, 24 (June 12, 1880), p. 382.

34 Frances Willard wrote in her diary, "Later we rode for miles through the delightful Bois de Boulogne—keenly noting the strange Parisians and their ways." Willard, July 26, 1868, *Diary #1*, p. 74, transcribed by Carolyn DeSwarte Gifford. Frances E. Willard Journal Transcriptions, Series 55/43, Northwestern University Archives, Evanston, Illinois.

35 Couturiers outfitted women to serve as living advertisements in upscale places like Longchamp. Simon 1995a, p. 29.

36 "Un Degas recuperato." Nicholson 1960, p. 537.

37 In 1972 William Wells connected the Dresden *Woman with Binoculars* (cat. 84) and related drawings to the painting *At the Racetrack*, in which a very similar figure was discovered in the center of the canvas under several layers of paint. Wells 1972.

38 See Druick et al. 1988, p. 263. Michael Pantazzi suggested that the model with binoculars may also have been intended for (but subsequently painted out of) *The Racecourse, Amateur Jockeys* (1875–76; Musée d'Orsay, Paris). See also ibid., pp. 266–67, cat. no. 157.

39 This work was also known as *Festivities Onboard a Ship*.

40 These same dresses appeared in a more suitable setting in *Conservatory/The Rivals* (1875–78; private collection), in which the title and narrative of the painting are clear. In *Conservatory* the same dresses are worn with a kerchief or undergarments of some kind beneath them. Matyjaszkiewicz 1984, pp. 73–76, 111.

41 *The Athenaeum* 2431 (May 30, 1874), p. 738, quoted in Marshall and Warner 1999, p. 13.

42 Delattre 2000, p. 115.

43 Clayson explored the impact of improved lighting on the art of Cassatt and other Impressionists. Critics of electric light had "concerns rang[ing] from fear of blindness and panic about surveillance to melancholy about the dispersal of the magic of the dark." Hollis Clayson, "Mary Cassatt's Lamp," paper presented at the University of Chicago Modern France Workshop, Oct. 7, 2011.

44 "Cela manquait à Paris. On l'a compris en allant au Salon, le soir. Nos passages actuels sont parfaitement ridicules. De son entresol, la Vie Moderne jette un regard de dédain sur le passage des Princes. Le passage des Panoramas n'a pas la hauteur de notre grand égout. Les passages Verdeau et Jouffroy ne sont que des couloirs, si j'osais le dire des collidors. Seule, la galerie d'Orléans a quelque majesté; mais quelle réputation! Et si loin du centre! C'est trop pour un passage seul. Il nous faudrait, au cœur de Paris, une belle et large galerie vitrée. Un boulevard couvert: deux rangées de maisons avec de riches magasins, des trottoirs spacieux, des arbres de serre, une belle chaussée pour les voitures, et par là-dessus, allant d'un toit à l'autre en développant une trajectoire hardie, un vaste toit de verre. Milan possède quelque chose d'approchant, la galerie Victor-Emmanuel, mais ce n'est qu'une rue. Paris veut plus et mieux. Il peut l'avoir. Qu'on achève le boulevard Haussmann et qu'on couvre la partie comprise entre le boulevard des Italiens et la rue Taitbout. C'est un projet. Il a du bon. Le succès des soirées au Salon le prouve. On demande un conseiller municipal pour le proposer à qui de droit." "Le Salon le soir," *La Vie Moderne* 1, 13 (July 3, 1879), pp. 205–06.

45 Iskin 2007, pp. 32–33.

46 For more on appropriate jewelry, see Steele 1998, p. 171. On the difference between matrons and unmarried young women in fashion, see ibid., p. 157.

47 "Si spirituelle et si animée, qui semble un vrai tour de force avec ses lampes lumineuses, ses femmes en toilette et ses hommes en habit noir." Castagnary 1892, vol. 2, p. 356.

48 "Un habit, c'est laid; deux habits, c'est plus laid. Mais rien ne dépasse en laideur la réunion de plusieurs milliers d'habits noirs. Je me suis demandé parfois par suite de quelle aberration inexplicable notre génération osait se montrer sous ce funèbre costume dans le merveilleux décor du palais de Charles Garnier. L'escalier de l'Opéra, avec ses ors, ses marbres, ses onyx, appelle des splendeurs de toilette que notre uniforme mondain ne lui donnera jamais." Saint-Juirs, "Chronique Parisienne," *La Vie Moderne* 4, 3 (Jan. 21, 1882), p. 34.

49 See, especially, G. Dargenty, "Exposition de J. J. Tissot," *Le Courrier d'Art*, Apr. 24, 1885, p. 200, which complained: "How exciting this title is! But it involves its author too much, this is too heavy to carry when one doesn't have the shoulders of [Paul] Gavarni or [Honoré] Daumier. . . . A woman should be judged from her shoes to her hat exclusively, just as one would measure a fish between its tail and its head." (Bien affriolant ce titre! mais il engage trop à fond l'auteur. Il est lourd à porter, quand on n'a point les épaules de Gavarni ou de Daumier. . . . Il faut juger des femmes depuis la chaussure jusqu'à la coiffure exclusivement, à peu près comme on mesure le poisson entre queue et tête.)

50 See Lochnan 1999, p. 11; Wood 1986, p. 150. The fact that these were shown under glass might also have increased their appraisal as specimens of society and fashion.

51 Although Morisot continued to paint contemporary fashion, mostly using her daughter as a model, shortly before her death in 1894, during her fall trip to Brittany, she acquired regional costumes that she brought to Paris for her models to wear. Bill Scott, e-mail correspondence with the author, Sept. 19, 2010.

Ribeiro, "Gustave Caillebotte: *Paris Street; Rainy Day*"

1 "Un art nouveau, aussi élevé que l'ancien, un art tout contemporain, approprié aux besoins de notre temps." Huysmans 1883, p. 87. Unless otherwise noted, all translations are the author's own.

2 Herbert 1988, p. 13. As Herbert remarked, *Paris Street; Rainy Day* pays homage to Haussmann (ibid., p. 20).

3 Varnedoe 1987, p. 90. Apropos *Paris Street; Rainy Day* and Caillebotte's other great masterpiece, *The Pont de l'Europe* (cat. 80), which was exhibited with it in 1877, Varnedoe noted that historians now have to examine "the histories of iron bridges, railroad stations, new boulevards and building types, and urbanism in general"; see Varnedoe 1995, p. 14.

4 *Paris Street; Rainy Day* excludes almost any detail of the shops that represent the consumer culture of modern Paris; the only sign is the barely visible "pharmacie" at the apex of the large building that dominates the painting. See Iskin 2007, pp. 116–17.

5 Quoted in Berhaut 1978, p. 44. Robert Rosenblum had similar thoughts, describing the painting as "scientifically predetermined . . . academically precise . . . and oddly personal"; see Rosenblum 1977, p. 50.

6 Blanc 1877, pp. 14–15. He might also have been making a specific point about Caillebotte's painting by stating that when an architect makes "several streets converge round a central space, [he] decorates a great town magnificently, and gives it importance"; see ibid., p. 39.

7 "Dans nos villes, la rue est grise. . . . gris sont les murs, qui ont reçu grêle, pluie et neige; gris le pavé; gris l'air ambient, chargé de vapeurs et de brouillards"; "dans nos climats gris, toute couleur, portée sur la rue, doit s'assoupir et moduler sans force." Prévost 1884, p. 71.

8 *Le Radical*, Apr. 8, 1877; quoted in Varnedoe 1987, p. 188.

9 "Enfin, je nommerai M. Caillebotte, un jeune peintre du plus beau courage et qui ne recule pas devant les sujets modernes grandeur nature." *Le Sémaphore de Marseille*, Apr. 19, 1877; quoted in Moffett 1986, p. 209. Zola was less enthusiastic about Caillebotte's work at the Second Impressionist Exhibition, in 1876, claiming his paintings were "entirely anti-artistic, clear as glass, bourgeois" (C'est une peinture tout à fait anti-artistique, une peinture claire comme le verre, bourgeoise); Émile Zola, *Lettres de Paris*, June 1876, quoted in Smith 1995, p. 41.

10 On the sudden death of Caillebotte in the spring of 1894, Camille Pissarro wrote, "He is one we can really mourn, he was good and generous, and a painter of talent to boot" (En voilà un que nous pouvons pleurer, il a été bon et généreux et, ce qui ne gâte rien, un peintre de talent); see Pissarro 1943, p. 235. Caillebotte donated many of the works of his contemporaries that he collected to the French state.

11 See Galassi 1987. Paul Sébillot, in an Apr. 7, 1877, article in *Le Bien Public*, said that the painting presented "an idea of what photography will become when the means are found to reproduce colors with their full intensity and subtlety" (Cela donne l'idée de ce que sera la photographie quand on aura trouvé le moyen de reproduire les couleurs avec leur intensité et leur finesse). Paul Sébillot, "L'Exposition des impressionnistes," *Le Bien Public*, Apr. 7, 1877, p. 2, quoted in Moffett 1986, p. 209.

12 Quoted in Varnedoe 1987, p. 188.

13 This statement was ironic because it was made about the antihero Leonard Bast, a shabby, impoverished lower-middle-class clerk who is desirous of improving himself "by means of Literature and Art" (Forster, while mocking him, is also sympathetic to his character). The loss of his umbrella (taken by mistake at a concert of classical music) is symbolic of his decline in fortune and his failure in life. Such a state might be seen in the man on the left of *Paris Street; Rainy Day*, to the right of the carriage wheels: huddled in his coat, the awkwardness of his gait is compounded by his lack of an umbrella, the possession of which gives a measured pace and degree of poise to the other men.

14 A contrary view is expressed in Fried 2002, p. 91; taking issue with writers who see the umbrella as "unsociable," Michael Fried found it symbolic of "the sharing or merging of individual lifeworlds," an argument this author does not find altogether convincing.

15 *La Chronique des Arts et de la Curiosité*, Apr. 14, 1877. "Il n'y a aucun flocon sur les habits." Thomas Grimm, "Les Impressionnistes," *Le Petit Journal*, Apr. 7, 1877, p. 1. Both quoted in Moffett 1986, pp. 208–09.

16 "On n'a pas voulu y voir non plus la recherché d'atmosphère et de lumière." Georges Rivière, "L'Exposition des impressionnistes," *L'Impressioniste*, Apr. 14, 1877, pp. 1, 4, 6, quoted in Moffett 1986, p. 209.

17 Fried 2002, p. 94.

18 Blanc 1877, p. 36.

19 Herbert 1991, p. 34. The dandy was, as Walter Benjamin noted, perceptive and uninvolved, the product of modern life.

20 Perrot 1994, p. 9.

21 "Sie ist Nachahmung eines gegebenen Musters und genügt damit dem Bedürfnis nach sozialer Anlehnung, sie führt den Einzelnen auf die Bahn, die Alle gehen, sie gibt ein Allgemeines, das das Verhalten jedes Einzelnen zu einem bloßen Beispiel macht." Georg Simmel, *Philosophische Kultur: Gesammelte Essais* (W. Klinkhardt, 1911), p. 32; translated in Simmel 1997,

p. 189. Simmel, writing at a time when the middle class seemed all-important ("inherently so much more variable, so much more restless in its rhythms"), declared that as a class it had more influence on dress than the upper and working classes, which he characterized as conservative (ibid., p. 202). There is something to be said for this theory, but precisely how this bourgeois attribute of variety was translated into dress was not expanded on by Simmel.

22 Huysmans 1883, p. 94.

23 Blanc 1877, p. 67.

24 Flügel 1950, p. 112. For what many historians of menswear view as Flügel's oversimplistic argument, see, for example, Breward 1999.

25 Byrde 1979, p. 14.

26 Blanc 1877, pp. 97, 119.

27 Hollander 1994, p. 113.

28 *Journal des Tailleurs: The Cutter's Monthly Journal of London and Paris Fashions* (June 1877), p. 21.

29 *Journal des Tailleurs: The Cutter's Monthly Journal of London and Paris Fashions* (Oct. 1876), p. 38.

30 Perrot 1994, p. 115.

31 *Journal des Tailleurs: The Cutter's Monthly Journal of London and Paris Fashions* (Nov. 1876), p. 41; (Apr. 1877), p. 13.

32 Blanc 1877, p. 122.

33 Ibid., p. 79.

34 Ibid., pp. 93, 96. In the 1850s, the top hat began to be made in silk—hatter's plush, "a very fine silk shag applied to the felt to give it a nap"—instead of beaver; see Byrde 1979, p. 184.

35 "Absurde et hideux." Prévost 1884, p. 105. Prévost claimed that the top hat also made the head look too big and the face insignificant.

36 Perrot 1994, p. 122.

37 Caillebotte's *Rower in a Top Hat* of 1877 (private collection) presents a somewhat incongruous appearance in his top hat, but he is actually a middle-class man dressed in his city clothes, enjoying perhaps an impromptu row as relaxation from his work.

38 *Journal des Modes* (Dec. 1876), p. 6.

39 *Journal des Modes* (Oct. 1876), p. 5; (Apr. 1877), p. 5.

40 *Journal des Modes* (June 1878), p. 5. In May 1878, when the Exposition Universelle opened in Paris in muddy weather, *La Vie Parisienne* published sketches of the different ways in which women could cope with their trains, some of which were modest, while others were more revealing.

41 Like her male companion, this attractive woman's identity is unknown. One of the preliminary figure studies for the painting (Distel et al. 1995, no. 43) is titled *Clotilde*. Could this be the name of the model used by Caillebotte to work out the details of dress of the main female figure? This seems to be Berhaut's suggestion in Berhaut 1978, p. 98. But it could equally (more possibly perhaps) be a study for one of the two women to the left of the flaneur's head.

42 Prévost 1884, p. 365.

43 Blanc 1877, p. 143.

44 Challamel 1881. Popular furs included

marmot and skunk (ibid., p. 278); sable, always fashionable, remained too expensive except for the wealthy elite (ibid., p. 283). On the influence of the Russo-Turkish war, see ibid., p. 289.

45 Blanc 1877, p. 154.

46 Perrot 1994, p. 91. An English publication by William and George Audsley suggested that the "Pale Brunette type" with pale skin should wear dark colors, especially near the face and on the head; see Audsley and Audsley 1863, p. 17.

47 "En nuance Rachel pour les brunes." Huysmans 1883, p. 96. The color Rachel was named after either the famous French actress Elisa Rachel Félix (1821–1858) or the infamous confidence trickster and cosmetician Rachel Leverson (1806 [?]–1880).

48 Marni Kessler presented a rather overwrought argument that the veil serves to control a woman's "exposure to the city, the male gaze, and even her sexuality" in Kessler 2006a, p. 59.

49 Blanc 1877, p. 115.

50 "Avec un dos nous voulons que se révèle un tempérament, un âge, un état social"; "Des mains qu'on tient dans les poches pourront être éloquentes." Duranty 1988, p. 35.

51 Varnedoe 1987, p. 19.

52 The Apr. 8, 1877, issue of *Le Radical* commented that it was Caillebotte's great talent to give an extraordinary intensity of life to the people depicted in *Paris Street; Rainy Day* ("c'est le grand talent de M. Caillebotte de donner une intensité de vie extraordinaire à tous les personnages de sa composition"); quoted in Varnedoe 1987, p. 187.

53 "Il peut ajouter ici, diminuer là, suivant son caprice ou sa fantaisie; il peut sacrifier un détail à l'ensemble, ou simplifier l'ensemble pour mettre en relief un détail heureux." Prévost 1884, p. 2.

54 Herbert 1991, p. 178.

55 Challamel 1881, p. 303.

CHAPTER 10
McCauley, "Photography, Fashion, and the Cult of Appearances"

1 "Chacun pose, / Pour sa cause; / Il ne s'agit que d'oser. / C'est la vie; / La manie: / Poser et faire poser." Mayer 1859. Unless otherwise noted, all translations are by the author, with the assistance of Marie-Caroline Dihu.

2 "Le paraître est la passion dominante des français." Rimsky-Korsakow 1863, p. 187.

3 Engraved views of clothing, usually documenting the desired presentation of "persons of quality," were produced by the early seventeenth century. Their insertion into specialized magazines devoted to fashion occurred during the reign of Louis XVI (1774–92). See Gaudriault 1988 for an inventory of French fashion plates produced between 1610 and 1815.

4 The nature of the contracts between sitters and photographers varied from studio to studio. In some cases, sitters were given free portraits and sittings if the photographer

was allowed to sell the resulting pictures. Nadar, soliciting photographic portraits to serve as the basis for the faces in the second edition of his large comic lithograph of Parisian notables, called the *Panthéon*, formally asked sitters to cede the rights to their images to him. Novelist Alexandre Dumas, in response to a letter asking his permission to publish a photograph of him, jokingly wrote, "I authorize my friend Nadar to make me as ugly as possible" (J'authorise mon ami Nadar à me faire aussi laid que possible). Dumas to Nadar, Apr. 22, 1858. Nadar Archives, N.A.F. 24269, Bibliothèque Nationale de France. Similarly, the playwright Clairville (Louis-François Nicolae) responded, "I authorize M. Nadar to publish my portrait in his new gallery entitled *Galerie contemporaine de Nadar*" (J'autorise M. Nadar à publier mon portait dans sa nouvelle galerie intitulée *Les Contemporains de Nadar*.) Clairville to Nadar, Aug. 27, 1858. Nadar Archives, N.A.F. 24265, Bibliothèque Nationale de France. A lawsuit was lodged by Dumas in 1867 against the photographic firm Liébert, which had sold compromising cartes de visite of the aging writer in his shirtsleeves with a scantily clad young equestrienne, Adah Menken, sitting on his lap and embracing him. The court decided that, since Dumas had paid nothing for the pictures and had implicitly authorized their sale, he was due no recompense. On appeal the judge ruled that, because Dumas no longer authorized the photographs, they must be withdrawn upon his payment of one hundred francs to compensate Liébert for his labor. "Portraits photographiques—Autorisation tacite de publication—Retrait de l'authorisation—Dommage-intérêts—Cour de Paris, 25 mai 1867," *Annales de la Propriété* 1439 (1867), pp. 249–50.

5 The absence of scholarly literature on the early history of fashion photography has resulted in confusion over the definition of the genre and its origins. Contrary to the assertions of Hall-Duncan 1979, commercial portraits such as cartes de visite commissioned by an individual and subsequently collected by friends or used as advertising or promotion for an entertainer cannot be considered fashion photographs. A true "fashion photograph" was one whose main purpose was to sell or market clothing, whether that image was commissioned by a clothing manufacturer or was a repurposed private portrait with the name of the dressmaker included in the caption or accompanying article. According to Brigitte Scart, the first photomechanical reproduction of a commercial portrait in the fashion press appeared in 1880 in *L'Art et la Mode* (by the photographic firm Walery). Scart conceded that it was only after 1891 that photographs regularly illustrated the fashion magazine *La Mode Pratique* and that fashion photography effectively dates to the twentieth century. See Scart 1977, p. 5.

6 Nadar and others experimented with artificial lighting for photography in the early 1860s. Even after the introduction of electric lighting in the 1870s, however, commercial portraits continued to be shot in natural light throughout the nineteenth century.

7 Disdéri 1862, pp. 265–74. Another writer who included unusual detail on posing and the importance of color was the American photographer Marcus Root in Root 1864. Although Root and Disdéri had previous experience as painters, many photographers borrowed advice from commercial guides to portrait painting and undoubtedly hired ghostwriters to style their texts.

8 It is difficult to measure the responses of elite sitters to their oil or photographic portraits. Clearly, the fact that the rich and famous continued to commission oils at the same time that they sat for and collected mass-produced commercial photographic portraits complicates any conventional division between high and low art. Cartes formed part of a social discourse and were more contemporary than paintings, shown in albums and exchanged with friends; they also allowed for more play and experimentation with poses and dress. Depending on the prestige of the artist and the size of the canvas, an oil portrait represented a substantial investment and was hung in a prominent place in the home. Thus, it presumably had to be a more flattering and formal likeness than a carte, distilling the sitter's essential traits through his or her lifetime. Obviously, the styles of oil portraits vary with time and cultures, but their persistence into the post-photographic era hinges on the recognition that they function differently as representations, historic records, and signifiers of wealth and social status than do photographs. For an analysis of the stylistic sources of cartes and their relationships to conventional portraits, see McCauley 1985.

9 Marguerite-Eugénie-Mathilde Marcel (1846–1877)—the daughter of the eminent notary, antiquarian, and recipient of the Légion d'honneur Eugène Marcel—married Louis Joachim Gaudibert (1838–1870) on July 11, 1864, in Le Havre. Monet, desperate for funds and living in Le Havre with his family, with his mistress and young son in a separate apartment, received a commission from Gaudibert for portraits of himself, his wife, and his young son in the fall of 1868. The portrait of Monsieur Gaudibert has disappeared, but that of Madame Gaudibert belonged to and was paid for by her family (for the reportedly modest sum of 130 francs, in comparison with the 800 francs that Arsène Houssaye paid for *Camille* [cat. 16] in Oct. 1868); at some point, it ended up in the possession of Madame Gaudibert's sister, Gabrielle-Mathilde-Léopoldine Lamotte. According to Wildenstein 1996, the portrait was painted in the Château des Ardennes-Saint-Louis. This property in the village of Montivilliers seems to have become the permanent residence of Eugène Marcel after his retirement from his notarial practice in Le Havre and was his country house at the time the painting was made. Marcel could have known Monet, who briefly studied under François-Charles Ochard at the Collège du Havre before dropping out without receiving a baccalaureate, because the notary served on the bureau of administration for the high school between 1857 and 1865. On the life of Eugène Marcel, see Anthiaume 1905, pp. 364–65. On the history of the commission, see Wildenstein 1996, p. 59.

10 "En y feuilletant les albums, en examinant les portraits exposés, en interrogeant sur la valeur artistique, sur le caractère propre à chacun d'eux, il ait pu apprécier et saisir les poses et l'expression qui lui conviennent le mieux." Ken 1864, p. 208.

11 "Saisissez-moi bien! Il faudra me prendre au moment où, en me voyant sortir des Folies-Nouvelles, une jeune dame s'écrie: —Ah! Qu'il est donc bien, ce monsieur!" Marcelin, "Fantaisies photographiques," *Petit Journal pour Rire* 130 (1858), p. 3.

12 "Donnez-m'en vingt-cinq de chaque." Pierre [Hippolyte de Villemessant], "Paris au jour le jour," *Le Figaro*, May 27, 1860, p. 3.

13 Goncourt and Goncourt 1956, p. 775 (entry for July 29, 1860).

14 "Choses et autres," *Petit Journal pour Rire* 272 (1861).

15 Outrage over the display of photographs of entertainers occurred frequently during the 1860s. For example, Hippolyte Taine, upon arriving in Rome, found that "photographs of dancers and famous *lorettes* from Paris were displayed here in shop windows; I have seen everywhere overseas that these women principally define our reputation." (Les photographies des danseuses et des lorettes illustres de Paris sont ici affichées aux vitres; j'ai vu partout à l'étranger que ces dames faisaient notre principale réputation.) Taine 1866, p. 23.

16 The best analyses of Castiglione's obsession with photographic portraiture are Solomon-Godeau 1986 and Apraxine and Demange 2000.

17 Constantin 1859, pp. 18–20, 44–45; Frémy 1868, p. 31.

18 *Le Savoir-Vivre* 1884, pp. 54–55. Etiquette books normally lamented the decline of polite behavior in France and advocated deportments more formal than actual behavior. Their intended audiences were young people, parvenus, and nouveaux riches, who might be insecure about how to negotiate social situations that were inconsistent with their upbringings.

19 The model for these genre views included caricatures, particularly works by Paul Gavarni, Édouard de Beaumont, or Edmond Morin that featured pretty girls or elegant couples in conversation. One series of stereos marketed by the firm Chevalier in 1859 even included printed captions of dialogue spoken by the characters, akin to the slangy repartee of *lorettes* and their lovers appended to Gavarni's caricatures. For reproductions of samples of these stereoscopic views, see Pellerin 1995, pp. 68–81.

20 Baudelaire 1980, p. 791.

21 Ibid., pp. 746–50.

22 "Un artiste amateur, M. Delessert, photographia un groupe de femmes au milieu desquelles se tenait l'Impératrice. Ces messieurs eurent leur tour. Les épreuves tirées, tous les personnages, sans exception, furent trouvés laids." Baroche 1921, p. 45 (entry for Nov. 2, 1856).

23 "Allons donc, Madame, mettez-vous bien vite une paire de bottes, un chapeau en tuyau de cheminée, un cigare à la bouche, un lorgnet dans l'oeil gauche, et faites-vous photographier par Disdéri comme type de la fashion élégante de 1855." Vicomtesse de Renneville, "Les Modes de la saison," L'Artiste 15 (July 29, 1855), p. 181. Seemingly neutral fashion reviews were often paid advertisements in disguise, known as "réclames," which filled the back pages of newspapers. W. Blanchard Jerrold singled out the Viscomtesse de Renneville's puff pieces for particular criticism in Jerrold 1864, pp. 96–104.

24 "Un portrait . . . doit avoir, s'il est possible, l'exactitude d'une photographie; il doit, de plus que la photographie, exprimer la vie, la pensée intime, habituelle du sujet. Tandis que la lumière non pensante, instantanée dans son action, ne peut donner qu'une image brusquement arrêtée du modèle, l'artiste, plus habile que la lumière, parce qu'il réfléchit et qu'il sent, fera passer dans sa figure un sentiment prolongé." Proudhon 1865, p. 147.

25 "La plus belle photographie, fût-elle coloriée par le soleil en personne, obtiendrait moins de succès en exposition publique que les peintures idéalisées de M. Dubufe et de M. Winterhalter." About 1858, p. 33.

26 "Le daguerréotype, est venu démontrer toute la distance qui sépare, même sous le rapport de la ressemblance, un véritable portrait de la reproduction mathémathique des formes d'une tête dans tous ses détails." Laprade 1861, pp. 24–25.

27 Ibid., p. 139.

28 Baudelaire 1980, p. 688.

29 "Le XIXe siècle n'est pas si laid qu'on veut bien le dire. Nos toilettes de femmes sont charmantes, légères et frissonnantes, ondoyant autour du corps, caressant les formes du corsage. Quant au costume masculin, on lui reproche ses nuances sombres et sans éclat; mais, s'il faut le répéter, il n'y a pas de couleurs dans la nature, il y a de la lumière. Qu'un grande peintre, pas un prétendu coloriste, un lumiériste (si j'ose forger ce mot barbare) aborde hardiment la vie moderne, et s'il est vraiment peintre, s'il n'a pas seulement de vagues aspirations de bien faire, s'il ne se moque pas de son sujet, s'il a de l'audace et un peu de génie, il fera un chef-d'oeuvre avec nos habits noirs, nos paletots, et nos robes, avec nos châles, avec le costume de l'homme et de la femme au XIXe siècle." Chesneau 1864, pp. 175–76.

30 "Il faut compter aussi l'influence de la mode, qui dénature l'originalité personnelle, efface les particularités et les traits excentriques, use les angles où il y en avait, effile des pointes où il n'y en avait pas, creuse les

formes en un endroit, les arrondit où il faut, éteint ou ravive les couleurs, blanchit la peau, noircit les cheveux, à moins qu'elle ne les blondisse ou ne les poudre d'or et d'argent, garrotte les épaules, gonfle les coudes, allonge les doigts, étrécit les pieds, serre la taille, la descend jusqu'au nombril ou la remonte jusque sous les aisselles et, une fois le mannequin refait du haut en bas, l'emprisonne dans un fourreau, un panier, une cage, et le revêt des mêmes étoffes, taillées sur les mêmes patrons. Cela s'est vu de tout temps, mais surtout dans les époques de décadence." Bürger 1870, vol. 1, p. 139.

31 "Soignez la ressemblance de la robe au moins autant que celle de la figure; rendez-en avec scrupule, avec respect, la couleur, le dessin, la coupe, les fleurs, la richesse; surpassez-vous dans les dentelles, la gaze et les bijoux, et vous serez un grand peintre." Fournel 1858, p. 389.

32 Castagnary 1892, vol. 2, p. 24.

33 Duranty 1998, p. 582.

CHAPTER 11
Tétart–Vittu, "Shops versus Department Stores"

1 Zola 1986.

2 For example, Les Grands Magasins du Louvre department store was located in the same building as the Hôtel du Louvre. La Société du Louvre, set up by Faré, Chauchard, Hériot et Cie on Mar. 26, 1855, was a product of the enterprise Compagnie anonyme de l'hôtel et des immeubles de la rue de Rivoli, whose principal stockholders were the Pereire brothers. See Da Silveira 1995.

3 Musée de la Mode 1992, pp. 16–29.

4 This became all the more appropriate as shops took the titles of plays or operas as names, used pasteboard scenery to create window displays, and piped gas into these displays to provide lighting for the scene.

5 These are located in the Cabinet des Estampes du Musée Carnavalet.

6 Girardin's chronicles (published in 1847) appeared in Le Courrier de paris and La Presse under the pseudonym Vicomte de Launay. See Girardin 1986.

7 Gaillard 1977, pp. 525–58, 621–31. An elevator was installed at La Ville de Saint Denis in 1869, Au Printemps in 1874, and Les Grands Magasins du Louvre in 1876.

8 In Jan. 1884, Duluc Sisters Couture and Félicien Rops moved to 19 and 21, rue de Grammont, to the former Choiseul mansion. Rops commented: "The apartment at 19 . . . is superb, its reception room painted by Paillet, a student of Boucher, with wooden paneling from the same period." (L'appartement du 19 . . . est superbe, le salon peint par Paillet l'élève de Boucher avec les boiseries du temps.) Rops to Léon Dammartin, Oct. 31, 1883, Brussels, bibl. royale Albert Ier, Mss. II 6655 VII 468.

9 "Des costumes ravissants qui n'on rien à envier à ceux de Worth"; "Un salon Renaissance, aux boiseries artistiquement sculptées, encadrant d'énormes glaces de Venise." Musée de la Mode 1992, p. 24.

10 "Toute la vie moderne est à étudier encore, bals, vie familière, artisane et bourgeoise, les magasins." Simon 1995b, p. 231, n. 202.

11 "Avant tout je voudrais peindre notre époque. Quand je dis qu'un peintre doit être de son temps, je crois qu'il doit peindre surtout le caractère avant de peindre les costumes et les accessoires—On ne me persuadera jamais qu'une dame lisant une lettre (en robe jaune), qu'une demoiselle contemplant un magot japonais (en robe bleue), qu'une bonne personne (en robe de velours) s'admirant dans une glace, constituent les plus palpitants et les plus intéressants de la modernité—d'autant qu'elles n'ont pas été prises sur le fait, mais sont amenées à cent sous la séance dans l'atelier, revêtues de la robe jaune, bleue, rose, blanche ou de velours pour représenter les femmes du monde pour les gens qui n'en n'ont jamais vues—Je veux bien qu'en revanche les robes soient des merveilles d'exécution—mais la vie moderne, la modernité où est-elle?" Basseporte 1998, pp. 151–53. Edmond Picard (1836–1924) was a major celebrity in Brussels and one of the originators of L'Art Moderne: Revue des arts et de la littérature in 1881. This may explain why the Rops text circulated in this artistic milieu.

Groom, "Edgar Degas: The Millinery Shop"

1 "La source de l'ornement. Penser à un traité d'ornement pour les femmes ou par les femmes, d'après leur manière d'observer, de combiner, de sentir leur toilette et toutes choses. Elles comparent journellement plus que les homes mille choses visibles les unes aux autres." Degas, notebook 23, pp. 46–47 (dated 1868–72); published in Reff 1976, vol. 1, pp. 117–18; translated in Iskin 2007, p. 60. This essay would not have been possible without the insights and advice of Douglas Druick, whose appointment as President and Eloise W. Martin Director of the Art Institute of Chicago in Aug. 2011 prevented his involvement as an author for this catalogue.

2 See Guérin 1945, p. 147, n. 1, in which Guérin recounted Madame Straus's comment that Degas often accompanied her to fittings at couturiers because, according to the artist, he enjoyed seeing "the red hands of the young women who hold the pins" (les mains rouges de la petite fille qui tient les épingles). Guérin 1945, p. 144, n.1 See also Druick et al. 1988, p. 606.

3 As Marie Simon noted, the irrevocable rules of fashion required that women did not bare their heads or shoulders except at dinner parties and the theater. Simon 1995a, p. 25.

4 Degas showed his unidentified modiste in 1876 (no. 57), but the fact that one critic referred to it as "atelier des modistes" and another commented on "their" ugliness suggests that there was more than one figure in the painting. See Berson 1996, p. 36. Although scholars agree on the number of works by Degas on this subject

(four oil paintings, seventeen pastels, and one unidentified *modiste* shown in 1876), they are not in accord on whether the subject was treated in 1882–98 or 1881–1910.

5 See Iskin 2007, p. 98. The earliest reference to the painting is in the Durand-Ruel stockbooks; the gallery acquired it from the artist on Feb. 22, 1913, for 50,000 francs. The painting was then sent to the New York office of Durand-Ruel and sold to Mrs. Lewis Larned Coburn (d. 1932) on Jan. 19, 1932. Durand-Ruel stockbook, no. 4114, Durand-Ruel Archives. The Durand-Ruel stockbook reference is contradicted by a loan receipt referring to "Millinery Shop, 1882" and dated Jan. 23, 1930. Curatorial Object File, Art Institute of Chicago.

6 Iskin 2007, p. 95.

7 Brettell and McCullagh 1984, pp. 131–32. I am indebted to Frank Zuccari, Grainger Executive Director of Conservation at the Art Institute, who recently reexamined the painting using X-radiography and infrared reflectography. His findings, especially on the painting's relationship to the three drawings related to the final composition, will be published in a future study.

8 See Iskin 2007, pp. 108–10.

9 Aileen Ribeiro found that the dress "although restrained in color, is quite sophisticated in cut. . . . I think it's a fine, greenish day dress, suitable for morning." Ribeiro, e-mail correspondence with the author, Dec. 19, 2011.

10 Ibid.

11 Lipton 1986, p. 153, assumes that the glove is a sewing glove. Coming to the same conclusion, Tinterow noted that no other shopgirl in the series wears gloves; Druick et al. 1988, p. 400.

12 Brettell and McCullagh 1984, p. 131.

13 Gustave Geffroy reviewed Degas's bathers at the Eighth Impressionist Exhibition: "Anxious/uneasy about lines that one doesn't try to arrange, that one doesn't even search to see, he wanted to paint the woman who doesn't know she is looked at, as one would see her, hidden by a curtain or through a key hole." (Inquiet des lignes qu'on ne cherche pas à fixer, qu'on ne cherche pas même à voir, il a voulu peindre la femme qui ne se sait pas regardée, telle qu'on la verrait, cache par un Rideau, ou par le trou d'une serrure.) Gustave Geffroy, "M. Degas," *La Justice*, May 26, 1886, p. 2, translated in Kendall and Pollock 1991, p. 141.

14 Iskin 2007, p. 71.

15 "Degas, avec ses pastels, une femme essayant un chapeau chez sa modiste, et ses petites modistes, d'excellente tenue, de juste observation, mais pas bien hardis, pas très nouveaux." Jules Christophe, "Chronique: Rue Lafitte, no. 1," *Journal des Artistes*, June 13, 1886, p. 193.

16 Clayson 1991, pp. 118–21; Lipton 1986, p. 163.

17 *Mémoires* 1866. The book tells how apprentices at a milliner's shop are sold by its owner to rich and powerful men, whose mistresses they are forced to become. The whole book is about the shame they feel for being kept women.

18 See, for example, Combe 1956, plate VI.

19 Moffett 1986, p. 431.

20 Lipton 1986, p. 161. For other drawings of a milliner by Renoir, see Bailey 2012, pp. 147–48, figs. 7, 9, 11. Although Renoir did not show milliners at work, he made a number of works on paper of this type, presumably for reproduction in *La Vie Moderne*. For images and a full discussion of these works, see Bailey 2012, pp. 143–48, figs. 7–11.

21 Bailey 2012, p. 145.

22 Brown 1994, p. 14, identifies Degas's first use of the term *articles* in a c. 1879 letter to Félix Bracquemond, referring to "j'aurai fini deux articles." Degas also used it to designate art made by his friends, as in a letter to Jules Cazin referring to "vos articles." See Guérin 1945, pp. 59, 61, 202.

23 Distel et al. 1995, p. 232.

24 Reff 1968, p. 91. Interestingly, "remaindered or returned" was an innovation of large department stores, whose enlightened policies (fixed prices, refunds for exchanges, sales) were not necessarily translatable to artist's studio negotiations.

25 According to Iskin, Degas's millinery shop works appealed to men because they offered an intimate opportunity for observation. In turn, the sumptuous depictions of decorated hats appealed to women, and the artful arrangement and painterly execution was geared toward collectors. See Iskin 2007, pp. 104–05.

26 Distel et al. 1995, p. 250.

27 Iskin 2007, p. 76.

28 For the notion of milliners as creators as well as *vendeuses*, see Gamber 1997, p. 30.

29 Druick et al. 1988, p. 377.

30 Breward 1994, pp. 75–76.

31 "Il passa une journée en extase devant des étoffes que déroulait devant lui Mme Derot. Le lendemain, s'étaient les chapeaux d'une modiste célèbre, Mme Virot, qui l'enthousiasmaient. Il voulait composer une toilette pour Jeanne, qui est devenue depuis au théâtre Mlle Demarsy et après laquelle il a peint cette toile exquise du *Printemps*." Antonin Proust, "Edouard Manet: Souvenirs (1)," *La Revue Blanche*, Mar. 15, 1897, p. 310. The translation of this quotation is the author's own.

32 "Elevé dans un monde elegant, il n'ose s'extasie devant ces magasins des modistes de la rue de la Paix, les jolies dentelles, ces fameux tours-de-main de nos Parisiennes, pour vous torcher un chapeau extravagant." Paul Gauguin, "Paul Gauguin," *Mercure de France*, vol. 48 (Oct.–Dec. 1903), pp. 120–21, translated in Iskin 2007, p. 102.

33 I am grateful to Douglas Druick, who was the first to note the analogies between the painter and the collector Charles Ephrussi, the editor of the *Gazette des Beaux-Arts*, whose collection and installation of netsuke over a period of one hundred years is the subject of *The Hare with Amber Eyes*. In describing the way Ephrussi arranged his netsuke, De Waal wrote, "A collector friend of Charles is described in the act of placing Japanese objects in a vitrine 'like a painter applying a stroke to a canvas.' The harmony is complete and the refinement exquisite." De Waal 2011, p. 77.

34 Ibid., p. 78. I am again indebted to Douglas Druick for making the link between the opening of the vitrine and the selection of a hat from the shelf.

35 Iskin 2007, p. 101.

36 "Les coquins créent des rayons de fleurs, de modes, de parfumerie, de cordonnerie, que sais-je encore?" Zola 1883, p. 447, translated in Zola 2008, p. 371.

37 "Et elle avait passé une heure aux modes, installée dans un salon neuf du premier étage, faisant vider les armoires, prenant les chapeaux sur les champignons de palissandre qui garnissaient deux tables, les essayant tous, à elle et à sa fille, les chapeaux blancs, les capotes blanches, les toques blanches. Puis, elle était redescendue à la cordonnerie, au fond d'une galerie du rez-de-chaussée, derrière les cravates, un comptoir ouvert de ce jour-là, dont elle avait bouleversé les vitrines, prise de désirs maladifs devant les mules de soie blanche garnies de cygne, les souliers et les bottines de satin blanc montés sur de grands talons Louis XVI." Zola 1883, pp. 501–02, translated in Zola 2008, p. 416. I am grateful to department research associate Marina Kliger for making me aware of this passage in Zola's novel.

38 On the popularity of the slip-on style known as the court or pump, see Mitchell 1997, p. 34. White slippers were worn by brides beginning in the mid-nineteenth century; see Caovilla 1998, p. 98.

39 Indeed, until the 1880s, these slight, light, superficial fashion elements were only infrequently featured in paintings. Of the thirty-five paintings by Gonzalès that include full-length figures, only seven reveal shoes below the dress. Sainsaulieu and Mons 1990.

40 It is possible that this painting, datable to 1873–84, had some sentimental connection with her first encounter with Guérard, whom she met in 1874. They were engaged in 1876, and they married in 1879. See Grant 1994, p. 73.

41 Ives 1988, p. 15.

42 Cahn 1989.

43 Iskin saw Degas's millinery shops as a testament to the tradition of hat making, which was gradually being mechanized; Iskin 2007, pp. 60–113.

CHAPTER 12
De Young, "Fashion and the Press"

1 "Par la seule inspection de l'extérieur d'une femme, une autre femme, si elle a de l'intelligence et de l'habitude, saura à quelle classe elle appartient, quelle a été son éducation, quelle société elle a vue. Elle devinera même ses goûts, son caractère, si elle se donne la peine d'observer; souvent la manière de placer son châle, de mettre son chapeau, d'attacher ses gants, révèlent une

existence." Dash 1868, p. 76. Unless otherwise noted, all translations are the author's own.

2 For more on the historical association of dress and morality, see Ribeiro 1986.

3 "L'extravagance de la toilette appelle l'extravagance de la tenue et des paroles, de même que l'abîme appelle l'abîme. La Mode, soyez-en convaincues, exerce sur les moeurs une grande influence." Madame de Simiane, "De la modiste dans la tenue et le langage," *Magasin des Demoiselles* 23 (Nov. 1866), p. 34.

4 "Si le costume est une révélation du goût de la personne, il est aussi un miroir exact des moeurs." Nadault de Buffon 1870, p. 135.

5 Baudelaire 1998, p. 504.

6 "Elle a peut-être des bas bleus cachés sous les longues draperies de son jupon noir. Toujours a-t-elle un éclatant caraco rouge, trop rouge." Bürger 1870, p. 102.

7 For a consideration of costume in Tissot's paintings, see Matyjaszkiewicz 1984, pp. 64–77. See also Dolan 1994.

8 "C'est une de nos femmes, une de nos maîtresses plutôt, peinte avec une grande vérité." Zola 1959, p. 132.

9 De Young 2011.

10 Chabanne 1990, p. 39.

11 Emmeline Raymond, "A Coté la mode," *La Mode Illustrée* 27 (July 4, 1869), p. 211.

12 "Voilà l'élégance parfaite à laquelle le demi-monde n'atteindra jamais car, malgré l'impudence qu'il affiche, il sent sa misère, la bassesse de son origine doublée de la bassesse de l'âme et de la vulgarité vicieuse de tous les jours, et croit n'avoir jamais assez accumulé de soieries, de dentelles et de colifichets étagés, comme une pagode chinoise, pour dissimuler ses pauvres turpitudes et tirer l'oeil au passant." Horace de Viel-Castel, "Salon de 1869," *Le Pays*, May 13, 1869.

13 For a full discussion of this print and of female allegory during the Franco-Prussian War, see Hollis Clayson, "Gender and Allegory in Flux," in Clayson 2002.

14 For more on the war's effect on art, fashion, and the press, see De Young 2009.

15 "Vrai costume, celui dont la décence est le plus bel ornement." Gaston de Cambronne, "Le Costume et les moeurs," *La Semaine des Familles* 9 (May 27, 1871), p. 144.

16 "L'art est un soldat; lui aussi, il a ses batailles à livrer comme les armées. Il doit concourir à régénérer les esprits, à refaire une France vigoureuse et forte. L'art doit produire des oeuvres viriles et grandes, dignes de la tâche que nous poursuivons tous, dignes des temps terribles que nous avons traversés et de l'avenir qui nous attend." A. Delzant, "Salon de 1872," *Le Courrier de France* 188 (July 9, 1872), p. 3. For further discussion, see Tucker 1986.

17 Roos 1999, p. 52.

18 Ibid. See Mainardi 1993.

19 It is not known for certain whether Morisot submitted *Interior* to the Salon, but Stuckey suggested that it was perhaps the painting rejected by the 1872 Salon jury that was mentioned elliptically by Puvis de Chavannes in a sympathetic letter: "How

long is needed for old-fashioned conventional eyes to bear frank, innocent natural light?" Stuckey and Scott 1987, pp. 48–49.

20 Farwell 1990.

21 Cachin et al. 1983, p. 315.

22 "Créature morne, chétive, et chétivement habillée, ses bras étiques sentent le fil de fer, et de son visage maussade à son petit pied elle est on ne peut plus sèche, souffrante et de mauvaise humeur." Théophile Silvestre, *Le Pays*, July 13, 1873; quoted in Tabarant 1947, p. 211.

23 "La foule est restée rétive et ombrageuse devant cette oeuvre." Paul Alexis, *L'Avenir National*, May 19, 1873; quoted in Tabarant 1947, p. 207.

24 For an extensive consideration of costume in Renoir's *The Loge* and at the theater more generally, see Ribeiro 2008.

25 "La 'cocotte' noire et blanche de [*The Loge*] retien[dra] l'attention par son charme coupab[l]e et par le luxe joyeux [et] léger des étoffes." Jean Prouvaire, "L'Exposition du boulevard des Capucines," *Le Rappel*, Apr. 20, 1874, p. 3; quoted in Berson 1996, p. 34.

26 "Montrer ses jambes, elle s'en garde bien. C'est à peine si l'on entrevoit le bout de sa bottine, pareil à une petite souris noire. Le chapeau, presque sur l'oreille, est d'une coquetterie téméraire; la robe est trop close. Rien de plus irritant que les portes fermées. Est-ce un portrait, ce tableau? Cela est à craindre. Le visage, bizarrement vieillot et puéril aussi, sourit d'un faux sourire. L'ensemble, pourtant, conserve quelque chose de naïf. On dirait que cette petite personne fait exprès d'être chatte." Ibid.

27 "Les joues blanchies de blanc de perle, les yeux allumés d'un regard banalement passionné, vous serez ainsi, la lorgn[e]tte d'or à la main, attrayantes et nulles, délicieuses et stupides." Ibid.

28 Bailey 1997, p. 164.

29 Ibid., p. 167.

30 Robida 1958, p. 55.

31 Buck 1961, p. 198.

32 Bailey 1997, p. 161.

33 "Une femme jolie, gracieuse, d'une nature riche et agréable, sachant se mettre avec goût." Bertall, "Souvenirs du salon," *L'Artiste* 30 (Aug. 1879), pp. 86–87.

34 "La famille d'un éditeur connu du monde entier et aimé de tous les gens de lettres." F.-C. de Syène, "Salon de 1879," *L'Artiste* 30 (July 1879), p. 11.

35 "Lecteurs de *La Vie moderne* en savent tout autant que moi sur le talent original et si fin de M. Renoir." Armand Silvestre, "Le Monde des arts: Demi-dieux et simples mortels au salon de 1879," *La Vie Moderne* 8 (May 29, 1879), p. 118.

36 "Peut-être est-il temps aussi de démontrer que toutes les femmes élégantes ne sont pas nécessairement des aventurières, toutes les grandes dames des gourgandines, et que l'amour de l'intérieur n'est pas l'apanage exclusif des classes pauvres." Émile Bergerat, "Notre programme," *La Vie Moderne* 1 (Apr. 10, 1879), pp. 2–3; translated in Armstrong 2002, p. 237. See Armstrong

2002, pp. 227–67, "Facturing Femininity, Fashioning the Commodity: Between *Nana* and *La Vie Moderne*," for a fuller discussion of *La Vie Moderne*'s fashion and art columns and Manet's exhibition.

37 "Longtemps la légende s'est plu à le représenter comme un rapin farouche, à barbe en broussaille, à longs cheveux, excentriquement vêtu, coiffé d'un chapeau pointu à larges ailes, un de ces chapeaux qui ont fait la révolution de 1830." Gustave Goetschy, "Edouard Manet," *La Vie Moderne* 16 (Apr. 17, 1880), p. 247.

38 "On sait aujourd'hui que Édouard Manet porte la barbe courte et bien taillée, que ses cheveux sont d'une longueur raisonnable, qu'il s'habille comme M. Tout le Monde chez le tailleur d'à côté, et chose plus rare, que c'est un homme d'éducation parfaite, d'excellentes manières, d'esprit cultivé et de caractère aimable." Ibid.

39 "Ce qu'Édouard Manet a apporté de nouveau dans l'art, c'est d'abord sa façon de placer ses figures et ses objets dans l'atmosphère, sa recherche scrupuleuse à préciser exactement les milieux. On sait toujours, en contemplant ses toiles, où, quand, à quelle époque, à quelle heure elles ont été faites." Ibid., p. 250.

40 Armstrong 2002, p. 244, argues that *Woman Reading* appeared in the 1880 *La Vie Moderne* exhibition. Juliet Wilson-Bareau recently maintained this is impossible in light of the background; see Bareau 2011, p. 822.

41 Tabarant 1947, p. 328.

42 "Et tous ces gens-là vivent, respirent et palpitent; ils sont de chair et d'os." Gustave Goetschy, "Edouard Manet," *La Vie Moderne* 16 (Apr. 17, 1880), p. 250.

43 "Chacun est de sa race, de son temps et de son milieu; les femmes du monde sont de vraies femmes du monde, les filles de vraies filles, les voyous de vrais voyous!" Ibid.

44 Thanks to Maureen O'Brien of the Rhode Island School of Design for graciously discussing the picture with me.

45 "Une dame à sa table de travail n'est pas nécessairement une vertu, si simple que soit sa toilette. Une dame devant son miroir n'est pas nécessairement une courtisane, si luxeuse soit sa robe." Castagnary 1869, pp. 353–54.

46 Translated in Simon 1995a, p. 192. Simon cited Moreau-Vauthier 1903.

Patry, "Pierre–Auguste Renoir: *Madame Georges Charpentier and Her Children*"

The author would like to thank Philippe Thiébaut, Colin Bailey, Augustin de Butler, Isabelle Gaëtan, Charlotte Hale, Geneviève Lacambre, Virginie Meyer, Asher Miller, James Moske, Susan Stein, and Françoise Tétart-Vittu, as well as Clément Bernard and Adrienne Farb. This essay focuses on certain issues specific to the Charpentier circle during the years 1878–79 and the question of fashion and elegance in this painting. For studies of other aspects, see entries 31 and 32 in Bailey 1997, pp. 161–67; House and

Distel 1985, pp. 156–58; and Distel 2010, pp. 159–64. For the history of the Maison Charpentier, see Virginie Serrepuy, "Georges Charpentier, 1846–1905: Éditeur de romans, roman d'un éditeur" (Ph.D. diss., Ecole Nationale des Chartes, 2005).

1 "Moi, je n'ai jamais été à pareille fête." Renoir to Théodore Duret [mid-May 1879], quoted in Distel 2010, pp. 169–65. *Explication des ouvrages de peinture, sculpture, architecture, gravures et lithographies des artistes vivants exposés au Palais des Champs-Elysées le 12 mai 1879*, no. 2527. The other paintings sent were a *Portrait of Miss Jeanne Sammary* [sic], *Member of the Comédie-Française* (no. 2528) and two pastels, *Portrait of M. Paul C.* [harpentier] (no. 44776) and *Portrait of Théophile B.* (no 44777).
2 Vollard 1994, p. 194.
3 See Mollier 1988, pp. 213–24.
4 See Mitterand 2001, vol. 2, p. 319.
5 Dreyfous 1913, p. 263. Clotilde Schultz gave Georges the dog. She was the niece and assistant of Philarète Chasles, and she published his posthumous work with Charpentier in 1875. Schultz provided a preface in the form of a letter "to Mr. Charpentier."
6 "[Elle] mérite une place à part dans la galerie des femmes qui ont marqué leurs passage dans le monde des Lettres et des Idées durant le dernier quart du XIXe siècle. Elle avait, entre autres avantage, celui d'avoir l'air très intelligente et aussi très bon, et celui d'air." Dreyfous 1913, p. 176.
7 Flaubert 1973–2007, vol. 5, p. 464. In the end, the request was refused; Madame Charpentier passed on the news to Flaubert, much to his disappointment.
8 Mollier 1988, p. 223.
9 Dreyfous 1913, p. 177.
10 Samary, an actress, met Renoir at a Charpentier salon, possibly in 1876 or 1877, and subsequently became one of Renoir's favorite models.
11 "Femme de salon"; "Est-il besoin d'ajouter qu'elle est réaliste et prend en pitié tous les dissidents de cet art nouveau? Réaliste en littérature, aussi bien qu'en peinture, elle éprouvera beaucoup d'inclination pour les écrivains qui, ne pouvant faire de belles choses, disent les choses laides avec un certain art et dont sa curiosité est affriandée. [. . .] l'idéal? Qu'est-ce que cela pourrait bien être? Ce qui lui importe, c'est l'emploi de mots nouveaux, c'est le langage violemment coloré et produisant des effets nouveaux. N'est-elle point elle-même un néologisme ambulant?" E. [mmeline] R. [aymond], "Types et Caractères. La Femme Pratique," *La Mode Illustrée*, Mar. 3, 1878, p. 70.
12 Duret 1878, p. 9. Bodelsen 1968, pp. 334–36. For *The Fisherman* (c. 1874), see *Impressionists and Modern Drawings, Painting and Sculpture*, sale cat. (Christie's, London, July 6, 1971), "The Property of the Tournon-Charpentier Family," no. 30. The date and present location of *The Dahlia Garden* are unknown, as is the location of *Woman's Head* (1874).

13 See Anne Distel, "Georges et Marguerite Charpentier," in Distel 1990, pp. 140–49.
14 *Catalogue des tableaux composant la collection de feu Mr. Charpentier*, Paris, Apr. 11, 1907.
15 "Peintre ordinaire." Florisoone 1938, p. 35.
16 Robida 1958, pp. 42–43. Dreyfous 1913, p. 176.
17 Renoir painted Georgette in 1876 (*Mademoiselle Georgette Charpentier Seated*; Bridgestone Museum of Art, Ishibashi Foundation), Paul in 1878 (sold, Christie's, London, July 6, 1971), and then Jane in 1882 (location unknown; see Florisoone 1938, p. 36). Patry 2009, p. 53.
18 According to Distel 2010, p. 159, and Albert Kostenevich, "Man on a Stair/Woman on a Stair," in Hermitage Museum 1995, pp. 88–94. Marguerite's nephew wrote: "the woman however was a model from Montmartre who came from God knows where, pretended to know my great-aunt, and ended up stealing from her"; Robida 1955, p. 135.
19 This painting was enlarged before it entered the museum in 1907, as can be deduced from the traces of former nails on the lower border, and is confirmed by a record photograph taken upon its arrival in New York. Conservator Charlotte Hale notes that the bottom tacking edge was turned out, most likely when the painting was lined. Roger Fry, "The Charpentier Family by Renoir," *Bulletin of the Metropolitan Museum of Art*, June 1907, pp. 102–04.
20 Duranty 1876, pp. 27–28.
21 "[Son frère] se laisse entraîner par son sujet et surtout par le milieu dans lequel il se trouve. C'est le caractère particulier de son oeuvre; on le retrouve partout et toujours, [. . .], jusqu'au portrait de Mme Charpentier et de ses enfants, peint chez elle, sans que ses meubles aient été dérangés de la place qu'ils occupent tous les jours, sans que rien ait été préparé pour faire valoir une partie ou l'autre du tableau." Edmond Renoir, "Pierre-Auguste Renoir, mon frère," *La Vie Moderne*, June 19, 1879, pp. 174–75.
22 "Japonaiseries partout." Renoir quoted in Vollard 1920, p. 166. Philippe Burty quoted in Bailey 1997, p. 167. A "little Japanese living room that was used as a smoking room" (petit salon japonais qui servait de fumoir), according to Rivière 1921, p. 172. Bailey thinks that this is a private boudoir, but an unpublished biographical note sent by Renoir mentions "a little living room where most of the famous men of the end of the nineteenth century gathered: Gambetta, Ferry, Général Billot, Flaubert, Edmond de Goncourt, Théodore de Banville, etc." (un petit salon où se réunissaient la plupart des hommes célèbres de la fin du XIXe siècle: Gambetta, Ferry, général Billot, Flaubert, Edmond de Goncourt, Théodore de Banville, etc.). Copy of biographical note, Aug. 21, 1907, "Purchases—Authorized—Paintings—Renoir, *La Famille Charpentier*," Office of the Secretary Records, on file in The Metropolitan Museum of Art Archives. Flaubert to Madame Régnier, Nov. 19, 1879, Flaubert 1973–2007, vol. 5, p. 272.

23 The screens have sometimes been identified as the dismantled panels of a Rimpa screen (Bailey 1997, p. 164), but Geneviève Lacambre notes that horizontal stripes are visible on the three panels, and this is more typical of painted screens (letter to the author, May 23, 2012). Lacambre mentions that such furniture sets appear in the catalogue of the famous department store Au Printemps in 1876, and that there is a comparable example, for the table, at the Musée de Beaux-Arts de Dijon (Trimolet Bequest, 1878).
24 Émile Zola, *Une page d'amour* (Folio, 1989), pp. 72–74. The Charpentiers were fervent connoisseurs and also collected more important objects than those shown in the portrait. Some of these significant pieces were lent to the Exposition Universelle of 1878; Bailey 1997, p. 165.
25 "Goût oriental se mêle à la fashion moderne." Gustave Flaubert to Edmond de Goncourt, [Apr. 24, 1879], in Flaubert 1973–2007, vol. 5, p. 6135. Armand Silvestre, "Demi-Dieux et simples mortels au Salon de 1879," *La Vie Moderne* 8 (May 28, 1879), p. 118.
26 "Noir comme la reine des couleurs." Renoir quoted in De Butler 2009, p. 152.
27 Julius Meier-Graefe, *Auguste Renoir* (Floury, 1912), p. 54.
28 I am indebted to Françoise Tétart-Vittu for the description of the costumes and their social significance; letter to the author, May 22, 2012.
29 "Strictement limitée à la soirée." *La Mode Illustrée*, July 21, 1878, p. 228.
30 "Petite bourgeoise ridicule." Proust 1995, p. 590.
31 "Que vient faire [. . .] ce volant de dentelle tout au bout de la jupe si longue de Madame Charpentier; qui nous dit que cette femme charmante, qui est assez petite, n'aurait choisi ce subterfuge de toilette, ou est-ce Renoir qui a préféré égayer un peu cet angle de son assez morne tableau?" Drucker 1944, p. 51.
32 "Yesterday I saw—at last—the famous portrait and I have nothing to say. I would however make an observation about the collar, but I am afraid of saying something wrong, so I will let it pass for now." (J'ai vu hier [et enfin] le fameux portrait, auquel je ne trouve rien a redire. Cependant je te ferai une observation sur le col, mais j'ai peur de dire une bêtise, et provisoirement je m'abstiens.) Gustave Flaubert to his niece Caroline, [June 12 1879], in Flaubert 1973–2007, vol. 5, p. 656.
33 Eugénie's crown, created by Alexandre-Gabriel Lemonnier, now belongs to the Louvre collections (OA 11160); http://www.louvre.fr/oeuvre-notices/. couronne-de-imperatrice-eugenie.
34 Jean Prouvaire, *Le Rappel*, Apr. 20, 1874, described Morisot's watercolors as a mix of "Worth with God" (mêl[aient] Worth au bon Dieu). Prouvaire further characterized this tendency of the new school as "an eccentric Worth, very little concerned by fashion plates and producing fanciful dresses"(mais un Worth excentrique, assez peu soucieux

des gravures de mode, et produisant des robes chimériques).

35 The author is grateful to Harold Koda, Curator in Charge, the Costume Institute, at The Metropolitan Museum of Art for sharing his insights and observations about Madame Charpentier's dress (e-mail correspondence with Susan Stein, June 19, 2012), and to Laura Dickey for bringing the fashion plate to her attention.

36 "Éffacées avec un tampon de linge"; Meier-Graefe 1912, p. 62.

37 See Sylvie Patry, "Renoir's Early Career: From Artisan to Painter," in Bâle Kunstmuseum 2011, pp. 53–76.

38 "Mode de la semaine"; "Je me chargerai de faire les dessins très exactement dès mon retour à Paris. [. . .] On peut faire un arrangement avec modistes et couturières. Une semaine de chapeaux, l'autre de robes etc. J'irai chez elles faire le dessin d'après nature de différents côtés." Renoir to Marguerite Charpentier, June 12, 1879, in Florisoone1938, p. 35.

39 He drew a portrait of Léon Riesener for the cover of the second issue; La Vie Moderne, Apr. 17, 1879, no. 2.

40 "Artiste, désormais tu veux peindre la Vie / Moderne, frémissante, avide, inassouvie, / Belle de douleur calme et de sévérité; / Car ton esprit a soif de vérité." Théodore de Banville, "Aimer Paris," La Vie Moderne, July 10, 1879. Renoir, Théodore de Banville, illustration on the cover of La Vie Moderne 14 (July 10, 1879); pastel, 1882, Musée d'Orsay, Paris, RF 12385.

41 "Lecteur, voici la Vie moderne. Faire ce que personne n'a jamais osé faire [. . . .] Nous n'hésiterons pas, par exemple, à donner une bonne place à cette vie de famille dont les plus sceptiques n'osent point avouer les bonheurs tranquilles [. . . .] Nous aurons, parmi toutes les audaces, celle d'encourager chez les mères, l'orgueil de leur maternité; de traiter des questions domestiques et des choses du foyer [. . .] Peut-être est-il temps aussi de démontrer que toutes les femmes élégantes ne sont pas nécessairement des aventurières, toutes les grandes dames des gourgandines, et que l'amour de l'intérieur n'est pas l'apanage exclusif des classes pauvres." Bergerat 1879, pp. 2–3.

42 Madame Charpentier helped found La Société Maternelle Parisienne in 1891, which created numerous pouponnières, or day-care centers, around Paris, and she served as its president; City Archives, Paris, death certificate, Dec. 1, 1904. Rivière 1921, pp. 148–49. See also Meyer 2005, pp. 75–76.

43 "Que l'on pût exposer au Salon une robe, un tapis, un meuble, et qu'un jury leur affectât des médailles." Bergerat 1879, p. 3.

44 "Messieurs habiles qui habillent leurs poupées de robes copiées dans des gravures de modes." Émile Zola, "Mon Salon. Édouard Manet," May 10, 1868, repr. in Zola 1991, p. 198. Huysmans 2006, p. 147.

45 See Herbert 2000, pp. 12–13.

46 "La poésie d'un élégant foyer et des belles toilettes de notre temps." Proust 1995, p. 590.

47 "Durand-Ruel made him realize that hats were getting out of fashion and that his paintings would be more successful if they represented women bare-headed." (Durand-Ruel lui fit remarquer que les chapeaux se démodaient et que ses oeuvres auraient peut-être plus de succès si elles représentaient des femmes en cheveux.) Baudot 1949, p. 15.

48 "On va décrocher votre portrait puisque c'est la seule chose qui m'a fait accepter." Renoir to Marguerite Charpentier, [spring 1886], quoted in Florisoone 1938, p. 38.

49 "Madame Charpentier . . . qu'on la colle au Louvre et qu'on me foute la paix." Quoted in De Butler 2009, p. 141. The same comment is sometimes said to have been made about The Loge (cat. 12).

50 "Je ne sais si c'est bon ou mauvais." Renoir to Durand-Ruel, Grasse, Jan. 4, 1900, in Godfroy 1995, p. 118.

51 The Metropolitan Museum of Art, New York, Archives (see note 22 above), quoted in Anne Distel, "Renoir's Collectors: The Pâtissier, the Priest, and the Prince," in Raeburn 1985, p. 29, n. 77. Durand-Ruel to Osborne, Mar. 11, 1907, "Purchases—Authorized—Paintings—Renoir, La Famille Charpentier," Office of the Secretary Records, on file in The Metropolitan Museum of Art Archives.

52 Roger Fry wrote to Assistant Director Edward Robinson, "I instructed Durand Ruel of Paris to bid for us. I have just heard from him that he got the picture for 84,000 frs which with the 10% charged on sales in Paris brings the price up to 92,400 frs (about $19,680)." Roger Fry to Edward Robinson, Apr. 12, 1907, "Purchases—Authorized—Paintings—Renoir, La Famille Charpentier," Office of the Secretary Records, on file in The Metropolitan Museum of Art Archives. This spectacular purchase was financed by the fund of Catharine Lorillard Wolfe, whose personal tastes leaned more toward Alexandre Cabanel or Pierre-Auguste Cot. Rebecca A. Rabinow, "Catharine Lorillard Wolfe: The First Woman Benefactor of the Metropolitan Museum," Apollo (Mar. 1998), pp. 48–56.

CHAPTER 13
Burnham, "Changing Silhouettes"

1 Blanc 1877, p. ii. "Cette jolie femme qui est enfermée à son insu dans un réseau de parallèles inexorables, comme le serait un oiseau dans sa cage, un invisible treillis de verticals et d'horizontales emprisonne sa beauté mouvante et libre."

2 On the etching, see Reed and Shapiro 1984, pp. 168–97; Druick et al. 1988, pp. 322–24. On the pastel, see Druick et al. 1988, p. 440; Art Institute 2000, p. 73.

3 On Cassatt and Degas in this period, see Mathews 1981; Barbara Stern Shapiro, "Mary Cassatt's Color Prints and Contemporary French Painting," in Mathews and Shapiro 1989, pp. 57–87; Mathews 1994, pp. 114–17; Druick et al. 1988, pp. 320–22; and Shackelford 1998.

4 Mary Cassatt to Louisine Havemeyer, Dec. 7, 1918. Archives, The Metropolitan Museum of Art. Quoted in Druick et al. 1988, p. 321. Her accessory is identifiable as an umbrella, not a parasol, because of its "length (equivalent to that of a walking stick), slender profile, and lack of decoration." Nicholas Wise, Frick Collection, e-mail correspondence with the author, Dec. 1, 2011. On umbrellas, parasols, and other types of sun and rain shades, see Uzanne 1883; Crawford 1970; Farrell 1985; Hiner 2010, especially chap. 4, "Mademoiselle Ombrelle: Shielding the Fair Sex," pp. 107–44. Note the similarity between Cassatt's pose and that in Ludovic Halévy and Albert Boulanger-Cavé Backstage at the Opéra (fig. 4, p. 144).

5 Mathews 1994, p. 117.

6 On Mary Cassatt and fashion, see Mathews 1984, pp. 237–38, n. 1; Mathews 1994, pp. 52, 97, 117; Barter 1998, p. 45, n. 2; Mathews, "Cassatt's Paris Fashions," lecture delivered at Tobias Theater, Indianapolis Museum of Art, Mar. 31, 2011. When commissioned many years later to create the mural of "Modern Woman" for the Woman's Building of the World's Columbian Exposition of 1892, Cassatt, in her own words, "tried to express the modern woman in the fashions of our day and . . . to represent those fashions as accurately and in as much detail as possible." See Mary Cassatt to Bertha Palmer, Oct. 11, 1892; published in Mathews 1984, pp. 237–38.

7 My analysis of the fashions in these works is greatly indebted to conversations with Lauren Whitley, Curator of Textiles and Fashion Arts at the Museum of Fine Arts, Boston.

8 On the energy and sexuality suggested by the female suit, see Hollander 1994. The slim proportions of walking dresses in the late 1870s could actually restrict the figure, though that does not seem to be the case with Cassatt's apparel.

9 On the development of suits for women and the tailor-made, see Waugh 1968; Davray-Piekolek 1990, especially pp. 44–46; Hollander 1994; Chaumette 1995; Chaumette 2004.

10 On the amazone, see Pellier 1987; Arnold 1999; David 2002; MacDonald et al. 2003, pp. 116–31.

11 Boggs 1962, p. 53. See also Callen 1995.

12 Shackelford 1984, pp. 80–81; Druick et al. 1988, pp. 318–20; Berson 1996, p. 1808; and Kinney 1996, p. 288. On the exhibition of this work hors catalogue in 1881, see Shackelford 1998, p. 142, n. 72.

13 Degas described a similar idea in a notebook of 1859–64; see Druick et al. 1988, p. 320, n. 9.

14 Reff compares her to The Schoolgirl (c. 1881). See Reff 1987, pp. 255–61.

15 Tabarant 1947, p. 314. Tabarant did not specifically include Young Woman in a Round Hat in what he described as a "naturaliste" series, but it is closely related in subject and composition to that group. On representing the Third Republic, see Antonin Proust, "Édouard Manet (Souvenirs),"

La Revue Blanche (1897), p. 206. See also Cachin et al. 1983, pp. 441–42.

16 Hanson 1977, p. 86. Tabarant mocked the idea that she was an *amazone*, although he described her "aspect tout masculin"; Tabarant 1947, p. 315. See also Wilson-Bareau 2012, pp. 256–59.

17 Moffett 1986, p. 441; Kessler 2006b, pp. 145–46.

18 Hanson quoted in Kessler 2006b, pp. 145–46.

19 On the anxiety attending ambiguities of fashion, see Clayson 1991.

20 Hamilton 1954, p. 249.

21 Compare her dress to the c. 1885 *robe de jour* (Kyoto Inv. AC2236 79-10-9AB) illustrated in Fukai et al. 2002, pp. 252–53.

22 De Leiris 1969, p. 83; Chiarenza 1969; Cachin et al. 1983, pp. 486–88; Herbert 2004, pp. 163–65.

23 For a relevant discussion of the significance of the profile portrait in Renaissance portraiture, see Simons 1992.

24 See O'Brien 2005.

25 See the description of this Musée d'Orsay acquisition in Lobstein 1994. The pastel is dedicated in the lower left: "A mon ami H. Wallet, J. E. Blanche, 87."

26 Steele 1988, pp. 114–15.

27 Bailey 2012, pp. 138–65. The luxurious clothes they wear suggest this date, according to Colin Bailey's analysis. My analysis of the painting and its fashions relies on Bailey's chapter on *The Umbrellas*. On the painting, see also House and Distel 1985, pp. 228–29; Bomford et al. 1990.

28 Bailey 2012, p.138.

29 See Christie's, New York, *Nineteenth-Century European Paintings, Drawings, Watercolors, and Sculpture*, sale cat. (Christie's, Nov. 1–2, 1995), lot 176.

30 "The Fine Arts. The Loan Collection at the Metropolitan Museum, New York," *Philadelphia Telegraph*, Nov. 8, 1886. Object file, Department of European Paintings, The Metropolitan Museum of Art, New York.

31 Duvernois 2010.

32 Ibid., p. 220.

33 "Une jeune fille en costume vert sombre, coiffée d'un large chapeau à plumes jaunes . . . en robe brune, vêtue de noir, des fleurs jaunes à son chapeau." Lafenestre 1885, p. 46, ill. between pp. 46 and 47. Unless otherwise noted, all translations are the author's own.

34 Certain details of dress stand out as unusual, such as the fact that the woman in front is not wearing a hat (it was painted out by Lerolle). A hatless woman in a church "would have been unconventional and rather provocative in the 1880s" (Duvernois 2010, p. 222). Yet contemporary critics did not seem to find this strange; it may simply have contributed to the sense of easy camaraderie among the choir members— themselves part of the artistic circles in which the rules of dress might be bent.

35 "Gallery and Studio—An Important Lerolle in Brooklyn," *Brooklyn Eagle*, Mar. 27, 1887, p. 2. Object file, Department of European Paintings, The Metropolitan Museum of Art, New York.

36 It also irked the occasional observer, who accused it of being overly traditional.

37 Hoschedé 1960, p. 126. See also Spate 1992, p. 175, n. 55.

38 "Toiles d'inspiration personnelle, où le costume moderne, la mise en toile imprévue, un régime, simplifié de valeurs et des gris distingués, mettaient une note nouvelle, une poésie de notre temps." Denis 1932, p. 14; quoted in Armstrong 2000, p. 27.

39 "M. Catallucci a dessiné sur une grande ardoise une femme, et au moyen de triangles, de carrés, et autres figures géometriques, il a démontré les rapports qui doivent exister entre les différentes parties du corps." Lauzun, "Le Mois mondain," *L'Art et la Mode* (1882), pp. 140–41.

40 Blanc 1875, pp. 57–58.

41 "En depit des innombrables variétés que comporte l'art de la toilette, cet art est soumis, comme tous les autres, aux trois conditions invariables du beau, qui sont l'ordre, la proportion et l'harmonie." Blanc 1882, p. 164.

42 Richard Thomson observed similarities between Lerolle's *Rehearsal* and Seurat's *La Grande Jatte*, finding that the two artists seemed to have "independently agreed that the modern had to be subjected to a style, to a legible order which would be proof of the artist's transformation of nature . . . and his ability to give pictorial cohesion to the confusion of contemporary existence." See Thomson 1997, p. 98.

43 Blanc 1867. The treatise first appeared in the *Gazette des Beaux-Arts* in installments between 1860 and 1866. On Blanc and fashion in relation to Seurat, see Kinney 1996, pp. 287–88, n. 308. On Seurat and Blanc, see Homer 1964, especially pp. 17–18, 29–36, 244–49; Zimmermann 1989; Herbert 1991, pp. 383–86.

44 Fashion has long been central to the interpretation of Seurat's *La Grande Jatte*. Robert Herbert gave an overview of the critical reception of the painting, with a particular focus on fashion, in Herbert 2004, pp. 162–75. Most recent analyses of the painting take dress into account; the more relevant of these are House 1980; Clark 1984, pp. 261–68; Ward 1986; Nochlin 1989; Thomson 1989; Clayson 1989; and, for the most sustained discussion of the topic, Kinney 1996.

45 On class difference, see Clark 1984, pp. 261–68; on disharmony, see Nochlin 1989.

46 Simon 1995a, pp. 64–65. Marie Simon compared the fashions in *La Grande Jatte* to Jean Béraud's *The Box by the Stalls* (c. 1883; Musée Carnavalet) to note that the woman in the stall box appears to be a kept woman. She is at the theater in a closed box with an older male admirer, looking at herself in a mirror and fixing her makeup.

47 See a comparable dress and description of this style in Johnston et al. 2005, p. 26.

48 See Ward 1986, p. 434.

49 Perrot 1994, pp. 168–70; Clayson 1989, p. 244, n. 45.

50 Perrot 1994, p. 180.

51 On the monkey, see Thomson 1989, p. 186; on the dog, see Thomson 1985, pp. 123–26. See also Clark 1984, p. 266; Ward 1986, pp. 434–36; Clayson 1989, p. 163, n. 45. George Moore was the reviewer who called her a cocotte, and he later (anonymously) commented on the scandal caused by the long tail of the monkey; see Ward 1986, p. 434, n. 42. "Neo-impressionist supporter" Jules Christophe later referred to the woman and man as the "hieratic and scandalous couple: the elegant young man giving his arm to his pretentious companion with a monkey on a leash" in his 1890 biography of Seurat. See Jules Christophe, "Georges Seurat/Maximilien Luce," *Les Hommes d'Aujourd'hui* 8, 368 (1890).

52 Robert Herbert argued that we cannot assume that she is a cocotte. Herbert 2004, p. 162. We do not know the quality of the fabric and accessories in this outfit, which might have been composed of some ready-to-wear elements and thereby not out of reach for a member of the bourgeoisie, though the excellent cut of the bodice suggests the hand of a skilled tailor or dressmaker.

53 Jules Christophe quoted in Ward 1986, p. 434. See also Clayson 1991, pp. 56–92.

54 Zuccari and Langley 2004.

55 See technical illustrations in ibid., p. 185.

56 Ibid., pp. 190–91.

57 According to Thomson 1989, pp. 186–87, "The notion that a prostitute is someone who 'fishes' for men was standard at the time, and was compounded by caricatures . . . [that] pun on the words pêche (fishing) and peché (sin)."

58 Is she a "flaneuse"? For a discussion of the flaneuse, see D'Souza and McDonough 2006.

Selected Bibliography

About, Edmond. 1858. *Nos artistes au Salon de 1857*. Hachette.

Académie Française. 1835. *Dictionnaire de l'académie française*, 6th ed., vol. 1. Firmin Didot frères.

Andia, Béatrice de, and Caroline François, eds. 2006. *Les Cathédrales du commerce parisien: Grands magasins et enseignes*. Action artistique de la ville de Paris.

Annuaire Almanach de l'industrie. 1870. Firmin-Didot.

Anthiaume, Albert. 1905. *Le Collège du Havre: Contribution à l'histoire de l'enseignement secondaire en France*, vol. 2. Havre-Éclair.

Apraxine, Pierre, and Xavier Demange. 2000. *La Divine Comtesse: Photographs of the Countess of Castiglione*. Exh. cat. The Metropolitan Museum of Art/Yale University Press.

Armstrong, Agnes. 2000. "A L'Orgue d'Henry Lerolle: Le Tableau et ses sujets." *La Flûte harmonique, Publication de l'Association Aristide Cavaillé-Coll* 79/80, pp. 19–35.

Armstrong, Carol M. 2002. *Manet Manette*. Yale University Press.

Arnold, Janet. 1999. "Dashing Amazons: The Development of Women's Riding Dress, c. 1500–1900." In *Defining Dress: Dress as Object, Meaning, and Identity*, ed. Amy de la Haye and Elizabeth Wilson, pp. 10–29. Studies in Design and Material Culture. Manchester University Press/ St. Martin's Press.

Art Institute of Chicago. 2000. *Impressionism and Post-Impressionism in the Art Institute of Chicago*. Art Institute of Chicago/Hudson Hills.

Audsley, William, and George Audsley. 1863. *Taste versus Fashionable Colors: A Manual for Ladies on Colour in Dress*. Longman, Green.

Bailey, Colin B. 1997. *Renoir's Portraits: Impressions of an Age*. Exh. cat. Yale University Press.

———. 2012. *Renoir: Impressionism and Full-Length Painting*. Yale University Press.

Bâle Kunstmuseum. 2011. *Renoir: Zwischen Bohême und Bourgeoisie, die frühen Jahre*. Bâle Kunstmuseum/ Hatje Cantz.

Balzac, Honoré de. 1869. *Oeuvres complètes de H. de Balzac*, vol. 4. Michel Lévy frères.

———. 2000. *Traité de la vie élégante*, ed. Marie-Christine Natta. Presses Universitaires Blaise Pascal. First published 1830.

Baroche, Céleste. 1921. *Second empire: Notes et souvenirs*. G. Crès et cie.

Barter, Judith A. 1998. "Mary Cassatt: Themes, Sources, and the Modern Woman." In *Mary Cassatt: Modern Woman*, ed. Judith A. Barter, pp. 45–107. Exh. cat. Art Institute of Chicago/H. N. Abrams.

Basseporte, Gérald. 1998. *Regards sur Félicien Rops: Peintre à essonnes*. Presses du management.

Baudelaire, Charles. 1962a. "Le Peintre de la vie moderne." In *Curiosités esthétiques: L'Art romantique et autres oeuvres critiques*, ed. Henri Lemaître, pp. 453–502. Classiques Garnier. Éditions Garnier frères.

———. 1962b. "Salon de 1845." In *Curiosités esthétiques: L'Art romantique et autres oeuvres critiques*, ed. Henri Lemaître, pp. 3–85. Classiques Garnier. Éditions Garnier frères.

———. 1964. *The Painter of Modern Life and Other Essays*, ed. and trans. Jonathan Mayne. Phaidon.

———. 1967. *Petits poèmes en prose*. Garnier-Flammarion.

———. 1975. *Oeuvres completes*, ed. Claude Pichois. 2 vols. Bibliothèque de la Pléiade. Gallimard.

———. 1980. *Oeuvres completes*, ed. Michel Jamet. Laffont.

———. 1998. "Women and Prostitutes." In *Art in Theory, 1815–1900: An Anthology of Changing Ideas*, ed. Charles Harrison, Paul Wood, and Jason Gaiger, pp. 503–05. Blackwell.

———. 2003. *Les Fleurs du Mal*, trans. Richard Howard. David R. Godine.

Baudot, Jeanne. 1949. *Renoir, ses amis, ses modèles*. Éditions littéraires de France.

Bazille, Frédéric. 1992. *Frédéric Bazille: Correspondance*, ed. Didier Vatuone and Guy Barral. Presses du Languedoc.

Bergerat, Émile. 1879. "Notre programme," *La Vie Moderne*, Apr. 10, 1879, pp. 2–3.

Berhaut, Marie. 1978. *Caillebotte: Sa Vie et son oeuvre, catalogue raisonné des peintures et sculptures*. Bibliothèque des Arts.

Berson, Ruth, ed. 1996. *The New Painting: Impressionism, 1874–1886, Documentation*. Fine Arts Museums of San Francisco/University of Washington Press.

Blanc, Charles. 1867. *Grammaire des arts du dessin, architecture, sculpture, peinture*. Renouard.

———. 1875. *L'Art dans la parure et dans le vêtement*. Renouard.

———. 1877. *Art in Ornament and Dress*. Scribner, Welford, and Armstrong.

———. 1882. *Grammaire des arts décoratifs*. Librairie Renouard.

Bodelsen, Merete. 1968. "Early Impressionist Sales (1874–94) in the Light of Some Unpublished 'Procès-Verbaux.'" *Burlington Magazine* 110, 783 (June), pp. 330–49.

Bodt, Saskia de, Danielle Derrey-Capon, Michel Draguet, Ingrid Goddeeris, D. Marechal, and Jean-Claude Yon. 2009. *Alfred Stevens: Brussels, 1823–Paris, 1906*. Exh. cat. Royal Museums of Fine Arts of Belgium/Van Gogh Museum.

Boggs, Jean Sutherland. 1962. *Portraits by Degas*. California Studies in the History of Art 2. University of California Press.

Boime, Albert. 1979. "Les Hommes d'affaires et les arts en France au XIX siècle." *Actes de la recherche en sciences sociales* 28 (June), p. 66.

Bomford, David, et al. 1990. *Impressionism: Art in the Making*. Exh. cat. National Gallery/Yale University Press.

Bonnier, Bernadette, et al. 1998. *Félicien Rops: Rops suis, aultre ne veulx ester*. Exh. cat. Complexe.

Bonnier, Louis. 1903. *Conférences faites dans l'hémicycle de l'Ecole Nationale des Beaux-Arts les 22 et 29 octobre 1902 sur les règlements de voirie*. C. Schmid.

Boyce, M. Schoeser. 1981. "The Barbier Manuscripts." *Textile History* 12, pp. 37–58.

Brettell, Richard R., and Suzanne Folds McCullagh. 1984. *Degas in the Art Institute of Chicago*. Exh. cat. Art Institute of Chicago/H. N. Abrams.

Breward, Christopher. 1994. "Femininity and Consumption: The Problem of the Late Nineteenth-Century Fashion Journal." *Journal of Design History* 7, 2 (Jan. 1), pp. 71–89.

———. 1995. *The Culture of Fashion: A New History of Fashionable Dress*. Studies in Design and Material Culture. Manchester University Press/St. Martin's Press.

———. 1999. *The Hidden Consumer: Masculinities, Fashion, and City Life, 1860–1914*. Studies in Design and Material Culture. Manchester University Press.

Bringel, Anne-Rose, and Jacqueline Jacqué, eds. 2009. *Rêve de Cachemire, cachemires de rêve*. Exh. cat. I. D. l'Edition.

Brombert, Beth Archer. 1996. *Edouard Manet: Rebel in a Frock Coat*. Little Brown.

Brooks, Peter. 1993. *Body Work: Objects of Desire in Modern Narrative*. Harvard University Press.

Brown, Marilyn. 1994. *Degas and the Business of Art: A Cotton Office in New Orleans*. Pennsylvania State University Press.

Buck, Anne. 1961. *Victorian Costume and Costume Accessories*. Victorian Collector Series. H. Jenkins.

Bürger, William [Théophile Thoré]. 1870. *Salons de W. Bürger, 1861 à 1868*. Jules Renouard.

Burnham, Helen. 2007. "Fashion and the Representation of Modernity: Studies in the Late Work of Édouard Manet (1832–1883)." Ph.D. diss., New York University.

Busch, Günter. 1981. *Claude Monet "Camille—Die Dame im grünen Kleid": Vom Realismus zum Impressionismus*. Themen 31. Die Stiftung.

Butler, Ruth. 2008. *Hidden in the Shadow of the Master: The Model-Wives of Cézanne, Monet, and Rodin*. Yale University Press.

Byrde, Penelope. 1979. *The Male Image: Men's Fashion in Britain, 1300–1970*. B. T. Batsford.

Cachin, Françoise, ed. 1996. *Cézanne*, trans. John Goodman. Exh. cat. Abrams/ Philadelphia Museum of Art.

———, et al. 1983. *Manet, 1832–1883*. Exh. cat. The Metropolitan Museum of Art/Abrams.

Cahn, Isabelle. 1989. "Degas's Frames." *Burlington Magazine* 131, 1033 (Apr. 1), pp. 289–93.

———. 2008. "Édouard Manet et Son Entourage." In *Le Mystère et l'éclat: Pastels du Musée D'Orsay*, ed. Musée d'Orsay, pp. 50–53. Exh. cat. Réunion des Musées Nationaux.

Callen, Anthea. 1995. *The Spectacular Body: Science, Method, and Meaning in the Work of Degas*. Yale University Press.

Caovilla, Paola Buratto. 1998. *Shoes: Objects of Art and Seduction*. Skira/ Abbeville.

Carette, Madame. 1889–91. *Souvenirs intimes de la cour des Tuileries*. P. Ollendorff.

Carter, Edward Carlos, Robert Forster, and Joseph N. Moody, eds. 1976. *Enterprise and Entrepreneurs in Nineteenth- and Twentieth-Century France*. Johns Hopkins University Press.

Castagnary, Jules-Antoine. 1869. "Beaux-Arts. Salon de 1868." In André Laurie, Arthur Ranc, Françoise Sarcey, and Jules-Antoine Castagnary, Le Bilan de l'année 1868, politique, littéraire, dramatique, pp. 291–368. Armand le Chevalier.

———. 1892. Salons (1872–1879). 2 vols. Charpentier et Fasquelle.

Chabanne, Thierry. 1990. Les Salons caricaturaux. Exh. cat. Réunion des Musées Nationaux.

Challamel, Auguste. 1881. Histoire de la mode en France. Hennuyer.

Champa, Kermit Swiler. 1973. Studies in Early Impressionism. Yale Publications in the History of Art 22. Yale University Press.

Chaumette, Xavier. 1995. Le Costume tailleur: La Culture vestimentaire en France au XIXè siècle. Esmod Ed.

———. 2004. "The Tailored Suit." In Encyclopedia of Clothing and Fashion, ed. Valerie Steele, pp. 259–61. Scribner Library of Daily Life. Charles Scribner's Sons.

Chenoune, Farid. 1993. A History of Men's Fashion. Flammarion.

Chesneau, Ernest. 1864. L'Art et les artistes modernes en France et en Angleterre. Didier et Cie.

Chiarenza, Carl. 1969. "Manet's Use of Photography in the Creation of a Drawing." Master Drawings 7, 1, pp. 38–45.

Claerbergen, Ernst Vegelin van, and Barnaby Wright, eds. 2008. Renoir at the Theatre: Looking at La Loge. Exh. cat. Courtauld Gallery/Paul Holberton Pub.

Clark, T. J. 1984. The Painting of Modern Life: Paris in the Art of Manet and His Followers. Princeton University Press.

Clausen, Meredith L. 1987. Frantz Jourdain and the Samaritaine. E. J. Brill.

Clayson, Hollis. 1989. "The Family and the Father: The Grande Jatte and Its Absences." Art Institute of Chicago Museum Studies 14, 2, pp. 155–64.

———. 1991. Painted Love: Prostitution in French Art of the Impressionist Era. Yale University Press.

———. 2002. Paris in Despair: Art and Everyday Life under Siege (1870–71). University of Chicago Press.

———. 2003. "Testing the Limits: The Menace of Fashion." In Painted Love: Prostitution in French Art of the Impressionist Era, pp. 56–93. Getty Research Institute.

Coleman, Elizabeth A. 1989. The Opulent Era: Fashions of Worth, Doucet, and Pingat. Exh. cat. Thames and Hudson/Brooklyn Museum.

Collins, John Bruce. 2001. "Seeking l'Esprit Gaulois: Renoir's Bal du Moulin de la Galette and Aspects of French Social History and Popular Culture." Ph.D. diss., McGill University.

Combe, Paul. 1956. Niveau de vie et progrés technique en France, 1860–1939; Contribution à l'étude de l'économie française contemporaine: Postface, 1939–1949. Presses Universitaires de France.

Connolly, John L., Jr. 1973. "Ingres and the Erotic Intellect." In Woman as Sex Object: Studies in Erotic Art, 1730–1970, ed. Thomas B. Hess and Linda Nochlin, pp. 16–31. Allen Lane.

Constantin, Marc. 1859. Almanach du savoir-vivre. Desloges.

Crawford, T. S. 1970. A History of the Umbrella. Newton Abbot, David and Charles.

D'Alcq, Louise. 1902. Souvenirs d'Antan. Paris.

D'Argencourt, Louise. 1999. European Paintings of the 19th Century. 2 vols. Cleveland Museum of Art.

Darin, Michaël. 2003. "Place de l'Etoile." In Places de Paris, XIXe–XXe siècles, ed. Géraldine Texier-Rideau and Michaël Darin, pp. 46–49. Exh. cat. Action Artistique de la Ville de Paris.

Dash, Comtesse. 1868. Comment on fait son chemin dans le monde, code du savoir-vivre. Michel Lévy.

Da Silveira, Piedade. 1995. Les Grands magasins du Louvre au XIXe siècle. CCM.

Daulte, François. 1971. Catalogue raisonné de l'oeuvre peint. Editions Durand-Ruel.

David, Alison Matthews. 2002. "Elegant Amazons: Victorian Riding Habits and the Fashionable Horsewoman." Victorian Literature and Culture 30, 1, pp. 179–210.

Davray-Piekolek, Renée, ed. 1990. Femmes fin de siècle, 1885–1895. Exh. cat. Palais Galliéra.

De Amicis, Edmondo. 1879. Studies of Paris, trans. Wilhelmina W. Cady. Putnam's Sons.

De Butler, Augustin. 2009. Renoir: Ecrits, entretiens et lettres sur l'art. Hermann.

Delattre, Simone. 2000. Les Douze heures noires: La Nuit à Paris au XIXe siècle. Evolution de l'humanité. Albin Michel.

De Leiris, Alain. 1969. The Drawings of Edouard Manet. California Studies in the History of Art 10. University of California Press.

Denis, Maurice. 1932. Henry Lerolle et ses amis: Suivi de quelques lettres d'amis. Imprimerie Duranton.

Des Cars, Laurence. 2007. "Acqusitions: James Jacques Joseph Tissot." 48/14: Revue du Musée d'Orsay 25 (Autumn), pp. 42–43.

De Waal, Edmund. 2011. The Hare with Amber Eyes: A Family's Century of Art and Loss. Farrar, Straus and Giroux.

De Young, Justine. 2009. "Women in Black: Fashion, Modernity and Modernism in Paris, 1860–1890." Ph.D. diss., Northwestern University.

———. 2011. "'Housewife or Harlot': Art, Fashion and Morality in the Paris Salon of 1868." In Cultures of Femininity in Modern Fashion, ed. Ilya Parkins and Elizabeth M. Sheehan, pp. 124–47. Becoming Modern. University of New Hampshire Press.

Diaz, B. 2011. "Marie Bashkirtcheff (1858–1884): Portrait de l'artiste en jeune fille." Magasin du 19e siècle, pp. 92–99.

Dickens, Charles. 1963. Dombey and Son, ed. Edgar Johnson. Dell.

Disdéri, André-Adolphe-Eugène. 1862. L'Art de la photographie. Disderi.

Distel, Anne. 1990. Impressionism: The First Collectors., trans. Barbara Perroud-Benson. H. N. Abrams.

———. 2010. Renoir. Abbeville Press.

———, et al. 1995. Gustave Caillebotte: Urban Impressionist. Exh. cat. Musée d'Orsay/Art Institute of Chicago/Abbeville Press.

Dolan, Therese. 1994. "The Empress's New Clothes: Fashion and Politics in Second Empire France." Woman's Art Journal (Spring/Summer), pp. 22–28.

Dombrowski, André. 2006. "The Emperor's Last Clothes: Cézanne, Fashion, and 'L'Année Terrible." Burlington Magazine (Sept.), pp. 586–94.

Dragonetti, Roger. 1992. Un Fantôme dans le kiosque: Mallarmé et l'esthétique du quotidien. La Couleur des idées. Editions du Seuil.

Dreyfous, Maurice. 1913. Ce qu'il me reste à dire: un demi siècle de choses vues et entendues (1848–1900). Ollendorff.

Drucker, Michel. 1944. Renoir. Pierre Tisné.

Druick, Douglas, et al. 1988. Degas. Exh. cat. The Metropolitan Museum of Art/National Gallery of Canada.

D'Souza, Aruna. 2006. "Why the Impressionists Never Painted the Department Store." In The Invisible Flâneuse?: Gender, Public Space, and Visual Culture in Nineteenth-Century Paris, ed. Aruna D'Souza and Tom McDonough, pp. 128–47. Critical Perspectives in Art History. Manchester University Press.

———, and Tom McDonough, eds. 2006. The Invisible Flâneuse?: Gender, Public Space, and Visual Culture in Nineteenth-Century Paris. Critical Perspectives in Art History. Manchester University Press.

Duranty, Edmond. 1876. La Nouvelle peinture. E. Dentu.

———. 1988. La nouvelle peinture (1876). L'Échoppe.

———. 1998. "Edmond Duranty (1833–1880) from The New Painting." In Art in Theory, 1815–1900: An Anthology of Changing Ideas, ed. Charles Harrison, Paul Wood, and Jason Gaiger, pp. 576–85. Blackwell.

Duret, Théodore. 1878. Les Peintres Impressionnistes. Heymann et J. Perois.

Duvernois, Isabelle. 2010. "A Technical Study of Henry Lerolle's Organ Rehearsal." Metropolitan Museum Journal 45, pp. 217–24.

Emery, J. Spanabel. 1997. "Development of the American Commercial Pattern Industry: The First Generation, 1850–1880." Costume 31, pp. 78–91.

Farrell, Jeremy. 1985. Umbrellas and Parasols. B. T. Batsford/Drama Book Publishers.

Farwell, Beatrice. 1990. "Manet, Morisot, and Propriety." In Perspectives on Morisot, ed. T. J. Edelstein, pp. 45–56. Hudson Hills Press/Rizzoli.

Felski, Rita. 1995. The Gender of Modernity. Harvard University Press.

Flaubert, Gustave. Correspondance, ed. Jean Bruneau. Gallimard.

Florisoone, Michel. 1938. "Renoir et la famille Charpentier: Lettres inédites," L'Amour de l'Art, Feb. 1938, pp. 31–40.

Flügel, John Carl. 1930. The Psychology of Clothes. Hogarth Press.

———. 1950. The Psychology of Clothes. Hogarth Press/Institute of Psychoanalysis.

Forgione, Nancy. 2005. "Everyday Life in Motion: The Art of Walking in Late-Nineteenth-Century Paris." Art Bulletin 87, 4 (Dec.), pp. 664–87.

Fournel, Victor. 1858. *Ce qu'on voit dans les rues de Paris*. A. Delahays.

Fraisse, Geneviève, and Michelle Perrot, eds. 2002. *Le XIXe Siècle*, vol. 4 of *Histoire de femmes en Occident*, ed. Georges Duby and Michelle Perrot. Perrin.

Frémy, Arnould. 1868. *Les Gens mal élevés*. M. Lévy frères.

Fried, Michael. 2002. "Caillebotte's Impressionism." In *Gustave Caillebotte and the Fashioning of Identity in Impressionist Paris*, ed. Norma Broude, pp. 66–116. Rutgers University Press.

Froidevaux, Gérald. 1989. *Baudelaire: Représentation et modernité*. J. Corti.

Fukai, Akiko, et al. 2002. *Fashion: Une Histoire de la mode du XVIIIè au XXè siècle, les collections du Kyoto Costume Institute*. Taschen.

Gaillard, Jeanne. 1977. *Paris, la ville, 1852–1870: L'Urbanisme parisien à l'heure d'Haussmann*. H. Champion.

Galassi, Peter. 1987. "Caillebotte's Method." In *Gustave Caillebotte*, ed. Kirk Varnedoe, pp. 27–40. Yale University Press.

Gamber, Wendy. 1997. *The Female Economy: The Millinery and Dressmaking Trades, 1860–1930*. Women in American History/The Working Class in American History. University of Illinois Press.

Garb, Tamar. 1998. *Bodies of Modernity: Figure and Flesh in Fin-de-Siècle France*. Interplay. Thames and Hudson.

———. 1999. "Painting the *Parisienne*: James Tissot and the Making of the Modern Woman." In *Seductive Surfaces: The Art of Tissot*, ed. Katherine Jordan Lochnan, pp. 95–120. Studies in British Art 6. Yale University Press.

Garelick, Rhonda K. 1998. *Rising Star: Dandyism, Gender, and Performance in the Fin de Siècle*. Princeton University Press.

Gaudriault, Raymond. 1988. *Répertoire de la gravure de mode française des origins à 1815*. Promodis.

Gautier, Théophile. 1858. *De la mode*. Poulet-Malassis et de Broise.

Gedo, Mary Mathews. 2010. *Monet and His Muse: Camille Monet in the Artist's Life*. University of Chicago Press.

Girardin, Emile de. 1986. *Lettres parisiennes du vicomte de Launay*, ed. Anne Martin-Fugier. Mercure de France.

Godfroy, Caroline Durand-Ruel, ed. *Correspondance de Renoir et Durand-Ruel*. La Bibliothèque des Arts, 1995.

Goncourt, Edmond de, and Jules de Goncourt. 1868. *Manette Salomon*. A. Lacroix, Verboeckhoven.

———. 1956. *Journal: Mémoires de la vie littéraire*, 3 vols., ed. Robert Ricatte. Fasquelle.

Grant, Carol Jane. 1994. "Eva Gonzales (1849–1883): An Examination of the Artist's Style and Subject Matter." Ph.D. diss., Ohio State University.

Groom, Gloria. 1993. *Édouard Vuillard: Painter-Decorator, Patrons and Projects, 1892–1912*. Yale University Press.

Guégan, Stéphane, et al. 2011. *Manet: Inventeur du moderne*. Exh. cat. Gallimard/Musée d'Orsay.

Guérin, Marcel, ed. 1945. *Lettres de Degas*. Rev. ed. B. Grasset.

Haase, Birgit. 2001. "'All diese Farben von wunderbarer Schönheit . . . ' Die ersten synthetischen Textilfarbstoffe im 19. Jahrhundert." In *Berliner Chic— Mode von 1820 bis 1990*, ed. Christine Waidenschlager, pp. 25–33. Exh. cat. Stiftung Stadtmuseum.

———. 2002. *Fiktion und Realität: Untersuchungen zur Kleidung und ihrer Darstellung in der Malerei am Beispiel von Claude Monets "Femmes au jardin."* VDG.

———. 2005. "'Une toilette vaut un tableau'—Impressionismus und Mode." In *Monet und Camille: Frauenportraits im Impressionismus*, ed. Dorothee Hansen and Wulf Herzogenrath, pp. 228–37. Exh. cat. Hirmer.

———. 2010. "'Les toilettes politiques'— Mode und Staatsräson im Second Empire." In *Kleidung im Bild—Zur Ikonologie dargestellter Gewandung*, ed. Philipp Zitzlsperger, pp. 181–93. Textile Studies 1. Edition Imorde.

———. 2012. "'La passante'—Die Promenade als Modeschauplatz im Zeitalter des Impressionismus." In *Die Räume der Mode*, ed. Gertrud Lehnert, pp. 33–55. Wilhelm Fink.

Hall-Duncan, Nancy. 1979. *The History of Fashion Photography*. Exh. cat. Alpine Book Co.

Hamilton, George Heard. 1954. *Manet and His Critics*. Yale Historical Publications 7. Yale University Press.

Hansen, Dorothee. 2005. *Monet and Camille: Portraits of Women in Impressionism*. Exh. cat. Kunsthalle Bremen.

———, and Wulf Herzogenrath, eds. 2005. *Monet und Camille: Frauenportraits im Impressionismus*. Exh. cat. Hirmer.

Hanson, Anne Coffin. 1977. *Manet and the Modern Tradition*. Yale University Press.

Harent, Sophie, and Michèle Leinen. 2005. *Méry Laurent, Manet, Mallarmé et les autres*. Exh. cat. Artlys/Musée des Beaux-Arts de Nancy.

Herbert, Robert L. 1988. *Impressionism, Art, Leisure, and Parisian Society*. Yale University Press.

———. 1991. *Georges Seurat, 1859–1891*. Exh. cat. The Metropolitan Museum of Art/Abrams.

———. 2000. *Nature's Workshop: Renoir's Writings on the Decorative Arts*. Yale University Press.

———. 2004. *Seurat and the Making of "La Grande Jatte."* Exh. cat. Art Institute of Chicago/University of California Press.

Hermitage Museum. 1995. *Hidden Treasures Revealed: Impressionist Masterpieces and Other Important French Paintings Preserved by the State Hermitage Museum, St. Petersburg*. The State Hermitage Museum/H. N. Abrams.

Heydt, Imre von der. 2007. *Une Cigarette?: Défense lucide d'une passion*, trans. Philippe Abry. Actes Sud.

Higonnet, Anne. 1990. *Berthe Morisot*. Harper and Row.

———. 1992. *Berthe Morisot's Images of Women*. Harvard University Press.

Hiner, Susan. 2010. *Accessories to Modernity: Fashion and the Feminine in Nineteenth-Century France*. University of Pennsylvania Press.

Hollander, Anne. 1978. *Seeing through Clothes*. Viking Press.

———. 1994. *Sex and Suits: The Evolution of Modern Dress*. Knopf/Random House.

———. 2002. *Fabric of Vision: Dress and Drapery in Painting*. Exh. cat. National Gallery/Yale University Press.

Homer, William Innes. 1964. *Seurat and the Science of Painting*. MIT Press.

Hornborstel, Wilhelm, ed. 1991. *Voilà: Glanzstücke historischer Moden 1750–1960*. Exh. cat. Museum für Kunst und Gewerbe/Prestel.

Hoschedé, Jean-Pierre. 1960. *Claude Monet, ce mal connu: Intimité familiale d'un demi-siècle à Giverny de 1883 à 1926*, vol. 2. P. Cailler.

House, John. 1980. "Meaning in Seurat's Figure Paintings." *Art History* 3, 3 (Sept.), pp. 345–56.

———, and Anne Distel, eds. 1985. *Renoir*. Exh. cat. Editions de la Réunion de Musées Nationaux.

Houssaye, Arsène. 1869. *Les parisiennes: Les Femmes Déchues*, 4 vols. E. Dentu.

———. 1875. *Les mille et une nuits parisiennes*, 4 vols. E. Dentu.

———. 1881. *Life in Paris: Letters on Art, Literature, and Society*. Worthington.

———. 1885. *Les Confessions: Souvenirs d'un demi-siècle, 1830–1880*, vol. 2. E. Dentu.

Huysmans, Joris-Karl. 1883. *L'Art moderne*. G. Charpentier.

———. 1923. *L'Art moderne*. Plon-Nourrit.

———. 2006. *Ecrits sur l'art 1867–1905*. Bertillat.

Isaacson, Joel. 1967. "The Early Paintings of Claude Monet." Ph.D. diss., University of California, Berkeley.

———. 1972. *Monet: "Le Déjeuner sur l'herbe."* Art in Context. A. Lane.

———. 1978. *Claude Monet: Observation and Reflection*. Phaidon/Dutton.

Iskin, Ruth E. 2007. *Modern Women and Parisian Consumer Culture in Impressionist Painting*. Cambridge University Press.

Ives, Colta. 1988. "French Prints in the Era of Impressionism and Symbolism." *Metropolitan Museum of Art Bulletin* 46, 1 (July 1), pp. 1–56.

———, and Susan Alyson Stein. 2002. *The Lure of the Exotic: Gauguin in New York Collections*. Exh. cat. The Metropolitan Museum of Art, New York.

Jachimowicz, E. 1990. "Where to Shop in 1890, the European Addresses of a Chicago Lady." In *Aspects of Costume, the 19th Century*, ed. Mariliina Perkko, pp. 10–16. International Costume Committee, International Council of Museums.

Jerrold, W. Blanchard. 1864. *At Home in Paris: And a Trip through the Vineyards to Spain*. W. H. Allen and Co.

Johnston, Lucy, et al. 2005. *Nineteenth-Century Fashion in Detail*. V&A Publications/Harry N. Abrams.

Ken, Alexandre. 1864. *Dissertations historiques, artistiques et scientifiques sur la photographie*. Librairie nouvelle.

Kendall, Richard, and Griselda Pollock, eds. 1991. *Dealing with Degas: Representations of Women and the Politics of Vision*. Pandora Press.

Kessler, Marni. 2006a. "Dusting the Surface, or the Bourgeoisie, the Veil, and Haussmann's Paris." In *The Invisible Flâneuse? Gender, Public Space, and Visual Culture in Nineteenth-Century Paris*, ed. Aruna D'Souza and Tom McDonough, pp. 49–64. Critical Perspectives in Art History. Manchester University Press.

———. 2006b. *Sheer Presence: The Veil in Manet's Paris*. University of Minnesota Press.

Kinney, Leila W. 1996. "Fashion and Figuration in Modern Painting." In *Architecture in Fashion*, ed. Deborah Fausch, pp. 270–313. Princeton Architectural Press/Chronicle Books.

Lafenestre, Georges. 1885. *Le Livre d'or du salon de peinture et de sculpture*. Librarie des bibliophiles.

Landgrebe, Bettia. 2005. "Die Restaurierung des Gemaldes *Camille von Claude Monet*, 1866." In Dorothee Hansen, *Monet and Camille: Portraits of Women in Impressionism*, pp. 276–85. Exh. cat. Kunsthalle Bremen.

Lannoy, Pauline de, and Antoine Terrasse. 2003. *Mallarmé et "La Dernière mode": Velours et guipure*. Exh. cat. Musée Départemental Stéphane Mallarmé.

Laprade, Victor de. 1861. *Questions d'art et de morale*. 2nd ed. Didier et Cie.

Larousse, Pierre. 1867. *Grand dictionnaire universel du XIXe siècle*. Larousse et Boyer.

Lecadre, J. M. 1995. "Auguste Toulmouche (1829–1890)." Ph.D. diss., Université de Rennes II.

Lecercle, Jean-Pierre. 1989. *Mallarmé et la mode*. Séguier.

Lefebvre, Christiane. 2006. *Alfred Stevens, 1823–1906*. Brame and Lorenceau.

Lehmann, Ulrich. 2000. *Tigersprung: Fashion in Modernity*. MIT Press.

———. 2009. "Markets for Modernity." In *Fashion and Imagination: About Clothes and Art*, ed. Jan Brand, José Teunissen, and Catelijne de Muijnck, pp. 58–71. ArtEZ Press/D'Jonge Hond.

Lemonnier, Camille. 1888. *Le Peintres de la vie*. A. Savine.

Lipton, Eunice. 1986. *Looking into Degas: Uneasy Images of Women and Modern Life*. University of California Press.

Lobstein, Dominique. 1994. "45: Portrait de jeune femme." *Revue du Louvre* 43, 3 (June), p. 83.

Lochnan, Katharine Jordan, ed. 1999. *Seductive Surfaces: The Art of Tissot*. Studies in British Art 6. Yale University Press.

Loir, Christophe. 2009. *Bruxelles néoclassique: Mutation d'une espace urbaine, 1775–1840*. CFC.

Loyer, François. 1987. *Paris XIXe siècle: L'Immeuble et la rue*. Hazan.

———, and Helène Guéné. 1987. *Henri Sauvage: Les Immeubles à gradins*. Mardaga.

MacDonald, Margaret F., et al. 2003. *Whistler, Women, and Fashion*. Exh. cat. Frick Collection/Yale University Press.

Maeder, Edward. 1999. "Decent Exposure: Status, Excess, the World of Haute Couture, and Tissot." In *Seductive Surfaces: The Art of Tissot*, ed. Katherine Jordan Lochnan, pp. 77–94. Studies in British Art 6. Yale University Press.

Mainardi, Patricia. 1993. "Moral Order in the Fine Arts." In *The End of the Salon: Art and the State in the Early Third Republic*, pp. 37–55. Cambridge University Press.

Mallarmé, Stéphane. 1933. *La Dernière mode*. Institute of French Studies, Inc.

———. 1945. *Oeuvres completes*, ed. Henri Mondor and G. Jean-Aubry. Bibliothèque de la Pléiade 65. Gallimard.

———. 1959. *Correspondance, 1862–1871*, ed. Henri Mondor with Jean-Pierre Richard. Gallimard.

Marcheti, Luca. 2009. "From the Object to the Invisible." In *Fashion and Imagination: About Clothes and Art*, ed. Jan Brand, José Teunissen, and Catelijne de Muijnck, pp. 168–83. ArtEZ Press/D'Jonge Hond.

Marshall, Nancy Rose, and Malcolm Warner. 1999. *James Tissot: Victorian Life, Modern Love*. Exh. cat. American Federation of Arts/Yale University Press.

Mathews, Nancy Mowll. 1981. *Mary Cassatt and Edgar Degas*. Exh. cat. San Jose Museum of Art.

———. 1994. *Mary Cassatt: A Life*. Villard Books.

———, ed. 1984. *Cassatt and Her Circle: Selected Letters*. Abbeville Press.

———, and Barbara Stern Shapiro. 1989. *Mary Cassatt: The Color Prints*. Williams College/H. N. Abrams.

Matyjaszkiewicz, Krystyna, ed. 1984. *James Tissot*. Exh. cat. Phaidon Press/Barbican Art Gallery.

Mauer, Emil. 1983. "Zur Krise des Bildnisses im Impressionismus: Skizzen und Beiträge zu Monet." In *Von Angesicht zu Angesicht: Porträtstudien, Michale Stettler zum 70, Geburtstag*, ed. Florens Deuchler, Mechthild Flury-Lemberg, and Karel Otavsky, pp. 275–85. Stämpfli.

Mayer, Ernest. 1859. "Chacun Pose." In *La Photographie Mayer frères et Pierson aux Frères Provençaux*, p. 5. Imp. centrale de N. Chaix.

McCauley, Elizabeth Anne. 1985. *A. A. E. Disdéri and the Carte de Visite Portrait Photograph*. Yale University Press.

Meier-Graefe, Julius. 1912. *Auguste Renoir*. H. Floury.

Mémoires. 1866. *Mémoires d'une modiste écrits par elle-même*. F. Cournol.

Metternich-Sándor, Pauline. 1922. Éclairs du passé (1859–1870). Amalthea Verlag.

Meyer, Virginie. 2005. *Georges Charpentier (1846–1905): Figure d'éditeur*. Ph.D. diss., l'Ecole Pratique des Hautes Etudes.

Milbank, Caroline Rennolds. 2000. "Ahead of the World: New York City Fashion." In Catherine Hoover Voorsanger and John K. Howat, eds., *Art and the Empire City, New York, 1825–1861*, pp. 243–57. Exh. cat. The Metropolitan Museum of Art/Yale University Press.

Mitchell, Louise. 1997. *Stepping Out: Three Centuries of Shoes*. Powerhouse.

Mitterand, Henri. 2001. *Zola: L'homme de Germinal 1871–1893*. Fayard.

Moffett, Charles S. 1986. *The New Painting, Impressionism, 1874–1886*. Exh. cat. R. Burton/University of Washington Press.

Mollier, Jean-Yves. 1988. *L'Argent et les lettres. Histoire du Capitalisme d'Edition*. Fayard.

Moore, George. 1889. *Confessions d'un jeune anglais*. Nouvelle Librairie Parisienne.

Moreau-Vauthier, Charles. 1903. *Les Chefs-d'oeuvre des grands maîtres*. Hachette.

Mortemart de Boisse, François-Jérôme-Léonard de. 1857. *La Vie élégante à Paris*. L. Hachette.

Musée de la Mode et du Costume. 1992. *Au Paradis des dames: Nouveautés, modes et confections, 1810–1870*. Exh. cat. Editions Paris-Musées.

Musée d'Orsay. 2000. *La Dame aux éventails: Nina de Callias, modèle de Manet*. Exh. cat. Réunion des Musées Nationaux.

Musée Galliera. 2008. *Sous l'empire des crinolines*. Exh. cat. Paris-Musées.

Musées de la Ville de Paris. 1995. *Le Dessin sous toutes ses coutures*. Exh. cat. Paris-Musées.

Nadault de Buffon, Henri. 1870. *Notre ennemi le luxe*. 2nd ed. Furne, Jouvet.

Nead, Lynda. 1992. *The Female Nude: Art, Obscenity, and Sexuality*. Routledge.

Needham, Gerald. "The Paintings of Claude Monet, 1859–1878." Ph.D. diss., New York University.

Nicholson, Benedict. 1960. "The Recovery of a Degas Race Course Scene." *Burlington Magazine* 102, 693 (Dec.), pp. 534–37.

Nochlin, Linda. 1989. "Seurat's La Grande Jatte: An Anti-Utopian Allegory." In *The Politics of Vision: Essays on Nineteenth-Century Art and Society*, pp. 170–93. Harper and Row.

O'Brien, Maureen C., ed. 2005. *Edgar Degas: Six Friends at Dieppe*. Exh. cat. Museum of Art, Rhode Island School of Design.

Pakenham, Michael. "Une muse, une femme." In Musée d'Orsay, *La Dame aux éventails: Nina de Callias, modèle de Manet*. Exh. cat. Réunion des Musées Nationaux.

Pansu, Henri. 2003. *Claude-Joseph Bonnet: Soierie et société à Lyron et en Bugey au XIXe siècle*. H. Pansu.

Parrot, Nicole. 2002. *Le Stiff et le cool: Une Histoire de maille, de mode et de liberté*. NIL.

Patry, Sylvie. 2009. "Renoir et la décoration, 'un plaisir sans pareil,'" in Sylvie Patry and Claudia Einecke, eds., *Renoir au XXe siècle*, pp. 44–59. Réunion des Musées Nationaux/Musée d'Orsay.

Pellerin, Denis. 1995. *La Photographie stéréoscopique sous le Second Empire.* Bibliothèque Nationale de France.

Pellier, Jules. 1987. *La Selle et le costume de l'amazone.* J-M Place.

Perrot, Philippe. 1981. *Les Dessus et les dessous de la bourgeoisie.* Fayard.

———. 1994. *Fashioning the Bourgeoisie: A History of Clothing in the Nineteenth Century,* trans. Richard Bienvenu. Princeton University Press.

Pissarro, Camille. 1943. *Letters to His Son Lucien,* ed. John Rewald with Lucien Pissarro, trans. Lionel Abel. K. Paul, Trench, Trubner.

Pollock, Griselda. 1988. *Vision and Difference: Femininity, Feminism, and Histories of Art.* Routledge.

Potvin, John, ed. 2009. *The Places and Spaces of Fashion, 1800–2007.* Routledge Research in Cultural and Media Studies 16. Routledge.

Prévost, Gabriel. 1884. *Le Nu, le vêtement, la parure chez l'homme et chez la femme.* Paris.

Proudhon, Pierre J. 1865. *Du Principe de l'art et de sa destination sociale.* Garnier frères.

Proust, Marcel. 1995. *Le Temps retrouvé.* Robert Laffont.

Racinet, Auguste. 1888. *Le Costume historique.* Firmin-Didot et cie.

Raeburn, Michael. 1985. *Renoir.* Exh. cat. Arts Council of Great Britain.

Recueil des actes. 1876. *Recueil des actes administratifs de la préfecture du department de la Seine,* vol. 4. 1876. Paul Dupont.

Reed, Sue Welsh, and Barbara Stern Shapiro. 1984. *Edgar Degas: The Painter as Printmaker.* Exh. cat. Museum of Fine Arts.

Reff, Theodore. 1968. "Some Unpublished Letters of Degas." *Art Bulletin* 50, 1 (Mar.), pp. 87–94.

———. 1976. *The Notebooks of Edgar Degas: A Catalogue of the Thirty-Eight Notebooks in the Bibliothèque Nationale and Other Collections.* 2 vols. Clarendon Press.

———. 1987. *Degas: The Artist's Mind.* Belknap Press.

Rey, Xavier. 2011. "*Le Cercle de la rue Royale* (1868) de James Tissot." *La Revue des Musées de France. Revue du Louvre* 61, 5 (Dec.), pp. 21–22.

Ribeiro, Aileen. 1986. *Dress and Morality.* B. T. Batsford.

———. 1999. *Ingres in Fashion: Representations of Dress and Appearance in Ingres's Images of Women.* Yale University Press.

———. 2008. "The Art of Dress: Fashion in Renoir's *La Loge,*" pp. 45–63. In *Renoir at the Theatre: Looking at La Loge,* exh cat, ed. Ernst Vegelin van Claerbergen and Barnaby Wright. Courtauld Gallery/Paul Holberton Pub.

Rimsky-Korsakow, Mme. 1863. *Une Saison à Paris.* E. Dentu.

Rivière, Georges. 1921. *Renoir et ses amis.* H. Floury.

Robida, Michel. 1955. *Ces Bourgeois de Paris: Trois siècles de chronique familiale de 1675 à nos jours.* Julliard.

———. 1958. *Le Salon Charpentier et les impressionistes.* Bibliothèque des Arts.

Roos, Jane Mayo. 1999. *A Painter's Poet: Stéphane Mallarmé and His Impressionist Circle.* Exh. cat. Bertha and Karl Leubsdorf Art Gallery/Bibliothèque Littéraire Jacques Doucet.

Root, M. A. 1864. *The Camera and the Pencil, or the Heliographic Art.* Lippincott/Appleton.

Rosenblum, Robert. 1977. "Gustave Caillebotte: The 1970s and the 1870s." *Artforum* 15 (Mar.), pp. 46–52.

Roskill, Mark. 1970. "Early Impressionism and the Fashion Print." *Burlington Magazine* 112, 807 (June 1), pp. 391–95.

Sagraves, Julia. 1995. "The Street." In Anne Distel et al., *Gustave Caillebotte: Urban Impressionist,* pp. 88–101. Exh. cat. Art Institute of Chicago/Abbeville Press.

Sainsaulieu, Marie-Caroline, and Jacques de Mons. 1990. *Eva Gonzales: 1849–1883: Étude critique et catalogue raisonné.* Bibliothèque des Arts.

Salomon, Jacques. 1968. *Vuillard.* Gallimard.

Le Savoir-vivre. 1884. *Le Savoir-vivre et la politesse.* T. Lefèvre.

Scart, Brigitte. 1977. *L'Atelier Nadar et la mode, 1865–1913.* Exh. cat. Imp. Chiffolean.

Schirrmeister, Anne. 1990. "La Dernière Mode: Berthe Morisot and Costume." In *Perspectives on Morisot,* ed. T. J. Edelstein, pp. 103–15. Hudson Hills Press/Rizzoli.

Schoonbaert, Sylvain. 2007. *Le Voirie bordelaise au XIXe siècle.* PUPS.

Seitz, William C. 1988. *Claude Monet.* DuMont.

Shackelford, George T. M. 1984. *Degas: The Dancers.* Exh. cat. National Gallery of Art.

———. 1998. "*Pas de deux*: Mary Cassatt and Edgar Degas." In *Mary Cassatt: Modern Woman,* ed. Judith A. Barter, pp. 109–43. Exh. cat. Art Institute of Chicago/H. N. Abrams.

Simmel, Georg. 1997. "The Philosophy of Fashion." In *Simmel on Culture: Selected Writings,* ed. David Frisby and Mike Featherstone, pp. 187–206. Sage Publications.

Simon, Marie. 1995a. *Fashion in Art: The Second Empire and Impressionism.* Zwemmer.

———. 1995b. *Mode et peinture: Le Second Empire et l'impressionnisme.* Hazan.

Simons, Patricia. 1992. "Woman in Frames: The Gaze, the Eye, the Profile in Renaissance Portraiture." In *The Expanding Discourse: Feminism and Art History,* ed. Norma Broude and Mary D. Garrard, pp. 39–57. WestView Press.

Sloane, Joseph C. 1951. *French Painting between the Past and the Present.* Princeton University Press.

Smith, Paul. 1995. *Impressionism: Beneath the Surface.* Harry N. Abrams.

Solomon-Godeau, Abigail. 1986. "The Legs of the Countess." *October* 39 (Winter), pp. 65–108.

Spate, Virginia. 1992. *Claude Monet: The Colour of Time.* Thames and Hudson.

Stadler, Eva Maria. 2001. "Mallarmé's *La Dernière Mode*: The Poet as Journalist." *Antemnae,* pp. 258–73.

Steele, Valerie. 1985. *Fashion and Eroticism: Ideals of Feminine Beauty from the Victorian Era to the Jazz Age.* Oxford University Press.

———. 1988. *Paris Fashion: A Cultural History.* Oxford University Press.

———. 1998. *Paris Fashion: A Cultural History.* 2nd ed. Berg.

———. 2001. *The Corset: A Cultural History.* Yale University Press.

Stein, Susan, and Asher Miller, eds. 2009. *The Annenberg Collection: Masterpieces of Impressionism and Post-Impressionism.* The Metropolitan Museum of Art/Yale University Press.

Sterckx, Marjan. 2010. "Alfred Stevens." *Nineteenth Century Art History Worldwide* 9, 1 (Spring). http://www.19thc-artworldwide.org/index.php/spring10/alfred-stevens.

Strauber, Susan. 2006. "Manet's *Portrait of Jeanne Duval. Baudelaire's Mistress Reclining*: Femininity, Modernity and New Painting." In Sidsel Maria Søndergaard, ed., *Women in Impressionism: From Mythical Feminine to Modern Woman,* pp. 99–133. Exh. cat. Skira.

Stuckey, Charles F., and William P. Scott. 1987. *Berthe Morisot, Impressionist.* Exh. cat. Hudson Hills Press/Rizzoli.

Syndicat des entreprises de vente par correspondence. 1984. *Souvenirs de catalogues.* Syndicat de la V. P. C.

Tabarant, Adolphe. 1931. *Manet: Histoire catalographique.* Éd. Montaigne.

———. 1947. *Manet et ses oeuvres.* 2nd ed. Gallimard.

Taine, Hippolyte. 1866. *Voyage en Italie.* Hachette.

———. 1867a. *De l'idéal dans l'art.* G. Baillière.

———. 1867b. *Notes sur Paris: Vie et opinions de M. Frédéric-Thomas Graindorge recueillies et publiées par H. Taine, son exécuteur testamentaire.* L. Hachette & Cie, 1867.

———. 1874. *On the Ideal in Art,* trans. J. Durand. Henry Holt and Company.

———. 1888. *Notes on Paris,* trans. John Austin Stevens. Henry Holt and Company, 1888.

Tétart-Vittu, Françoise. 1990. "Le Chic parisien: Images et modèles dans la presse illustrée." In *Femmes fin de siècle, 1885–1895,* pp. 93–101. Paris-Musées.

———. 1992. "The French-English Go-Between: Le Modèle de Paris or the Beginning of the Designer, 1820–1880." *Costume* 26 (1992), pp. 40–45.

———. 1995a. "Des Menus Plaisirs au studio de couture." In Musées de la Ville de Paris, *Le Dessin sous toutes ses coutures*, pp. 25–39. Exh. cat. Paris-Musées.

———. 1995b. "L'Art de la mode, une idée du XIXe siècle." In Musées de la Ville de Paris, *Le Dessin sous toutes ses coutures*, pp. 113–17. Exh. cat. Paris-Musées.

———. 1998. "La Maison Duluc soeurs." In *Félicien Rops, Rops suis, aultre ne veulx estre*, ed. Bernadette Bonnier, pp. 68–71. Exh. cat. Complexe.

———. 2003. "Auguste Racinet's *Le Costume historique*, a Monumental Nineteenth-Century Achievement." In Auguste Racinet, *The Complete Costume History*, pp. 8–19. Taschen.

———. 2008. "Petits costumes et robes courtes." In *Sous l'Empire des Crinolines*, pp. 104–09. Exh. cat. Musée Galliera.

Thomas, Greg M. 2006. "Women in Public: The Display of Femininity in the Parks of Paris." In *The Invisible Flâneuse?: Gender, Public Space, and Visual Culture in Nineteenth-Century Paris*, ed. Aruna D'Souza and Tom McDonough, pp. 32–48. Critical Perspectives in Art History. Manchester University Press.

Thomine, Alice. 1999. "Administration et architecture: L'Exemple de la ville de Paris (1850–1900)." *Cahiers de la rotonde* 21, pp. 121–46.

Thomson, Richard. 1985. *Seurat*. Phaidon/Salem House.

———. 1989. "The Grande Jatte: Notes on Drawing and Meaning." *Museum Studies* 14, 2, pp. 181–97.

———. 1997. "Representing the Modern: The Bathers and Its Contexts." In John Leighton and Richard Thomson, *Seurat and the Bathers*, pp. 96–105. National Gallery Publications/Yale University Press.

Tiersten, Lisa. 2001. *Marianne in the Market: Envisioning Consumer Society in Fin-de-Siècle France*. University of California Press.

Tinterow, Gary. 2003. "The Second Empire: 1852–1870." In *The Art and Spirit of Paris*, ed. Michel Laclotte, vol. 2, pp. 906–1017. Abbeville Press.

———, and Henri Loyrette. 1994. *Origins of Impressionism*. Exh. cat. The Metropolitan Museum of Art/Harry N. Abrams.

Tucker, Paul. 1986. "The First Impressionist Exhibition in Context." In *The New Paintings: Impressionism 1874–1886*, ed. Charles S. Moffett, pp. 93–117. Exh. cat. R. Burton/University of Washington Press.

———. 1995. *Claude Monet: Life and Art*. Yale University Press.

Ulbach, Louis. 1878. *Guide sentimental de l'étranger dans Paris*. C. Levy.

Union Centrale des Beaux-Arts Appliqués à l'Industrie. 1874. *Union Centrale des Beaux-Arts Appliqués à l'Industrie: Quatrième exposition, 1874, Musée Historique du Costume*. Exh. cat. Chaix.

Uzanne, Octave. 1883. *L'Ombrelle, le gant, le manchon*. A. Quantin.

———. 1902. *L'Art et les artifices de la beauté*. Felix Juven.

Van Zanten, David. 2010. "Paris Space: What Might Have Constituted Haussmannization." In *Manifestoes and Transformation in the Early Modernist City*, ed. Christian Hermansen Cordua, pp. 179–210. Ashgate.

Varnedoe, Kirk. 1987. *Gustave Caillebotte*. Yale University Press.

———. 1995. "Odd Man In." In Anne Distel et al., *Gustave Caillebotte: Urban Impressionist*, pp. 13–16. Exh. cat. Musée d'Orsay/Art Institute of Chicago/Abbeville Press.

Veblen, Thorstein Bunde. 1899. *The Theory of the Leisure Class: An Economic Study of Institutions*. Macmillan Company.

Viollet-le-Duc, Eugène-Emmanuel. 1872. *Entretiens sur l'architecture*, vol. 2. Morel.

Vollard, Ambroise. 1920. *Auguste Renoir*. G. Crès et Cie.

———. 1961. *August Renoir: Gespräche und Erinnerungen*. Arche.

———. 1994. *En écoutant Cézanne, Degas, Renoir*. Bernard Grasset, 1994.

Wadley, Nicholas. 1987. *Renoir: A Retrospective*. H. L. Levin Associates/Macmillan Pub. Co.

Waelti-Walters, Jennifer, and Steven C. Hause, eds. 1994. *Feminisms of the Belle Epoque: A Historical and Literary Anthology*. University of Nebraska Press.

Waller, Susan. 2006. *The Invention of the Model: Artists and Models in Paris, 1830–1870*. Ashgate.

Ward, Martha. 1986. "The Rhetoric of Independence and Innovation." In Charles S. Moffett, *The New Painting: Impressionism, 1874–1886*, 2nd ed., pp. 421–42. Exh cat. Fine Arts Museums of San Francisco.

———. 1996. *Pissarro, Neo-Impressionism, and the Spaces of the Avant-Garde*. University of Chicago Press.

Waugh, Norah. 1968. *The Cut of Women's Clothes, 1600–1930*. Faber.

Weitzenhoffer, Frances. 1986. *The Havemeyers, Impressionism Comes to America*. H. N. Abrams.

Wells, William. 1972. "Who Was Degas's Lyda?" *Apollo* 95, pp. 129–34.

Wentworth, Michael. 1984. *James Tissot*. Oxford Studies in the History of Art and Architecture. Clarendon Press/University of Oxford Press.

Westfehling, Uwe. 1974. "J. I. Hittorffs Pläne für ein Denkmalsforum in Paris." *Wallraf-Richartz-Jahrbuch* 36, pp. 273–94.

White, Barbara Ehrlich. 1984. *Renoir: His Life, Art, and Letters*. Abrams.

Wildenstein, Daniel. 1974. *Claude Monet*, vol. 1. Bibliothèque des Arts.

———. 1979. *Claude Monet*, vol. 3. Bibliothèque des Arts.

———. 1996. *Monet, or the Triumph of Impressionism*, vol. 2. Taschen/Wildenstein Institute.

———. 1999. *Monet, or the Triumph of Impressionism*. Taschen.

Wilson-Bareau, Juliet. 2011. "The Manet Exhibition in Paris, 2011." *Burlington Magazine* 153, 1305 (Dec.), pp. 816–24.

———. 2012. "Manet's 'Amazon': A Final Salon Painting," *Burlington Magazine* 154, 1309 (Apr. 2012), pp. 256–59.

Wolff, Janet. 1988. "The Culture of Separate Spheres: The Role of Culture in Nineteenth-Century Public and Private Life." In *The Culture of Capital: Art, Power, and the Nineteenth-Century Middle Class*, ed. Janet Wolff and John Seed, pp. 117–34. Manchester University Press.

Wood, Christopher. 1986. *Tissot: The Life and Work of Jacques Joseph Tissot, 1836–1902*. Little, Brown.

Zimmermann, Michael F. 1989. "Seurat, Charles Blanc, and Naturalist Art Criticism." *Museum Studies* 14, 2, pp. 198–209, 246–47.

Zola, Émile. 1883. *Au Bonheur des Dames*. Georges Charpentier.

———. 1959. *Salons*, ed. F. W. J. Hemmings and Robert J. Niess. Société de publications romanes et françaises 63. Minard and E. Droz.

———. 1968. *Au Bonheur des dames*. Livre de Poche/Fasquelle.

———. 1984. *La Curée*, ed. Philippe Bonnefis. Pasquelle.

———. 1986. *Carnets d'enquêtes: Une Ethnographie inédite de la France*, ed. Henri Mitterand. Plon.

———. 1991. *Ecrits sur l'art*, ed. Jean-Pierre Leduc-Adine. Gallimard.

———. 1998a. *The Ladies' Paradise*, trans. Brian Nelson. Oxford University Press.

———. 1998b. *Pot-bouille*, ed. Marie-Ange Voisin-Fougère. Librairie générale française.

———. 2008. *The Ladies' Paradise*. Oxford University Press.

Zuccari, Frank, and Alison Langley. 2004. "Seurat's Working Process: The Compositional Evolution of La Grande Jatte." In Robert Herbert, *Seurat and the Making of "La Grande Jatte,"* pp. 178–93. Exh. cat. Art Institute of Chicago/University of California Press.

Index

Numbers in **bold** refer to pages with illustrations. All sections have been indexed, including the chronology, checklist, and appendixes.

Photography Credits

FSC
www.fsc.org
MIX
Paper from responsible sources
FSC® C016114